The Rita & Frits Markus Collection
of European Ceramics & Enamels

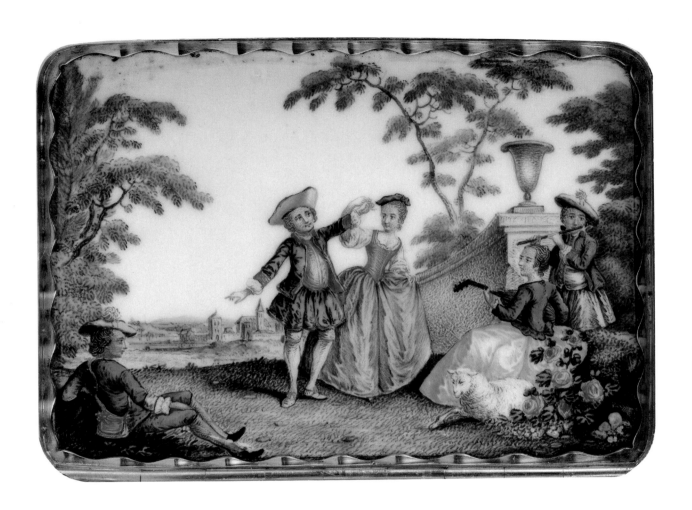

The Rita & Frits Markus Collection
of European Ceramics & Enamels

VIVIAN S. HAWES, CHRISTINA S. CORSIGLIA,
and members of the staff of the Department of European Decorative Arts and Sculpture

Museum of Fine Arts, Boston

Copyright © 1984 by
Museum of Fine Arts, Boston, Massachusetts
ISBN: 0-87846-238-4
Library of Congress Catalogue Card Number: 83-63520
Typeset by Schooley Graphics, Dayton, Ohio
Printed by The Meriden Gravure Company, Meriden, Con-
necticut, and The Stinehour Press, Lunenburg, Vermont
Photographs by Lynn Diane De Marco
Designed by Carl Zahn

Cover and Frontispiece:
No. 46. Snuffbox
Germany, Meissen, about 1745-1750
Detail of base and interior of lid

Contents

The subject of this catalogue is the collection of seventeenth- and eighteenth-century European faience, porcelain, and enamels that was formed by Rita and Frits Markus in the years between 1945 and 1982. Mr. Markus became interested in porcelain in Holland as a young man, when he saw two notable private collections of ceramics in Amsterdam. His first acquisition was made when he was seventeen years old, and he steadily added objects as he found them and could afford them. This first collection was lost during the war. Mr. and Mrs. Markus moved to New York in 1941 and a few years later began again to make acquisitions, gradually adding to and refining their ceramics collection.

Never purchasing their works of art at auction, the Markuses preferred to acquire through a small group of dealers. Their most active years of collecting were the 1950s and 1960s. Many of the major factories of Germany, Holland, France, and England are represented in their collection; tablewares predominate, but there is a small selection of figures.

Mr. and Mrs. Markus have presented this important collection to the Department of European Decorative Arts and Sculpture of the Museum of Fine Arts. In so doing they join a distinguished group of collectors whose generous donations to the museum have expanded and enriched our holdings in European ceramics and to a great extent given the collection its present scope and distinctive character.

Mr. and Mrs. Markus have also been generous in underwriting the research for and publication of the present catalogue. The authors of the catalogue were thus given the opportunity to study other important private and public collections of ceramics and enamels, both in Europe and in the United States, and were able to discover and compare objects related to the Markus pieces. In addition, it has been possible to fully illustrate the catalogue with photographs of each object and its marks.

This catalogue is the first publication of its type to be devoted to the museum's permanent collection of European decorative arts. It will serve as a lasting record of the extraordinary quality of the Markus Collection as well as of the enlightened generosity of the donors.

JAN FONTEIN
Director

The collection formed by Rita and Frits Markus is unusual in its diversity. Consisting of objects in faience, stoneware, soft- and hard-paste porcelain, and enamel from a number of different Continental and English factories, it covers a period of more than one hundred years, from about 1650 to about 1785. Although wares predominate, there are several figures in the collection, including pairs from Mennecy (no. 55), Chantilly (no. 54), and Meissen (no. 45).

Since the Markuses have also been interested in and collected Dutch seventeenth-century paintings and old master drawings, it is not surprising that the quality of painting on many of their ceramics and enamels is high and that there are numerous depictions of landscapes and seascapes as well as fruits and flowers on these objects. A large number of faience and porcelain pieces bear decorations inspired by Japanese or Chinese ceramics, which were first imported into Europe in the early seventeenth century by the Dutch East India Company.

Mr. and Mrs. Markus, who were born and educated in Holland, acquired some fine examples of Delft ware and Dutch porcelain. One of the outstanding Delft objects is the tobacco box and cover (no. 9), which was probably made at Het Oude Moriaenshooft (The Old Moor's Head) factory in the third quarter of the eighteenth century. Its *bombé* shape, inspired by earlier Dutch silver forms, is enhanced by skillfully painted river scenes.

The Markus gift will greatly strengthen the museum's holdings of Dutch porcelain. Consisting entirely of hard-paste wares manufactured at Loosdrecht and Amstel in the last quarter of the eighteenth century, this porcelain is characterized by fine monochromatic painting. The pair of bottles (no. 88) made at Loosdrecht in about 1775 and decorated in puce enamel and gold is representative of the production of that factory. The form of these bottles was inspired by examples made earlier at Meissen, while the painted decoration is typical of Loosdrecht wares. Also represented are wares that were decorated in the Hague at the workshop of Anton Lyncker, a well-known porcelain merchant: a covered cup and saucer (no. 86), made in Tournai, and a milk jug, teacup, and saucer (no. 87), made in Ansbach.

The largest and most important group of objects in the collection is the German ceramics. Numbering forty pieces, the group includes faience, stoneware, and hard-paste porcelain. Although most of the objects are from the Meissen factory, there are also wares from other major factories such as Fürstenberg and Ludwigsburg. Notable among the German faience is a wine jug, or *Enghalskrug* (no. 11), distinguished by the quality of its painted landscape decoration and contemporary silver mounts. Its long neck and bulbous body are typical of jugs produced by South German factories in the late seventennth century. Of an entirely different character and design is the Böttger brown stoneware tankard and cover (no. 16) made at Meissen in 1712-1713. Its wheel-cut scale decoration and matching cover make it highly unusual. The Meissen porcelain in the Markus Collection includes a number of rare objects such as the pair of octagonal turquoise ground sake bottles (no. 25) known to have been made for the Japanese Palace in Dresden, which housed the collection of Augustus the Strong.

Four other German porcelain factories are represented in the collection by a group of finely painted snuffboxes. Among them is a Fürstenberg box (no. 48) decorated in puce enamel with a hunting scene after a print by Johann Elias Ridinger; the painting has been tentatively attributed to Johann Heinrich Eisenträger. Since German snuffboxes made outside of Meissen are very rare in American collections, this group of snuffboxes constitutes an especially important addition to the holdings of the Museum of Fine Arts.

The French porcelain in the Markus Collection complements and broadens the group of soft- and hard-paste wares given to the museum by Forsyth Wickes in 1965. Exemplifying the products of the soft-paste porcelain factories are a pair of coolers for liqueur bottles (no. 52) from Saint-Cloud, with imaginatively painted and gilded chinoiserie decoration, and a pair of dwarfs (no. 55) from Mennecy, which may have been intended for mounting as candelabra. Exercising a taste that is quite different from that of Forsyth Wickes, the Markuses acquired a richly decorated Vincennes *écuelle* and stand of 1754 that has a *bleu-céleste*

ground combined with superbly tooled gilding and reserves painted with fruits and flowers (no. 63). With the acquisition of a similarly elaborate Sèvres rose ground ewer and basin (no. 64), the Markuses added two masterpieces to the collection, which in both style and form are major additions to the museum's French porcelains.

Reflecting the production of the independent porcelain factories that flourished in England in the eighteenth century are the wares and figures from Chelsea, Derby, Bow, and Worcester. More modest in scale and more fanciful in design than the French porcelains, the English soft-paste porcelains in the collection vary considerably in texture, form, and color of paste. From Chelsea comes a salt in the shape of a sea shell resting on branches of coral (no. 71) and from Worcester a bell-shaped mug (no. 80) decorated with polychrome sprays of flowers, insects, and a butterfly.

A similar sense of fantasy and of interest in naturalistic decoration is evident in the English enamels. Manufacturing in porcelain and enamel began in England in the mid-1740s, and some painters are thought to have worked on both media. The style of painting on the Markus green ground tea caddy (no. 93) has been linked to that of certain porcelain painters active at Chelsea in the 1750s. The English enamels given by the Markuses offer valuable comparisons with the large collection of English porcelain in the museum.

The Markuses have an excellent example of eighteenth-century German enamelwork in their collection: a pair of candlesticks richly ornamented with gold reliefwork and polychrome painting (no. 92), dating from 1725-1735 and probably part of a toilet service. They have been attributed to the workshop of Pierre Fromery, a Huguenot goldsmith who moved to Berlin in 1668. Of superb craftsmanship, these candlesticks are a significant addition to the museum's holdings of Continental enamels.

In writing the present catalogue the authors have treated each object as an individual work of art and have considered the collection in the context of the history of European ceramics. The catalogue has been organized by material, country, and then chronologically by factory. The background of each factory or type of ware is outlined in the introductions, which are intended to give a broad overview; in each entry the form and decoration are described, and the artists, sources of design, technique, use, and related pieces in other collections are discussed in detail.

ANNE L. POULET
Curator
Department of European Decorative
Arts and Sculpture

Acknowledgments

When Mr. and Mrs. Markus generously agreed to fund the production of a complete scholarly catalogue to accompany the exhibition of their collection of ceramics and enamels, it was decided that, owing to the great diversity of their collection, it would be best to have more than one author. Four staff members and one former staff member of the Department of European Decorative Arts and Sculpture were chiefly responsible for the preparation and writing of the catalogue. They have all given a great deal of their time to the complex task of its production while continuing to help with the daily running of the department. This is the first publication of its type to come from the department, and I should like to thank each contributor for his or her diligence and commitment in bringing it to fruition.

Vivian S. Hawes, research associate for ceramics and a distinguished scholar in the field, wrote all the introductions and entries for the French and English porcelain. Christina S. Corsiglia, former curatorial assistant in the department and now a graduate student in fine arts at Columbia University, wrote all the entries and introductions for the Delft ware, Belgian and Dutch porcelain, and English and German enamels.

The preliminary research for the German faience, stoneware, and porcelain was undertaken by Yvonne Hackenbroch, curator emerita of the Metropolitan Museum of Art in New York. She brought to this project her considerable knowledge in the field of German ceramics. Mrs. Hawes, in collaboration with Jeffrey H. Munger, assistant curator in the department, and Ellenor M. Alcorn, curatorial assistant, wrote the final introductions and entries for the German ceramics. The contributions of the various authors are indicated by their initials.

The task of measuring the objects, checking marks, photographs, and technical information fell to Michele D. Marincola, department assistant. She and Ms. Alcorn compiled the bibliography and index and entered much of the manuscript on the word processor. Yolanta Ciechanowska assisted in typing the bibliography and reading proof. Mary Laux and Susan Odell entered sections of the manuscript on the word processor.

During the preparation of the catalogue Lambertus van Zelst, director of research, and Pamela England, research scientist at the museum, were of invaluable assistance in testing and examining the objects in order to identify materials and techniques. In a spirit of goodwill and cooperation, Nancy Allen, librarian at the museum, and her staff sought publications needed for research, obtained books through interlibrary loan, and checked bibliographical references. We are also grateful to Patricia Marr, manager of the museum's Data Processing Department, who helped to solve problems encountered when the text was entered on the computer.

A number of staff members from other curatorial departments in the museum were generous in providing answers to individual inquiries. We should especially like to thank David Becker, assistant curator, Department of Prints, Drawings, and Photographs, who aided in identifying print sources for ceramics and enamels; John Herrmann, assistant curator, Classical Department, who advised on classical iconography; and James Watt, curator, Diane Nelson, junior research fellow in Chinese art, and Denise Patry-Leidy, research assistant, all of the Asiatic Department, who provided information concerning Asian sources. In addition, Clifford S. Ackley, associate curator, Department of Prints, Drawings, and Photographs; Monique van Dorp, research associate; Ilse Fang; and Peter der Manuelian, consultant, Department of Egyptian and Ancient Near Eastern Art, all assisted the authors with translations from Dutch and German texts.

During the many months of research for the catalogue, the authors were assisted by a number of colleagues from other museums, scholars, dealers, and collectors. We particularly want to thank Judith Anderson, assistant keeper of art, City of Derby Museums and Art Gallery; John C. Austin, curator, Ceramics and Glass, Colonial Williamsburg Foundation, Williamsburg, Virginia; Betty Bailey, Royal Crown Derby Museum, Derby; Geoffrey de Bellaigue, keeper of the Royal Collection, Works of Art, London; Susan Benjamin, Halcyon Days, London; Gertie van Berge, assistant, Department of Sculpture and Applied Arts, Rijksmuseum, Amsterdam; A.L. den Blaauwen, director, Department of Sculpture and Applied

Arts, Rijksmuseum, Amsterdam; Julia Brant, assistant keeper of applied art, Bantock House Museum, Wolverhampton; T.G. Burn, Rous Lench Court, Evesham, Worcestershire; Robert J. Charleston, Richmond, Surrey; Meredith Chilton, curator, The George R. Gardiner Museum of Ceramic Art, Toronto; Timothy H. Clarke, London; Clare Le Corbeiller, associate curator, Department of European Sculpture and Decorative Arts, The Metropolitan Museum of Art, New York; Jan D. van Dam, curator, Gemeentelijk Het Princessehof, Leeuwarden; Carl C. Dauterman, curator emeritus, Department of European Sculpture and Decorative Arts, The Metropolitan Museum of Art, New York; Aileen Dawson, research assistant, Department of Medieval and Late Antiquities, British Museum, London; Bernard Dragesco, Paris; Pierre Ennès, curator, Works of Art, Musée du Louvre, Paris; A. van der Goes, Kasteel Sypesteyn Museum, Loosdrecht; Anton Gabszewicz, Christie's, London; Malcolm D. Gutter, professor of decorative arts, Foothill College, Los Altos Hills, California; Antoinette Hallé, curator, Musée National de Céramique, Sèvres, et du Musée National Adrien Dubouché, Limoges; Tjark Hausmann, curator, Staatliche Museen Preussicher Kulturbesitz, Kunstgewerbemuseum, Berlin; Henry Hawley, chief curator of later Western art, The Cleveland Museum of Art, Cleveland, Ohio; Linda J. Horvitz, assistant curator of the Morgan Collection, Wadsworth Atheneum, Hartford, Connecticut; A. L. Hulshoff, director, Rijksmuseum Twenthe, Enschede; Hermann Jedding, keeper, European Applied Arts, Museum für Kunst und Gewerbe, Hamburg; Catherine Join-Dieterle, curator, Musée du Petit Palais, Paris; Mireille Jottrand, curator, Musée Royal de Mariemont; David Kiehl, assistant curator, Department of Prints and Photographs, The Metropolitan Museum of Art, New York; Ekkart Klinge, curator of ceramics, Hetjens-Museum, Deutsches Keramikmuseum, Düsseldorf; Olivier Lévy, Paris; Mrs. Jack Linsky, New York; Ian Lowe, assistant keeper, Department of Western Art, The Ashmolean Museum, Oxford; Mr. Daniel F. Lunsingh Scheurleer, The Hague; Gérard Mabille, curator, Musée des Arts Décoratifs, Paris; J.V.G. Mallet, keeper, Department of Ceramics, Victoria and Albert Museum, London;

Anne-Marie Mariën-Dugardin, curator, Musées Royaux d'Arts et d'Histoire and Musée Bellevue, Brussels; Ingelore Menzhausen, director, Porzellansammlung Staatliche Kunstsammlungen, Dresden; Johan R. ter Molen, curator, Department of Decorative Arts, Museum Boymans-van Beuningen, Rotterdam; Hugo Morley-Fletcher, Christie's, London; Susan Myers, curator of Glass and Ceramics, National Museum of American History, Washington, D.C.; Riet Neerincx, curator of applied arts, Gemeentemuseum, Arnhem; P.N. Hj. Domela Nieuwenhuis, director, Simon Van Gijn Museum, Dordrecht; Jock Palmer, Sotheby Parke Bernet, London; Tamara Préaud, archivist, Manufacture Nationale de Sèvres, Sèvres; Henry Sandon, former curator, The Dyson Perrins Museum, Worcester, England; William Sargent, assistant curator, Museum of the American China Trade, Milton, Massachusetts; Rosalind Savill, assistant to the director, The Wallace Collection, London; Hugh Tait, keeper of medieval and later antiquities, British Museum, London; Charles Truman, assistant keeper, Department of Ceramics, Victoria and Albert Museum, London; Bernard Watney, M.D., London; A. Westers, keeper of applied arts, Gemeentemuseum, The Hague; J.J.L. Whiteley, assistant keeper, Department of Western Art, The Ashmolean Museum, Oxford, and Robert Williams, London.

The challenge of editing and making consistent the contributions of several authors for the catalogue was superbly met by Margaret Jupe, senior editor at the museum, who with patience, diplomacy, and infinite understanding, saw the manuscript through to its completion. The sensitive and beautiful design of the book is the work of Carl Zahn, the museum's director of publications. Under the guidance of Ms. Corsiglia, Lynn Diane De Marco of New York photographed the objects in color and black and white, and Rica Monique Asaban photographed the marks. They have succeeded in creating photographs that accurately convey the texture, shape, and decoration of the diverse works in the Markus Collection.

It has been my great pleasure to work with Mr. and Mrs. Markus and my colleagues at the Museum of Fine Arts in the realization of this catalogue.

A.L.P.

14

Plates

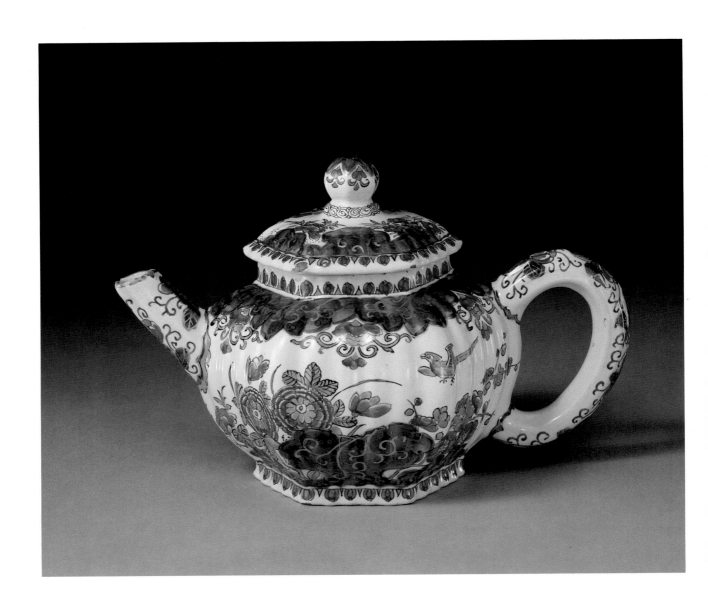

PLATE I. *3. Teapot and cover*
The Netherlands, Delft, first quarter of the 18th century

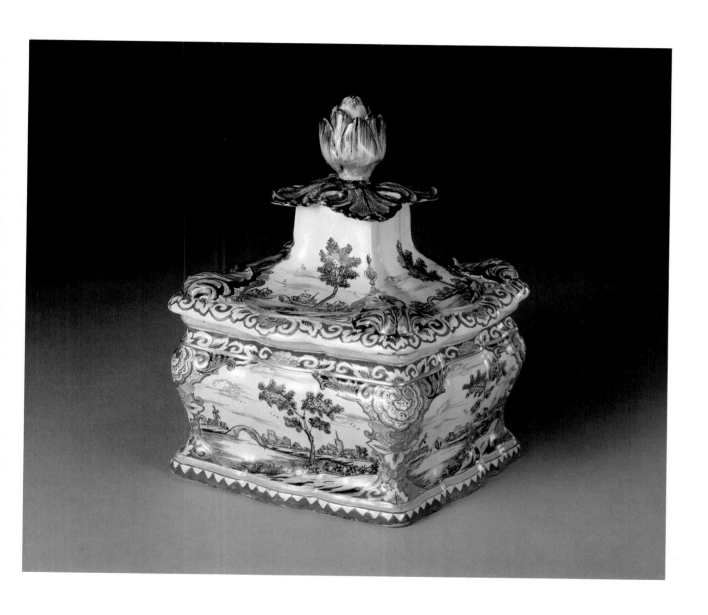

PLATE II. *9. Tobacco box and cover*
The Netherlands, Delft, about 1760-1770

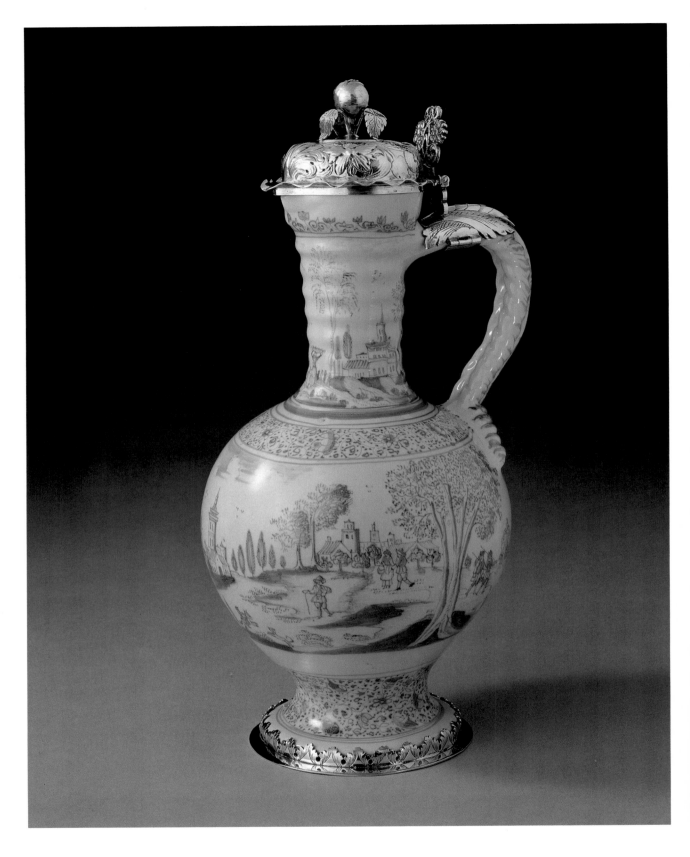

PLATE III. *11. Jug*
Germany, Frankfurt am Main, 1696

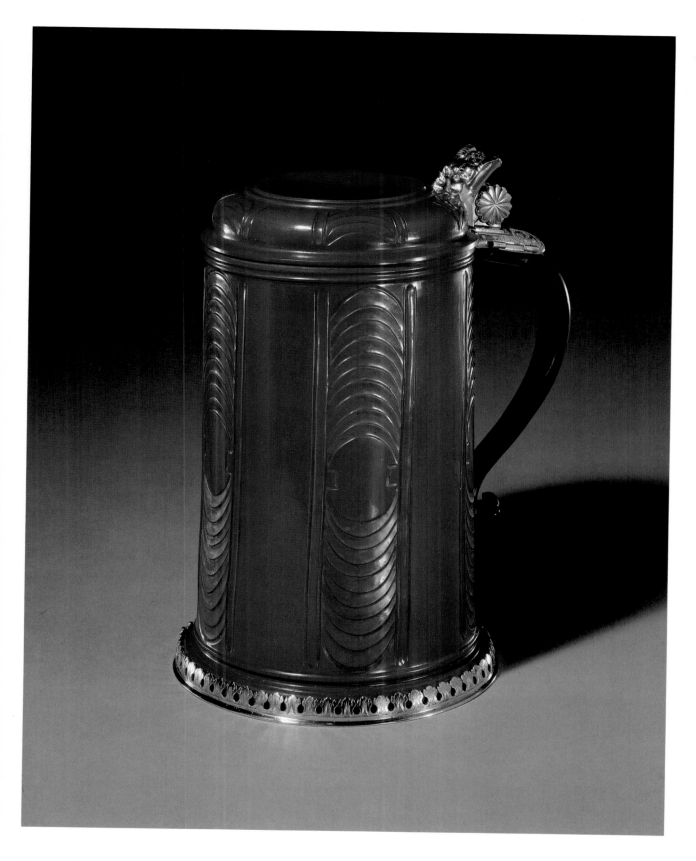

PLATE IV. *16. Tankard and cover*
Germany, Meissen, about 1712-1713

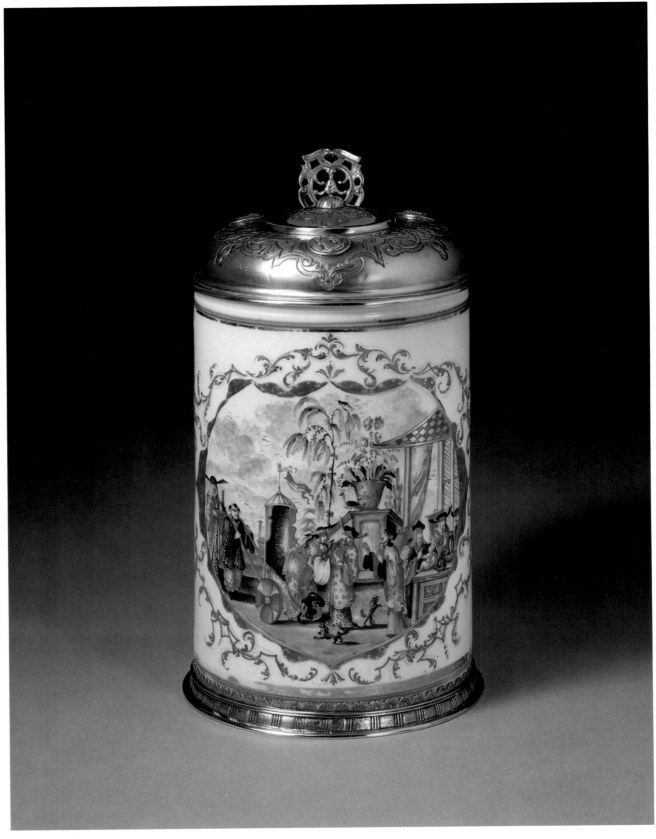

PLATE V. *17. Tankard*
Germany, Meissen, about 1723-1724

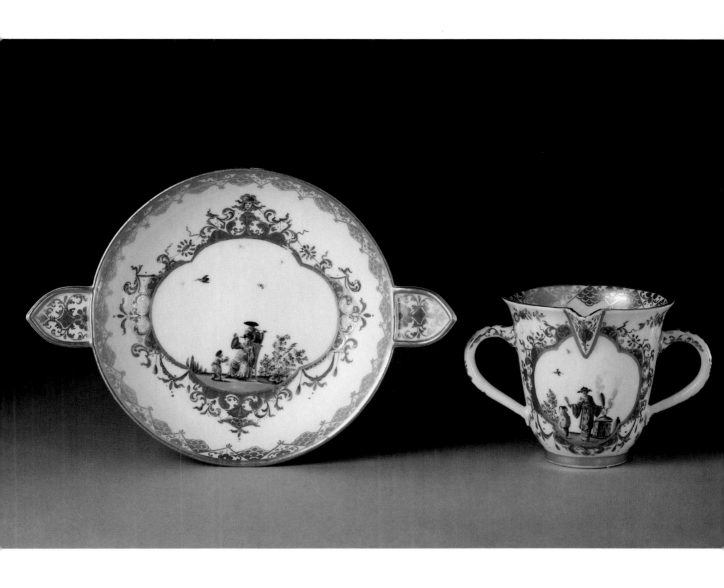

PLATE VI. *19. Two-handled cup and stand*
Germany, Meissen, about 1725-1730

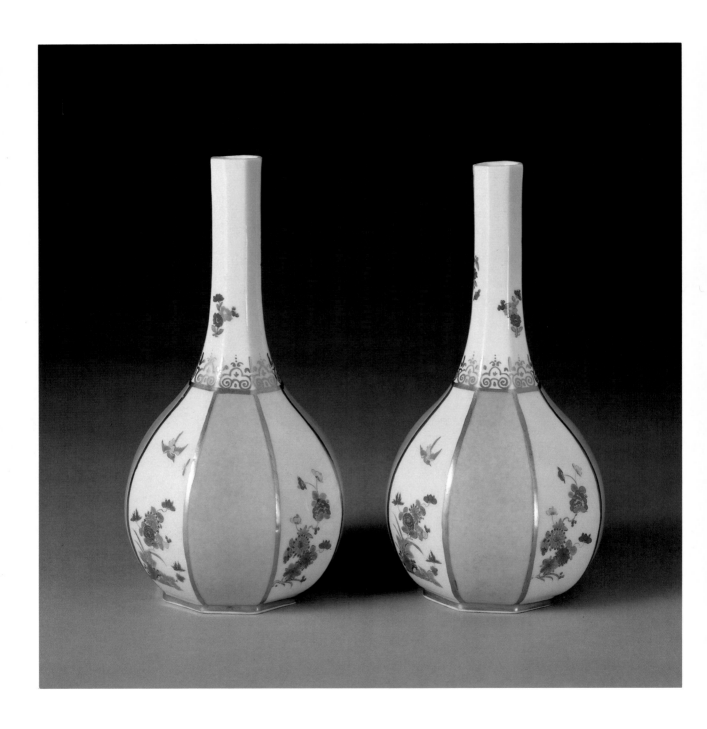

PLATE VII. *25. Pair of sake bottles*
Germany, Meissen, about 1730-1735

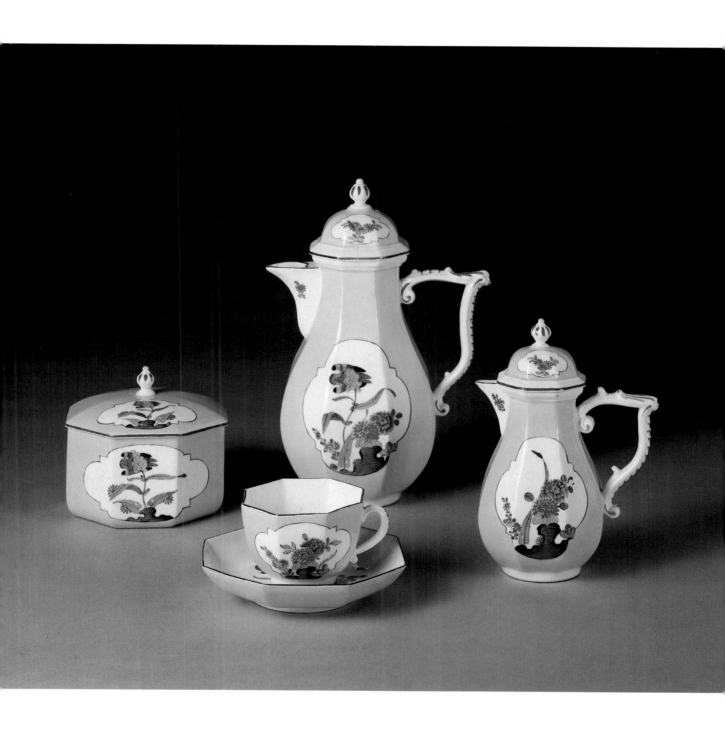

PLATE VIII. *36. Coffee service*
Germany, Meissen, about 1740

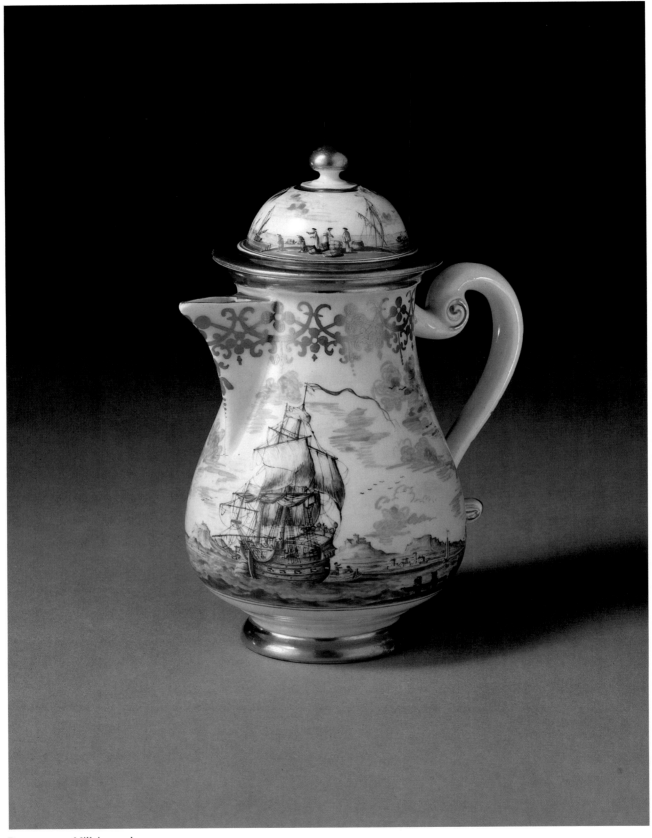

PLATE IX. *22. Milk jug and cover*
Germany, Meissen, about 1725-1728

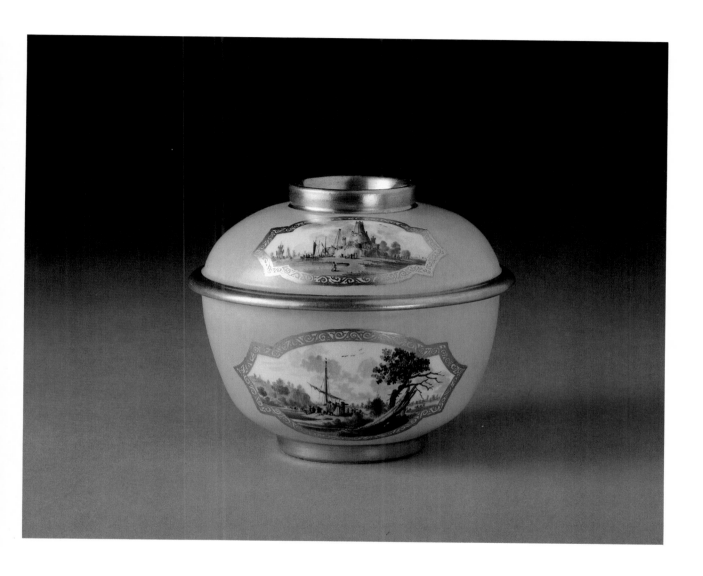

PLATE X. *37. Sugar bowl and cover*
Germany, Meissen, about 1730-1735

PLATE XI. *43. Teacup and saucer*
Germany, Meissen, about 1753

PLATE XII.
A. 52. *Two coolers for liqueur bottles*
 France, Saint-Cloud, about 1730
B. 55. *Two grotesque figurines*
 France, Mennecy, about 1740

PLATE XIII. 57. *Water jug and cover*
France, Vincennes, about 1750

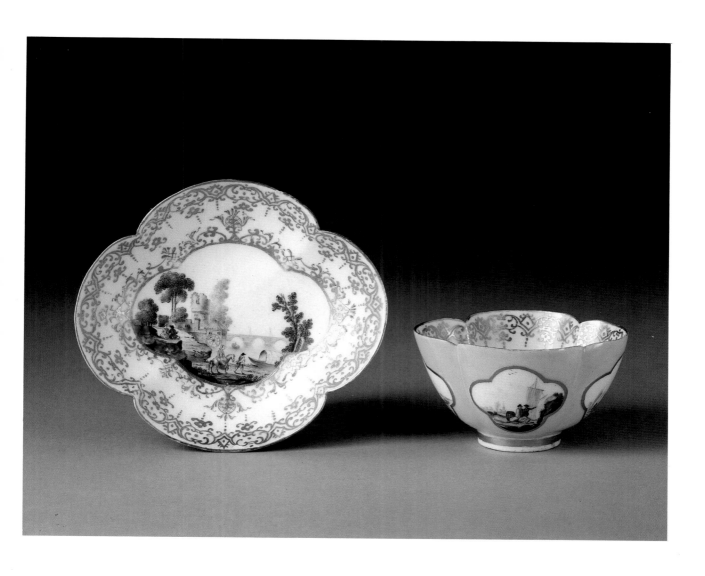

PLATE XIV. *58. Quatrefoil teabowl and saucer*
France, Vincennes, about 1750

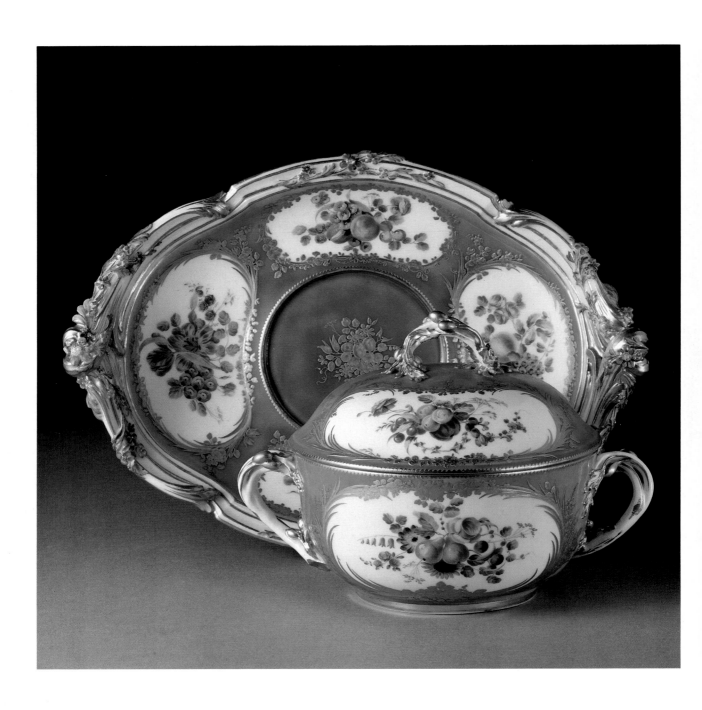

PLATE XV. *63. Covered bowl and stand*
France, Vincennes, 1754

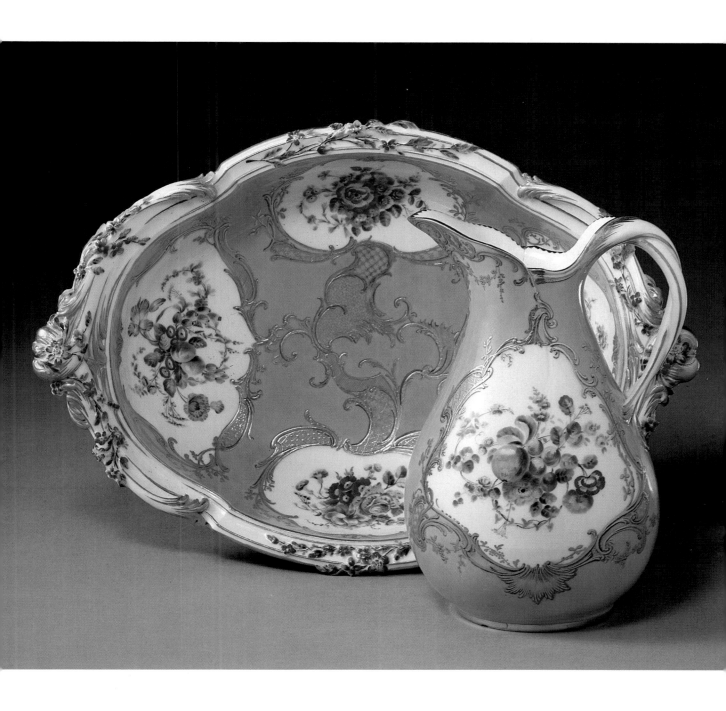

PLATE XVI. *64. Ewer and basin*
France, Sèvres, 1757

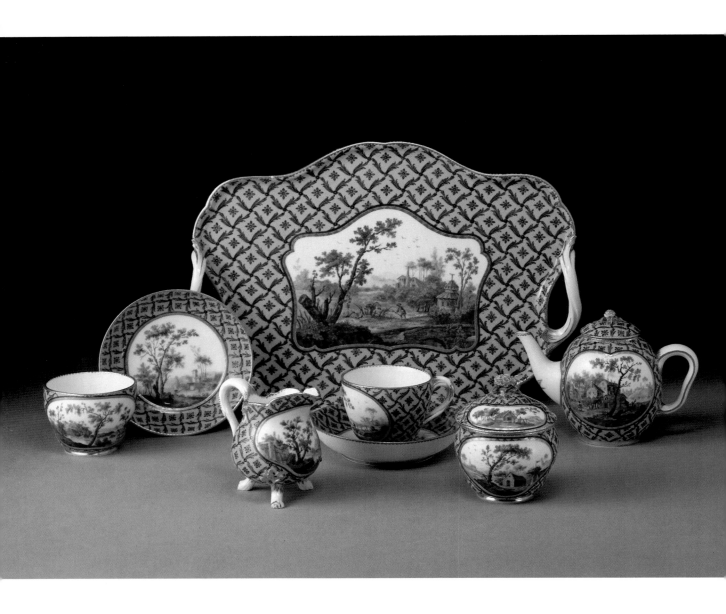

PLATE XVII. *69. Tea or breakfast service*
France, Sèvres, 1761

PLATE XVIII. *72. Dish (or stand)*
England, Chelsea, 1750-1752

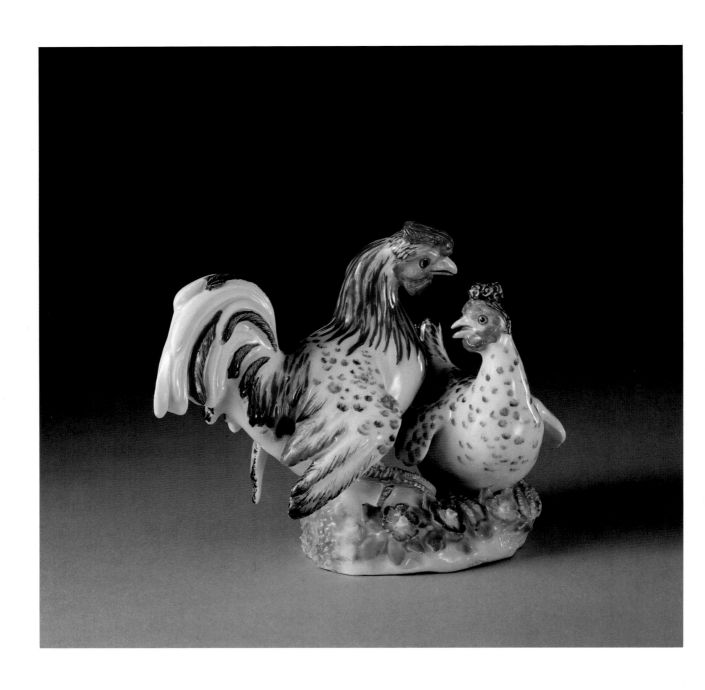

PLATE XIX. *78. Group of a cock and a hen*
England, Bow, about 1755-1760

PLATE XX. *80. Bell-shaped mug*
England, Worcester, about 1760-1762

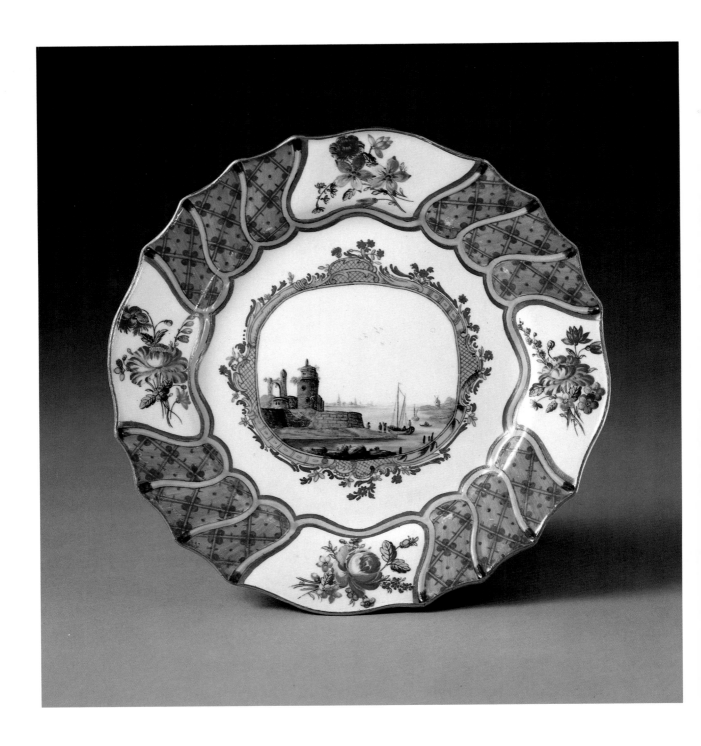

PLATE XXI. *85. Plate*
Belgium, Tournai, about 1775

36

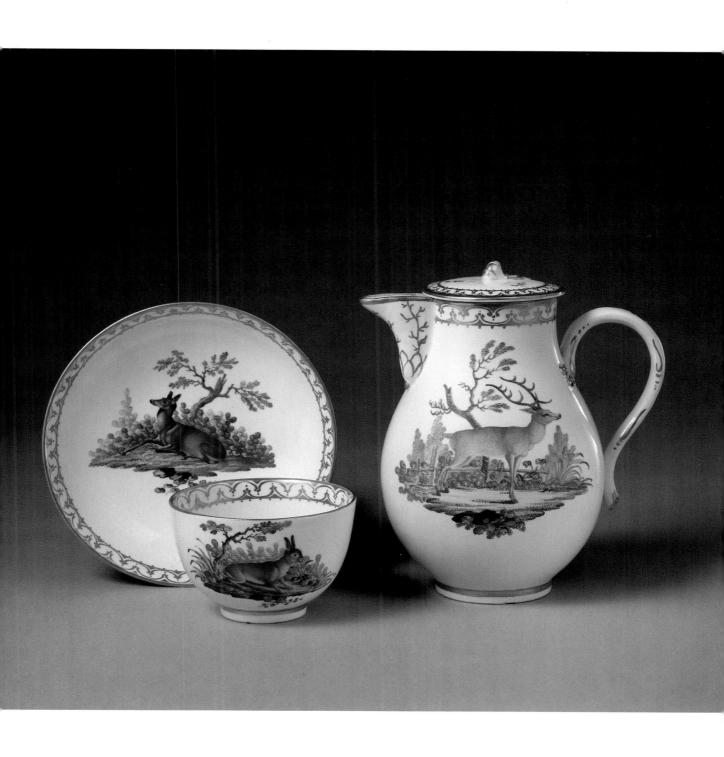

PLATE XXII. *87. Milk jug, cup, and saucer*
Germany, probably Ansbach, decorated in the Hague, about 1777-1790

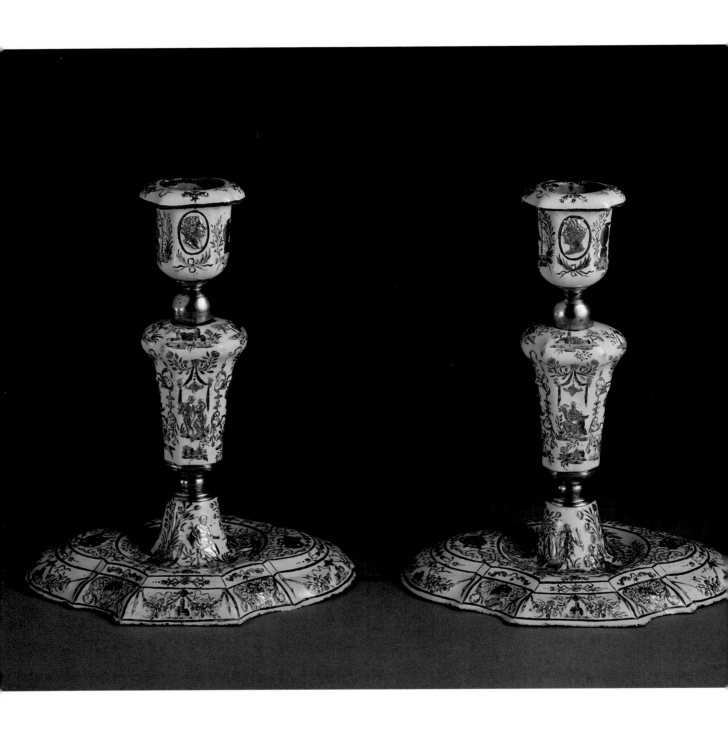

PLATE XXIII. *92. Pair of candlesticks*
Germany, Berlin, about 1725-1735

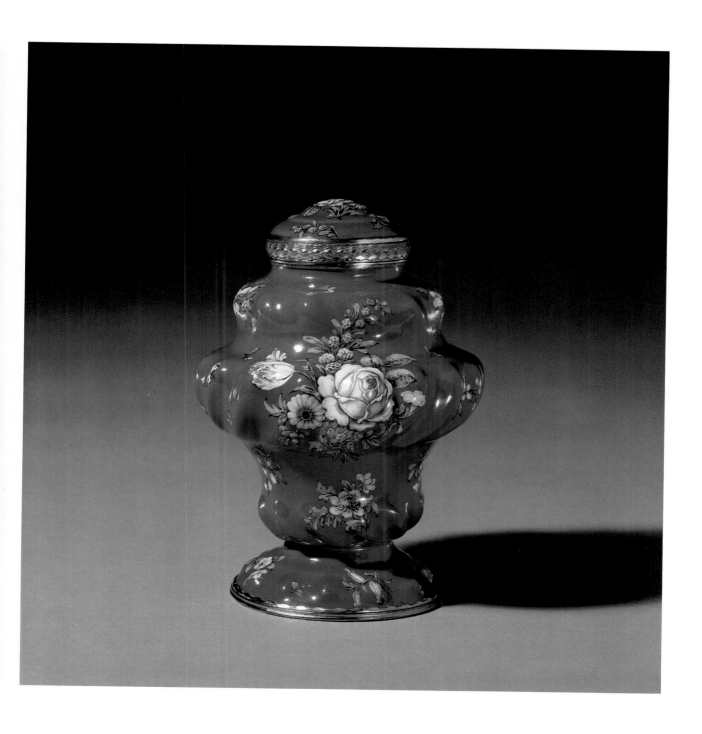

PLATE XXIV. *93. Tea caddy*
England, probably London, about 1755-1760

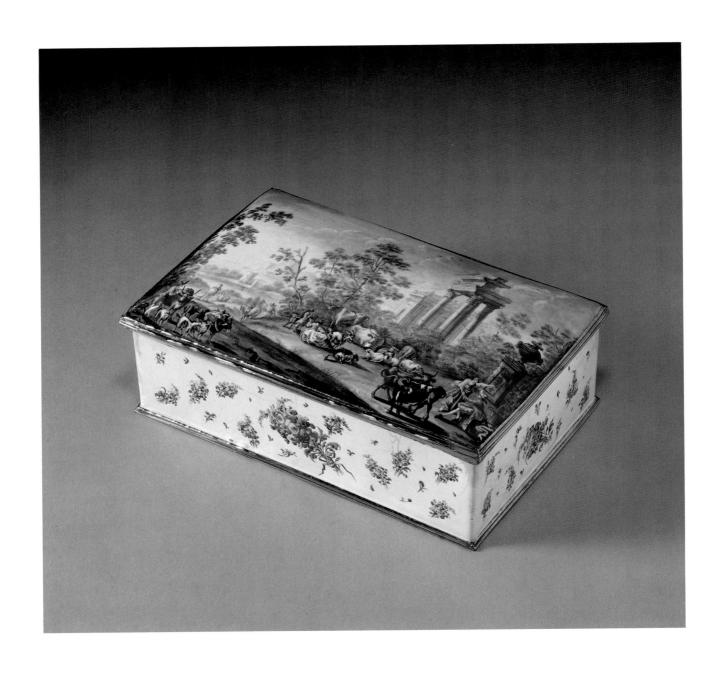

PLATE XXV. *94. Box*
England, probably Birmingham, about 1755-1760

USE OF THE CATALOGUE

Measurements are listed as follows: *H.* indicates the overall height of each object; in some instances, height without cover or stopper is also included. *W.* designates the overall width of each object (including handles); *D.* indicates the overall depth of an object. For objects with a circular rim or base, the greater diameter (*Diam.*) is given.

All marks are illustrated, unless otherwise noted.

Objects in photographs showing pairs or groups are numbered from left to right, unless otherwise noted.

The authors' names are abbreviated as follows:

ELLENOR M. ALCORN	E.M.A.
CHRISTINA S. CORSIGLIA	C.S.C.
YVONNE HACKENBROCH	Y.H.
VIVIAN S. HAWES	V.S.H.
JEFFREY H. MUNGER	J.H.M.

I Delft Ware

Tin-glazed earthenware was made throughout the Netherlands during the sixteenth century, much of it by Italian potters who had emigrated to Antwerp. Working in their native tradition, the potters produced wares with bright polychrome palettes inspired by majolica (Italian tin-glazed earthenware), which had been sold in the Netherlands for some time. From Antwerp, potters moved to Amsterdam, Haarlem, Rotterdam, Gouda, and, by about 1585, to the town of Delft. By the early seventeenth century, Delft potters had begun to experiment with different clay and glaze formulas in order to copy the Chinese blue and white porcelain then being brought to the Netherlands.

Before the Dutch East India Company, founded in 1602, had begun official importation of Chinese porcelain (for which they remained the sole agents until 1795), their capture of three Portuguese ships provided the Netherlands with its first substantial quantities of Chinese porcelain. The porcelain from the ships was sold in 1602 and 1604 in Middelburg and Amsterdam at two very successful auctions, both of which attracted buyers from all over Europe and stimulated considerable interest in Chinese porcelain.

The export porcelain transported by Iberian ships and known in Holland as *kraakporselein*, as well as that brought to the Netherlands somewhat later by the Dutch East India Company, consisted primarily of tablewares painted with designs of flowers, insects, and Chinese symbols in underglaze blue on a white ground. By 1614 the availability of Chinese porcelain was such that the Dutch historian Erycius Puteanus (1574-1646) remarked that it was almost commonplace in Amsterdam. In the following year an auction of Chinese porcelain in Delft gave additional stimulus to the attempts of local potteries to emulate the imported wares. The fact that the auction was held in Delft also indicates the emerging importance of that town as a center of trade.

Situated on the Schie River and equipped with an extensive canal system, Delft was an ideal location for the establishment and growth of the pottery industry. The decline of the brewing industry in the early seventeenth century provided potters with easily adaptable premises in which to work, as well as with sufficient labor. Several of the potteries retained the names originally given to the breweries, such as De Griecksche A (The Greek A), De Drei Vergulde Astonnekens (The Three Golden Ash Barrels), and De Dobbelde Schenckan (The Double Jug). As the potteries began to flourish in the mid-seventeenth century, the town's location also proved valuable for the export of its pottery and the import of clays from abroad. The potteries were encouraged and partially supported by the local government. Most were owned and managed not by potters but by affluent Delft citizens who invested in the potteries solely as business enterprises. The rapid growth of the potteries is attested to by the records of the Delft Guild of Saint Luke, which was originally restricted to painters and eventually admitted master potters.

Part of the difficulty in attributing Delft tin-glazed earthenware (hereafter referred to as Delft ware) to a particular factory or painter lies in the variety of marks employed by the potteries. Some of the master potters registered with the Guild of St. Luke used their marks with no indication of a factory; other pieces were marked with the initials of one of several directors or proprietors, who were merely shareholders. By the second half of the century, some of the more famous factory marks were copied, making accurate attribution even more difficult.

By the 1650s, the Delft potters had begun to develop their own decorative style. They had also introduced some innovative techniques, including a device, known as *trek*, whereby the outlines of the decoration were drawn in manganese purple to give a firmer sense of design to the otherwise monochromatic painting. A clear lead glaze, known as *kwaart*, was added to the front of the plates and the exterior of other objects to impart a glossy surface similar to that of the Chinese porcelain being copied. Chinese motifs were more freely mixed and were increasingly combined with European decoration. Conventional baroque motifs and European forms were borrowed from faience (tin-glazed earthenware made in France, Germany, and Scandinavia), particularly that made at Rouen. These began to appear by the late seventeenth century, as did decoration derived from engravings, a source used with increasing frequency in the eighteenth century.

As the Dutch began to import polychrome Kangxi (K'ang Hsi, 1662-1722) porcelain from China and Japanese polychrome porcelain from the Kakiemon and Arita kilns at the turn of the century, Delft potters again had to develop special pigments to reproduce the colorful palettes of these wares, which were especially popular because of their gilded decoration. Until this time only one

Delft potter, Rochus Hoppesteyn (1661-1692) at Het Jonge Moriaenshoofd (The Young Moor's Head) factory, had learned how to decorate tin-glazed earthenware with fire-resistant colors and gold. Delft potters eventually produced green, yellow, and iron-red pigments, all of which could withstand the high temperatures of their kilns. These pigments, often referred to as "high fire" colors, were applied simultaneously with the cobalt blue and manganese purple already being used (see nos. 4, 6, 7, and 10). After being thrown or molded, Delft ware was given a "biscuit" (unglazed) firing; the piece was then coated with a layer of the thick, white tin glaze. The white tin glaze, actually a lead glaze to which tin ashes were added for opacity, provided the best material with which to emulate the white ground of Chinese and Japanese porcelain. When the tin glaze had dried, the painted decoration was applied over it. The *kwaart*, if used, was then sprayed onto the surface, and the piece was fired at 900-1,000 degrees centigrade for about twenty hours.

True porcelain was never produced at Delft, although the tin glaze was continually perfected, as was the earthenware body. The high-fire technique, though useful, still did not allow for the application of gold or for the more subtle shades of green and blue found on Japanese porcelain, which required lower firing temperatures than did the other glaze pigments. A low-fire technique was developed in the early eighteenth century whereby colors, known as enamels, were applied over the fired tin glaze in a "muffle-kiln" (see nos. 5 and 8). Repeated firings at progressively lower temperatures allowed for a greatly expanded palette as well as the use of gold, which was applied after all the other decoration had been fired. Once the low-fire technique was perfected, it was often used in conjunction with high-fire decoration (see nos. 2 and 4).

The low-fire or muffle technique was particularly valuable later in the eighteenth century, when the Delft potteries were forced to compete with Chinese *famille rose* porcelain as well as that being produced by the Meissen and Vienna factories (nos. 8 and 9). This rivalry was manifested by the conscious borrowing of motifs and shapes from porcelain factories and, once again, from the rival faience factory at Rouen.

From the second half of the seventeenth century until the middle of the eighteenth century, the Delft potteries flourished. Despite their constant efforts throughout the eighteenth century to improve their product, however, they were unable to maintain their preeminence. They were forced out of business by the technically superior, English salt-glazed stoneware and the cream-colored, lead-glazed earthenware developed by Josiah Wedgwood (1730-1795), the importation of which was facilitated by a commercial treaty of 1786. By 1790 only ten Delft potteries were still operating. The decline of the potteries in Delft was paralleled by the decline of faience potteries elsewhere in Europe, many of which were begun in the second half of the seventeenth century under the impetus provided by the popularity of Delft ware.

The contribution of Delft potteries to European ceramic art lay primarily in their refinement of the tin-glaze technique, their original interpretations of Chinese and Japanese decorative schemes, and their skillful painting in this difficult medium.[1]

C.S.C.

NOTE

1. Information for this introduction is based primarily on the following sources: Ferrand W. Hudig, *Delfter Fayence* (Berlin, 1929); Caroline Henriette de Jonge, *Oud-Nederlandsche majolica en Delftsch aardewerk* (The Hague, 1947); Siv Rahm, "Chinese Export Porcelain and Its Influence on Dutch Ceramic Art," *Mededelingenblad vrienden van de Nederlandse ceramiek, no.* 30 (March 1963), pp. 12-25; Caroline Henriette de Jonge, *Delft Ceramics*, trans. Marie-Christine Hellin (New York, 1970); Kunstgewerbe Museum, Cologne, *Fayence I: Niederlande, Frankreich, England*, catalogue by Brigitte Tietzel (1980).

1 Jug

The Netherlands, Delft, about 1650

Tin-glazed earthenware with silver lid and foot rim

Marks:

(1) on base, incised: five parallel lines
(2) on inside of lid, struck: town mark of Leeuwarden, date letter b for 1653, maker's mark AB conjoined for Augustinus Brunsvelt
(3) on underside of silver thumbpiece, engraved: five parallel lines (not illustrated)
(4) on base, incised: V (not illustrated)

H. 24.2 cm. (9½ in.), h. without cover 22.4 cm. (8 13/16 in.), w. 14 cm. (5½ in.), diam. at base 9.4 cm. (3 11/16 in.)

1983.596

The thrown baluster-shaped jug has a straight-sided neck with a slightly extended spout above double bands of ribbing and a pinched waist, which flares to a wide shoulder. The bulbous body

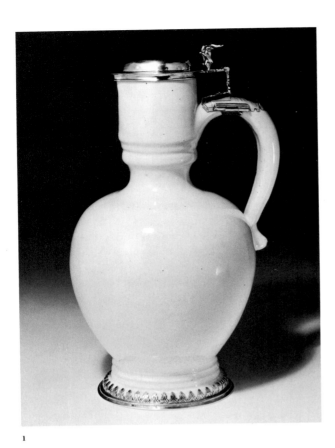

1

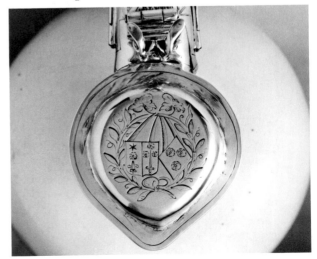

White Delft was primarily utilitarian, although some forms were purely ornamental. An inventory of 1624 lists "witte aerde kannetjes, bordetgens, commen, boterschotelen, suyckerpotten, room-kannen en tafelborden: (white earthenware jugs, small plates, bowls, butter dishes, sugar bowls, cream pitchers and plates).[1] Other objects made of white Delft noted in lists of household belongings include candlesticks, shaving basins, chamber pots, pap boats, and lamps. Factory inventories between 1620 and 1678 indicate that such objects were designed to be decorative as well as functional. A sampling of these entries lists "aerde pronckscho-telen," "witte aerde schaalen voor de schoorsteen," and "grote schotelen zoo voor de schoorsteenman-tel, bedstee als ander" (earthenware bowls for cere-monials, white earthenware bowls for the mantle, large bowls for the mantle as well as for the bed alcove).[2]

The form of the Markus jug is probably based on European stoneware[3] and, more specific-ally, on German stoneware of the early seven-teenth century.[4] Jugs of this type were quite common and were probably used for serving wine.[5] They were generally fitted with a tin, pew-ter, or silver lid, attached by means of a thumb-piece secured to the handle, and occasionally with a foot rim, as in the case of the present example. The jugs are said to have been used during the sev-enteenth century by Protestant churches for ad-ministering wine during Holy Communion.[6] Some of these, which are evidently still owned by some Dutch churches, have engraved religious scenes on their lids. The undecorated jugs were both molded and thrown, the molded examples generally fluted in a loose spiral pattern. These jugs are frequently depicted in the works of contemporary painters from Delft[7] and are sometimes referred to as "Ver-

1. Detail of engraved silver cover

tapers from the shoulder to a band of triple rib-bing, which joins the foot to the body of the jug. A high loop handle with a small terminal is joined to the body at the neck above the ribbing and to the lower half of the jug just below the shoulder. The silver lid is of teardrop shape, the central section raised and engraved with the coat of arms of the Alyva Meckema-Van Eysinga families. A single en-graved line follows the outline of the flat lower edge of the lid. The silver thumbpiece is formed as a pair of wing-like objects atop an L-shaped hinge, which is joined to an engraved and shaped mount affixed to the top of the handle by a smaller hinge. The unmarked silver base rim consists of three decorative bands: a plain outer band, a raised and vertically ribbed central band, and an upper band with leaf-shaped and engraved prongs, which are bent over the lower edge of the foot of the jug. The interior of the jug is glazed and the foot un-glazed.

White Delft, known in Holland as "wit goet," con-stitutes a distinct category of Dutch faience first produced in the early seventeenth century. Its dis-tinction lies in the fact that the white tin glaze is fired onto the surface without the addition of pig-ments, enamels, oxides, or gilding. The only orna-mentation is that added to the body itself, before glazing, while the piece is being thrown or molded.

1(1) 1(2)

meer" or "Pieter de Hoogh" jugs. Since they were less expensive and less highly regarded than their decorated counterparts, few examples have survived.

The majority of extant white Delft jugs are unmarked; the incised parallel marks on the Markus jug and cover seem to correspond to one another and may be symbols used to identify the maker and thus facilitate payment, or they may indicate a system of marking by the silversmith to match the jug to the proper mount.[8] Frederik van Frytom (1632-1702), a well-known independent Delft ceramic decorator, reportedly made many of these white jugs,[9] but further research is needed to ascertain this. Whether they were made en suite with lobed white dishes, as has been proposed, is also difficult to substantiate.

Comparison with other white Delft jugs,[10] most of which are dated to the second half of the seventeenth century, shows the Markus jug to be most similar to examples from about 1650 to 1675. Those made earlier lack the surface details of ribbing on the foot and shoulder and the pronounced transition between the neck and the body of the jug. The Markus jug is apparently one of a pair; its mate was recently on the art market in Leeuwarden.[11] The mounts on the jugs, which were made by Augustinus Brunsvelt in 1653, are also identical.[12] The engraved coats of arms on the covers indicate the jugs were made to commemorate the marriage of Lisk van Eysinga to Sippe Douwes Meckema van Alyva in 1650.[13] Brunsvelt worked in Leeuwarden, where he became a master in 1642, and is recorded as the maker of the silver mounts on two white Delft jugs formerly in the Gevaerts Collection,[14] almost certainly this pair.

Among the Japanese porcelain wares produced for the Dutch East India Company during the period under consideration are several jugs nearly identical in form to the Markus piece, except for the ribbing of the lower neck.[15] One of these jugs (British Museum, Franks Collection, 635A) has gold and silver floral decoration on a dark blue ground, while the others have underglaze blue decoration on a white ground. One of

the latter, which has painted armorials and was made for an official of the Dutch East India Company, is mounted with a Dutch silver lid similar to that of the Markus jug. It has been suggested that these jugs were based on earthenware models sent to Japan from Holland in 1661.[16] The silver lid on one jug has been assigned to 1677,[17] which provides further evidence for the dating of this group. The style of decoration and the coats of arms on the unmounted jugs place them between 1660 and 1680.

The Markus jug and its mate, then, must be very close in form to the Dutch model for these Japanese porcelain jugs. Both their shape and the silver hallmarks provide reason to date them about 1650.

C.S.C.

NOTES

1. Caroline Henriette de Jonge, *Delft Ceramics*, trans. Marie-Christine Hellin (New York, 1970), p. 148.

2. Ibid.

3. National Gallery, London, *Art in Seventeenth Century Holland* (1976), fig. 194, p. 136.

4. Daniel F. Lunsingh Scheurleer, "Enkele zeventiende eeuwse Japanse porseleinen schenkkannetjes naar westerse voorbeelden II," *Antiek* 2 (Oct. 1967), pl. 10, p. 104.

5. Kunstgewerbe Museum, Cologne, *Fayence I: Niederlande, Frankreich, England*, catalogue by Brigitte Tietzel (1980). p. 130. Tietzel states that white Delft jugs were used for both wine and beer, but she refers to those found in Vermeer's pictures as "Weinkrüge" (wine jugs).

6. A. Vecht, *Frederik van Frytom 1632-1702: Life and Work of a Delft Pottery-Decorator* (Amsterdam, 1968), pp. 43-44.

7. For a list of paintings that include similar jugs, see Kunstgewerbe Museum, Cologne, *Fayence I*, p. 130.

8. The five incised lines on the foot and the engraved lines under the thumbpiece are similarly executed. Those on the foot appear to have been scratched into the clay after firing. The silversmith probably fitted several jugs with silver mounts at the same time, and these simple marks would have aided in matching the mounts and lids after hallmarking.

9. Vecht, *Frederik van Frytom*, pp. 42-43.

10. See Alan Caiger-Smith, *Tin-glaze Pottery in Europe and the Islamic World* (London, 1973), fig. 104; Robert J. Charleston and Daniel F. Lunsingh Scheurleer, *English and Dutch Ceramics*, Masterpieces of Western and Near Eastern Ceramics, vol. 7 (Tokyo, 1979), monochrome plates, fig. 94; National Gallery, London, *Seventeenth Century Holland*, fig. 176, p. 129; Abraham C. Beeling, Leeuwarden, *Nederlands zilver, 1600-1813*, sale catalogue, vol. 2 (1980), pp. 94-95; Caroline Henriette de Jonge, *Oud-Nederlandsche majolica en Delftsch aardewerk* (The Hague, 1947), fig. 293.

11. *Antiek* 18 (Jan. 1984), verso of front cover, illus.

12. Elias Voet, Jr., and R. Visscher, *Merken van Friesche gouden zilversmeden* (The Hague, 1932), no. 28c, pp. 146, 121. I am grateful to Ellenor M. Alcorn, Department of European Decorative Arts and Sculpture, Museum of Fine Arts, Boston, for her help in identifying the silver hallmarks.

13. See note 11.

14. Voet and Visscher, *Merken*, p. 146.

15. See T. Volker, "Porcelain and the Dutch East India Company," *Mededelingen van het Rijksmuseum voor Volkenkunde, Leiden* 11 (1954), pl. 15, fig. 33; Daniel F. Lunsingh Scheurleer, "Enkele zeventiende eeuwse Japanse porseleinen schenkkannetjes naar westerse voorbeelden I," *Antiek* 2 (Aug.- Sept. 1967), pl. 9, p. 61; Clare Le Corbeiller, *China Trade Porcelain: Patterns of Exchange* (New York, 1974), fig. 46; National Gallery, London, *Seventeenth Century Holland*, fig. 194; Fujio Koyama and John A. Pope, eds., *Oriental Ceramics: The World's Great Collections*, vol. 5: *The British Museum* (Tokyo, 1974), fig. 258, p. 246; Martin Lerner, *Blue and White: Early Japanese Export Ware* (New York, 1978), fig. 51; H. A. Daendels, "Catalogus tentoonstelling Japans blauw et wit porselein," *Mededelingenblad Nederlandse vereniging van vrienden van de ceramiek* 101-102 (1981), fig. 97.

16. Volker, "Porcelain and the Dutch East India Company," p. 141.

17. Le Corbeiller, *China Trade Porcelain*, fig. 46, p. 87; Lerner, *Blue and White*, fig. 51.

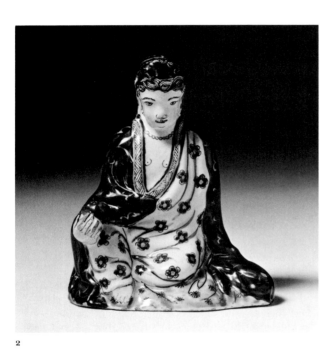

2

2 Guanyin

The Netherlands, Delft, first quarter of the 18th century

Tin-glazed earthenware (faience) decorated in cobalt blue, polychrome enamels, and gold

Mark:
(1) on inside of figure, in black enamel: PAK in monogram

H. 13 cm. (5⅛ in.), w. 10.5 cm. (4⅛ in.), d. 6.2 cm. (2⁷⁄₁₆ in.)

1983.597

Provenance: Purchased, Amsterdam, May 1966

The press-molded figure of the goddess Guanyin (Kuan Yin) is seated on a grassy mound with her left leg bent and tucked behind her right leg, which is raised at the knee. Her right hand and head have been modeled separately; the hand was attached through a hole in the sleeve of her white robe, and the head was applied to the body. A cobalt blue shawl, gilded with scrollwork, is drawn across her back, covering her right shoulder and part of her left shoulder, and draped over her raised right leg; the rest is spread over the grass on either side of her. Under the shawl, Guanyin wears a long, loose-fitting white robe with red and gold flowers. The soft folds of the robe, gathered around her legs, are accentuated in red. A wide collar, with a red chevron design and edged in gold and blue borders the inside neckline of the robe and shawl. Her garments are open, showing her breasts and a short necklace of gold and red beads. Guanyin holds a circular red object in her extended right hand, which rests on her raised knee. Her left arm is concealed beneath her robe, and part of her bare right foot is visible at the lower edge of the robe. Her facial features are modeled in shallow relief; her eyes and eyebrows are painted black, her lips and nose red. Her elongated ears are outlined in red and gilded at the center. The piece is hollow and the interior glazed.

Delft figures of Guanyin provide some of the most intriguing examples of Dutch adaptations of Chinese porcelain. Porcelain and stoneware figures of Guanyin were first brought to Holland soon after the Dutch East India Company was firmly established in China. An early reference to one is included in the 1637 inventory of the Dutch painter Jan Bassé the Elder (about 1571–before 1637), and an illustration of Guanyin appears in an atlas by the Jesuit Father Martinius, published in Amsterdam in 1655.[1]

Whereas much of the Delft ware made from the mid- to the late seventeenth century directly copied Chinese designs and forms (for example, the copies of the blue and white porcelain plates made for export to Europe in the reign of the emperor Wanli [1573-1620]), by the early eighteenth century, Delft painters and potters showed more originality in their products. Such inventiveness was necessary in the adaptation of Chinese porcelain figures for production in earthenware. Fine modeling is nearly impossible in earthenware,

2(1)

which is a dense clay, less suited than porcelain to figural representation. The thick, opaque tin glaze used by the Delft potters obscured any detail that may have been attained in the modeling. Thus the Delft modeler had to modify his versions of Chinese figures with an eye to evoking their character rather than producing them with absolute accuracy. The carefully rendered details of facial features, hair, drapery, and personal adornments that so concerned the Chinese potter had to be sacrificed by the Delft potter. The results were often awkward and unconvincing interpretations of their Chinese counterparts.

In regard to religious figures like Guanyin, the question of interpretation takes on added significance. Some of the problems presented by this particular figure are perhaps caused by the Delft ceramist's lack of understanding of the Buddhist religion. Guanyin was originally the Indian Buddhist god Avalokitesvara, companion to the Buddha and depicted in the bejeweled robes of an Indian prince. Introduced into China as a male deity and renamed Guanyin, he became the most worshiped figure in the Buddhist pantheon. More sculptures of Guanyin have been made in China than of any other religious personage.[2] He frequently assumes the *lalitasana* ("royal ease") position, usually reserved for the Buddha.[3] The figure was so popular that nine out of ten *blanc de chine* figures represent Guanyin in one or another manifestation.[4] These can include a Buddha, a prince, a priest, a nun, or a scholar. Guanyin was neither male nor female but a supernatural being who was represented originally as a male deity and as a female beginning in the Sung dynasty (960-1279).[5] As a female deity, she became Goddess of Mercy, giver of children and protector of seafarers. Nearly all temples have a chapel for Guanyin, who is one of the few gods worshiped out of love rather than fear. She also represents infinite compassion, one of the two qualities of the Buddha, which, in conjunction with her role as patron goddess of mothers, explains why figures in her likeness are found in so many Chinese homes.

Guanyin, then, would seem to be to Buddhism what Mary is to Catholicism. In one of two letters describing the kilns of Jingdezhen (Ching-tê-Chên), Père d'Entrecolles (1664-1741), a Jesuit priest who lived in China from 1698 until his death, wrote, "they make here, too, very many Kuan Yin, a goddess celebrated throughout all China represented holding an infant in her arms and worshiped by sterile women who wish to have children."[6] It has even been suggested that this Virgin-and-Child-like personification of Guanyin was due to the influence of the Christian missionaries from Europe who preceded Père d'Entrecolles, since this representation of the deity first appeared in the mid-sixteenth century, about the time of their arrival.[7] To this day, some Japanese museums keep figures of Guanyin as relics of the first Christians in that country.

Figures of Guanyin intended for export to Europe were not restricted to this form alone, however. They were sometimes rather Western in appearance, with heavy wigs, or tall and thin, standing on heavily ornamented bases.[8] The forms most popular in Europe, though, seem to be the goddess in the pose of royal ease or standing with a child in her arms. The figures of Guanyin made for export to Europe or for the Chinese domestic market show her with various attributes, owing to her numerous popular associations. She is most often shown as a young woman, with small, delicate features and long ears, wearing a full-length robe and shawl, which are draped loosely over her body. Her robes are worn open, revealing a long, beaded necklace, which can be quite elaborate and of several strands but is more often a single strand terminating in a cross (a variant of the swastika, symbol of life, procreation, and charity). She is also apt to be wearing bracelets on her wrists. The *urna,* a symbol of superior wisdom and one of the marks of a Buddha, is sometimes shown on her brow, and she frequently wears a headdress incorporating a likeness of the Amitabha Buddha, her spiritual advisor. Her long hair falls in loose braids over her shoulders or is gathered in a single or double chignon atop her head, draped with the veil of compassion. When she is seated, her eyes and head are usually lowered, suggesting repose or meditation. She may hold a lotus blossom, a sacred scroll, a scepter representing lightning, a dagger or an axe symbolizing good fortune, or the book of the law. The goddess is customarily shown with at least one bare foot, which indicates that the change from male to female was never fully realized, since no completely female Chinese deity would be shown with an unbound or bare foot.[9] The lotus blossom and bare feet may have been retained by the Chinese as being fundamental to Buddhist deities. These export figures vary from the *blanc de chine* examples to those from other potteries, which were frequently painted in a rather bright polychrome palette.

From this brief examination of the Chinese versions of Guanyin, the discrepancies in the Markus Delft copy are apparent. Some of these are understandable. The fine articulation of the facial features, necklace, and drapery achieved in the porcelain examples, for instance, is lost in the earthenware version. More curious, however, are the

lack of a cross or other symbol on her necklace, her painted breasts, and the object in her right hand. In Chinese porcelain examples, although Guanyin's robes are often open from her neck to just above her waist (a holdover from Indian art, in which Buddhist goddesses are frequently shown this way),[10] her breasts are never painted or even suggested in the modeling. There is precedent for this in seventeenth- and eighteenth-century Dutch pottery, however. Among the Delft chargers (large circular plates) painted with figures of the ruling monarchs is an example showing Queen Mary with uncovered breasts.[11]

It is difficult to identify with certainty the red object in this figure's right hand, since no Chinese prototype has been found. Among the possibilities are an orb, a pomegranate (symbol of fertility), a peach (symbol of longevity), or a flaming pearl, which purportedly endows Guanyin with the ability to read sacred scripts. An orb seems a plausible explanation on the basis of a standing Delft figure of the Virgin and Child, dated 1752, in the Prinsenhof Museum in Delft.[12] The Virgin holds in her left hand an orb that resembles the one held by the Markus figure; a scepter, now lost, was originally in her right hand. Some Chinese export figures of the goddess depict her holding a peach, which is realistically colored. The patterned collar on the Markus figure, which is joined to two separate pieces of clothing, has also been misunderstood. Her diadem, too, has lost something in translation and has become confused with her hair.

Another curious aspect of this figure of Guanyin is the mark. One of the best-known factories in Delft, De Grieksche A (The Greek A), used the mark PAK beginning in 1701. The mark represents the initials of Peter Adriaensz Kocx (d. 1703), who managed the factory with his father, Adriaen (d. 1701), its owner from about 1679. Until 1722 this mark was used by Pieter's widow, Johanna van der Heul, who assumed management of the factory after his death. De Grieksche A specialized in imitations of Japanese Imari-style decoration and was one of the few factories to use low-fire enamels on its wares. On pieces by this factory decorated in polychrome, the mark PAK is invariably in red, but on the Markus figure it seems to be of the same black glaze as the hair and diadem. It is possible that it was applied at a later date.

The palette and the gilding on this figure of Guanyin are consistent with the products of De Grieksche A during the period when the PAK mark was in use,[13] but the absence of a comparable polychrome example makes attribution difficult. There are two unmarked Delft blue and white figures of Guanyin in this form;[14] they are about one

centimeter larger than no. 2, and the robes and shawls are similarly decorated with foliage and flowers. If, as has been suggested, the only wares consistently marked at De Grieksche A were those decorated with polychrome enamels and fired in the muffle kiln,[15] it is possible that the two unmarked Delft blue and white figures of Guanyin are products of this factory, taken from the same mold as the Markus piece.

A blue and white standing figure of Guanyin marked PAK has been illustrated with a Chinese stoneware example, presumably Yixing (I-Hsing), from which it was doubtless copied or even molded.[16] It seems reasonable to assume that this stoneware figure was owned by De Grieksche A; it is also tempting to postulate that the factory owned another Chinese stoneware version from which the Markus piece was copied with the same fidelity.

C.S.C.

NOTES
1. Soame Jenyns, *Ming Pottery and Porcelain* (London, 1953), p. 146.

2. Fong Chow, "Chinese Buddhist Sculpture," pt. 1, *Metropolitan Museum of Art Bulletin* 23 (May 1965), 323.

3. The *lalitasana* position is assumed by flexing the left leg in front and raising the other at the knee, on which the extended right arm is supported. The left arm often rests on a small stand.

4. P.J. Donnelly, *Blanc de chine: The porcelain of Têhua in Fukien* (London, 1969), p. 53. *Blanc de chine* is the name given to the white porcelain, usually unpainted, that is made at Dehua in the Chinese province of Fujian.

5. Daniel F. Lunsingh Scheurleer, *Chinese Export Porcelain: Chine de commande* (New York, 1974), p. 200.

6. Soame Jenyns, *Later Chinese Porcelain: The Ch'ing Dynasty (1644-1912)* (London, 1951), p. 9. Entrecolles's letters are dated September 1, 1712, and January 25, 1722. Jenyns does not specify which letter contains this mention of Guanyin figures.

7. Donnelly, *Blanc de chine*, p. 154.

8. Michel Beurdeley, *Chinese Trade Porcelain*, trans. Diana Imber (Rutland, Vermont, 1962), p. 33.

9. Donnelly, *Blanc de chine*, p. 154.

10. Chinese ivory figures of Guanyin depict the goddess in this fashion. For a discussion of this aspect of her dress, which also applies to porcelain examples, see Barry C. Eastham, *Chinese Art Ivory* (Tienstin, 1940), pp. 15-16, 32-33, 72.

11. See Sotheby Parke Bernet, London, sale catalogue, June 30, 1981, lot 253, illus.

12. Robert J. Charleston and Daniel F. Lunsingh Scheurleer, *English and Dutch Ceramics*, Masterpieces of Western and Near Eastern Ceramics, vol. 7 (Tokyo, 1979) fig. 103.

13. See Charleston and Lunsingh Scheurleer, *English and Dutch Ceramics*, fig. 95; Henry Pierre Fourest, *Delftware: Faience Production at Delft*, trans. Katherine Watson (New York, 1980), figs. 103, 105.

14. Earle D. Vandekar, London, *An Introduction to Dutch Delftware*, sale catalogue, July 1978, p. 7, illus.; Sotheby Parke Bernet, London, sale catalogue, July 1, 1980, lot 190, illus.

15. Caroline Henriette de Jonge, *Delft Ceramics*, trans. Marie-Christine Hellin (New York, 1970), p. 112.

16. Ferrand W. Hudig, *Delfter Fayence* (Berlin, 1929), fig. 120.

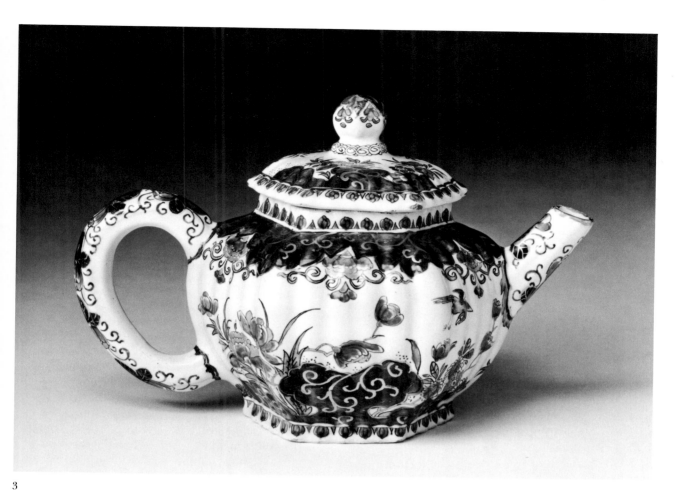

3

3 Teapot and cover

Plate I

The Netherlands, Delft, first quarter of the 18th century

Tin-glazed earthenware (faience) decorated in cobalt blue, polychrome enamels, and gold

Unmarked

H. 12.3 cm. (4⅞ in.), w. 19.2 cm. (7⁹⁄₁₆ in.), diam. at base 8 cm. (3⅛ in.)

1983.598a,b

The squat, molded teapot is hexagonal, with a C-shaped loop handle and a short, straight spout. The slightly domed cover has a rounded hexagonal finial. The body, cover, spout, and handle are vertically ribbed. The foot rim is echoed by an upper rim atop the shoulder to support the cover. The teapot is painted with birds and flowers in the Imari style and palette of cobalt blue, iron-red, and green. The upper shoulder of the pot has a scal-loped collar in blue with gold scrolls and edges and small floral bouquets of red and gold flowers with green tendrils. The center of the pot has been left white, while the lower midsection on either side is painted with "rockwork" in blue, with gold scrolls. On one side, a small red, green, and gold bird flies above the red and gold flowers and tall blades of grass, which grow out of the rockwork. The other side is similarly painted with larger, chrysanthe-mum-like flowers with green foliage and another bird. The outer rim of the cover, the upper rim of the pot, and the foot rim are decorated with a frieze of red flower buds alternating with green tri-angles. The tip of the finial is blue, edged with gold and small red and green floral sprays. A small band of interlaced red circles decorates the base of the finial. The handle of the teapot is painted on the outside with red flowers, blue and gold foliage, and red tendrils, while the inside has been left white. A blue and gold line delineates both ends of the handle where it joins the body. The spout is painted in the same manner, with an additional green foliate collar at its joint to the body.

That an appreciation of Delft ware, particularly that of the late seventeenth and early eighteenth centuries, is enhanced by a knowledge of the oriental ceramics on which it was so often based becomes obvious the more one looks at both. The affinities between the two are close enough to have moved one authority on Japanese export porcelain to encourage further study of its Dutch imitations as an aid in dating it.[1] This Markus teapot could well serve in such a capacity, although it would provide more conclusive evidence if it were marked or dated.

Tea was used in China as early as the Tang dynasty (618-906) but does not seem to have reached Europe until the seventeenth century. An early written reference to it, however, is contained in a book detailing the travels of Jan Huyghen van Linschooten, published in Holland in 1595.[2] The Dutch began to ship tea from the Japanese island of Hirado in 1610, and it probably arrived in Holland within a few years of that date.[3] It was several years before tea gained social acceptance, however, since it was originally used for purely medicinal purposes.

The imported tea was accompanied by stoneware teapots made in Yixing (I-Hsing), a district in Jiangsu (Kiangsu) Province. These small red teapots, renowned for their ability to retain heat and flavor, were made in many different forms, but among them were some that may have inspired the first *theepotbackers* (makers of teapots) of Delft. There are several examples of seventeenth-century Yixing teapots with ribbed bodies, simple loop handles, domed covers, and short spouts.[4] There are differences, certainly, but the similarities to this Delft teapot are too obvious to ignore. Before producing tin-glazed earthenware teapots, Delft potters made their own red stoneware teapots. These were made from the early 1670s until about 1730, by which time manufacture of tin-glazed earthenware examples was well underway.[5] The latter may have superseded the stoneware teapots because of their more colorful and decorative surfaces made possible by the tin glaze. Although the decoration of the red stoneware teapots has little in common with that of the tin-glazed earthenware teapots made in Delft, the forms of the stoneware teapots, which were modified versions of those from Yixing, had a direct influence on the tin-glaze examples.

The first Delft-ware teapots, which must have been made in about 1700, also have much in common with Chinese and Japanese export porcelain wine pots and teapots of the seventeenth and eighteenth centuries.[6] A few of these have Dutch metal mounts, which were probably added soon after their arrival in Holland. Teapots with round bowls, plain loop handles, straight spouts, and domed covers are of oriental origin,[7] but few early export examples survive. It is not surprising to find such a strong resemblance between export porcelain and European pottery; many Chinese and Japanese export forms were based on Dutch or European prototypes or even on Delft-ware adaptations of Chinese originals.[8]

In seeking the model for a closely ribbed body such as that of no. 3, one finds that neither Japanese nor Chinese porcelains provide a complete answer, since the surfaces of comparable oriental pots are incised or fluted at widely spaced intervals rather than molded in closely ribbed patterns. There exists an entire class of blue and white and polychrome Delft wares made between 1690 and 1710 with ribbed surfaces, including teapots, tea caddies, teabowls and saucers, vases and jars.[9] A ribbed, pear-shaped blue and white Delft teapot in the Van Heel Collection that has been dated about 1700 is probably the precursor to the Markus piece.[10] The rounder, squatter form of no. 3 was probably produced slightly later, in the first quarter of the eighteenth century. The same form was also made in Delft with a black ground.[11] A popular early eighteenth-century variation of this form can be seen in several extant teapots whose sides are flattened to form an oval reserve.[12] It has been suggested that the source for ribbed decoration may be found in European glass, where it occurs frequently.[13] Glass may well be the prototype, since neither of the usual sources, export ceramics and Dutch metalwork, provides sufficiently similar characteristics.[14]

Tracing the source for the painting of this Markus teapot is more straightforward, for the technique was taken directly from the so-called Imari porcelains. This name refers to a class of Japanese porcelain shipped to Europe from Imari but made in the factories of Arita, a town in the province of Hizen. Its decoration consists primarily of underglaze blue, iron-red enamel, and gold. Green, yellow, aubergine, and other enamel colors were added to the better pieces. The lavish use of gold on Imari porcelain (reflected in no. 3), was intended less as an embellishment than as a cover for the uneven and often runny underglaze blue pigment used in Arita. Previous to the arrival of Imari porcelains in Holland in about 1700, there had been only limited use of polychrome decoration on Delft ware, and the technique had been kept secret by the few potters who had learned it. The technique came into more general use after 1700 but was still only possible with a muffle kiln to fire the enamel colors and gilding. Only a few factories

used the muffle technique, but their results were partly responsible for the predominance of Delft as a pottery center in the first half of the eighteenth century.

One of the factories whose reputation was in part based on its use of the Imari palette was De Grieksche A (The Greek A; see discussion at no. 2). The accomplished painting, the colors, the gilding, the flowers and birds, even the red and green decoration of the shoulder rim and foot rim of no. 3 are very close to the same elements on some marked pieces from this factory, which are all datable to the first quarter of the eighteenth century.[15] A bourdalou made at De Grieksche A and marked PAK in the Musées Royaux d'Art et d'Histoire in Brussels provides an especially close comparison. It is similarly ribbed and is painted in the same style and palette.[16] Such similarities, however, may also be an indication of the extent to which the factory's wares were imitated.

This teapot is in unusually pristine condition; the gilding shows almost no evidence of wear except on a small part of the handle. The cracks on the inside of the pot, however, provide a more positive sign of age. They are to be expected on tinglazed earthenware, which is soft and thus not at all suitable for hot liquids. This is probably the reason that so few Delft teapots and coffee pots survive. Despite this drawback, tea wares in this medium continued to be produced until at least 1758, as attested by an inventory made in that year of the stock owned by De Grieksche A.[17] This included "2,133 dosijn gepaard theegoed" (2,133 dozen matching teasets), many of which may have been shipped to other parts of Europe.

We can only surmise, then, that this Markus teapot has been used only a few times. Its shape, ribbed surface, and the type of its Imari-style painting indicate a date in the first quarter of the eighteenth century. At present, the only clue to a factory attribution for no. 3 is its similarity to some pieces from De Grieksche A.[18]

C.S.C.

NOTES

1. T. Volker, "The Japanese Porcelain Trade of the Dutch East India Company between 1682 and 1795," *Mededelingblad vrienden van de Nederlandse ceramiek, no.* 10 (Jan. 1958), p. 3.

2. Frank Tilley, *Teapots and Tea,* (Newport, Eng., 1957), p. 74.

3. Ibid.

4. For examples see Terese Tse Bartholomew, *I-Hsing Ware* (New York: China Institute in America, 1978), figs. 2 and 5.

5. For more complete discussions of Dutch stoneware teapots, see Caroline Henriette de Jonge, *Delft Ceramics,* trans. Marie-Christine Hellin (New York, 1970), pp. 64-69; Minke a De Visser, "Roode Delftsche theepotten van Lambert van Eenhoorn en van De Rotte in het Groninger Museum," *Oud-Holland* 72, nos. 1-4 (1957), 104-110.

6. Soame Jenyns, *Japanese Porcelain* (London, 1965), pls. 40 A-B, 59 A, and 78 A-B.

7. John Goldsmith Phillips, *China-Trade Porcelain* (Cambridge, Mass., 1956), p. 55.

8. Oliver R. Impey, "The Earliest Japanese Porcelains: Styles and Techniques," in *Decorative Techniques and Styles in Asian Ceramics,* ed. Margaret Medley, Colloquies on Art and Archaeology in Asia, 8 (London, 1979), p. 135; Daniel F. Lunsingh Scheurleer, *Chinese Export Porcelain: Chine de commande* (New York, 1974), fig. 139.

9. This type of decoration is often referred to as "cachemire," but the derivation of the term is not clear, and there is not always agreement on its usage. For references to it, see Ferrand W. Hudig, *Delfter Fayence* (Berlin, 1929), p. 196; William B. Honey, *European Ceramic Art: A Dictionary of Factories, Artists, Technical Terms, et cetera* (London, 1952), p. 103; Henry Pierre Fourest, *Delftware: Faience Production at Delft,* trans. Katherine Watson (New York, 1980), p. 74; Salomon Stodel Antiquities, Amsterdam, *Blue Delftware, 1680-1720,* sale catalogue, text by M.E.W. Goosens (1981), fig. 34, p. 46; Daniel F. Lunsingh Scheurleer, "Collectie M.G. van Heel, oud Delfts aardewerk, Rijksmuseum Twenthe, Enschede," *Mededelingenblad vrienden van de Nederlandse ceramiek, no.* 54 (1969), fig. 81, p. 39.

10. Lunsingh Scheurleer, "Collectie M.G. van Heel," fig. 14, p. 12.

11. Reginald G. Haggar, *The Concise Encyclopedia of Continental Pottery and Porcelain* (New York, 1960), color plate 15, p. 317.

12. Caroline Henriette de Jonge, *Oud-Nederlandsche majolica en Delftsch aardewerk* (The Hague, 1947), fig. 231a,b, p. 266.

13. Clare Le Corbeiller, *China Trade Porcelain: Patterns of Exchange* (New York, 1974), p. 27.

14. Dutch silver teapots of the early eighteenth century have the same form of body and cover as no. 3, and the bands of fluted ornament on their covers and sides are quite similar to the ribbed molding found on Delft-ware examples, but the surviving silver examples are all too late in date to be considered as models. Their handles and spouts are more elaborate, often in the form of animals. For a silver example dated 1714, see A.L. den Blaauwen, ed., *Dutch Silver, 1580-1830* (The Hague, 1979), fig. 98, p. 203.

15. Kunstgewerbe Museum, Cologne, *Fayence I: Niederlande, Frankreich, England,* catalogue by Brigitte Tietzel (1980), pl. IV (color); De Jonge, *Oud-Nederlandsche majolica,* fig. 257, p. 291; Gemeentemuseum, The Hague, *Polychrome Delftware* (1969), fig. 17; Caroline Henriette de Jonge, "Een particuliere verzameling Delfts aardewerk," *Mededelingenblad vrienden van de Nederlandse ceramiek, no.* 48 (Sept. 1967), figs. 36, 38, p. 43; Fourest, *Delftware,* fig. 105, p. 111.

16. Musées Royaux d'Art et d'Histoire, *La Vie au XVIIIe siècle* (Brussels, 1970), fig. 34.

17. De Jonge, Delft Ceramics, p. 137.

18. Some of the other Delft factories that used the muffle technique were De Roos (The Rose), De Metalen Pot (The Metal Pot), and De Dobbelde Schenken (The Double Jug); Kunstgewerbe Museum, Cologne, *Fayence I,* p. 175.

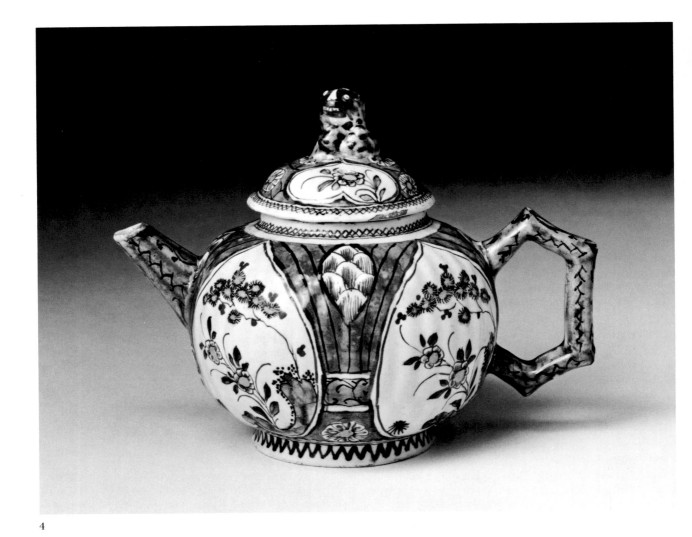

4

4 Teapot and cover

The Netherlands, Delft, De Grieksche A
factory, about 1725-1735

Tin-glazed earthenware (faience) with poly-
chrome decoration

Mark:
(1) on base, in iron red: D over symbol for a
 shaft

H. 12.8 cm. (5 in.), w. 17.2 cm. (6¾ in.),
diam. at base 6.4 cm. (2½ in.)

1983.599a,b

*The teapot is of globular shape with a short,
straight spout and a polygonal handle. The body
of the teapot is molded with vertical ribbing, which
is divided into three horizontal registers: one de-
fining the shoulder, one the midsection, and one
the area above the foot. The spout and cover are*
*also ribbed. The domed cover has a gently flaring
rim and a finial in the form of a lion. The finial
might also include a cub, but the rudimentary
modeling makes this difficult to ascertain. A small
hole directly beneath the lion allows for the escape
of steam. The foot ring is echoed by a rim atop the
shoulder, which supports the cover. The body of
the pot is decorated with four leaf-shaped re-
serves, each outlined in red and blue and contain-
ing similar Imari-style flowers. Large flowers
occupying the lower portion of the reserve have
yellow centers, manganese purple petals with red
outlining, and blue foliage and stems with red
tendrils; they grow out of manganese purple
rockwork edged with blue moss. Clusters of long-
stemmed, daisy-like flowers with yellow centers
and blue petals grow from the top of the rockwork.
Small areas of red paint amongst these flowers sug-
gest butterflies. A small chrysanthemum-shaped
decoration in blue is painted in the lower left of
each reserve. Between the reserves, parallel blue*

lines against a mottled green ground follow the contours of the leaves from beneath the shoulder rim to the lower half of the pot. A blue-edged, almond-shaped ornament painted with red scales is placed atop the line decoration and above the handle and spout. A short, pale blue band decorated with dark blue scrolls and bordered with white joins adjacent reserves. Beneath the band a large flower with a yellow center and manganese purple petals lined with red is centered on the mottled green ground, which is produced by the application of yellow pigment over cobalt blue. The spout and handle are both pale blue with dark blue scrolls and angled lines. A line of blue chevrons has been applied to the foot ring. The cover is painted with two leaf-shaped reserves. A single flower similar to the two large flowers of the lower reserves fills the white ground of both leaves. Yellow and manganese purple flowers against a mottled green ground with blue reticulation decorate the remainder of the cover. The lion is painted in blue, with white facial features outlined in red. The flared rim of the cover and the shoulder rim are decorated with a pattern of small red chevrons with blue lines above those on the cover and below those on the shoulder rim.

Because of its form, decoration, and mark, this teapot presents questions of dating often encountered with eighteenth-century Delft ware. In this case, form and decoration do not, upon initial examination, seem to be in complete agreement. Both, however, are known to have been used by the same factory during the eighteenth century.

This teapot form is derived from both native and oriental elements, as is customary for early eighteenth-century Delft wares. As discussed in the previous entry, the prototypes for early eighteenth-century Delft-ware teapots were the Chinese and Japanese teapots designed for export with tea. However, these forms were altered when they came in contact with indigenous tradition. Chief among the forms sent with the trading companies were those with wide, subtly fluted bodies and those with squatter, smooth-sided bodies. Dutch modelers soon altered these shapes, giving them rounder bodies, higher-domed covers, and closely ribbed surfaces, as evidenced by this example. The polygonal handle, the lion finial, and the short, straight spout are all derived from Chinese and Japanese stoneware and porcelain teapots made for export to Europe,[1] although the form of the handle (originally modeled in imitation of a bamboo stem), is usually less pronounced than on those wares. The ribbing may be a modification of the fluting and lobed decoration so often found on

Kangxi (K'ang Hsi, 1662-1722) teapots. As the first teapots to arrive in the Netherlands were ceramic, the earliest imitations of them may have been in the same medium. The ribbing on this example, though, which is divided into three sections, is more closely related to the fluting on Dutch silver teapots of the period.[2] As noted in the previous entry, however, extant silver examples do not sufficiently predate the ceramic teapots to be considered as models. It is thus possible that the form was adopted concurrently in Dutch earthenware and silver from an oriental model.[3] European glass has also been suggested as a possible source of this molded decoration.[4] By the beginning of the eighteenth century it had become firmly enough established to be used as decoration on some Chinese export porcelain made to order for the Dutch East India Company.[5]

The Delft-ware antecedents of this teapot form date from the late seventeenth century, by which time tea had become quite popular. One example, from the Rijksmuseum, Amsterdam, has a bell-shaped, ribbed body, domed cover, straight spout, and loop handle. Decorated in blue and white in the Chinese style and marked with one of De Dissel's symbols, it has been dated to before 1694.[6] Another precursor of this form is a teapot in the Vromen Collection that was probably made at De Metalen Pot (The Metal Pot) and has been dated between 1691 and 1715.[7] Its handle, spout, and finial are identical to those on the Markus teapot, but the body is less round, and each side has been molded with an eye-shaped reserve. Painted in blue and white with chinoiserie scenes, it lacks the vertical shoulder rim of the Markus version and has instead a recessed rim to support a smaller and only very slightly domed cover.

Although both the Markus teapot and the bell-shaped example from the Rijksmuseum are marked as products of De Dissel, only the latter can be attributed to this factory with any degree of certainty on the basis of its obvious seventeenth-century form and decoration. Established in 1640 and operative until 1701, De Dissel factory was completely taken over in that year by another factory, De Grieksche A (The Greek A), which had been responsible for its management since 1694.

4(1)

The dissolution of De Dissel did not, however, require retirement of the marks used by that concern, and De Grieksche A apparently decided to maintain the marks for certain types of objects.[8] What remains open to question is the rationale behind this system of marking. It seems reasonable to hypothesize that De Grieksche A used De Dissel's mark only for forms or types of decoration originally produced by that pottery.

Two teapots of the same form as the Markus teapot but painted with blue chinoiserie motifs on a white ground are also marked with De Dissel symbols, and both have been dated to the beginning of the eighteenth century. One of the examples is claimed to be of too late a date to have been made by De Dissel and is therefore attributed to De Grieksche A. The other example has been attributed to De Dissel, as about 1700, which, on the basis of its form and decoration, seems plausible.[9] Given the similarity of this form of teapot to the late seventeenth-century Delft-ware examples cited above as well as to oriental teapots, it is entirely possible that it was in production by the beginning of the eighteenth century. The decoration on the Markus teapot, however, precludes its attribution to De Dissel and suggests that this form of teapot was produced for some time by De Grieksche A.

The particular type of high-fire decoration used on the Markus teapot generally consists of heart-shaped reserves containing Imari-style flowers set against a mottled green ground outlined with blue and interspersed with red ornaments of pinecone-like structure. Yellow grounds are also known with this motif. Often referred to as the heart pattern, the motif is probably based on reserves symbolizing water lilies on Japanese porcelain.[10] According to some scholars, the pattern was first used on Delft wares in the seventeenth century, most notably a group of plates and bowls that have been attributed to Jan van der Laan.[11] The decoration on the Markus teapot is closer in execution and palette to pieces that are generally dated as eighteenth century, such as a puzzle jug dated about 1725 in The Hague Gemeente Museum; a set of oil and vinegar pitchers, the whereabouts of which are unknown, dated about 1750; and a covered tureen dated about 1740 in the Museum für Kunsthandwerk in Frankfurt.[12]

The discrepancies between the dates assigned to these last three pieces, all of which bear De Dissel marks, point either to the longevity of some motifs at certain of the Delft factories or to inaccurate dating. The form of the covered tureen is the same as that of another, differently decorated example that is marked as De Dissel and

given a date of about 1725.[13] The decoration on both the tureen and the oil and vinegar pitchers is very close to that on the Markus teapot. It seems entirely possible that the decoration could have been executed in this manner before the middle of the century, and, despite the later date assigned to the Frankfurt tureen and to the pair of covered pitchers, the Markus teapot must be given a date between 1725 and 1735.

C.S.C.

NOTES

1. See Geoffrey Hedley, "Yi-Hsing Ware," *Transactions of the Oriental Ceramic Society* 14 (London, 1937), pl. 37e, facing p. 76; Hong Kong Museum of Art, *Yixing Pottery* (1981), fig. 111; Soame Jenyns, *Japanese Porcelain* (London, 1965), fig. 40A.

2. See Abraham C. Beeling, Leeuwarden, *Nederlands zilver, 1600-1813*, sale catalogue, vol. 2 (1980), p. 157; A.L. den Blaauwen, ed., *Dutch Silver, 1580-1830* (The Hague, 1979), fig. 98, p. 203.

3. This must remain hypothesis, however, since so few seventeenth-century Dutch silver teapots have survived. The earliest silver teapot of comparable form I have found thus far was made in Haarlem in 1707; see Beeling, *Nederlands zilver,* vol. 2, p. 157.

4. Clare Le Corbeiller, *China Trade Porcelain: Patterns of Exchange* (New York, 1974), p. 27.

5. Daniel F. Lunsingh Scheurleer, "De Chinese porseleinkast: reizende tentoonstelling van Chinees porselein dat in de 17e en 18e eeuw door Nederland werd geïmporteerd," *Mededelingenblad vrienden van de Nederlandse ceramiek,* no. 52 (Sept. 1968), fig. 184, p. 43.

6. H.E. van Gelder, "Delftse plateelbakkerij 'de Dissel' (Abr. de Cooge, L. Boersse, C. van der Kloot)," *Mededelingenblad vrienden van de Nederlandse ceramiek,* no. 17 (Dec. 1959), fig. 3, p. 3.

7. Caroline Henriette de Jonge, "Een particuliere verzameling Delfts aardewerk," *Mededelingenblad vrienden van de Nederlandse ceramiek,* no. 48 (Sept. 1967), fig. 6, p. 8.

8. Van Gelder, "Delfts plateelbakkerij 'de Dissel,'" p. 9. Several marks were used, most of which combined D with either a number or a shaft sign beneath it. For examples of these see Van Gelder's article, p. 2; and De Jonge, "Een particuliere verzameling Delfts aardewerk," p. 68.

9. Salomon Stodel Antiquities, Amsterdam, *Blue Delftware, 1680-1720,* sale catalogue, text by M.E.W. Goosens (1981), fig. 18, p. 29; Kunsthaus Lempertz, Cologne, sale catalogue, Nov. 18-20, 1982, lot 1077, p. 113, illus. p. 109.

10. Henry Pierre Fourest, *Delftware: Faience Production at Delft,* trans. Katherine Watson (New York, 1980), p. 130.

11. Jan Boyazoglu and Louis de Neuville, *Les Faïences de Delft* (Paris, 1980), fig. 45, p. 232; Fourest, *Delftware,* fig. 124, p. 131. De Jonge seems doubtful of the seventeenth-century date given many of these plates; see *Delft Ceramics,* trans. Marie-Christine Hellin (New York, 1970), p. 82.

12. For the puzzle jug: De Jonge, *Delft Ceramics,* fig. 73, p. 76; oil and vinegar pitchers: Boyazoglu and Neuville, *Les Faïences de Delft,* pl. 43 (color), p. 231; tureen: Daniel F. Lunsingh Scheurleer, *Delft: Niederländische Fayence* (Munich, 1984), pl. 6 (color).

13. De Jonge, *Delft Ceramics,* fig. 72, p. 75.

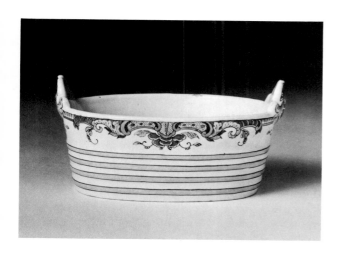

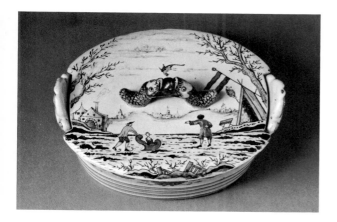

the brackets of the dish. The finial on the cover, which also serves as its handle, is formed by two facing dolphins, which balance a ball between their mouths. The dish is white, and the four bands are painted a pale beige with red outlining. Around the upper edge of the dish a Kakiemon-style motif of flower petals, foliage, and palmettes is painted in orange-red, pale green, and turquoise with some gilding. The cover depicts a Dutch skating scene. Two sections of blue fence in the foreground and a blue, red, green, and black hillock with some brush suggest a bank of the river. A man on skates in blue breeches, mauve jacket and stockings, and a black hat pushes a red sledge in which a woman dressed in blue is seated. Another man, seen from the back, wears a blue coat, red breeches, and a black hat. He gestures toward the sledge with his left arm; his right arm is folded behind his back. The river is pale green with areas of black. On the far right bank of the river stands a tall, mauve-colored, open warming tent. A large Dutch flag, attached to the top of the tent, flies overhead. Beneath the flag a long-handled broom is staked to the left of the tent. A tall tree stands on the other side of the tent and extends over it. Two buildings, one with a smoking chimmney, are on the far left bank of the river. Above the buildings, the branches of a large tree are visible. In the distance is a hilly cityscape, and overhead are several thin, wispy clouds and a red bird with blue wings.

5 *Butter dish and cover*

The Netherlands, Delft, about 1730

Tin-glazed earthenware (faience) decorated in polychrome enamels and gold

Marks:
(1) inside dish, in red enamel: j o
(2) underside of cover, in red enamel: 5

H. without cover 6.3 cm. (2½ in.), with cover 8.3 cm. (3¼ in.), w. 12.8 cm. (5 in.), d. 9.5 cm. (3¾ in.)

1983. 600a,b

The molded oval dish has slightly canted sides with four rows of horizontal ribbing on the lower portion. Two raised brackets at each end are molded on the exterior in the form of leaves. The thin, flat cover has notches on both ends to accommodate

Judging from the number of Delft butter dishes that have survived, they were quite popular throughout the eighteenth century. If, as has been suggested, butter dishes were made in white,[1] it is likely that the form was first produced in the late seventeenth or very early eighteenth century, when whiteware was most popular. These undecorated dishes would have been treated as utilitarian objects, and it would not be surprising if few have survived. The earliest painted examples, on the evidence of their decoration, seem to date from the end of the first quarter of the eighteenth century. Whether decorated or not, these early dishes were probably circular in form. The prototype for the form is the small, round wooden tubs

5(1) 5(2)

that were used to transport freshly made butter. The raised bands on the exterior of the dishes represent the willow twigs used to hold the narrow wood staves in place.[2] The bands do not, then, as is sometimes suggested, simulate rope binding; nor is the dish intended to represent a basket.[3] The bands are frequently painted to simulate twigs, just as the ribs, entwined in garlands, on the Delft mustard pot in this collection (no. 8) are painted to represent roots and knots.

A pair of Delft objects in the form of peasants in rowboats dates from the second half of the eighteenth century.[4] One of the peasant couples transports wheels of cheese, and the other couple a circular tub containing four large mounds of butter. Although both circular and oval butter dishes were produced in the first half of the eighteenth century,[5] it seems likely that the Delft modelers would have adopted the circular form of the prototype before introducing the oval variant. One factor indicating a slightly later date for oval dishes such as no. 5 is the form of the raised brackets on either side of the dish. These are adaptations of those on the wooden tubs, which were flat with squared corners and supported a handle. Brackets on the circular Delft dishes are either the same as those on the wooden originals or of rounded shape and retain the hole in the center for a handle,[6] even though the ceramic dishes had no such handles. The brackets serve a function, though, since they hold the flat, ceramic covers in place. Brackets on oval dishes like the Markus example are relief-molded on the exterior in the form of leaves and do not retain the hole. The designer of the oval butter dish has not merely copied but has also interpreted the prototype and modified it for domestic use; the result is a more decorative piece of tableware.

Considering their fragility, a surprising number of these dishes seem to have their original covers. Butter dishes and covers were presumably always accompanied by stands, although very few of the latter survive. The stands were not always specially fitted for the dishes and may have been used separately from and more frequently than the dishes themselves, thus incurring greater risk of breakage. Enough stands of different form and decoration survive, however, to prove they were made throughout the century.[7] The Markus dish would have had a shaped oval stand similar to one (en suite with its dish and cover) in the Musées Royaux d'Art et d'Histoire in Brussels.[8]

Butter was a plentiful commodity in the Netherlands during the eighteenth century, and its production was a thriving industry. The number and variety of dishes made for butter in Delft

throughout the century attest to its widespread use.[9] By midcentury, in addition to the circular and oval dishes, octagonal dishes and stands were being made,[10] and by the third quarter of the century the octagonal form began to reflect rococo ornament with wavy-edged covers and stands, domed covers, and slightly waisted dishes.[11] Modelers may well have been influenced by contemporary Dutch silver, although the form itself was not made in silver. Finials also took on various shapes; especially popular were cows, dogs, snails, and fruit, as well as simple voluted forms or painted knops like that on the cover of the Delft mustard pot in this collection (no. 8). Small covered dishes molded as figures were also made in the second half of the century, but it is not clear whether these were used for butter or small pies or pastries.[12] Indeed, an oval dish similar to no. 5 has been published simply as a "bakje" (dish).[13] The rationale for this nomenclature seems to be that the dish is thought to be part of a condiment set, which includes a circular butter dish and a mustard pot. The decorations of the "oval dish" and the circular butter dish, however, do not match and therefore cannot be from the same set. The oval dish and mustard pot are painted in the same palette with figures in European landscapes, and the circular dish in a different palette with chinoiserie flowers and birds. The matching decoration on the oval dish and the mustard pot indicates that small containers like nos. 5 and 8 were made as part of Delft table services. Other service pieces would have included soup tureens, individual salts or salt and pepper casters, cruet sets, and possibly preserve jars and candlesticks. Although no complete services of this kind appear to have survived intact, enough pieces with the same decoration are known to substantiate the theory that such wares were made in sets.[14] The existence of several of these wares in children's (miniature) sets is another indication they may have been produced in full size.[15]

The decoration of Delft butter dishes may be divided into three main categories: that inspired by Japanese (Imari and Kakiemon) porcelain, European landscapes (with and without figures), and European harbor scenes based on the porcelain painting of Johann Gregor Höroldt (1696-1775) at the Meissen factory. The decoration of the majority of extant butter dishes falls into the first or second category. The white ground, the motif, and the predominantly red palette of the Markus dish are based on Japanese Kakiemon-style porcelain, many pieces of which were brought to Holland by the Dutch East India Company from about 1700 on. The Kakiemon family, beginning in the mid-seventeenth century,

produced wares with a flawless, soft white ground onto which was fired a limited range of enamel colors, including orange-red, pale green (as on the brackets here), pale blue, turquoise, and occasionally yellow and gold. The decoration of the Markus butter dish reflects the restrained use of these colors on Kakiemon porcelain, allowing the white ground to be shown off to best advantage. Other Delft butter dishes, including one of the few extant dated examples, were decorated exclusively in cobalt blue.[16] Most of these dishes are of circular or octagonal form. The oval dishes seem more often to be polychrome, and, as has been observed, most of these are painted in low-fire enamels,[17] as is the Markus example.

Only a small number of the Delft potteries produced wares decorated with low-fire enamels and gold. The process was more costly than the high-fire technique not only because of the greater expense of the materials involved but also because more kiln firings were necessary and painters had to be retrained before they were able to use the enamels properly. The factories that employed the low-fire, or muffle, technique began to do so shortly after 1710.[18] De Grieksche A (The Greek A) is the best-known of the Delft factories to have used the muffle technique, and it has been stated that all objects fired by this method at this factory are marked.[19] Moreover, most of the objects painted with low-fire enamels from De Grieksche A also incorporate cobalt blue in their decoration (fired before the application of the enamels). Other factories employing the muffle technique were De Dobbelde Schenckan (The Double Jug), De Drei Vergulde Astonnekens (The Three Golden Ash Barrels), De Metalen Pot (The Metal Pot), and De Roos (The Rose). The Markus butter dish is not sufficiently similar in style to pieces from any of these potteries to permit an attribution. The rather restrained decoration of the dish and its reliance on a Kakiemon palette rather than on European porcelain decoration indicate a date previous to 1735, when the influence of the latter becomes more evident on butter dishes.

The cover of no. 5, although possibly of the same period as the dish, seems to be a replacement for the original. One would expect the decoration on the cover to be in keeping with that on the dish, both in subject and palette. Neither matches in this case. The painter of the dish has used a Japanese model, and the painter of the cover has adapted the scene for January from a set of Delft plates depicting the twelve months.[20] Such series were made in Delft as early as the middle of the seventeenth century and were based on prints by Jan van de Velde II (1593-1641) and Simon Frisius (about

1580-1628), among others.[21] Although no butter dishes decorated in this manner have come to light, the cover may have become separated from its original dish and paired with the Markus tub at a later date. No other butter dishes are known that combine European and Japanese or Chinese decoration. The finial does not resemble that on any other covers and is not relevant to the winter scene. It obscures the bird and the overall legibility of the scene. It is quite similar, however, to the handles on the sides of some Delft pierced fruit dishes.[22]

The red enamel letters and numerals do not help with an attribution, since they are not factory marks or otherwise identifiable. Delft ware was often marked with such numerals or letters, but these have seldom been identified. It is also possible that such marks may have been added later by an owner.

<div style="text-align: right">C.S.C.</div>

NOTES

1. Alan Caiger-Smith, *Tin-glaze Pottery in Europe and the Islamic World* (London, 1973), p. 132.

2. Robert J. Charleston and Daniel F. Lunsingh Scheurleer, *English and Dutch Ceramics*, Masterpieces of Western and Near Eastern Ceramics, vol. 7 (Tokyo, 1979), fig. 99, p. 313.

3. As stated by Henry Pierre Fourest, *Delftware: Faience Production at Delft*, trans. Katherine Watson (New York, 1980), fig. 141, p. 145. Fourest also classifies the form as a work of trompe l'oeil; ibid., p. 123.

4. Charleston and Lunsingh Scheurleer, *English and Dutch Ceramics*, fig. 106, p. 314.

5. Ibid, p. 313.

6. Museum Boymans en historisch Museum der Stad Rotterdam, *Jaarverslag*, 1941-1943, fig. [104b], p. [153].

7. Caroline Henriette de Jonge, "Een particuliere verzameling Delfts aardewerk," *Mededelingenblad vrienden van de Nederlandse ceramiek, no.* 48 (Sept. 1967), figs. 45, 46, p. 52; Rijksmuseum, Amsterdam, *Delfts aardewerk - Dutch Delftware*, catalogue by M.-A. Henkensfeldt Jansen (1967), fig. 31; Daniel F. Lunsingh Scheurleer, "Collectie M.G. van Heel: oud Delfts aardewerk, Rijksmuseum Twenthe, Enschede," *Mededelingenblad vrienden van de Nederlandse ceramiek, no.* 54 (1969), no. 26, p. 19; Christie's, London, sale catalogue, June 16, 1969, lot 40, illus.; Caroline Henriette de Jonge, *Delft Ceramics*, trans. Marie-Christine Hellin (New York, 1970), fig. 131, p. 128; Anne Marie Mariën-Dugardin and Chantal Kozyreff, *Ceramic Road* (Tokyo, 1982), figs. 42, 61, 62; Sotheby Parke Bernet, New York, sale catalogue, Dec. 17, 1982, lot 187, illus.

8. See Mariën-Dugardin and Kozyreff, *Ceramic Road*, fig. 62 (color).

9. These dishes were so popular that Delft potters were unable to meet the demand for them. They were being made in China for the European market by at least 1738, and by 1765 the Dutch East India Company was ordering porcelain butter dishes "with hoops on the outside," undoubtedly referring to Delft-ware dishes like no. 5. See C.J.A. Jörg, *Porcelain and the Dutch China Trade*, trans. Patricia Wardle (The Hague, 1982),

p. 163. Jörg states that the term "hoops" refers to the raised brackets on the Delft butter dishes, but it is more likely that it refers to the raised molded bands discussed above.

10. De Jonge, "Een particuliere verzameling," figs. 45, 46, p. 52.

11. Lunsingh Scheurleer, "Collectie M.G. van Heel," fig. 36, p. 23.

12. De Jonge, "Een particuliere verzameling," figs. 51, 52, p. 56; Lunsingh Scheurleer, "Collectie M.G. van Heel," fig. 213, p. 58; De Jonge, *Delft Ceramics*, fig. 146, p. 139; Charleston and Lunsingh Scheurleer, *English and Dutch Ceramics*, fig. 86.

13. De Jonge, "Een particuliere verzameling," fig. 48, p. 55.

14. A group of eighteenth-century Delft wares with similar decoration and palette, which includes a soup tureen, butter dishes, and mustard pots, indicates that such tablewares were made in sets. This particular group is discussed in relation to the mustard pot in this collection, no. 8.

15. Gemeentemuseum, The Hague, *Gekleurd delfts aardewerk - Polychrome Delft Ware*, catalogue by S.M. van Gelder (1969), fig. 21.

16. Ferrand W. Hudig, *Delfter Fayence* (Berlin, 1929), fig. 217, p. 225.

17. Kunstgewerbe Museum, Cologne, *Fayence I: Niederlande, Frankreich, England,* catalogue by Brigitte Tietzel (1980), fig. 81, p. 199.

18. For a discussion of low-fired Delft wares, see De Jonge, *Delft Ceramics*, pp. 109-119; see also Caiger-Smith, *Tin-glaze Pottery*, pp. 133-134.

19. De Jonge, *Delft Ceramics*, p. 112. See also the discussion at no. 2 in this catalogue.

20. See Hudig, *Delfter Fayence*, fig. 252, p. 262; Sotheby Parke Bernet, New York, sale catalogue, Dec. 17, 1982, lot 196, illus.

21. Caroline Henriette de Jonge, *Oud-Nederlandsche majolica en Delftsch aardewerk* (The Hague, 1947), fig. 164, p. 189; Charleston and Lunsingh Scheurleer, *English and Dutch Ceramics*, fig. 78.

22. See Lunsingh Scheurleer, "Collectie M.G. van Heel," fig. 37, p. 23.

6 *Parrot*

The Netherlands, Delft, about 1730-1735

Tin-glazed earthenware (faience) with polychrome decoration

Unmarked

H. 17.8 cm. (7 in.), w. 11 cm. (4⁵⁄₁₆ in.), d. 6.7 cm. (2⅝ in.)

1983.601

Provenance: Purchased, New York, May 1959

The parrot stands upright, astride an open teardrop-shaped stand, which is attached to the tip of the bird's tail and both legs. The exterior of the

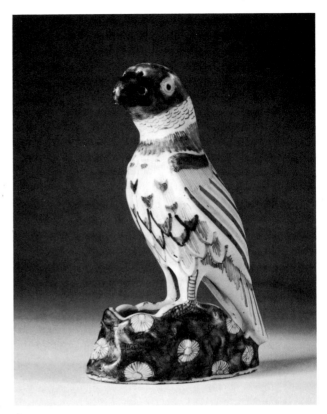

6

stand has an irregular surface suggesting rockwork, with an undulating top edge at the front and a sloped edge behind the legs, echoing the parrot's tail. The stand and bird seem to have been molded as one piece and separated by cutting the clay, leaving an opening between the bird's tail and the upper edge of the stand. Decorating the base are circular blossoms in pale yellow and orange on a mottled light blue ground with a bubbly blue wash and a fine network of lines suggesting rockwork. The bird's head is turned slightly to the left, and the lower edges of the wings protrude slightly from the body. The parrot has a dark blue bill, with a small circular hole on each side, indicating the upper and lower mandibles, and two holes for the nostrils at the top of the bill. Its head is bluegreen, with a yellow crown. The blue eyes are framed by a white circle within a yellow one. The pale blue neck has a white ring with red feathers. The upper body has red feathers edged in yellow and dark blue, and the lower body, blue feathers edged in orange, all against a white ground. The tops of both wings are green-blue, with fine orange lines beneath and bolder orange and yellow stripes over the rest of the wing. The tail feathers are striped in the same way, and the legs and talons are striped in light blue. The body is hollow, and the interior glazed.

Parrots were probably first brought to Europe at the time of the explorations of Asia and America during the fifteenth and sixteenth centuries.[1] Owing to their unusual talent for mimicry, their colorful plumage, and their relative longevity, they quickly became popular as domestic pets. The more exotic parrots were considered luxuries because of their cost. They were often kept in elaborate and equally expensive cages, a few of which were even made in Delft ware by the early eighteenth century.[2]

The still-life painters of the seventeenth century convey the high status accorded parrots, depicting them beside tables set with elaborately wrought silver vessels and fine Chinese export porcelain plates.[3] Seventeenth-century Dutch silversmiths also paid homage to these birds by making table ornaments to represent them.[4]

Delft tiles of the seventeenth century provide the earliest depictions of parrots in the ceramic medium. The birds are painted in blue or manganese purple on individual tiles[5] and large tile pictures,[6] and by the early eighteenth century on Delft plates in the Imari and Kakiemon styles.[7] Standing earthenware parrots, like nos. 6 and 7 in the Markus Collection, were generally made in pairs, as were the porcelain examples made for the Dutch in China. They seem to have been decorated exclusively with high-fire pigments and vary in height from about 17.8 cm. (7 in.) to 30.5 cm. (12 in.).

The ceramic, free-standing parrot forms vary only slightly, the greatest difference being in the shape of the stands, which, as in no. 6, is a tall mound, sloping toward the lower part of the parrot's breast, or a simple, flat platform. These birds perched astride stands were all made in direct imitation of Chinese Kangxi (K'ang Hsi, 1662-1722) porcelain examples, which were manufactured to order for the Dutch beginning in the late seventeenth or early eighteenth century. The Delft modelers also created their own forms, the most notable of which were birds perched on a circular ring fitted for suspension.[8] Responding to the rococo taste for utilitarian wares in the form of animals and food, the Delft factories produced, in addition, jugs, salt and pepper shakers, and cruets in the shape of parrots and other birds.[9] Forms such as these, however, seem to be of later eighteenth-century manufacture.

In all probability, production of Delft parrots like nos. 6 and 7 had begun by the early eighteenth century, but there is little evidence with which to date any of the surviving examples beyond stylistic comparison with a parrot in the Rijksmuseum, Amsterdam, which is dated 1729

and marked IDV.[10] The Amsterdam bird is 19 cm. (7½ in.) in height, slightly larger than no. 6, and is attached at the breast, legs, and tail to a mound-shaped base with circular perforations. It is more elaborately modeled than the Markus parrot, the talons and some of the feathers being in low relief; like no. 6, it has a double set of holes at the front of the head and is painted in a predominantly pale blue palette. The individual feathers are more clearly defined than on either parrot in this collection. The wings of the Amsterdam parrot are also more skillfully painted than those on no. 6. These factors suggest a date slightly later than 1729 for this Markus parrot, but earlier than that of no. 7. The attention to details on this piece, as in the painting of the base as rockwork, the painting of the feathers, and the subtle palette, shows a closer affinity than do later Delft examples to the Chinese porcelain parrots, whose feathers were incised and separately painted. Later Delft examples show less reliance on the Chinese prototypes and more individuality on the part of the painters and modelers. A date of 1730 – 1735 for no. 6 thus seems reasonable.

C.S.C.

NOTES

1. Joseph M. Forshaw, *Parrots of the World* (Neptune, N.J., 1979), p. 33. Forshaw also suggests that tame parrots were introduced into Europe by Alexander the Great.

2. Robert J. Charleston and Daniel F. Lunsingh Scheurleer, *English and Dutch Ceramics*, Masterpieces of Western and Near Eastern Ceramics, vol. 7 (Tokyo, 1979), fig. 75, p. 253; Henry Havard, *Histoire de la faïence de Delft* (Paris, 1878), pl. 11.

3. See *Still-life with Parrots*, by Jan Davidsz de Heem (1606-1683/84), Isaac Delgado Museum of Art, New Orleans, *Fêtes de la palette* (1962), fig. 35, pl. 55; *Still-life* by Balthasar van der Ast (1593/94-1657), Ingvar Bergström, *Dutch Still-life Painting in the Seventeenth Century*, trans. Christina Hedström and Gerald Taylor (New York, 1956), fig. 59, p. 77.

4. Abraham C. Beeling, Leeuwarden, *Dutch Silver, 1600-1813*, sale catalogue, published in conjunction with the exhibition "Fine Arts of the Netherlands," New York, Nov. 20-28, 1982 (Leeuwarden, 1982), p. 8.

5. Caroline Henriette de Jonge, *Oud-Nederlandsche majolica en Delftsch aardewerk* (The Hague, 1947), fig. 138, p. 147.

6. Idem, *Delft Ceramics*, trans. Marie-Christine Hellin (New York, 1970), fig. 100, p. 101.

7. Kunstgewerbe Museum, Cologne, *Fayence I: Niederlande, Frankreich, England*, catalogue by Brigitte Tietzel (1980), pl. VI (color).

8. Elisabeth Neurdenburg and Bernard Rackham, *Old Dutch Pottery and Tiles* (London, 1923), fig. 81, pl. 50.

9. Sotheby Parke Bernet, London, sale catalogue, April 23, 1974, lot 102, pl. 5; De Jonge, *Delft Ceramics*, fig. 51, p. 56, and fig. 98, p. 98.

10. Ferrand W. Hudig, *Delfter Fayence* (Berlin, 1929), fig. 153, p. 161.

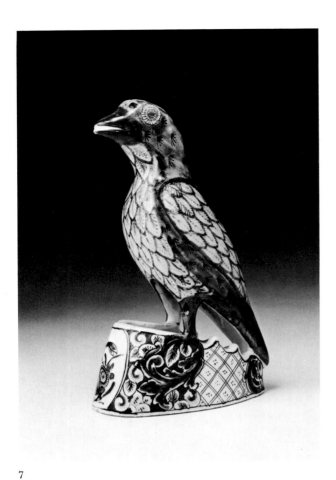

7

7　Parrot

The Netherlands, Delft, about 1735-1745

Tin-glazed earthenware (faience) with polychrome decoration

Unmarked

H. 17.9 cm. (7 in.), w. 10.4 cm. (4⅜ in.) d. 5.6 cm. (2¼ in.)

10.1980

Published: Ruth Berges, *Collector's Choice of Porcelain and Faïence* (South Brunswick, N.J., and New York, 1967), fig. 114: "faience of Delft, 1700-1720."

Like no. 6, the parrot stands upright, astride an open, teardrop-shaped stand, which is attached to the tip of the bird's tail and both legs. The smooth-sided stand is gently sloped, roughly echoing the angle of the underside of the parrot's body. The stand and bird were molded as one piece and separated by cutting the clay, leaving an opening between the bird's body and the edge of the stand. Both sides of the upper edge of the stand between

the bird's legs and the end of its tail are decoratively scalloped, and the front portion of the stand has been left plain. The bird faces straight ahead, its right side slightly lower than the left because of an indentation in the base under its right leg. The lower edges of the wings protrude slightly from the body. Painted in a famille verte *palette, the parrot has a green body (produced by applying a thin wash of yellow over blue), with feathers suggested by small clusters of blue marks over the entire body. The talons are the same green as the body. The bill is blue; the upper and lower mandibles are edged in red at the mouth, which is painted white to appear open. Two small circular holes just above the upper mandible indicate the nostrils. The eyes are encircled by a tuft of yellow and red feathers. The feathers on the crown, wings, and breast are yellow with a red herringbone pattern, each edged in blue, as are the wings.*

Each side of the stand is divided into three zones of ornament. At the front is an oval reserve with a small bouquet of red and yellow flowers, green foliage, and blue grass against a white ground, outlined with double lines of blue. On either side of this is a large reserve with a green foliate scroll against a red ground with blue-veined leaves and yellow and white scrolls. Adjoining this is a band of iron-red latticework against a white ground, bordered on the far side by a smaller green foliate scroll against a red ground. The back of the stand under the tail has been left white. The upper and lower edges of the stand are edged in blue. The figure is hollow, and the interior glazed.

Delft parrots provide another opportunity to study Dutch ceramists' interpretations of the Chinese porcelains brought to Europe by the trading companies. Seemingly in answer to the European demand for "Eastern curiosities," porcelain parrots were first made by the Chinese during the Kangxi (K'ang Hsi) period (1662-1722).[1] Most of the figures were painted in the *famille verte* palette so popular in China during that period. Given its name by the nineteenth-century French ceramics collector and author Albert Jacquemart, this palette consists of colored enamels including a translucent green in several shades, a thin, opaque red, a dense black (used primarily for drawing), a clear, translucent yellow, aubergine-violet, and blue. Its use for Chinese and Delft parrots is not entirely fanciful, since many parrots are predominantly green. *Famille verte* was the most frequently used polychrome palette for Chinese porcelain from the sixteenth century until the end of the Kangxi period and was also employed for the decoration of Chinese "biscuit," or unglazed, porcelain. The lat-

ter use of enamel pigments results in particularly vibrant colors, and many of the porcelain parrots sent to Europe were painted in this manner. Just as the Delft ceramists modified Chinese porcelain figures of Guanyin (no. 2) for production in earthenware, so they adapted Kangxi porcelain parrots. In this case, however, the adaptation was probably made for economic rather than artistic reasons, since the porcelain parrots were not nearly as complex in form as figures of Guanyin and were therefore easier to copy. What little modeling was required was certainly not beyond the ability of the Delft potters, although, as mentioned, their skill lay rather in decoration. If the surviving numbers of Delft parrots are any indication, they were produced in large quantities and were probably available at fairly reasonable prices.

The most noticeable difference between Chinese and Delft parrots is that the former are more spiritedly modeled. The eyes are more sharply defined by incisions and coloring, the beak is nearly always realistically formed with an opening between the upper and lower sections, and the bird's head is often turned slightly. The body of a Chinese parrot is generally plumper, and the talons are larger and more prominent than those of Delft versions. The green talons of no. 7 are barely distinguishable from the green foliage underneath, and no attempt has been made to model them, which results in the bird's rather static and unnatural pose, particularly when viewed from the front. The plumage of this parrot has been painted rather summarily, unlike most Chinese and some early Delft examples,[2] where the plumage is carefully outlined or incised, or both, to give a more realistic effect.

The form of the stand under the parrot has been altered considerably from that of the Chinese stands, which were made to resemble "perforated rocks." Traditionally the base for figures of Buddhas, the perforated rock was later used as a base for a wide variety of figures.[3] Although it has been stated that these bases (and the parrots) were reproduced almost exactly in Delft,[4] a survey of published examples shows that, with few exceptions, the Delft bases are far less naturalistic and only suggest the perforations or circular holes of the Chinese bases; they are seldom modeled with the rough texture and irregular surface of their Chinese counterparts. The Delft bases are often shaped as smooth-sided, ovoid mounds, sometimes pierced to suggest foliage. Their decoration differs dramatically from that of the Chinese bases, which are often "splashed" with a variety of glazes, emphasizing the irregular form, or painted in aubergine enamel, a color not available to Delft potters.

The alternating patterns of polychrome ornament on the base of this Markus parrot give the figure a distinctly "Delft" (and European) character.

Two factors indicate that no. 7 is of a date later than that given by Berges, 1700-1720.[5] It seems reasonable to assume that this rather abbreviated form of base was developed by Delft modelers after they had copied the Chinese pierced rockwork bases, which would not have been familiar or necessarily understandable forms. Secondly, the floral and foliate painting of the base is not in keeping with other Delft figural decoration from the first quarter of the century. It is, however, similar to that found as border decoration on some Delft plaques from the second quarter of the century.

C.S.C.

NOTES

1. Just as the Chinese had produced tablewares specifically for export (often based on drawings and models provided by members of the Dutch East India Company), so they designed animal figures that had no precedent in China; David Howard and John Ayers, *China for the West: Chinese Porcelain and Other Decorative Arts for Export Illustrated from the Mottahedeh Collection* (New York, 1978), vol. 2, pp. 575-576.

2. Anne Marie Mariën-Dugardin and Chantal Kozyreff, *Ceramic Road* (Tokyo, 1982), fig. 54 (color). For a black and white photograph of the same piece that shows the painting in greater detail, see Henry Pierre Fourest, *Delftware: Faience Production at Delft*, trans. Katherine Watson (New York, 1980), fig. 160, p. 162.

3. I am grateful to James Watt, Curator, Department of Asiatic Art, Museum of Fine Arts, Boston, for providing this information.

4. Fourest, *Delftware*, p. 155.

5. Ruth Berges, *Collector's Choice of Porcelain and Faïence* (South Brunswick, N.J., and New York, 1967), fig. 114.

8 Mustard pot

The Netherlands, Delft, about 1745-1750

Tin-glazed earthenware (faience) decorated in polychrome enamels and gold

Mark:

(1) in blue on underside of cover: unidentified mark

H. 8.7 cm. (3 7/16 in.), diam. 5.3 cm. (2 1/16 in.)

1983.602a,b

The barrel-shaped mustard pot has a flat cover with an aperture for a spoon and a small, pointed finial. The continuous decoration on the pot depicts a rural landscape with ruins and figures. The

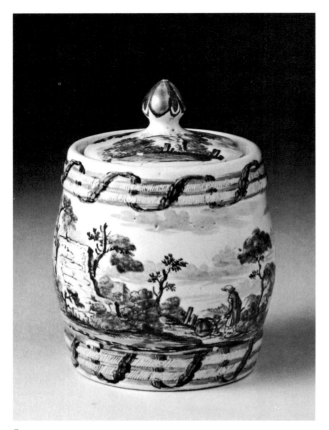

8

remains of a tall, yellow wall stand amid shrubbery
and trees. To the right of this a man wearing a
knee-length coat and a hat pushes a small tiller.
The scene continues with the remains of another
yellow building, this one on the left bank of a
pond. A stack of wood rests beside the ruin. At the
far end of the pond a building is visible among the
trees, and beyond this are forested hills. To the
right of a tall tree on the right bank of the pond
two men walk side by side, one dressed in a yellow
cape, the other in a mauve coat and carrying a yel-
low sack on his back and a walking stick in his right
hand. Both men wear blue hats and knee boots. A
building can be seen in the hills beyond, and a
fence is on a rise to the right of the men. The sky is
filled with blue clouds. A triple row of horizontal
ribs is molded in low relief around the top and bot-
tom of the pot. Two of the ribs at both top and bot-
tom are painted in red in imitation of roots with
fine lines and knots. A garland of green leaves is
looped around the ribs. The cover is painted with
two small ruins in a wooded landscape in
the same palette as the pot. Gilt and rust-colored,
almond-shaped lozenges decorate the finial.

Few Delft mustard pots of any description have
survived, even though mustard was certainly in
common use throughout the seventeenth and
eighteenth centuries.[1] Its popularity is recorded
by the metal and ceramic containers that figure
prominently in seventeenth-century Dutch still-life
paintings. Some of these paintings show the simple
German earthenware and stoneware pots, which
had probably been in use for some time. Some of
the latter are mounted in pewter.[2] By the 1630s,
pewter and silver baluster-shaped mustard pots
with covers were in use.[3] The pots are nearly al-
ways shown with a wide-bowled silver spoon with
straight or twisted handles. The covers sometimes
have an opening in the center for the spoon.

The earliest Delft-ware mustard pot de-
picted would seem to be a blue and white baluster-
shaped example with a handle and a pewter lid in a
still life of 1654 by Pieter Claesz (about 1597/98-
1661).[4] This form was almost certainly taken from
Dutch pewter and silver examples, as were those of
slightly different shape which were imported to
the Netherlands from China and Japan by the sec-
ond quarter of the seventeenth century.[5]

One assumes that eighteenth-century Delft-
ware mustard pots were similar in form to those in
silver, but there are not enough extant examples to
permit accurate judgment. The most popular form
of silver mustard pot from early in the century
through the 1770s seems to have been that of a ta-
pered cup on a spreading foot with loop handle
and domed cover. The spoon aperture on one side
of the domed cover, as on no. 8, appears in silver
by the late 1720s.[6]

The next form of mustard pot made at
Delft was octagonal with a loop handle and domed
cover. This shape has been dated to the second
half of the eighteenth century and is said to be de-
rived from that of a Chinese pagoda.[7] It is more
probable, however, that it is based on native silver
mustard pots in the Louis XIV style.[8] The octago-
nal shape was apparently followed by the barrel-
shaped mustard pot. The earliest located silver
mustard pot in this form dates from 1761, with
feet, handle, and finial formed as twigs with leaves.
The accompanying spoon has a leaf-shaped stem.[9]

8(1)

The body of the pot is made to resemble a barrel,[10] and, more specifically, it probably derives from the wooden casks with metal hoops that had long been used to pack commercially made mustard flour.[11] Wooden (generally oak) casks were used to package and transport various commodities during the seventeenth and eighteenth centuries, and the form was naturally adopted in miniature for tablewares. As has been mentioned, the shape of the Delft butter dish in the Markus Collection (no. 5), which is similar to that of this mustard pot, was taken from the wooden tubs used to transport fresh butter. It is likely that the barrel form was originally produced in silver well before 1761, at which time it would probably have been closer in conception to the mustard-flour casks. Silver mustard pots of this shape were being made in France by 1740,[12] and there is little doubt that Dutch silversmiths were heavily influenced by French metalwork,[13] although there was generally an interval of several years before they adopted the French styles.

The Vromen Collection includes a mustard pot identical in shape and very similar in decoration to no. 8 and a butter dish of the same form as no. 5.[14] The Vromen Collection mustard pot and butter dish were probably part of a larger table service, and the same would be true of no. 8. As this example is one of a pair (the mate is broken), it is likely that the Vromen Collection pot also had a mate. C.H. de Jonge reports that she knows of only one other mustard pot of this form, that in the Boymans-van-Beuningen Museum in Rotterdam.[15] It is painted in the Kakiemon style and is marked PAK, signifying the Grieksche A factory. The mark indicates a date previous to 1722, after which the factory stopped using these initials (see discussion at no. 2). The argument that such wares were made as part of table services is strengthened by the existence of several other objects similar in form or painting or both.

A mustard pot in the Rijksmuseum, Amsterdam, is larger than the Markus example but of the same shape and with landscapes that are similar though more extensive.[16] The Rijksmuseum also owns a covered butter dish (in the same form as no. 5) painted with similar subject matter and in the same palette; it is marked in blue on the inside of the dish with j 4 and F.[17] Other butter dishes, again with very similar decoration, include one given a date of about 1735; one formerly in the collection of Dr. and Mrs. Warren Baker, which is marked with V and j in blue on the inside of the dish and cover and dated about 1740; and a pair with stands, which are marked V.A.[18] The Musées Royaux in Brussels own a pair of sauceboats,

marked with V in blue on the bases, with stands and a covered tureen with similar but more elaborate painting.[19]

It would seem that these pieces represent either one or more services or individually made wares decorated in a popular "pattern." The decoration on the Vromen Collection pieces has been classified as *famille rose*,[20] a style of enamel painting on Chinese porcelain, primarily for export to Europe, that is characterized by figure subjects in pale pinks and soft greens; it was given its name by the nineteenth-century French ceramics collector and author Albert Jacquemart.[21] This decoration as well as a more refined sense of form were due to the influence of German porcelain and were not found on Delft wares until at least the second quarter of the eighteenth century.[22] The painting of Western figures in European landscapes on Delft ware is often referred to as "painting in the Meissen style,"[23] and although it is certainly reminiscent of the landscape painting that began to appear on Meissen about 1735, it must also be remembered that landscape painting with European figures, in blue and white, can be found as early as the late seventeenth century on tin-glazed earthenware by Frederik van Frytom (1632-1702) and others.[24]

In assigning a date for this mustard pot, then, the subject, style, and palette of the painting as well as the form must be taken into account. On the basis of the painting, a date of about 1745-1750 seems most reasonable, considering the possible sources of inspiration. Assuming that the form is taken from Dutch silver, it must also be assumed that it appeared in the Netherlands previous to 1761 and nearer 1740, when it was being produced in French silver (and in French porcelain at the Chantilly factory). More accurate dating of this mustard pot and the group of Delft wares to which it belongs will only be possible when an identifiable mark can be associated with comparable painting.

C.S.C.

NOTES

1. "Prepared" table mustard as it is known today seems to have been available in England by about 1720. See *The Colman Collection of Silver Mustard Pots*, catalogue by Honor Godfrey (Norwich, Eng., 1979), p. 11. It is not known when such a refined mustard flour was first available in the Netherlands.

2. In a still life dated 1635, Willem Claesz Heda includes a rather humble earthenware (or perhaps stoneware) mustard pot without a cover. Another still life by Pieter Claesz, dated 1643, shows a more refined stoneware pot with a domed pewter lid. For both see Ingvar Bergström, *Dutch Still-Life Painting in the Seventeenth Century*, trans. Christina Hedström and Gerald Taylor (New York, 1956), fig. 111, p. 126, and fig. 108, p. 121.

3. See a still life by Jan Jansz. den Uyl, about 1633, in the Museum of Fine Arts, Boston, 54.1606; Walther Bernt, *The Netherlandish Painters of the Sevententh Century*, vol. 3, trans. P.S. Falla (New York, 1969), pl. 1203, p. 119.

4. The Jane Voorhees Zimmerli Art Museum, The State University of New Jersey, Rutgers, *Haarlem: The Seventeenth Century*, catalogue by Firma Fox Hofrichter (1983), fig. 26, p. 71. This is the earliest depiction I have discovered. I would be interested to know of any earlier examples.

5. T. Volker, "Porcelain and the Dutch East India Company," *Mededelingen van het Rijksmuseum Volkenkunde, Leiden* 11 (1954), p. 111, fig. 18; Soame Jenyns, *Japanese Porcelain* (London, 1965), pls. 21A (i), 58B (i).

6. Abraham C. Beeling, Leeuwarden, *Dutch Silver, 1600-1813*, sale catalogue, published in conjunction with the exhibition "Fine Arts of the Netherlands," New York, Nov. 20-28, 1982 (Leeuwarden, 1982), p. 23.

7. Daniel F. Lunsingh Scheurleer, "Collectie M.G. van Heel, oud Delfts aardewerk, Rijksmuseum Twenthe, Enschede," *Mededelingenblad vrienden van de Nederlandse ceramiek, no. 54* (1969), fig. 27, p. 22, text p. 19.

8. Abraham C. Beeling, Leeuwarden, *Nederlands zilver, 1600-1813*, sale catalogue, vol. 1 (1980), p. 167.

9. J.W. Frederiks, *Dutch Silver*, vol. 2: *Wrought Plate of North and South-Holland from the Renaissance until the End of the Eighteenth Century* (The Hague, 1958), pl. 266, fig. 533.

10. Ibid., p. 177.

11. Information accompanying the traveling exhibition of The Colman Collection of Silver Mustard Pots (Norwich, England).

12. Faith Dennis, *Three Centuries of French Domestic Silver: Its Makers and Its Marks*, vol. 1 (New York: Metropolitan Museum of Art, 1960), fig. 289, p. 198.

13. M.H. Gans and Th. M. Duyvene de Wit-Klinkhamer, *Dutch Silver*, trans. Oliver van Oss (London, 1961), pp. 27-36.

14. Caroline Henriette de Jonge, "Een particuliere verzameling Delfts aardewerk," *Mededelingenblad vrienden van de Nederlandse ceramiek, no. 48* (Sept. 1967), figs. 48-49, p. 55.

15. Ibid., p. 53.

16. Loudon Collection, 12400 #410.

17. RBK 1953, 61B.

18. Henry Pierre Fourest, *Delftware: Faience Production at Delft*, trans. Katherine Watson (New York, 1980), fig. 141, p. 145; Sotheby Parke Bernet, New York, sale catalogue, Dec. 17, 1982, lot 188, illus.; Christie's, London, sale catalogue, June 16, 1969, lot 40, illus.

19. Sauceboats: EV83B; tureen: EV117B.

20. De Jonge, "Een particuliere verzameling," p. 53.

21. H.A. Crosby Forbes, in his recent catalogue, suggests adoption of the term "rose palette" instead of the more traditional and somewhat misleading term *famille rose*; see *Yang-ts'ai: The Foreign Colors: Rose Porcelains of the Ch'ing Dynasty* (Milton, Mass., 1982), pp. 4-6.

22. De Jonge, "Een particuliere verzameling," p. 53.

23. Delft ware with this type of decoration is also frequently described as Italianate in style, but there seems to be little reason for this, as neither the landscapes nor the buildings are particularly Italian.

24. A. Vecht, *Frederik van Frytom, 1632-1702: Life and Work of a Delft Pottery-Decorator* (Amsterdam, 1968), pp. 57-97; Caroline Henriette de Jonge, *Oud-Nederlandsche majolica en Delftsch aardewerk* (The Hague, 1947), fig. 165, p. 190.

9 Tobacco box and cover

Plate II
The Netherlands, Delft, possibly made at Het Oude Moriaenshooft factory, about 1760-1770
Tin-glazed earthenware (faience) decorated in polychrome enamels and gold
Unmarked
H. 19.1 cm. (7½ in.), w. 13.9 cm. (5½ in.)
Published: Daniel F. Lunsingh Scheurleer, *Delft: Niederländische Fayence* (Munich, 1984), fig. 163.
Provenance: Purchased, Amsterdam, April 1967
1983.603a,b

The square, molded box is bombé in form. The base and cover have two grooves evenly spaced on each side, running from just below the protruding foliage beneath the finial to the splayed foot. The base, slightly indented at the top edge, swells to a full, rounded shoulder then curves inward, terminating in a flared foot. The cover, fitted with an inner rim, extends slightly over the upper rim of the base. Each corner of the cover is decorated with an applied green tobacco (?) leaf, heavily outlined in black. A low, gold ridge separates the outer lip from the smooth area above it reserved for the landscape decoration. Above the ridge, the cover gradually rises to a square-shaped support surmounted by four green tobacco (?) leaves extending well beyond the support. Between each leaf is an orange oval-shaped indentation. A closed yellow-green tulip (or artichoke?) with petals striped in manganese purple forms the finial. The box and cover have a pale gray-blue ground, and their sides are painted with river landscapes. On the base in the right foreground of each panel is a pale yellow, sloping river bank with a tall, four-branched tree whose foliage is yellow and green. The edges of the widening river are a deep blue; a rust-colored humpbacked bridge spans the river. A windmill and two smaller houses occupy the left bank; the right bank is more extensive, with several small rust-colored buildings and a tall church spire. Clouds and groups of birds are in the sky. Each reserve is enclosed by a red and gold shaped border with green leaves on either side at the top. The four corners of the box are embellished with a series of flowers and foliage beneath a large scallop shell. The wavy edges of the shell are indicated by red and gold lines, the radial ribs by thinner red lines. Tiny black dots separate the ribs. Beneath

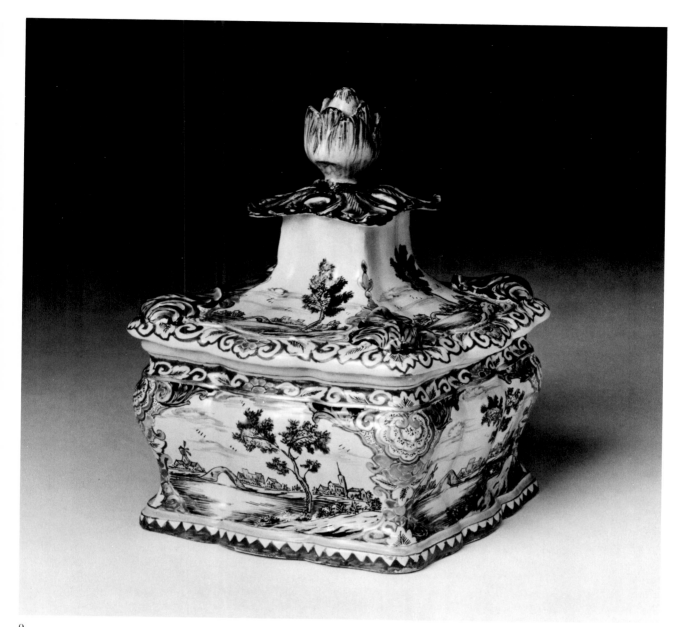

9

the shell are a pink, peony-like flower, three black-veined leaves, a blue-petaled flower with a gold center, and another black-veined leaf flanked by red and gold scrollwork. The foot is divided into two zones of ornament: a solid yellow band edged in red and a red sawtooth border along the lower part. The waisted band beneath the upper rim of the base is painted with red-bordered scrolls and black-veined leaves. At the center of each band are gold and mauve flowers. This motif is repeated on the lower rim of the cover. The river landscapes on the cover are partially enclosed by less elaborate red and gold decoration. The scenes themselves are quite similar to those on the base, though with fewer buildings and fuller trees.

Tobacco was probably first brought to Holland by mariners who had been introduced to it in the seaports of England and Spain. The plant was being cultivated in the province of Utrecht as early as 1615, and its manufacture and processing soon became one of the most profitable branches of Dutch trade.[1] Within Holland, tobacco was also an important commodity. It was thought to be a panacea for countless ills, the plague (which struck Holland in 1636) among them;[2] and by midcentury it had become extremely popular for smoking.

As documents of the various accoutrements used by smokers, Dutch still-life paintings of the late seventeenth and early eighteenth century are helpful,[3] but the only tobacco boxes shown are the

small portable examples, which were undoubtedly filled from larger table models such as no. 9. Delft wares of the seventeenth century also give us information about smoking habits but do not illustrate any metal or ceramic boxes that resemble the Markus piece.[4]

From the second half of the seventeenth century until the end of the nineteenth century, lead was the most commonly used material for tobacco jars.[5] Pewter was also used extensively, and it is probably from jars of this metal that silversmiths derived the forms for the first silver tobacco boxes made in the early eighteenth century. By the middle of the century, these boxes had come into general use among those who could afford them.[6] Made in the Louis XIV and Louis XV styles, they were used for storing prepared tobacco.

As was so often the case, it was not long before the enterprising Delft factories began to copy these silver forms in pottery. The majority of extant Delft tobacco boxes can be dated to the second half of the eighteenth century, many on the basis of factory marks.[7] The painted decoration on a box made at De Porceleyne Bijl (The Porcelain Axe), in the Musées Royaux d'Art et d'Histoire in Brussels, shows the various stages of tobacco preparation, indicating that these boxes were in fact used to hold tobacco.[8]

The Markus tobacco box may be from Het Oude Moriaenshooft (The Old Moor's Head) factory and probably dates from the end of the third quarter of the eighteenth century. The exaggerated bombé form, the finial, and the sculptural modeling of this piece are all features that are found on four teakettles made at this factory in about 1765.[9] An unmarked box of this period in the Van Heel Collection at the Twenthe Museum in Enschede, which has been dated to the third quarter of the eighteenth century, is identical in form and size to no. 9 and is also painted with river landscapes.[10] There are slight differences in palette, border decoration, and the painting of the river scenes, but there can be no doubt that the two are contemporary and were made in the same factory; it is possible that they were decorated by the same artist. The Gemeente Museum in Arnhem owns a smaller unmarked box of the same form but painted with flowers and in a completely different palette.[11] It could well be another product of the same factory, but this is not known with certainty.

The initials EKS on the inside of the Markus box do not help with an attribution since they are probably those of a former owner, perhaps the person for whom the box was originally made. They are too large (h. 1.3 cm [½ in.]) and in too

9. *Initials in black enamel on inside of box*

prominent a position to be those of a painter or master potter.[12] Silver tobacco boxes were frequently engraved and presented as gifts to commemorate special occasions, and the Delft boxes, which cannot have been inexpensive, may have attained similar status.

In an effort to compete with European porcelain and to a degree with other European faience (particularly that made in France), the Delft potteries began to produce wares that were distinctly European in form, palette, and subject. The Markus box is a testimony to their success, but it is also illustrative of the extent to which oriental motifs had influenced the Dutch taste for pottery decoration. The peony-like flowers and stylized shells on the shoulders of this box are unquestionably inspired by Japanese porcelain painting. The river landscapes, on the other hand, are slightly freer interpretations of their source: the river and harbor views found on Meissen porcelain beginning in about 1735. The Markus box relates to an important group of finely painted Delft wares of the mid-eighteenth century that are also based upon Meissen decoration of this kind.[13] Once again, however, as for other Delft pieces in this collection (nos. 7 and 10), a later date is indicated by the lack of reliance by the Delft painter on a particular source.

C.S.C.

NOTES

1. Georg A. Brongers, *Nicotiana tabacum: The History of Tobacco and Tobacco Smoking in the Netherlands*, trans. W.C. Ter Spill (Groningen, 1964), p. 71.

2. For a discussion of the varied opinions on smoking and tobacco in general, see Brongers, *Nicotiana tabacum*.

3. In particular, the still-life paintings known as *toebackje* illustrate the country's preoccupation with tobacco; see N.R.A. Vroom, *A Modest Message, as Intimated by the Painters of the "Monochrome Banketje,"* trans. Peter Gidman (Schiedam, 1980), figs. 28, 156, 198, 216-218, 272, 301, 303.

4. Gemeentemuseum, The Hague, *Gallipotters Ware and Blue Delft* (1958), fig. 12.; Henry Pierre Fourest, *Delftware: Faience Production at Delft,* trans. Katherine Watson (New York, 1980), figs. 64, 114.

5. Amoret and Christopher Scott, *Tobacco and the Collector* (London, 1966), p. 59.

6. For examples of Dutch silver tobacco boxes, see J.W. Frederiks, *Dutch Silver*, vols. 2, 3, 4 (The Hague, 1960).

7. Both Brongers and Carl Ehwa illustrate a blue and white Delft-ware tobacco box in the Niemeyer Nederlands Tabacologisch Museum, which they date 1707, apparently on the basis of the initials WVD, attributed by them to Wilem van Dalen, who was owner of De Vergulde Boot (The Golden Boot) factory in that year; Brongers, *Nicotiana tabacum,* p. 185; Carl Ehwa, Jr., *The Book of Pipes and Tobacco* (New York, 1973), p. 214. According to Brongers, the shape resembles that of silver tobacco boxes of the same period. It is much closer, however, to silver examples from the 1730s. It is almost identical in form to a silver box made by Joannes Winter, dated 1734; see Museum Het Prinsenhof, Delft, *24E kunst-en antiekbeurs der Vereeniging van Handelaren in Oude Kunst in Nederland* (1972), p. 86. Allowing some time for the adaptation of the form into pottery, it is more likely that the Delft box was made in the third quarter of the century. The same initials (WVD) were registered by Wilem van der Does of De Drye Clocken (The Three Wooden Shoes) factory in 1764. Support for this dating is provided by another box in this form, now in the Rijksmuseum, Amsterdam, which was made by Geertruy Verstelle of Het Oude Moriaenshooft factory between 1761 and 1769; see Ferrand W. Hudig, *Delfter Fayence* (Berlin, 1929), fig. 239, p. 248.

8. Musées Royaux d'Art et d'Histoire, *La Vie au XVIIIe siècle* (Brussels, 1970), fig. 467.

9. (1) W. Pitcairn Knowles, *Dutch Pottery and Porcelain* (New York, n.d.), pl. XLVIII; Henry Sandon, *Coffee Pots and Teapots for the Collector* (New York, 1974), pl. 61, p. 52, reverse view of kettle shown in Knowles, *Dutch Pottery*; (2) Gemeentemuseum, The Hague, *Polychrome Delftware* (1969), fig. 11, catalogued as a chocolate pot; (3) Caroline Henriette de Jonge, *Delft Ceramics*, trans. Marie-Christine Hellin (New York, 1970), pl. XIX; (4) The Metropolitan Museum of Art, New York, 94.4.98-100; the decoration on this example is the most similar to that of the Markus tobacco box.

10. Daniel F. Lunsingh Scheurleer, "Collectie M.G. van Heel, oud Delfts aardewerk, Rijksmuseum Twenthe, Enschede," *Mededelingenblad vrienden van de Nederlandse ceramiek, no.* 54 (1969), fig. 121, p. 55; Robert J. Charleston and Daniel F. Lunsingh Scheurleer, *English and Dutch Ceramics,* Masterpieces of Western and Near Eastern Ceramics, vol. 7 (Tokyo, 1979), fig. 102.

11. V457. The blue finial is in the form of fruit, and the floral painting is in manganese purple, yellow, and green.

12. The initials do not coincide with those of any of the potters or factory owners published in two of the most comprehensive list of marks: Jean Justice, *Dictionary of Marks and Monograms of Delft Pottery* (London, 1930); Caroline Henriette de Jonge, *Oud-Nederlandsche majolica en Delftsch aardewerk* (The Hague, 1947), pp. 347-409.

13. This group includes a fountain and basin set in the Rijksmuseum, Amsterdam: see Fourest, *Delftware*, fig. 139, p. 143; a covered tureen in the Museum für Kunsthandwerk, Frankfurt am Main: see *Europäische Fayencen,* catalogue by Margrit Bauer (1977), fig. 389, p. 198; a covered tureen with stand: see De Jonge, *Delft Ceramics*, fig. 117, p. 117; a bowl: see Sotheby Parke Bernet, London, sale catalogue, Oct. 25, 1977, lot 77, p. 29; and a pair of bowls: see Jean Helbig, *Faïences hollandaises,* vol. 1: *Pièces marquées* (Brussels [1960?]), fig. 22; vol. 2: *Pièces non marquées*, fig. 130.

10 Plaque

The Netherlands, Delft, last quarter of the 18th century

Tin-glazed earthenware (faience) with polychrome decoration

Unmarked

H. 34.9 cm. (13¾ in.), w. 31 cm. (12.3 in.), d. 2.1 cm. (¹³/₁₆ in.)

1983.604

The molded plaque is flat with a raised rim, whose undulating outer edge gives the plaque its shape. The top of the plaque is pierced with two holes for hanging. Against a pale blue ground a man and woman are shown in a forest clearing. The woman wears a full-length dress with a low neckline with a yellow ruffle. The bodice and full, elbow-length sleeves are blue and the skirt orange. Her hair is tied on top of her head with yellow and red ribbons. She is seated on a stone bench, leaning on her right arm. Her left arm, bent at the elbow, rests on her raised left hip. On the ground in front of her is a cage containing a rooster and a hen. Standing to the woman's left is a man wearing a black hat, an orange waistcoat, a yellow shirt, blue breeches, yellow-green stockings, and black shoes with ties. With his right hand, the man offers the woman a yellow and red pear attached to a leafy branch; he gestures toward the cage with his left hand. On the ground to the man's left are a scythe and a sheaf of wheat, and three loose wheat stalks lie in front of the cage. The ground in front of the couple is terminated by a blue scalloped edge. Behind the bench a large green bush obscures the base of a tall tree with a manganese purple trunk and green foliage; to the right stands a pollarded tree, also in manganese purple, with tall, blue grass at its base. The molded rim is painted with floral and foliate motifs in blue and green against an orange ground, with yellow and manganese purple flowers at the points of the molding and larger flowers at the center of each side. A plain white band borders the rim, whose outermost edge is painted blue.

This plaque, the latest piece of Delft ware in the Markus Collection, represents the continuation of a Dutch ceramic tradition dating from the middle of the seventeenth century. The first plaques, which were rectangular and made at about that time,[1] were painted in blue with landscapes and portraits. Frederik van Frytom (about 1632-1703) was among the first to decorate plaques in this

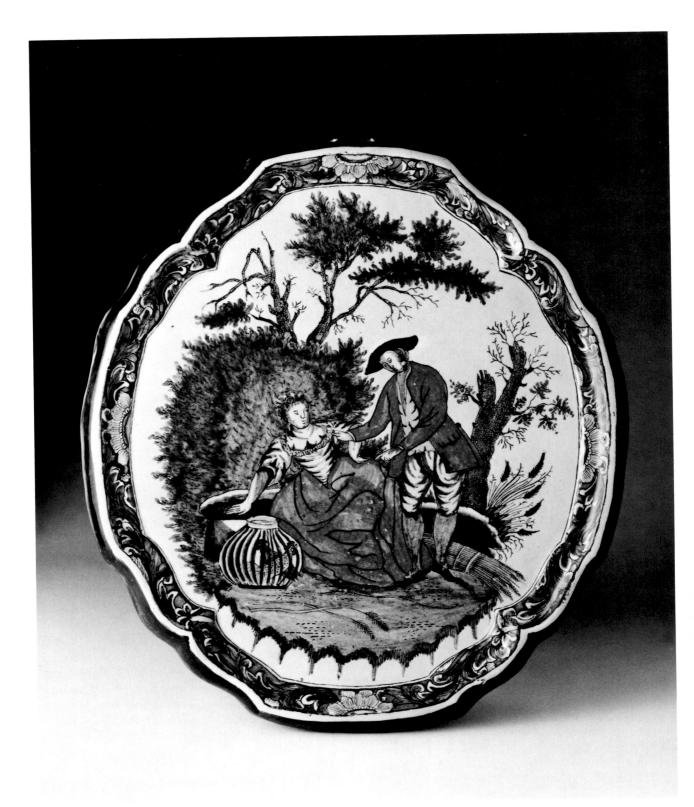

10

manner; he derived his precise style of painting, limited to a blue palette, from prints, a practice that was to become commonplace. Van Frytom's early followers soon diverged in their subject matter from scenes of the Dutch countryside and began to decorate their plaques with blue and white chinoiserie scenes and designs after engravings by Daniel Marot (1663-1752), a French architect and designer employed by King William III. By the beginning of the eighteenth century, plaques began to replace the flower paintings that had been popular for so long in the Netherlands.[2] It was also at this time that the dark borders first began to appear on Delft plaques, purportedly in imitation of the black wood frames used by Van Frytom for his landscape plaques.[3] These raised rims were painted with stylized foliage and scrollwork or molded with decorations in low relief. Later in the century, under the influence of the rococo style, the rims were often quite ornate. This tradition of "framing" Delft plaques survived into the nineteenth century.

Nearly all of the extant eighteenth-century plaques are painted either in blue on a white ground or, more often, in polychrome with high-fire decoration; low-fire enamels and gilding were used very rarely.[4] Enough plaques survive to indicate that at least as many were made in pairs as were made singly. The shaped and "framed" plaques (as distinct from those of rectangular or square shape with unfinished edges) were nearly always pierced with one or two holes along the top edge for suspension. They were reportedly hung over fireplaces, on either side of a door, or elsewhere in the house.[5] From their high-fire polychrome decoration, their lack of gilding, and their use as wall decoration, it is clear that plaques were an outgrowth of the tile industry, the eighteenth-century answer to the framed, monochromatic landscape tiles of the previous century. The form most widely produced, from at least the first quarter of the century until the nineteenth century, seems to have been a cartouche shape like that of the Markus example.

Because plaques were almost never marked, factory attribution is difficult, and dating must therefore be done on the basis of style, subject matter, and quality. Like many Delft plaques, the Markus example is decorated with a scene derived from a print, which can be of some help for purposes of dating.[6] The scene is based on an engraving by Joseph Wagner (1706-1780) after a composition, *Summer*, by Jacopo Amigoni, or Amiconi (1676-1752).[7] Amigoni, an Italian artist, executed a series of allegories of the seasons, each of which depicts a young man and woman in a nat-

ural setting with attributes representing the four seasons. Wagner, who began studying with Amigoni in about 1720, apparently engraved the series in about 1750 while in Venice.[8]

Amigoni's pastoral scenes like the *Four Seasons* were particularly well suited to late eighteenth-century European taste and were adapted by other European porcelain and faience factories for the decoration of their wares and as models for figures. Most of these pieces date from the third quarter of the eighteenth century. Wagner's engravings after Amigoni were used extensively as sources for porcelain decoration, particularly at the Fürstenberg factory, where a series of plates based on the *Four Seasons* was produced about 1755.[9] Other porcelain factories that adapted Amigoni's motifs include Frankenthal, Limbach, Kloster-Veilsdorf, Strasbourg, and Capodimonte. Among the faience factories that used his designs were Proskau in Germany, the Castelli factories in Italy, and various factories in Delft. De Bloempot (The Flowerpot) factory of Rotterdam made extensive use of Amigoni's depiction of the elements for a series of large tile pictures.[10]

Although the degree of fidelity to source material is not always indicative of date, a comparison of mid-eighteenth-century Delft plaques with scenes after Amigoni and those done later in the century reveals the earlier plaques to be closer to the engravings in details such as dress and landscape.[11] The qualitative variations may also have occurred because later painters often worked from earlier plaques rather than from prints and were thus even further removed from the original source.

The scene on the Markus plaque departs from Amigoni's original conception primarily in the lack of refinement and delicacy in the painting and the facial expressions of the figures. In translation Amigoni's carefully rendered landscape has been quite simplified, and the figures have become somewhat coarse. The seated woman now leans heavily on the bench with her right arm, her left arm rather gracelessly placed on her hip. Amigoni's composition shows the woman balancing herself gently on the bench with her right arm, while she rests her left hand lightly on the man's left forearm. The man playfully touches her chin with his right hand while pointing to the cage with his left hand. In this Delft-ware example, the flirtatious character of the scene is no longer evident. The man now offers the woman a pear, and both figures are far more rigid than they are in the engraving or in the painted scene on the porcelain plates.[12] The difficulty of painting on tin-glazed earthenware rather than on porcelain certainly ac-

counts for some of this awkwardness, but not completely, since the scenes on the other Delft plaques noted above, which are based on similar sources, are less contrived. A Delft plaque with the same scene as that on no. 10 but painted only in blue shows precisely the same variations from the engraving, even in details such as the abbreviated ruffle on the bodice of the woman's dress and the folds of her skirt. Judging from the softer quality of the painting, however, it would seem to be slightly earlier in date than the Markus example.[13] The rather harsh polychrome palette of no. 10 and the lack of finesse of the painting are also indicative of a later date, most probably in the last quarter of the eighteenth century.

<div align="right">C.S.C.</div>

NOTES

1. Daniel F. Lunsingh Scheurleer, "Collectie M.G. van Heel, oud Delfts aardewerk, Rijksmuseum Twenthe, Enschede," *Mededelingenblad vrienden van de Nederlandse ceramiek, no. 54* (1969), p. 27.

2. Caroline Henriette de Jonge, *Delft Ceramics*, trans. Marie-Christine Hellin (New York, 1970), p. 86.

3. Ibid.

4. For an example of a plaque painted with low-fire enamels, see Robert J. Charleston and Daniel F. Lunsingh Scheurleer, *English and Dutch Ceramics*, Masterpieces of Western and Near Eastern Ceramic Art, vol. 7 (Tokyo, 1979), fig. 97.

5. Henry Pierre Fourest, *Delftware: Faience Production at Delft*, trans. Katherine Watson (New York, 1980), p. 94; De Jonge, *Delft Ceramics*, p. 100.

6. For a selected list of references to printed sources for Delft plaques see Anne Marie Mariën-Dugardin, "Plaques de Delft et leurs modèles," *Faenza* 65, no. 6 (1979), 376-381.

7. I am indebted to Mr. Daniel F. Lunsingh Scheurleer for bringing this to my attention. See Siegfried Ducret, *Keramik und Graphik des 18. Jahrhunderts: Vorlagen für Maler und Modelleure* (Brunswick, 1973), fig. 156, p. 122.

8. Siegfried Ducret, *Fürstenberger Porzellan*, vol. 2 (Brunswick, 1965), p. 25.

9. Ibid., figs. 25-31, pp. 44-46.

10. Hellmuth Meyer and Ursula Meyer-Küpper, "Allegorien der Elemente auf Fliesen," *Mededelingenblad Nederlandse vereniging van vrienden van de ceramiek, no. 105* (1982), pp. 15-19.

11. Compare two blue and white Delft plaques with polychrome borders after Amigoni's *Allegory of Spring*. The earlier example, dated 1750, is in the Rijksmuseum, Amsterdam, and is illustrated in Fourest, *Delftware*, fig. 129, p. 135. The other plaque, which is undoubtedly later, is not nearly as faithful to Amigoni. For example, the young man's bagpipes are missing their drones. For illustrations of both this plaque and Amigoni's composition, see Ducret, *Keramik und Graphik*, fig. 177, p. 131, and fig. 152, p. 120.

12. Ducret, *Fürstenberger Porzellan*, vol. 2, fig. 25, p. 44; idem, *Keramik und Graphik*, fig. 157, p. 123.

13. Museum Het Prinsenhof, Delft, *23E Oude Kunst- en antiekbeurs der Vereeniging van Handelaren in Oude Kunst in Nederland* (1971), p. 58.

II German Faience

The first German tin-glazed earthenware was produced for a short time in the mid-sixteenth century, mainly in Nuremberg. Inspired by Italian tin-glazed earthenware, known as majolica, it was made in the same potteries as lead-glazed earthenware, known as Hafnerware, the production of which was a well-established native industry. The manufacture of sixteenth-century German tin-glazed earthenware seems to have been confined to a limited range of forms, which were supplied to a middle-class clientele. Dishes, jugs, and a group of vessels in the shape of owls all show the influence of Italian Renaissance and Mannerist decoration. By the end of the Thirty Years' War in 1618, however, this small tin-glazed earthenware industry had dwindled. Only a small group of wares made in Hamburg between 1624 and 1668 survive to represent the German faience industry in the ensuing decades. Unfortunately, there are no documents pertaining to the history of this factory. The few extant pieces indicate that their production included jugs of a distinctive pear shape, with painted decoration in blue on a white ground inspired by Chinese porcelain of the Wanli period (1575-1619).

In 1661 Daniel Behagel and Jacobus van der Walle established a faience factory at Hanau. It was the first of several German factories to be founded by Dutch entrepreneurs, who brought with them Dutch potters and a knowledge of the wares that they hoped to rival: Chinese export porcelain and the Delft ware that emulated it. In rapid succession factories were built at Frankfurt (1666) and Berlin (1678), also by the Dutch, and by the middle of the eighteenth century there were more than one hundred faience factories in Germany. Many remained quite small and never exported their wares in large numbers, but from their broad distribution throughout Germany it is clear that they exploited the abundant local supplies of clay.

The growth of the German faience industry in the early years of the eighteenth century coincided with the vogue in court circles for collecting Chinese and Japanese porcelain on a vast scale, as evidenced by the "Japanese Palace" at Dresden, for example. Unlike the Delft potteries, many of which were founded and maintained by middle-class entrepreneurs solely as an investment, several

of the German potteries, including Ansbach, Berlin, and Fulda, were established under princely patronage. The aristocratic German patrons were attracted by the promise of richly decorated table wares that resembled the much-desired porcelain of China and Japan; moreover, the enormous success of the faience industry in Holland had demonstrated to them the soundness of such an enterprise. The privately owned factories prospered under lenient export laws and reduced taxation.

The early German tin-glazed wares were first intended as a cheaper and more plentiful substitute for the expensive imported porcelain, the formula for which was unknown in Europe until its discovery in Dresden in 1709. Although the earliest wares, decorated in blue and white, show a strong dependence on Dutch and Chinese forms, it was not long before characteristically German shapes were introduced. Lobed dishes, cylindrical tankards (see nos. 12 and 13), and narrow-necked jugs (see no. 11) were made throughout the first half of the eighteenth century. Germany's preeminence in porcelain production at this time led to innovations in style. Unlike the Delft potters, whose work shows the continued influence of imported Chinese and Japanese porcelain, German faience modelers adopted baroque and rococo forms. The monumental wares of the Nuremberg factory (founded 1712) and the Bayreuth factory (founded 1714), in particular, reveal the unusual skill of the faience modelers, who based their forms on porcelain and metalwork prototypes. The close relationship between porcelain and faience wares is demonstrated by the fact that at the Höchst factory, which made faience from its founding in 1746 and porcelain from 1750, the same molds were used for wares in both media.

The sources of decoration on German faience were extremely varied. Among the most important influences was that of porcelain, both Chinese and German. The introduction of low-fired enamels (see the introduction to Section I) permitted a wide range of colors, and the decorative styles of the Meissen and Vienna factories, in particular, exerted a strong influence between about 1730 and 1740. The elaborate *Laub- und Bandelwerk* decoration framing chinoiserie scenes on Meissen cylindrical tankards (see nos. 17 and 18) was adapted to faience, and Meissen's use of the Kakiemon style found its way to earthenware vessels. This exchange of decorative motifs was facilitated by the migration of painters from factory to factory. Among the best-known painters whose distinctive style appears both on porcelain and faience was Adam Friedrich von Löwenfinck (1714-

1754), who worked at Meissen from 1727 to 1736, founded the Höchst factory in 1746, and eventually became a director of the Strasbourg faience factory in 1750. Decorators also relied increasingly on engravings as sources for both scenes and floral motifs. Hunting scenes (see nos. 12 and 13) and pastoral and mythological scenes were particularly popular, and painters were adept at integrating these subjects into geometric and floral borders. Naturalistic flower painting (known as *deutsche Blumen*) was introduced on Meissen porcelain in about 1740 and was quickly adopted by enamelers, both in Germany and in France.

Some of the most inventive faience decoration was painted by *Hausmaler* (independent decorators who worked in their homes). The earliest *Hausmaler* were glass enamelers, who, in the late seventeenth century, worked in a grisaille palette (*Schwarzlot*). On faience and subsequently on porcelain, *Hausmaler* painted chinoiserie and European landscape scenes in a wide range of low-fire enamel colors. Their independent workshop practices were among the few characteristics of the manufacture of German faience to have any influence abroad; a few similar studios were established in England. Unlike the Dutch and French faience industries, which generated offshoots in Spain and Scandinavia, the German faience industries did not have a widespread influence abroad. Their wares, distinguished by a variety of forms and decoration not only based on native German and Eastern models, but also reflecting current baroque and rococo taste, were sold mainly within Germany.[1]

E.M.A.

NOTE

1. The following works have been consulted in preparing this introduction: O. Riesebieter, *Die deutschen Fayencen des 17. und 18. Jahrhunderts* (Leipzig, 1921); William Bowyer Honey, *European Ceramic Art from the End of the Middle Ages to about 1815* (London, 1952); Siegfried Ducret, *German Porcelain and Faience,* trans. Diana Imber (New York, 1962). References to works that discuss the history of the various factories in greater detail may be found in the notes for nos. 11-13.

11 Jug

Plate III
Germany, Frankfurt am Main, 1696
Probably painted by Johann Balthasar Thau
(1660–1713)
Tin-glazed earthenware (faience) decorated
in cobalt and manganese, with silver mounts
Marks:
(1) on unglazed base: monogram BLT (?)
and date 1696
(2) on silver finial leaf, struck: lozenge-
shaped stamp enclosing ZII
(3) on silver foot rim, struck: lozenge-
shaped stamp enclosing ZII
(4) on silver lid flange, struck: maker's mark
I H flanking three leaves, in circle
(5) on silver foot rim, struck: maker's mark
I H flanking three leaves, in circle
H. 29 cm. (11 ⁷⁄₁₆ in.), h. without cover 24.5
cm. (9 ⅝ in.), w. 15.7 cm. (6 ³⁄₁₆ in.), diam. of
base 9.6 cm. (3 ¾ in.)
1980.612

*The jug has a globular body from which a slightly
flaring, horizontally ribbed neck rises to a wider
circular mouth with a pinched spout. The handle
is braided from a central rib; the braiding bifur-
cates at the juncture with the body. The body rests
on a flared foot. The ground color of the jug is
pale blue; the painted decoration is in cobalt blue
and manganese purple. The primary register,
which occupies the belly of the jug, depicts a con-
tinuous landscape with clusters of buildings, trees
in the near, middle, and far distance, and groups
of figures engaged in a variety of activities includ-
ing fishing, boating, and riding. This register is
bordered at top and bottom by double cobalt blue
bands enclosing spiral tendrils with flowers. The
ribbed neck is decorated with a similar continuous
landscape with trees, buildings, and two figures
conversing. A band of scrolls alternating with flow-
ers encircles the mouth. Scrolls and a continuous
leaf motif decorate the handle. The pale blue glaze
covers the interior of the jug, and slight traces are
visible on the base. The jug is fitted with silver
mounts, which comprise the cover and thumb-
piece, handle sleeve, and foot rim. The domed
cover has an undulating rim and is decorated with
a repoussé floral band; the finial is in the form of
a round piece of fruit supported by three leaves.
The cast foliate thumbpiece is pierced, and the
sleeve on the handle is engraved with simple linear
designs. The foot rim is foliated. An inventory
number, INV. 10367, is painted in black on the un-
glazed base.*

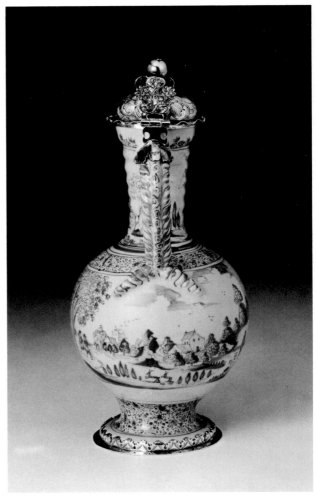

11

11(1)

11(2)

11(3)

11(4)

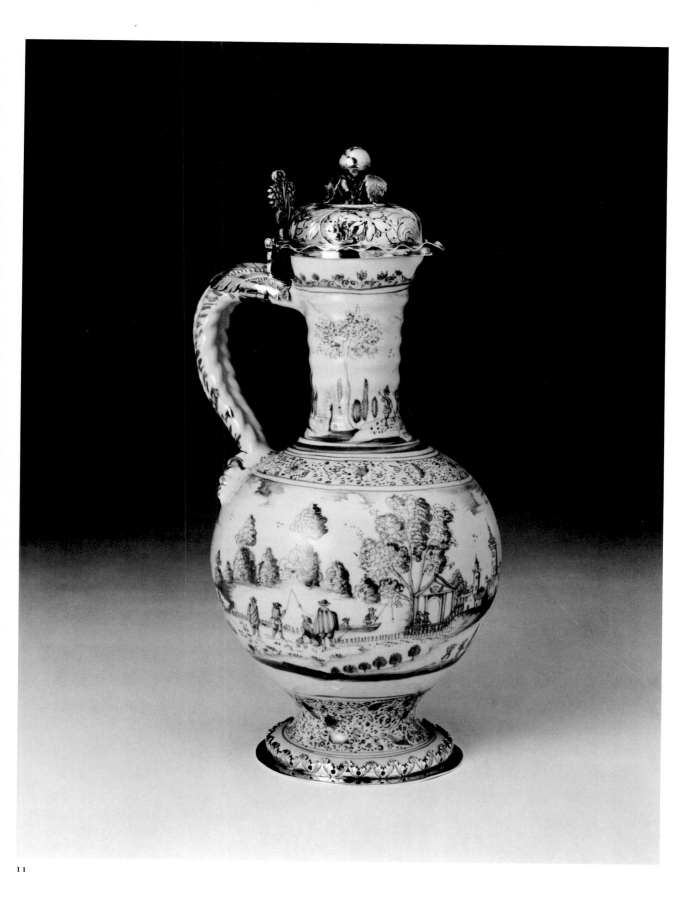

11

This form of wine jug, *Enghalskrug* (literally, narrow-necked jug), which developed from Dutch forms such as no. 1, was produced by all the South German faience factories from the late seventeenth until well into the eighteenth century. In the German wine jug the body became more bulbous, while the contraction at the neck and foot were emphasized. Sometimes the body was further elaborated by spiral or vertical fluting. The factories at Hanau am Main (founded in 1661), Frankfurt am Main (founded in 1666), Ansbach (founded in 1710), and Nuremberg (founded in 1712) were especially known for jugs of this form, which were mounted usually in pewter and more rarely, as here, in silver.

The painter to whom the monogram (BLT?) on this jug is ascribed, Johann Balthasar Thau (Tau, Trau, Dau), was born in Oppenheim on March 13, 1660, and died in Frankfurt am Main on January 19, 1713.[1] Two other works attributed to Thau, dated 1693 and 1695, are marked with F for Frankfurt or Fehr (Johann Christoph Fehr, proprietor of the factory) together with the initials B.T.[2] The first piece, in the Städtisches Museum, Frankfurt, is an *Enghalskrug* with armorial decoration; the second piece, in the Landes-Museum, Kassel, is an oval dish with a biblical scene in an architectural setting not unlike the buildings on no. 11. The border decoration on this dish is a bolder version of the condensed spiral tendrils of the borders on no. 11. Unsigned pieces attributed to Thau are a dish, marked F, with a scene of three putti with grapes in the center,[3] and an unmarked *Enghalskrug* of about 1700 in the Hetjens-Museum, Düsseldorf.[4] The Düsseldorf jug also has a bluish glaze, which is not common for Frankfurt, and an allover pattern of small flowers, leaves, insects, and birds, the so-called *Vogelsdekor*.

Three other related pieces are of interest. A Frankfurt *Enghalskrug* of about 1680 shows the same arrangement of painted decoration found on no. 11, with bands of tendrils on the lip, shoulder, and foot separating the decoration on the neck and body; a European scene, the Adoration of Christ by the Shepherds, is painted on the body.[5] This jug, like no. 11, is distinguished by a silver cover. A Hanau *Enghalskrug* of about 1710 is even closer to the Markus jug in decoration, with landscapes on both neck and body but with oriental rather than European figures;[6] the bands of compact spiral tendrils at the shoulder and the foot, the design of which derives from Ming porcelain, are very similar to those on no. 11. A Nuremberg *Enghalskrug* dated 1715 has European figures in landscapes on both the neck and the body,[7] but

the figures are larger in scale than those on no. 11. It was probably this 1715 jug, or others like it, that led to an earlier attribution of no. 11 to Nuremberg.

Y.H., V.S.H.

NOTES

1. Adolf Feulner, *Frankfurter Fayencen* (Berlin, 1935), p. 110; Konrad Hüseler, *Deutsche Fayencen*, vol. 3 (Stuttgart, 1958), p. 427.

2. Feulner, *Frankfurter Fayencen*, figs. 14, 209; Hüseler, *Deutsche Fayencen*, vol. 1, figs. 57 and 7.

3. Feulner, *Frankfurter Fayencen*, fig. 210; Hüseler, *Deutsche Fayencen*, vol. 1, fig. 190.

4. Kunstmuseum der Stadt Düsseldorf, *Deutsche Fayencen im Hetjens-Museum*, catalogue by Adalbert Klein (1962), no. 73, illus.

5. Museum für Kunsthandwerk, Frankfurt am Main, *Europäische Fayencen*, catalogue by Margrit Bauer (1977), no. 110, illus.

6. Karl Dielmann, *Historisches Museum Hanau im Schloss Philippsruhe* (Hanau, 1967), fig. 31, left; Anton Merk, *Hanauer Fayence 1661-1806* (Hanau, 1979), no. 56, illus.

7. Kunstmuseum der Stadt Düsseldorf, *Deutsche Fayencen*, no. 333, fig. 54.

12 *Tankard*

Germany, Bayreuth, 1731
Painted by Georg Friedrich Grebner (active 1718-1744)
Tin-glazed earthenware (faience) with polychrome decoration and pewter mounts
Marks:
(1) on side of tankard, at right of scene, in brown: factory mark B.K.
(2) on side of tankard, at left of scene, in brown: Grebner 1731
(3) on pewter lid, engraved: K HR 1782
H. 24.8 cm. (9 ¾ in.), h. without cover 17.5 cm. (6 ⅞ in.), w. 16.3 cm. (6 ⁷⁄₁₆ in.), diam. at base 13.2 cm. (5 ³⁄₁₆ in.)
1983.605
Provenance: Purchased, New York, October 1964

The cylindrical tankard with an ear-shaped handle is painted with a continuous scene depicting the departure of two mounted hunters, one assisted by a companion on foot, the other leading a hound. The three men wear puce coats, and their horses are painted in manganese purple; the hound is painted in yellow. The foliage of the trees is green and turquoise; the lightly clouded sky is painted in blue. Both the interior and the base of the tankard are glazed in pale blue. The tankard has been fit-

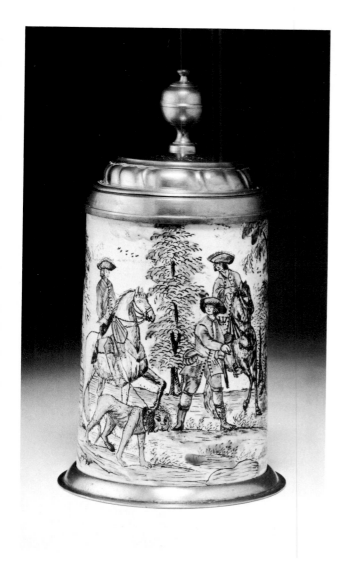

12

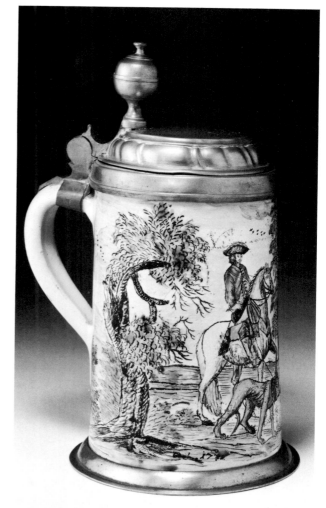

12

12(1)

12(2)

12(3)

ted with pewter mounts comprising a stepped domed cover with a large baluster thumbpiece, a simple molded mouth rim, and a flared foot. The pewter lid, probably contemporary with the tankard, was inscribed by a later owner: K HR / 1782.

The Bayreuth factory (1714-1835) was founded as a private undertaking by Johann Georg Knöller, who seems to have come from Nuremberg, bringing with him as the first technical manager the painter Johann Kaspar Rib (1681-1726), an itinerant faience artisan trained at Delft.[1] Except for five years, 1724-1728, when the factory was administered by the court, Knöller was proprietor until his death in 1744. The B.K. mark denoted Bayreuth-Knöller and was used from 1728 until 1744.

Georg Friedrich Grebner, who signed and dated this tankard, arrived in the same year, 1731, from Nuremberg, where he had been employed since 1717. A very prolific painter, Grebner is dis-

tinguished from his fellow artisans by the number of his works that are fully signed and dated, often with the month and day as well as the year.[2] Grebner seems to have specialized in biblical and commemorative subjects, many from print sources, and he worked both in high-fire colors, such as those on no. 12, and in enamels, the latter perhaps outside the factory.

The design source for this hunting scene is an engraving after Johann Elias Ridinger (1698-1767), *Auszug zur Jagd* (*Departure for the Hunt*), dedicated in Latin to Lothar Franz, Count of Schönborn, Archbishop of Mainz.[3] This is the first of a series of at least four unnumbered prints invented and drawn by Ridinger and engraved by Johann Daniel Hertz for the Augsburg printer Jeremias Wolff in 1723.[4] Grebner used only a portion from the left side of a large foreground group, omitting the figure of a lady on horseback, who, in the original engraving, is between the standing man and the right-hand equestrian. A detail of the same engraving also appears on a Crailsheim tankard of about 1750 in the Kunstgewerbemuseum, Cologne.[5]

Y.H., V.S.H.

NOTES

1. Konrad Hüseler, *Deutsche Fayencen*, vol. 3 (Stuttgart, 1958), pp. 402, 417.

2. Gustav E. Pazaurek, *Deutsche Fayence- und Porzellan-Hausmaler* (Leipzig, 1935), vol. 1, p. 77, n. 2. Products of the Bayreuth factory were frequently signed and dated, however; see Friedrich H. Hofmann, "Beiträge zur Geschichte der Fayencefabrik zu Bayreuth," *Münchner Jahrbuch der bildenden Kunst*, n.s. 1 (1924), 172-206.

3. Ign. Schwarz, *Katalog einer Ridinger-Sammlung* [R. von Gutmann], vol. 1 (Vienna, 1910), pl. 3.

4. Georg August Wilhelm Thienemann, *Leben und Wirken des unvergleichlichen Tiermalers und Kupferstichers Johann Elias Ridinger* (Leipzig, 1856), p. 6.

5. Manfred Meinz and Konrad Strauss, *Jagdliche Fayencen deutscher Manufakturen* (Hamburg and Berlin, 1976), pl. 63.

13 Tankard

Germany, probably Ansbach, about 1740
Tin-glazed earthenware (faience) with polychrome decoration and pewter mounts
Unmarked
H. 24.4 cm. (9 ⅝ in.), h. without cover 18.8 cm. (7 ⅜ in.), w. 18.3 cm. (7 ⁸⁄₁₆ in.), diam. at base 14.4 cm. (5 ¹¹⁄₁₆ in.)
1983.606
Provenance: Purchased, London, June 1964

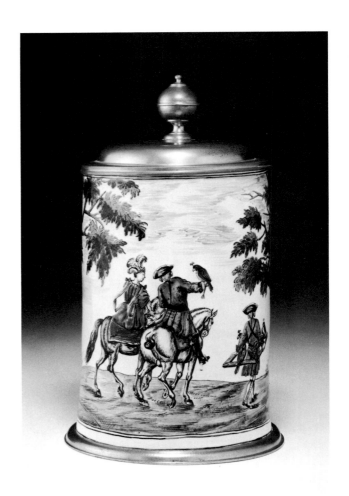

13

The cylindrical tankard is decorated with a continuous scene depicting a man and a woman on horseback and a companion on foot, all of whom are seen from the back. The woman wears a plumed hat and a blue dress with red bows and yellow ribbons. The male rider wears an olive green coat and carries a falcon on his outstretched right arm. Their companion, who wears a similar green coat, carries a wooden cadge (frame) on which four falcons are perched. The trunks of the two trees in the foreground are painted in mustard, brown, and black. The foliage is painted in blue-green and olive green. The same colors have been employed for the slightly undulating ground. The sky is painted with yellow and blue. The ear-shaped handle is decorated with bold flowers in blue, red, yellow, and green. The interior of the tankard is glazed white; the glaze on the base has been scraped away around the edges. The tankard has been equipped with pewter mounts consisting of a stepped domed cover with a baluster thumbpiece and a rounded foot rim.

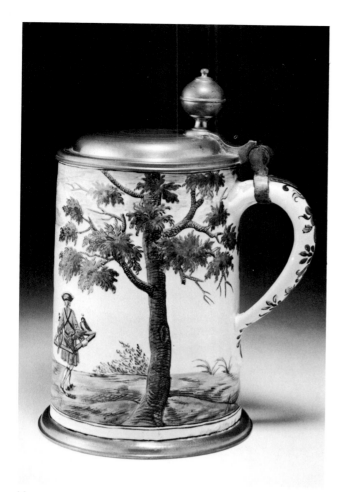

13

"Augsburg," perhaps because of the similarity of its decoration to enamel painting by *Hausmaler* (outside decorators who often worked in their homes). However, its palette strongly indicates that it is a product of the Ansbach factory. An Ansbach tankard in the Museum für Kunst und Gewerbe, Hamburg, with almost identical decoration was first published as late *Grüne Familie*, about 1770,[4] but more recent scholarship has changed this dating to about 1740 on the basis of the style of painting, the costumes, and the pewter mounts.[5] In the absence of signatures or marks, the attribution of the Markus tankard must at present remain tentative.

<div style="text-align: right">Y.H., V.S.H.</div>

NOTES

1. Konrad Hüseler, *Deutsche Fayencen*, vol. 1 (Stuttgart, 1956), pp. 24-25; vol. 3 (Stuttgart, 1958), p. 415.

2. For a discussion of the term *famille verte*, see no. 7 in this catalogue.

3. Manfred Meinz and Konrad Strauss, *Jagdliche Fayencen deutscher Manufakturen* (Hamburg and Berlin, 1976), pp. 17-18.

4. Hüseler, *Deutsche Fayencen*, vol. 1, fig. 241; Adolf Bayer, *Die Ansbacher Fayence-Fabriken* (Brunswick, 1959), fig. 153.

5. Meinz and Strauss, *Jagdliche Fayencen*, pl. 27.

The Ansbach factory (1710-1814), one of the largest in South Germany, was founded by Margrave Friedrich Wilhelm. In 1710 Johann Bernhard Westernacher and Johann Kaspar Rib were engaged as "Porcelinmacher" and "Porcelinmaler" respectively. Rib left in 1712 to found the Nuremberg factory and later went on to Bayreuth (see no. 12). The finest period of the Ansbach factory was from 1725 to 1757, under the guidance and management of the painter Johann Georg Christoph Popp (1697-1784).[1] During this period, wares known as the *Grüne Familie* ("green family" or *famille verte*) were introduced.[2] These were chiefly copies of Chinese porcelain of the Kangxi (K'ang Hsi) period (1662-1722). The high-fire colors developed for this group are found on no. 13; they are exceptionally brilliant and resemble enamels, especially the green and the light blue. Given the Margrave's passion for hunting, it is understandable that Ansbach should have produced many faience pieces with hunting scenes.[3]

This Markus tankard was acquired as

III *Niderviller Faience*

The production of faience in France achieved commercial and artistic success in the eighteenth century to a great extent as a result of the 1709 sumptuary laws of Louis XIV requiring the nobility to send their silver and gold to the mint. Again, in 1759, during the Seven Years' War, Louis XV made similar demands. Thus, during the first half of the century faience gradually replaced silver and gold on the courtly tables. Many of the potteries that sprang up to meet the increasing need were sponsored by courtiers of Louis XV, who himself was deeply concerned with the manufacture of porcelain at Sèvres. It was in part because of the restrictions imposed on other potters who were trying to produce porcelain that Paul Hannong introduced as an alternative the use of the enamel-painting technique (*petit feu*) at Strasbourg in about 1740. In 1748-1749 a group of German artists from Höchst and elsewhere, including Adam Friedrich von Löwenfinck,[1] were in Hannong's employ. The members of the Anstett family, natives of Strasbourg, quickly adapted to the new painting technique, specializing in naturalistic floral arrangements (*fleurs fines*), which were also introduced at Meissen about 1740.

About 1748 Jean-Louis Beyerlé, director of the Royal Mint at Strasbourg, acquired the seigniorial rights of the village of Niderviller in Lorraine. There had been a small *faïencerie* there before, but Beyerlé built a completely new manufactory, which was in production by 1754, the year that François-Antoine Anstett, a painter and chemist aged twenty-two, arrived from Strasbourg. Beyerlé recognized his value and named him director, a post he held until 1778. In 1759 Anstett engaged his younger brother, François-Michel Anstett, then only nineteen years of age, who was especially talented as a painter of flowers. Beyerlé, like Hannong, attempted to manufacture hard-paste porcelain about 1765, but when Lorraine reverted to France upon the death of Stanislas I Leszczynski in 1766, it was politically too difficult in view of the royal privileges of Sèvres.

On December 6, 1770, Beyerlé sold the Niderviller manufacture to Adam Philippe de Custine, a general who served with distinction in America during the Revolution. Under Custine, porcelain was successfully produced at Niderviller, but the production of faience continued into the nineteenth century. François-Antoine Anstett left in 1778 to found a pottery at Hagenau, and François Lanfrey, who was also from Strasbourg, replaced him as director. When Custine died by the guillotine in 1793, the factory was sold by the nation and purchased by Lanfrey.

The early products of Niderviller were very similar to those of Strasbourg, but the more French-oriented taste of Beyerlé and his wife, who herself was traditionally a flower painter, has been suggested as the basis for the softer colors and lighter forms for which Niderviller became known. Among the typical products are dishes and plates pierced in basketwork, outlined and shaded in tones of purple.[2]

V.S.H

NOTES

1. See nos. 31, 32, 34.
2. This brief history of Niderviller is based upon the works cited at no. 14, especially notes 1, 4, and 7, as well as upon the following works: Alan Caiger-Smith, *Tin-Glaze Pottery in Europe and the Islamic World: The Tradition of 1000 Years in Maiolica, Faience, and Delftware* (London, 1973); Henry Pierre Fourest and Jeanne Giacomotti, *L'Oeuvre des faïenciers français du XVIe à la fin du XVIIIe siècle* (Paris, 1966); William Bowyer Honey, *European Ceramic Art from the End of the Middle Ages to about 1815: A Dictionary of Factories, Artists, Technical Terms, etc.* (London, 1952); Arthur Lane, *French Faience* (New York, 1948); Adrien Lesur, *Les Poteries et les faïences françaises*, pt. 2 (Paris, 1958).

14 *Basket*

France, Niderviller, about 1775-1780 (Custine period)
Tin-glazed earthenware (faience) decorated in polychrome enamels
Unmarked
H. 9.5 cm. (3 ¾ in.), w. 36.5 cm. (14 ⅜ in.), d. 26.5 cm. (10 ⁷⁄₁₆ in.)
Provenance: Purchased, Paris, April 1960

The large oval dish is molded and pierced to simulate basketwork. The cupped walls, which curve in slightly at the top and sharply to the base, are decorated with a broad upper border of interlaced strapwork above three tiers of upright straps linked by three cross bands. The foot flares slightly, and there are two twisted handles at the ends. The outside is outlined and shaded with purple enamel to accentuate the basketwork, and the piercing is outlined with the same color on the inside. In the center on the inside is a large floral bouquet painted in natural colors. It consists of two pink roses and two purple tulips, one above and one

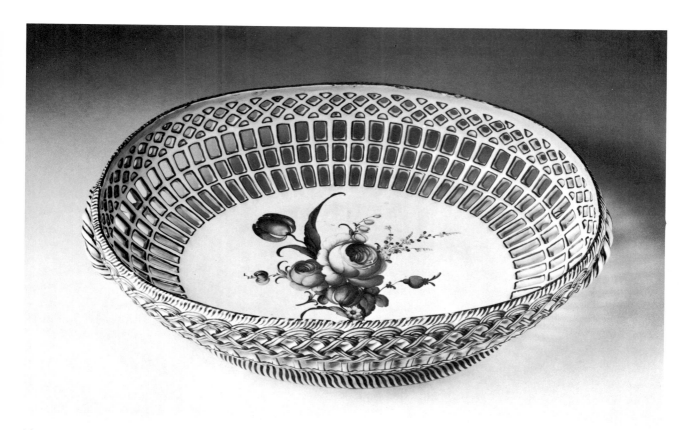

14

below the roses, with smaller flowers and buds in
yellow, blue, and purple. The flowers are finely de-
lineated and shaded in their individual colors, ex-
cept for those in yellow, which are shaded with
puce to give a tannish appearance. The leaves are
slightly bluish green, outlined and shaded with
black.

An exceptionally large but similar composition of
two roses surmounted by a tulip occurs on a stand

14. *Detail*

(*plateau*) in the Musée des Arts Décoratifs, Stras-
bourg, said to be typical of Niderviller at about
1775, the Custine period.[1] A pair of smaller bas-
kets with stands, formerly in the collection of Gil-
bert Lévy,[2] is related to no. 14 but is of a different
model, with a pierced pedestal foot and without an
interlaced upper border; the interlaced borders of
the stands are simpler. This pair of baskets also has
painted bouquets showing the same spirit, but the
flowers are composed differently.

Piercing, which was done when the clay was in its
raw, unfired state, required a great deal of extra
work and skill and seems to have been a specialty
of Niderviller. A smaller basket with similar inter-
laced work but decorated with a landscape with
ruins in puce monochrome (*camaïeu pourpre*) is in
the Château d'Ecouen, Musée de la Renaissance;
this is assigned to the Beyerlé period, 1760-1770.[3]
A dessert service with the crest and motto of the
Comte de Custine has plates with similar basket-
work borders;[4] as there are no records of their
manufacture, these are assigned to the first ten
years of the Custine period.

Besides requiring additional work in their
manufacture, faience baskets are understandably

more fragile than other forms. Perhaps for this reason, few have survived. The 1932 Paris exhibition of French faience included among the 3,337 items only eleven baskets (*corbeilles*), of which seven were eighteenth-century faience.[5] Two of these were Niderviller, the pair (no. 2641) cited above (see note 2) and another (no. 2643), even larger than no. 14. The other five were a signed Strasbourg piece (no. 2145) of the size of the Niderviller pair, an earlier Paris circular basket (no. 1714), a hand-built Rouen basket (no. 623), a rococo-shaped basket by the Robert factory, Marseilles (no. 1645), and another, smaller, from the same factory (no. 1548). Two other Marseilles baskets are in the Musée Contini, Marseilles.[6] A rectangular Sinceny basket in the museum at Sèvres is pierced in two tiers,[7] while another from the same factory, also in the Sèvres museum, is built up of woven and twisted rolls of clay.[8] The Victoria and Albert Museum has a smaller Niderviller basket on exhibition (C. 153-1912), not as elaborately molded and pierced as no. 14.

The purpose for which such faience baskets were made is a matter of speculation. Still-life paintings from the seventeenth into the nineteenth century show wicker baskets used for serving fruit and for arranging flowers. Silver baskets, which the faience may well have been replacing, were designed for serving breads and cakes. That this basket, no. 14, was much used before becoming a collector's item is evidenced by the chipping and repair of the upper edge. There is also a hairline crack at the left side.

V.S.H.

NOTES

1. Grand Palais, Paris, *Faïences françaises XVIe-XVIIIe siècles* (1980), no. 240, illus. (catalogue of this section by Jacques Bastian).

2. J. Chompret et al., *Répertoire de la faïence française* (Paris, 1933-1935), vol. 3: *Niderviller*, pl. 7B (one of a pair).

3. Grand Palais, Paris, *Faïences françaises*, no. 231, illus.

4. Jeanne Giacomotti, *French Faience*, trans. Diana Imber (London, 1963), fig. 114; Grand Palais, Paris, *Faïences françaises*, no. 239, illus.

5. Palais du Louvre, Paris, Pavillon de Marsan, *La faïence française de 1525 à 1820* (1932). Most of the pieces illustrated in Chompret et al., *Répertoire*, were in this exhibition.

6. Emile Tilmans, *Faïence de France* (Paris, 1954), figs. 128, 129.

7. Henry Pierre Fourest, *French Ceramics*, Masterpieces of Western and Near Eastern Ceramics, vol. 6 (Tokyo, 1979), fig. 49.

8. Giacomotti, *French Faience*, pl. 22; Chompret et al., *Répertoire*, vol. 5: *Sinceny*, pl. 10B; Grand Palais, Paris, *Faïences françaises*, no. 420, illus.

IV *Meissen Stoneware and Porcelain*

One of the greatest collectors of the oriental porcelains being brought to Europe by the Dutch was Augustus II, King of Poland and Elector of Saxony, called Augustus the Strong (1670-1733). One of his ministers, Ehrenfried Walther von Tschirnhaus (1651-1708), concerned that so much money was leaving the Saxon treasury for purchases of Japanese and Chinese porcelains and cognisant of the efforts elsewhere in Europe to produce porcelain (he had visited the factory at Saint-Cloud, see section VI), asked the king to permit the alchemist Johann Friedrich Böttger (1682-1719) to assist him in his experiments to produce a true, or hard-paste, porcelain body like that made in China and Japan. Böttger had been trained as an apothecary, but his claims to be able to make gold from base metals led to his incarceration in Dresden by the king and he was never really free for the rest of his career.

Tschirnhaus and Böttger successfully discovered, first, the secret of making a red-brown stoneware like the Chinese wares from Yixing (I-Hsing). This varied in color and in degree of vitrification; it was sometimes so hard that it could be polished on the lapidary wheel and at other times so soft that it required a glaze to render it impervious to liquids. As production on a commercial scale began only after the death of Tschirnhaus, this red stoneware came to be known as Böttger stoneware. White porcelain seems also to have been discovered just about the time of Tschirnhaus's death. On March 28, 1709, Böttger announced this success to Augustus, who, a year later, established the porcelain factory at Meissen, near Dresden. By 1713 "red porcelain," as it was called, and some white porcelain were being sold commercially. The latter, called Böttger porcelain, which had a warm, creamy white appearance, continued to be manufactured for about four years after Böttger's death. In addition to molded and applied relief decoration, Böttger developed a limited palette of enamel colors and a copper luster; he used gilding or sent the wares to Augsburg for gilding and mounting.

Shortly after Böttger's death, Augustus the Strong, who already dreamed of more ambitious objects in porcelain, engaged as painter a very gifted artist, Johann Gregorius Höroldt (1696-

1775), who had learned to paint porcelain at the rival factory established at Vienna with the assistance of the fugitive kilnmaster from Meissen, Samuel Stöltzel. It was Stöltzel who brought Höroldt to Augustus, and he was rewarded by being reemployed rather than imprisoned. Höroldt began immediately to improve and develop the enamel colors, as well as to create the wide repertoire of chinoiserie scenes inspired by the still popular travel books about the fascinating countries of China, India, and Japan. Some of Böttger's porcelain forms were appropriate for this widening range of painted decoration (to chinoiseries were added stylized oriental flowers known as *indianische Blumen,* mercantile and harbor scenes, and a variety of colored grounds), and other forms were added as Höroldt began, about 1723-1724, to fill the king's orders for porcelain to decorate his new Japanese Palace in Dresden; among these were the large garnitures of vases as well as a variety of other more modest pieces in the Kakiemon style. By 1724, too, a harder, whiter glaze and body had been developed, and the famous Meissen crossed-swords mark was in use.

In 1727 Gottlieb Kirchner was engaged as the first chief modeler of the factory, responsible for the overall decoration of the Japanese Palace as well as for new designs for commercial wares. In 1731, however, the king brought to the factory another gifted artist, Johann Joachim Kändler (1706-1775), a pupil of the court sculptor, Benjamin Thomae. Kändler was adept not only in the creation of the monumental porcelain figures desired by the king for the Japanese Palace but also in designing smaller figures and vessels to enhance the dining tables of the nobility.

Augustus the Strong died in 1733, before the completion of his porcelain palace, but his son and successor, Augustus III, continued to benefit from the products of the Meissen factory, by then widely sought by the courts of France, Prussia, and Russia, among others. Many great table services were created in the period 1735-1745, along with the highly prized figures of such diverse types as characters from the *commedia dell'arte,* lovers, miners, beggars, musicians, and gods and goddesses. In the early 1750s many figures were richly mounted in ormolu.

With the outbreak of the Seven Years' War in 1756, and the emergence of the new rococo style, the dominance of Meissen gave way to the French and other German factories. In the neoclassic period that followed, Meissen produced figures and wares in imitation of antique marble sculpture. Some excellent painting was done in the early nineteenth century, after which the Meissen

factory, still in production today, continued to use principally the old models, painted to appeal to current taste.[1]

V.S.H.

NOTES

1. J. Jefferson Miller II concluded his catalogue *Eighteenth-Century Meissen Porcelain from the Margaret M. and Arthur J. Mourot Collection in the Virginia Museum* (Richmond, 1983) with a selected bibliography of publications in English available at major libraries; most of these are cited in the following entries. Two recent translations from the German are also useful: Otto Walcha, *Meissen Porcelain* (New York, 1981); Peter Wilhelm Meister and Horst Reber, *European Porcelain of the 18th Century* (Ithaca, N.Y., 1983).

15 Tankard

Germany, Meissen, about 1710-1715

Brown-glazed Böttger stoneware decorated in lacquer colors and gold

Marks:
(1) on base, in ink (?): traces of No 32 (?) (not illustrated)

H. 16.6 cm. (6⁹⁄₁₆ in.), w. 14.3 cm. (5⅝ in.), diam. at base 11.8 cm. (4⅝ in.)

1983.607

Published: Parke-Bernet, New York, sale catalogue (Felix Kramarsky Collection), Jan. 7-10, 1959, lot 681, illus. p. 161.

Provenance: Coll. Felix Kramarsky, New Rochelle, N.Y. (sale, Parke-Bernet, New York, Jan. 7-10, 1959)

The thrown tankard is cylindrical, with turned moldings at the rim and above the foot. The ear-shaped strap handle is attached at the rim, where a small square of clay was added and pierced through to receive the mount for the cover, now lacking. The exterior of the tankard, including the handle, and the underside of the foot are covered with a lustrous brown-black glaze. The rim and foot rim are decorated with a band of dull gold; inside this band are scrolled borders with pendant trefoils, also in dull gold. The painting on the body of the tankard, at the base of the handle, depicts flowering branches springing from rocks that are painted in a textured gold and copper. The flowers are painted in red, white, and two shades of blue, with gilt outlines and tendrils. The leaves are gray-green. Above, on either side of the handle, are two birds in flight, each carrying a branch. They are outlined in gold and have pink and red feathers. Opposite the handle, on the front of the tankard, is an exotic flowering tree, outlined in gold, with

15

15

*gray-green leaves, red, blue, and white flowers,
and bearing a gourd-like fruit that is painted in red
and white. To the left of the tree stands a gesturing
man, who wears a pink robe with red highlights
and a blue sash (?). To his right is a fantastic bird
with a blue, striped serpent's tail, an orange beak,
red and white wings, and gold claws.*

The Böttger red stoneware body was probably per-
fected toward the end of 1708 and was in full com-
mercial production during 1709. The *Leipziger
Zeitung* of May 4, 1710, which reported on the un-
usual and very beautiful wares on display at the
Easter Fair, listed almost all the varieties of Böttger
stoneware known today.[1] The first forms noted in
the *Leipziger Zeitung* account were "Tisch-
Krüge," which referred to the simple beer mugs or
tankards (*Walzenkrüge*) that had been made in
various materials since the seventeenth century.[2]

 Because of the uncertainty of firing this red
ware in the early trial years, some of the pieces
proved to be insufficiently vitrified, almost too soft
and porous to be called stoneware. For these Bött-
ger developed a lustrous glaze using cobalt and
manganese oxides. In 1710 he wrote to Augustus
the Strong that the glaze had been perfected; he

suggested that oriental lacquers could be repro-
duced by the right expert, such as the recently
named court lacquer-master Schnell.[3]

 Martin Schnell (about 1685- about 1740)
had displayed his talents to Augustus as early as
1703, when he was working in the Berlin shop of
Gerhard Dagy, and in 1710 he was invited by the
king to set up a similar workshop in Dresden.
Schnell supplied lacquer furnishings for the three
palaces of Augustus: a Japanese palace (1716-
1717), a Turkish palace (completed 1719), and an
Indian palace in Pillnitz (1722-1723).[4] Schnell may
have lacquered Böttger stoneware pieces as early
as 1710, but he first appears on the salary lists of
the porcelain manufactory in 1712.[5]

 Since these lacquered pieces were never
signed, attribution to a particular artist can be only
tentative. Several hands are identifiable on the
published examples, some of which have been at-
tributed to Martin Schnell (as no. 15 has been)[6] or
to his workshop. Four pieces closely related to no.
15 can be cited. A *Bierkrug* with a silver-gilt cover
by the Augsburg goldsmith Andreas Wickhardt, in
the Rijksmuseum, Amsterdam, is approximately
the same size and shows the type of cover no. 15
must once have had.[7] A beaker-form vase in the

Staatliche Kunstsammlung, Dresden (Porzellan-sammlung), is decorated only in gold but with an identical scene of a gesturing Chinese man beside a flowering tree, a similar lambrequin motif above, and the same treatment of the ground with dots and overlapping arcs.[8] A covered vase in Dresden and a bottle vase in Berlin have painted chinoiserie figures and flowering plants after a common design source, and both are attributed to Schnell.[9]

V.S.H.

NOTES

1. Quoted in full by Otto Walcha, "Böttgersteinzeug in der Sammlung Dr. Schneider...," in *250 Jahre Meissner Porzellan: Die Sammlung Dr. Ernst Schneider im Schloss "Jägerhof," Düsseldorf, Keramikfreunde der Schweiz Mitteilungsblatt*, no. 50 (April 1960), pp. 15-16, fig. 12.

2. Ingelore Menzhausen, "Das Älteste aus Meissen: Böttgersteinzeug und Böttgerporzellan," in Staatliche Kunstsammlungen, Dresden, *Meissen: Frühzeit und Gegenwart: Johann Friedrich Böttger zum 300. Geburtstag* (1982), p. 89.

3. Ibid., p. 92.

4. Hans Huth, *Lacquer of the West* (Chicago and London, 1971), p. 74.

5. Menzhausen, "Das Älteste aus Meissen," p. 92.

6. Parke-Bernet, New York, sale catalogue, Jan. 7-10, 1959, lot 681, illus.

7. Willi Goder et al., *Johann Friedrich Böttger: Die Erfindung des Europäischen Porzellans* (Leipzig, 1982), pl. 124 (color); Rijksmuseum, Amsterdam, *Saksisch Porselein 1710-1740; Dresden China*, text by A. L. den Blaauwen (1962), fig. 3; Siegfried Ducret, *German Porcelain and Faience*, trans. Diana Imber (New York, 1962), pl. 2 (color).

8. Goder et al., *Johann Friedrich Böttger*, pl. 130 (color); Staatliche Kunstsammlungen, Dresden, *Meissen: Frühzeit und Gegenwart: Johann Friedrich Böttger zum 300. Geburtstag* (1982), pl. I/34.

9. Goder et al., *Johann Friedrich Böttger*, pl. 129 (color); Stefan Bursche, *Meissen: Steinzeug und Porzellan des 18. Jahrhunderts, Kunstgewerbemuseum, Berlin* (Berlin, 1980), no. 1, illus.

16 *Tankard and cover*

Plate IV

Germany, Meissen, about 1712-1713

Brown Böttger stoneware, polished, with cut decoration and silver-gilt mounts

Unmarked

H. 20 cm. (7⅞ in.), h. without cover 19.1 cm. (7½ in.), diam. at base 12.4 cm. (4⅞ in.)

1980.613

The brown stoneware tankard was thrown and is cylindrical in shape, with turned moldings at the rim and foot. The scroll handle is molded in two pieces with a ribbed spine. The cover is in the form of a stepped, flattened dome. The body of the tan-

16

kard is decorated with wheel-cut vertical bands that are alternately plain and faceted with a scale pattern emanating from a central notched oval. This treatment is continued on the cover but stops short of the plain circular field at the center. The exterior and half the interior of the tankard are polished. The cover is hinged with a silver-gilt mount; the cast thumbpiece is in the form of a satyr's head. The hinge itself is secured with a screw terminating in two florets, and the sleeve encasing the top of the handle is chased and engraved with a scroll pattern against a stippled ground. The foot of the tankard is mounted with a silver-gilt band that has cut, engraved dentils bent over the foot rim.

The primary characteristic of the red stoneware developed by Böttger (see no. 15) was its fine, hard body. He himself called it "Jaspis-Porcellan," a name that reflects its relationship both to porcelain and to gemstones. In a manuscript preserved in the Dresden state archives, Böttger wrote that three qualities arouse the desire of man: beauty, rarity, and usefulness; these make a thing pleasing, costly, and necessary.[1] This Markus tankard can be considered to meet all these requirements.

The cutting and polishing of gems and semiprecious stones had been a leading industry in Saxony since the end of the sixteenth century. In the last years of the seventeenth century Ehrenfried Walther von Tschirnhaus, who was instrumental in redirecting Böttger's efforts from alchemy to porcelain, established a cutting and polishing mill at Weisseritz, near Dresden. The mill was damaged and abandoned in 1706/07 as a result of the Swedish invasion of Dresden. As early as 1710, however, Augustus the Strong instructed Böttger (Tschirnhaus having died in 1708) to revive this gem-cutting industry. Two cut-stone pieces supplied by Böttger are preserved in the Grünes Gewölbe, Dresden. The similarity of the scale ornament on no. 16 and on related tankards (*Walzenkrüge*) to the Dresden cut-stone vessels suggests that these rare and unusual stoneware items were finished on Böttger's stone-cutting machine rather than, as is usually stated, by glass workers from Bohemia.[2]

The present location is known for only two other tankards with similar cut decoration. On one, in the Kunstgewerbemuseum, Berlin,[3] the body is completely filled with scale-decorated columns that have circular rather than buckle-shaped central motifs, and the overlapping leaves, on alternating columns, are curved, as here, and pointed; the size is the same but the handle is different, and there is a 1713 silver cover, apparently contemporary with the piece and valuable in dating this group. The second tankard is in the Museum of Fine Arts, Boston; it is shorter than the others, only 12 cm. (4¾ in.) high, and the scales are arranged in only one direction; like no. 16, it has alternately plain and scaled panels; the silver cover is not original to the piece.[4] A third tankard belonging to this group was formerly in the Hermann Emden collection, Hamburg,[5] but its present location is unknown to me. It is taller than no. 16 and has a mid-band decoration very similar to that of the Berlin tankard but only 7 cm. (2¾ in.) high; this band is halved and repeated at both the rim and base; the lid is silver, mounted with a medal, 7 cm. (2¾ in.) in diameter, of the great elector Frederick William of Brandenburg and the Battle of Fehrbellin (June 18, 1675).

Böttger stoneware *Walzenkrüge* with covers of the same material are rarer than those with silver or other metal mounts, but some examples have been published.[6] Handles of this scroll form with a trifid ending are also uncommon, but three can be cited for comparison.[7]

V.S.H.

NOTES

1. Ingelore Menzhausen, "Das Älteste aus Meissen: Böttgersteinzeug und Böttgerporzellan," in Staatliche Kunstsammlungen, Dresden, *Meissen: Frühzeit und Gegenwart: Johann Friedrich Böttger zum 300. Geburtstag* (1982), p. 84.

2. Joachim Menzhausen, "Böttgers Schleif- und Poliermühle," in Staatliche Kunstsammlungen, Dresden, *Meissen: Frühzeit und Gegenwart: Johann Friedrich Böttger zum 300. Geburtstag* (1982), p. 215, illus. (color).

3. Stefan Bursche, *Meissen: Steinzeug und Porzellan des 18. Jahrhunderts, Kunstgewerbemuseum, Berlin* (Berlin, 1980), no. 6, illus.

4. 1954.677, gift of Jessie and Sigmund Katz; see George Savage, *18th-Century German Porcelain* (London, 1958), pl. 4b; since this was misprinted as 4a (the illustration exchanged with that of a piece in the Hastings Museum), it was incorrectly cited by Bursche (see note 3 above).

5. Rudolph Lepke, Berlin, sale catalogue (Hermann Emden Collection), Nov. 3-7, 1908, lot 461, pl. 46.

6. *The Splendor of Dresden: Five Centuries of Art Collecting, an Exhibition from the State Art Collections of Dresden...* (New York: The Metropolitan Museum of Art, 1978), no. 446, illus., and, the same piece, Otto Walcha, *Meissen Porcelain* (New York, 1981), p. 465, fig. 7; Bursche, *Meissen*, no. 4, illus. p. 42; Hans Syz, J. Jefferson Miller II, and Rainer Rückert, *Catalogue of the Hans Syz Collection,* vol. 1: *Meissen Porcelain and Hausmalerei* (Washington, D.C.: The Smithsonian Institution, 1979), nos. 7, 9, illus. pp. 25, 27; Rainer Rückert, *Meissener Porzellan 1710-1810,* exhibition catalogue, Bayerisches Nationalmuseum, Munich (Munich, 1966), no. 10, pl. 4.

7. *Splendor of Dresden,* no. 446, illus., and, the same piece, Walcha, *Meissen Porcelain,* p. 465, fig. 7; Syz, Miller, and Rückert, *Catalogue,* vol. 1, no. 2, illus. p. 19; Rückert, *Meissener Porzellan,* no. 101, pl. 31.

17 Tankard

Plate V

Germany, Meissen, about 1723-1724

Probably painted by Johann Gregorius Höroldt (1696-1775)

Hard-paste porcelain decorated in underglaze blue, polychrome enamels, luster, and gold, with silver-gilt mounts

Marks:
(1) on silver-gilt cover, struck: year mark A for 1726, city mark for Dresden, unidentified maker's mark TOS (?)

H. 19.4 cm. (7⅝ in.), h. without cover 16.4 cm. (6⁷⁄₁₆ in.), w. 15.1 cm. (5¹⁵⁄₁₆ in.), diam. at base 10.9 cm. (4⁵⁄₁₆ in.)

1980.615

Published: Hermann Ball and Paul Graupe, *Die Sammlung Erich von Goldschmidt-Rothschild,* sale catalogue, text by Ludwig Schnorr von Carolsfeld and Hans Huth, March 23-25, 1931, lot 598, pl. 86.

Provenance: Coll. Erich von Goldschmidt-Rothschild, Berlin (sale, Ball-Graupe, Berlin, March 23-25, 1931)

The cylindrical tankard has an ear-shaped handle and a tall, recessed mouth rim over which the silver-gilt cover fits. A shield-shaped panel outlined in gold, opposite the handle, fills almost the entire height of the tankard; it is further elaborated with areas of Böttger luster within gold scrolls and intricate scrolling in iron-red. The chinoiserie scene in the panel shows, in the center, a dignitary descending from a hand-pushed carriage to be greeted by two figures and two small barking dogs. On the left of the scene are two men, one of whom pushes the carriage, while the other brings a tray laden with vessels. On the right are three figures gathered around a table on which a naked child is sitting. All the adult figures are elaborately dressed in patterned robes, most of which are trimmed in gold. The robes are variously painted in shades of puce, iron-red, and black. Behind the figures is a tall structure supported on two yellow columns with one trellised side and a blue and gold diamond-patterned roof. Immediately to the left is a wall that supports a large vase filled with iron-red flowers and green foliage. A red bird rests on the rim of the vase, and a peacock sits near the base. Nearby is a tall tree with drooping foliage in puce, iron-red, and brown and iron-red fruit. The sky is filled with clouds in blue with traces of orange. The grass of the foreground is a vivid green. Near the handle are painted two large sprays of flowers (indianische Blumen) in puce, iron-red, and yellow with green leaves and two birds and three flying insects in the same palette. A similar spray of flowers decorates the handle. Two birds painted in puce, iron-red, yellow, and gold fly above the terminations of the iron-red scrollwork that encloses the chinoiserie scene. The top and bottom of the tankard are each encircled by two underglaze-blue lines and a gilt band.

17

17

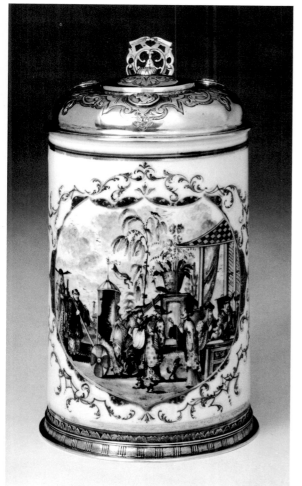

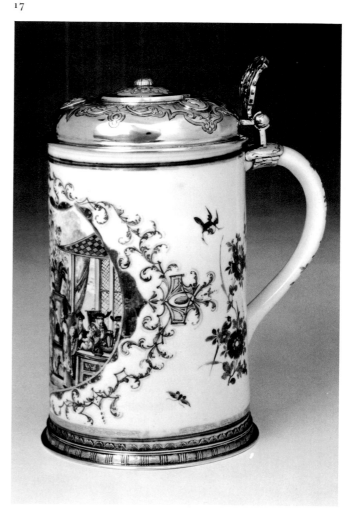

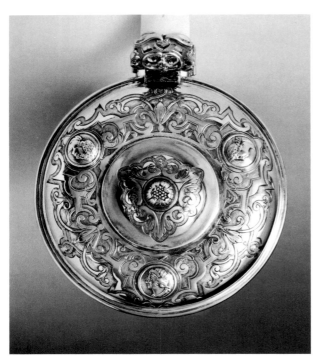

17. *Detail of silver cover*

*The domed silver-gilt cover is decorated
with a wide band of chased strapwork on a mat
ground and three applied medallions with classical
heads in profile. The center of the cover is raised
and is decorated with a chased foliate motif and a
boss in the form of an opening flower bud. The
molded silver-gilt foot rim has a chased dentil rim
band above a band with alternating striped and
matted grounds. The thumbpiece is in the form of
a baroque cartouche, chased and pierced.*

It is hardly surprising to find some of the finest
Höroldt-style chinoiseries on cylindrical tankards
(Walzenkrüge) and on coffeepots. Except for
vases, these vessels offered the largest uninter-
rupted surface for painted decoration. During the
first years of the Meissen factory, under the leader-
ship of Böttger, applied ornaments derived from
silver models were preferred; sculptural details
again competed with flat surfaces after the arrival
of Kändler in 1731. The period of the 1720s and
early 1730s, however, saw the full development of
new enamel colors and decorative themes under
the direction of the painter Johann Gregorius
Höroldt (1696-1775).

Höroldt, who was born in Jena, was known
to have painted wallpapers in Vienna early in
1719. He then spent about a year painting porce-
lain at the Du Paquier factory. In April 1720 he
was brought to Meissen by Samuel Stöltzel, who
had worked under Böttger as arcanist and who, al-
though he had carried the Meissen secrets to Vi-
enna in 1718, was readmitted at the Saxon factory.
Höroldt's artistry was such that, in 1723, he was
named court painter, and in 1731 he was ap-
pointed director of the twenty-nine painters and
ten apprentices.

Chinoiseries, the European vision of the
Orient, had been a part of the vocabulary of the
decorative arts since the end of the seventeenth
century. However, the fanciful and ever changing
miniature style developed by Höroldt had no pro-
totype in the decorations on oriental or European
ceramics. Using illustrated travel books and en-
gravings for inspiration, Höroldt and his fellow
painters skillfully adapted rather than copied
them.

The scene in the cartouche of no. 17 is al-
most identical to a pen-and-ink drawing in the so-
called Schulz-Codex.[1] The drawings in this group
are named for the collector G.W. Schulz, who pub-
lished a few of them as early as the 1920s.[2] Al-
though some of the drawings may be by other
painters at Meissen, all are conceptually the work
of Johann Gregorius Höroldt, and this one is in-
cluded in a list of the sheets regarded as "definitely
the work of Heroldt himself."[3] It may, therefore,
have been a sketch for the Markus tankard, but it
could as well have been a record of the design for
future reference.

The scene of the oriental dignitary descend-
ing from a canopied carriage was repeated several
times by Höroldt and his colleagues, always with
variations. On a coffeepot in the Syz Collection at
the Smithsonian Institution, Washington, D.C., the
man pushing the carriage, the dignitary, and the
man assisting him to dismount (or mount) the car-
riage are shown in a similarly richly decorated car-
touche on one side.[4] A variation of this group, the
dignitary being greeted by a woman and child, not
in a cartouche, is on one side of a teapot in the
McClellan Collection at the Metropolitan Museum
of Art, New York.[5] The Augsburg *Hausmaler* also
used this theme for their gold chinoiseries.[6]

17(1)

Other early Meissen tankards have panels of the same shape as that on no. 17, enclosing different chinoiserie scenes of comparable quality.[7] Two of these have original porcelain covers, but by far the larger number of *Walzenkrüge* are mounted in silver or silver gilt. Several covers, like that of no. 17, have medallions with profile heads in relief and baroque scrollwork.[8]

V.S.H.

NOTES

1. Rainer Behrends, *Das Meissener Musterbuch für Höroldt-Chinoiserien: Musterblätter aus der Malstube der Meissener Porzellanmanufaktur (Schulz-Codex)* (Munich, 1978), 1 text vol., 2 portfolios of facsimile plates of the drawings preserved in the Museum des Kunsthandwerks, Leipzig (Grassimuseum), catalogue no. 60.66/1-124, pl. 77.

2. G.W. Schulz, "Neues über die Vorbilder der Chinesereien des Meissner Porzellans," *Mitteilungen des städtischen Kunstgewerbemuseums zu Leipzig*, no. 11-12 (1922), p. 129; "Augsburger Chinesereien und ihre Verwendung in der Keramik," in *Das schwäbische Museum*, 1926, p. 190, and 1928, p. 121. These are cited in William Bowyer Honey, *Dresden China* (New York, 1946), p. 183, n. 74.

3. Behrends, *Meissener Musterbuch*, p. 75.

4. Hans Syz, J. Jefferson Miller II, and Rainer Rückert, *Catalogue of the Hans Syz Collection*, vol. 1: *Meissen Porcelain and Hausmalerei* (Washington, D.C.: The Smithsonian Institution, 1979), no. 28, illus.; Markus no. 17 (lot 598 in the catalogue of the Goldschmidt-Rothschild sale) is noted for comparison.

5. George B. McClellan, *A Guide to the McClellan Collection of German and Austrian Porcelain* (New York, 1946), fig. 12.

6. Siegfried Ducret, *Meissner Porzellan bemalt in Augsburg, 1718 bis um 1750*, vol. 1 (Brunswick, 1971), figs. 162, 165, 167.

7. Yvonne Hackenbroch, *Meissen and Other Continental Porcelain, Faience and Enamel in the Irwin Untermyer Collection* (Cambridge, Mass., 1956), pl. 94, fig. 142; *Keramos*, no. 32 (April 1966), p. 17, fig. 3; Sotheby & Co., London, sale catalogues, May 12, 1959, lot 112, illus.; May 24, 1966, lot 158, illus.; March 14, 1967, lot 128, illus.; Richard Seyffarth, *Johann Gregorius Höroldt* (Dresden, 1981), fig. 19 (color); Syz, Miller, and Rückert, *Catalogue*, vol. 1, no. 52, illus. (color).

8. *Keramikfreunde der Schweiz Mitteilungsblatt*, no. 39 (1967), fig. 19; Ducret, *Meissner Porzellan*, vol. 1, figs. 249, 253; Stefan Bursche, *Meissen: Steinzeug und Porzellan des 18. Jahrhunderts, Kunstgewerbemuseum, Berlin* (Berlin, 1980), no. 57, illus. p. 86; George Savage, *18th-Century German Porcelain* (London, 1958), pl. 12: Museum of Fine Arts, Boston, 1934.1352.

18 Tankard

Germany, Meissen, 1725-1726

Possibly painted by Johann Gregorius Höroldt (1696-1775) and Johann Leonhard Koch (1702-1744)

Hard-paste porcelain decorated in polychrome enamels, luster, and gold, with silver mounts

Marks:
(1) on side of tankard, on pedestal in cartouche, in puce enamel: K
(2) on silver cover, struck: year mark W for 1746, city mark for Dresden (12/crossed swords/D in shaped shield)
(3) on silver cover, struck: maker's mark GHE (?) in shaped shield
(4) inside silver cover, struck twice: duty mark for Prussia after 1809 (a crowned eagle)

H. 19.7 cm. (7¾ in.), h. without cover 15.8 cm. (6¼ in.), w. 15.2 cm. (6 in.), diam. at base 10.5 cm. (4⅛ in.)

1983.608

Published: New York Association for the Blind, *Artistic Beauty of the Centuries* (New York, 1966), p. 61, illus; Ruth Berges, *Collector's Choice of Porcelain and Faïence* (South Brunswick, N.J., and New York, 1967), p. 46, fig. 42, and color illus. facing p. 96.

Provenance: Purchased, New York, October 1960

The cylindrical tankard has an ear-shaped handle with a spade-shaped lower terminal. It is decorated with a large, mirror-shaped panel framed by a gilt band and gilt decoration including scrollwork, clusters of fruit, and baskets of flowers. Scrolling gilt bands enclose areas of *Böttger* luster on each side of the panel. Further scrolling in iron-red is found to the far left and right of the gilt framework. In the panel, the scene features four figures wearing oriental robes of brown, iron-red, and puce. One figure, at the left in front of a lattice fence, carries a basket of flowers on his head; another arranges flowers in an urn, which surmounts a tall, decorated pedestal at the right. One of the seated figures prepares food at the right, while, just below, a cat contemplates a bowl of food. The central figure sits at a table covered with a puce cloth on which is placed a folded scroll, several bottles, and what appears to be a large hookah. The grassy foreground is painted a vivid green. The

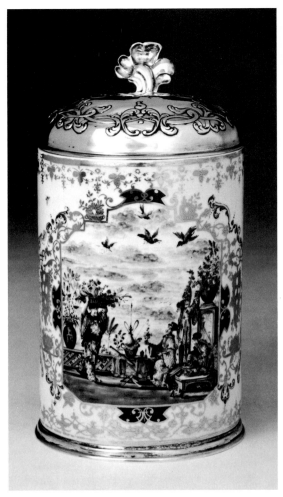

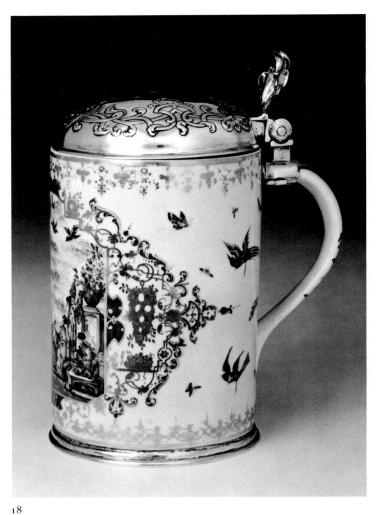

18 18

heavily clouded sky is blue with traces of orange.
Four brightly colored birds fly above the group.
Four much larger birds, painted in green, puce,
iron-red, yellow, black, and brown, and numerous
butterflies and flying insects painted in the same
palette decorate the area surrounding the handle.
A gilt band incorporating scrollwork and trefoils
encircles the top; at the bottom is a gilt band with
different scrolling. The handle is decorated with
indianische Blumen in iron-red, puce, yellow, and
green. The base is unglazed.

The tankard has been fitted with silver
mounts comprising a domed cover with repoussé
strapwork, a thumbpiece in the form of a baroque
scrolling leaf, and a molded foot rim. The outer-
most ridge of the cover and the foot rim are
gilded, as is the inside of the cover.

The form of this tankard, which is similar to that
of several examples in the Kunstgewerbemuseum,
Berlin, is thought to have been used for only a

short time.[1] The spade-like terminal of the handle
is also found on no. 30.

Acquired as a work by the master painter
Johann Gregorius Höroldt, no. 18 is comparable in
quality to no. 17 and to signed works by Höroldt.
One of these is the Berlin tankard dated 1725, in
which the vase of flowers, the sky, and the birds are
similarly treated.[2] The finely tooled gold decora-
tion on no. 18 is comparable to that on the AR vase
at Dresden, signed and dated by Höroldt in 1726.[3]
However, on the right of the cartouche on the
Markus tankard, hidden in the sky of the deco-
rated pedestal, is the letter K. Of the artists work-
ing with Höroldt at this early period whose names
begin with K (listed in detail by Rückert),[4] the one
most likely to have worked on this piece is Johann
Leonard(t) Koch (Knoch).

A document of April 1731 in the Meissen
Archives lists the thirty painters, eight apprentices,
and two color grinders employed in the painting
workshop of the factory.[5] For each worker the in-

formation includes the full name, age, place of birth, pay rate, type of work, number of years employed in the factory, and size of family. "Johann Gregorius Herold der Hof-Mahler" is first on the list, at age thirty-four, having worked eleven years in the factory. There seems to be no order to the following twenty-nine painters listed. "22. Joh. Leonh. Knoch," age twenty-nine, had worked in the factory five and a half years (therefore since 1725/26), and "mahlet das Gold, auch Laubwerck, Bluhmen u. Grotesco Arbeit" (painted gold, also foliage, flowers and grotesque work). To this report Rückert added the information that Koch also chiefly painted cartouches.[6] On May 30, 1731, Höroldt sent Augustus a long report, consisting of thirteen sections that covered all aspects of the work for which he was responsible. The list of journeymen painters in section VI differs slightly from that of a month earlier; a few were selected for further discussion, and the first of these was Koch, who was described as a gilder of small pieces who painted flowers and grotesques as well.[7] Unless this Markus tankard was a test or trial piece, on which painters of necessity had to place some identifying mark, it would seem that Koch (if it were he) secreted the K when he was adding gold and perhaps even some of the flowers and other details to the scene painted by Höroldt or another artist specializing in figures.

Although the full scene on no. 18 does not appear in the Schulz-Codex, there are almost identical floral arrangements in large vases placed on a terrace in plate 13 in that work, which, like plate 77 (see no. 17), is considered to have been drawn by Höroldt himself.[8]

V.S.H.

NOTES

1. Stefan Bursche, *Meissen: Steinzeug und Porzellan des 18. Jahrhunderts, Kunstgewerbemuseum, Berlin* (Berlin, 1980), no. 57, p. 84, referring also to nos. 86, 204.

2. Bursche, *Meissen*, no. 57.

3. Siegfried Ducret, *Meissner Porzellan bemalt in Augsburg 1718 bis um 1750*, vol. 1 (Brunswick, 1971), p. 61, fig. 124; Ingelore Handt and Hilde Rakebrand, *Meissner Porzellan des achtzehnten Jahrhunderts, 1710-1750* (Dresden, 1956), fig. 36.

4. Rainer Rückert, *Meissener Porzellan 1710-1810*, exhibition catalogue, Bayerisches Nationalmuseum, Munich (Munich, 1966), pp. 30-31.

5. Arno Schönberger, *Meissener Porzellan mit Höroldt-Malerei* (Darmstadt [1953]), pp. [37-38].

6. Rückert, *Meissener Porzellan*, p. 31.

7. Rudolph Seyffarth, *Johann Gregorius Höroldt* (Dresden, 1981), p. 137.

8. Rainer Behrends, *Das Meissener Musterbuch für Höroldt-Chinoiserien: Musterblätter aus der Malstube der Meissener Porzellanmanufaktur (Schulz-Codex)* (Munich, 1978), p. 75.

19 *Two-handled cup and stand*

Plate VI

Germany, Meissen, about 1725-1730

Hard-paste porcelain decorated in polychrome enamels, luster, and gold

Marks:
(1) on base of cup, in underglaze blue: AR in monogram
(2) inside foot ring of cup, impressed: two dots
(3) on base of stand, in underglaze blue: AR in monogram
(4) inside foot ring of stand, impressed: two dots

Cup: h. 8.3 cm. (3¼ in.), w. 11.7 cm. (4⅝ in.), diam. at rim 8.2 cm. (3¼ in.); stand: h. 4 cm. (1⁹⁄₁₆ in.), w. 20.5 cm. (8¹⁄₁₆ in.), diam. at rim 14.8 cm. (5¹³⁄₁₆ in.)

1979.795a,b

Published: Ruth Berges, *The Collector's Cabinet* (New York and London, 1980), color illus. facing p. 64.

Provenance: Purchased, New York, December 1961

18(1)

18(2)

18(3) 18(4)

The tall cup with a flared rim and angular spout tapers to a plain foot ring. It is fitted with two ear-shaped handles. The interior rim of the cup is decorated with a gold band below which is scrollwork incorporating a scale pattern. The inside of the spout is entirely gilded. On the outside of the cup two elaborately painted quatrefoil cartouches frame chinoiserie scenes. Each shaped cartouche is decorated with gilt scrollwork enclosing areas of Böttger luster; further scrollwork in iron-red and puce surrounds the gilded design. In one cartouche two men in oriental dress converse, one of whom stands holding an umbrella, while the other sits facing him. Both men wear wide-brimmed hats; the standing figure wears an iron-red robe and puce trousers, while his companion is dressed in a yellow and brown robe. Between the two men on the ground can be seen a jug and a tall beaker from which steam rises. To the left of the figures is a spray of iron-red flowers with green leaves. The cartouche on the other side of the cup depicts a standing figure in a puce robe holding a fan in one hand and a feather in the other. He converses with a child wearing an iron-red robe. A clump of flowers is to the left; on the right is a small structure, probably a kiln, from which smoke rises. A jug of the same height as the kiln stands further to the right. Two sprays of indianische Blumen extend toward the rim from the top of each handle, on which a third spray is centered. There is gilt scrolling at both junctures of the handle to the cup, and bell flowers in gold descend from the upper join. At either side of the terminus are two insects painted in iron-red, yellow, and puce. A plain gilt band covers the foot ring. The circular stand has two lug handles, each of which is decorated with gilt scrollwork including a trellised lozenge on a Böttger luster ground, all within a plain gold border. The interior rim of the stand is decorated with a gilt scrollwork band similar to that on the interior of the cup. A horizontally disposed quatrefoil cartouche is framed by gilt scrollwork enclosing a luster ground. Further scrollwork in iron-red and puce surrounds the gilt design, and masks in puce and iron-red are centered at the top and bottom. The enclosed scene depicts a seated oriental man in a puce robe holding a sheet of paper, possibly sheet music. A child presents another sheet of paper to the seated man, behind whom stands a man playing a flute. Flowers grow to the right of the group; trees are seen on the left in the far distance. The exterior of the stand is decorated with sprays of indianische Blumen in iron-red, puce, yellow, and green.

No recorded name, and therefore no contemporary eighteenth-century use, has been discovered for this almost unique form of spouted, two-handled beaker. The only other example known is in the porcelain collection at the Zwinger in Dresden (inv. no. PE 1514).[1] The Dresden example also has the eared stand, bears the AR mark, and has the same gilding and different chinoiserie scenes in quatrefoil reserves in the same palette.

It is possible that this type of cup was designed for serving cream or a cream sauce. Very similar examples are known of this spouted beaker form with only one handle opposite the spout and with a stand of this eared form.[2] The same stand occurs with the more common low cream jug like no. 32.[3]

Ingelore Menzhausen proposed that these two-handled, spouted beakers be called chocolate cups since two-handled cups are generally so named. On chocolate cups these simple handles are uncommon. The one example located, in a private collection in Hamburg, has a regular saucer rather than a stand.[4] Most chocolate cups have handles like those of nos. 24 and 35.

19(1)

19(2)

19(3)

19(4)

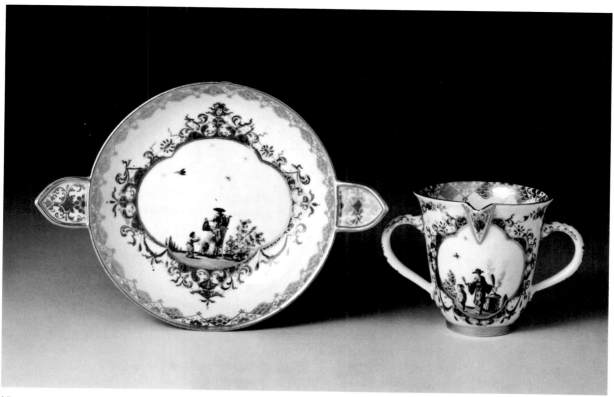

19

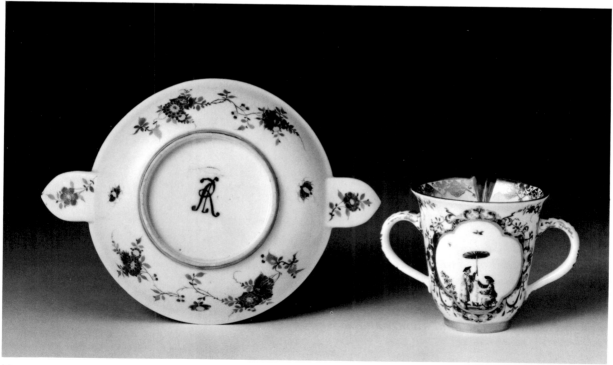

19

The chinoiserie scenes on no. 19 are painted in the style of J.G. Höroldt. It is typical to find the figures engaged in everyday activities, although musicians are rather uncommon. These scenes do not relate to those in the drawings preserved in the Schulz-Codex (see nos. 17 and 18).

Tablewares and large vases made for Augustus the Strong and marked with the monogram AR (Augustus Rex) were used by him either in his palaces or as gifts to nobility at home and abroad. The mark is rare on pieces other than vases. It was used from 1723 well into the 1730s.

The *Formerzeichen* (former's marks) impressed on pieces at this period were first published by Otto Walcha.[5] The two dots were used by a *Dreher* (turner) named Küttel about whom nothing more is known. Another *Dreher*, Künnel, used a similar mark, shown by Walcha as two minute circles; in later publications, these are often reproduced as two dots.[6] Rückert identified the Küttel mark on five pieces in the 1966 exhibition, all within the 1730-1740 period.[7] Since the marks were not reproduced photographically, one must assume that Walcha's chart was used to distinguish them from those in the same exhibition bearing the mark of Künnel.[8]

V.S.H.

NOTES

1. Seen by Christina Corsiglia in 1982; in a recent letter, Frau Dr. Ingelore Menzhausen has informed us that the Dresden cup and stand were purchased from the Spitzner collection in 1890.

2. Hermann Ball and Paul Graupe, Berlin, *Die Sammlung Erich von Goldschmidt-Rothschild*, sale catalogue, text by Ludwig Schnorr von Carolsfeld and Hans Huth, March 23-25, 1931, lot 575, pl. 85: "Henkelbecher nebst Unterschale," both pieces with AR mark; Christie's, London, sale catalogues [Edmund de Rothschild Collection], March 28, 1977, lot 41, illus.: "A pair of Meissen Augustus Rex chinoiserie deep cream jugs and eared stands," the jugs with AR marks, the stands with crosssed-swords marks; Oct. 17, 1977, lots 67 (illus.) and 68, another pair matching lot 41 in the first part of the sale (March 28).

3. Christie's, London, sale catalogue [Edmund de Rothschild Collection], March 28, 1977, lot 60, illus.

4. Hermann Jedding, *Meissener Porzellan des 18. Jahrhunderts in Hamburger Privatbesitz* (Hamburg: Museum für Kunst und Gewerbe, 1982), no. 47, pl. II (color).

5. Otto Walcha, "Die Formerzeichen der Manufaktur Meissen aus der Zeit von 1730-1740," *Keramikfreunde der Schweiz Mitteilungsblatt*, no. 42 (1958), p. 24.

6. Rainer Rückert, *Meissener Porzellan 1710-1810*, exhibition catalogue, Bayerisches Nationalmuseum, Munich (Munich, 1966), p. 43, no. 60; Hans Syz, J. Jefferson Miller II, and Rainer Rückert, *Catalogue of the Hans Syz Collection*, vol. 1: *Meissen Porcelain and Hausmalerei* (Washington, D.C.: The Smithsonian Institution, 1979), p. 594.

7. Rückert, *Meissener Porzellan*, nos. 288, 327, 332, 466, 473.

8. Ibid., nos. 123, 124, 244, 273, 329, 363, 646.

20 Cup and saucer

Germany, Meissen, about 1740

Hard-paste porcelain decorated in polychrome enamels and gold

Marks:
(1) on base of cup, in underglaze blue: crossed swords
(2) inside foot ring of cup, impressed: 2
(3) on base of saucer, in underglaze blue: crossed swords
(4) inside foot ring of saucer, impressed: two six-rayed stars

Cup: h. 4.1 cm. (1⅝ in.), w. 9.5 cm. (3¾ in.), diam. at rim 8 cm. (3⅛ in.): saucer: h. 2.5 cm. (1 in.), diam. at rim 12.7 cm. (5 in.)

1983.609a,b

The cup is hemispherical in shape and has an ear-shaped handle. It has a white ground decorated with two vignettes of men, women, and children in exotic dress, engaged in various activities. To the left of the handle, a seated figure in an iron-red robe with green sleeves offers a bowl, from which steam rises, to a standing figure who wears a gray, patterned robe. Nearby, a figure in a puce and brown robe accompanies a small child who gestures toward the other two figures. A man carrying a folded parasol offers a small gold object in the direction of the child. A flowering bush separates this group from the second vignette, which includes a woman in an iron-red robe on her knees, blowing on a concealed fire that heats a large steaming kettle. A child in blue looks on. Next to him a standing figure in a brown, puce, and iron-red robe swings a censer. To the left a man dressed in iron-red, bowing from the waist, carries a banner. Insects painted in black fly above the figures. The ground on which the figures stand is painted brown and green. Two parallel iron-red lines are painted along the bottom of the scenes. A gilt band encircles the foot ring, and the handle is decorated with gilt lines, dots, and a trellised lozenge. The rim of the cup is gilded, and a spray of flowers in iron-red, green, and yellow is painted inside the cup. The saucer is decorated with a large, circular scene enclosed by two parallel iron-red lines. A figure in a puce robe, smoking a pipe, sits in front of a tall pedestal on which are placed two large vessels, one blue, one yellow. He rests his left elbow on a round table, which is draped with a cloth and bears two vessels. The central figure, who wears an iron-red robe, offers the seated figure a tray on which a small cat or dog stands. Directly below is a basket of

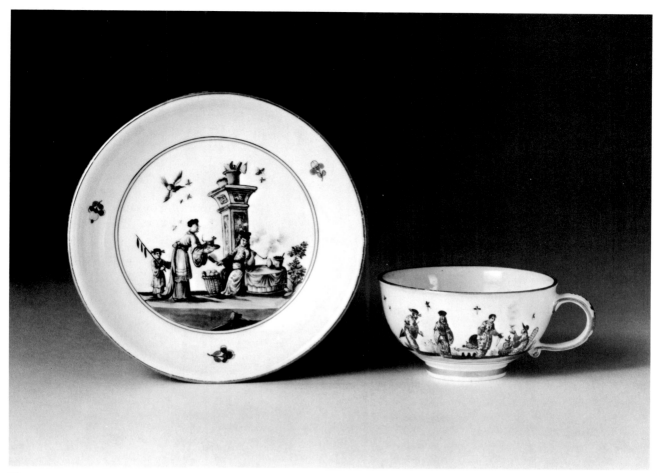

20

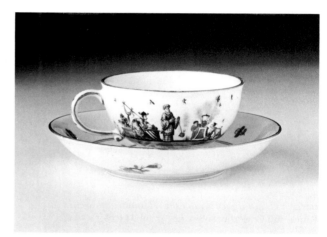

20

oranges. A child in a puce robe carrying a banner stands on the left. Insects and a bird painted in brown, iron-red, yellow, and puce fly above. Three sprigs of flowers in yellow, blue, green, and iron-red on puce stems decorate the area outside the central scene. Three larger sprays of flowers in the same palette are painted on the exterior of the saucer. The rim is gilded, and a gilt band encircles the foot ring.

It has been suggested that this form of hemispherical cup with one handle (see also nos. 42, 43) was made first about 1740 and continued in popularity for several decades.[1] Tea and coffee services had been the principal production of the Meissen factory from the beginning, but at that time, except for the chocolate beakers, no distinction was made between the shapes of the cups and their use. Apparently the first documentary mention of making handles appeared in Kändler's work report of February 1735: "1 verzierten Henken an ein Coppgen, wie auch einen ohne Zierrathen gemacht" (made one decorated handle for a cup and also one without decoration).[2] Teabowls (handle-

20 (1)

20 (2)

20 (3)

20 (4)

impressed number 2 such as can be seen faintly on the cup of no. 20. A pair of taller cups and saucers in the Syz Collection have an impressed 3 on each cup and 2 on one saucer;[8] like no. 20, these have chinoiserie decoration in a continuous frieze around the cups and filling the center of the saucers, but they also have gilt scrolled borders, continuing the earlier style.

The impressed former's mark on the foot ring of the saucer is that of the *Dreher* (turner) Meinert.[9] Two saucers in the Syz Collection and one in the Schneider Collection have the same impressed mark.[10] According to Kändler's proposal mentioned above (see note 6), the numeral 2 would have replaced Meinert's symbol; thus, it is very likely that Meinert finished both the cup and saucer in the Markus Collection during the period when the change was taking place.

V.S.H.

less) of similar form to no. 20 are often dated earlier than teacups with handles but were probably made contemporaneously over a long period. A teabowl and saucer in the Syz Collection, about 1725-1730, are similar in form to no. 20; they have crossed-swords marks together with the Johanneum inventory marks N = 243/W. According to the Meissen section of the 1779 inventory preserved at Dresden, no. 243 comprised thirty-six dozen and three "Thee-Schaalgen" (tea saucers) and thirty-six dozen and four "Kopgen" (cups).[3] It was intended that the walls of the Japanese Palace of Augustus the Strong be covered with such pieces, which in this instance have Kakiemon decoration.

The placement of the Höroldt-style figures in a frieze-like row was more appropriate for this shape of cup than were the earlier cartouche designs, which were ideally suited to the flaring teabowl shape. A service with teabowls of this hemispherical form, decorated in a very similar fashion but with larger sprays of flowers in the borders of the saucers, was on the London market in the 1950s.[4] The figures on no. 20 lack the liveliness and humor of those drawn by the master but are colorful and show an interest in detail. The central scene on the saucer resembles part of one of Höroldt's drawings in the Schulz-Codex.[5]

The use by the workmen of impressed (sometimes incised) numbers, replacing the earlier symbols (*Formerzeichen*), was begun in 1739 in accordance with a proposal by Kändler.[6] A teacup and saucer in the Bayerisches Nationalmuseum, Munich, are of the same form as no. 20 but have Kakiemon-style decoration;[7] they both have the

NOTES

1. Stefan Bursche, *Meissen: Steinzeug und Porzellan des 18. Jahrhunderts, Kunstgewerbemuseum, Berlin* (Berlin, 1980), p. 194.

2. Ibid.

3. Hans Syz, J. Jefferson Miller II, and Rainer Rückert, *Catalogue of the Hans Syz Collection*, vol. 1: *Meissen Porcelain and Hausmalerei* (Washington, D.C.: The Smithsonian Institution, 1979), no. 92.

4. George Savage, *18th-Century German Porcelain* (London, 1958), pl. 10.

5. Rainer Behrends, *Das Meissener Musterbuch für Höroldt-Chinoiserien: Musterblätter aus der Malstube der Meissener Porzellanmanufaktur (Schulz-Codex)* (Munich, 1978), pl. 67; see also Markus no. 17.

6. Syz, Miller, and Rückert, *Catalogue*, vol. 1, p. 592; Otto Walcha, "Incunabeln aus dem Meissner Werkarchiv," *Keramikfreunde der Schweiz Mitteilungsblatt*, no. 46 (1959), p. 25.

7. Rainer Rückert, *Meissener Porzellan 1710-1810*, exhibition catalogue, Bayerisches Nationalmuseum, Munich (Munich, 1966), no. 299, pl. 77.

8. Syz, Miller, and Rückert, *Catalogue*, vol. 1, no. 36, illus. p. 79.

9. Otto Walcha, "Die Formerzeichen der Manufaktur Meissen aus der Zeit von 1730-1740," *Keramikfreunde der Schweiz Mitteilungsblatt*, no. 42 (1958), p. 24.

10. Syz, Miller, and Rückert, *Catalogue*, vol. 1, nos. 119, 120; Rückert, *Meissener Porzellan*, no. 269, pl. 71.

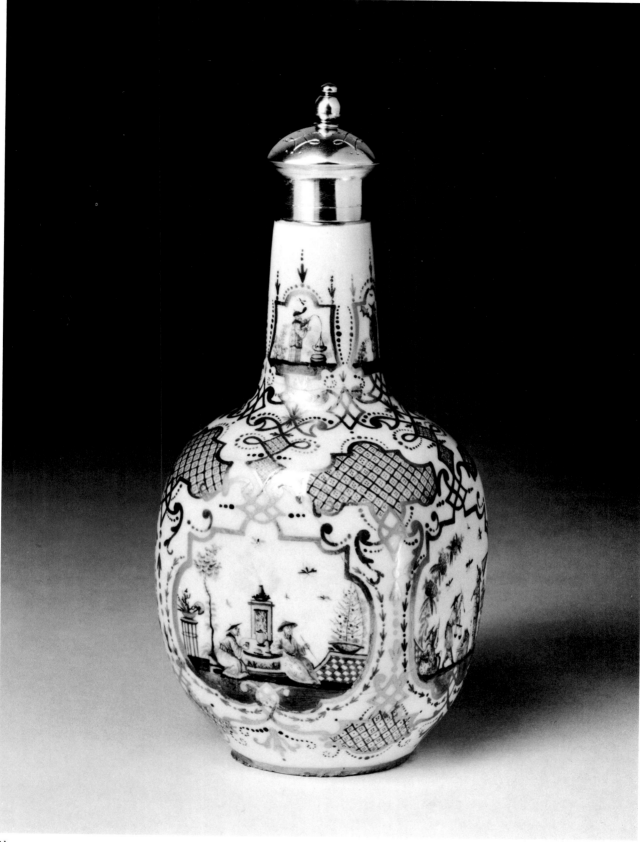

21 Tea bottle

Germany, Meissen, about 1715-1719

Decorated in Augsburg, about 1730, possibly by Sabina Aufenwerth (1706-1782)

Hard-paste porcelain decorated in polychrome enamels and gold, with silver-gilt stopper

Unmarked

Overall h. 18.2 cm. (7³⁄₁₆ in.), h. without stopper 15.2 cm. (6 in.), diam. at base 4.8 cm. (1⅞ in.)

1983.612a,b

Published: Rudolph Lepke, Berlin, *Sammlung Darmstaedter, Berlin: Europäisches Porzellan des XVIII Jahrhunderts*, sale catalogue, text by Ludwig Schnorr von Carolsfeld, March 24- 26, 1925, lot 396, pl. 92.

Provenance: Coll. Darmstaedter, Berlin (sale, Rudolph Lepke, Berlin, March 24-26, 1925); purchased, New York, November 1959

21. *Detail*

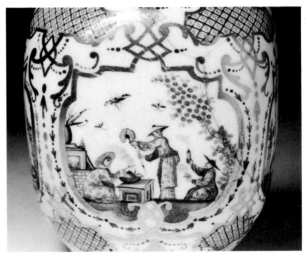

21. *Detail*

The bottle swells from a circular foot to a bulbous quadrangular midsection and then contracts at the shoulder to form an elongated, tapering neck, which ends in a tall, recessed lip. The gilt strapwork, which fully decorates the shoulder of the bottle, extends upward to form four shaped panels on the neck that are further elaborated with iron-red and purple dots and trefoils. Each panel contains a standing Chinese figure in a garden. The four corners of the shoulder are decorated with shaped panels outlined in gold and containing a diaper pattern, painted in purple, enclosing iron-red dots. A large shaped panel outlined in gold decorates each of the four sides of the midsection of the bottle. Each panel contains Chinese figures in garden settings, engaged in various pursuits including drinking tea, preparing food, using a balance scale, and smoking a pipe. The four scenes are elaborated with various pieces of furniture and foliage painted in iron-red, purple, green, and blue. The foreground of each is painted a vivid green. Further shaped panels also enclosing a diaper pattern are found near the bases of the scenes where the body tapers to the foot. Both the foot rim and the mouth rim are gilded, as is the base.

The bottle had been broken and repaired before the 1925 auction sale. The stopper, silver-gilt with a knop finial and decorated with repeating engraved curvilinear motifs, is a replacement since that sale.

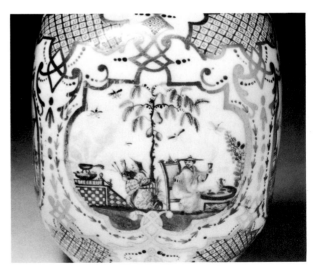

21. *Detail*

This type of bottle, thrown in a spherical shape then flattened on four sides while the clay was still soft, is not common. Except for a pair of bottles with underglaze-blue ornaments and polychrome chinoiserie decoration,[1] the comparable pieces that can be cited were decorated outside the factory and may have come from the stock of thousands of pieces of undecorated porcelain and stoneware remaining at the time of Böttger's death in 1719. Two "tea-bottles" of similar shape, in the G. Tillmann Collection, Hamburg, were signed and dated by the Breslau *Hausmaler* Ignaz Bottengruber in 1727.[2] Another, in the Untermyer Collection at the Metropolitan Museum of Art, also attributed to Bottengruber,[3] has the same coat of arms as a bottle formerly on the art market in Munich.[4] A pair of similar tea bottles decorated by Bottengruber about 1725-1730 are in the Museum für Kunst und Gewerbe, Hamburg (27,271).[5] Like the Untermyer example, these were attributed to Vienna but are now catalogued as early Meissen. Bottengruber's affiliation with Vienna did not begin until about 1730, when it had become more difficult to obtain undecorated porcelain from the Meissen factory.

The atelier of Johann Aufenwerth (1662-1728), the Augsburg *Hausmaler*, decorated *Böttgerporzellan* with gold and silver chinoiseries from about 1720 onwards. Brightly colored chinoiserie scenes in the Höroldt manner, often, as here, showing figures preparing and drinking tea and coffee, were typical of the work of two daughters of Johann Aufenwerth, Anna Elisabeth (b. 1696), who married the Nuremberg goldsmith Jakob Wald in 1722, and Sabina (b. 1706), who married Isaac Heinrich Hosennestel, the owner of a coffee house, on 3 December 1731. A tea and coffee service signed by Sabina appears to have been painted in 1731 as a gift to her husband-to-be.[6] The chinoiserie scenes on this service, as on no. 23, are embellished by a particular form of *Laub- und Bandelwerk* (leaf and strapwork), the interlacing baroque scrolls enclosing panels of trellis diaper that are reminiscent of a type of Du Paquier (Vienna) porcelain made during the same period, 1725-1735. Based on pattern books of Paul Decker of Nuremberg (d. 1713), this decoration parallels that of the interiors of the upper and lower Belvedere palaces of Prince Eugen in Vienna.[7]

Other *Böttgerporzellan* pieces that relate even more closely to no. 21 in decoration are a set of three bottles attributed to the workshop of Johann Aufenwerth, about 1720, in the Untermyer Collection (formerly in the Felix Kramarsky collection);[8] two sake bottles in the Residenz, Munich (one of which is Japanese porcelain), probably painted in Augsburg about 1730; and two covered tureens in the Bayerisches Nationalmuseum, Munich, of such high quality that they could have been decorated at Meissen about 1725-1730.[9] On all of these, as on no. 21, the chinoiserie scenes are enclosed in scrolled cartouches, with similar husk pattern, dots, and trefoils as ground decoration.

Y.H., V.S.H.

NOTES

1. Karl Berling, *Das Meissner Porzellan und seine Geschichte* (Leipzig, 1900), fig. 179; J.M. Heberle, Cologne, sale catalogue (C.H. Fischer Collection, Dresden) Oct. 22-25, 1906, lot 945, illus.

2. William Bowyer Honey, *European Ceramic Art from the End of the Middle Ages to about 1815: Illustrated Historical Survey*, 2nd ed. (London, 1963), pl. 150e; idem, *European Ceramic Art...: A Dictionary of Factories, Artists, Technical Terms, et cetera* (London, 1952), p. 84; Gustav E. Pazaurek, *Deutsche Fayence- und Porzellan-Hausmaler* (Leipzig, 1925), vol. 1, pls. 13 (color), 14, each showing three sides.

3. Yvonne Hackenbroch, *Meissen and Other Continental Porcelain, Faience and Enamel in the Irwin Untermyer Collection* (Cambridge, Mass., 1956), fig. 151, pl. 98.

4. Pazaurek, *Deutsche Hausmaler*, vol. 1, fig. 157.

5. Max Sauerlandt, *Das Museum für Kunst und Gewerbe in Hamburg 1877-1927* (Hamburg, 1929), pl. 111, as Vienna; Ruth Berges, *From Gold to Porcelain: The Art of Porcelain and Faience* (New York and London, 1963), fig. 175, as Vienna; Hermann Jedding, *Europäisches Porzellan*, vol. 1: *Von den Anfängen bis 1800* (Munich, 1971), fig. 592, as Meissen.

6. T.H. Clarke, "A Meissen Discovery—Sabina Aufenwerth at Augsburg," *Connoisseur* 181 (Oct. 1972), 94-99; Sotheby Parke Bernet, London, sale catalogue, Nov. 7, 1972, lots 125-133, illus. Both cite Siegfried Ducret, *Meissner Porzellan bemalt in Augsburg, 1718 bis um 1750*, vol. 1 (Brunswick, 1971), chaps. 2 and 12, vol. 2 (Brunswick, 1972), chaps. 4 and 5; and Pazaurek, *Deutsche Hausmaler*, vol. 1, pp. 107ff. See also T.H. Clarke, "Eine Meissen-Entdeckung—Sabina Aufenwerth in Augsburg," *Keramos*, no. 60 (1973), pp. 17-40; Siegfried Ducret, "Anna Elisabeth Wald, eine geborene Aufenwerth," *Keramos*, no. 50 (1970), pp. 3-29.

7. John Forrest Hayward, *Viennnese Porcelain of the Du Paquier Period* (London, 1952), pp. 167-169.

8. The Metropolitan Museum of Art, New York, *Highlights of the Untermyer Collection of English and Continental Decorative Arts* (New York, 1977), no. 189, illus.; Parke Bernet, New York, sale catalogue (Felix Kramarsky Collection), Jan. 9, 1959, lot 598, illus.

9. Rainer Rückert, *Meissener Porzellan 1710-1810*, exhibition catalogue, Bayerisches Nationalmuseum, Munich (Munich, 1966), nos. 115-116, 117-118, pl. 37; for the sake bottles, see also Ducret, *Meissner Porzellan*, vol. 1, figs. 358, 359.

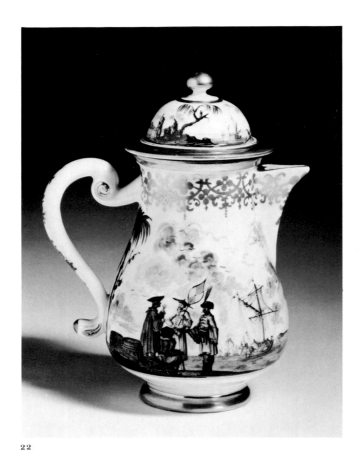

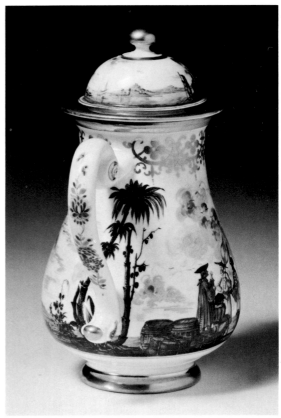

22

22

22 *Milk jug and cover*

Plate IX

Germany, Meissen, about 1725-1728

Hard-paste porcelain decorated in poly-chrome enamels, luster, and gold

Marks:
(1) on base, in underglaze blue: crossed swords; incised: three dots in triangle form, very faint

H. 15.3 cm. (6¹/₁₆ in.), h. without cover 11.6 cm. (4⅝ in.), w. 12.2 cm. (4¹³/₁₆ in.), diam. at rim 5.9 cm. (2⁵/₁₆ in.)

1980.614a,b

Provenance: Purchased, New York, September 1965

The body of the pot is pear-shaped with a simple everted molded rim, a flared molded foot, and an S-shaped scroll handle. The pointed spout is gently curved and has an elongated heart-shaped opening. The domed cover has a simple wide lip and a bun finial.

The gilded rim of the pot has a lustered top surface. Gilded Laub- und Bandelwerk *encircles the pot just below the rim and includes the spout. A continuous harbor scene occupies the body of the vessel, extending to just below the termination of the handle. In the foreground two men in Euro-pean dress converse with a Chinese and a Turk in robes of purple and gray respectively. To the left of the group are two barrels and two bundles near a palm tree and some broad-leaved vegetation, all of which are painted in shades of brown. Two sail-ing vessels intricately painted in brown, gray, and yellow occupy the middle distance. Visible in the far distance are small clusters of buildings set in a craggy landscape, which is painted in tones of green and gray. Much of the sky is filled with clouds, which are broadly painted in gray and blue. The water is densely painted in various shades of blue and mauve. Two thin parallel lines of red en-circle the pot at the bottom of the scene; the foot rim is gilded. The handle is decorated with indi-anische Blumen and gilding, which is applied at the base and at the scroll near the top of the han-dle. The cover is decorated with a harbor scene be-neath a gilded finial and a simple gilt band. In the foreground two figures are seen in profile amidst*

crates and a tree, all of which are painted in brown save for the puce robe of the figure on the left. Five figures wearing robes of orange, puce, and brown stand on a green expanse of land in the middle distance, with large bundles painted in the same palette as their robes. The body of water is painted in blue and mauve; sailing vessels and two small barges dot the harbor. A mountainous landscape with buildings is in the far distance, and birds and clouds are seen above. Two thin parallel red lines are at the bottom of the scene, above the simple, broad gilt band of the rim.

22 (1)

This pot, probably for hot milk, is a smaller version of a Böttger porcelain coffeepot, the form of which continued in popularity through the 1720s; it is based on a silver prototype, even emulating the "bridge" fitting for a carved wood handle. A slightly larger pot of the same form in Berlin has also been identified as a milk jug from a tea and coffee service, the coffeepot from the same service being known.[1] Three pots of approximately the same size and form as the Berlin piece are called coffeepots in the Syz Collection.[2] In a thirty-piece Meissen tea and coffee service in the Pauls Collection, decorated by Elisabeth Wald-Aufenwerth, the coffeepot is even smaller than no. 22, 14 cm. (5½ in.) high; the smaller milk pot is more squat than this Markus jug.[3] Such jugs with a vent hole in the cover might have also been used for hot water.

The high quality of the painting of the rather rare, continuous harbor landscape with figures suggests that this piece, which was acquired as a work of Johann Gregorius Höroldt, may have been by him, although attribution of unsigned work can only be tentative. Höroldt was known to have originated these *Kauffahrteiszenen* (scenes of sea trade). Such scenes are more generally attributed to one of the two leading painters in Höroldt's studio at Meissen: Johann George Heintze (active 1720-1749) or Christian Friedrich Herold (at Meissen 1725-1778).[4]

Three other pieces from the same service as no. 22 are known. The waste bowl is in the Rijksmuseum, Amsterdam.[5] The coffeepot, now lacking its cover, is in the Wadsworth Atheneum, Hartford, Connecticut (1925.432, bequest of the Rever-

end Alfred Duane Pell), and a teabowl is in the collection of Professor Malcolm D. Gutter.[6] All these pieces appear to be by the same painter, but the distinguishing feature is the design of the gilding. This is identical on all four pieces, and it appears that Meissen never used the same pattern of gilding on more than one service.

V.S.H.

NOTES

1. Stefan Bursche, *Meissen: Steinzeug und Porzellan des 18. Jahrhunderts, Kunstgewerbemuseum, Berlin* (Berlin, 1980), no. 58, p. 87; Rainer Rückert, *Meissener Porzellan 1710-1810*, exhibition catalogue, Bayerisches Nationalmuseum, Munich (Munich, 1966), p. 17, questions that a 1731 document indicates the earliest date for the production of milk pots and cream ewers.

2. Hans Syz, J. Jefferson Miller II, and Rainer Rückert, *Catalogue of the Hans Syz Collection*, vol. 1: *Meissen Porcelain and Hausmalerei* (Washington, D.C.: The Smithsonian Institution, 1979), nos. 35, 44, 336.

3. Siegfried Ducret, *Meissner Porzellan bemalt in Augsburg, 1718 bis um 1750*, vol. 1 (Brunswick, 1971), figs. 381-383; see also figs. 221-216, a service with two teapots of different size, two coffeepots (18.5 cm. [7¼ in.] and 20.6 cm. [8⅛ in.]), two tea caddies, two sugar boxes, two waste bowls, but no milk jugs.

4. Otto Walcha, "Höroldts erster Lehrjunge, Johann George Heintze," *Keramikfreunde der Schweiz Mitteilungsblatt*, no. 48 (1959), pp. 32-35; Monika Hornig-Sutter, "Der Stil Christian Friedrich Herolds," *Keramos*, no. 57 (1972), pp. 11-25.

5. Rijksmuseum, Amsterdam, *Saksisch Porselein 1710-1740; Dresden China*, text by A. L. den Blaauwen (1962), fig. 13, p. 17.

6. We are grateful to Professor Gutter for calling our attention to these unpublished pieces.

23 Beaker

Germany, Meissen, about 1730-1735

Hard-paste porcelain decorated in polychrome enamels, luster, and gold

Marks:

(1) on base, in underglaze blue: crossed swords; in gold: 1

H. 13.2 cm. (5³⁄₁₆ in.), diam. at rim 10.5 cm. (4⅛ in.)

1983.611

Published: Frederik Muller & Cie., Amsterdam, sale catalogue, Oct. 14-21, 1952, lot 325, illus.

Provenance: Coll. Dr. F. Mannheimer, Amsterdam (sale, Muller & Cie., Amsterdam, Oct. 14-21, 1952)

The thistle-shaped beaker has a thrown upper section that tapers to a low waist and then swells to

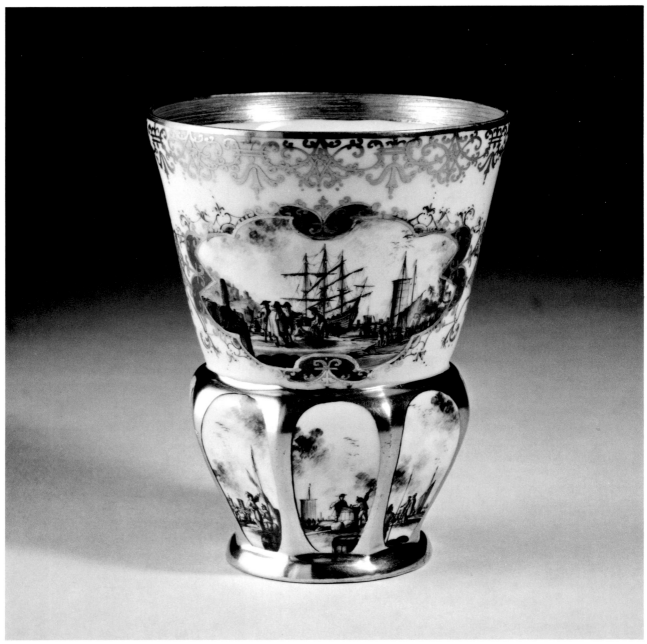

23

form a molded, octagonal lower section, which is
supported by a circular foot. Below a band of gilt
scrollwork that encircles the rim of the beaker are
two cartouches framed in Laub- und Bandelwerk
in gold, iron-red, and puce, incorporating areas of
Böttger luster. These two cartouches are joined by
two much smaller cartouches that contain ovals
painted in puce enclosing Chinese figures. Elabo-
rate framework in iron-red surrounds each oval,
from which a puce mask with a yellow crown de-
pends. The two primary cartouches contain har-
bor scenes in which men in coats of puce or iron-
red converse in groups amongst barrels and bales

of merchandise. In both scenes, a ship painted in
brown is seen in the middle distance, and clusters
of buildings are on the right and left; the distant
landscape is painted in puce and green, and the
clouded sky is gray-blue and orange. The eight
oval panels of the octagonal lower section of the
beaker are reserved on a gold ground and are
painted in puce monochrome. Each oval depicts
men in both European and oriental costume stand-
ing beside merchandise in an abbreviated harbor
scene with a ship in the middle distance; clouds
and birds are seen above. The unglazed inside rim
has been gilded. The cover is lacking.

This form has been described as "of modified Chinese beaker shape."[1] It is also very similar to a Dresden silver-gilt covered beaker of about 1725, with an eight-paneled lower section and conforming octagonal molding on the cover.[2] Covers that have survived on Meissen beakers similar to no. 23 have the same octagonal molding. The unglazed band inside the rim, sometimes gilded as on no. 23, is characteristic of covered vessels (see no. 31). The cover was biscuit-fired on the base so that the fit was perfect; after the glaze was applied but before it was fired, the inner rim of the base and the outer rim of the cover were wiped clean so that the pieces would still fit perfectly.

A covered beaker with a dragon knop was lent by A. Schöller to the 1904 exhibition of eighteenth-century porcelain in Berlin.[3] It was not illustrated in the catalogue, but the description applies so closely to no. 23 that it might have been either the same piece or a mate: on the upper portion are two panels with polychrome harbor landscapes framed in *Laub- und Bandelwerk* in gold, luster, iron-red, and purple, joined by small cartouches with purple chinoiseries and masks; the eight lower panels have purple harbor landscapes, and the marks are crossed swords and a gold 1.

Seventeen other beakers (including five pairs) of this form have been compared with no. 23. Of these, two have similar harbor scenes in cartouches of the same shape, linked in the same way as those on no. 23, but the lower panels are alternately iron-red and puce, the gold scrollwork borders are different, and the gold marks are C and 4 respectively. One of these, with a cover, is in the Pauls Collection, Riehen, Switzerland, the other, without cover, was sold at auction in New York in 1983.[4] These two are almost 2 cm. (¾ in.) smaller than no. 23, but another six similar examples (including two pairs), all with covers, are about the same size as no. 23, with harbor scenes in cartouches, the lower panels alternately iron-red and puce, and gold marks "Z" (possibly 2), 6, 2, and 5 respectively.[5] On all the covered pieces the same gold mark is on both the beaker and the cover. Three additional beakers, without covers, have Dutch landscapes in the cartouches: two of these, a pair, in the Dr. Ernst Schneider Collection, Düsseldorf, have purple grounds on the upper part, lower panels painted alternately red and black on the usual gold ground, and the gold numeral 1 as on no. 23;[6] the third beaker, in the Darmstaedter collection sale, 1925, with a gold 7, has all eight lower panels painted in "Purpur camaïeu," like no. 23.[7]

Covered beakers of the same form are also known with continuous harbor landscapes on the

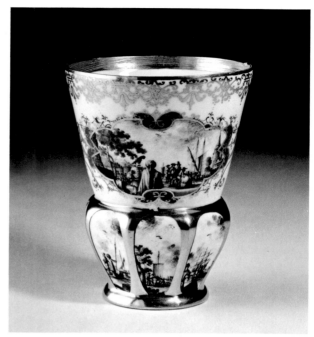

23

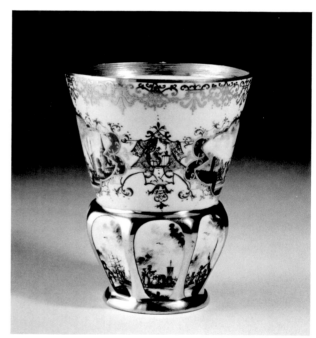

23

23 (1)

upper section: a pair in a Hamburg private collection, formerly in the Schwarz collection, Berlin, is marked with the gold numeral 4;[8] another beaker, on the London market in 1967 and 1973, seems to have had only the underglaze-blue crossed swords that are found on all examples noted.[9]

Dates suggested for pieces cited in the above references varied: about 1730, 1730-1735, and about 1740. An uncovered beaker in the Wrightsman Collection at the Metropolitan Museum of Art, New York, decorated with a continuous band of chinoiserie figures on the upper portion and single figures in the lower panels, has two bands of gold lacework but no gold mark; Dauterman assigned it a 1725-1730 date because of the decoration but referred to the continuation of the form into the 1740s.[10] Relative to this form, Rückert quoted Kändler's records of October 1739: "1 passigten Becher in Thon poussiret für Herrn Gledischen gehörig" (one octagonal beaker molded in clay, ordered for Mr. Gledischen).[11] The many examples that, like no. 23, have decoration of an earlier date (the luster, for example, was rarely used after 1735) would suggest that Kändler's 1739 record may not have referred to the initial modeling of this form.

The popularity of this type of beaker is shown by both the number of surviving examples and the rich decoration applied to them. Another indication is that similar pieces were produced in the manner of no. 23 as late as the second half of the nineteenth century.[12]

The meaning of the numerals (always under 100) and letters used by Meissen gilders has not yet been determined. From the examples cited above it seems that they served to unite beakers with their covers and, in the case of pairs, their mates. However, in several instances the same numeral appeared on pieces that were not pairs, and the numeral 1, as on no. 23, has been found on pieces of a different form and an earlier date.[13] As Rückert has pointed out, pieces belonging to a service are all marked with the same numeral; he suggested that the considerable number of such marks as well as their careful execution seem to rule out their being used as a control to record the amount of gold used by individual gilders.[14]

V.S.H.

NOTES

1. Carl Christian Dauterman, *The Wrightsman Collection,* vol. 4: *Porcelain* (New York: The Metropolitan Museum of Art, 1970), no. 46, p. 98 (hereafter cited as Dauterman, *Wrightsman Porcelain*).

2. Sotheby & Co., Geneva, sale catalogue, Nov. 15, 1983, lot 218, illus.: Dresden, about 1725.

3. Adolf Brüning et al., *Europäisches Porzellan des XVIII. Jahrhunderts,* exhibition catalogue, Kunstgewerbemuseum, Berlin (Berlin, 1904), no. 190.

4. Erika Pauls-Eissenbeiss, *German Porcelain of the 18th Century,* vol. 1: *Meissen* (London, 1972), pp. 454, 455, illus.; Sotheby Parke Bernet, New York, sale catalogue, Oct. 13-15, 1983, lot 99, illus.

5. Christie's, London, sale catalogue [Edmund de Rothschild Collection], March 28, 1977, a pair, lots 34, illus., 35 (the latter sold again, Christie's, New York, May 3, 1983, lot 352, illus.); Christie's, London, sale catalogue [Edmund de Rothschild Collection], Oct. 17, 1977, a pair, lot 34, illus.; Kunstgewerbemuseum, Cologne, *Europäisches Porzellan und ostasiatisches Exportporzellan: Geschirr und Ziergerät,* catalogue by Barbara Beaucamp-Markowsky (1980), no. 32, illus., p. 110, pl. 13; Christie's, London, sale catalogue, Dec. 5, 1983, lot 222, illus.

6. Rainer Rückert, *Meissener Porzellan 1710-1810,* exhibition catalogue, Bayerisches Nationalmuseum, Munich (Munich, 1966), nos. 410, 411, pl. 104; these may be the same as nos. 271, 272 in Otto von Falke, *Die Kunstsammlung von Pannwitz,* vol. 2 (Munich [1926]), p. 26.

7. Rudolph Lepke, Berlin, *Sammlung Darmstaedter, Berlin: Europäisches Porzellan des XVIII Jahrhunderts,* sale catalogue, text by Ludwig Schnorr von Carolsfeld, March 24-26, 1925, lot 122, pl. 34.

8. Hermann Jedding, *Meissener Porzellan des 18. Jahrhunderts in Hamburger Privatbesitz* (Hamburg: Museum für Kunst und Gewerbe, 1982), no. 72 (one of a pair), illus.; Hugo Helbing, Frankfurt am Main, sale catalogue, May 21-24, 1935, lots 329, 330, pl. 49.

9. Sotheby Parke Bernet, London, sale catalogues, Nov. 28, 1967, lot 122, illus.; July 10, 1973, lot 33, illus.

10. Dauterman, *Wrightsman Porcelain,* no. 46, pp. 98-99, illus.

11. Rückert, *Meissener Porzellan,* no. 410, p. 105.

12. Sotheby Parke Bernet, London, sale catalogue, Nov. 25-26, 1982, lot 110, illus.

13. Dauterman, *Wrightsman Porcelain,* nos. 57A-D, set of four cups, 1724-1725.

14. Rückert, *Meissener Porzellan,* p. 40.

24

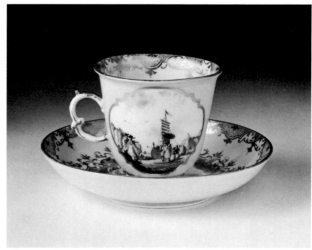

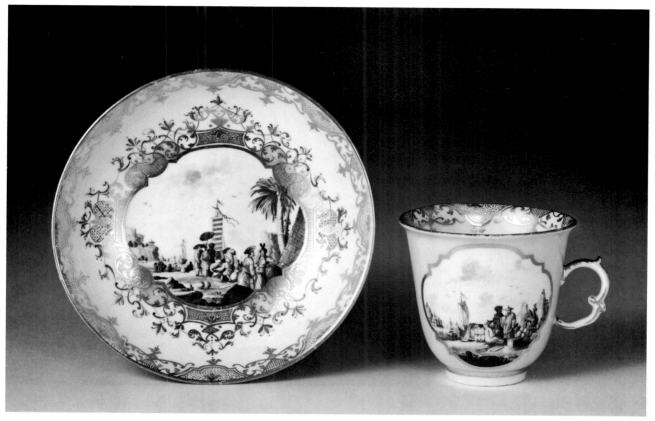

24

24 *Coffee cup and saucer*

Germany, Meissen, about 1740

Hard-paste porcelain with yellow ground, decorated in polychrome enamels, pale luster, and gold

Marks:
(1) on base of cup, in underglaze blue: crossed swords; in gold: 4.
(2) on base of saucer, in underglaze blue: crossed swords; in gold: 4.
(3) on base of saucer, impressed: 63

Cup: h. 6.8 cm. (2¹¹/₁₆ in.), w. 8.7 cm. (3⁷/₁₆ in.), diam. at rim 7.4 cm. (2¹⁵/₁₆ in.); saucer: h. 2.7 cm. (1¹/₁₆ in.), diam. 13.5 cm. (5⁵/₁₆ in.)

1983.610a,b

Published: Sotheby Parke Bernet, New York, sale catalogue, Dec. 9, 1972, lot 71, illus.

Provenance: Colls. Baroness Renée de Becker, Brussels, New York, Rome; Mr. and Mrs. Deane Johnson, Bel Air, California (sale, Sotheby Parke Bernet, New York, Dec. 9, 1972)

The thrown cup has an everted rim and a scrolled, ear-shaped handle. It is painted with a yellow ground on which are two shaped reserves outlined in gold. Both reserves contain harbor scenes in which figures in oriental dress are seen standing among bales of merchandise. Darkly shaded rocks are painted in the foreground, with patches of green and yellow grass beyond. In both scenes, ships are moored in the middle distance, and in the far distance buildings in oriental style are visible in the craggy landscape, painted in puce. The lightly clouded sky is painted in blue with small patches of orange. A gold band encircles the foot, and the details of the handle are picked out in gold. The interior rim is decorated with a scrolling band in gold enclosing alternately striped and dotted areas. A similar gilt band is painted on the interior rim of the saucer. In the center of the saucer an elaborate framework, composed of scrolls painted in puce, iron-red, and gold, with areas of pale Böttger luster, encloses a shaped quatrefoil panel containing a harbor scene. In the foreground is a barrel painted in black and a rocky outcrop in brown; farther back to the right is a large palm tree. Standing beyond on a yellow and green patch of land are several figures in exotic dress

conversing or loading bales of merchandise onto a camel. The yellow and brown striped sail of a ship is seen in the middle distance. Other ships are visible in the far distance, sailing past buildings set on a cliff. The exterior of the saucer is painted with a yellow ground; a gold band encircles the foot ring.

24 (1) 24 (2)

24 (3)

The earliest Meissen tea and coffee services included beakers that, like the teabowls, sometimes were without handles but usually had one or two handles. These were called "Choccoladen Becher" (chocolate beakers) in the early sales records.[1] There is no documentary evidence of the designing of cups specifically for coffee as distinct from tea. The 1721 inventory preserved at Dresden, published in 1969, lists tea and coffee services in which the cups are more often called "Caffe Tassen" than "Thee Tassen," even when associated with a teapot rather than a coffeepot. Some cups that can be linked with the list through their inventory mark, though called "Caffe Tassen," look like the typical teabowl.[2]

The early beakers were somewhat taller and slenderer than no. 24, the diameter of which is slightly greater than its height. Catalogued in 1972 as a "coffee cup and saucer," no. 24 may have been intended for just such a special use, but this supposition could be supported only by locating other pieces from the same service. A partial service with four similar single-handled beakers and saucers, also yellow ground but with chinoiserie painting,

was in the Edmund de Rothschild collection; the service also included a teapot and a tea caddy but no teabowls or coffeepot.[3]

The shape of the handle of no. 24 seems to have evolved from that of a similar, earlier handle found on two-handled beakers.[4] The earlier form lacks the acanthus leaf on the shoulder of the handle and has more curves in the lower lobe. This form, with the acanthus leaf and the simple lower lobe, is found on both single-handled and two-handled beakers, some decorated as late as 1740-1745.[5]

As part of the effort to imitate oriental prototypes, colored grounds were developed at Meissen by Höroldt. There are only a few references to ground colors or colored glazes in the factory records. A yellow ground is mentioned in 1725, and in 1733 it is recorded that Höroldt discovered a "lieblich anstehende gelbe Glasur" (a lovely pleasing yellow glaze).[6] Prized as the Chinese "Imperial" color, the yellow ground is often found on vases made for Augustus the Strong.

The fine painting of the harbor scenes is in keeping with the richness of the gilt borders and the elaborate framing of the central cartouche on the saucer. Each of the scenes includes, in the middle distance, a figure painted entirely in black, in contrast to the bright costumes of his companions. Could this be a "signature" of the unidentified artist?

Although this type of decoration was in use in the 1730-1735 period, the impressed numeral on the saucer is the type first used in 1739 (see no. 20). Therefore, all pieces with such numerals must have been formed and decorated after that date.

V.S.H.

NOTES

1. Richard Seyffarth, *Johann Gregorius Höroldt* (Dresden, 1981), p. 33, document of Feb. 17, 1720, and p. 63, document of 1730; Karl Berling, *Das Meissner Porzellan und seine Geschichte* (Leipzig, 1900), p. 170, n. 69: invoice of 1718.

2. Staatliche Kunstsammlungen, Dresden, *Böttgersteinzeug, Böttgerporzellan aus der Dresdener Porzellansammlung* (1969), fig. 40 and p. 50, no. 58.

3. Christie's, London, sale catalogues [Edmund de Rothschild Collection], March 28, 1977, lot 62, illus. (color); Oct. 17, 1977, lots 80, 81, 83, 84, illus. (color).

4. Stefan Bursche, *Meissen: Steinzeug und Porzellan des 18. Jahrhunderts, Kunstgewerbemuseum, Berlin* (Berlin, 1980), nos. 51-54, illus.

5. Ibid., no. 185, illus.; Sotheby Parke Bernet, Zurich, sale catalogue, Dec. 2, 1981, lot 1, illus. (color); Rainer Rückert, *Meissener Porzellan 1710-1810*, exhibition catalogue, Bayerisches Nationalmuseum, Munich (Munich, 1966), no. 651, pl. 152.

6. Rückert, *Meissener Porzellan*, pp. 15, 18, 98.

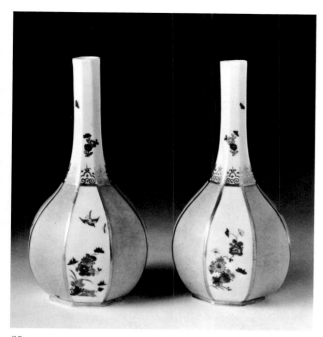

25

25 Pair of sake bottles

Plate VII

Germany, Meissen, about 1730-1735

Hard-paste porcelain with turquoise ("seladon") ground, decorated in polychrome enamels and gold

Marks:

(1) on side of 25a, in underglaze blue: crossed swords

(2) on base of 25a, wheel-cut: Johanneum mark N = 291- over W

(3) on side of 25b, in underglaze blue: crossed swords

(4) on base of 25b, wheel-cut: Johanneum mark N = 291- over W

25a: h. 20.8 cm. (8³⁄₁₆ in.). w. at base, 6.3 cm. (2½ in.); 25b: h. 20.7 cm. (8⅛ in.), w. at base 6.3 cm. (2½ in.)

1979.810, 811

Provenance: Colls. Augustus the Strong; Baroness Renée de Becker, Brussels, New York, Rome; purchased, New York, June 1958

Each of these bottles is of a bulbous octagonal shape with an elongated neck and a short octagonal foot. The white neck is decorated with random sprays of flowers in the Kakiemon style painted in iron-red, green, blue, and yellow and with insects

in iron-red or blue. At the base of the neck is a band of gilt ruyi (ju-i) heads above alternating panels of white and turquoise ground, all of which are bordered by bands of gilding. The white panels contain alternately sprays of flowers in the Kakiemon style and branches of similar flowers growing from a rock formation with ferns, in the same palette as on the neck, with the addition of gold. In the latter panels a bird painted in blue, yellow, and iron-red is shown in flight. A band of gilding decorates the foot.

The Japanese prototype for this octagonal sake bottle, an Arita piece of 1675-1710, is still in the state porcelain collection at Dresden (inv. no. P.O. 4767).[1]

The pale turquoise ground color, applied by spraying or pouncing, has been called *meergrün* or *seegrün* (sea or lake green) in earlier literature.[2] Since 1971, however, the name "seladon" has become more prevalent.[3]

Augustus the Strong had purchased the Holländisches Palais, in Neustadt, near Dresden, in 1717 and renamed it the Japanese Palace since he intended it to house his rapidly growing collection of oriental porcelains. The building was enlarged and nearly doubled in size in 1729. The lower floor was designated for Japanese and Chinese porcelains. The upper floor, which was devoted entirely to Meissen, included a gallery for large vases, dishes, and animals; a chapel; rooms for porcelains with "seladon," yellow, dark blue, and purple, and, in the buffet, green grounds — all with gilding. The walls of each room were fitted with mirrors, brackets, and other furnishings to hold the porcelain of various sizes and shapes, in the fashionable style of the porcelain chambers of the period. The king died before the project was completed, and about 1780, the nearly forty thousand pieces housed in the Japanese Palace were stored in the cellars. After almost one hundred years, the porcelain collection was moved to the Johanneum Museum in Dresden; ninety years later, following a shorter period of storage during the second World War, the collection was reinstalled in the restored Zwinger, following in part the early designs for the Japanese Palace.

The specifications for the outfitting of the second room of the east wing on the upper floor of the Japanese Palace read: "Seladon-Couleur mit weissen Feldern und mit schmalen goldenen Rändchen eingefasst und mit wenig Malerei" (celadon color with white panels and bordered with narrow gold bands and with little painting). A great quantity of turquoise-ground porcelain was made, judging by the accumulation of wares of this

25 (1)

25 (2)

25 (3)

25 (4)

type in the porcelain collection in Dresden.

An inventory of the royal porcelain collection, begun in 1721, survives. Most of the wheel-cut numbers (called Johanneum marks), especially those over No. 102, agree with those listed in a second inventory of 1779.[4] The entry that includes the Markus pair of bottles reads: "Neun und Fünfsig Stück diverse Aufsatz Bouteillen, Celadon Couleur mit weissen Feldern, darin kleine Blümgen und Zierraten gemahlt, auch vergoldte Rändgen, No. 291" (Fifty-nine pieces of different display bottles, celadon color with white panels, small flowers and ornaments painted in them, also gilt borders, No. 291).[5]

At least eighteen of the fifty-nine bottles entered under No. 291 have been published recently. Only one other is octagonal with the same decoration as Markus no. 25.[6] Another octagonal bottle, with a cover, has the turquoise ground color over the entire surface, except for three quatrefoil reserves with points above and below, enclosing three different polychrome oriental flower designs with butterflies.[7] Nine bottles are four-sided (like Markus no. 26), two of them with plain gold bands framing the quatrefoil reserves;[8] the other seven have the reserves framed in a gold scroll between two narrow gold lines, five of them with oriental flowers,[9] the other two with chinoiserie figures alternating with flowering shrubs.[10] A pair of pear-shaped bottles has three barbed quatrefoil panels: one with a red tiger and bamboo, the other two with prunus and chrysanthemum sprays, and all with birds in flight, within simple gold bands.[11] A pear-shaped bottle identical to the pair just described is in the Schneider Collection;[12] one (or more) is in the porcelain collection, Dresden;[13] another was on the London market in 1983.[14]

Pieces with the wheel-cut inventory numbers were undoubtedly withdrawn from the collection at various times after their entry into the records, but the largest group was sold in two auctions in 1919 and 1920. It is chiefly these pieces that can now be found in public and private collections throughout the world.

V.S.H.

NOTES

1. Masako Shono, *Japanisches Aritaporzellan im sogennanten "Kakiemonstil" als Vorbild für die Meissener Porzellanmanufaktur* (Munich, 1973), figs. 91, 100; Friedrich Reichel, *Early Japanese Porcelain, Arita Porcelain, in the Dresden Collection* (London, 1981), pl. 25 (color).

2. Ingelore Handt and Hilde Rakebrand, *Meissner Porzellan des achtzehnten Jahrhunderts*, 1710-1750 (Dresden, 1956), pl. 19; Rainer Rückert, *Meissener Porzellan 1710-1810*, exhibition catalogue, Bayerisches Nationalmuseum, Munich (Munich, 1966), pp. 106-108.

3. Staatliche Kunstsammlungen, Dresden, *Kunstschätze aus Dresden* (Zurich, 1971), nos. 331-337.

4. Hans Syz, J. Jefferson Miller II, and Rainer Rückert, *Catalogue of the Hans Syz Collection*, vol. 1: *Meissen Porcelain and Hausmalerei*, (Washington, D.C.: The Smithsonian Institution, 1979), pp. 592-593; *The Splendor of Dresden: Five Centuries of Art Collecting*, an Exhibition from the State Art Collections of Dresden...(New York: The Metropolitan Museum of Art, 1978), p. 170.

5. Information supplied to Yvonne Hackenbroch by Ingelore Menzhauzen, Dresden.

6. Christie's, London, sale catalogue [Edmund de Rothschild Collection], Oct. 17, 1977, lot 65, illus.

7. Stefan Bursche, *Meissen: Steinzeug und Porzellan des 18. Jahrhunderts, Kunstgewerbemuseum, Berlin* (Berlin, 1980), no. 225, illus., and reference to an identical bottle in the Dresden porcelain collection (inv. no. P.E. 5257).

8. Handt and Rakebrand, *Meissner Porzellan*, pl. 19; Rückert, *Meissener Porzellan*, no. 417, pl. 106 (Dr. Ernst Schneider Collection, Düsseldorf).

9. Sotheby Parke Bernet, New York, sale catalogue, Dec. 9, 1972, lot 35, illus.: pair (Collection of Mr. and Mrs. Deane Johnson, formerly Collection of Baroness Renée de Becker); Christie's, London, sale catalogue, March 28, 1977, lot 38, illus.: pair [Edmund de Rothschild Collection]; Christie's, London, sale catalogue, Oct. 17, 1977, lot 64, illus. [Edmund de Rothschild Collection].

10. Sotheby Parke Bernet, London, sale catalogue, Dec. 4, 1973, lot 179, illus. (one color); these were sold again in the Galerie Koller, Zurich, Oct.-Nov. 1980.

11. Sotheby Parke Bernet, New York, sale catalogue, Dec. 9, 1972, lot 36, illus. (Collection of Mr. and Mrs. Deane Johnson, formerly Collection of Baroness Renée de Becker); these were sold again, Sotheby Parke Bernet, London, June 17, 1975, lot 160, illus.

12. Rückert, *Meissener Porzellan*, no. 433, pl. 109.

13. Staatliche Kunstsammlung, Dresden, *Kunstschätze* (Zurich, 1971), no. 336. No. 335 in this catalogue seems to be an additional example.

14. Sotheby Parke Bernet, London, sale catalogue, Nov. 22, 1983, lot 64, illus.

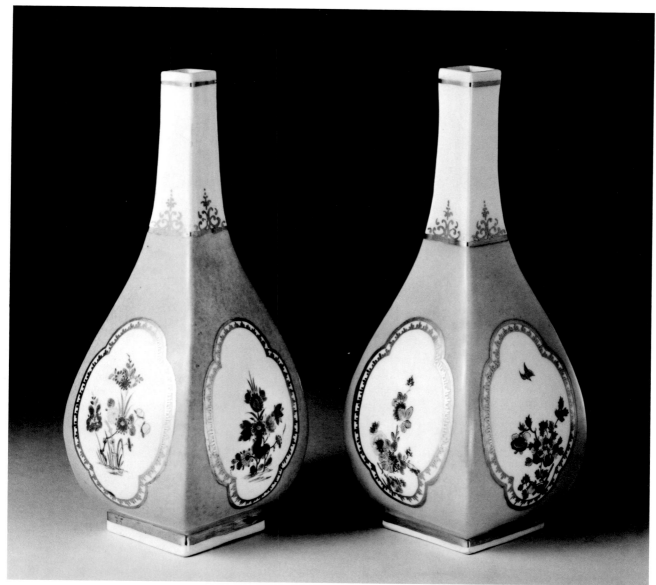

26

26 *Two sake bottles*

Germany, Meissen, about 1730-1735

Hard-paste porcelain with turquoise ("seladon") ground, decorated in polychrome enamels and gold

Marks:
(1) on base of 26a, in cobalt blue (very faint): crossed swords; wheel-cut: Johanneum mark N = 332- over W; in ink: old inventory number 280 and other numerals
(2) on base of 26a, impressed: MB in monogram

(3) on base of 26b, in cobalt blue (very faint): crossed swords; wheel-cut: Johanneum mark N = 332- over W; impressed: three circles arranged in triangle

26a: h. 20.8 cm. (8³⁄₁₆ in.), w. of base 5 cm. (2 in.); 26b: h. 21 cm. (8¼ in.), w. of base 5.2 cm. (2⅙ in.)

1979.806, 807

Provenance: Colls. Augustus the Strong; Baroness Renée de Becker, Brussels, New York, Rome; purchased, New York, June 1958

The quadrangular, pear-shaped bottles have elongated necks and are approximately square in cross section (both apparently warped in the kiln). The flat bases are unglazed. The pale turquoise ground extends from the shoulder of each bottle to the square foot. A quatrefoil reserve, centered on each side, is framed by a double gilt band enclosing a simple linear motif. Each reserve contains sprays of flowers painted in the Kakiemon style in iron-red, blue, turquoise, green, yellow, puce, and gold. On each bottle are two different arrangements of these flowers, each one repeated on the reverse. Two reserves on one bottle include a shoot of bamboo painted in turquoise; a bird painted in the same color appears in two reserves on the other bottle. The white neck is decorated with a gilt band below the mouth and, at the shoulder, with a gilt band with scrollwork above; the pattern of this scrollwork is identical on the two bottles.

A Japanese porcelain bottle of this same form is in the British Museum and resembles three Kakiemon pieces that were illustrated in the 1920 Berlin sale of the Saxon state collection from the Johanneum.[1] Augustus the Strong lent examples from his collection of oriental porcelains for use as models as early as the beginning of Böttger's stoneware production. A receipt for such a loan, dated November 28, 1709, and addressed to "Mons. Böttgern," is preserved by the Staatliche Porzellansammlung, Dresden; it includes "1 längliche 4 eckig kleine Bouteillie" (1 slender 4-sided small bottle).[2]

The earliest document mentioning the production of such Böttger stoneware bottles is an inventory of the Meissen factory dated August 3, 1711: "Form 30: 4Eckichte Boutillie" (model 30: 4-sided bottle).[3] Variations of the model are described as smaller, higher, ready to be glazed, or as yet unfired, and some with "auf allen 4 seiten etwas Blumenwerk" (on all 4 sides some floral work). A plain example in Böttger's stoneware, dating from 1710, is in the Dresden porcelain collection.[4]

Böttger also produced this form in his white porcelain; many examples were decorated outside the factory, especially in Augsburg (see no. 21, notes 8, 9) and also in Holland.[5] As seen in no. 25, this was one of three bottle forms produced in large numbers to decorate the "seladon" room of the Japanese Palace.

The 1779 Japanese Palace inventory entry for this number reads: "Neun Stück Aufsatz Bouteillen Céladon Couleur, different Sorten, mit weissen Schildern und goldenen Rändgen, No. 332" (Nine pieces display bottles of celadon color, different kinds, with white reserves and gilded

26 (1)

26 (2)

26 (3)

borders, No. 332).[6] In addition to Markus no. 26, two bottles in the Dresden Porzellansammlung have been published as having the same Johanneum mark, one of which is this square shape but with Chinese figures in the reserves, the other pear-shaped and painted with flowers.[7] All four of these bottles have the same flame-like pattern framing the reserves; the three square bottles also have the same gold ornament at the neck. A fifth bottle, in the Dr. Ernst Schneider Collection, Düsseldorf, is also square but has a different border for the reserves (a narrow inner and wider outer gold band) and, like no. 26a, has an old inventory mark, 280.[8]

The impressed marks on the two Markus bottles are those of workmen who formed the pieces from slabs of clay, possibly with the aid of molds. On no. 26b the three small circles arranged in a triangle is the same mark as that identified as the former's mark of a workman named Seidel in a packet of notes of about 1730-1740 found in the factory archives at Meissen; Seidel's name was also listed in a 1739 factory specification (WA I Aa 25).[9] The impressed mark MB on no. 26a, which has not been published previously, is probably also that of a former and turner.

Y.H., V.S.H.

NOTES

1. Soame Jenyns, *Japanese Porcelain* (London, 1965), fig. 59C and p. 243. This bottle is similar to a pair that has been at Hampton Court since before 1694 and is the direct prototype in both form and decoration of a Meissen bottle (N. 302/W) in the porcelain collection at Dresden; see Masako Shono, *Japanisches Aritaporzellan im sogenannten "Kakiemonstil" als Vorbild für die Meissener Porzellanmanufaktur* (Munich, 1973), fig. 77, left.

2. Information given to Yvonne Hackenbroch by Ingelore Menzhausen, Dresden.

3. Claus Boltz, "Formen des Böttgersteinzeugs im Jahre 1711," *Keramikfreunde der Schweiz Mitteilungsblatt*, no. 96 (March 1982), p. 21.

4. Ingelore Handt and Hilde Rakebrand, *Meissner Porzellan des achtzehnten Jahrhunderts, 1710-1750* (Dresden, 1956), pl. 1.

5. Hans Syz, J. Jefferson Miller II, and Rainer Rückert, *Catalogue of the Hans Syz Collection*, vol. 1: *Meissen Porcelain and Hausmalerei* (Washington, D.C.: The Smithsonian Institution, 1979), no. 382, illus.

6. Information supplied by Ingelore Menzhausen, Dresden.

7. Shono, *Japanisches Aritaporzellan*, figs. 100 and 76.

8. Richard Seyffarth, "Marken der 'Königlichen-Porzellan-Manufactur' zu Meissen von 1721 - 1750," in *250 Jahre Meissner Porzellan: Die Sammlung Dr. Ernst Schneider im Schloss "Jägerhof," Düsseldorf, Keramikfreunde der Schweiz Mitteilungsblatt*, no. 50 (April 1960), fig. M9 (incl. detail of base).

9. Otto Walcha, "Die Formerzeichen der Manufaktur Meissen aus der Zeit von 1730-1740," *Keramikfreunde der Schweiz Mitteilungsblatt*, no. 42 (April 1958), p. 24; reprinted in English, in Syz, Miller, and Rückert, *Catalogue*, vol. 1, p. 594, where the three circles are reproduced as dots. Rainer Rückert, *Meissener Porzellan 1710-1810*, exhibition catalogue, Bayerisches Nationalmuseum, Munich (Munich, 1966), p. 43, also reproduces Seidel's mark as three large dots; three catalogue items have marks attributed to Seidel: nos. 227, 253, and 350, indicating that he was both a former and a turner (*Dreher*).

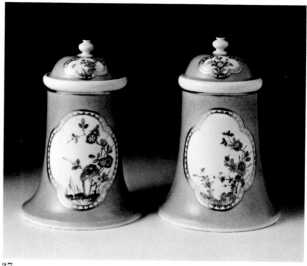

27

27 Pair of covered jars

Germany, Meissen, about 1730-1735

Hard-paste porcelain with turquoise ("seladon") ground, decorated in polychrome enamels and gold

Marks:
(1) on base of 27a, in underglaze blue: crossed swords; wheel-cut: Johanneum mark N = 336- over W
(2) on base of 27a, impressed: two square florets
(3) inside cover of 27a, wheel-cut: Johanneum mark N = 336- over W
(4) on edge of cover of 27a, incised: N3 (?)
(5) on base of 27b, in underglaze blue: crossed swords; wheel-cut: Johanneum mark N = 336- over W
(6) on base of 27b, impressed: two square florets
(7) inside cover of 27b, wheel-cut: Johanneum mark N = 336- over W

27a: h. 17.6 cm. (6 15/16 in.), diam. at base 11.7 cm. (4 5/8 in.); 27b: h. 18.2 cm. (7 3/16 in.), diam. at base 11.7 cm. (4 5/8 in.)

1979.808, 809

Published (27b): C. Louise Avery, *Masterpieces of European Porcelain: A Catalogue of a Special Exhibition* (New York: The Metropolitan Museum of Art, 1949), no. 325.

Provenance: Colls. Augustus the Strong; Baroness Renée de Becker, Brussels, New York, Rome; purchased, New York, June 1958

Each of these vessels flares markedly near the base of its cylindrical body to form a wide, undifferentiated foot; the two silhouettes are not identical, however, since the angle of the flare is slightly more pronounced on 27a. A rounded, molded lip contains an inner ridge, which supports a domed cover surmounted by a baluster finial. The two vessels bear similar painted decoration. The pale turquoise ground extends from the gilt band beneath a white lip to just above the bottom of the foot. A double gilt band enclosing a simple linear design frames the two quatrefoil reserves on the body of each vessel. These two reserves contain flowering branches painted in the Kakiemon style in iron-red, blue, turquoise, yellow, puce, and gold. In one reserve a rock formation is painted in orange, blue, and yellow; in the other, puce also has been used for the rocks, and the foreground is in yellow and puce. The two quatrefoil reserves on each lid contain sprays of Kakiemon-style flowers painted in the same palette as those on the body of the vessel. The top of each finial has been gilded. (There is a small chip at the top of 27b). The slightly concave base of each vessel has been glazed; the wide foot rim is unglazed.

27 (1)

27 (2)

No other examples of Meissen jars of this form are known from the published sources available, but an early coffeepot with Höroldt-style decoration, about 1735, has the same tall, cylindrical body with a broad, flaring base.[1] The prototype of the coffeepot may be found in German pewter guild flagons of the seventeenth century.[2]

Entry No. 336 is missing in the 1779 royal inventory (see Markus nos. 25 and 26), but these covered jars were clearly made as part of the decoration of the "seladon" room of the Japanese Palace, not for domestic use. Therefore, it is unlikely that they were "tobacco jars," as they have been called.[3] One can speculate further that the form grew out of a simple inversion of the contemporary beaker vases with flaring rims.[4]

27 (3)

The form was not a practical one and obviously presented technical problems for the potter, since both pieces have many fire cracks around the base. It is unlikely, therefore, that such pieces were made commercially.

The border decoration of the quatrefoil reserves is the same as on no. 26 (inv. No. 332) and is also found on a 7⅜-inch jug, originally covered, which has the Johanneum mark N = 333 /W.[5] Probably also intended for the "seladon" room, this jug is another indication of the variety of forms that were incorporated in the total design of the Japanese Palace.

27 (4)

27 (5)

27 (6)

27 (7)

The impressed workman's mark, two square florets, on both pieces, like the one on no. 26a, appears not to have been published previously.

<div align="right">V.S.H.</div>

NOTES

1. Christie's, London, sale catalogues, July 7, 1969, lot 197, illus.; Oct. 6, 1980, lot 189, illus. (color).

2. A.J.G. Verster, *Old European Pewter* (New York, 1958), pl. 37; Malcolm Bell, *Old Pewter* (London, n.d.), pl. 53.

3. C. Louise Avery, *Masterpieces of European Porcelain: A Catalogue of a Special Exhibition* (New York: The Metropolitan Museum of Art, 1949), no. 325.

4. Two such vases, marked AR in underglaze blue, are in the Schneider Collection, Düsseldorf, and another, with the same mark and also a Johanneum mark N = 401- /W, is in the Germanisches Nationalmuseum, Nuremberg; see Rainer Rückert, *Meissener Porzellan 1710-1810*, exhibition catalogue, Bayerisches Nationalmuseum, Munich (Munich, 1966), nos. 274, 281, 275, respectively.

5. Ibid., no. 418, pl. 106.

28 Tankard and cover

Germany, Meissen, about 1730-1735

Hard-paste porcelain with yellow ground, decorated in polychrome enamels and gold; silver-gilt mounts

Mark:
(1) on base, in blue enamel: crossed swords

H. 22.2 cm. (8¾ in.), w. 16.2 cm. (6⅜ in.), diam. at rim 9.1 cm. (2⁹⁄₁₆ in.)

1983.613

Published: Hermann Ball and Paul Graupe, Berlin, *Die Sammlung Erich von Goldschmidt-Rothschild,* sale catalogue, text by Ludwig Schnorr von Carolsfeld and Hans Huth, March 23-25, 1931, lot 578, pl. 95; C. Louise Avery, *Masterpieces of European Porcelain: A Catalogue of a Special Exhibition* (New York: The Metropolitan Museum of Art, 1949), no. 312 (Collection of Mrs. de Becker).

Provenance: Colls. Erich von Goldschmidt-Rothschild, Berlin (sale, Ball-Graupe, Berlin, March 23-25, 1931); Baroness Renée de Becker, Brussels, New York, Rome; purchased, New York, July 1958

The thrown tankard is pear-shaped, with a wide mouth, and has a ridged, flared foot ring, an ear-shaped handle, and a domed cover. The body of the tankard and the cover are painted with a deep yellow ground, with a single, white quatrefoil panel reserved on each. The reserve on the tankard is painted with a large spray of peonies and bamboo in the Kakiemon style in sea-green, iron-red, gray-blue, and gold. Above, there is a flying crane, painted in gray-blue, yellow, black, and gold, and below, to the left is a standing crane, painted in two tones of iron-red with a gold crest. The panel on the cover is decorated with a spray of flowers in the same palette, and a trail of similar flowers is painted on the spine of the white handle. The cover is attached with a gilt-metal hinged mount that is fitted to the rim and cover with an engraved dentated edge. The box hinge is bolted to the porcelain cover through a leaf-shaped plaque and attached to an engraved and chased sleeve on the handle. The thumbpiece is in the form of a pierced and bisected circle.

Beer jugs of this pear shape were sent to Japan by the Dutch East India Company in the late seventeenth century as models for porcelains produced at Arita in the Imari and Kakiemon styles. Japa-

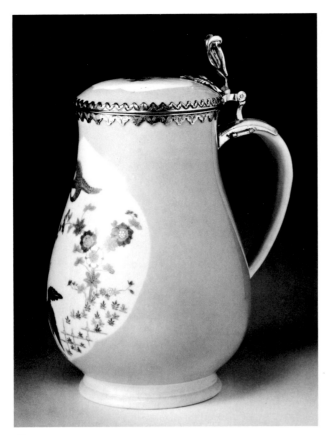

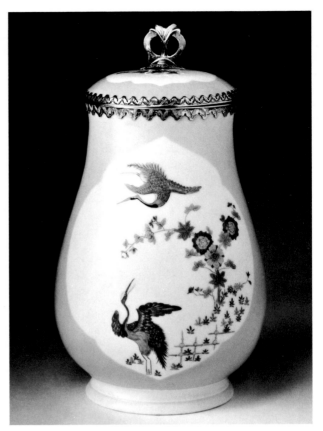

28

28

nese pieces were sometimes copied exactly at Meissen.[1] At other times, as in this case, the Meissen artists adapted the Japanese designs.

The deep yellow ground color of this tankard is one of the colors cited by W. B. Honey as on "some very interesting bowls in the Dresden Collection, possibly made by Herold as trial pieces for a service for the King, but more probably as proofs of the range of his accomplishment in this matter."[2] Some of those trial bowls were inscribed "Meissen" and dated "1726" and "1727" in addition to having the crossed-swords mark. The famous "gelbes Jagdservice" (yellow hunting service), made for Augustus the Strong about 1732, has similar unbordered panels in reserves, decorated with Kakiemon flowers, birds, and insects.[3] In a surviving Meissen price list of 1731 one finds the description of No. 370: "Bierkrüge m. gelb. Grund u. f. M." (beer mugs with yellow ground and fine painting).[4]

The crane is a symbol of longevity in both China and Japan, and the other elements of the design of Markus no. 28 also originally had symbolic connotations. However, as Masako Shono has pointed out, the Japanese painters favored cranes as much for their elegant appearance as for their

significance. This grouping of two cranes with a bamboo fence and grasses is one of three types of Meissen copies discussed by Shono, combining decorative elements from various Japanese prototypes.[5] He illustrated a Japanese export porcelain plate with a related pattern showing Western influence and two Meissen pieces with similar design elements; one of these, a plate in the Ernst Schneider Collection, Düsseldorf, has an identical spray of peonies arching between the cranes.[6] Other related pieces, including Markus no. 28, are cited in the catalogue entry for a saucer in the Hans Syz Collection.[7]

No adequate explanation has yet been proposed for the continued use of blue enamel for the crossed-swords mark on Kakiemon-style pieces into the 1730s, after the underglaze-blue mark had come into regular use.[8] Many pieces with enamel marks also have Johanneum marks. Since such a great quantity of pieces with Kakiemon decoration was required to fulfill the king's expectations for the Japanese Palace, it is possible that many stock pieces glazed before 1725 but as yet undecorated were used. Seyffarth refers to a document of 1731 in which Augustus the Strong requested a report from the commissioners of the factory as to how

many pieces with overglaze swords were delivered to Rudolphe Lemaire, the Paris merchant; unfortunately no such records had been kept.[9] Carl Heinrich Graf von Hoym was director of the Meissen factory from 1729 to 1731, and it seems that during these years Lemaire held exclusive rights to sell Meissen porcelain in France. Lemaire had apparently been acquainted with Count Hoym when the latter was ambassador to France.[10] Lemaire ordered quantities of wares, in large part after designs and models he supplied, and asked that they be unmarked. This request was denied, but possibly many such pieces were made and glazed before the official refusal was received.

Honey noted that some of the Meissen jugs and coffeepots without knobs on the lids were probably made to French order to be mounted with silver rims and thumbpieces.[11] The mounts of no. 28 may therefore be French, although they were suggested to be of Dresden workmanship when the piece was sold in 1931.[12]

<div align="right">V.S.H.</div>

28 (1)

NOTES

1. *The Splendor of Dresden: Five Centuries of Art Collecting, an Exhibition from the State Art Collections of Dresden . . .* (New York: The Metropolitan Museum of Art, 1978), nos. 426, 427, illus.: Arita and Meissen; Masako Shono, *Japanisches Aritaporzellan im sogenannten "Kakiemonstil" als Vorbild für die Meissener Porzellanmanufaktur* (Munich, 1973), fig. 88: Meissen and Arita (Syz Collection); Erika Pauls-Eisenbeiss, *German Porcelain of the 18th Century,* vol. 1: *Meissen* (London, 1972), pp. 408-409, illus.: three Meissen jugs; Christie's, London, sale catalogue, Dec. 2, 1980, lot 77, illus.; *Christie's Review of the Season 1981* (London, 1982), p. 397, illus.: Kakiemon tankard (now in the George R. Gardiner Museum of Ceramic Art, Toronto, G83.1.1103). Except for the first example, the Meissen jugs cited here, like no. 28, differ from their Japanese counterparts in having shorter necks.

2. William Bowyer Honey, *Dresden China* (Troy, N.Y., 1946), pp. 56-57; see also Karl Berling, *Das Meissner Porzellan und seine Geschichte* (Leipzig, 1900), p. 171, n. 141.

3. *Splendor of Dresden,* nos. 501, 502: two bowls; Sotheby Parke Bernet, New York, sale catalogue (Collection of Mr. and Mrs. Deane Johnson, Bel Air, Calif.), Dec. 9, 1972, lot 67, illus. (formerly Collection of Baroness Renée de Becker); Hilde Rakebrand, *Meissener Tafelgeschirre des 18. Jahrhunderts* (Darmstadt, 1958), fig. 1: tureen and two plates (Porzellan-

sammlung, Dresden); Ernst Zimmermann, *Meissner Porzellan* (Leipzig, 1926), fig. 31, same illus.; Berling, *Meissner Porzellan* pl. 8, 1 (color): tureen alone, called *Eistopf* (ice pot).

4. Berling, *Meissner Porzellan,* p. 183.

5. Shono, *Japanisches Aritaporzellan als Vorbild,* pp. 33-35.

6. Ibid., figs. 62, 59-61.

7. Hans Syz, J. Jefferson Miller II, and Rainer Rückert, *Catalogue of the Hans Syz Collection,* vol. 1: *Meissen Porcelain and Hausmalerei* (Washington, D.C.: The Smithsonian Institution, 1979), no. 80, pp. 150-151, illus.

8. Honey, *Dresden China,* pp. 64, 164.

9. Richard Seyffarth, *Johann Gregorius Höroldt* (Dresden, 1981), fig. 69, p. [277].

10. Ibid., pp. 90ff.

11. Honey, *Dresden China,* p. 180, n. 37A.

12. Ball and Graupe, Berlin, *Sammlung Erich von Goldschmidt-Rothschild,* sale catalogue, March 23-25, 1931, lot 578, p. 170.

29 Bell

Germany, Meissen, about 1730-1735
Hard-paste porcelain with yellow ground, decorated in polychrome enamels and gold

Mark:
(1) inside, in underglaze blue: crossed swords

H. 12.7 cm. (5 in.), diam. 10.5 cm. (4⅛ in.)

1983.219

Published: C. Louise Avery, *Masterpieces of European Porcelain: A Catalogue of a Special Exhibition* (New York: The Metropolitan Museum of Art, 1949), no. 233 (Collection of Mrs. de Becker); Sotheby Parke Bernet, New York, sale catalogue (Collection of Mr. and Mrs. Deane Johnson, Bel Air, California), Dec. 9, 1972, lot 52, illus. (color).

Provenance: Colls. Baroness Renée de Becker, Brussels, New York, Rome; Mr. and Mrs. Deane Johnson, Bel Air, California (sale, Sotheby Parke Bernet, New York, Dec. 9, 1972); purchased, New York, 1983

The thrown bell has a high-domed profile with a flared rim. The upright handle, which was molded in two lengthwise pieces, has three waisted registers, a flaring base, and a rounded end. The bell is painted with a yellow ground with three white quatrefoils reserved at equal intervals. The handle and lower outside rim of the bell are also white. The reserves, which are outlined in puce, are filled

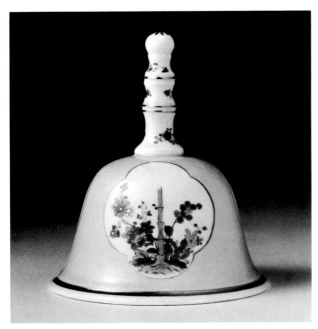

29

29 (1)

29. Detail

with clusters of flowers in the Kakiemon style, painted in sea-green, blue, iron-red, and puce, with black outlines and gilt highlights. Small sprays of similar flowers are painted on the handle. The horizontal ribs on the handle are outlined with gold bands, and the terminus has a gold floret. Above the rim is a thick band of gold. The white interior of the bell, which is undecorated, shows the location of a loop, now broken off, that would have secured the clapper.

Hand bells of this form, modeled after those in silver and other metals, were made at Meissen both for use at the dinner table (*Tischglocke*) and as part of writing or desk sets.[1] Those for use at the table were generally accompanied by a matching square tray or stand with indented corners. This square tray may be the new form mentioned in a 1728/29 report, cited by Ernst Zimmermann, of a salver (*Kredenzteller*) with an accompanying bell made after a Viennese (porcelain) model.[2] Origi-

nally the porcelain clapper, missing from no. 29, was decorated to match the bell.[3] The shape of both the handle and the bell varied, as did the size, each example being formed individually. The Markus bell is broader in relation to its height than other examples, but its flared shape and three-tiered handle resemble those of the Darmstaedter bell (see note 1), the Pauls Collection example (see note 3), and another formerly in the Edmund de Rothschild collection.[4]

A desk set of about 1740 in the James A. de Rothschild Collection at Waddesdon Manor consists of a tray, a bell (larger than no. 29 and without a flared rim), a square inkpot with a pineapple finial, and a square pounce pot. Discussing this set, Robert Charleston quoted a 1765 Meissen price list and also cited other surviving writing sets of the same period, one with a taper holder in place of the bell.[5]

Writing sets including bells and dinner bells with stands were made by the Augsburg goldsmiths at this period; they had chased and relief decoration related to the chinoiserie and landscape decoration of the Meissen examples cited above.[6] The Markus bell is simpler; the soft yellow ground color and the Kakiemon-style painting in the reserves may well have complemented a breakfast or dinner service. The yellow ground is like that of the coffee service in this collection, no. 36 (Plate VIII).

V.S.H.

NOTES

1. Rudolph Lepke, Berlin, *Sammlung Darmstaedter, Berlin, Europäisches Porzellan des XVIII Jahrhunderts*, sale catalogue, text by Ludwig Schnorr von Carolsfeld, March 24-26, 1925, lot 104, pl. 28.

2. Ernst Zimmermann, *Meissner Porzellan* (Leipzig, 1926), pp. 59-60; see also Rainer Rückert, *Meissener Porzellan 1710-1810*, exhibition catalogue, Bayerisches Nationalmuseum, Munich (Munich, 1966), p. 16.

3. Christie's, London, sale catalogue [Edmund de Rothschild Collection], March 28, 1977, lot 19, illus.; *Sammlung Pauls, Riehen, Switzerland, Porzellan des 18. Jahrhunderts*, text by Peter Wilhelm Meister, vol. 1: *Meissen* (Frankfurt, 1967), pp. 138-139, illus.; Hermann Ball and Paul Graupe, Berlin, *Die Sammlung Erich von Goldschmidt-Rothschild*, sale catalogue, text by Ludwig Schnorr von Carolsfeld and Hans Huth, March 23-25, 1931, lot 471, pl. 91.

4. Christie's, London, sale catalogue [Edmund de Rothschild Collection], Oct. 17, 1977, lot 37, illus.

5. Robert J. Charleston, *The James A. de Rothschild Collection at Waddesdon Manor: Meissen and Other European Porcelain* (Fribourg, 1971), no. 5, illus.

6. Ball and Graupe, Berlin, *Sammlung Erich von Goldschmidt-Rothschild*, sale catalogue, March 23-25, 1931, lots 219-221, pls. 53, 55.

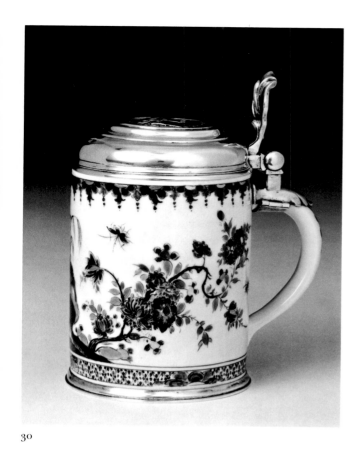

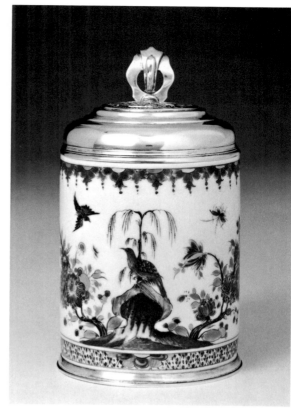

30

30

30 Tankard

Germany, Meissen, about 1730-1735

Hard-paste porcelain decorated in polychrome enamels and gold, with silver mounts

Marks:

(1) on unglazed base, in blue enamel: crossed swords
(2) on underside of silver handle mount, struck: town mark for Dresden, date letter N for 1738, maker's mark PI over star for Paul Ingermann

H. 14.7 cm. (5¹³⁄₁₆ in.), h. without cover 10.9 cm. (4⁵⁄₁₆ in.), w. 12.1 cm. (4¾ in.), diam. at base 8.5 cm. (3⁵⁄₁₆ in.)

1983.616

Provenance: Purchased, New York, March 1967

The cylindrical tankard has a simple C-shaped handle with spade-shaped terminus. In the center of the body of the tankard, opposite the handle, a bird painted in iron-red and puce sits on a rock formation painted in puce, brown, and yellow; di-

rectly behind the rock is a black-trunked tree with pendulous iron-red foliage. The immediate foreground is iron-red. Flowering branches (indianische Blumen) in iron-red, puce, blue, yellow, gold, and green on either side of the rock formation extend toward the handle. A flying bird painted in black, iron-red, and puce and a large insect (butterfly?) in iron-red and puce are to the left and right respectively of the perched bird. Two similar insects are painted beneath the farthest blossom of each flowering branch. Encircling the top of the tankard is a band of stylized foliate motifs with gilt centers, iron-red petals, and blue and red trefoils. At the base is a diaper-patterned band in iron-red and puce, broken by halved floral motifs alternately painted in puce and blue and iron-red and blue. A spray of flowers painted in iron-red, puce, yellow, green, blue, and gold decorates the handle.

The tankard has been fitted with silver mounts comprising a stepped, domed cover, a pierced oval thumbpiece, and a molded foot. A silver medal depicting Augustus II has been set into the center of the cover. It bears the following inscriptions: D.G. AVGVSTVS II. REX POLON. ELECT. SAXON. (the great Augustus II, King of Poland, Elector of Saxony) and, below the trunca-

tion of the portrait, GROSKURT *(for the medallist Heinrich Peter Grosskurt, active 1694-1734). The reverse of the medal is decorated with the star and badge of the Order of the White Eagle of Poland, which are set against the back of a throne. Surrounding the throne is the inscription RESTAV-RATOR ORDINIS ACQVILAE ALBAE (restoration of the Order of the White Eagle).*

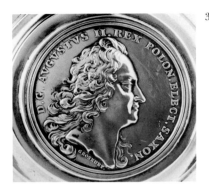

30. *Detail of silver cover*

30 (1)

30 (2)

This small tankard has a handle terminus like that on no. 18. Although an attribution to the Meissen artist Johann Ehrenfried Stadler (1701-1741) has been suggested on the basis of the colors, no. 30 seems more closely related to a tankard that has been associated with the work of A.F. von Löwenfinck; decorated with an oriental figure standing between two flowering trees very similar to those on no. 30, it has a comparable diaper-patterned lower border with demi-florets, but the border at the rim is a scroll more oriental in style.[1]

Two other tankards, both with versions of a Chinese warrior battling a dragon, have borders of diapers and demi-florets above and below the scenes. One has the crossed-swords mark in blue enamel overglaze;[2] the other has indistinct crossed swords on an unglazed base as on no. 30.[3] As mentioned in the entry for no. 28, the enamel crossed-swords mark seems to have been used most frequently on Kakiemon-style pieces.

Unlike the three tankards cited, no. 30 has a bird rather than a figure as a central motif. The Worcester porcelain mug, no. 79, is based on a similar Japanese or Chinese prototype. A related design can be seen on a Japanese gourd-shaped

bottle of about 1670, which is now in the Umezawa Memorial Museum, Tokyo, but which had been in Europe from the seventeenth century until recently; it has two birds perched on a rock and flowering branches that are very similar to those on no. 30.[4] A large Japanese bowl in a private collection in Tokyo in 1953 has a similar design, although the two birds are in a different position; it is assigned to the Genroku era of the Edo period (1688-1703) because, although in the Kakiemon style, it is patterned after the Kangxi (K'ang Hsi) porcelain of the Qing (Ch'ing) dynasty of China.[5]

Heinrich Peter Grosskurt, who signed the portrait of Augustus II on the silver medal mounted on the cover, was active from about 1694 to 1734, first in Berlin but mainly in Dresden, where he died in 1751. The medal may date from 1713, ten years after the Polish Order of the White Eagle was established by the king to honor those noblemen who had been faithful during the Swedish invasion; the word "restaurator" indicates that Augustus wished to suggest that this order had been established in earlier times so that the Polish people who craved equality would not be troubled by such a mark of distinction.[6]

The goldsmith who made the silver cover, Paul Ingermann, became a master in Dresden in 1698 and died there in 1747. He was named *Oberältester* (senior master) of the guild in 1738, the year he mounted this tankard.[7]

Y.H., V.S.H.

NOTES

1. Sotheby Parke Bernet, London, sale catalogue, Nov. 23, 1982, lot 173, illus.; O. Seitler, "Adam Friedrich von Löwenfinck als Blumenmaler in Meissen," *Keramos*, no. 11 (1961), p. 26, pls. 8, 9.

2. Willy Doenges, *Meissner Porzellan: Seine Geschichte und kunstlerische Entwicklung* (Berlin, 1907), pl. II (color); H.W. Lange, Berlin, sale catalogue, 1941, pl. 63, cited in Rainer Rückert, *Meissener Porzellan 1710-1810*, exhibition catalogue, Bayerisches Nationalmuseum, Munich (Munich, 1966), p. 82, no. 226.

3. Rückert, *Meissener Porzellan*, no. 226, pl. VI (color); Masako Shono, *Japanische Aritaporzellan im sogenannten "Kakiemonstil" als Vorbild für die Meissener Porzellanmanufaktur* (Munich, 1973), fig. 22.

4. Seattle Art Museum, *Ceramic Art of Japan: One Hundred Masterpieces from Japanese Collections* (1972), no. 64, illus.; for a similar vase see Soame Jenyns, *Japanese Porcelain* (London, 1965), pl. 56A.

5. Tokyo National Museum, *Ceramics and Metalwork*, Pageant of Japanese Art (1958), pl. 21 (color).

6. Emeric Hutten-Czapski, *Catalogue de la collection des médailles et monnaies Polonaises* (Graz, 1957), vol. 2, no. 2709, pp. 25-26. This reference was given to Yvonne Hackenbroch by Marc Salton, Hartsdale, N.Y.

7. Marc Rosenberg, *Der Goldschmiede Merkzeichen*, vol. 2, 3rd ed. (Frankfurt, 1923), p. 43.

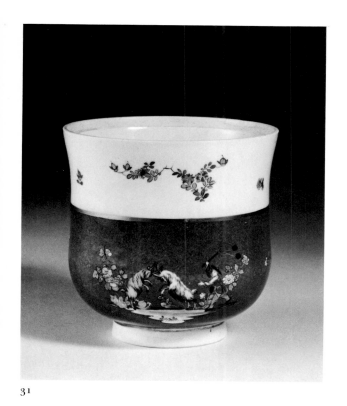

31

group is set on a shaped plot of land painted in green and brown and is framed by flowers painted in the Kakiemon style in yellow, turquoise, blue, iron-red, and green. In one, a Chinese boy in a red robe and blue trousers raises a whip in one hand to strike one of two goats whose horns are locked in combat. Another group comprises two fighting Chinese boys: a pig-tailed boy in an iron-red robe, yellow trousers, and black shoes grabs the hair of a boy who bends forward at the waist, arms outstretched, and who wears a brown robe, black trousers, and blue shoes; to the left of the two figures stands a blue pole, which is crossed near the top at a forty-five degree angle by a black stick. The remaining group depicts an exotic bird attacking a fantastic creature with a tiger-like body; the bird's plumage is yellow, blue, turquoise, green, and iron-red; the fantastic animal is painted in a different shade of yellow with black markings; its eye, eyebrow, and tongue are iron-red. The interior of the bowl is undecorated, and an unglazed band around the interior rim indicates that it would have been fitted originally with a cover.

31 Jar

Germany, Meissen, about 1735

Possibly painted by Adam Friedrich von Löwenfinck (1714-1754)

Hard-paste porcelain with puce ground (*Purpurfond*), decorated in polychrome enamels and gold

Mark:
(1) on base, in underglaze blue: crossed swords

H. 12.1 cm. (4¾ in.), diam. at rim 12.2 cm. (4¹³⁄₁₆ in.)

27.1980

Provenance: Purchased, New York, November 1960

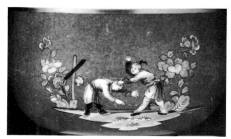

31. Detail

31 (1)

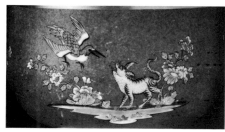

31. Detail

The tall bowl with a gently flared rim, a high, slightly contracted waist, and a rounded base rests on a tall foot ring. A puce ground extends from the top of the foot ring to the middle of the bowl's waist and is bordered at top and bottom by a simple gilt band. Flowers painted in the Kakiemon style in iron-red, green, turquoise, and gold are disposed singly and in sprays on the white ground of the upper portion of the bowl. Three figural groups are painted on the puce ground: each

The bell-shaped cylindrical vessel with its high foot ring is probably based on a Chinese prototype. The similarity to Chinese jars is more evident in the comparable Meissen examples that still have their low-domed covers with simple ball knops. The best known of these, in the Blohm Collection, is undecorated except for an overall green ground; it has the wheel-cut Johanneum number: N = 90-/ W and was probably made before 1725 for the green room of the Japanese Palace.[1] A yellow-

ground example, in the George R. Gardiner Museum of Ceramic Art, Toronto (G83.1.605), has harbor scenes in reserved panels framed in gold and luster; it is marked with the crossed swords in blue enamel (like no. 28) and has the neighboring Johanneum mark N = 89-/W on the base and cover.[2] Hermann Jedding's designation of the Blohm piece as a tobacco jar was used as early as 1900 by Karl Berling in describing a piece in the Royal Palace, Dresden, which is of the same form, with three reserved panels on a *Purpurfond*.[3] A fourth piece, in the porcelain collection now in the Zwinger, Dresden, is of the same form but lacks the high foot ring; it has a "meergrün" ("seladon") ground with reserves.[4] The present location of a fifth example is unknown; it also has a turquoise ("seladon") ground and reserves decorated like the fourth example, but it has a foot ring.[5]

No. 31 differs from the pieces cited above in the application of the ground color to the lower section only, as well as in having the three scenes reserved directly on the ground, rather than in panels. This technique is found more often on vases and usually on the areas between the reserved panels. In discussing one such vase in the Kunstgewerbemuseum, Cologne, Barbara Beaucamp-Markowsky pointed out that "Purpur" as a ground color was first mentioned in 1731, and orders from the king followed in 1732; she described the technique (probably that mentioned in 1734 as "flowers and figures painted on the colored glazes") as scratching away the ground color after it was applied, then painting the design on the bare glaze, so that it would not be absorbed in the fluid ground color during firing.[6]

The Cologne vase and three very similar vases in Lübeck are attributed to Adam Friedrich von Löwenfinck (1714-1754), who worked at Meissen as a painter from 1727 to 1736. Löwenfinck has achieved fame as an ingenious and innovative artist, who, after fleeing from Meissen in 1736, was employed at Bayreuth, Ansbach, Fulda, Mainz, and Höchst before becoming director of the faience factory at Strasbourg. Löwenfinck was one of eight apprentices listed in the account of the painting studio at Meissen in April 1731.[7] He was then seventeen years old and painted flowers in enamel colors. On the basis of initials found hidden on certain key pieces, it has been possible to attribute to him several services as well as vases decorated with especially lively Japanese figures and fantastic animals.[8]

No. 31 was acquired as by A. F. von Löwenfinck. The island type of base for each of the groups of figures or animals is not unlike those on a service with black and gold bands in which fabulous animals are surrounded by landscapes combining oriental and European elements.[9] The figures on no. 31, whether by Löwenfinck or another painter working under Höroldt's direction, were probably based on some of the many prints from Asiatic travel books, notably those by Petrus Schenk, Jr., Johann Christoph Weigel, and Martin Engelbrecht, known to have been used at Meissen.[10]

V.S.H.

NOTES

1. Hermann Jedding, *Meissener Porzellan des 18. Jahrhunderts in Hamburger Privatbesitz* (Hamburg: Museum für Kunst und Gewerbe, 1982), no. 105, illus., p. 123, with references to seven earlier publications of this piece from 1919 to 1972.

2. Sotheby Parke Bernet, New York, sale catalogue (Collection of Mr. and Mrs. Deane Johnson, Bel Air, California), Dec. 9, 1972, lot 76, illus. (formerly Collection of Baroness Renée de Becker).

3. Karl Berling, *Das Meissner Porzellan und seine Geschichte* (Leipzig, 1900), pl. VIII, 4 (color).

4. Ingelore Handt and Hilde Rakebrand, *Meissner Porzellan des achtzehnten Jahrhunderts, 1710-1750* (Dresden, 1956), pl. 21; Otto Walcha, *Meissen Porcelain* (New York, 1981), pl. 45 (color).

5. Rudolph Lepke, Berlin, sale catalogue (Collection of Hermann Emden, Hamburg), Nov. 3-7, 1908, lot 593, pl. 42.

6. Kunstgewerbemuseum, Cologne, *Europäisches Porzellan und ostasiatisches Exportporzellan: Geschirr und Ziergerät*, catalogue by Barbara Beaucamp-Markowsky (1980), no. 28, pl. 1 (color), and pp. 100-101, illus.

7. Arno Schönberger, *Meissener Porzellan mit Höroldt-Malerei* (Darmstadt [1953]), pp. [37-38].

8. Hermann Jedding, *Meissener Porzellan des 18. Jahrhunderts* (Munich, 1979), pp. 60-63, figs. 83-88; see also Hans Syz, J. Jefferson Miller II, and Rainer Rückert, *Catalogue of the Hans Syz Collection*, vol 1: *Meissen Porcelain and Hausmalerei* (Washington, D.C.: The Smithsonian Institution, 1979), p. 95: an extensive list of the ceramic literature on the "Löwenfinck problem."

9. Jedding, *Meissener Porzellan* (1979), fig. 84b; idem, *Meissener Porzellan* (1982), nos. 88-91, illus. pp. 104-106; Rainer Rückert, *Meissener Porzellan 1710-1810*, exhibition catalogue, Bayerisches Nationalmuseum, Munich (Munich, 1966), no. 231, pl. 63.

10. Siegfried Ducret, "Vorbilder für Porzellanmalereien," *Keramos*, no. 44 (April 1969), figs. 23 (Schenk), 12, 13 (Weigel), 11, 15 (Engelbrecht).

32 (1)

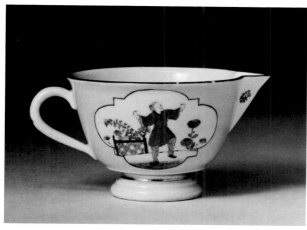

32

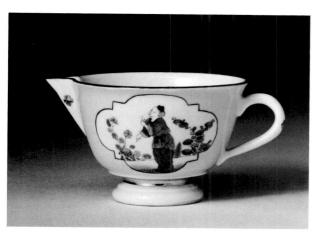

32

32 *Cream pitcher*

Germany, Meissen, about 1730-1735

Possibly painted by Adam Friedrich von Löwenfinck (1714-1754)

Hard-paste porcelain with yellow ground, decorated in polychrome enamels and gold

Mark:

(1) on base, in underglaze blue: crossed swords

H. 5.6 cm. (2³/₁₆ in.), w. 10.8 cm. (4¼ in.), diam. at rim 8 cm. (3⅛ in.)

1980.616

The thrown, cup-shaped pitcher has flared sides rising from a flattened base. At the junction of the high, ridged foot ring is a stepped collar. The straight spout is triangular in section, and the handle ear-shaped. The exterior of the jug is painted with a light yellow ground, with two white quatre-

foils reserved on opposite sides; they are outlined in puce. The spout, handle, and foot are white. The foot is decorated with a band of gold, and the rim is painted with a brown line. Each reserve shows an oriental boy standing on a patch of ground, painted in blue-gray, and surrounded by flowers painted in the Kakiemon style in turquoise, iron-red, green, puce, blue-gray, and gold. In one reserve the boy wears robes of green and iron-red, the latter highlighted with gold. In the second reserve the boy, wearing an iron-red robe and sea-green trousers, stands before a fence composed of a blue and gold diaper pattern. The handle, spout, and interior are painted with small sprays of flowers in iron-red, turquoise, and blue.

As mentioned in the entry for no. 22, note 1, possibly the earliest reference to the production at Meissen of cream ewers (*Sahnegiessern*) was in 1731, but examples of pitchers of this form, with stands like no. 19, have been assigned dates as early at the mid-1720s.[1] A cream pitcher, with a saucer, in the Hans Syz Collection is possibly 1722-1724, while a pair in the same collection is about 1745.[2] All the pieces of this form located for comparison have either a *kapuzinerbraun* (dead-leaf brown) or a yellow ground, the two earliest ground colors developed by Höroldt. The brown glaze always occurs on pieces with underglaze-blue decoration, while the yellow ground is combined with either chinoiseries or Kakiemon designs.

A cream jug sold recently in London is possibly a mate to no. 32; it is of the same form and color, has reserve panels of the same shape, and similar painting in the manner of Adam Friedrich von Löwenfinck.[3] Another jug, with the same ground color, has quatrefoil reserves outlined in puce, with the design of two cranes and bamboo (like no. 28).[4]

The angular postures of the figures, the outlining of faces and hands in black, and of the folds of the garments in gold are characteristic of A. F. von Löwenfinck (see no. 31).

V.S.H.

NOTES

1. Christie's, London, sale catalogues, March 28, 1977, lot 60, illus.; Oct. 11, 1976, lot 187, pl. 33; Christie's, New York, sale catalogue, Nov. 21, 1980, lot 334, illus.

2. Hans Syz, J. Jefferson Miller II, and Rainer Rückert, *Catalogue of the Hans Syz Collection*, vol. 1: *Meissen Porcelain and Hausmalerei* (Washington, D.C.: The Smithsonian Institution, 1979), nos. 143, 236, both illus.

3. Sotheby Parke Bernet, London, sale catalogue, June 14, 1983, lot 84, illus.

4. Christie's, London, sale catalogue, March 28, 1983, lot 161, illus.

33 Plate

Germany, Meissen, about 1740

Hard-paste porcelain decorated in poly-chrome enamels and gold

Marks:
(1) on base, in underglaze blue: crossed swords
(2) on base, impressed: 16

H. 3.5 cm. (1⅜ in.), diam. 23.6 cm. (9¼ in.)

1983.615

Provenance: Purchased, New York, October 1960

The round plate has a twelve-lobed, petal-shaped rim edged in brown enamel. In the center, on the white ground, is a scene depicting a Japanese man, dressed in a green robe with black and puce details and an iron-red skirt, holding a young child, also wearing an iron-red robe. The child leans forward, reaching with his left arm toward a second child standing on the right, who wears a puce jacket and yellow trousers. They are shown in a landscape composed of exotic flowers painted in the Kakiemon style in iron-red, puce, green, turquoise, blue, and yellow. The ground and rocks are painted in yellow with brown and black enamel, highlighted with red dots. A stylized tree with green and turquoise leaves and a trunk incorporating puce dots grows from the rock formation. Scattered on the white ground of the plate are various flowers and insects, some with gilt highlights.

The shape of this plate, with twelve indentations on the rim, called "Alter Ausschnitt" (ancient scallop) when it was modeled in 1730, is Japanese in origin.[1] It was used for some pieces of the "Krö-nungs-Service" possibly made for the coronation of Augustus III in 1733 but most frequently for services decorated in the Kakiemon style.[2]

No. 33 was acquired as a piece from the Earl of Jersey service, one of the few services attributed to Adam Friedrich von Löwenfinck (see no. 31), but the presence of the impressed numeral, as noted in the entry for no. 20, indicates that this plate must have been formed after 1739 and there-fore after Löwenfinck had fled from Meissen. Two plates in the Schneider Collection that can more definitely be attributed to that service have more sharply indented rims than no. 33 has, and though involving figures in landscapes, they exhibit a dif-ferent painting style.[3] Nor does the painting of no. 33 resemble that of the many other known plates in the distinctive "Jersey Service" type, most of

which are also marked with the impressed numeral 16.[4] It is thought that Löwenfinck's designs for this service may have been inspired by the engravings of Petrus Schenk, Jr., of Amsterdam, and that those engravings continued to be used by other painters at Meissen for similar services.[5] Like the Schenk engravings, the plates in the Jersey service have more extensive landscape settings for the fig-ure groups than no. 33 has.

The scene represented on no. 33 is very similar to that in one of three reserves on a yellow-ground AR vase in the Lesley and Emma Sheafer Collection at the Metropolitan Museum of Art, New York.[6] The mirror image of this scene is on one side of each of a pair of AR vases with purple grounds, formerly in the collection of Baron Tos-sizza.[7] Another scene on the Sheafer vase is the mirror image of the other scene on the Tossizza vases and of one scene on a Bayreuth faience tan-kard signed by Löwenfinck, also in the Sheafer Collection.[8] The other scene on the tankard and the third scene on the Sheafer vase, its mirror image, relate in part to one of a group of water-colors by Löwenfinck preserved in the Meissen fac-tory archives.[9] Ralph Wark suggested that the earlier versions of the scene on no. 33, together with the other scenes in this group attributable to Löwenfinck, were probably based on prints by Jo-hann Christoph Weigel (see Markus no. 31); also it might have been a book of such prints that Löwen-finck stole when he fled from Meissen.[10]

The Markus plate, therefore, was probably part of a service painted at Meissen after Löwen-finck's departure, inspired not by Schenk's engrav-ings but by the Weigel prints used by Löwenfinck or the watercolor sketches from them that he left behind.

V.S.H.

NOTES

1. Stefan Bursche, *Meissen: Steinzeug und Porzellan des 18. Jahrhunderts, Kunstgewerbemuseum, Berlin* (Berlin, 1980), p. 204, no. 179; Rainer Rückert, *Meissener Porzellan 1710-1810,* exhibition catalogue, Bayerisches Nationalmuseum, Munich (Munich, 1966), p. 16; Soame Jenyns, *Japanese Porcelain* (Lon-don, 1965), pl. 43C; Masako Shono, *Japanisches Aritaporzellan im sogenannte "Kakiemonstil" als Vorbild Meissener Porzellan-manufaktur* (Munich, 1973), figs. 55, 56. The Japanese and ear-lier Meissen copies had ten sides.

2. Ernst Zimmermann, *Meissner Porzellan* (Leipzig, 1926), pl. 28; Hans Syz, J. Jefferson Miller II, and Rainer Rückert, *Cata-logue of the Hans Syz Collection,* vol. 1: *Meissen Porcelain and Hausmalerei* (Washington, D.C.: The Smithsonian Institution, 1979), no. 180: lists further literature on the coronation service; nos. 78, 88, 132, all illus.: these have different patterns in the Kakiemon style, and all have the impressed former's numeral 16.

3. Hermann Jedding, *Meissener Porzellan des 18. Jahrhun-derts* (Munich, 1979), fig. 80; Rückert, *Meissener Porzellan,* no.

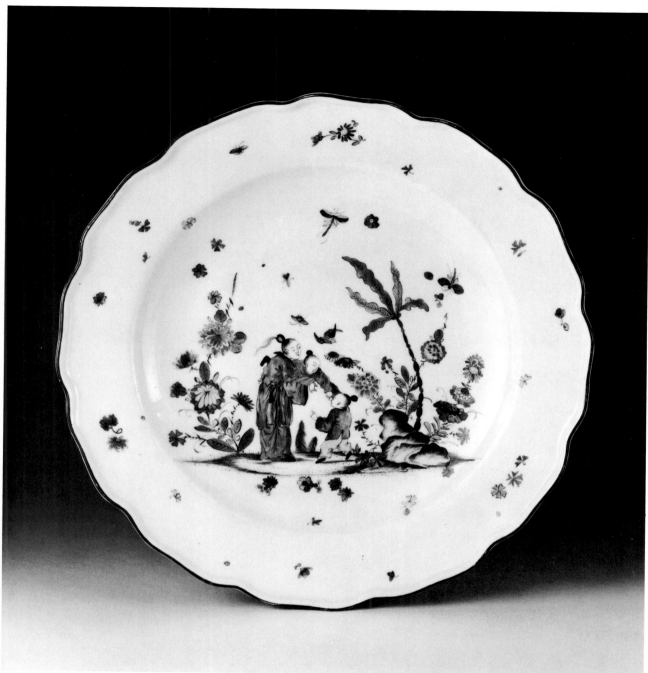

33

33 (1)　　　　　33 (2)

227, pl. VII (color), no. 228, pl. 62; Ralph H. Wark, "Adam Friedrich von Löwenfinck," in *250 Jahre Meissner Porzellan: Die Sammlung Dr. Ernst Schneider im Schloss "Jägershof," Düsseldorf, Keramikfreunde der Schweiz Mitteilungsblatt,* no. 50 (April 1960), figs. 91, 92.

4. Sotheby Parke Bernet, London, sale catalogues, June 17, 1975, lots 192-196 (ten plates, nine with impressed 16, one illus.); Oct. 9, 1973, lot 95, illus.; Rückert, *Meissener Porzellan,* no. 229, pl. 62; Wark, "Löwenfinck," fig. 100.

5. A.L. den Blaauwen, "Keramik mit Chinoiserien nach Stichen von Petrus Schenk jun.," *Keramos,* no. 31 (Jan. 1966), pp. 3-18: illus. of the thirty-six prints in the series "Nieuwe geinventeerde Sineesen," between pp. 12 and 13; see also Siegfried Ducret, "Die Vorbilder zu einigen Chinoiserien von Peter Schenk," ibid., pp. 19-28: prints from a 1670 book by Dr. O. Dapper, the models for Schenk.

6. 1974.356, 363. Ruth Berges, *From Gold to Porcelain: The Art of Porcelain and Faïence* (New York and London, 1963), fig. 140: the figures hold an umbrella and a staff.

7. Ralph Wark, "Aktuelle Betrachtungen über Adam Friedrich von Löwenfinck," *Keramos,* no. 38 (Oct. 1967), fig. 10, right: one figure holds a staff.

8. Yvonne Hackenbroch and James Parker, *The Lesley and Emma Sheafer Collection: A Selective Presentation* (New York: The Metropolitan Museum of Art, 1975), fig. 2; Wark, "Aktuelle Betrachtungen," figs. 9, 10 left, 7.

9. Wark, "Aktuelle Betrachtungen," figs. 6, 8, 3 respectively.

10. Ibid., p. 17.

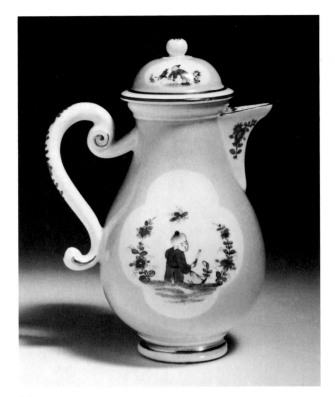

34

34

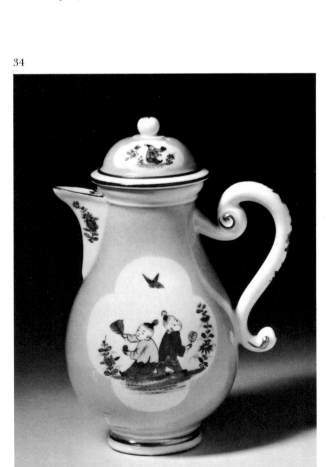

34 Milk jug and cover

Germany, Meissen, about 1735-1740

Hard-paste porcelain with lime-green ground, decorated in polychrome enamels and gold

Mark:
(1) on base, in underglaze blue: crossed swords

H. 15.5 cm. (6⅛ in.), w. 11.1 cm. (4⅜ in.), diam. at rim 5 cm. (1¹⁵⁄₁₆ in.)

1983.614

Provenance: Purchased, New York, November 1956

The thrown jug is pear-shaped and stands on a shaped foot ring. The handle is S-shaped, and the gently curved spout has a heart-shaped opening. The cover is domed and has a broad rim and round finial; it is pierced through. The body of the jug and the cover are painted with a lime-green ground. There are two white quatrefoil reserves on both body and cover, which are painted in blue, iron-red, yellow, green, and black in the Kakiemon style. On the body one reserve has two Japanese children holding fans, the other a single seated child, also holding a fan, both between flowering plants. The reserves on the cover are similarly

painted, and the finial is painted with a star motif in iron-red. The handle, apparently warped in the firing, is decorated with *indianische Blumen and gold*, as is the spout. The foot ring, the inner rim of the cover, the scrolls on the handle, and the edges of the spout are gilded.

As suggested in relation to no. 22, this pot may have been used for coffee or hot water as well as milk. This plain form with its simple S-scroll handle first appeared in the Böttger period. It was probably popular for such a long time because it was as well suited to Kakiemon-style painting as to the earlier chinoiseries.

A teapot in the collection of Mrs. C.B. Stout may be from the same service as no. 34.[1] The ground color of the teapot is described as pale apple green, and the figures in the unframed quatrefoil reserve are identical to those on one side of no. 34. It has been suggested that the form of the teapot, with a molded J handle and dragon-head and acanthus-leaf spout, dates from shortly before 1740.[2] J. Jefferson Miller doubted that a service would include pieces with two such different handles;[3] however, a service illustrated by George Savage includes a coffeepot and a milk jug similar in shape to no. 34 and a teapot like the Stout example.[4]

Both the Stout Collection teapot and no. 34 were acquired as works by Adam Friedrich von Löwenfinck, but the figures lack his clearly defined outlines and expressive features. The children's doll-like faces are egg-shaped, their postures ornamental rather than functional. Both pieces are clearly standard commercial products in the Kakiemon style.

Y.H., V.S.H.

NOTES

1. Brooks Memorial Art Gallery, Memphis, Tennessee, *Mrs. C.B. Stout Collection of Early Meissen Porcelain ca. 1708–1750* (1966), no. 66, illus.; George Savage, *18th-Century German Porcelain* (London, 1958), pl. 13b.

2. Stefan Bursche, *Meissen: Steinzeug und Porzellan des 18. Jahrhunderts, Kunstgewerbemuseum, Berlin* (Berlin, 1980), p. 268, no. 275, illus.

3. Virginia Museum, Richmond, *Eighteenth-Century Meissen Porcelain from the Margaret M. and Arthur J. Mourot Collection*, catalogue by J. Jefferson Miller II (1983), p. 25, nos. 19, 20, illus. p. 24.

4. Savage, *18th-Century German Porcelain*, pl. 10.

34 (1)

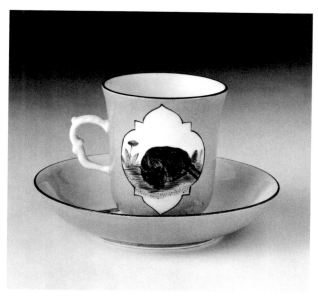

35

35 Cup and saucer

Germany, Meissen, about 1740

Hard-paste porcelain with pale lilac ground, decorated in polychrome enamels and gold

Marks:
(1) on unglazed base of cup, in blue: crossed swords
(2) on base of saucer, in underglaze blue: crossed swords
(3) inside foot ring of saucer, impressed (?): 2

Cup: h. 6.8 cm. (2¹¹⁄₁₆ in.), w. 7.8 cm. (3¹⁄₁₆ in.), diam. at rim 6 cm. (2³⁄₈ in.); saucer: h. 2.6 cm. (1 in.), diam. 11.9 cm. (4¹¹⁄₁₆ in.)

1983.617a,b

Provenance: Purchased, New York, December 1965

The slender cup, which rests on a rimless base, has an ear-shaped, double-scrolled handle and a slightly flaring rim. The pale lilac ground contains two shaped ogival reserves diametrically placed. The reserves and the rim are outlined in dark brown. Each reserve contains an animal in an abbreviated landscape of flowers painted in blue, iron-red, turquoise, purple, and green and distant trees in blue and iron-red. The animals depicted are a ram, which stands in three-quarter view, and a reclining boar. A gold band encircles the base. The interior of the saucer is decorated with a camel painted in dark brown seen in profile, placed within a landscape that is slightly more elaborate than those depicted on the cup. The exterior

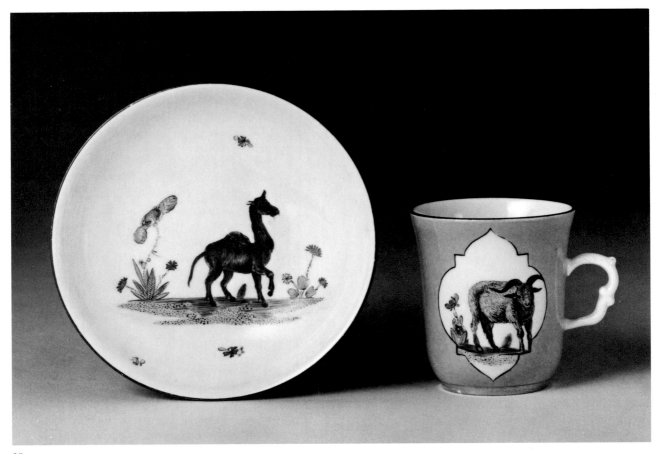

35

NOTES

1. George B. McClellan, *A Guide to the McClellan Collection of German and Austrian Porcelain* (New York, 1946), fig. 23.

2. Sotheby Parke Bernet, London, sale catalogue, June 30, 1981, lot 124, illus.

of the saucer is painted with a pale lilac ground; a gold band encircles the foot ring.

The beaker-shaped cup has a handle like that of no. 24, but, since it is taller in relation to its diameter, it may have been intended for chocolate as well as for coffee. Another cup and saucer from the same service are in the McClellan Collection at the Metropolitan Museum of Art, New York, and the cup appears to have the same unusual flat base.[1]

The Markus cup and saucer were acquired as by Adam Friedrich von Löwenfinck, about 1733, but, as mentioned in the entry for no. 20, which has a similar impressed numeral 2, these former's marks replaced the earlier symbols in 1739.

This type of decoration with single animals on islands (*Inselstil*) was the main feature of a service attributed to A. F. von Löwenfinck (see no. 31), although his fabulous animals were more spirited. Other Meissen artists painted services in this popular style after Löwenfinck's departure in 1736. One such example by a different painter, with a cup the shape of no. 20, was sold in London as "in the style of A. F. von Löwenfinck."[2]

V.S.H.

35 (1)

35 (2)

35 (3)

Consisting of (a) a coffeepot and cover, (b) a hot milk jug and cover, (c) a sugar basin and cover, (d-o) six cups and saucers

Plate VIII

Germany, Meissen, about 1740

Hard-paste porcelain with yellow ground, decorated in polychrome enamels

Marks:

(1) 36a, on base, in underglaze blue: crossed swords

(2) 36a, inside foot ring, impressed: 26

(3) 36b, on base, in underglaze blue: crossed swords; inside foot ring, incised: 26

(4) 36c, on unglazed base, in blue: crossed swords (faint); in black: crossed swords

(5) 36e, on base, in underglaze blue: crossed swords

(6) 36e, on base, incised: 23

(7) 36d, on base, in underglaze blue: crossed swords

(8) 36d, inside foot ring, incised: two parallel lines

(9) 36k, on base, in underglaze blue: crossed swords

(10) 36k, inside foot ring, incised: two parallel lines (all the remaining cups and saucers, 36f-j, l-o, have the crossed swords and, except for 36g, incised parallel lines, not illustrated)

36a: h. 22.7 cm. (8^{15}/₁₆ in.), w. 15.3 cm. (6 in.), diam. at base 5.9 cm. (2⁵/₁₆ in.); 36b: h. 15.8 cm. (6¼ in.), w. 10.9 cm. (4⁵/₁₆ in.), diam. at base 4.5 cm. (1^{15}/₁₆ in.); 36c: h. 9.9 cm. (3⅞ in.), w. 10.8 cm. (4¼ in.), d. 10.8 cm. (4¼ in.); 36d: h. 5.1 cm. (2 in.), w. 8.7 cm. (3⁷/₁₆ in.), diam. at base 3.8 cm. (1½ in.); 36e: h. 3.1 cm. (1¼ in.), w. 11.4 cm. (4½ in.), diam. at base 6.1 cm. (2⅜ in.); 36f: h. 5.1 cm. (2 in.), w. 8.5 cm. (3⅜ in.), diam. at base 3.8 cm. (1½ in.); 36g: h. 2.7 cm. (1¹/₁₆ in.), w. 11.7 cm. (4⅝ in.), diam. at base 6.2 cm. (2⁷/₁₆ in.); 36h: h. 5.1 cm. (2 in.), w. 8.7 cm. (3⁷/₁₆ in.), diam. at base 3.7 cm. (1⁷/₁₆ in.); 36i: h. 2.8 cm. (1⅛ in.), w. 11.6 cm. (4⁹/₁₆ in.), diam. at base 6.1 cm. (2⅜ in.); 36j: h. 5.1 cm. (2 in.), w. 8.6 cm. (3⅜ in.), diam. at base 3.8 cm. (1½ in.); 36k: h. 2.7 cm. (1¹/₁₆ in.), w. 11.5 cm. (4⁹/₁₆ in.), diam. at base 6.1 cm. (2⅜ in.); 36l: h. 5.1 cm. (2 in.), w. 8.6 cm. (2⅜ in.), diam. at base 3.8 cm. (1½ in.); 36m: h. 2.7 cm. (1¹/₁₆ in.), w. 11.7 cm. (4⅝ in.), diam. at base 6.2 cm. (2⁷/₁₆ in.); 36n: h. 5.1 cm. (2 in.), w. 8.8 cm. (3⁷/₁₆ in.), diam. at base 3.8 cm. (1½ in.); 36o: h. 2.6 cm. (1 in.), w. 12 cm. (4¾ in.), diam. at base 6.2 cm. (2⁷/₁₆ in.)

1979.796-804

Published: Ruth Berges, *The Collector's Cabinet* (New York and London, 1980), illus. (color) facing p. 64; Museum of Fine Arts, Boston, *Annual Report*, 1979-80, p. 24, illus.

Provenance: Purchased, Amsterdam, May 1959

The coffee service includes a coffeepot, hot milk jug, sugar basin, and six cups and saucers. The octagonal, pear-shaped coffeepot, made from a two-part mold, has a domed octagonal cover and a wishbone handle. The flared spout has an elongated heart-shaped opening. The smaller hot milk jug is of the same form as the coffeepot; only its spout differs in having a simple triangular opening. The octagonal sugar basin rests on a flat, unglazed base and has a slightly domed octagonal cover surmounted by an octagonal finial similar to that on the cover of the coffeepot and of the milk jug. The cups are also octagonal, and each is fitted with an ear-shaped handle. The saucers are octagonal. All the pieces in the service are painted with a pale yellow ground color, but the degree of saturation varies; the ground of the coffeepot is the palest. The rims of each piece are painted in brown, and black has been used to outline the shaped reserves on the two pots, the sugar basin, and five of the six cups. The painted decoration in the reserves and in the interiors of the saucers includes a hawk-like bird and flowers painted in the Kakiemon style. The bird is painted in puce, black, turquoise, and yellow; it picks at a bunch of blue grapes growing from a vine that springs from a brown rock formation. The flowers are painted in iron-red, blue, and puce, and their foliage is turquoise and green. The handles of the coffeepot and the milk jug have details picked out in purple, and the spouts of each are decorated with two iron-red flowers with green leaves. The finials of the three covers have iron-red markings. A motif recalling bellflowers is painted in iron-red on the handles of five of the six cups. One cup and saucer (36d,e) are noticeably different from the others: the saucer is deeper, the reserves are outlined in puce rather than black, and the painted decoration is clearly by a hand other than that responsible for the painting found elsewhere on the service.

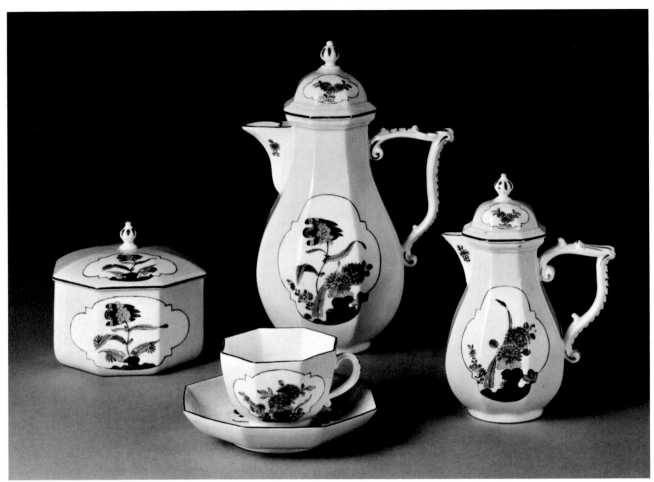

36

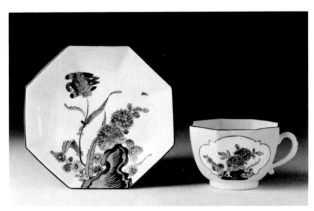

36

This octagonal form, inspired by Japanese Arita porcelain but adapted, probably under the influence of Johann Joachim Kändler, to Western needs, was used as early as 1725-1730 with scroll handles from the Böttger period.[1] The "J-Henkel" (J handle) used on nos. 36a and 36b was modeled in 1735.[2]

Unlike the chinoiserie tea and coffee services, of which the decoration differed within each panel, services and other matching pieces in the Japanese style (see nos. 25-27) repeated the same two or three designs on each piece. Also, by the time services like no. 36 were produced, the same designs were repeated on any number of services, with only small details, such as the form of the finials or the color of the outlines of the panels, distinguishing one from another. The cup 36d, with puce rather than black outlines for the panels and without decoration on the handle, is probably just such a "married" piece, originally having been made for a similar service. Its saucer, 36e, may have originated with it, being deeper and smaller than the other saucers in the Markus service.

A coffeepot in the Syz Collection seems at first glance identical to 36a, but it has a slightly different finial.[3] It has the same former's mark, 26, as nos. 36a and 36b have, and the painted decoration is the same. A similar cup and saucer are in the collection of Dr. Ernst Schneider; the saucer has the

same former's number, 23, as the odd saucer, 36e, in the Markus service. The lines forming the reserves on the Schneider cup are described as brown, and the handle is ornamented in iron-red.[4] An octagonal teapot, with two cups and saucers *en suite*, also has the same decoration, but the teapot has a faceted loop handle and more spherical knop, and the cups have simpler loop handles than no. 36; there is no description of the color of the framing of the panels, but the saucers have an incised 23.[5]

The same design of a bird clinging to a bunch of grapes (or a mimosa-like inflorescence) is to be found on a small pot in the Kunstgewerbemuseum, Berlin,[6] and on a purple-ground teabowl and saucer in a 1981 sale in London.[7] Both of these have an additional feature, a soft iron-red (or pink) streak with a gold dot (rising sun?), which was probably on the original oriental model. Stefan Bursche commented on the relation of the design on these pieces to the rare lotus-like decoration in the Chinese *famille-verte* style on several other pieces in Berlin, possibly by J. E. Stadler, about 1725–1730.[8]

It is entirely possible that A.F. von Löwenfinck may have been responsible for some examples with this kind of floral decoration before he left Meissen in 1736, but the former's numbers on the Markus service place its manufacture too late for this to have been his work. Otto Seitler illustrated a Fulda faience tankard that Löwenfinck may have decorated when he worked there from 1741 to 1745; it is called the "Hirschkäferkrug" (stag-beetle tankard) because it features a large beetle being pecked at by a bird, but above the beetle is another bird perched on a grape-like cluster, the mirror image of the Meissen pattern.[9]

V.S.H.

NOTES

1. Stefan Bursche, *Meissen: Steinzeug und Porzellan des 18. Jahrhunderts, Kunstgewerbemuseum, Berlin* (Berlin, 1980), no. 211, illus. p. 223; Rainer Rückert, *Meissener Porzellan 1710-1810*, exhibition catalogue, Bayerisches Nationalmuseum, Munich (Munich, 1966), no. 352, pl. XIII (color), with a handle like that of no. 22 in the Markus Collection.

2. Rückert, *Meissener Porzellan*, no. 238, p. 84.

3. Hans Syz, J. Jefferson Miller II, and Rainer Rückert, *Catalogue of the Hans Syz Collection*, vol. 1: *Meissen Porcelain and Hausmalerei* (Washington, D.C.: The Smithsonian Institution, 1979), no. 113, illus. (color).

4. Rückert, *Meissener Porzellan*, no. 370, pl. 94.

5. Otto Seitler, "Adam Friedrich von Löwenfinck als Blumenmaler in Meissen," *Keramos*, no. 11 (1961), figs. 4, 5; Sotheby Parke Bernet, London, sale catalogue, Nov. 23, 1982, lots 140, 141, illus.

6. Bursche, *Meissen*, no. 207, illus., p. 220.

7. Sotheby Parke Bernet, London, sale catalogue, June 30, 1981, lot 126.

8. Bursche, *Meissen*, nos. 201-206.

9. Seitler, "Löwenfinck," fig. 1.

36 (1) 36 (2) 36 (3) 36 (4) 36 (5) 36 (6) 36 (7) 36 (8) 36 (9) 36 (10)

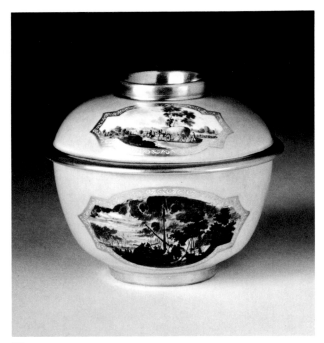

37

37 Sugar bowl and cover

Plate X

Germany, Meissen, about 1730-1735

Hard-paste porcelain with turquoise ("seladon") ground, decorated in polychrome enamels and gold

Marks:
(1) on base, in underglaze blue: crossed swords
(2) on inside of foot ring, impressed: a dot

H. 9 cm. (3⁹⁄₁₆ in.), diam. at rim 10.8 cm. (4¼ in.)

1979.805a,b

Published: Glückselig and Wärndorfer, Vienna, *Sammlung Dr. Max Strauss, Wien: Porzellan und deutsches Glas*, sale catalogue, Jan. 1922, lot 188, illus.

Provenance: Colls. Dr. Max Strauss, Vienna (sale, Glückselig and Wärndorfer, Vienna, Jan. 1922); Baroness Renée de Becker, Brussels, New York, Rome; purchased, New York, June 1958

The thrown bowl with cover is round in section and in profile has a flattened ovoid form. The bowl has a plain, high foot ring, and the cover has a similarly shaped gallery; both rings are gilt. Inside the gallery on the cover, against a white ground, indianische Blumen are painted in puce, blue, tur-

quoise green, yellow, and iron-red. The cover has a gilt flaring rim. The outside of both bowl and cover are painted with a turquoise ground, each with two cartouche-shaped reserves, diametrically placed. The reserves are framed by gilt-scrolled bands. On the bowl is a harbor scene, painted in a wide range of naturalistic colors including green, manganese violet, yellow, puce, iron-red, brown, and black. In the right foreground a dead tree leans in front of another tree. Standing on a promontory of land is a group of people. Beyond them is a boat, and in the distance, another group of people stands at the base of rocky cliffs. At the right is a large body of water. On the opposite side of the bowl is a scene of a night encampment near a harbor. It is painted in several shades of brown, black, and manganese violet, with yellow and red used to indicate the moon at the left and the campfire at the lower right. Several men are silhouetted against the fire, some kneeling in front of tents at the right. The night sky is streaked with dark clouds that are outlined with stickwork. On the cover one reserve shows a hay wagon, pulled by a team of horses and followed by several farmhands. The rolling hills in the background are painted in several shades of manganese violet, green, blue, and yellow. In the opposite reserve, a rocky island with a walled tower is painted against a sky filled with gray, manganese violet, and pale orange clouds. Winding toward the island from the left foreground is a green causeway, on which a single figure may be seen.

37 (1) 37 (2)

This sugar bowl was originally part of a service in the Strauss collection, which, in 1922, consisted of a coffeepot, teapot, tea caddy, the Markus sugar bowl, a waste bowl, and four cups and saucers.[1] The waste bowl is now in the Hans Syz Collection at the Smithsonian Institution, Washington, D.C.[2] The coffeepot from the Strauss service is similar in form to no. 22 but has a flat cover; the cups are beaker-shaped with two auricular handles, like the single-handled no. 24.

The simple form of the sugar bowl, with a gallery finial that could serve as a foot ring when the cover was removed and inverted, is based on

an oriental prototype.[3] The use of this form at Meissen, and that of the sake bottles, nos. 25 and 26, reflected the interest of Augustus the Strong in emulating Chinese and Japanese porcelains; the earlier baroque forms based on German silver were no longer in favor.

The turquoise ground color of this sugar bowl is very close to that of the six pieces in the Markus Collection, nos. 25-27, made for Augustus the Strong's Japanese Palace. It is also noteworthy that the panels on the interior of the waste bowl and on the saucers from the Strauss service are framed with gold ornamental bands similar to those on nos. 26 and 27.

The scenes painted on all pieces from this service are of exceptionally high quality. They are all landscapes with figures but with different settings: river, sea, ruins, and countryside. All were probably based on graphic sources. The two on the sides of the Syz Collection bowl have been identified as views of Königstein and Pirna after engravings of 1726 by Johann Alexander Thiele (1685-1752).[4]

V.S.H.

NOTES

1. Glückselig and Wärndorfer, Vienna, *Sammlung Dr. Max Strauss, Wien: Porzellan und deutsches Glas,* sale catalogue, Jan. 1922, lot 188, illus.: coffeepot, sugar bowl, waste bowl, one two-handled, beaker-shaped cup, and one saucer; reference is made to the 1920 catalogue of the Dr. Max Strauss collection, *Kunstschätze,* p. 32, and it is noted that the milk pot is broken.

2. Hans Syz, J. Jefferson Miller II, and Rainer Rückert, *Catalogue of the Hans Syz Collection,* vol. 1: *Meissen Porcelain and Hausmalerei* (Washington, D.C.: The Smithsonian Institution, 1979), no. 183, illus. (1 color).

3. Rainer Rückert, *Meissener Porzellan 1710-1810,* exhibition catalogue, Bayerisches Nationalmuseum, Munich (Munich, 1966), no. 171, pl. 50.

4. See notes 1 and 2 above.

38 Coffeepot and cover

Germany, Meissen, 1735-1740

Hard-paste porcelain with turquoise ("seladon") ground, decorated in polychrome enamels and gold

Marks:
(1) on base, in underglaze blue: crossed swords; in gold: B.

(2) inside foot ring, impressed: circle

H. 15.9 cm. (6¼ in.), h. without cover 13.3 cm. (5¼ in.), w. 12.5 cm. (4¹⁵⁄₁₆ in.), diam. at base 5.1 cm. (2 in.)

1983.618a,b

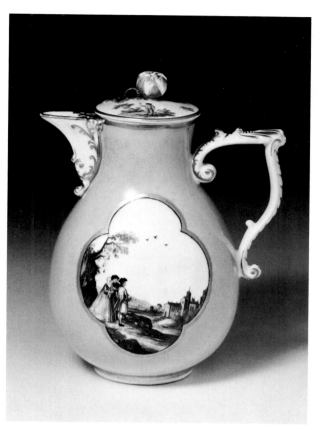

38

The pear-shaped jug has a wishbone handle and a low, plain foot ring. Both the handle and the spout have molded and gilt scrollwork. The jug is painted with a turquoise ground with two white quatrefoil reserves outlined in brown and gold. The foot and rim of the jug are also edged in gold. One scene on the jug shows two men, one in a puce coat and tricorn hat, the other in oriental dress, standing at the edge of the shore. In the center foreground, a man sits in front of a group of barrels, and another man is seated in the middle ground. There are three boats in the harbor and on the right a building on an outcrop of land. In the other reserve, two men and a woman stand in front of a cliff in the left foreground looking at a building on the far side of a river. The figures are painted in puce, yellow, brown, and iron-red. A pollarded tree frames the left side of the scene. The flat cover, which does not match the jug, has an applied floral finial painted in blue and yellow, with a green stem and leaves and a gilt rim. The cover is white and is painted with two male figures, each standing in an abbreviated landscape.

This pot is almost too small to be designated a coffeepot, but it is somewhat larger than comparable milk jugs.[1] Generally, at this period hot-milk jugs

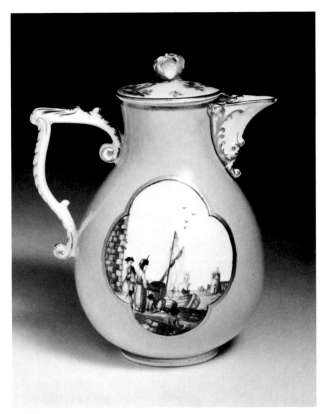

38

38 (1)

38 (2)

The combination of two different kinds of scenes, on one side merchants in an Eastern port, on the other a noble lady and gentleman in a European landscape, though not unique, is not common and was probably a transitional practice at this period, before the full development of scenes in the style of Watteau.

V.S.H.

NOTES

1. Kunstgewerbemuseum, Cologne, *Europäisches Porzellan und ostasiatisches Exportporzellan: Geschirr und Ziergerät*, catalogue by Barbara Beaucamp-Markowsky (1980), no. 96, illus.

2. Christie's (International), Geneva, sale catalogue, Nov. 20, 1970, lot 396; Hans Syz, J. Jefferson Miller II, and Rainer Rückert, *Catalogue of the Hans Syz Collection*, vol. 1: *Meissen Porcelain and Hausmalerei* (Washington, D.C.: The Smithsonian Institution, 1979), nos. 100, 211, illus.

3. Syz, Miller, and Rückert, *Catalogue*, vol. 1, no. 199, illus.

4. Hermann Jedding, *Meissener Porzellan des 18. Jahrhunderts in Hamburger Privatbesitz* (Hamburg: Museum für Kunst und Gewerbe, 1982), no. 84, illus.

5. Christie's, London, sale catalogue, June 30, 1980, lot 278, illus.

had a flat cover and a handle and spout of the same form as those on no. 38, whereas coffeepots had a domed cover and a handle without the lower inside scroll.[2] The handle of this small coffeepot is like those of both the coffeepot and the milk jug of no. 36.

Although the cover of no. 38 is clearly not the original one, it is in all likelihood the correct shape. A milk jug and cover in the Syz Collection is about the same size but later in date; its cover is very similar to the Markus one.[3] A small pot very close to this in size and form, with chinoiserie scenes in similar quatrefoil reserves on a yellow ground, was exhibited in Hamburg in 1982.[4] What was possibly the same pot was sold at auction in London in 1980.[5]

39 Tea caddy and cover

Germany, Meissen, about 1740

Hard-paste porcelain with turquoise ("seladon") ground, decorated in polychrome enamels and gold

Marks:
(1) on unglazed base, in blue: crossed swords; in gold: 1.
(2) on unglazed base, impressed: 28
(3) inside cover, in gold: 1.

H. 10.7 cm. (4³⁄₁₆ in.), w. 8.4 cm. (3⁵⁄₁₆ in.), d. 5.2 cm. (2¹⁄₁₆ in.)

1983.620a,b

The rectangular tea caddy is formed from two molded diagonal pieces. The circular opening at the top has a collar that is fitted with a flat-topped circular cover. The sides of the caddy are painted with a turquoise ground edged in gold with four quatrefoil panels reserved in white. The white shoulders of the caddy are painted with forget-me-nots in blue, yellow, and green. On the top of the cover, within a gold circle, is a scene depicting a man and a woman, wearing puce and iron-red garments, standing in a flat, open landscape. Landscape scenes in blue, blue-gray, green, yellow, and puce fill the four panels on the sides of the caddy.

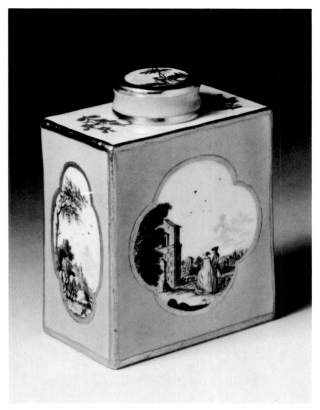

39

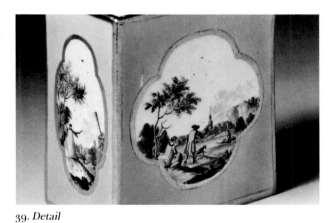

39. *Detail*

39. *Detail of cover*

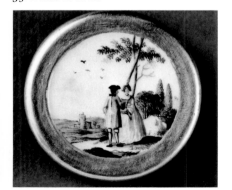

In each, two figures may be seen from the back. In three of the quatrefoils, a brown and iron-red tree frames the left side of the scene; in the fourth, a green tree and a stone building fill the left side of the panel. In each scene there are small clusters of blue-gray clouds in the sky, and a small flock of birds flies above the clouds.

Tea caddies were essential parts of tea and coffee services. Shapes and decoration varied according to fashion. In this instance, it is clear that the long-lasting oriental influence had not only waned but had also been superseded by more familiar scenes with European figures in contemporary costumes, surrounded by native flowers, rendered in natural-istic colors.

This form of tea caddy was in use through-out the 1730s, but the impressed numeral places this example after 1739. An example very similar in form, ground color, and decoration was sold in Geneva in 1969.[1] It was not from the same service as no. 39, since it had a gold letter S on both the base and inside the cover and an impressed 19. The painting was attributed to J.G. Heintze.

Johann George Heintze (Heinze, Heintz) was born in Dresden about 1707. He specialized in painting fine figures and landscapes and about 1739 or 1740 was named "Aufseher" (foreman) of painters.[2] Another painter of fine figures and land-scapes, Bonaventura Gottlieb Häuer (Hoyer, Hayer), born in 1710, was "Vorsteher" (manager) of painters from 1739 until his death at Meissen in 1782.[3] Either of these painters, or someone work-ing under them, might have painted this tea caddy.

V.S.H.

NOTES

1. Christie's (International), Geneva, sale catalogue, Oct. 2, 1969, lot 107, pl. 19.

2. Rainer Rückert, *Meissener Porzellan 1710-1810*, exhibition catalogue, Bayerisches Nationalmuseum, Munich (Munich, 1966), p. 29; see also Markus no. 22, note 4.

3. Rückert, *Meissener Porzellan*, p. 28.

39 (1) 39 (2) 39 (3)

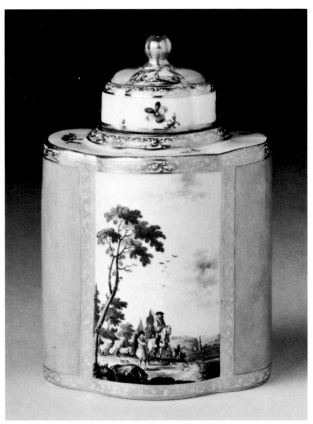

40

a white ground. The two scenes on the caddy show figures in broad landscapes. In the center foreground of one, a standing man dressed in an iron-red coat converses with a rider, who wears a puce coat. A large tree on the left frames the scene. Beyond, to the right, two other figures may be seen, one mounted on a horse, and toward the horizon, across a body of water, are another pair of figures, a church, and rolling hills. The reserve panel on the other side of the caddy shows a large tree in the left foreground framing three male figures at the edge of a body of water; one, wearing an iron-red coat, is mounted on a horse and converses with a standing man who is dressed in puce. The third stands in a small skiff, which he poles away from the shore. In the middle distance at left is a thatch-roofed cottage surrounded by a picket fence, and among the rolling hills of the background, painted in soft blues and purple, are several buildings. The cover is also treated with alternating bands of turquoise and polychrome scenes. In one scene, a reclining man converses with a standing woman, who gestures to him. In the right background is a tent. The other reserve shows a harbor, where, in the right foreground, two men are in a boat. On the left is a bank, where two figures, a tent, and a mast may be seen. At the horizon are several ships. The figures are dressed in puce, black, and iron-red.

40 Tea caddy and cover

Germany, Meissen, about 1740

Hard-paste porcelain with turquoise ("seladon") ground, decorated in polychrome enamels and gold

Marks:
(1) on unglazed base, in blue: crossed swords; in puce (faint): triangle enclosing .S.
(2) inside cover, in puce (faint): triangle enclosing .S. (not illustrated)

H. 13 cm. (5⅛ in.), w. 8.3 cm. (3¼ in.), d. 6.6 cm. (2⅝ in.)

1983.619a,b

The straight-sided caddy, molded in two pieces, is quatrefoil in section, with a flat shoulder rising to a lip that is fitted with a quatrefoil cover. The cover has straight sides, rising to a dome surmounted by a gilt, lobed finial. The body is decorated with vertical bands of turquoise alternating with polychrome panels, all framed by bands of gold scrollwork. The shoulders and edge of the cover are painted with polychrome deutsche Blumen *on*

Oval quatrefoil tea caddies were designed as part of services that included tea- and coffeepots (see no. 41), sugar and waste bowls, and cups and saucers (see nos. 58 and 76) of the same oval, quatrefoil form. In each case, the lobed molding of the cover matches the lower portion of the piece, and the cover either has a knob, as here, or is slightly domed, like the cover of an example sold in Geneva in 1969.[1] The reserve panels on the Geneva caddy are quadrilobed, an apparently more usual practice. It is possible that the Geneva caddy is from the same service as the Markus coffeepot, no. 41.

The Markus quatrefoil tea caddy is almost neoclassical in the way in which the panels follow the structure of the piece. A similar treatment can be noted on a partial service with yellow ground of about 1750, lent by Dr. Ernst Schneider to the 1966 Munich exhibition.[2] The quatrefoil forms have Watteau-style figures in park landscapes in panels framed by scale-patterned as well as scroll-work bands. In the same exhibition was a circular, turquoise-ground covered bowl with similar reserve panels, framed like those on the Schneider service; since the strawberry finial on the cover was modeled in 1742, the bowl was probably decorated about 1745.[3]

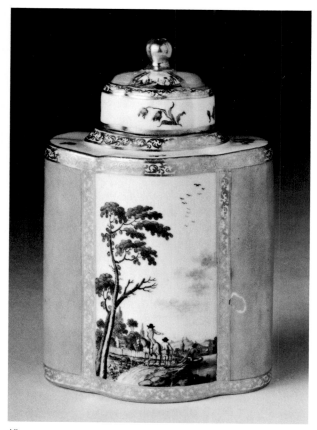

40

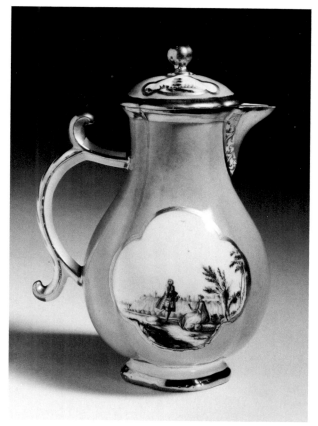

41

The painter's (?) mark on no. 40, .S. within a triangle, has not been identified. It seems related to a mark in gold on a coffee cup and saucer, about 1740, decorated with figures and horses in landscapes, and formerly in the W. von Dallwitz collection.[4]

V.S.H.

NOTES

1. Christie's (International), Geneva, sale catalogue, Oct. 2, 1969, lot 103, pl. 18.

2. Rainer Rückert, *Meissener Porzellan 1710-1810*, exhibition catalogue, Bayerisches Nationalmuseum, Munich (Munich, 1966), nos. 384-389, pl. 98.

3. Ibid., no. 436, pl. 109.

4. Adolf Brüning et al., *Europäisches Porzellan des XVIII. Jahrhunderts*, exhibition catalogue, Kunstgewerbemuseum, Berlin (Berlin, 1904), no. 197.

40 (1)

41 Coffeepot and cover

Germany, Meissen, about 1740-1745

Hard-paste porcelain with turquoise ("seladon") ground decorated in puce enamel and gold

Marks:
(1) on base, in underglaze blue: crossed swords; in gold: S.
(2) inside foot ring, incised: R
(3) inside cover, in gold: S. (not illustrated)

H. 17.8 cm. (7 in.), w. 12.3 cm. (4⅞ in.), diam. at rim 5.7 cm. (2¼ in.)

1983.621a,b

The pear-shaped jug is quatrefoil in section, with a shaped quatrefoil foot, which is decorated with two gold bands. The handle is harp-shaped and has gold edges and a leaf pattern running down the spine. The domed, quatrefoil cover has a gilt rim and lobed, gilt finial; it is pierced to allow for the escape of steam. The curved spout is gilt, with a scrolled gilt border where it joins the body. The body of the jug and the cover have a turquoise

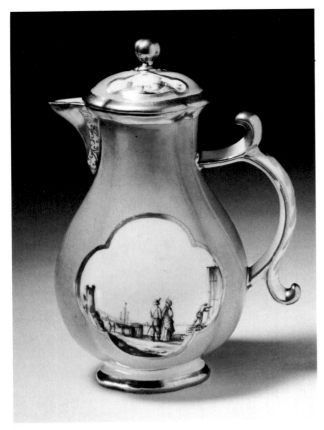

41

The four-sided harp- or lyre-shaped handle appears to have been designed for quatrefoil tea- and coffeepots. Examples are known from about 1730 to about 1750.[1] This shape has not been found on other forms, although an early quatrefoil teapot has an ear-shaped handle.[2]

The 1740-1745 period suggested for the Markus coffeepot is based in part on the figures in the style of Watteau on one side and the scrollwork band defining the spout. This band is similar to the bands defining the panels of the tea caddy, no. 40.

The incised R has not been identified; it does not occur in the lists of former's marks published by Walcha (see no. 20, note 9). It may be datable, as are the incised and impressed numerals (see no. 20, note 6), to the period after 1739.

The oval, quatrefoil tea caddy with turquoise ground mentioned in the entry for no. 40, sold in Geneva in 1969, is quite probably from the same service as the Markus quatrefoil coffeepot.[3] Like this coffeepot, the caddy has scenes in puce monochrome, both a port and a landscape with figures; the caddy also has gilt S marks.

V.S.H.

NOTES

1. Rainer Rückert, *Meissener Porzellan 1710-1810*, exhibition catalogue, Bayerisches Nationalmuseum, Munich (Munich, 1966), no. 376, pl. 95: teapot, probably about 1730-1735; no. 383. pl. 97: coffeepot, probably about 1740-1745; no. 386, pl. 98: coffeepot, probably about 1750. See also Hans Syz, J. Jefferson Miller II, and Rainer Rückert, *Catalogue of the Hans Syz Collection*, vol. 1: *Meissen Porcelain and Hausmalerei* (Washington, D.C.: The Smithsonian Institution, 1979), no. 184, illus.: coffeepot, 1735-1740.

2. Rückert, *Meissener Porzellan*, no. 350, pl. 90: probably about 1730-1735.

3. Christie's (International), Geneva, sale catalogue, Oct. 2, 1969, lot 103, pl. 18.

ground with two white, gold-framed quatrefoils reserved on each. These contain harbor scenes painted in puce monochrome. On the body of the jug, one reserve shows a conversing couple in the center foreground. The man stands, at left, gesturing with his left hand to the woman, who is seated, at right, on a log. To the right of the woman is a pollarded tree. Beyond the couple is a steep cliff with buildings and trees along its crest, and trees lining the shore of a lake below. In the other reserve is a harbor scene framed on the left by a ruined building and on the right by a sailor who is trimming a large sail. Two men in Turkish dress stand in the center foreground. To their left are two barrels. Two men converse on the edge of the harbor, and there is a three-masted ship beyond. The opposite shore of the harbor is visible on the horizon. On the cover one scene shows a cliff with a ruined castle and a tree at the right, above a harbor; in the left foreground is a junk, and in the center on the shore stands a man. The second reserve on the cover depicts two figures walking along a rocky path, which ascends to the left; a large tree stands in the middle, and a row of trees is visible on the horizon.

41 (1)

41 (2)

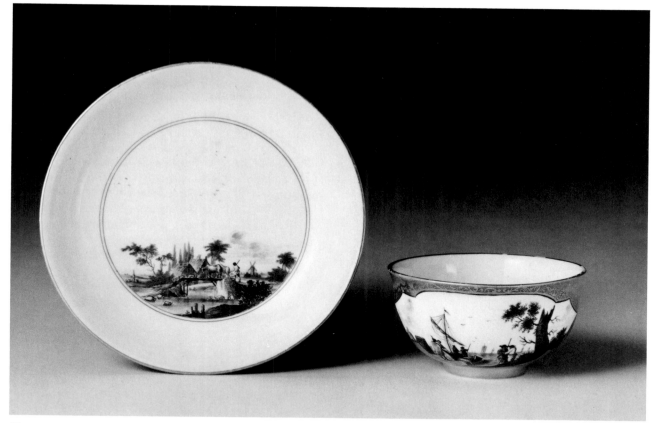

42

42 *Teacup and saucer*

Germany, Meissen, about 1740

Hard-paste porcelain with orange-red ground, decorated in polychrome enamels and gold

Marks:

(1) on base of cup, in underglaze blue: crossed swords
(2) on base of cup, impressed: 4
(3) on base of saucer, in underglaze blue: crossed swords
(4) on base of saucer, incised: 2

Cup: h. 4.3 cm. (1¹¹⁄₁₆ in.), diam. 8.1 cm. (3³⁄₁₆ in.); saucer: h. 2.9 cm. (1⅛ in.), diam. 13.1 cm. (5⅛ in.)

1983.622a,b

The shallow cup with everted rim has a low foot ring and an ear-shaped handle. The round saucer has a low foot ring. The exteriors of both pieces are painted with a mottled orange-red ground. On the exterior of the cup, opposite the handle, is a cartouche-shaped reserve edged in brown and containing a harbor scene painted in puce, iron-

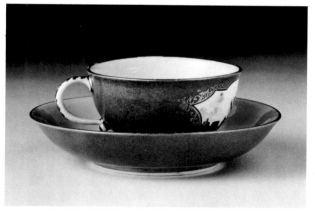

42

red, brown, green, and yellow. On the right, beside a pollarded tree, two men converse. On an embankment to the left a man, wearing an iron-red cape, talks to a woman in a puce gown. The reserve is framed with gold scrollwork. The rim and foot ring of both the cup and saucer are gilt, and the handle of the teacup has gilt and polychrome floral decoration. The white interior of both the cup and saucer is painted with a circular scene that is rimmed by a double line of iron-red. In the cup, there is a harbor with an arch and a tower in the

42 (1)

42 (2)

42 (3)

42 (4)

left foreground, and in the center two figures are standing before a boat. The scene on the interior of the saucer shows a peasant, clad in an iron-red shirt and puce breeches driving a pair of cattle and a flock of sheep over a bridge that spans a stream. Beyond, there is a cottage in a cluster of trees and a landscape with a windmill and other buildings, in colors of green and puce.

In form this cup is like no. 20, which it also resembles in the use of a double red line to define the scene inside both the cup and the saucer.

The ground color, which was probably sprayed on, is rare. It appears on a small AR vase in the Rijksmuseum.[1] It is called "tomato-red" on a partial service in the collection of Dr. Ernst Schneider.[2] A red-ground teabowl and saucer from the Schneider service was sold in London in 1982.[3] The landscape paintings on all these examples are in a style similar to that of the Markus cup and saucer, but the shape of the panels and the gilding on the Markus pieces indicate that they are from a different service. A red-ground covered bowl on loan to the Cleveland Museum of Art (744.76) has panels shaped like that on no. 42a and similar scenes, but the panels are edged only in black, without the gold scrollwork of the Markus cup. This gold scrollwork is similar to that bordering the panels on the AR vase in the Rijksmuseum, mentioned above. A pair of teabowls with a saucer in the Mrs. C.B. Stout Collection may be from the same service as no. 42.[4]

By 1740, a date suggested for this piece by the impressed and incised numerals (the marks of the formers, who turned the pieces and perhaps applied the handle), the painters' studios at the Meissen factory had a large collection of prints and drawings to use as models. The scene in the saucer shows the influence of Dutch paintings and engravings, while the harbor scenes inside and outside the cup might have an Italian source.

V.S.H.

NOTES

1. Rijksmuseum, Amsterdam, *Saksisch Porselein 1710-1740; Dresden China,* text by A.L. den Blaauwen (1962), fig. 30.

2. Rainer Rückert, *Meissener Porzellan 1710-1810,* exhibition catalogue, Bayerisches Nationalmuseum, Munich (Munich, 1966), nos. 440-444, pl. 111.

3. Sotheby Parke Bernet, London, sale catalogue, June 29, 1982, lot 48, illus. (color).

4. Brooks Memorial Art Gallery, Memphis, Tennessee, *Mrs. C.B. Stout Collection of Early Meissen Porcelain ca. 1708-1750* (1966), no. 62, illus.

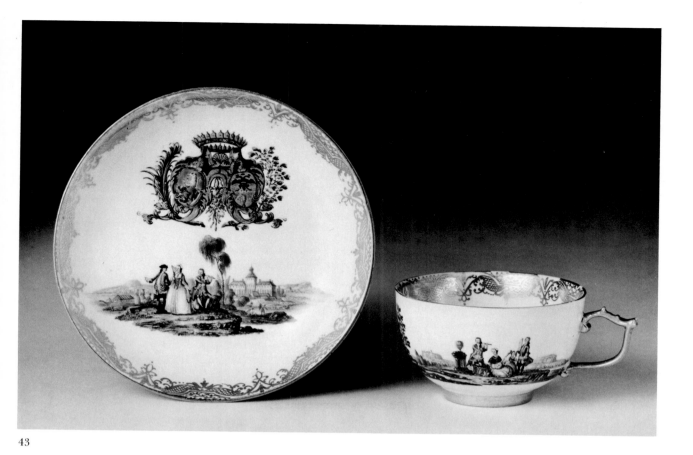

43

43 Teacup and saucer

Plate XI

Germany, Meissen, about 1753

Hard-paste porcelain decorated in poly-
chrome enamels and gold

Marks:
(1) on base of cup, in underglaze blue:
 crossed swords; in gold: 7.
(2) on base of cup, impressed: 66
(3) on base of saucer, in underglaze blue:
 crossed swords; in gold: 7.; impressed: 2

Cup: h. 4.8 cm. (1⅞ in.), w. 10.1 cm. (4 in.),
diam. at rim 8 cm. (3⅛ in.); saucer: h. 3.2
cm. (1¼ in.), diam. 13.4 cm. (5 ¼ in.)

1982.774a,b

The cup is hemispherical in shape and has a wish-
bone handle. The continuous landscape that deco-
rates the exterior is interrupted by the accolé coats
of arms of the Pisani and Gambara families of Ven-
ice, which are painted opposite the handle. To the
right of the coat of arms a music-making group
comprising four figures is situated near a pedestal
supporting an urn. To the left of the arms in the

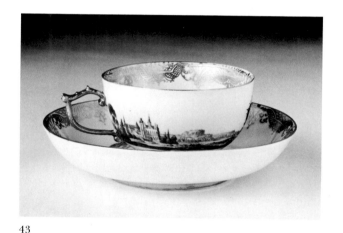

43

43. Coat of arms on cup

middle distance is a cluster of tall buildings surrounded by trees. A body of water and a series of flat-topped mountains are visible in the far distance. The figures wear clothes of the following colors: iron-red, puce, purple, green, blue, and yellow. The landscape is painted in various soft tones of green, yellow, blue, orange, and brown. The coats of arms are painted in gold, blue, puce, iron-red, and black; a rush and a branch are painted on either side of the arms. The handle and the foot ring are gilded. A scrolling gilt band encircles the inner rim of the cup. A spray of deutsche Blumen *(European flowers) painted in puce, yellow, iron-red, and green decorates the inside of the cup. The matching saucer is painted with the same band of gilt scrollwork around the inner rim, and the coat of arms appears above a landscape that features in the foreground a seated man playing a flute and a promenading couple. Figures engaged in various activities occupy the landscape of the middle distance; just beyond, at the edge of a body of water is a large building with orange roofs. A craggy landscape is in the far distance. The exterior of the saucer is undecorated; a gold band encircles the foot ring.*

The cup is the same shape as nos. 20 and 42, but the shape of the handle corresponds with that of no. 38, which appears to have been modeled in the second half of the 1730s. This cup and saucer were previously dated about 1740 because of their form and decoration, but the conjoined arms seem to indicate a later period, about 1753.

The only other pieces from the same armorial service that have been located are two coffee cups and saucers. One was sold at auction in London in 1976, the other in Geneva in 1981.[1] The latter catalogue identified the *Allianzwappen* (joined arms) as those of Ermolao III Alvise detto Luigi Pisani, Procuratore di San Marco (b. April 28, 1701, d. February 12, 1767), and his wife, Paolina Gambara, who were married April 30, 1753.

Armorial services were made for many other families of the Venetian nobility, among them the Foscari, Morosini, Pisani-Cornaro, Scala, and Tiepolo.[2] All of these have similar, finely painted landscapes with figures, some attributed to B.G. Häuer (1710-1782), who had worked as a painter at Meissen from 1724. Others were attributed to Johann George Heintze (b. 1707), one of the best painters, according to Höroldt's report of 1731, who was pensioned in 1746 because of illness. It is thought that a service made as a wedding gift from Augustus III to his daughter on the occasion of her marriage in 1738 to Charles IV, King of the Two Sicilies (later Charles III, King of Spain),

may have inspired the Venetian nobility, some of whom undoubtedly attended the wedding, to order similar services.[3]

V.S.H.

NOTES

1. Christie's, London, sale catalogue, June 28, 1976, lot 117, pl. 23; Christie's (International), Geneva, sale catalogue, May 11, 1981, lot 147, illus.

2. Christie's, London, sale catalogue, June 28, 1976, lots 114-116; Christie's (International), Geneva, sale catalogue, May 11, 1981, lot 149; Paul Schnyder von Wartensee, "Meissner Wappenservice des 18. Jahrhunderts," in *250 Jahre Meissner Porzellan: Die Sammlung Dr. Ernst Schneider im Schloss "Jägerhof," Düsseldorf, Keramikfreunde der Schweiz Mitteilungsblatt,* no. 50 (April 1960), pp. 43-50, especially figs. 145, 148, 149.

3. Rainer Rückert, *Meissener Porzellan 1710-1810,* exhibition catalogue, Bayerisches Nationalmuseum, Munich (Munich, 1966), pp. 109-110; Schnyder von Wartensee, "Meissner Wappenservice," pp. 45-46.

43 (1)

43 (3)

43 (2)

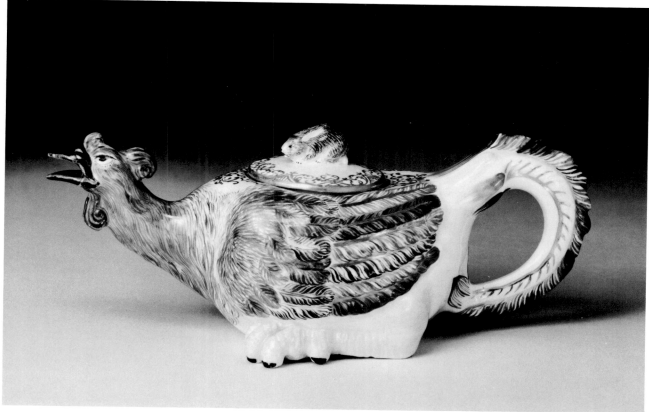

44

44 Teapot and cover

Germany, Meissen, about 1734

Modeled by Johann Joachim Kändler (1706-1775)

Hard-paste porcelain decorated in polychrome enamels and gold

Marks:
(1) on base, in underglaze blue: crossed swords

H. 7.5 cm. (2¹⁵⁄₁₆ in.), w. 19.5 cm. (7¹¹⁄₁₆ in.), d. 8 cm. (3⅛ in.)

1983.623a,b

Published: Sotheby Parke Bernet, London, sale catalogue, March 14, 1967, lot 11, illus.

Provenance: Coll. G.K. Galliers-Pratt (sold Sotheby Parke Bernet, London, March 14, 1967)

In the form of a brightly colored cockerel, the teapot is molded in two pieces that are joined along the middle of the neck, belly, and tail. The crouching bird has an extended neck with open beak, which forms the spout. The beak is black, and the interior of the mouth is iron-red, as are the comb and wattles. The eyes are black and are rimmed in iron-red with puce lashes. Black and brown brushstrokes represent feathers on the green and yellow neck. The sides of the teapot are modeled as wings and are painted in iron-red, green, yellow, and blue, with gold delineating the shaft of the feathers. The yellow legs, with incised striations and black claws, are tucked under the bird against the body. Forming an open circle to serve as a handle, the tail rises from the upper back, bending down to join the body at the base. Clumps of feathers in iron-red, blue, puce, and green form a fluted ridge along the edge of the tail. The circular opening of the teapot is edged with gilt scrollwork, as is the edge of the round, white cover, although the two patterns do not match. The finial is modeled as a rabbit, painted in pink and brown. The cover is too large for the opening and is not original to the piece.

An entry in Johann Joachim Kändler's *Taxa* of May 1734 provides a firm attribution and date for this model: "Ebenfalls ist noch zu einem Thee Pot ein Hahn gefertigt worden von mittelmässiger Grösse, wo ebenfalls der Thee zum Schnabel her-

aus läuft. Der Schwanz ist so beschaffen, dass man den Hahn dabei gut in die Höhe heben kann und daraus einschenken." (Another teapot in the shape of a cockerel, of medium size, from which the tea runs out of the beak. The tail is made so that the pot can be held by the handle without difficulty in pouring.)[1]

Numerous other examples of this form are known, although they are considerably rarer than those of a related model, in which the head of the cock is turned back toward the tail, and the base of the neck is pierced for pouring.[2] The source of the design for the latter model is unquestionably a Chinese stoneware pot, dated about 1700, an example of which is in the Dresden collections.[3] This second cockerel teapot by Kändler is more naturalistically finished than its Chinese prototype and seems to vary significantly only in the design of the finial on the cover, which appears in several forms, including a rabbit, a bird, a puppy, and a lion.[4] The finial on the cover of the Chinese stoneware pot represents a cluster of flowers.

It has been suggested that the Chinese vessel represents the mythical bird Fêng Huang (phoenix) rather than a cockerel,[5] and that it was used as a brush pot. There are early precedents for the use of the Fêng Huang bird as the form for a pouring vessel. A mid-sixteenth-century Chinese example in the Dresden collections is modeled as a ewer, with the neck and head forming the spout, and the back pierced for filling.[6] It is unclear whether the Yixing (I-Hsing) stoneware pot is intended to represent the phoenix or a cockerel, but Kändler certainly interpreted it as the latter when forming his porcelain teapots. He may also have been familiar with another Chinese pouring vessel of about 1700-1720, an example of which is now in the Mottaheda Collection.[7] Roughly the same size as the Meissen and Yixing versions, it represents a seated hen, of which the tail is formed as a handle (though not pierced) and the beak as a spout. The finial represents a chick seated on a lotus leaf, and two more chicks nestle below the hen. Kändler's teapot in the shape of a hen, also modeled in 1734,

the same year as no. 44, is extremely close in conception to the Chinese form. Like the cockerel teapot, the hen is more naturalistically modeled than its Chinese prototype.[8]

The painting on Meissen cockerel teapots varies in palette and style. The Markus teapot differs from all other examples of the model in the painting of the wings and neck, which is looser and less precise. The full painting of the neck is unusual, as are the iron-red feathers of the upper wings, which on most other examples are depicted with stickwork against a solid ground.

Y.H., E.M.A.

NOTES

1. Carl C. Dauterman, *The Wrightsman Collection*, vol. 4: *Porcelain* (New York: The Metropolitan Museum of Art, 1970), no. 44 A,B, p. 110, illus.

2. See, for example, Sotheby Parke Bernet, London, sale catalogue (Robert Goelet Collection), Oct. 13, 14, and 15, 1966, lot 373, illus.; Sotheby Parke Bernet, New York, sale catalogue (Mrs. Charles E. Dunlap Collection) Dec. 3, 4, and 6, 1975, lot 295, illus.

3. Otto Walcha, *Meissen Porcelain* (New York, 1981), p. 113.

4. Karl Berling, ed. *Meissen China: An Illustrated History* (New York, 1972), p. 34.

5. Walcha, *Meissen Porcelain*, p. 484.

6. Sotheby Parke Bernet, New York, sale catalogue, Oct. 31, 1981, lots 189 and 199, illus. See also Museum of Fine Arts, Boston, 65.2075, Forsyth Wickes Collection; this piece is believed to date from the nineteenth century.

7. Rainer Rückert, *Meissener Porzellan 1710-1810*, exhibition catalogue, Bayerisches Nationalmuseum, Munich (Munich, 1966), no. 921, p. 175, pl. 225; Hermann Jedding, "Erwerbung der Europäischen Sammlungen im Jahre 1975," *Sonderdruck aus dem Jahrbuch der Hamburger Kunstsammlung* 21 (1976), 243.

8. Rückert, *Meissener Porzellan*, no. 921, p. 175, pl. 225.

9. Jedding, "Erwerbung der Europäischen Sammlungen," p. 243.

10. I am grateful to James Watt, Curator of Asian Art, Museum of Fine Arts, Boston, for supplying this information.

11. William Bowyer Honey, *Dresden China: An Introduction to the Study of Meissen Porcelain* (Troy, N.Y., 1946), p. 117.

12. Chelsea Society, London, *Illustrated Catalogue of the Loan Exhibition of Chelsea China at the Royal Hospital, Chelsea* (1951), no. 69, p. 12, illus. p. 16.

44 (1)

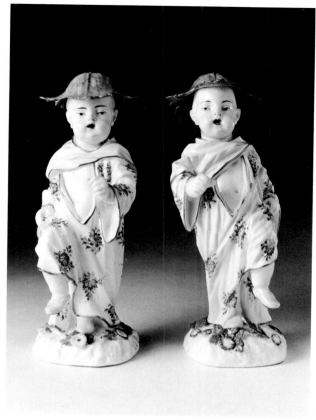

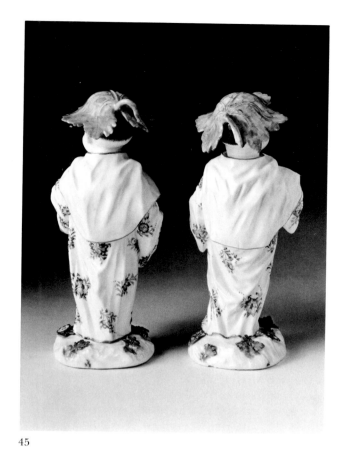

45

45

45 *Pair of Chinese boys*

Germany, Meissen, about 1750-1755

Hard-paste porcelain decorated in poly-chrome enamels and gold

Marks:
(1) 45a, on back edge of base, in underglaze blue: crossed swords
(2) 45b, on back edge of base, in underglaze blue: crossed swords

45a: h. 21.4 cm. (8⁷⁄₁₆ in.), w. 8.9 cm. (3½ in.), d. 9.8 cm. (3⁷⁄₈ in.)

45b: h. 21.4 cm. (8⁷⁄₁₆ in.), w. 9 cm. (3⁹⁄₁₆ in.), d. 11 cm. (4⁵⁄₁₆ in.)

1983.624,625

Published: Ruth Berges, *Collector's Choice of Porcelain and Faïence* (South Brunswick, N.J., and New York, 1967), fig. 125.

Each of the Chinese boys is modeled as if marching or dancing, with one knee raised and the opposite arm extended. Each stands on a nearly rectangular base, which simulates rockwork and is encrusted with applied flowers. Both wear, over their black hair, leaf hats painted in green with puce veining. Their mouths are partially open (the mouth of 45a is actually a hole into the body), and their heads are turned slightly to one side. Light flesh tones have been applied to the cheeks, nose, chin, ears, and forehead. The eyes are painted in brown, and the eyebrows in black. Both boys wear cloaks over loosely fitting tunics that are open to the waist and yellow slippers. 45b wears a yellow cloak over a white tunic decorated with blue flowers and gilt foliage; the cloak of the other boy has been left white, and his tunic is decorated with puce flowers and gilt foliage. Their cloaks and tunics are bordered with gold. The applied flowers on the bases are painted in either yellow or puce, with green leaves.

These figures seem to have been intended for mounting in ormolu to be used as candelabra. Figures of exotics, particularly Chinese pagods (or *magots de la Chine*), were made by both French and German porcelain factories for mounting in ormolu (see no. 54). A pair of dancing Chinese boys in the Wrightsman Collection, apparently similar to the Markus model, are set in French rococo mounts that have been dated about 1750.[1] Or-

molu mounts on other Meissen figures of this model vary considerably in design, and many are doubtless of the nineteenth century.[2]

Johann Joachim Kändler (1706-1775), chief modeler at Meissen from 1733 to 1756, produced his first small figures in about 1738.[3] Many of these may have been used in a series as table decorations, but the best-known groups, such as the craftsmen or the *commedia dell'arte* figures, would certainly also have been collected as pairs. The pairs (or *Gegner*), often representing a man and a woman, were designed to complement each other with opposing gestures or postures, as in the case of the Markus figures. Kändler's first groups of small-scale figures were probably those representing Chinese family scenes, and figures representing the nations were introduced in the middle of the century.[4] Children representing occupations or national types were introduced between 1755 and 1760, and among them were Chinese children.[5] The model of no. 45 is considerably larger than that of all the other single figures of children, however, and it does not seem to have been part of a series.

Two models related to this form, with slight variations, are known. The Markus model is distinguished by the diagonally draped garment and the deep V of the open robe at the stomach. One variation has a detachable, nodding head but is otherwise identical.[6] The second variation is comparable in size and represents the Chinese boy in a more static pose, with the arms lower and the head held straight, rather than pitched back as in no. 45. Two examples of this type are known.[7] This model's robe does not form a V shape but is open to reveal the entire stomach, and the boy wears a collar resembling acanthus leaves. Further distinguishing features include distinctly narrower eyes, darkly painted eyebrows, and a larger lotus-leaf hat. The last model has been attributed to Kändler and dated 1749 on the basis of the impressed number 1257 on the base. Friedrich Elias Meyer (b. 1724) has also been credited with the design of this variant.[8] Meyer's figures, however, are characterized by slender, twisting forms, and most seem to have rocaille motifs decorating their bases.

The dancing Chinese boy wearing a lotus-leaf hat may be an adaptation of a Chinese porcelain or stoneware figure, as has been suggested,[9] or may be based on a European print of a Chinese scene, perhaps a garden scene. The lotus hat appears frequently in Chinese works of art from the tenth century as a plaything for children, often as an umbrella.[10] The apparent variations in style between the model numbered 1257 and no. 45 would suggest either that they were produced by differ-

ent hands or that the Markus models were made several years later. Kändler's visit to Paris in 1748 has been traditionally viewed as marking the beginning of French rococo influence on the modeling of the Meissen figures as well as the introduction of a lighter palette.[11] The pronounced Asian features, the squatter proportions, and more frontal orientation of model number 1257 are closer in style to the *pagod* figures produced at Meissen. By contrast, composition of the Markus pair emphasizes the diagonal in the posture and in the disposition of the drapery. The more youthful features of the face are virtually European, a characteristic generally assigned to the later variations of the exotics produced around 1760. The absence of rocaille motifs on the bases, however, points to a date closer to 1750, that is, prior to Meyer's frequent use of rococo C scrolls on bases. It is interesting to note that the form was interpreted by the Chelsea factory,[12] where the figure (a boy bishop?) is fitted with a crown rather than a leaf hat. The English figure is marked with a red anchor, used 1755-1758, suggesting that its prototype, the Meissen model, was executed by that date.

Y.H., E.M.A.

45a (1)

45b (2)

NOTES

1. Rainer Rückert, *Meissener Porzellan 1710-1810*, exhibition catalogue, Bayerisches Nationalmuseum, Munich (Munich, 1966), p. 198.

2. Kunstgewerbemuseum, Cologne, *Europäisches Porzellan und ostasiatisches Exportporzellan: Geschirr und Ziergerät*, catalogue by Barbara Beaucamp-Markowsky (1980), p. 123, no. 50, illus. The author cites eight examples with the turned neck and two with outstretched neck, like the Markus model. In addition, the following examples with outstretched neck may be noted: Hermann Jedding, *Meissener Porzellan des 18. Jahrhunderts in Hamburger Privatbesitz* (Hamburg: Museum für Kunst und Gewerbe, 1982), no. 122, p. 134, illus.; Sotheby Parke Bernet, New York, sale catalogue (Nelson A. Rockefeller Collection), April 5, 1980, lot 164, illus.

3. Carl Albiker, *Die Meissner Porzellantiere im 18. Jahrhunderts* (Berlin, 1935), p. 86.

4. Carl Albiker, *Die Meissner Porzellantiere im 18. Jahrhunderts* (Berlin, 1959), no. 147, p. 18, illus. (bird); Christie's (International), Geneva, Oct. 2, 1969, lot 142, pl. 29 (puppy); Museum of Fine Arts, Boston, 34.1347, gift of Dudley Leavitt Pickmann (lion).

5. Erika Pauls-Eisenbeiss, *German Porcelain of the 18th Century*, vol. 1: *Meissen* (London, 1972), pp. 516-519, illus.; see also Anne-Marie Mariën-Dugardin and Chantal Kozyreff, *Ceramic Road* (Tokyo, 1982), no. 178, illus., where the same model is catalogued as a phoenix.

6. Staatliche Kunstsammlungen, Dresden, *Porzellan Sammlung* (1982), p. 9, illus. (color).

7. David Howard and John Ayers, *China for the West: Chinese Porcelain and Other Decorative Arts for Export Illustrated from the Mottaheda Collection* (London and New York, 1978), no. 602, illus.

8. Rückert, *Meissener Porzellan*, p. 198, no. 1131, illus. p. 278.

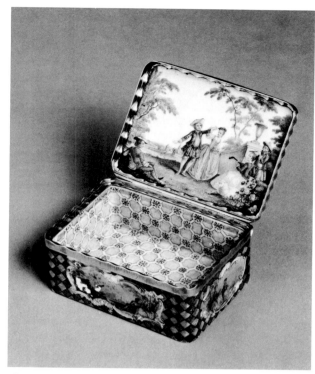

46

46 Snuffbox

Cover illustration

Germany, Meissen, about 1745-1750

Hard-paste porcelain decorated in polychrome enamels and gold, with gold mounts

Unmarked

H. 3.5 cm. (1⅜ in.), w. 7.5 cm. (2¹⁵⁄₁₆ in.), d. 5.7 cm. (2¼ in.)

1982.775

The rectangular molded box has a slightly domed cover and is fitted with gold mounts. The top, sides, and base of the exterior of the box are decorated with shaped reserves framed by polychrome scrolls, shells, and flowers within which are thin lines of gold. The scenes in the reserve panels, painted in dark brown, were applied before the copper-green enamel was fired and are in, rather than under, the translucent ground. Each scene depicts figures in landscape settings with a cityscape in the distance. On the cover a seated couple converse with a man who holds a tall staff; the reserve on the front of the box depicts a seated couple serenaded by a reclining boy playing the mandolin; on the base of the box a seated woman is entertained by a man playing a flute and a young boy playing a clarinet; the back reserve shows a

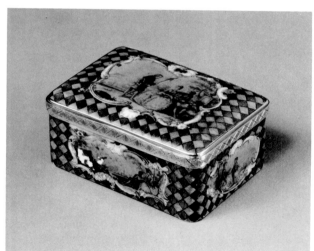

46

seated couple in conversation with a young girl standing to the left; on the right side of the box a couple embrace, and on the left side a woman converses with a young girl. The remainder of the surface of the box is covered with a lozenge-patterned ground in two tones of puce. Painted on the inside of the cover is a polychrome landscape scene of a couple dancing accompanied by a woman playing a mandolin and a man playing a flute. Behind the musicians and to the right of the dancers is a curved, smooth-sided stone wall surmounted by a tall vase. A sheep lies next to the mandolin player and to the side of a flowering rose bush. A young man is seated on the ground in the left foreground. In the distance a river and cityscape are visible. A diaper pattern painted in puce covers the inside of the lower section of the box. The gold mounts are engraved with a lozenge pattern matching the painted puce ground and are waved on the inside edges.

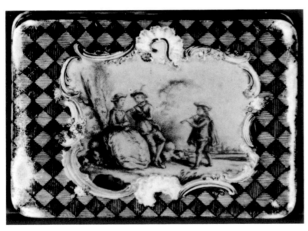

46. Base of box

This gold-mounted snuffbox, with painted decoration that completely covers its exterior and interior, is a particularly fine example of the most lavishly decorated and hence the most expensive boxes produced at the Meissen factory during the mid-eighteenth century.[1] The richness of the decorative scheme on the exterior of the box is evident in the copper-green enamel, known as *kupfergrün*, that serves as the ground for the figural scenes in the reserves, in the polychrome *rocaille* scrollwork that frames each reserve, and in the two-tone puce lozenge ground. The interior is decorated with equal elaborateness with a polychrome *fête champêtre* on the cover and a puce diaper pattern covering the lower body of the box, a feature that seems to be quite rare.[2]

The figural scenes on the exterior and interior of the box belong to the category often referred to as *Watteaumalerei*, a type of painted decoration comprising figures reminiscent of those painted and engraved by Watteau. The groups are often engaged in music-making or courtship in pastoral settings. Subjects derived from compositions by Watteau became popular on Meissen wares with the production of a service made as a wedding gift for the daughter of Augustus III, Maria Amalia, who in 1738 married Charles IV, King of the Two Sicilies (later Charles III, King of Spain). The decoration of this service consisted of gilded scrollwork with vignettes of Watteau-esque figures in abbreviated landscapes painted in black under green enamel.[3] The popularity of Watteau-inspired figures and of painting in copper green is attested to by the production of a "green Watteau service" for Augustus III in about 1745 in which flesh tints, painted in pale iron-red, are added to the dominant green.[4] Another "green Watteau service" was made at approximately the same time for Empress Elisabeth of Russia.[5]

The vogue for French subject matter had led Count von Hennicke, vice-director of the Meissen factory beginning in 1739, to procure several hundred engravings after works by Watteau and Lancret for the Meissen factory in 1741. Additional engravings were sent from Paris by a Monsieur LeLeu in 1746/47.[6] The individual figures in these prints, which were executed by engravers such as Lebas, Audran, Tardieu, Cochin, and Cars, were followed closely by the Meissen painters, but the arrangement of the figures often differed from the prints, as did the settings, in part to suit the format of the porcelain they decorated. For reasons of practicality, the landscape settings were frequently simplified by Meissen painters, and figures were added or subtracted at will. An interesting illustration of this practice is offered by comparing the scene on the interior cover of no. 46 with that similarly placed on another Meissen box, which was on the art market in 1982.[7] Although the specific source of this *fête champêtre* is not at present known, it is clear that the same composition served as the model for both boxes. The scenes on the two boxes differ, however; the music-making couple on the right side of the Markus scene has been eliminated from the scene on the other box, an arch above a bust on a tall pedestal appears in place of the wall and the urn, and a seated male figure is placed next to the seated man seen in profile at the lower left. The foliage is much the same at the left of the composition but is treated differently to the right of the central couple. It appears that the painting inside the cover of

the other box is by a different hand than no. 46, which is the work of a more accomplished artist.

A closer stylistic comparison with the Markus box is offered by another Meissen snuffbox, on the London art market in 1980.[8] The interior of its cover depicts a shepherd, a shepherdess, and a woman playing a stringed instrument in a landscape with architectural elements in the middle ground and a building in the far distance. The similarity between this scene and that on no. 47 in palette, in the proportions of the figures, and in the treatment of their clothing and the landscape suggests they are the work of the same painter. Like the Markus box, the box sold in London is decorated on the exterior with figures in pastoral settings within reserves framed by polychrome *rocaille* scrollwork, but on the latter example a polychromatic palette has been used. The effect of the ground — gilt trelliswork over chalk blue — is similar to and even more lavish than the two-tone puce lozenge ground of the Markus box; the mounts are gold. This box has been dated to about 1765, but a very similar box, sold at auction in 1983, decorated with the same ground and with Arcadian scenes in the reserves, is more plausibly dated between 1745 and 1750, when Watteau-inspired subjects were most popular.[9] Also dated about 1745 is a Meissen snuffbox on the New York art market in 1980, painted on the exterior with panels of "green Watteau" figures enclosed by scroll and diaperwork.[10]

The Markus box is distinguished from the boxes mentioned above by the puce diaper pattern on the interior of the body of the box. Monochromatic and two-color latticework and scale patterns were especially popular from about 1740 through the third quarter of the century. They were used both as grounds and as borders for animal and Kakiemon painting.[11] Two different lozenge patterns are used on a chessboard and chesspieces made at Meissen in the middle of the century; the squares in the center of the board are painted alternately in purple and green.[12] The diaper pattern inside the Markus box, though unusual in both its design and its placement, is an early use of the abstract grounds and borders which were popular on Meissen wares in the 1750s and 1760s. The choice of Watteau-inspired subjects and the use of copper green suggest the earlier date of 1745-1750 for this particular box.

J.H.M., Y.H.

NOTES

1. Clare Le Corbeiller, *European and American Snuff Boxes* (London, 1966), p. 68.

2. I know of no other example.

3. William Bowyer Honey, *Dresden China* (Troy, N.Y., 1946), p. 92.

4. Ibid.

5. Ibid.

6. Ibid., p. 88.

7. Christie's (International), Geneva, sale catalogue, Dec. 3, 1982, lot 159, illus.

8. Christie's, London, sale catalogue, June 30, 1980, lot 307, illus.

9. Christie's (International), Geneva, sale catalogue, Nov. 14, 1983, lot 134, illus.

10. Sotheby Parke Bernet, New York, sale catalogue, Oct. 15-16, 1980, lot 97, illus.

11. Rainer Rückert, *Meissener Porzellan 1710-1810*, exhibition catalogue, Bayerisches Nationalmuseum, Munich (1966), pls. 168-171; Hans Syz, J. Jefferson Miller II, and Rainer Rückert, *Catalogue of the Hans Syz Collection*, vol. 1: *Meissen Porcelain and Hausmalerei* (Washington, D.C.: The Smithsonian Institution, 1979), no. 70, illus. (color).

12. Rückert, *Meissener Porzellan*, no. 798, pl. 189.

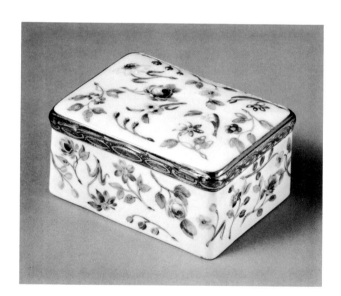

47 Snuffbox

Germany, Meissen, about 1745-1750

Hard-paste porcelain molded and decorated in polychrome enamels, with gilt-metal mounts

Unmarked

H. 4.4 cm. (1¾ in.), w. 7.9 cm. (3⅛ in.), d. 6 cm. (2⅜ in.)

1983.627

The molded, rectangular snuffbox has a flat base, slightly rounded corners, and a slightly domed

cover. It is mounted in gilt metal. The exterior of the cover is molded in very low relief with sprays of various flowers, including a rose and forget-me-nots. These are painted in puce, yellow, iron-red, blue, and blue-green, with green foliage. The sides and bottom of the box do not have molded decoration but are painted with similar sprays of flowers. The interior of the cover of the box shows the upper torso of a woman in three-quarter view, seated at a table in a chair with red upholstery. She wears a low-cut black dress and a black veil. To her left, a white poodle sits on the table. The background is a heavily stippled gray, which is lighter around the head of the woman and increasingly dark toward the edges. The hinged gilt-metal mount has a shaped thumbpiece and is engraved on the outside with a pattern of linked ovals against a sunburst ground.

47. *Interior of cover*

The decoration of the exterior of this box with naturalistic flowers suggests a date for the box after the mid-1740s, at which time the somewhat conventionalized *natürliche Blumen* became more commonly used than the very detailed and botanically accurate *deutsche Blumen*.

The depiction of the woman on the interior of the cover is taken directly from a painting by the Veronese artist Pietro Rotari (1707-1762).[1] In Rotari's painting, a veiled woman with her head slightly tilted to her left looks directly at the viewer. Her head and torso fill the picture space. The unknown sitter wears a prominent pearl earring in her right ear and a white ruffled choker around her neck. White lace is tucked into her bodice. The sitter's hair, tied back with a ribbon, falls in a ringlet across her left shoulder.[2]

The porcelain painter has followed Rotari's portrait closely, repeating the pose, expression, and costume of the original with little variation. To accommodate the horizontal format of the porcelain cover, however, he has placed the woman in a setting comprising her chair, the table in front of her, and the small dog looking back at his mistress. The porcelain painter has chosen to depict more of the woman's torso, and her stomacher is decorated with cutwork or lace. Her left arm is partially visible, as is a portion of her white ruffled sleeve.

The choice of Rotari's painting of the veiled woman for reproduction on the interior cover of the box is noteworthy for several reasons. Rotari's oeuvre, though little known today, was highly regarded during his lifetime. He specialized in portraits of young women, establishing a formula that is exemplified by the depiction on the cover of no. 47. The models were usually painted in a half-length format, their hands seldom visible. A black velvet band or white ruffle at the throat appears frequently. The numbers in which these portraits were produced attest to their popularity. Invited to Russia in 1756 by the Empress Elisabeth, Rotari painted hundreds of portraits for the court and aristocracy. His royal patron presented 50 paintings to the newly founded Russian Academy of Art, and Catherine the Great purchased 367 portraits after Rotari's death.

Rotari had visited Vienna and Dresden before establishing himself in Russia, and it is tempting to think that his painting of the veiled woman was available to the painter at the Meissen factory. Two female portraits by Rotari recently on the art market are reputed to have a royal Saxon provenance,[3] and "König Friedrich Wilhelm von Sachsen" has been listed in a Berlin catalogue as a former owner of the *Veiled Woman*.[4] Friedrich Wilhelm, however, is the name shared by four kings of Prussia, not Saxony, and the Rotari portrait, if indeed owned by a Prussian king, could have been in the collection of any of the last three to bear that name. The ruler of Saxony at the time that the snuffbox was painted was Friedrich Augustus II (1696-1763) and he bore the title of elector, not king, of Saxony. The inaccuracy in the Berlin catalogue of the title of the royal owner of Rotari's *Veiled Woman* permits only a supposition that the painting may have been in Dresden in the mid-eighteenth century for the Meissen painter to copy.[5]

The stippling technique used on the interior of the cover was frequently employed by porcelain painters, and numerous portraits with backgrounds executed in this manner are to be found on Meissen snuffboxes dating from the middle of the century. J.M. Henrici is cited as the painter of a half-length portrait of a seated woman holding a

mask that appears on a Meissen rectangular snuff-box of about 1745.[6] The depiction on a Meissen rectangular snuffbox of about 1750 of a seated woman sewing at a table[7] is similar in technique and style to the painting on no. 47, and the type of model chosen as well as her pose recall the numerous portraits for which Rotari was so esteemed. The similarity of this Markus snuffbox to these two Meissen examples suggests a date for no. 47 of about 1745-1750.

J.H.M.

NOTES

1. Signed P.A. Rotari.f.; Gallery Bachstitz, Berlin; Wertheim, Berlin, sale catalogue (Han Coray Collection), Oct. 1, 1930, lot 39, illus.; present location unknown. I would like to thank John Herrmann and Matthew Rutenberg, of the Museum of Fine Arts, Boston, who independently suggested Pietro Rotari as the source of the portrait on Markus no. 47.

2. I have seen only a black and white reproduction of Rotari's painting and thus cannot address similarities or differences of palette.

3. *Pilgrim Girl*, exhibited Munich Antique Dealers' Fair, Oct. 22- Nov. 1, 1976, reproduced in *Apollo* 104 (Oct. 1976), 102; *Russian Girl with Bonnet*, Rosenberg and Stiebel, New York, reproduced in *Art News* 76 (April 1977), 11.

4. Wertheim, Berlin, sale catalogue (Han Coray Collection), Oct. 1, 1930, lot 39, illus.

5. No print of the subject is known to me.

6. Christie's, London, sale catalogue, July 4, 1983, lot 163, illus.

7. Arne Bruun Rasmussen, Copenhagen, sale catalogue, May 3, 1984, lot 230, illus.

V Other German Porcelain

Four snuffboxes in the Markus Collection reflect the high quality of the porcelain produced at German factories other than Meissen in the second half of the eighteenth century. The Meissen factory dominated the production of porcelain in Europe during the first half of the century and provided artistic inspiration for other German factories even throughout the second half. However, Meissen did not regain its preeminent position after the Seven Years' War (1756-1763), when, for the first time, it faced competition not only from other factories in Germany but also from the Sèvres factory in France. The creative vitality that characterized the products of Meissen before 1756 is largely absent from those pieces made at the factory during the third quarter of the century, and records indicate that in 1764 representatives were sent from Meissen to Paris, Vienna, Ludwigsburg, and Höchst in search of models to imitate.

Of the German factories represented by the snuffboxes in the Markus Collection, Fürstenberg was the first to be established. Founded in 1747 by Duke Carl I of Brunswick, the factory did not produce porcelain until six years later with the arrival from Höchst of the arcanist Johann Benckgraff, the painter Johann Zeschinger, and the modeler Simon Feilner. The paste first developed by the factory was often slightly flawed by impurities and had a gray or yellowish cast. Consequently, wares were frequently molded with relief patterns often incorporating rococo scrollwork to help mask these flaws. Figures from the *commedia dell'arte* as well as those of miners were among the early important works of the factory. The period from about 1768 to 1790 marked the greatest successes of Fürstenberg, although the quality of the figures declined somewhat after the forced departure of Feilner in 1768. Porcelain plaques with elaborate, molded rococo frames were produced in significant numbers and were usually superbly painted with landscapes, birds, or figures. A number of these plaques are signed by the painter, permitting tentative attribution of the decoration on many unsigned wares. Vases were another speciality of the Fürstenberg factory and served as vehicles for the very accomplished painting practiced there. A painting academy had been established at the ducal palace in Brunswick in 1756, and the enamel painting work-

shop was moved to the palace from the factory in 1774. Fürstenberg painting is characterized by great refinement and attention to detail, as can be seen in the decoration of no. 48. The strong rococo character of the forms of the earlier Fürstenberg pieces waned in the 1770s, and the neoclassical style increasingly dominated production at the factory. Biscuit medallions and busts after the antique were produced in the last quarter of the century, and busts made of black basalt in imitation of Wedgwood were produced in the 1790s. In this last decade, wares were decorated with antique-inspired ornament, which in the early nineteenth century was superseded by Empire motifs.

The Frankenthal factory was founded in 1755 by Paul-Antoine Hannong, who was prevented from making porcelain at his faience factory at Strasbourg by the royal privilege granted solely to Vincennes. Elector Karl Theodore, who had granted Hannong the privilege to found the factory at Frankenthal, purchased the concern from the latter's son in 1762. Simon Feilner, previously of Fürstenberg, came to the factory in 1770 as inspector but soon became director, a post he held until 1797. Feilner, who was a chemist, modeler, and painter, has been credited with improving the quality of the paste produced at the factory. The porcelain made at Frankenthal during its most artistically successful period, which lasted from 1755 to 1775, had a creamy white tone and a highly absorbent glaze into which the enamel colors fused to produce an effect somewhat similar to soft paste. The thin glaze also allowed the modeling to remain crisp. Figures soon became the chief product of the factory, and over eight hundred figure types were invented by the different modelers in the course of the century. In the early years of the factory, Johann Wilhelm Lanz, who trained at Meissen, skillfully modeled many figures including those taken from the *commedia dell'arte* as well as from contemporary life, all of which continued to be produced until the factory closed in 1799. Karl Gottlieb Lueck, also from Meissen, was another important modeler at Frankenthal, as was his predecessor, the court sculptor Franz Konrad Linck, who supplied the factory with models from 1762 until at least 1775. The modelers Adam Bauer and Johann Peter Melchior, formerly *Modellmeister* at Höchst, successively assumed the position of chief modeler, and both continued to introduce new figure types. The production of new models of any quality ceased with Melchior's departure in 1793.

Although wares at Frankenthal were secondary in importance to figures and were often strongly influenced by Meissen and Sèvres, they were generally decorated with painting of high quality. Elaborate rococo molding is found on early wares, and exuberant rococo chandeliers, frames, centerpieces, and other decorative objects, probably designed by Gottlieb Friedrich Riedel, were made in the late 1750s. Influenced by Meissen, Frankenthal wares in the first decade or so of production were decorated variously with naturalistic flower painting, *indianische Blumen*, raised flowers, and *ozier* rims. Under the influence of Sèvres, diapered grounds were used with increasing frequency, to be supplanted by *oeil de perdrix* grounds in the 1780s. Exotic birds, particularly popular at Sèvres, appear as decoration especially on wares of the same decade.

The Frankenthal factory was confiscated by the French during the wars of 1794-1795. It was reclaimed in 1796 by the elector, only to be lost again to the French the following year. The factory closed in 1799.

A factory was founded at Ludwigsburg in 1756, but it is unlikely that porcelain was made there until after the arrival in January 1759 of Josef Jacob Ringler, an arcanist formerly employed at Vienna, Höchst, Strasbourg, and Nymphenburg. In the following month Ringler was made director, and he ran the factory for the next forty years. Despite the factory's artistic successes, it was always in financial difficulty, requiring its owner, Duke Karl Eugen, to subsidize the enterprise until his death in 1793. The duke is reputed to have believed that ownership of a porcelain factory was "necessary to the splendour and dignity" of his realm, and he was successful in his effort to employ the finest modelers and painters at his factory. Much of the best work produced at Ludwigsburg was figural, and it has been observed that the imperfection of the Ludwigsburg paste, which was grayish in tone (see no. 50), made it more suitable for figures than for wares. Among the early modelers of importance at Ludwigsburg were Johann Göz, Johann Jakob Louis, and Joseph Nees, the last perhaps responsible for a series of dancers, which rank among the most accomplished figures produced at the factory. A sculptor, Johann Christian Wilhelm Beyer, headed the modeling workshop from 1759 to 1767. The identification of some of his work at Ludwigsburg has been made possible by the publication of two collections of his engravings.

One of the most influential artists employed at the factory was G.F. Riedel, formerly at Frankenthal, who was made chief painter in 1759 and remained in that position for twenty years. Riedel was responsible for many of the designs at Ludwigsburg, one of which was for a toilet and supper

service made in 1763 for the Marchesa Giovanelli-Martinego of Venice, and the various wares decorated with relief scale pattern are based on his designs. It appears that Riedel supervised all painting at Ludwigsburg, the general quality of which (including the standard range of landscapes, figures, and birds) is high. The best flower painting (which includes sprays of *deutsche Blumen* and large bouquets) is attributed to Friedrich Kirschner. Josef Philipp Dannhofer was regarded as one of the most accomplished painters at the factory, as was Johann Friedrich Steinkopf, who specialized in landscapes and animals.

The years from 1764 to 1775, when the duke was in residence in Ludwigsburg, marked the period of the factory's finest production. With the removal of the court to Stuttgart in 1775, the quality of the factory's products began to decline, and the factory was dealt a severe blow with the duke's death in 1793 and the consequent termination of subsidies. The works produced in the later years of the century are undistinguished. In 1824 the factory finally closed.[1]

J.H.M.

NOTE

1. The following works have been consulted in the preparation of this introduction: William Bowyer Honey, *European Ceramic Art from the End of the Middle Ages to about 1815* (London, 1952); George Savage, *18th-Century German Porcelain* (London, 1958); Siegfried Ducret, *German Porcelain and Faience*, trans. Diana Imber (New York, 1962); Peter Wilhelm Meister, *Porzellan des 18. Jahrhunderts*, 2 vols. (Frankfurt, 1967). References to works that discuss the history of the various factories in greater detail may be found in the notes for nos. 48-51.

48

48 Snuffbox

Germany, probably Fürstenberg, 1754-1768

Possibly painted by Johann Heinrich Eisenträger (1730-active until 1768)

Hard-paste porcelain decorated in puce enamel, with gilt-metal mounts

Unmarked

H. 4.2 cm. (1⅝ in.), w. 9.1 cm. (3⁹⁄₁₆ in.), d. 7 cm. (2¾ in.)

1983.626

The rectangular snuffbox has a slightly domed cover that is mounted with a hinged gilt-metal rim. The exterior of the box is painted on the cover, base, and sides with landscape scenes in puce monochrome on a white ground. The cover of the box shows a walled church overlooking a moat. To the right is a stone archway and a drawbridge (?). Flanking the scene are large outcrops of rock with shrubs and trees. The four side panels are decorated with similar scenes, each including an octagonal or cruciform towered building on the edge of a body of water; a second building is visible in the distance. The scenes are framed at the left and right by clusters of rocks or tree trunks with leafy branches. The scene on the bottom of the box is similarly composed but is distinguished by a masonry arch. On the interior of the lid of the box is a painting of a leaping stag, closely pursued by three hounds. A mounted hunter, his sword drawn, rides along a river bank, just behind the stag. A

fourth hound runs beside the horse and rider on the bank. In the center of the frame, behind the stag, rises a rocky promontory surmounted by trees and a hut. In the middle distance on the left is a cluster of buildings, one with a tower. At the right the river winds through a forest. The gilt-metal mount is defined on the exterior by a fine molding and a shaped thumbpiece; the interior edges are decorated with a wavy pattern.

48. *Base of box*

48. *Interior of cover*

Both the landscapes that decorate the exterior of no. 48 and the hunting scene painted on the interior cover are typical of the subjects chosen as decoration for porcelain wares produced at various German factories during the third quarter of the eighteenth century. The type of painting on the Markus box is similar to that found on pieces made at factories such as Meissen, Höchst, and Fürstenberg, a fact that further complicates the attribution of no. 48.

Each of the landscapes painted on the exterior of the box floats on the white ground, without

any framing device, and tendrils and branches extend downward from the foreground into the white space. Both these features are found in much of the landscape painting practiced at various German factories in the 1760s and 1770s. Many of the Watteau scenes on wares at Meissen around 1750 are painted in this style,[1] and landscapes with similar features continued to be painted at that factory into the 1770s.[2] In the 1760s Höchst produced many wares decorated with floating landscapes and trailing vegetation,[3] and similarly decorated wares were made at Nymphenburg and Frankenthal,[4] particularly in the 1770s. The same features are also found on wares produced at Fürstenberg in the 1750s through the 1770s,[5] and it is with this factory's pieces that the Markus box has the most affinities. Stylistically, the landscapes on no. 48 are particularly close to the work of Johann Heinrich Eisenträger, who was employed from 1754 to 1768 at Fürstenberg, and who is recorded as a painter of landscapes, battle scenes, and figures.[6] A landscape painted by Eisenträger on a plate in the Fockemuseum, Bremen, offers the closest comparison to the landscapes on the Markus box.[7] There are notable similarities in the rendering of the leaves of the trees, the shading of the rocks, the patches of light and dark that make up the foreground, the close parallel strokes of the water, and the tendrils that descend from the foreground. The decoration on a pair of plates from a service made for Duke Carl, which is attributed to Eisenträger,[8] provides a further stylistic link with the decoration on the Markus box, particularly in the treatment of the trunks and branches of the trees, the buildings in the middle distance, and the reflections in the water. On the basis of these affinities with the work of Eisenträger, a tentative attribution for no. 48 to his hand can be made. It is therefore plausible to date the Markus box between 1754 and 1768, the years in which Eisenträger was employed at Fürstenberg and the period in which this type of landscape painting was used by other artists at the factory as well.

An examination of the paste of the Markus box further supports the attribution to the Fürstenberg factory. The smooth white paste of no. 48, with its slightly bluish cast, is noticeably different from the milky white paste of Meissen, the creamy paste of Höchst, or the grayish paste of Frankenthal, and it compares favorably with other examples of Fürstenberg in the collections of the Museum of Fine Arts.

The hunting scene painted on the interior cover of no. 48 is taken from an etching by Johann Elias Ridinger (1698-1767) entitled *Die Par-Force Jagd,* the ninth print from the series *Der Fürsten*

Jagdlust, which was issued in 1729.[9] The painter of the Markus box has based the horse and rider and the deer pursued by hounds on those found in Ridinger's print, but their setting is unrelated to Ridinger's landscape. The rocky outcrop with trees at the right of *Die Par-Force Jagd* has been replaced by a stream receding into the distance, and the clearing with figures in the center of the print has been eliminated; a small promontory with a building amidst trees appears in its place. The five horsemen behind the lead rider in the print have been deleted from the scene on no. 48, as has the tree trunk in the left foreground, and the painter of the Markus box has added a cluster of buildings in the far distance at the left. The great popularity of hunting scenes as decoration of porcelain began in the 1740s and lasted for the next two decades, and they appear on wares produced at many of the German factories. An early example of a hunting scene occurs on the interior cover of a Meissen snuffbox of about 1740;[10] a late example is found on a Meissen coffeepot of about 1770 sold at auction.[11] Ridinger executed numerous etchings of horses and the hunt, and his prints were used with great frequency by porcelain painters as a source for their decoration.

<div align="right">J.H.M.</div>

NOTES

1. Rainer Rückert, *Meissener Porzellan 1710-1810*, exhibition catalogue, Bayerisches Nationalmuseum, Munich (Munich, 1966), no. 605, pl. 147.

2. See Christie's, London, sale catalogue, June 30, 1980, lots 210 and 212, illus.

3. See Christie's, London, sale catalogue, July 6, 1981, lot 79, illus.; Sotheby Parke Bernet, London, sale catalogue, April 11, 1978, lot 45, illus.

4. See Christie's, London, sale catalogue, Dec. 3, 1979, lot 38, illus.: Nymphenburg; Kunstgewerbemuseum, Cologne, *Europäisches Porzellan*, catalogue by Barbara Beaucamp-Markowsky (1980), no. 293, illus.: Frankenthal.

5. See Siegfried Ducret, *Fürstenberger Porzellan*, vol. 2 (Brunswick, 1965), fig. 91.

6. Ibid., vol. 1, p. 267. I would like to thank Christina Corsiglia for bringing to my attention the similarity of the decoration on the Markus box to the work of Eisenträger.

7. Dueret, *Fürstenberger Porzellan*, vol. 2, fig. 88.

8. Ibid., figs. 83, 84.

9. Johann Elias Ridinger, *Die edle Jagdbarkeit: 18 Kupferstiche ...aus dem Jahre 1729* (Stuttgart, 1961).

10. Rückert, *Meissener Porzellan*, no. 814, pl. 193.

11. Christie's, London, sale catalogue, July 4, 1983, lot 116, illus.

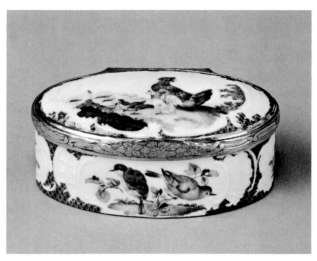

49

49 Snuffbox

Germany, probably Frankenthal, 1765-1775

Hard-paste porcelain with molded decoration and polychrome enamels; gilt-metal mounts

Unmarked

H. 3.5 cm. (1⅜ in.), w. 7.8 cm. (3¹⁄₁₆ in.), d. 5.1 cm. (2 in.)

1983.628

The molded snuffbox is oval in section, with straight sides and a flat base. It is modeled in low relief with six rocaille cartouches: one on the cover, one on the base, and four around the sides. The irregular areas between the rocaille frames and the edges of the boxes are filled with puce scale painting. The slightly domed cover is painted with a hen and two chicks in black, brown, and brownish red. They stand on a patch of ground painted in yellow, brown, dark green, and purple. In the background is a building with orange roofs. The reserves on the sides and base are painted in naturalistic colors with groups of birds perched on branches or standing in an abbreviated landscape. The interior of the oval cover is decorated with a duck, a hen, and two doves, painted in reddish brown, yellow, puce, and orange. They stand on a patch of ground that is mainly yellow, and beyond is a landscape with dark green trees and an orange-roofed building. The box is mounted with a hinged gilt-metal rim that has a shaped thumbpiece and is chased with flowers and scrolls. The interior edge of the mount has a wavy rim.

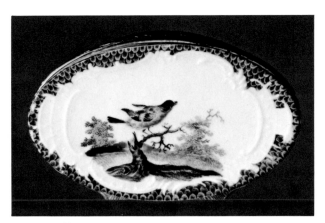

49. *Base of box*

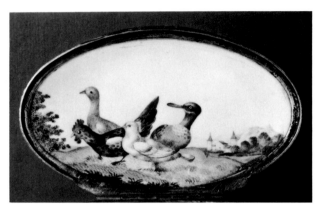

49. *Interior of cover*

Because snuffboxes were very rarely marked, their attribution is especially difficult and must be based on the comparison of the paste and the painted decoration with those of a factory's marked wares.[1] A study of no. 49 indicates that it was probably made at the Frankenthal factory in about 1765-1775.

Two snuffboxes in particular provide very close stylistic comparisons with the Markus box. One is an oval box sold at auction with an attribution to the Meissen factory.[2] The interior cover is painted with a turkey amongst aquatic fowl in a marshy landscape, and the sides are decorated with aquatic fowl and shaped puce borders edged with polychrome rocaille scrollwork. The second is a rectangular snuffbox, formerly in the Wrightsman Collection and recently sold at auction.[3] It is decorated on the exterior and interior of the cover with scenes of domestic fowl extremely close to those on the Markus box. A diaper pattern painted in blue-green enclosed by puce rococo scrolls frames the reserves on the exterior of the box. The Wrightsman box was catalogued in 1970 as Frankenthal but has been attributed to Meissen in the

1984 auction catalogue.[4] Although there are differences in shape and design between no. 49 and the box formerly in the Wrightsman Collection, it seems clear that the scenes on the exterior and interior covers of the boxes were derived from the same two sources. Furthermore, these scenes are painted in a very similar manner. The three barnyard fowl on the exterior cover of no. 49 are arranged in the same configuration as those on the Wrightsman box, although the cluster of buildings at the left and the foliage at the right of no. 49 do not appear on the other box. The ground on which the birds are placed is similarly treated on both boxes. The scene on the interior of the cover of no. 49 appears with only minimal variation on the Wrightsman box. However, there is no easily discernible difference between the two boxes in the treatment of the four birds, the ground on which they stand, and the foliage at the left, except for the slightly more brilliant palette employed for the duck on the Markus box.

Since the scenes on these two boxes appear to be the work of the same hand, it is probable that they are the product of the same factory. The Wrightsman box may have been attributed to Meissen in part because of the blue-green diaper panels, which are most commonly associated with that factory's wares.[5] Moreover, the painting is of a very high standard, equaling that typically found on products of the Meissen factory. Bird painting became popular there in the 1750s and remained so throughout the 1770s, which corresponds to the period in which no. 49 was probably made.

Several aspects of the Markus box, however, suggest that it was not made at Meissen. The barnyard fowl painted on the exterior and interior of the cover are found far less frequently on Meissen wares than songbirds or exotic birds, the choice of the latter probably influenced by the popularity of Sèvres porcelain so decorated. Both songbirds and exotic birds on Meissen wares are commonly painted with a harsher palette than that employed on the Markus box, and bright orange, blue, and puce frequently predominate. Meissen birds are also usually painted with large expanses of color, with little internal definition and noticeably hard outlines. Frequently, the birds are set into highly schematized and rather two-dimensional landscapes. The naturalism of both the birds and the landscapes on the Markus box is more highly developed than is customarily found in Meissen bird painting of this period.

It is the color of the paste of the Markus box, however, that most strongly indicates it was made not at Meissen but at another German factory, probably Frankenthal. The paste of the box is

somewhat yellow-gray, and that of the cover is slightly gray. It is interesting that the paste of the Wrightsman box is also slightly yellowish.[6] Neither the box nor the cover of no. 49 is made of the pure white paste most commonly associated with Meissen wares and figures. Thus the painting style, the choice of domestic fowl for decoration, and the color of the paste point to a different origin for the Markus box.

Bird painting at Frankenthal is seen at its best on a cooler from the "Vogelservice" decorated with a pheasant in a landscape, elaborate foliage, and a puce trellis pattern bordered with polychrome rocaille scrollwork.[7] Although the painting on this cooler is particularly ambitious in its scope and is of extraordinarily high quality, the specificity and naturalism of the landscape, the vegetation, and the pheasant have certain parallels with the painting on the Markus box. Birds became especially popular as decoration at Frankenthal after the arrival in 1771 of a gift from Louis XV to Elector Karl Theodore of a large Sèvres service. Ornithological plates were produced in large quantities at Frankenthal in the 1770s, and their decoration often includes landscapes of some elaboration.[8] The stylistic similarities in decoration between no. 49 and many of these examples and other Frankenthal wares such as two ice-cups[9] strongly suggest Frankenthal as the place of manufacture for the Markus box and a date between 1765 and 1775.

J.H.M.

NOTES

1. A rare instance of a marked snuffbox is offered by a Nymphenburg example in the Forsyth Wickes Collection, Museum of Fine Arts, Boston, which is marked with the arms of Bavaria impressed into the base of the interior.

2. Christie's (International), Geneva, sale catalogue, May 12, 1980, lot 195, illus.

3. Carl C. Dauterman, *The Wrightsman Collection, vol. 4: Porcelain* (New York: The Metropolitan Museum of Art, 1970), p. 213, no. 92; Sotheby Parke Bernet, New York, sale catalogue, May 5, 1984, lot 103, illus.

4. Sotheby Parke Bernet, New York, sale catalogue, May 5, 1984, lot 103, illus.

5. See Rainer Rückert, *Meissener Porzellan 1710-1810*, exhibition catalogue, Bayerisches Nationalmuseum, Munich (Munich, 1966), no. 727, pl. 169.

6. As reported by Christina Corsiglia.

7. Friedrich H. Hofmann, *Das Porzellan der europäischen Manufakturen* (Frankfurt, 1980), no. 129, illus. (color).

8. Christie's, London, sale catalogue, Dec. 1, 1980, lot 112, illus.

9. Christie's, London, sale catalogue, Oct. 6, 1980, lot 84, illus.

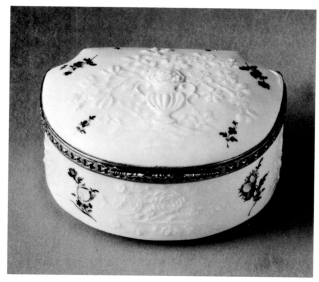

50

50 Snuffbox

Germany, Ludwigsburg, 1760-1775

Hard-paste porcelain with molded decoration and polychrome enamels; gilt-metal mounts

Unmarked

H. 5.2 cm. (2 1/16 in.), w. 8.5 cm. (3 5/16 in.), d. 6.6 cm. (2 5/8 in.)

1983.629

The molded snuffbox is cartouche-shaped in section, with straight sides, a domed cover, and a flat base that is framed by a carved, molded edge cut into the bottom of the box. The outside surface is molded with floral decoration in low relief; on the cover a two-handled, urn-shaped vase is filled with trailing flowers, and around the sides, in lower relief, are flowering branches inhabited by birds. The back panel contains a low basket filled with flowers. Interspersed among the molded decoration are sprays of flowers painted in puce. The bottom of the box, painted in puce monochrome, depicts a walled tower beside an estuary. Beyond it are ships' masts. In the foreground are several people standing among barrels and a mule with a rider. On the opposite bank is a group of buildings, including a round tower, and ships can be seen in the estuary in the far distance. Painted on the concave surface of the inside of the cover is a classical ruin situated at the edge of a harbor. Several men converse at the base of the columns, and

another group in the left middle ground observes two boats at dock. On the far bank is a fortified city. The box is fitted with hinged, gilt-metal mounts and an applied thumbpiece. The mount has a wavy edge on the interior and an engraved repeating X pattern on the exterior. The painting on the base of the box is worn in several places.

50. *Base of box*

50. *Interior of cover*

This cartouche-shaped box is attributed to Ludwigsburg in part because its form is the same as that of a snuffbox, exhibited in 1906, that is marked with the double Cs of the Ludwigsburg factory.[1] The marked box is painted with sprays of flowers on the sides and with a large basket of flowers, which almost completely fills the interior cover. It is described in the exhibition catalogue as being decorated with Kirschner painting, a reference to the work of the Ludwigsburg flower painter

Friedrich Kirschner.[2] The box does not appear to have any relief decoration. Its dimensions, h. 4.5 cm. (1¾ in.), w. 8.6 cm. (3⅜ in.), are close but not identical to those of the Markus box.

The attribution for no. 50 to Ludwigsburg is further supported by the color of its paste, which has a pronounced grayish hue. The paste of the Markus box is slightly less gray than but not dissimilar to marked Ludwigsburg pieces in the collection of the Museum of Fine Arts. It has been observed that the poor quality of the clays used by the Ludwigsburg factory resulted in the characteristic grayness of its paste,[3] which is generally acknowledged as inferior to the pastes made at other German factories.[4] As is common among other examples of Ludwigsburg, the body of no. 50 shows various imperfections.

An unusual feature of the Markus box is the use of harbor scenes to decorate the base and the interior cover. Floral painting appears to have been the most common type of decoration on Ludwigsburg wares in the eighteenth century. Birds were occasionally chosen as decorative motifs, and landscapes appear with even less frequency. No harbor scenes are found on any of the wares in the 1906 exhibition catalogue, which remains the major source for illustrations of Ludwigsburg porcelain. There are examples of Ludwigsburg wares painted with landscapes that include rivers or other bodies of water, but none is specifically a harbor scene.[5]

The skill evident in the painting of the harbor scene on the base of no. 50 is surprising in light of the rarity of this subject at Ludwigsburg. Considerable attention is given to detail, especially in the depiction of the buildings in the middle distance and of the masts visible behind them. The boats in the far distance are executed with deft brushwork, despite their minuscule scale. The scene on the interior cover is only slightly less skillfully painted. The figures and boats in particular are the work of a very accomplished hand, but problems of perspective are evident in the rendering of the pillared structure, which extends awkwardly into the harbor.

No print source has yet been identified for either of the two harbor scenes on no. 50, but both reflect the general influence of Claude Lorrain's harbor scenes of the previous century. Claude's paintings of landscapes and harbors were enormously popular, and his compositions were engraved and widely disseminated in Europe throughout the eighteenth century. It is likely that prints after Claude or after compositions influenced by his work would have been available to the painter of the Markus box.

Decoration in low relief appears on wares made at Ludwigsburg throughout the 1760s and 1770s but is most often in the form of raised C scrolls. The flowers in relief on the Markus box, the arrangement of which includes variously a vase, a basket, and a bird, are particularly elaborate and technically fine. The seeming uniqueness of the decoration of no. 50 makes it difficult to date, and, unfortunately, no date is assigned to the marked box of the same form.[6] It may not be possible without further evidence to date the Markus box more precisely than to the years between 1760 and 1775, when the Ludwigsburg factory was producing its finest work.

J.H.M.

NOTES

1. Bertold Pfeiffer, *Album der Erzeugnisse der ehemaligen Württembergischen Manufaktur Alt-Ludwigsburg* (Stuttgart, 1906), no. 542, illus.

2. Ibid., p. 54.

3. Württembergisches Landesmuseum, Stuttgart, *Ludwigsburger Porzellan* (1963), p. [1].

4. George Savage, *18th-Century German Porcelain* (London, 1958), p. 163.

5. Pfeiffer, *Alt-Ludwigsburg*, no. 1008, illus.; Württembergisches Landesmuseum, Stuttgart, *Ludwigsburger Porzellan*, no. 39, illus.

6. Pfeiffer, *Alt-Ludwigsburg*, p. 54.

51 *Snuffbox*

Germany, Fürstenberg, about 1770

Hard-paste porcelain with a dark blue ground, decorated in polychrome enamels and gold; gilt-metal mounts

Unmarked

H. 4.4 cm. (1¾ in.), w. 9.1 cm. (3⁹⁄₁₆ in.), d. 7.1 cm. (2⁹⁄₁₆ in.)

1983.630

The rectangular, molded box has a slightly domed cover that is attached with a gilt-metal mount. The top and sides of the exterior of the box have a dark blue ground, with white reserves that are framed by rocaille ornament in manganese violet heightened with pale green and white. The reserves are painted with both exotic and common birds in simple landscapes in various naturalistic colors including brown, puce, green, blue, and red. On the

51

bottom of the box are depicted two geese and a brightly colored bird (a guinea fowl?) in a simple landscape against a white ground. The interior of the cover shows a more detailed landscape and three birds perched on a branch: a pair of parrots, painted in yellow, red, and blue, and a cockatoo, which has white plumage tinged with red.

The attribution of no. 51 to the Fürstenberg factory is based on the style of the bird painting and on the unusual elaborateness of the framing rocaille ornament on the cover and sides. A contemporary marked Fürstenberg coffeepot in the Museum für Kunsthandwerk, Hamburg, provides an example of the same features in combination, although the rocaille ornament on that piece serves as the dominant decorative motif around which the birds are placed.[1] The rocaille decoration on the Markus box is larger in scale and is painted with greater detail than that customarily found on comparable wares from other German factories. Examples of similar Fürstenberg rocaille ornament include an earlier coffeepot in Berlin and a cup and saucer in Zurich.[2] On all these pieces, the motifs of C scrolls and the spiraling vegetal forms are broadly painted with considerable shading and hatching.

The birds on the interior and exterior of the cover and on the base of no. 51 are especially well painted and have close stylistic parallels in the work of two painters at Fürstenberg, Johann Christof Kind and C.G. Albert, who were among the five bird painters recorded as being employed there from 1753 to 1800.[3] Kind worked at Fürstenberg from 1751 to 1798 as a painter of birds and flowers; Albert was employed there only from 1767 to 1772 but was considered "the best bird

51. *Interior of cover*

51. *Base of box*

painter."[4] The birds painted by Albert, which were usually domestic fowl, are more naturalistic and frequently placed in a more highly detailed and extensive landscape than is found in the work of Kind.[5] Moreover, Albert's painting is often more refined than that of Kind, whose style is somewhat bolder and less specific.[6]

Although the rendering of the birds and their settings on the Markus box can be associated with the styles of both these painters, on the whole it is closer to that of Albert. The most accomplished painting occurs on the interior cover, where the three parrots and the abbreviated landscape are depicted with a high degree of naturalism and animation. The landscape is simple but is painted with great attention to detail. The scenes on the lid and base are slightly less carefully painted, and the settings are even more abbreviated. The birds that decorate the reserves on the four sides are far less skillfully executed, but this may be due in part to the especially small format. The quality of the painting on the interior cover compares favorably with the work of Albert, and it is tempting to attribute the decoration of no. 51 to his hand, but a definite attribution is not possible

without direct comparisons with other works thought to be by him.

An unusual aspect of no. 51 is the underglaze blue ground surrounding the reserves of the exterior cover and sides. It is rare to find a snuffbox on which the ground has been applied under the glaze, and the wares of the Fürstenberg factory seldom had colored grounds, the exceptions being sea-green and underglaze blue.[7] The blue ground of no. 51 is slightly mottled and has bubbled in certain areas where it appears thickest. The paste of the Markus box is close to that of no. 48, the other Fürstenberg box in the Markus Collection. Both pastes are smooth in texture, finely grained, and somewhat gray in color; that of no. 51 also has a slightly bluish cast.

A date of about 1770 is likely for no. 51, not only because this falls precisely in the middle of Albert's years at Fürstenberg but also because bird painting generally similar in style to that on the Markus box decorates many Fürstenberg wares made in the late 1760s and early 1770s.

J.H.M., Y.H.

NOTES

1. Siegfried Ducret, *Fürstenberger Porzellan*, vol. 2 (Brunswick, 1965), fig. 206.

2. Ibid., figs. 82 (Berlin), 81 (Zurich).

3. Ibid., p. 173.

4. Ibid.

5. For examples of Albert's work, see Ducret, *Fürstenberger Porzellan*, vol. 1, pls. 7, 19, 20.

6. For examples of Kind's work, see Ducret, *Fürstenberger Porzellan*, vol. 1, pls. 5, 6, 24.

7. George Savage, *18th-Century German Porcelain* (London, 1958), p. 160.

VI Early French Porcelain

The enthusiasm for collecting Chinese porcelain was as great in France as in Germany and resulted in the successful production of a kind of porcelain at least a decade before the foundation of the Meissen factory. This French porcelain is called soft-paste (*pâte tendre*) or frit porcelain because it is composed of a ground-up vitreous mass (frit), close in composition to glass, that was mixed with a small quantity of a white plastic clay. It had to be fired, first, at a low temperature to a state called biscuit and was then covered with a lead glaze and fired a second time. The resulting piece was ready for decoration in enamels and gold and was fired as many more times as necessary at lower temperatures. In this process many of the enamel colors sink into and become a part of the soft lead glaze.

Although there is documentary reference to the manufacture of porcelain in Paris in 1664 by Claude Réverend, a potter and dealer in Dutch tin-glazed wares, the earliest surviving examples of French porcelain are attributed to the Rouen faience factory of Edmé Poterat and his son Louis, who obtained a license in his own name in 1673 to manufacture porcelain and pottery in the fashion of Holland. These late seventeenth-century porcelains are usually decorated in cobalt blue *lambrequins* (scallops) and other designs related to the faience of the period. Only a small quantity of porcelain was produced at Rouen, and Louis Poterat claimed to have made those pieces himself. The secret seems to have died with him in 1696.

Porcelain very similar to that of Rouen was successfully produced at Saint-Cloud, near Paris, by Pierre Chicaneau, also a maker of faience, who died before 1678. His widow married another Saint-Cloud potter, Henri-Charles Trou, whose factory was on the estate of "Monsieur," Philippe, Duc d'Orléans, brother of King Louis XIV; the Chicaneaus and Trous, under the protection of the duke and duchess, pursued the manufacture of porcelain on a commercial scale never achieved at Rouen. Contemporary seventeenth-century references to visits by the English physician and metallurgist Dr. Martin Lister and others have even led to the suggestion that there may have been a second factory producing porcelain in Saint-Cloud before 1700. The factory of the Chicaneau-Trou family survived and flourished into the eighteenth century; in the 1720s and 1730s it was producing wares with a great variety of forms and decoration in the fashion of Meissen, especially imitating the Japanese Kakiemon style and the Chinese white wares of Fujian (Fukien), but with a completely different result because of the quality of the soft paste. Plates were rare, but among the popular items were tea wares; articles for toilet use; boxes of all shapes for spices, tobacco, comfits (confections to sweeten the breath), and patches; wine coolers; tureens; and figurines. Like faience, these early porcelains often replaced silver on the tables of the nobility, and even they commented on the high prices. Saint-Cloud, with its contingent sales rooms and branch factory in Paris, closed in 1766, probably no longer able to survive in view of the restrictions imposed by the king in favor of Sèvres (see the introduction to section VII).

Historically, the next French factory to produce porcelain was founded in 1726 by Louis-Henri de Bourbon, Prince de Condé (1692-1740), at his château at Chantilly, near Paris, to which he had retired upon his exile from the court of Versailles. From the beginning the factory was under the direction of Sicaire (Cicaire, Ciquaire) Cirou, who had possibly worked at the Paris branch of the Saint-Cloud factory. The porcelain paste of the two factories is not dissimilar, but the Chantilly porcelains of the first period (until about 1750) are distinguished by a tin glaze such as is used on faience. This milky white, smooth glaze was especially suited to the most characteristic wares of Chantilly, whose forms and decoration were inspired by the Japanese Kakiemon porcelains in the noted collection of the Prince de Condé. The prince also collected Meissen porcelain in this style, the designs of some of which were also copied. Because the nineteenth-century ceramic historian Albert Jacquemart believed these Japanese wares to be Korean, the name "coréen" is still used for the Chantilly versions. About the middle of the eighteenth century the influence of Vincennes was evident both in changing forms and in the use of monochrome decoration due to the restrictions. Porcelain was produced at Chantilly until about 1800, the years between 1755 and 1780 being known for large quantities of tableware with a clear lead glaze and tasteful decoration, one of the patterns being the often imitated "Chantilly sprig."

Paris was also the site for the establishment of the next porcelain factory, this protected by Louis-François de Neufville, Duc de Villeroy (1695-1766). The Villeroy factory was managed from its beginning in 1734, by François Barbin, a *faïencier*. In 1748, undoubtedly because of the royal privileges granted Vincennes, the factory was

transferred from the rue de Charonne, Paris, to one of the outbuildings of the Château de Villeroy at Mennecy, on the way from Paris to Fontainebleau. In 1751 Barbin's son Jean-Baptiste joined him in the management of the factory. Both father and son died in 1765, and the factory was acquired in 1768 by Joseph Jullien and Symphorien Jacques of Sceaux, who transferred the works to Bourg-la-Reine in 1773. Like the Chantilly wares, the earlier Mennecy productions were decorated in Kakiemon style, to be followed by rococo forms and decoration inspired by Vincennes and Sèvres. Mennecy made a specialty of small objects: ointment pots, cane and knife handles, small vases, figurines, and boxes of varying forms, especially human and animal. These last, as at Saint-Cloud and Chantilly, were mounted in silver, since gold was tacitly reserved for Vincennes-Sèvres. The DV mark, used at both the Paris and Mennecy sites, signifies Duc de Villeroy or Duché de Villeroy, not, as has sometimes been stated, "de Villeroy." The mark was usually painted on the earlier pieces and incised on the later ones.

The products of the porcelain factory at Sceaux are usually discussed together with those of nearby Mennecy, which they closely resemble, especially during the 1768-1772 period, when both factories were under the management of Jullien and Jacques. The Sceaux factory, founded in 1748 under the protection of the Duchesse de Maine (d. 1753), is known for the production of faience of fine quality, intended to rival porcelain. The production of porcelain was attempted there as early as 1749-1752 but was suppressed under the Vincennes privilege. When Jullien and Jacques took over the Sceaux factory in 1763, the Sèvres monopoly was relaxed in view of the protection of the Duc de Penthièvre, who had succeeded his aunt, the Duchesse de Maine, as patron of the factory. In 1772 Sceaux was purchased by Richard Glot, and, by the time he sold it to P.A. Cabaret in 1795, the production of soft-paste porcelain had ceased.[1]

V.S.H.

NOTE

1. These very brief historical notes have been compiled from a number of standard reference books, to which the reader is directed for more specific details and for illustrations of the full range of production of the factories discussed. See especially Claude Frégnac, ed., *Les Porcelainiers du XVIIIe siècle français* (Paris, 1964); Hubert Landais, *French Porcelain* (New York, 1961); George Savage, *Seventeenth and Eighteenth Century French Porcelain* (London, 1960); William Bowyer Honey, *European Ceramic Art from the End of the Middle Ages to about 1815: A Dictionary...* (London, 1952); idem, *French Porcelain of the 18th Century* (London [1950]).

52 Two coolers for liqueur bottles

(Seaux à liqueur)

Plate XII

France, Saint-Cloud, about 1730

Soft-paste porcelain *(pâte tendre)* decorated in polychrome enamels and gold

Unmarked

52a: h. 11 cm. (4⁵⁄₁₆ in.), w. 14.3 cm. (5⅝ in.), diam. at rim 12 cm. (4¾ in.)

52b: h. 11.1 cm. (4⅜ in.), w. 14.1 cm. (5⁹⁄₁₆ in.), diam. at rim 11.9 cm. (4¹¹⁄₁₆ in.)

1983.631,632

Published: Hôtel Drouot, Paris, sale catalogue, Gilbert Lévy Collection, Nov. 23, 1967, lot 84, illus. (black and white and color); *Connoisseur* 166 (Nov. 1967), xx, illus. of 52b.

Provenance: Coll. Gilbert Lévy, Paris (sale, Hôtel Drouot, Paris, November 23, 1967)

The cylindrical pots are thrown on the wheel. Each has two grotesque mask handles, molded and applied, near the top. Above the masks, just below the rim, and below the in-curved base, just above the foot ring, are two moldings of hand-tooled gadrooning. The masks are in the form of a human head wearing a helmet-like headdress with a band with five indentations over the forehead and wing-like flaps over the ears; the eyes are bulging, the nose sharply pointed, and the mouth open, showing the upper teeth and the tongue, which is extended. The tongue and lips are colored with red enamel, the eyebrows and pupils in black.

The coolers, which are creamy in tone, are decorated with the same two scenes delineated in black, red, and gold, and colored with blue, gray-blue (manganese?), turquoise green, and yellow. On one side six Chinese figures stand in groups of three on either side of a circular table. On the left a man wearing a long gray-blue robe and a conical blue hat with a brim stands behind a boy wearing a green robe and holding a red box; a woman (?) wearing a blue garment with a red cord at the waist over gray-blue trousers, turns her head to her right, and holds a green and gray quadrangular fan on a pole.[1] On the yellow table, which has a red molding and four wavy legs, is a jar with a cover and a red flask. The figures at the right all look toward the left group. The man on the left is bareheaded, with two tufts of hair; he wears a long green robe with red and blue ties and holds a yel-

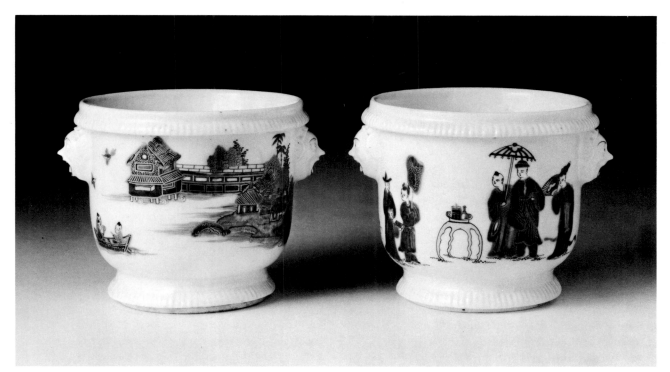

52

low umbrella ornamented in red over the head of a man wearing a red and blue hat, a gray-blue robe ornamented with a red band across the chest and gold-dotted circles; his left hand is at his belt, and he wears blue trousers. The woman (?) at the right has a high headdress and holds a red fan with a yellow ornament in her right hand; she wears a short, light green robe over a dark blue gown, with blue, gold, and red ribbons, two of which extend to either side, about knee height. Groups of three red dots and red stippling mark the ground under each figure and under the legs of the table. The details are slightly different on each piece: the heads on no. 52b are rounder than on no. 52a; the faces and hands are more carefully drawn; and the article in the boy's hands on no. 52b is possibly a square tray.

On the reverse side of each piece is a lake scene with, at the left, three Chinese figures seated in a blue, red, and gold boat; two of the figures sit side by side on the left, one holding a pear-shaped fan and wearing a blue garment, his companion in green; at the other end of the boat a figure in green holds a paddle or steering device. Above are two birds flying toward each other, their bodies red and their wings green and gold; the bird on the right has elaborate tail feathers. Next, to the right, there is a large building in blue, red, yellow, and gold, on six yellow piles. Attached to this and extending to the right is a long gallery with a yellow tile roof and, behind this, trees in green, gold,

and red. At the right is a large island with a group of smaller houses; the grass is blue, with green and gray-blue rocks, green and gold trees, red palm trees and flowering shrubs, and, at the far right, a small fence. The water is shown by wavy red lines, swirling at the ends of the boat, around the piles, and at the front of the island. Again, the details of no. 52b are more precise than those of no. 52a, so that the feeling for the form of the boat, the movement of the birds, and the form of the houses and rocks is more successfully conveyed.

The glaze has a slight orange-peel texture, and there are scattered, minute black imperfections and some evidence of the flowing of the colors, especially the copper green, under the gold outlining and ornamental hatching. The foot rings, which are set back under the lower gadrooned molding, are unglazed, perhaps intended for mounting in metal or wood. The pieces show a greenish translucency, with moons, by transmitted light.

These pieces were sold in Paris in 1967 as a "paire de petits cache-pots," rare, eighteenth century, with reference to a similar "cache-pot" in the Chavagnac sale, June 1911, lot 82, which had been in the Dupont Auberville (1891) and Montigny (1899) collections; reference was also made to the Watelin collection and the du Sartel collection (June 1894). The sale of the late M.O. du Sartel took place at the Hôtel Drouot, Paris, June 4-9,

1894,[2] and the "paire de cache-pots" sold as lot 159, formerly in the Watelin collection, might be these two *seaux*. The "cache-pot" sold as lot 82 of the collection of M. le Comte X. de Chavagnac, Hôtel Drouot, Paris, June 19-21, 1911, was illustrated, but comparison of the details of the painting indicate that it is not the single example now in the Metropolitan Musuem of Art, New York.[3] It was lent by Mme. Henri Decloux to the French porcelain exhibition in Paris,[4] but its present location is unknown at the time of this writing.

The examples of this model with the earliest recorded provenance would seem to be the pair in the Museo Duca di Martina (inv. nos. 2121, 2127).[5] At least three additional pairs have been located; but since none have a provenance as early as the du Sartel sale of 1894, any of them might also be the du Sartel pieces. In order of the dates of their earliest located publication, these are: (1) the pair in the Cleveland Museum of Art (44.226, 227), ex collection J. Pierpont Morgan, purchased from the J.H. Wade Fund;[6] (2) the pair in the Mr. and Mrs. Jack Linsky collection (given in 1983 to the Metropolitan Museum of Art);[7] and (3) the pair formerly in the collection of Mrs. Charles E. Dunlap,[8] which has not yet been located but must be counted as an addition to the list. We can conclude, therefore, that twelve of these *seaux* have survived into the twentieth century, seven more than were known to Chavagnac and Grollier in 1906.[9]

Also in the Dunlap sale were two related pieces, illustrated in the same plate. Lot 232 was sold as a *seau à bouteille,* although only 17.2 cm. (6¾ in.) high.[10] This piece, the only one so far located, has lion-mask handles but otherwise has the same decoration as the Markus *seaux à liqueur*. It was illustrated as early as 1911, side by side with the tureen mentioned in note 1, when it was lent by M. Félix Doistau to a special exhibition of chinoiserie.[11] The central figure at the right in this larger version is more eminent and worthy of his identification as a "mandarin," as he was called in the Dupuy sale (see note 11). Lot 234 in the Dunlap sale was a *pot de crême* and cover with different but related landscape and figural decoration and bearing an incised St C / T mark. The very similar covered cup in the Musée National de Céramique, Sèvres, was depicted from both sides by H. P. Fourest, who, classifying these as from the second period of production at Saint-Cloud, with a whiter glaze and flatter gold, in the "style Japonais," calls the decoration "au chinois" and "à la pagode."[12]

The scenes on these coolers have many of the same elements of design as the engravings by Jean-Antoine Fraise, chief designer of Louis-Henri de Bourbon, Prince de Condé (1692-1740) at

52a. *Detail*

Chantilly, which were based on oriental fabrics, lacquers, and porcelains in the prince's collection and published as *Livre de dessins chinois* (Paris, 1735).[13]

Coolers with the same grimacing head as handles were also produced at Saint-Cloud about 1725 in white with relief decoration reminiscent of the *blanc-de-Chine* porcelains of Fujian (Fukien) province made during the Ming dynasty. A pair of *seaux à rafraîchir* at the Musée National de Céramique, Sèvres (inv. 13.377[1-2]), are of this same small size,[14] but similar models were produced in the larger size.[15] With their reeded lower section, these white coolers closely resemble two depicted by Nicolas Lancret (1690-1745) in his *Le déjeuner de jambon*, painted in 1735 for the *petits appartements* at Versailles and now in the Musée Condé, Chantilly. A small version of the painting is in the Forsyth Wickes Collection at the Museum of Fine Arts, Boston.[16]

It was only in the nineteenth century that this form came to be called a *cache-pot* (literally, a flower-pot cover) or, in England, a flower pot or jardinière.[17] Most of the publications noted here, with the exception of the 1910 and 1944 Morgan catalogues, the Naples catalogue, and the Dunlap sale, have used the name now known to be erroneous in reference to eighteenth-century usage. Chavagnac, in cataloguing the pair of coolers in the Morgan Collection, called them "seaux à rafraîchir, pour bouteilles à liqueurs." Although he does not refer to it, he was probably basing his identification on the list of "Porcelaines de Saint Cloud" announced for sale in Paris in 1731; it included "grands Sceaux à rafraichir du vin & des Liqueurs."[18] The form was refined later at Vincennes and Sèvres, where coolers were produced in four sizes.[19] It appears, however, on the basis of the limited eighteenth-century documentary evidence available, that the Markus examples were probably designed and used for cooling liqueur bottles.

V.S.H.

NOTES

1. The same figures, but reversed, are at the right on both the bowl and cover of a Saint-Cloud tureen in the Musée des Arts Décoratifs, Paris; see Jacques Guérin, *La Chinoiserie en Europe au XVIIIe siècle* (Paris, 1911), pl. 54; Claude Frégnac, ed., *Les Porcelainiers du XVIIIe siècle français* (Paris, 1964), illus. p. 74.

2. I wish to thank Mme. Hallé of the Musée National de Céramique, Sèvres, for providing a copy of this catalogue entry.

3. Gift of R. Thornton Wilson, 1950, in memory of Florence Ellsworth Wilson. The piece was exhibited at the Metropolitan Museum of Art in 1949; see C. Louise Avery, *Masterpieces of European Porcelain*, no. 141. See also George Savage, *Seventeenth and Eighteenth Century French Porcelain* (London, 1960), pl. 7a; George Savage, *Porcelain through the Ages* (London, 1954), pl. 38b; Louise Ade Boger, *The Dictionary of World Pottery and Porcelain* (New York, 1971), fig. 343.

4. Pavillon de Marsan, Palais du Louvre, Paris, *La Porcelaine française de 1673 à 1914: La Porcelaine contemporaine de Limoges* (1929), no. 96.

5. Maria L. Casanova, *Le Porcellane francesi nei musei di Napoli* (Naples, 1974), pl. 4 (color), p. 69; see also p. 59, where it is stated that Placido di Sangro duca di Martina (1829-1891) acquired his French porcelains in Paris on a visit between 1866 and 1869, mainly from sales at the Hôtel Drouot.

6. Comte Xavier de Chavagnac, *Catalogue des porcelaines françaises…J. Pierpont Morgan* (Paris, 1910), no. 2, pl. 2 (color); Parke-Bernet, New York, sale catalogue, pt. 2, March 22-25, 1944, lot 638, p. 166; Helen S. Foote, "Early French and German Porcelain Formerly in the J. Pierpont Morgan Collection," *Bulletin of the Cleveland Museum of Art* 31 (Nov. 1944), 166; Helen S. Foote, "Soft-paste Porcelain in France," *Art Quarterly* 11, no. 4 (1948), fig. 9, p. 340; Cleveland Museum of Art, *Handbook* (1966), p. 134; California Palace of the Legion of Honor, San Francisco, *Cathay Invoked* (1966), no. 59; Herman Jedding, *Europäisches Porzellan, vol. 1* (Munich, 1971), fig. 827.

7. Ruth Berges, *Collector's Choice of Porcelain and Faïence* (South Brunswick, N.J., and New York, 1967), fig. 27; Christie's, London, sale catalogue, Oct. 28, 1963, lot 105, illus.; these may be the examples lent by M. X. to the 1929 exhibition in Paris (see note 4), no. 129.

8. Sotheby Parke Bernet, New York, sale catalogue, Dec. 3-6, 1975, lot 233, illus. (color); reference is made, in error, to the single example in the Metropolitan Museum of Art as being from the Morgan collection; as provenance, the Gilbert Lévy collection, Paris, is cited, but these were not the examples in the 1967 sale.

9. Comte Xavier de Chavagnac and Marquis G. de Grollier, *Histoire des manufactures françaises de porcelaine* (Paris, 1906), p. 21.

10. See no. 60 for a pair of Vincennes wine coolers of the same size.

11. Subsequently it was no. 33 (illus.) in the sale of the collection of M. Félix Doistau, June 18-19, 1928, Galerie Georges Petit, Paris; later, lot 384 (two views illus.), sale of the collection of Mrs. H. Dupuy, April 2-3, 1948, Parke Bernet, New York; exhibited at the Metropolitan Museum of Art, New York, March 18-May 15, 1949; see Avery, *Masterpieces of European Porcelain*, no. 142. The Sotheby Parke Bernet sale catalogue of Dec. 3-6, 1975, was in error in placing this piece in the former Dupont Auberville, Montigny, and Chavagnac sales.

12. Henry Pierre Fourest, "Sur l'apparition de la polychromie dans la porcelaine française," *Cahiers de la céramique du verre*

et des arts du feu 19 (1960), color pl. p. 177 and fig. 1, p. 175.

13. Chantal Soudée-Lacombe, "Grande époque des faïences de Sinceny (1737-1765)," *Cahiers…* 36 (1964), 224-253; see the reproduction of folio 54, fig. 2, p. 227.

14. "Catalogue of the exhibition of Ceramics of France from the Middle Ages to the Revolution," *Cahiers…* 48-49 (1971), no. 116, illus. p. 111.

15. A pair, 19.4 cm. (7 5/8 in.) high, and marked, were sold at Sotheby Parke Bernet, New York; see sale catalogue, Oct. 15-16, 1980, lot 347, illus.

16. Frégnac, *Les Porcellainiers*, illus. p. 55: detail of large painting; Perry T. Rathbone, *The Forsyth Wickes Collection* (Boston: Museum of Fine Arts, 1968), p. 19, color illus. of small version.

17. Carl C. Dauterman, *The Wrightsman Collection*, vol. 4 : *Porcelain* (New York: The Metropolitan Museum of Art, 1970), pp. 446-447; also p. 226, where reference is made to a piece like a Vincennes example used as a cache-pot on the mantle in Ingres's portrait of the Comtesse d'Haussonville, painted about 1840-1845, and now in the Frick Collection, New York.

18. Chavagnac and Grollier, *Histoire*, p. 32.

19. Svend Eriksen, *The James A. de Rothschild Collection at Waddesdon Manor: Sèvres Porcelain* (Fribourg, 1968), p. 74; Grand Palais, Paris, *Porcelaines de Vincennes: Les Origines de Sèvres*, catalogue by Antoinette Faÿ Hallé and Tamara Préaud (1977), p. 98; see also no. 60 in the Markus Collection.

53 *Snuffbox*

France, attributed to Saint-Cloud, about 1750

Soft-paste porcelain (*pâte tendre*) decorated in polychrome enamels, with silver mounts

Mark:
(1) on silver mount, struck: head of a hen, discharge mark of Julien Berthe (1750-1756) (not illustrated)

H. 5.7 cm. (2¼ in.), w. 8.2 cm. (3¼ in.), d. 6.2 cm. (2⁷⁄₁₆ in.)

1983.633

The creamy white paste was press-molded in the form of an oval basket with two rope handles at the ends, a double rope molding at the top and a single one at the bottom. It is possible that the details of the rope and of the wicker were hand-tooled, as was also the radiating wicker pattern on the recessed base; this is centered by an oval pad, painted to represent a flower in the Imari style. The oval top, molded separately, has a bouquet of flowers, including a rose, in relief. The enamel palette is limited to iron red, an opaque medium blue, a

53

53. *Interior of cover*

53. *Base of box*

translucent turquoise green, and a pale yellow. On the cover, the rose is yellow, the larger flowers blue with a red center, and red and white striped with a yellow center, the leaves are green, and all are outlined and detailed in red. The upper rope moldings and the handles are green, the lower one yellow, all also with red outlines. The oval rosette on the bottom has a blue center, surrounded by red, then by alternating blue and green petals. On the inside of the lid is a scene showing a Chinese man, wearing a broad-brimmed hat, standing in a flower garden. The scene is painted in the same four colors and finely delineated in red; the man's garments are yellow, red, and blue. There is an insect above, and another inside the lower part of the box. The colors are similar to those on the seaux, no. 52, but are applied with a minimum of brushstrokes to a very thin glaze so that they do not sink into it or tend to flow.

The silver mounts are molded and fitted over the edges of the porcelain; a wavy, or fluted, ridge on the upper edge of the lower part emulates the same refinement found on early gold boxes. A shaped thumbpiece balances the projecting hinge, which is of the type characteristic of early gold boxes up to about 1735.[1]

This piece was acquired as an example of Saint-Cloud porcelain, but snuffboxes of this oval basket form were produced at both Chantilly[2] and Mennecy as well. Those attributed to Mennecy are more numerous; they seem generally to be smaller, to have a different arrangement of the flowers in relief and sometimes a different pattern to the basketry.[3] A variant in the Firestone Collection has a wicker top rather than flowers in relief.[4] A snuffbox in the collection of the Museo Duca di Martina, Naples, is about the same size as this example, but the roping of the upper border is reversed, the reeding of the sides much less precise, and the floral bouquet inside the lid more in the Mennecy style, as it is catalogued.[5]

The chinoiserie painting on the inside of the lid of no. 53 is not unlike that of Chantilly,[6] but one finds it also at Saint-Cloud in the second quarter of the eighteenth century.[7]

It seems reasonable to date this box by the silver discharge mark of 1750-1756, applied to confirm the payment of the government tax on the finished silver mount. It would then fall at the very end of the period in which Saint-Cloud is known to have produced snuffboxes.[8]

There is a gold and enamel box at the Musée du Louvre, attributed to Paris, about 1750, which is modeled as an open-plaited strawwork basket heaped to the brim with fruit.[9] The fruits

on the top and bursting through the sides are enameled in natural colors on the gold. The Paris goldsmiths did not often turn to such fantasies, but the porcelain factories, as Saint-Cloud advertised in 1731, produced "Tabatières de toutes sortes de contours, garnies & non garnies."[10]

V.S.H.

NOTES

1. A. Kenneth Snowman, *Eighteenth Century Gold Boxes of Europe* (Boston, Mass., 1966), p. 54.

2. The only example I have been able to locate was in Christie's (International), Geneva, sale catalogue, May 7, 1979, lot 207, illus.

3. Cf. collection of M. Félix Doistau, Galerie Georges Petit, Paris, sale catalogue, June 18-19, 1928, lot 83, illus.; William Bowyer Honey, *French Porcelain of the 18th Century* (London [1950]), pl. 50H (one of two examples in the Joicey Collection at the Victoria and Albert Museum); collection of Mrs. Alan L. Corey, Sotheby Parke Bernet, New York, sale catalogue, June 11, 1975, lots 135, 137, illus.

4. Clare Le Corbeiller, *European and American Snuff Boxes, 1730-1830* (London, 1966), fig. 531.

5. Maria L. Casanova, *Le Porcellane francesi nei musei di Napoli* (Naples, 1974), no. 50, illus.

6. Cf. Le Corbeiller, *Snuff Boxes*, figs. 524, 525, 527.

7. Honey, *French Porcelain*, pl. 17B,C; Sotheby Parke Bernet, London, sale catalogue, Oct. 6, 1981, lot 137.

8. Le Corbeiller, *Snuff Boxes*, p. 69.

9. Henry and Sidney Berry-Hill, *Antique Gold Boxes: Their Lore and Their Lure* (New York, 1953), illus. 8.

10. Le Corbeiller, *Snuff Boxes*, p. 69; Comte Xavier de Chavagnac and Marquis G. de Grollier, *Histoire des manufactures françaises de porcelaine* (Paris, 1906), p. 32.

54 Two pagods

(*Magots de la Chine*) mounted as candlesticks

France, Chantilly, about 1730-1740

Soft-paste porcelain (*pâte tendre*) decorated in polychrome enamels and gold (probably later), with ormolu mounts

Unmarked

54a: h. 14.5 cm. (5 11/16 in.), without mounts: h. 10.8 cm. (4¼ in.), w. 13 cm. (5¼ in.), d. 9.8 cm. (3⅞ in.); 54b: h. 15.5 cm. (6¼ in.), without mounts: h. 10.8 cm. (4¼ in.), w. 12.4 cm. (4⅞ in.), d. 9.8 cm. (3⅞ in.)

1983.634a,b, 635a,b

Provenance: Purchased, Paris, November 1966

The two figures, each of a rotund, seated or squatting Chinese man, with a shaved head, grinning mouth, and long earlobes, are pressed from the same two-part mold. The hands, the left holding a peach, the right resting on the right knee, are modeled separately and inserted into holes in the full sleeves of the loose robe, which falls open in front to reveal the bare chest and belly. The bare toes of both feet are visible under the folds of the edge of the robe (no. 54a has only four toes on the right foot). The flesh areas are naturalistically colored and shaded. The eyes are blue. The robe is painted with scattered flowers in puce, yellow, blue, green, and gold on a ground irregularly dotted in black; the border of the robe around the neck and front is puce, with a conventional pattern in gold of striped triangles; the same gold pattern, but on white, borders the full sleeves. A mottled pale turquoise is painted inside the sleeves and as a belt at the back. A cushion at the back, with incised and impressed straw-like ornaments, is painted dark green. On both pieces a crescent-shaped cut was made on the cushion to fit the bronze trunk of the candle branches, and the color was clearly applied after the cut. The porcelain flowers, which are enameled light blue, are probably contemporary with the nineteenth-century mounts.

These figures seem to have been modeled after representations of the popular Buddhist cult figure, emblematic of good luck or good fortune, known as Budai (Pu-t'ai) in China, Ho-tei in Japan. A manifestation of the Buddha of the Future, Maitreya, the figure is usually dressed as a Buddhist monk and is seated cross-legged, or with the right knee bent and the left leg crossed so that only the right foot is visible. He is always depicted with the long earlobes characteristic of all Buddhist deities.

A single figure from the same mold, in white, on a similar ormolu base with two candle-sockets and white porcelain flowers, was sold at auction in London in 1974; called a "magot," he held a peach in his left hand and a spray of flowers in his right.[1] The English term *magot* is defined as "a small grotesque figure of Chinese or Japanese style or workmanship."[2] The word derives from the French *magot*, which is used especially for grotesque figures in porcelain; Larousse gives as an example a quotation from Georges-Louis LeClerc de Buffon (1707-1788): "Des magots de la Chine. Le goût pour les magots est le dernier degré de la stupidité."[3]

Both the English term *pagod* and the French *pagode* derive from the Portuguese *pagode*. In France the term is used for both the temple itself and the idol adored within it, with a

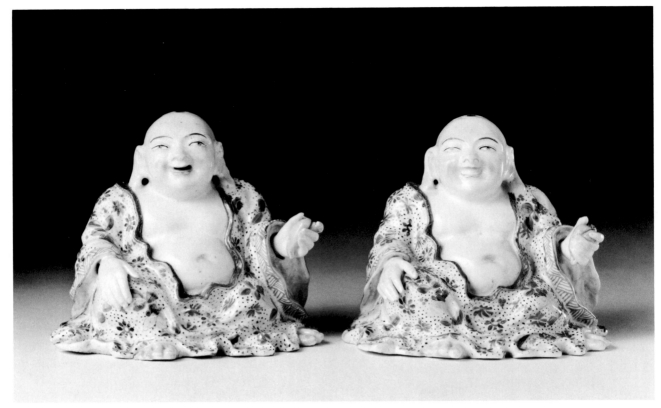

54

54

54b. *Fitting for mount*

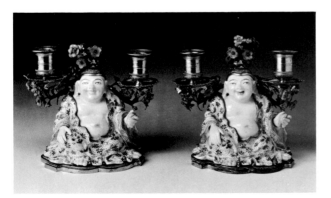

54b,a. *With ormulu mounts*

second meaning: "petite figure chinoise en porce-laine, qui remue la tête: magot de la Chine."[4] The Paris merchant Lazare Duvaux handled both *pa-godes* and *magots,* mentioning the former thirty-five times and the latter fifty in his *Livre-Journal.*[5] Most of these figures were Chinese and were in all likelihood versions of Budai, which, in spite of their rather repulsive aspect, were so greatly ad-mired that they became one of the symbols of chi-noiserie, in France at least.[6] One can be seen on a shelf in the painting *Le Déjeuner* by François Boucher, for example.[7]

Chantilly produced other versions of seated Chinese figures. In one a grinning pagod is sitting with a jar between his feet, his hands on his knees,[8] and in another, in the George R. Gardiner Mu-seum of Ceramic Art, Toronto (G 83.1.1069), he has a globe between his feet, and his hands are raised.[9] All of these are painted in Kakiemon style.

When the Markus figures were mounted, circular holes were drilled into the tops of the heads to accommodate the shaft of the ormolu caps, which fasten through the bases. Also, each figure was marked in puce on the unglazed inte-rior, no. 54a with a large numeral 3, no. 54b with a cross. The ormolu mounts have corresponding in-cised marks (III and +) at the base of the tree trunks.

<div align="right">V.S.H.</div>

NOTES

1. Sotheby Parke Bernet, London, sale catalogue, July 2, 1974, lot 195, illus.

2. *Webster's Third New International Dictionary of the English Language* (1961), s.v. "magot."

3. Pierre Larousse, *Grand dictionnaire universel* (Paris, 1866), s.v. "magot."

4. Ibid., s.v. "pagode."

5. Lazare Duvaux, *Livre-Journal de Lazare Duvaux, marchand-bijoutier ordinaire du Roy 1748-1758,* ed. Louis Courajod (Paris, 1873), vol. 1, index.

6. Oliver Impey, *Chinoiserie: The Impact of Oriental Styles on Western Art and Decoration* (London, 1977), p. 96.

7. Musée du Louvre, Paris.

8. William Bowyer Honey, *French Porcelain of the 18th Cen-tury* (London [1950]), pl. 28B; Robert J. Charleston, ed., *World Ceramics* (New York, 1968), fig. 663; Helen S. Foote, "Soft-Paste Porcelain of France," *Art Quarterly* 11, no. 4 (1948), fig. 2, p. 337.

9. Christie's, London, sale catalogue, April 6, 1981, lot 29, illus. (color), also with blue eyes. Reference is made to the similar pair in the Sydney J. Lamon collection: Christie's, London, sale cata-logue, Nov. 29, 1973, lot 49, illus. (color); these are of interest in having ormolu rather than porcelain hands. Another similar figure was sold at Sotheby Parke Bernet, New York, Feb. 27, 28, March 1, 1975, lot 560, illus., but it was made in the nineteenth century by Samson, Paris.

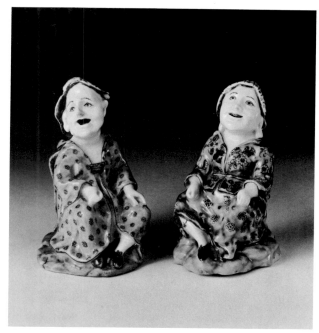

55

55 Two grotesque figurines

(Magots)

Plate XIII

France, Mennecy, about 1740

Soft-paste porcelain *(pâte tendre)* decorated in polychrome enamels

Marks:
(1) 55a: inside figure, in black (unglazed): ·D·V·
(2) 55b: inside figure, in black (unglazed): ·D·V·

55a: h. 11.4 cm. (4½ in.), w. at base 7.1 cm. (2¹³⁄₁₆ in.), d. at base 7.5 cm. (2¹⁵⁄₁₆ in.); 55b: h. 11.1 cm. (4⅜ in.), w. at base 6.6 cm. (2⅝ in.), d. at base 7.6 cm. (3 in.)

1982.778, 779

Published: Hôtel Drouot, Paris, sale cata-logue, Gilbert Lévy Collection, Nov. 23, 1967, lot 64, illus. (black and white and color); *Connoisseur* 168 (May 1968) 43, fig. 4, illus. of 55b; Museum of Fine Arts, Bos-ton, *Annual Report,* 1982-1983, p. 27, illus.

Provenance: Colls. Abbé Samson, Cayeux sur Mer (Somme); Gilbert Lévy, Paris (sale, Hôtel Drouot, Paris, November 23, 1967)

The two figures, a man and a woman, are seated on grassy mounds. They have the large heads and

small hands and feet of dwarfs, and the woman has elongated earlobes. They are press-molded with heads, hands, and legs refined by the repairer. The man, no. 55a, wears a long, mustard yellow, one-piece garment open at the front, with wide sleeves and a double clasp at the chest; it is edged with an iron-red line and decorated with an allover pattern of small red sunbursts. The clasp is pale manganese purple with red star-like designs. At the back, a powdered manganese purple cape falls from under the collar to the ground. On his head is a cap that falls loosely from his forehead back to the top of his collar; it has a molded red and black feather at the top front. Lined with red, the cap has a pattern of red sunbursts set in diamonds, intersected by white stripes outlined in black. The man wears manganese purple shoes with a red bow visible on the left. The inside of his lower lip is red, and his eyes, like those of his companion, are defined in black; the brows are a series of curved lines, a double line defines the upper lid, the pupil is encircled with dots, and the lower part of the eye is dotted. The mounds on which the figures are seated were painted with an underglaze yellow, visible in areas at the lower edge that are bare of glaze, and the glaze, slightly bluish, has given it a green color, darker where it has pooled in crevasses.

The woman, no. 55b, wears a two-piece garment. The belted jacket, open at the front, has wide sleeves and a slit at the back; also colored with underglaze yellow, turned greenish by the glaze, it has an allover pattern of sprays of chrysanthemums and scrolling leaves in red, yellow, blue, and green, delineated in red and black, and there is a thin red line at all the edges. The woman's skirt, pulled up to reveal her right leg almost to the knee, is turquoise green with scattered five-petaled florets outlined in red and smaller red sunbursts. Her cap, which appears to have a scalloped edge at the forehead, ends in two points over the collar at her back. It has a three-lobed red knop at the crown and is white with rows of red sunbursts and dotted florets, divided by black wavy lines; it is also lined in red. Her visible shoe is black with a red bow, and she wears a red garter below her knee. Her open mouth is defined inside with red, suggesting a tongue.

The slightly opaque quality of the glaze where it pools in some areas (e.g., on the yellow garment of the man) may indicate that the glaze contains tin oxide. Some writers have mentioned the occasional presence of tin in the early period at Mennecy. The interiors are unglazed and show the creamy color of the paste. There are a few spots where the glaze has run through openings onto

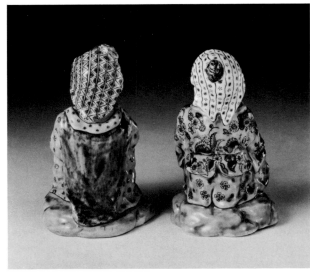

55

55 (1) 55 (2)

the inside. The mark is probably in cobalt blue, which looks black when not combined with the glaze materials. There are a few fire cracks conforming, mainly, with the line where the two molded sections were joined. Both pieces have suffered some damage, which is evident in the photographs: the tip of the nose of the man, no. 55a, has been restored, and there is a chip in his cap just over his left ear; there is a chip on the edge of the woman's cap just to the right of her right eyebrow, and another larger one, not visible on the photographs, inside the left tail of her cap.

Pieces of this type were intended for mounting in ormolu as candelabra or other decorative items. A figure very like the woman in attitude, but apparently male and wearing a different garment and no cap, was mounted as one of a pair of candelabra with rococo ormolu bases and soft-paste porcelain flowers.[1] Two other figures in related attitudes are in the Musée des Arts Décoratifs, Château de Saumur.[2] Some of these may be from the same basic mold, but each is different in the facial details and in the positioning of the hands and feet. None of the others, for example, display the same amount of leg as the Markus pair.

The dating of these pieces is tentative. The relation to faience technique suggests that they may be of the "première époque" (as catalogued in the Lévy sale),[3] that is, from the early years of the factory in Paris before the transfer to Mennecy. The figures in Saumur, however, are published as the second half of the eighteenth century in the guidebook and as about 1760 by Landais.[4]

Gilbert Lévy (1884-1944) was a Paris collector and dealer who lent generously to the 1929 exhibition at the Louvre (105 pieces)[5] and the 1934 exhibition at the Musée National de Céramique, Sèvres (35 pieces).[6] He was a member of the organizing committee of the latter exhibition, and in both catalogues he advertised his shop at 38, Rue de Penthièvre. His valuable assistance in research and cataloguing was particularly recognized in 1929. The catalogue of the 1967 sale of the pieces he had retained, many now in museum collections, was introduced with a tribute to his exceptional knowledge and refined taste, comparing the quality of the assembled pieces with the 1911 sale of the collection of the Comte X. de Chavagnac.

V.S.H.

NOTES

1. Christie's, London, sale catalogue, June 3, 1974, lot 8, the property of R. Alistair McAlpine, Esq.

2. Château de Saumur, *Le Musée des Arts Décoratifs* [guidebook, 1980?], pl. LXXXI (both figures); Hubert Landais, *La Porcelaine française XVIIIe siècle* (Paris, 1963), pl. XIV (one figure).

3. Hôtel Drouot, Paris, sale catalogue, Nov. 23, 1967, lot 64.

4. See note 2.

5. Pavillon de Marsan, Palais du Louvre, Paris, *La Porcelaine française de 1673 à 1914: La Porcelaine contemporaine de Limoges* (1929).

6. Musée National de Céramique, Sèvres, *La Vie française illustrée par la céramique* (1934).

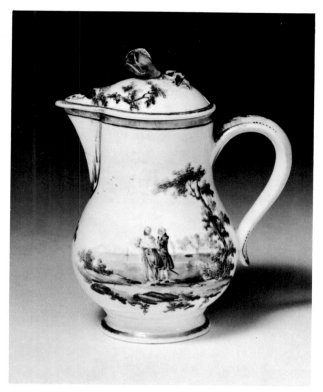

56

56 *Water jug and cover*

(*Pot à eau*)

France, Sceaux, about 1765-1770

Soft-paste porcelain (*pâte tendre*) decorated in polychrome enamels and gold

Mark:

(1) on base of jug, incised: S·X

H. 12.2 cm. (4¹³⁄₁₆ in.), w. 9.7 cm. (3¹³⁄₁₆ in.), diam. at rim 4.9 cm. (1¹⁵⁄₁₆ in.)

1983.636a,b

Provenance: Purchased, Paris, 1961

The pot, pear-shaped with a pedestal foot, has been thrown on a wheel. The V-shaped spout and plain C-shaped handle were applied opposite each other. The low-domed cover, which has an extension (broken and repaired) covering the spout, has a modeled rosebud finial with a stem and two leaves. The decoration on each side consists of a lady and a gentleman wearing powdered wigs and high-fashion garments, standing on the shore of a lake. The foreground on both sides is yellow, with brown rocks and blue-green shrubs and trees; in the background are houses with towers, sailing vessels, and distant mountains. On the obverse, the

56 (1)

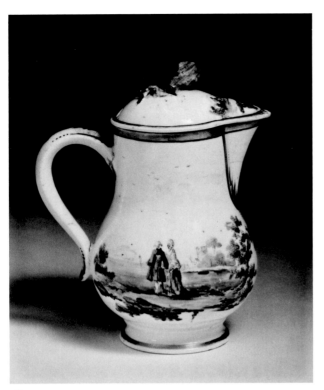

56

with a diamond-shaped flaw inside the spout. The circular hole on the lid opposite the spout is glazed and may have been for escaping steam or for attaching a hinge.

A lidded jug very similar in form and size to no. 56 but with different painting is in the Musée National de Céramique, Sèvres (inv. 23.255), from the Morel d'Arleux bequest. According to H.P. Fourest, it "belonged to a tea-service and was for holding water."[1] He comments on the strong similarity of the palette to that of Mennecy, because at that time Mennecy artists were working at Sceaux. On view at the Musée National de Céramique, Sèvres, are two other pieces from the same bequest with painting very similar to that of no. 56. One is a jug of the same shape (inv. 23.254), and the other is a covered cream custard pot (inv. 23.256).

<div style="text-align: right">V.S.H.</div>

NOTE

1. Henry Pierre Fourest, *French Ceramics,* Masterpieces of Western and Near Eastern Ceramics, vol. 6 (Tokyo, 1979), pl. 82 (color); the piece is decorated with birds rather than figures in landscapes.

lady holds a white fan and wears a white shawl, a long yellow skirt and a pink sacque gathered at the back. The gentleman wears a bag wig, indicated by the black ribbon; his coat is blue, his stockings white, and he wears a sword. On the reverse, the gentleman is seen from the back, again wearing a bag wig; he carries a black hat under his arm and is wearing a green coat, white stockings, and a sword. The lady, in three-quarter view, wears a pink gown with a blue skirt over panniers and a white shawl. On the cover a fisherman, in a black hat and pink shirt, is seated on the shore. There are many minute black birds and pale blue clouds in the sky in all three scenes. The rosebud finial is dark pink (repaired), and the leaves are green, shaded with yellow, with brown veins. A bright blue enamel was used to enrich the handle and lower part of the spout, as well as to outline the gold band at the rim and on the cover. A gold band outlines the spout, and there is a plain gold band on the foot, a three-pointed gold ornament under the upper attachment of the handle, and five gold diamonds along the outer side of the handle.

The porcelain is very white, with tiny black specks throughout. It has a creamy white translucency with pinpricks of light. There are fire cracks at the upper and lower attachments of the handle and a crack across the midsection of the spout,

VII Vincennes and Sèvres Porcelain

The founding date of the porcelain factory that was to become the Manufacture Royale de Sèvres (later the Manufacture Nationale) is given as 1738, although the earliest productions could not have dated from before 1741-1745. In 1738 two deserters from the Chantilly factory, Gilles Dubois, a sculptor, and his brother Robert Dubois, a *tourneur,* claiming to know the secret of porcelain manufacture, were given quarters in a tower of the royal castle at Vincennes, to the east of Paris, to pursue their experiments. Jean-Louis Orry de Fulvy (1703-1751), royal Intendant des Finances, who had been concerned about the French monies spent on Meissen porcelains, dreamt of establishing a rival production in France. He advanced large sums toward the research over the next three years and even borrowed money from King Louis XV. There were no satisfactory results until the intervention of a friend of the Dubois from Chantilly, François Gravant. Formerly a *faïencier,* Gravant took over the Dubois brothers' tests and succeeded in producing soft-paste porcelain at Vincennes in 1741.

More experimentation followed as the young factory spread out in the precincts of the Château de Vincennes during the next four years, increasing to about twenty workers. In 1745, to finance the manufacture, a stock company was formed in the name of Charles Adam, *valet de chambre* of Orry de Fulvy, and a royal patent assured the company exclusive license for twenty years to produce "porcelain in the manner of Saxony, that is, painted and gilded with human figures." A monopoly on the production of porcelain flowers soon followed, and by 1749 the company employed over one hundred workers, about half of whom were women who modeled the flowers.

In 1752, owing to its poor financial situation, the Compagnie de Ch. Adam was disbanded; a new company was formed under the name of Eloy Brichard and took over all the privileges. Louis XV acquired a quarter interest in this company, organized by royal decree 19 August 1753, and the interlaced Ls of the Manufacture Royale, which had been used earlier, became the official mark. From that year an annual date letter was usually added within the royal cipher, beginning with A and going through the alphabet, then continuing from AA in 1778.

As early as 1751 it was evident that the manufacture was outgrowing the accommodations at Vincennes, and the decree of 19 August 1753 also announced the plans for a new factory. This was to be built at Sèvres, to the west of Paris on the road to Versailles, near the new Château de Bellevue of Madame de Pompadour, the favorite of the king and a great connoisseur of porcelain. Construction took three years, and the move to Sèvres was made in stages throughout the summer of 1756.

The years between 1745 and 1756 at Vincennes were a period of great artistic and technical vitality in which the scope, personality, and success of the production were established. About 1750 the 110 workers were divided into seven studios: one for making the paste, one for turning, one for molding, one for putting on handles and spouts, one for sculpture, one for painting, and one for flower making. Each was under the direction of a master craftsman, and, as the factory was under royal jurisdiction, these included some of the best artists in France at the time. The spirit of the entire production tended to avoid the awkward and trivial in porcelain designs in favor of the fine and light, the new and diverse.

In spite of the artistic success of the factory, it continued to be a financial disaster for the investors. Three years after the move to the new building, the Brichard company was dissolved, and by a decree of 17 February 1760, the Manufacture Royale de Sèvres passed entirely under the authority of the king. The latest pieces in the Markus Collection, 1761, suggest that the trend toward richness and originality in forms and decoration continued while the high quality of workmanship was maintained.[1]

V.S.H.

NOTE

1. Most of the standard reference books on Vincennes-Sèvres are included in the notes for nos. 57 to 69. The most recent publication, by the Manufacture Nationale de Sèvres, *La Porcelaine de Sèvres* (Paris, 1982), has also been consulted in the preparation of these introductory remarks. It covers the history of the factory to the present day and also gives a concise account of the technology, with valuable addenda including brief biographical notes on persons cited, a list of heads of departments since 1745, technical terms, a bibliography, and a list of exhibitions.

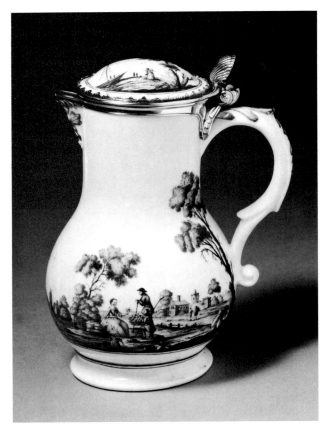

57

57 *Water jug and cover*

(*Pot à eau ordinaire*)

Plate XIII

France, Vincennes, about 1750

Soft-paste porcelain (*pâte tendre*) decorated in polychrome enamels, with silver mounts

Unmarked

H. 16.7 cm. (6⁹⁄₁₆ in.), h. without cover 14.8 cm. (5¹³⁄₁₆ in.), w. 13.5 cm. (5⁵⁄₁₆ in.), diam. at base 7.3 cm. (2⅞ in.)

1982.776a,b

Published: William Bowyer Honey, *French Porcelain of the 18th Century* (London [1950]), pl. 56.

The pear-shaped body with a splayed foot was thrown, apparently in two sections, and turned. The small, beak-shaped spout is ornamented with foliage in relief. The handle, opposite the spout, is molded in S-scroll shape and has a leaf in relief at the shoulder and a scroll terminal. The pot has sagged slightly, below the handle, in the firing.

Rose-pink (carmine) enamel has been used to enrich the spout and handle and for bands on the lid and lower body. A continuous landscape with figures is painted in polychrome enamels around the belly. Reading from left to right from the handle, we see a well house with a moss-grown peaked roof; a lake or river with a water wheel; a bridge with three arches and a castle-like structure; a fisherman seated on a mound in the foreground; a man poling a skiff, with a windmill in the background; bushes and a tree under which is seated a lady in a pink gown, holding flowers in her left hand; a man kneeling before her, presenting her with a basket of flowers, his hat on the ground with his bagpipes; another man, standing, leaning on his staff; two men standing in the middle distance, with two houses in the background; finally, to the left of the handle, a large tree with a broad-leaved plant at its base.

The circular cover is similarly painted in polychrome enamels with a harbor scene: a ship with two figures is at the left in the background, with two other figures next to it on the shore; in the middle ground are two larger figures of a man and a woman; at the right, in the far distance, is a castle, and in the foreground are a tree and a tree stump.

The silver mounts, which are unmarked, are very well worked, with chased dentils holding the circular porcelain lid; there are foliate details where the mount fits the beak-shaped spout; the thumbpiece is in the form of a delicate shell, and there is a bold scroll socket for the unusual ball-shaped hinge; the sleeve gripping the handle is saddle-shaped with a cascading loop decoration, instead of being wrapped around the handle in the more usual fashion.

This piece relates in form and approximate size to two water jugs (*pots à eau ordinaire*) shown in the 1977 exhibition of Vincennes porcelain at the Grand Palais, Paris.[1] In the Sèvres Archives it is recorded that these were made in four sizes (the ex-

57. *Cover*

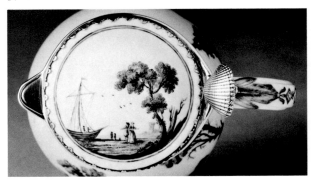

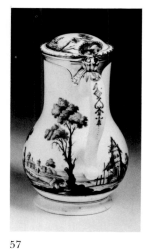

57 57

hibited pieces were about 4 cm. [1½ in.] higher than the Markus example) and would have been accompanied by either round or oval basins. In the same Grand Palais exhibition were milk jugs (*pots à lait*), slightly smaller but similar in form.[2]

When published in 1950 by W. B. Honey (see above), this piece was identified simply as a "jug." It was incorrectly described as "gilt" with "mark, crossed 'L's' in blue." A very similar piece, formerly in the Chavagnac collection,[3] was published by Honey in 1949 as a "milk-jug";[4] it was then in the collection of Mme. de Mandiargues, Paris. In 1979 the Chavagnac jug, now in a private collection in England, was sold at auction at Christie's, Geneva, as "ewer and cover,"[5] the designation it had carried in the Chavagnac sale in 1911 (*aiguière*). The Christie's catalogue entry refers to the Markus piece as "almost identical" and, wrongly, as the piece illustrated by Honey in 1949. Another very similar jug, without a cover, is in the David Collection, Copenhagen.[6]

As no basins that might have accompanied this small group of early water jugs are known to have been preserved, it is uncertain whether they were intended for use in the boudoir or in the service of tea and coffee. In the 1977 Paris exhibition of Vincennes porcelain, similar decoration was to be found on three wine-glass coolers, three bulb vases, two goblets, a milk jug, and a Meissen-form teapot.[7]

This type of continuous panoramic landscape with figures was introduced at Meissen by Johann Gregorius Höroldt in the 1730s and was also used by Christian Friedrich Herold and by Johann Georg Heintze, who is specially credited with harbor scenes (see no. 38). Here it is adapted to a piece showing the typical graceful French form in the tradition of Saint-Cloud and Chantilly and the work of the silversmiths. At about this time, 1750,

changes began to appear in this form, notably in simplification of the handle and foot and elongation of the body, accompanied by the enrichment of ground colors and gold.

V.S.H.

NOTES

1. Grand Palais, Paris, *Porcelaines de Vincennes: Les Origines de Sèvres,* catalogue by Antoinette Faÿ Hallé and Tamara Préaud (1977), nos. 148, 149 (hereafter cited as *Vincennes* [1977]).

2. Ibid., nos. 166-168.

3. Georges Lechevallier-Chivignard, *La Manufacture de porcelaine de Sèvres* (Paris, 1908), p. 15, illus.; Hôtel Drouot, Paris, sale catalogue (Chavagnac Collection), 19-21 June, 1911, lot 244.

4. William Bowyer Honey, *European Ceramic Art...,* vol. 1: *Illustrated Historical Survey* (London, 1949), pl. 128a.

5. Christie's (International), Geneva, sale catalogue, May 7, 1979, lot 34, illus. (color).

6. Svend Eriksen, *Davids Samling Fransk Porcelaen* (Copenhagen, 1980), no. 21, illus. (color).

7. *Vincennes* (1977), nos. 167, 272-274, 384-385, 400, 408-410.

58 Quatrefoil teabowl and saucer

(*Tasse-gobelet à quatre pans ronds et soucoupe*)

Plate XIV

France, Vincennes, about 1750

Soft-paste porcelain (*pâte tendre*) with a yellow ground, decorated in polychrome enamels and gold

Unmarked

Cup: h. 4.5 cm. (1¾ in.), w. 7.8 cm. (3⅟₁₆ in.), d. 7 cm. (2¾ in.); saucer: h. 2.7 cm. (1⅟₁₆ in.), w. 11.4 cm. (4½ in.), d. 10.3 cm. (4⅟₁₆ in.)

1980.617a,b

Published: Pavillon de Marsan, Musée du Louvre, Paris, *La Porcelaine française de 1673 à 1914...* (1929), p. 58, no. 671; Paul Alfassa and Jacques Guérin, *Porcelaine française du XVIIe au milieu du XIXe siècle* (Paris, n.d.), pp. 45-46, pl. 37a; Nicole Ballu, *La Porcelaine française* (Paris [1958]), p. 15, pl. 20b.

Provenance: Coll. M. Jaubert (1929); purchased, Paris, April 1960

Both the teabowl (cup) and the saucer are molded in a four-lobed oval form with circular foot rings.

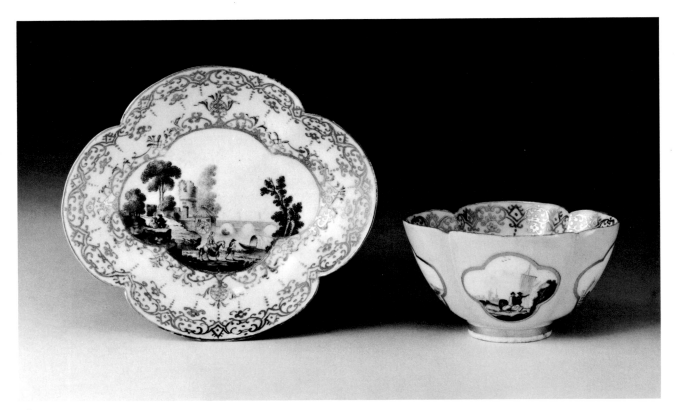

58

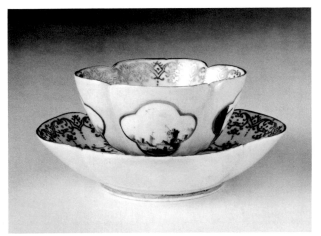

58

The cup has four quadrilobed panels reserved on the soft yellow ground.[1] Each panel is painted in polychrome enamels with a different harbor scene with figures: one is dominated by a castle with a circular tower; in another, a stone quay is at the left; another shows three men with a barrel and two bundles, with rocks in the foreground and at the left; in the last, there are two men with a barrel and two bundles. Inside is a polychrome flower spray in the oriental manner (indianische Blumen). There are plain gold bands at the foot, bordering the panels, and at the rim. Inside the rim is a gold lace-like pattern in the Meissen style.

The saucer is decorated on the inside with a quadrilobed panel framed in a gold and rose-pink lace-like pattern. There is also a gold pattern at the rim matching that on the cup. The panel is painted in polychrome enamels with a river landscape with figures: at the left there are trees and a woman and a man, seen from the back, seated on the rocks; a ruined round tower, a water wheel, and a bridge are in the background; in the center foreground there is a woman riding an ass, led by a man with a staff; a houseboat and a tree are at the right, The underside has a plain yellow ground and gold band at the foot. The unglazed foot rings have black flecks. There are repairs on the saucer on the rim above and below the scene.

A cup and saucer similar to no. 58 in size and decoration, in the Musée des Arts Décoratifs, Paris, and several other examples of the same form with floral and Imari decoration were included in the 1977 exhibition of Vincennes porcelain.[2] The October 1752 inventory of the Vincennes factory listed twenty-four molds (including both cups and saucers) called "à quatre pans ronds," and thirty-one sales were recorded up to the time of the transfer to Sèvres in 1756.[3] From the exhibited examples and a few others known,[4] it is apparent that the sizes of the cups vary from 4.5 cm. (1¾ in.) high, the size of the Markus cup, to 8.1 cm. (3³⁄₁₆ in.) high, the size of the example in the Rijksmuseum.[5] This variation in size may account in part for the large number of molds inventoried. As to the sales, the most expensive was priced at 12 livres and, like no. 58, had a yellow ground and landscapes.[6]

The partial Meissen service with a yellow ground in the Residenz, Munich, exhibited at the Bayerisches Nationalmuseum, Munich, in 1966, does not include teacups, but two of the four saucers are of the same size as no. 58.[7] The gold borders of the Markus Vincennes example are very similar to the Meissen *Goldspitzbordüre*, close enough to serve as a replacement. The Meissen saucer in the Forsyth Wickes Collection, Museum of Fine Arts, Boston, is between the two pairs of Residenz saucers in size, has the same outer lace-like border but has only the gold part of the framing of the cartouche;[8] it is undoubtedly of the same period, 1730-1735, as the Residenz service. The closeness of the ground colors of the Markus Vincennes and the Wickes Meissen examples strengthens the proposal that, in this instance, the French factory was supplying a replacement or additional piece for a Meissen service rather than working in the Meissen style.

It should be remembered also that French services at this date were of the *déjeuner* type, sometimes with only one cup and saucer and a sugar bowl, with variations adding a second cup and saucer, a milk pot, and a teapot, and with trays in varying sizes and shapes to accommodate the number of pieces desired.[9]

V.S.H.

NOTES

1. The yellow color of the ground is almost identical to that of the Meissen quatrefoil cup and saucer in the Forsyth Wickes Collection, Museum of Fine Arts, Boston, 65.2044a,b.

2. Grand Palais, Paris, *Porcelaines de Vincennes: Les Origines de Sèvres*, catalogue by Antoinette Faÿ Hallé and Tamara Préaud (1977), pp. 112-113, nos. 305-308 *bis*, the last being the Meissen model for the Vincennes example, no. 308 (hereafter cited as *Vincennes* [1977]).

3. Ibid., p. 112.

4. One, Paul Alfassa and Jacques Guérin, *Porcelaine française du XVIIe au milieu du XIXe siècle* (Paris, n.d.), p. 46, pl. 37b, Jaubert collection, no. 1879 *bis* in the 1929 Louvre exhibition, marked with crossed swords, cup 4.5 cm. (1¾ in.) h., saucer 11.5 cm. (4½ in.) w. Another, Sotheby & Co., London, sale catalogue, May 1, 1956, lot 133, p. 39, illus., Simon Goldblatt collection, marked with crossed swords, fleur-de-lis, and initials OFL.

5. *Vincennes* (1977), p. 113, no. 308.

6. Comte Xavier de Chavagnac and Marquis G. de Grollier, *Histoire des manufactures françaises de porcelaine* (Paris, 1906), p. 149: "Livres de ventes (1753)... Tasse fond jaune, 4 pans ronds, paysage, et soucoupe, 12 l."

7. Rainer Rückert, *Meissener Porzellan 1710-1810*, exhibition catalogue, Bayerisches National-museum, Munich (Munich, 1966), pp. 101-102, nos. 373-379, pls. 95, 96.

8. See note 1.

9. See no. 69.

59 Cup and saucer

(*Gobelet lizonné et soucoupe*)

France, Vincennes, about 1750

Soft-paste porcelain (*pâte tendre*) decorated in puce monochrome (*camaïeu pourpre*) and gold

Marks:
on base of cup:
(1) in blue enamel: interlaced Ls enclosing a dot
(2) incised: unidentified mark
on saucer:
(3) in blue enamel: interlaced Ls enclosing a dot
(4) incised: c

Cup: h. 6.7 cm. (2⅝ in.), w. 9.2 cm. (3⅝ in.), diam. at rim 7.5 cm. (2¹⁵⁄₁₆ in.); saucer: h. 3.2 cm. (1¼ in.), diam. 13.5 cm. (5⁵⁄₁₆ in.)

1982.777a,b

Provenance: Purchased, Paris, June 1961

Both the beaker-shaped cup and the saucer are octafoil, the sides gently lobed and the rims undulating. The handle of the cup is especially interesting. It is in the form of a twig, attached at the top with a six-petaled rosette, then making two loops, one at the top, the other at the bottom, before the final foliate terminal; there is a molded scroll on the top loop and a leaf in low relief on the shoulder. The rosette and foliate shoulder and terminal are gilded, and there is a gold band at the foot of the cup and on the rim of the saucer, with traces of

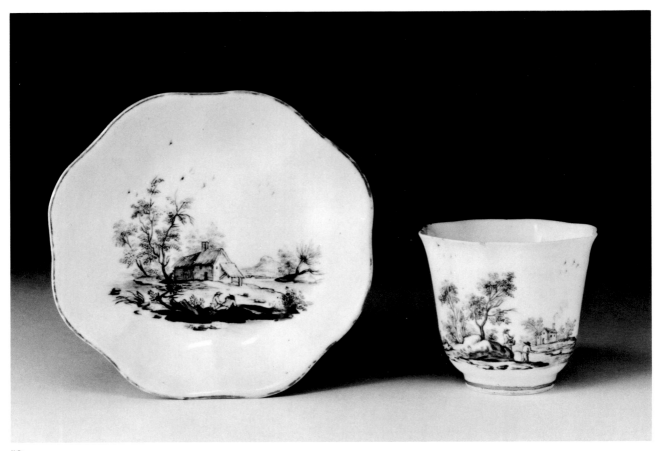

59

gold on the rim of the cup. The principal painted decoration is in puce monochrome (camaïeu pourpre) and consists of peopled landscapes with trees, rocks, and farmhouses; the cup shows two men standing on a river bank; the saucer also shows two men near a river, one seated, the other reclining. There are many birds in the sky, some covering pinhole-sized flaws in the glaze.

There were five *gobelets lizonnés* in the 1977 exhibition of Vincennes porcelain.[1] Tamara Préaud mentions, in relation to this form, that a drawing dated 19 February 1753 is preserved in the Manufacture de Sèvres and that 445 examples were sold, in two sizes, decorated with flowers, birds, or landscapes, in polychrome or in monochrome, at between 6 and 24 livres.[2] She does not suggest the reason for the name "lizonné" but notes with regard to the water jug and teapot of the same form that they have also been called "à côtes" (fluted).[3]

It seems that there was no established form of handle for a particular type of cup, at least in the Vincennes period. One of the five cups in the 1977 exhibition noted above, no. 370 (in the British Museum), has the same looped handle as the Markus cup; its lower loop was not completed and is a jog instead.[4] Other pieces in the 1977 exhibition with similar handles are two *gobelets Calabre* (nos. 334[5] and 340) and five teapots (nos. 391, 395, 396, 402, and 403) on which there is only one loop near the base of the handle. All have the mark of the royal cipher with dots only, placing them in the period before 1753. Two of the teapots are identified as "lizonnée" (nos. 395 and 396); the first has landscapes in puce monochrome and may relate to the Markus cup and saucer; the second has polychrome flowers that seem to relate to the cup and saucer in the British Museum. Since all of these early pieces are decorated in a style which reflects that of Meissen, it is possible that the form of no. 59, like that of no. 58, was also inspired by the Saxon factory. A Meissen coffee cup and saucer of this same octafoil shape was sold recently in London.[6]

Landscapes were frequently found on the porcelain of Vincennes,[7] and, since many of the early painters at Vincennes worked first as fan painters, their technique understandably reflected the gouache paintings on fans. One former fan painter who was known for his work in puce (*rose*

or *pourpre*) monochrome, Philippe Xhrouuet, began as a painter of landscapes in 1750.[8]

The incised workman's mark on the cup does not relate to any pieces in the 1977 exhibition catalogue or other publications consulted, but the c on the saucer occurs frequently. It is on the similar cup in the British Museum (no. 370) and was among the earliest incised marks to be published.[9] Some of the other pieces in the 1977 exhibition that bear the incised c are a saucer of 1753 (no. 75), a 1754 plate (no. 121), a 1756 oval dish (no. 124), a 1759 sugar bowl (no. 194), another early saucer (no. 338), and the upper part of a 1758 jardinière (no. 431). The workman who used the c mark was active as early as 1748 since the c also appears on the cup in the Musée National de Céramique, Sèvres, which is inscribed: "Inventaire. Fait ce 29 Août 1748 à Vincennes, Taunay fait."[10]

V.S.H.

59 (1)

59 (2)

59 (3)

59 (4)

NOTES

1. Grand Palais, Paris, *Porcelaines de Vincennes: Les Origines de Sèvres,* catalogue by Antoinette Faÿ Hallé and Tamara Préaud (1977), nos. 370-374.

2. Ibid., p. 125.

3. Ibid., pp. 73, 133.

4. William King, "Vincennes Porcelain in the British Museum, I," *Apollo* 12 (Oct. 1930), 280-284, fig. 3.

5. The handle of no. 334 is not visible in the illustration, but the related piece noted in the bibliography does have the handle with "double enroulement"; see Paul Alfassa and Jacques Guérin, *Porcelaine française du XVIIe au milieu du XIXe siècle* (Paris, n.d.), pl. 38b; William Bowyer Honey, *French Porcelain of the 18th Century* (London [1950]), pl. 61A.

6. Christie's, London, sale catalogue, April 5, 1982, lot 114; the scroll handle is not visible in the illustration, and the suggested date is about 1750. Which came first, the Meissen or the Vincennes?

7. Rosalind Savill, "François Boucher and the Porcelains of Vincennes and Sèvres," *Apollo* 115 (March 1982), 167.

8. See no. 61.

9. See note 4.

10. Svend Eriksen, *The James A. de Rothschild Collection at Waddesdon Manor: Sèvres Porcelain* (Fribourg, 1968), p. 116; other examples marked with the c are also listed.

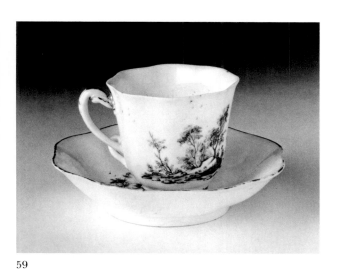

59

59

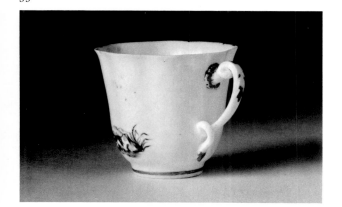

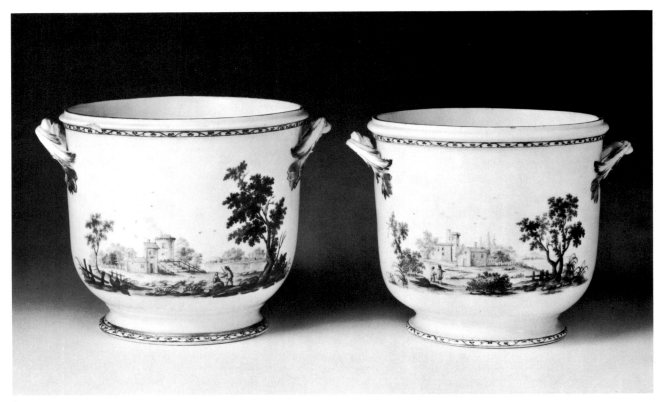

60

60 Two wine coolers

(Seaux à demi-bouteille ordinaire)

France, Vincennes, 1750-1752

Soft-paste porcelain (*pâte tendre*) decorated in puce monochrome (*camaïeu pourpre*) and gold

Marks:
(1) 6oa: on base, in blue enamel: interlaced Ls enclosing a dot, two dots above
(2) 6ob: on base, in blue enamel: interlaced Ls enclosing a broken dot (or two dots?)

6oa: h. 17.1 cm. (6¾ in.), w. 21.2 cm. (8⅜ in.), diam. at rim 17.3 cm. (6¹³⁄₁₆ in.); 6ob: h. 16.5 cm. (6½ in.), w. 21 cm. (8¼ in.), diam. at rim 17 cm. (6¹¹⁄₁₆ in.)

1983.637, 638

Provenance: Purchased, Paris, November 1963

These cylindrical coolers were made through the collaboration of several specialized workmen: they were thrown in molds by the tourneurs, *the molding at the top and the splayed foot were added by the* répareurs, *and the interlocking twig handles* were attached by the anseurs.[1] *In addition to the slight difference in the size of the two coolers, the molding at the top of no. 6oa is sharper than that of no. 6ob, and no. 6oa has an additional turned detail above the foot; also, the foliate terminals of the handles of no. 6oa are more ornate, with berries that are lacking in no. 6ob. Both coolers are decorated with two rural landscapes in puce monochrome* (camaïeu pourpre), *each with two people in the foreground of a scene with trees, rocks, fences, houses near and distant, and water; there is a monument, an urn on a tall pedestal, on one side of no. 6ob. All the scenes are wider than they are high, giving a feeling of a continuous landscape; the horizontal feeling is strengthened by the borders in puce below the top molding and, at the foot, a scroll pattern between bands. On no. 6oa there is a gold band above the puce border at the foot (there are slight indications that no. 6ob had a similar band); the upper edge of each is gilded, as are the leafy terminals of the handles, which are touched with puce.*

Eriksen compared the different examples of wine coolers with the drawings and molds preserved at the Manufacture de Sèvres and proposed a new way of identifying them by graduating size:[2] the

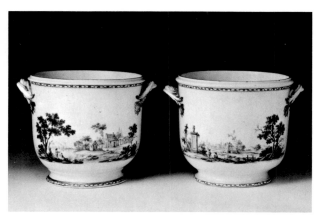

60

60 (1)

60 (2)

3. Grand Palais, Paris, *Porcelaines de Vincennes: Les Origines de Sèvres,* catalogue by Antoinette Faÿ Hallé and Tamara Préaud (1977), p. 98.

4. Ibid., p. 100.

5. O. du Sartel and E. Williamson, *Exposition rétrospective des porcelaines de Vincennes et de Sèvres* (Paris: Union Centrale des Arts Décoratifs, 1884), pp. 196, 792.

6. Claude Frégnac, ed., *Les Porcelainiers du XVIIIe siècle français* (Paris, 1964), pp. 222-223, illus.

61 Sugar bowl and cover

(Pot à sucre Hébert)

France, Vincennes, 1753

Painted by Philippe Xhrouuet (active 1750-1775)

Soft-paste porcelain (*pâte tendre*) decorated in puce monochrome (*camaïeu pourpre*) and gold

Marks:
(1) on base of bowl, in blue enamel: interlaced Ls enclosing the date letter A; painter's mark, a Maltese cross
(2) on base of bowl, incised: 4

H. 9.7 cm. (3¹³⁄₁₆ in.), diam. at rim 7.5 cm. (2¹⁵⁄₁₆ in.)

1983.639a,b

Provenance: Purchased, Paris, June 1961

The pear-shaped bowl with a domed cover has a finial in the form of a carnation with stem and leaves. On the bowl the painting, in puce monochrome, consists of two cupids with flying drapery, in clouds, after Boucher, one holding a torch, the other a wreath of flowers. On the cover are painted, in the same color, emblems of love: a bow and quiver and an arrow and torch. There are also one small flower spray on the cover and two larger and two smaller flower sprays on the bowl, all in puce. The rims of the cover and the bowl have rounded gold dentils and a puce band bound in gold; this puce band is repeated at the foot above a gold band. The flower finial is touched with puce, and the stem and leaves are gilded. The finial has been broken and repaired, and the gold dentils on the inside of the rim of the bowl are almost completely worn away with use; the glaze inside the bowl also shows wear.

seau à bouteille measures 19 cm. (7½ in.) or more in height; the *seau à demi-bouteille,* between 16 and 18 cm. (6⁵⁄₁₆ and 7¹⁄₁₆ in.); the *seau à liqueur* from 14 to 15 cm. (5½ to 5⅞ in.); and the *seau à verre,* 10 to 13 cm. (3¹⁵⁄₁₆ to 5⅛ in.).[3] There were molds of the *seau à demi-bouteille* listed in the inventory of October 1752, and sixty-one coolers of this size appeared in the records of sales, priced between 72 livres (landscapes in monochrome) and 240 livres (turquoise ground with flowers).[4]

Two of the three *seaux à demi-bouteille ordinaire* in the 1977 exhibition (nos. 251 and 252) have landscapes in puce monochrome, the first in cartouches and mounted (later, certainly) with a bouquet of porcelain flowers. There was another in the Dupont-Auberville collection.[5]

Wine coolers were sold in pairs, fours, or even larger sets in the Vincennes period; later they were an important part of the dinner service.[6]

V.S.H.

NOTES

1. Carl C. Dauterman, *The Wrightsman Collection, vol. 4: Porcelain* (New York: The Metropolitan Museum of Art, 1970), pp. 168-169.

2. Svend Eriksen, *The James A. de Rothschild Collection at Waddesdon Manor: Sèvres Porcelain* (Fribourg, 1968), p. 74.

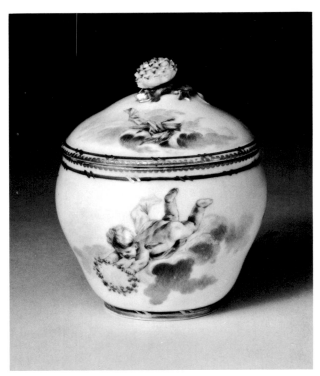

61

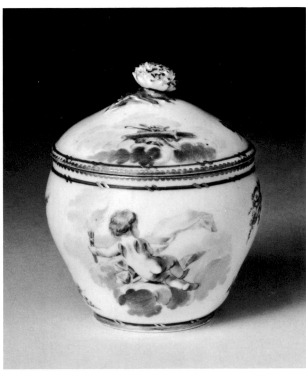

61

A sugar bowl of this form was called *sucrier Hébert* in the early records of the factory. There is a drawing in the Sèvres Archives inscribed: "Sucrÿe hebert no 2 faite suivan L'ordre de la Comande du 19 feurÿe 1753."[1] The inventory of January 1754 lists molds of the first and second size, and that of January 1756 contains the mold of the third size.[2] Since published pieces of this form range in size from 8.4 cm. (3¼ in.) to 10.5 cm. (4⅛ in.), the Markus piece should be considered to be the second size.

This *sucrier* may originally have been part of a breakfast service. The *déjeuner Hébert* of the same year in the Musée du Louvre, Paris, consists of a tray (*plateau*) with a sugar bowl, a covered milk jug, and a cup and saucer.[3] According to Svend Eriksen, the sales records show that only seven different types of *déjeuners* were made between 1753 and 1757; he suggests that the *déjeuner Hébert* was probably named for the famous dealer Thomas-Joachim Hébert, whose shop was in the rue Saint-Honoré.[4]

Philippe Xhrouuet, who decorated this *sucrier*, is mentioned frequently in the documents at the Sèvres factory and in parish records.[5] Born at Beauvais about 1730, he worked as a decorator of fans before entering the Manufacture de Vincennes in February 1750 at a monthly salary of 40 livres. By January 1753, the year he painted this *sucrier*, his salary had been increased to 80 livres per month, the level at which it remained until his death at Sèvres on December 20, 1775. He had married in 1755, and one of his seven children, his eldest daughter, Marie-Claude-Sophie, also worked at Sèvres as a flower painter.

Xhrouuet was recorded as a painter of landscapes when he began his service at Vincennes and as a painter of flowers in the later records. In addition to the Markus piece, at least one other example of his painting of cupids can be cited, a cup, also date 1753; the cupids in clouds, also in *camaïeu pourpre,* are enclosed in reserves on a *bleu lapis* ground.[6]

François Boucher's affiliation with the Vincennes factory, which began as early as 1749, is the subject of a recent article by Rosalind Savill.[7] Use of the sources indicated in her article made it possible to identify on the Markus bowl the cupid flying downward, holding a wreath. It is based on one of a group of three cupids doing a somersault, with an eagle, etched by Louis Félix de La Rue (1731-1765?) for the *Troisième Livre de Groupes d'Enfans Par François Boucher Peintre du Roy*, a suite of six plates, published in Paris by Huquier.[8]

The incised workman's mark on the bowl, the numeral 4, is known on many cup forms (see also nos. 62, 64, 65, and 67) that would have been

made in a mold then finished on a lathe by a *répareur*. It was this workman who, after perfecting the contour of the piece and the foot ring, incised his mark before the first firing.[9]

<div style="text-align: right">V.S.H.</div>

NOTES

1. Svend Eriksen, *The James A. de Rothschild Collection at Waddesdon Manor: Sèvres Porcelain* (Fribourg, 1968), p. 80.

2. Grand Palais, Paris, *Porcelaines de Vincennes: Les Origines de Sèvres,* catalogue by Antoinette Faÿ Hallé and Tamara Préaud (1977), p. 84 (hereafter cited as *Vincennes* [1977]).

3. Ibid., no. 75, pp. 46-47, with references to two earlier illustrations.

4. Eriksen, *Rothschild Collection: Sèvres,* p. 38.

5. Ibid., p. 339; Marcelle Brunet, "French Pottery and Porcelains," in *The Frick Collection: An Illustrated Catalogue,* vol. 7: *Porcelains, Oriental and French* (New York, 1974), pp. 337-339.

6. *Vincennes* (1977), no. 369, illus. p. 125.

7. Rosalind Savill, "François Boucher and the Porcelains of Vincennes and Sèvres," *Apollo* 115 (March 1982), 162-170.

8. Pierrette Jean-Richard, *L'Oeuvre gravé de François Boucher dans la collection Edmond de Rothschild* (Paris: Musée du Louvre, 1978), no. 1288, illus. p. 314.

9. Carl C. Dauterman, *The Wrightsman Collection, vol. 4: Porcelain* (New York: The Metropolitan Museum of Art, 1970), p. 169; Mr. Dauterman has a book in preparation, *XVIIIth Century Sèvres: Makers and Marks,* recording all the incised marks used on Vincennes and Sèvres porcelain in the eighteenth century.

61 (1)

61 (2)

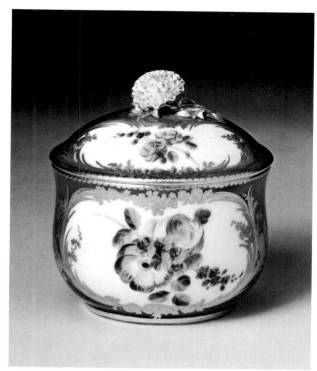

62

62 *Sugar bowl and cover*

(*Pot à sucre* or *boîte à sucre*)

France, Vincennes, 1754

Painted by Vincent Taillandier (active 1753-1790)

Soft-paste porcelain (*pâte tendre*) with a turquoise ground (*fond bleu céleste*), decorated in polychrome enamels and gold

Marks:
(1) on base of bowl, in blue enamel: interlaced Ls enclosing date letter B above painter's mark, a fleur-de-lis
(2) on base of bowl, incised: 4

H. 8.5 cm. (3⅜ in.), diam. at rim 7.6 cm. (3 in.)

1983.640a,b

Provenance: Purchased, Paris, November 1966

The bowl is tulip-shaped, and the cover low-domed with a finial in the form of a flower (carnation?) with stem and leaves. The four oval panels (two on the cover and two on the bowl) reserved on the turquoise (bleu céleste) ground are framed in sprays of palm leaves with flowers at the top and the bottom and sprays of flowers at each side, all in

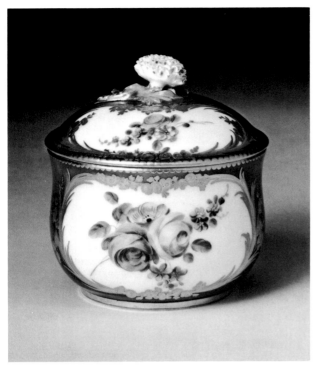

62

chased and tooled gold. Each of the panels is deco-
rated with a spray of mixed flowers. On one side of
the bowl are two full-blown roses, that on the left a
bluish lavender color shaded with puce, that on the
right, yellow shaded with light brown; an ane-
mone(?) in pink is above these, with a spray of pink
florets below and another of blue to the right; the
green leaves are delicately outlined and shaded on
all panels. In the cover cartouche above (in the
same illustration), similar blue florets descend to
the left from a yellow rose and pink flower. In the
cartouche on the other side of the bowl, the blue
florets are in front of a large pink rose (to the
right) and a large yellow flower with puce edges,
and a spray of puce florets descends to the right.
On the cover, the two larger flowers are blue (left)
and pink, and the ascending florets to the left are
deep purple. The flower finial is touched with
puce, and the leaves and stem are gold. The edges
of both the cover and the bowl are ornamented
with rounded gold dentils, and the foot ring has a
plain gold band.

The turquoise ground color of this bowl, which
was especially in vogue in the year of the transfer
of the factory from Vincennes to Sèvres, was prob-
ably "invented" by the chemist Jean Hellot about
1752 and may be the color referred to as "bleu
Hellot" in sales records of 1753. This color, which
required two firings, was used on Louis XV's din-

ner service, delivered from 1753 to 1755.[1] It was
referred to also as "bleu ancien," since it imitated
the brilliant turquoise glaze found on the then
popular Chinese wares of the Kangxi (K'ang Hsi)
period. The name "bleu céleste," which was estab-
lished by Christmas 1753, is the only name subse-
quently used in the factory records (abbreviated
usually to "B.C.").[2]

A drawing of a sugar bowl and cover, pre-
served at the Manufacture de Sèvres, that closely
resembles no. 62 and bears the inscription "boite a
sucre no 2 meme jour" is on a sheet dated 28 April,
1752.[3] Since no name is known by which this shape
can be distinguished in the inventory or sales rec-
ords of the factory, one cannot suggest the price at
which it might have been sold, but, generally,
pieces with *bleu céleste* grounds and flowers were
among the most expensive. A sugar bowl in the
Wrightsman Collection at the Metropolitan Mu-
seum of Art is very close in form and size to the
Markus example but has a rosebud finial.[4] It also
has a *bleu céleste* ground, with similar gold fram-
ing to the oval reserves. These, however, are
painted with flying birds in polychrome by
Xhrouuet, who painted the cupids on no. 61, and
the piece has the date letter A for 1753. Another
bleu céleste sugar bowl, painted by Taillandier in
1754, is in the Rothschild Collection at Waddesdon
Manor.[5] The flower sprays are very similar in feel-
ing, but, as is always the case, none are ever identi-
cal. The flower finial on the cover of the
Rothschild piece is similar to that of no. 62, but the
bowls differ in shape.

Vincent Taillandier, whose mark, a fleur-
de-lis, appears below the royal cipher on this piece,
was born in Sceaux, to the south of Paris. He re-
ceived his early training at the porcelain works in
his home town and was still only a boy, about six-
teen or seventeen, when he was employed at Vin-
cennes in August 1753. His beginning salary of 30
livres a month was quickly increased in recognition
of his talent, and, in the year in which he painted

62 (1)

62 (2)

this sugar bowl, he advanced in salary from 48 to 54 livres a month. In January 1757, at about the age of twenty, he was being paid 78 livres, a high salary for a flower painter. In 1770 he reached his maximum of 80 livres, at which he continued until his death, April 22, 1790. His wife, who survived him, was also a painter at Vincennes and Sèvres.[6]

The incised workman's mark on this bowl, the numeral 4, appears also on nos. 61, 64, 65, and 67.

V.S.H.

NOTES

1. Pierre Grégory, "Le Service bleu céleste de Louis XV à Versailles: Quelques pièces retrouvées," *Revue du Louvre* 1 (1982), 40-46.

2. Svend Eriksen, *The James A. de Rothschild Collection at Waddesdon Manor: Sèvres Porcelain* (Fribourg, 1968), p. 28.

3. Grand Palais, Paris, *Porcelaines de Vincennes: Les Origines de Sèvres*, catalogue by Antoinette Faÿ Hallé and Tamara Préaud (1977), p. 87. I am indebted to Mme. Préaud for supplying a photograph of the drawing, showing the inscription.

4. Carl C. Dauterman, *The Wrightsman Collection*, vol. 4: *Porcelain* (New York: The Metropolitan Museum of Art, 1970), p. 255, no. 92.

5. Eriksen, *Rothschild Collection: Sèvres*, p. 48, no. 8. Eriksen spells the painter's name "Taillandiez," p. 336.

6. Marcelle Brunet, "French Pottery and Porcelains," in *The Frick Collection: An Illustrated Catalogue*, vol. 7: *Porcelains, Oriental and French* (New York, 1974), pp. 333-334.

63 Covered bowl and stand

(*Ecuelle ronde à plateau à bord de relief*)
Plate XV

France, Vincennes, 1754

Soft-paste porcelain (*pâte tendre*) with turquoise ground (*fond bleu céleste*), decorated in polychrome enamels and gold

Marks:

(1) on base of bowl, incised: 3
 on base of stand:
(2) in blue enamel: interlaced Ls enclosing date letter B; 4
(3) incised: j o

Bowl: h. 15.2 cm. (6 in.), w. 21.3 cm. (8⅜ in.), diam. at rim 15.6 cm. (6⅛ in.); stand: h. 6.4 cm. (2½ in.), w. 31.5 cm. (12⅜ in.), d. 23.5 cm. (9¼ in.)

1980.618a-c

Published: Museum of Fine Arts, Boston, *Annual Report*, 1980-81, p. 22, illus; idem,

Masterpieces from the Boston Museum (1981), no. 51, illus. (color).

Provenance: Purchased, Paris, April 1968

The rather deep bowl (7 cm. [2¾ in.] on the inside) has a plain foot ring and two unusual scrolled handles in the form of an olive (or laurel) branch; the broken end of the branch is attached near the base, the upper end dividing into two branches, which overlap and fasten to the body with elaborate foliage; there is a twig with two olives at the base and another at the top. The cover is domed (bombé), and the knob is a similar tortuous branch with three fruited twigs. The stand is oval with a circular well to fit the foot of the bowl; the molded, undulating rim is enriched by overlapping leaf scrolls at the ends and sprays of flowers and leaves in relief at the ends and at the sides. There is a little piercing at the ends, where the scrolling fronds overlap. The exterior of the bowl and cover and interior of the stand have a somewhat clouded turquoise ground, indicative of the manner in which the enamel was applied around the intricate foliage of the knob and handles and the eight oval reserves. These reserves are decorated with delicately colored and shaded sprays of flowers and (except for one on the stand) fruit; black is used very sparingly to pick out stamen, and white for some highlights. The flowers in relief on the stand show a similar attention to detail, although the colors are somewhat bolder. Burnished gold is used for the ring at the foot of the bowl, the rounded dentil bands at the rim of the bowl, the edge of the cover, and around the well of the stand, and to outline and pick out details on the molded rim of the stand and the handles and knob of the bowl. The framing of the reserves combines mat and burnished gilding. The six larger cartouches are embellished with fronds of palm leaves joined at the lower and upper center by floral sprays, with more flowers and twigs placed randomly but skillfully against the blue ground; the two smaller reserves on the stand are completely wreathed in flowers, and the center of the well has an arrangement of flowers and fruit on the blue ground. All these flowers and leaves are given relief and detail with a chasing tool.

The French word *écuelle* can be translated as porringer, bowl, or basin. Usually with two handles and a cover, the bowl was designed for individual servings of liquids such as bouillon. In the records of 268 sales during the Vincennes period, no distinction is made in the entries as to the many different forms (quadrilobed, oval, or round bowl on round or oval, ornamented or plain stands, and

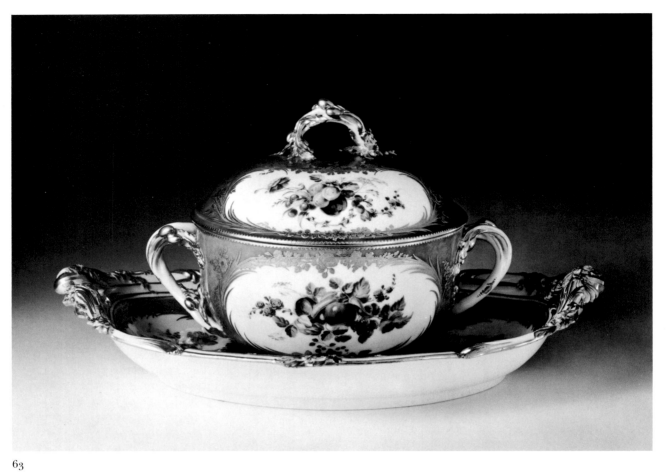

63

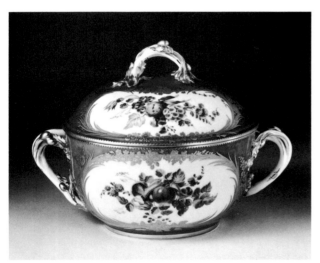

63

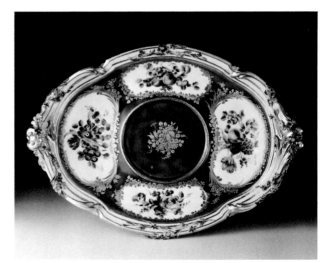

63

63 (2)

63 (3)

with various knobs and handles), but four variations of size and different types of painted decoration are listed, with prices ranging from 27 livres for the smallest size (*4e grandeur*) with flowers to 408 livres for an *écuelle* of the second largest size (*2e grandeur*) with a *bleu céleste* ground with flowers.[1]

The Markus *écuelle* is of the type entered as "ronde" in the October 1752 inventory, where forty-eight molds with their stands in four sizes are listed. Plaster models and drawings are preserved in the Manufacture de Sèvres for two types of cover: one rounded, like this example, the other with an undulating profile.[2] The October 1752 inventory also records a "Plateau à bord de relief" in association with an "Ecuelle Turque." It is unclear how the name "Turque" should be interpreted, but "à bord de relief" is also used for the basin accompanying the *broc Roussel* (see no. 64), and the relief decoration is identical in these two pieces. Four ensembles ("Ecuelle Turque et plateau à bord de relief") were listed in the records of sales, two of them "bleu céleste" with flowers at 600 livres.[3] The one that may possibly be the Markus piece is described: "Ecuelle Turque, plateau bords de reliefs bleu celeste fleurs 600 1."[4]

This *écuelle ronde* is the largest size made (*1re grandeur*), as is one dated 1753 in the Musée National de Céramique, Sèvres, which has a *bleu lapis* ground and a round stand.[5] A later (1760) example of the same size as no. 63, and with the same

molded, oval stand, is in the Wallace Collection, London.[6] Another, also 1760, is in a private collection in Lincolnshire.[7] In the Musée des Arts Décoratifs, Paris, is an *écuelle* with a similar, slightly smaller stand, decorated with cupids in puce monochrome and gold; it is marked with the interlaced Ls with the date letter for 1763, flanked by script initials h and g.[8] To date, these are the only examples known.

The turquoise blue ground has been discussed in the entry for no. 62; it is not unusual that both the sugar bowl and this *écuelle* and stand should have similar elaborately painted and chased gilding in keeping with the more costly ground color. The painter's mark, the numeral 4, occurs on two other pieces of this period: a square bowl of 1753 in the Thiers Collection at the Musée du Louvre, Paris, and a *bleu lapis* water jug and basin of the same year, 1753, in the Dutuit Collection at the Musée du Petit Palais, Paris.[9] Both are decorated with flowers, which must have been the specialty of this unidentified painter; and both are rather important items, indicating that he or she had, rightly, some status within the painters' *atelier*.

The incised marks do not tell much about these pieces. The 3 (or Z?), which is on the bowl, appears on twenty-eight pieces in the 1977 exhibition.[10] These date from before 1753-1757 and include both form pieces (a watering can, milk jugs, ewers, a basin, sugar bowls, teapots, and cups) and flat pieces (stands and saucers). Svend Eriksen calls the mark a numeral 3 and notes that it can be found on pieces dating from 1753 to 1767.[11] No other pieces have been located with the mark on the stand.

V.S.H.

NOTES

1. Grand Palais, Paris, *Porcelaines de Vincennes: Les Origines de Sèvres,* catalogue by Antoinette Faÿ Hallé and Tamara Préaud (1977), p. 49 (hereafter cited as *Vincennes* [1977]).

2. Ibid.

3. Ibid, p. 51.

4. Sèvres Archives, registre Vy 1, fol. 88, first half of 1755.

5. *Vincennes* (1977), no. 83.

6. Marcelle Brunet and Tamara Préaud, *Sèvres des origines à nos jours* (Fribourg, 1978), fig. 104: white ground, green scrolls, trophies in polychrome painted by Tandart.

7. Also painted by Tandart, it has a green ground and flowers in the reserves. I am indebted to G. de Bellaigue, keeper of the Royal Collection, London, for this information.

8. No. 36935, Hersent gift, 1952; I should like to thank Gérard Mabille, conservateur, for providing this information.

9. *Vincennes* (1977), nos. 97, 152.

10. Ibid, p. 189, incised mark no. 98.

11. Svend Eriksen, *The James A. de Rothschild Collection at Waddesdon Manor: Sèvres Porcelain* (Fribourg, 1968), p. 38.

64 Ewer and basin

(*Broc Roussel, jatte à bord de relief*)
Plate XVI

France, Sèvres, 1757

Painted by Philippe Parpette (active 1755-1757, 1773-1806)

Soft-paste porcelain (*pâte tendre*) with pink ground (*fond rose*), decorated in polychrome enamels and gold

Marks:
on base of ewer:
(1) in blue enamel; interlaced Ls enclosing date letter E above a script P
(2) incised: 4
(3) incised: R

on base of basin:
(4) in blue enamel: interlaced Ls enclosing date letter E above a script P
(5) incised: mLi

Ewer: h. 19.2 cm. (7⁹⁄₁₆ in.), w. 12.6 cm. (4¹⁵⁄₁₆ in.), diam. at base 7.3 cm. (2⅞ in.); basin: h. 9.9 cm. (3¹⁵⁄₁₆ in.), w. 31.7 cm. (12½ in.), d. 22.9 cm. (9 in.)

1982.173, 174

Provenance: Colls. Noailles family; Alfred Wenz, Paris; purchased, Paris, November 1967

The ewer is pear-shaped, the narrow neck gracefully rising from the bulbous body to the flaring spout, which is balanced by the twisted handle springing from the undulating and slightly molded rim. The foliate lower terminals of the handle are symmetrically arranged. A faint mold line is evident around the widest part of the body, about 4.5 cm. (1¾ in.) above the base. The form of the basin is that of the more common jatte ovale, *to which has been added a molded rim identical to that of the stand for the* écuelle, *no. 63. There is no piercing on this piece, however. The pink ground color is applied to the outside of the ewer, leaving two large reserved panels conforming to the shape of each side, and to the inside and outside of the basin, with eight reserved panels. On the basin, the upper side of the rim and the foot ring are also left white and are decorated with polychrome enamels and gold; there are two gold bands on the foot and gold banding and highlighting of the leafy scrolls and molding. The flowers in relief are painted in natural colors. The handle of the ewer is heightened with gold; there is a plain gold band at the foot and a gold rounded dentil band around the*

rim. The gilded ornament surrounding the reserves and, on the basin, joining the reserves at the center, is treated with a liveliness and grace that echo the forms and the floral bouquets of the reserves. The gilding, which is partially burnished and slightly chased, is outlined or shaded with puce enamel to give the effect of a third dimension to the scrolling leaves, shells, and shaped panels; these are so thickly applied that they are actually in relief. The larger shaped panels at the center of the basin, the smaller ones under the spout, and those which form part of the framing of the reserves are decorated with a great variety of diapering, hatching, stippling, and other ornamental filling. The framing also includes leafy tendrils with flowers that twine around the sides and form swags at the bases of the reserve panels. The polychrome bouquets, or clusters, of flowers and fruits in the reserves also have the quality of swirling movement, with smaller leaves, berries, vines, and flower sprays looping and curling around the central grouping of larger flowers and fruits. Each of the arrangements is different, and all are painted with a delicacy of line, a liveliness of color, and a vibrancy of shading that equal the richness of the gilding and the ground.

Rosewater ewers and basins, which held such an important place in the dining activities of the Renaissance, became part of the toilet equipment of the nobility in the age of Louis XV. This particular form of water jug was named Roussel after Jacques Roussel, a merchant shareholder of the Vincennes factory; the name first appears in a record of the unloading of a biscuit kiln on November 22, 1753.[1] Molds were made in two sizes in 1755,[2] and a series of molds and models are preserved today in the Manufacture de Sèvres, showing the variations of handle, spout, and body within this basic form. During the Vincennes period only forty examples of the *broc Roussel* were sold, of which eleven had this *jatte à bord de relief*, at prices between 192 and 720 livres. Of the known surviving examples of this ensemble, one in the Musée des Arts Décoratifs, Paris, and one in the David Collection, Copenhagen, have date letters for 1753 and have the early *bleu lapis* ground introduced in that year.[3] There is also an example with a turquoise ground in the museum in Warsaw.[4] The fourth example is in the Wallace Collection, London; like the Markus piece, it was made in 1757, but it has a *bleu lapis* ground with a gold *caillouté* pattern and has cherubs on clouds by Dodin after Boucher in the reserves.[5] The pieces most like the Markus ensemble are in the Tuck Collection at the Petit Palais, Paris.[6] They also have a pink ground and are the same

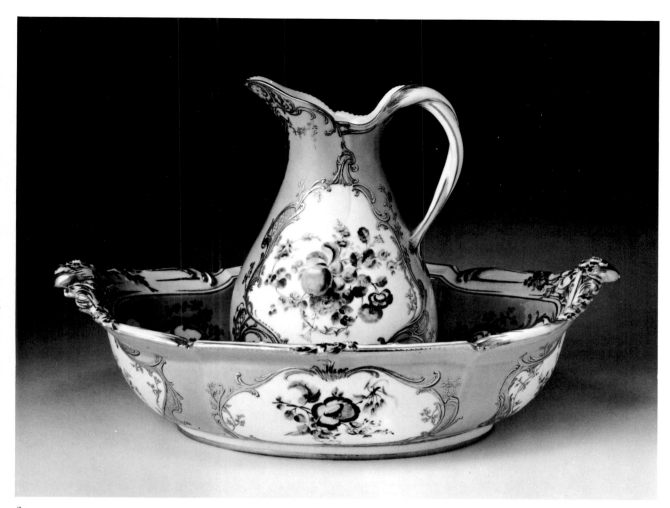

64

size, but they are marked only with interlaced Ls, with neither date letter nor painter's mark; the basin has the same incised mark as no. 64 (see below).

The pink ground (*fond rose*) has been described as "the color most envied by other porcelain makers...a subtle rose possessing a remarkable quality of freshness."[7] An entry in the personnel record of the painter Xhrouuet (see no. 61), dated January 1, 1758, states that he was awarded 150 livres for his invention of the "fond couleur de rose très frais et fort agréable." The chemist Hellot's notebook also includes a transcript of the secret of the pink color made by "M. Bailli" in May 1757. Marcelle Brunet suggests that Bailly was responsible for perfecting Xhrouuet's experiments.[8] Although a number of pieces, such as no. 64, bear the date letter for 1757, the color does not appear in the sales records of the factory until December 1758. It was produced only until the early 1760s at Sèvres. The name *rose Pompadour* seems to have been invented in England in the mid-

1760s, perhaps to honor the marquise, who had been such a strong influence on the arts in France until her death in 1764. The name *rose Dubarry*, which is sometimes applied to this color, is probably also an English invention, but of a much later date.

On the basis of the script P mark, the flower painting is attributed to Philippe Parpette, who worked at Vincennes and Sèvres from 1755 to 1757 and then from 1773 to 1806 as a flower painter and from 1793 as a gilder.[9] Born in Chantilly in 1738, Parpette had been working as a painter of porcelain there before he was hired at Vincennes at 42 livres a month. In 1757, when he painted these pieces, his salary was raised to 66 livres a month, and he reached the maximum 84 livres in 1780.[10] A 1756 plate in the Sèvres Museum has a mark very similar to that on the Markus ewer, but it has been published as by an unidentified painter.[11] The arrangement of the bouquet of flowers and fruit and the form of the cipher mark are clearly by the same hand.[12]

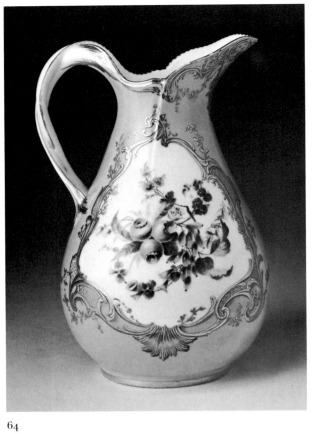

64

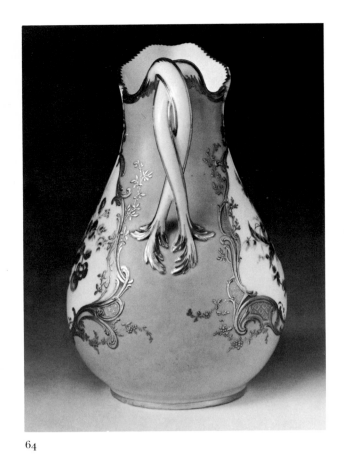

64

64. *Detail of basin, side view*

64 (1)

64 (2)

64 (3)

64 (4)

64 (5)

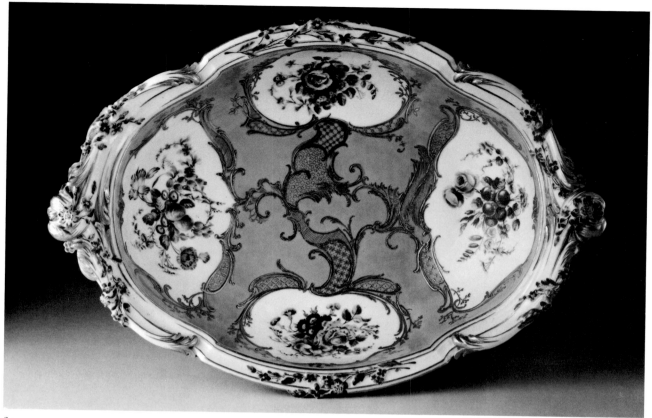

64

The script mLi incised on the basin is attributed to the *répareur en ornements* Antoine-Mathieu Liance, who worked at the factory between 1754 and 1777. An incised script Li is also ascribed to him, there being no recorded mark in the factory records.[13] Born in Paris, possibly the son of Mathieu Liance, a master-pewterer, in 1732, Liance died at Sèvres on May 6, 1777. Before his employment at Vincennes in June 1754, he had worked in Paris as a *tabletier*, a dealer in fancy turnery or toys. His initial salary of 30 livres a month was raised to 51 livres in 1756, when it was noted in the personnel record that he was one of the workers who was best at cutting the paste and who exerted the greatest care. A number of large and elaborate pieces, such as the well-known "elephant" candelabrum vases dating from the 1756-1761 period, were chased and finished by Liance. Eriksen lists many of them, including one in the Wrightsman Collection with the incised mark Lia; all the incised letters on these vases are similar to Liance's signatures in the parish registers at Vincennes.[14] In addition to the pieces noted by Eriksen, the basin in the Tuck Collection has a faint but unmistakable mLi mark incised.[15]

The Markus ewer has two incised workman's marks, a large, neatly executed Roman R and the numeral 4, both of which also appear on a water jug of 1776 in the Frick Collection.[16] The 4 is found also on nos. 61 (see note 9), 62, 65, and 67 in the Markus Collection.

V.S.H.

NOTES

1. Grand Palais, Paris, *Porcelaines de Vincennes: Les Origines de Sèvres,* catalogue by Antoinette Faÿ Hallé and Tamara Préaud (1977), p. 71 (hereafter cited as *Vincennes* [1977]).

2. Ibid.

3. For the Paris example, see *Vincennes* (1977), no. 141, illus. For the Copenhagen example, see Svend Eriksen, *Davids Samling Fransk Porcelaen* (1980), no. 35-36, illus. (color); Sotheby & Co., London, sale catalogue, Nov. 26, 1968, lot 69, illus.; *Apollo* 90 (Sept. 1969), cv, illus. (color).

4. Referred to in *Vincennes* (1977), no. 141.

5. Rosalind Savill, "François Boucher and the Porcelains of Vincennes and Sèvres," *Apollo* 115 (March 1982), 162-170, fig. 6.

6. Edward Tuck, *Some Works of Art Belonging to Edward Tuck in Paris* (London, 1910), no. 12, p. 108, illus. (color); Jean Nicolier, "L'Epoque rose de la porcelaine tendre de Sèvres," *Connaissance des arts* 79 (Sept. 1958), 72-77, illus. p. 74; Marcelle Brunet and Tamara Préaud, *Sèvres des origines à nos jours* (Fribourg, 1978), no. 105; the size and the mark on the basin are given here in error.

7. Carl C. Dauterman, *Sèvres* (New York, 1969), p. 19.

8. Marcelle Brunet, "French Pottery and Porcelains," in *The Frick Collection: An Illustrated Catalogue*, vol. 7: *Porcelains, Oriental and French* (New York, 1974), p. 192 (hereafter cited as Brunet, *Frick*).

9. Svend Eriksen, *The James A. de Rothschild Collection at Waddesdon Manor: Sèvres Porcelain* (Fribourg, 1968), p. 334; Brunet and Préaud, *Sèvres*, p. 376, give an alternate spelling of the name, Perpette, and different dates, 1755-1757, 1773-1786, 1789-1806, and refer to Dauterman's dates: 1755-1757, 1773-1774, 1777-1798, 1800.

10. Eriksen, *Rothschild Collection: Sèvres*, p. 334.

11. Pierre Verlet, "Sèvres en 1756, "*Cahiers de la céramique et des arts du feu* 4 (Sept. 1956), 34-41, figs. 3 and 3 *bis*.

12. Eriksen, *Rothschild Collection: Sèvres*, p. 182, illustration of a similar painter's mark on an inkstand of 1765, with reference to other pieces of 1761 and 1766, all in a period in which Parpette does not appear on the factory's payroll. Clare Le Corbeiller, *European and American Snuff Boxes 1730-1830* (London, 1966), p. 23, mentions a gold box of 1763-1764 at the Louvre, signed by Parpette.

13. Eriksen, *Rothschild Collection: Sèvres*, pp. 330, 331.

14. Ibid., p. 126.

15. I should like to thank Mme Catherine Join-Dieterle, conservateur, for permitting me to examine this piece.

16. Brunet, *Frick*, p. 284.

65 *Cup and saucer*

(Gobelet Calabre et soucoupe)

France, Sèvres, 1757

Painted by Pierre-Antoine (?) Méreaud, known as Méreaud *l'aîné* (active 1754-1791)

Soft-paste porcelain (*pâte tendre*) with pink ground (*fond rose*), decorated with polychrome enamels and gold

Marks:
on base of cup:
(1) in blue enamel: interlaced Ls enclosing date letter E below painter's mark S; incised: 4
(2) incised: FR
on base of saucer:
(3) in blue enamel: interlaced Ls enclosing date letter E below painter's mark S
(4) incised: cross within an oval

Cup: h. 6.2 cm. (2⁷⁄₁₆ in.), w. 8.6 cm. (3³⁄₈ in.), diam. at rim 6 cm. (2³⁄₈ in.); saucer: h. 3.1 cm. (1³⁄₁₆ in.), diam. 12.1 cm. (4³⁄₄ in.)

1983.641a,b

Published: Sotheby & Co., London, sale catalogue, Feb. 24, 1956, lot 17; *Connoisseur Year Book*, 1957, p. 113, fig. 33.

Provenance: Purchased, Paris, October, 1956

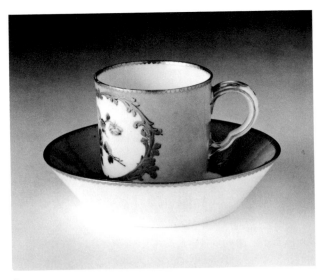

65

The cup has straight sides, which curve in slightly just above the foot ring; it is slightly wider at the top than at the base. The ear-shaped, molded handle has foliate terminals and a molded leaf at the shoulder. The saucer has straight, canted sides; the base is turned to produce a foot ring not visible in the side elevation. The exterior of the cup and the interior of the saucer have a thick pink ground with an orange-peel texture.[1] The reserved circular well of the saucer and oval panel on the cup opposite the handle are decorated with sprays of mixed flowers in natural colors, each with a rose and another large flower and a variety of smaller flowers, vines, and leaves. These panels are framed in scrolling leaves and flowers of burnished and chased gold heightened with puce. Both pieces have rounded gold dentil strings on the rims, and there is a gold band at the foot of the cup. The cup handle has gold banding and ornaments, and the foliate terminals and shoulder leaf are heightened with gold.

The designation *gobelet Calabre* appears in the factory records as early as the inventory of October 1752, but the records also show that the form evolved from a more flaring, bell-shaped profile to this type with straighter sides, very similar to the more popular *gobelet Bouillard*. The main difference between the two shapes is that the *gobelet Calabre* is almost equal in height and diameter, whereas the *Bouillard* is usually broader than it is high. A variety of handles might have been used for the *gobelet Calabre*, and sometimes it had a cover.[2] Marcelle Brunet refers to two drawings of the *gobelet Calabre* in two different sizes that show suggestions for handles "à consoles."[3] This may be

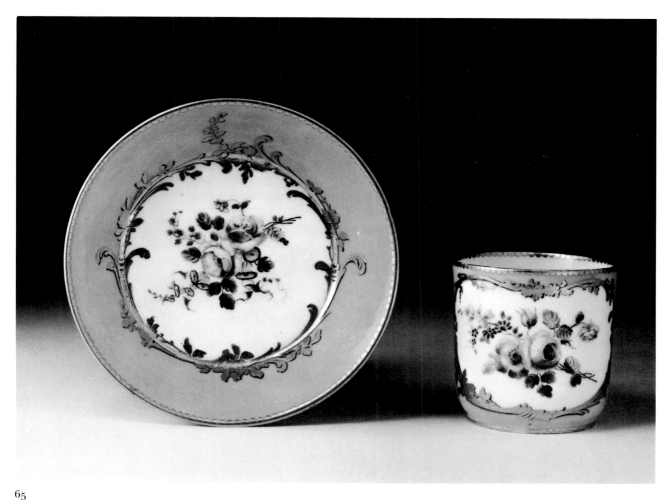

65

the same ear-shaped handle as that found on the Markus piece.

 Pierre Calabre, for whom forms designated *Calabre* were named, was a partner in the Compagnie Eloy Brichard, founded August 19, 1753. Like most of the sixteen investors, he was also in the service of the king as "écuyer, Conseiller Secrétaire du Roy, Maison Couronne de France et de ses Finances."[4]

 The painter of the flowers, known as Méreaud *l'aîné* (to distinguish him from his younger brother, who also worked at Sèvres as a painter), signed his work with a Roman S, and it is so recorded in the original manuscripts in the Sèvres Archives.[5] He was employed at Vincennes in 1754 at the age of nineteen, having previously been an easel painter, and he was noted as a tolerable painter of flowers. The most recent publication by Marcelle Brunet and Tamara Préaud questions the given names, Pierre-Antoine (first published by Svend Eriksen) and lists several of the alternate spellings of his surname: Méreau (preferred by Eriksen) and Méreaux;[6] other spellings have been

Mérault or Méraud (Chavagnac and Grollier). Two plant pots *(caisses à fleurs carrées)* datemarked for 1756, formerly in the Wrightsman Collection, have similar floral sprays by Méraud *l'aîné*.[7] There was also a cup and saucer in the J. Pierpont Morgan Collection, dated 1758, signed by Méraud with an S between two points.[8]

 A very similar cup and saucer with a pink ground but with a cover, also dated 1757, by the painter Xhrouuet, was in the collections of Mr. and Mrs. Deane Johnson and Dr. Annella Brown.[9] Another similar covered cup and saucer is in the Wallace Collection, London (inv. no. XII B 131); it is not dated, but the cup has two of the same incised workman's marks, the FR and the cross within an oval, found on no. 65. Eriksen suggests that FR may be the mark of the *répareur* François-Firmin Dufresne, born in 1739, who worked at Sèvres from 1756 until 1767, when he died there on August 23.[10]

 The workman's mark, an incised cross within an oval, may be the same as those on the cup and saucer, 1756-1757, in the Rothschild Collec-

tion, described as a cross within a small square but appearing to be within a circle in the illustration.[11] Four pieces, two saucers and two cups, catalogued as having the incised cross within a square mark, were in the 1977 Paris exhibition.[12] The incised 4, the other workman's mark on the cup, is to be found on four other pieces in the Markus Collection, nos. 61, 62, 64, and 67.

V.S.H.

65 (1)

65 (2)

65 (3)

65 (4)

NOTES

1. The Tuck Collection ewer and basin referred to in no. 64 have the same surface.

2. Grand Palais, Paris, *Porcelaines de Vincennes: Les Origines de Sèvres,* catalogue by Antoinette Faÿ Hallé and Tamara Préaud (1977), p. 334 (hereafter cited as *Vincennes* [1977]); see also below, note 9.

3. Marcelle Brunet, "French Pottery and Porcelains," in *The Frick Collection: An Illustrated Catalogue,* vol. 7: *Porcelains, Oriental and French* (New York, 1974), p. 270, n. 19 (hereafter cited as Brunet, *Frick*).

4. Ibid., p. 214.

5. Comte Xavier de Chavagnac and Marquis G. de Grollier, *Histoire des manufactures françaises de porcelaine* (Paris, 1906), p. 341; Svend Eriksen, *The James A. de Rothschild Collection at Waddesdon Manor: Sèvres Porcelain* (Fribourg, 1968), pp. 331-332.

6. Marcelle Brunet and Tamara Préaud, *Sèvres des origines à nos jours* (Fribourg, 1978), p. 374.

7. Carl C. Dauterman, *The Wrightsman Collection, vol. 4: Porcelain* (New York: The Metropolitan Museum of Art, 1970), no. 78A, B; Sotheby Parke Bernet, Monaco, sale catalogue, May 26, 1980, lot 328, illus. (color).

8. Parke-Bernet, New York, sale catalogue, March 25, 1944, lot 624, illus. p. 164; the marks were illustrated in Comte Xavier de Chavagnac, *Catalogue des porcelaines françaises...J. Pierpont Morgan* (Paris, 1910), p. 80, no. 95.

9. Sotheby Parke Bernet, New York, sale catalogues, Dec. 9, 1972, lot 24; April 23, 1977, lot 62.

10. Eriksen, *Rothschild Collection: Sèvres,* p. 324; see also p. 148 for illus. of FR mark on one of a pair of vases dated 1761 (no. 52) and for notes on the Wallace Collection cup (XII B131) and a *déjeuner* in the Sèvres Museum with the same mark. See also Pierre Verlet and Serge Grandjean, *Sèvres,* vol. 1: *Le XVIIIe siècle, les XIXe & XXe siècles* (Paris, 1953), pl. 52 and p. 210; Brunet, *Frick,* p. 246 (illus. of FR mark on a vase, about 1762) and p. 252 (a discussion of additional pieces with the FR mark); Brunet and Préaud, *Sèvres,* p. 366: "Fresne (François-Fermin): Tourneur ou répareur 1756-1767" (no FR mark shown).

11. Eriksen, *Rothschild Collection: Sèvres,* no. 19, p. 66.

12. *Vincennes* (1977), nos. 324, 327, 332, and 355; mark illus. p. 186, no. 120.

66 Cup and saucer

(*Gobelet Hébert et soucoupe*)

France, Sèvres, 1757

Painted by André-Vincent Vielliard (active 1752-1790) and Denis Levé (active 1754-1805)

Soft-paste porcelain (*pâte tendre*) with a pink (*rose*) trellis ground, decorated in polychrome enamels and gold

Marks:
(1) on base of cup, in blue enamel: interlaced Ls enclosing date letter E; incised: oo
(2) on base of saucer, in blue enamel: interlaced Ls enclosing date letter E
(3) on base of saucer, incised: 6 (not illustrated)

Cup: h. 6.3 cm. (2½ in.), w. 9.7 cm. (3¹³⁄₁₆ in.), diam. at rim. 7.5 cm. (2¹⁵⁄₁₆ in.); saucer: h. 2.6 cm. (1 in.), diam. 13.2 cm. (5³⁄₁₆ in.)

1983.642a,b

The cup is pear-shaped, with a handle of two twisted or interlacing branches with leaf terminals. The saucer has a five-lobed rim and a circular depression just fitting the foot of the cup. Both cup and saucer have a pink (rose) trellis ground,

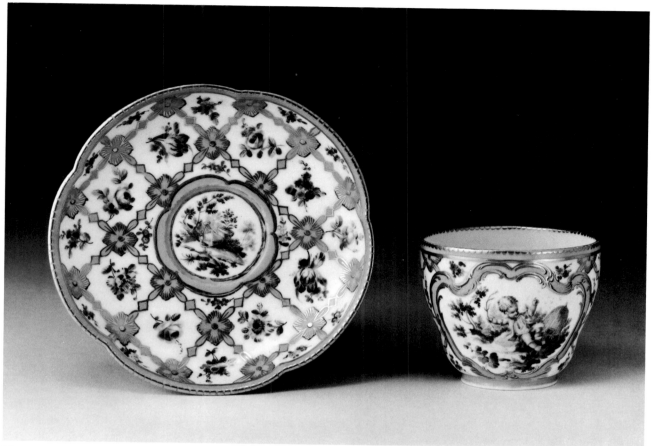

66

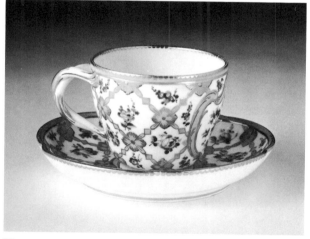

66

outlined with gold; the crossings are in the form of a square fringed with gold, shaded with puce. The rims and the symmetrically scrolled framing of the cartouche on the cup and the five-lobed framing of the well of the saucer are also pink outlined with gold and puce. Both pieces have rounded gold dentil edges and gold foot rings (the gold on the cup is largely gone). The handle is also partially gilded. The cartouche on the cup is painted in polychrome with a boy seated on a rock in a landscape, with a beehive to his left; in his right hand he holds a branch with which he is fighting off a swarm of bees. In the well of the saucer are a flowering shrub in a pot and an overturned watering can in a landscape, all in polychrome. The interstices of the trellis are painted with a great variety of flower sprays in natural colors.

There is no inscribed drawing of this type of cup and saucer in the Sèvres Archives, as there is for the sugar bowl (no. 61) named after the *marchand-mercier* Hébert, but it has been clearly established that this is the *gobelet Hébert*.[1] Molds identified as *gobelet Hébert* are listed in the inventory of January 1754, and the records of sales of 420 examples

show that three sizes were produced.[2] This cup is 0.9 cm. (⅜ in.) smaller than one in Waddesdon Manor,[3] which, at 7.2 cm. (2 13/16 in.), is probably the largest size (*1re grandeur*) and 0.9 cm. (⅜ in.) larger than the smallest size (*3e grandeur*) (see no. 67).

Several pieces with pink trellis grounds are known in museum collections and auction sales, but with one exception they differ enough in the shape of the framing of the cartouches to suggest that they were not from the same service. A cup and saucer in the Morgan Collection, Wadsworth Atheneum, Hartford, Connecticut (1917.998) are most like no. 66; on the cup the cartouche that encloses a girl in a similar landscape has the same shaped frame and the same date letter and also lacks a painter's mark; the saucer, however, is circular with a quatrefoil framing to the central cartouche, and the mark is only partially legible.[4] Of the four pieces in the Jones Collection at the Victoria and Albert Museum, London, only one has a date letter (1761);[5] this set must originally have had a matching tray. However, the tray in the Wallace Collection,[6] which has the same date letter as no. 66, differs from both the Jones piece and no. 66 in the shape of the cartouche. A related but undated cup and saucer in the Andrade Collection at the Ashmolean Museum, Oxford,[7] is by another, unidentified, painter, and the trellis design on the saucer is arched, rather than squared as on no. 66 and the above pieces.

The painter of the cartouches, André-Vincent Vielliard, has been the subject of a special study by Anne-Marie Belfort.[8] Biographical details were also given by Eriksen,[9] who established this spelling of the painter's name, based on his own signatures, as opposed to other sources, who spelled it "Vieillard." According to factory records, Vielliard was born in Paris about 1718 and worked as a fan painter before he came to Vincennes in September 1752 at 30 livres a month. He was older than most beginning painters at the factory and was already married. His salary was rapidly increased in the next few years until he reached the maximum for his type of painting, 84 livres a month in September 1755.[10] He continued with the manufacture until he died at Sèvres on June 8, 1790. In addition to painting children, such as are seen here and on no. 67, and arrangements of garden tools and accessories, he did landscapes with figures and genre scenes in the manner of David Teniers. Some of Vielliard's paintings were based directly on prints of Boucher's children, both clothed and nude. Belfort has shown, however, the way in which he used the cupids of Boucher as paper dolls, dressing them in contemporary cos-

66 (1) 66 (2)

tume and giving them occupations in relation to the garden landscapes in which he placed them (see note 8).

Although this cup does not bear Vielliard's mark, the boy has the typical features of what came to be known as "Vielliard's infants." His attitude—head down, arms out to the sides, right leg forward, left knee raised—is identical to that of the central cupid in the group of three representing Spring (*Le Printems* [sic]) in a suite of four etchings of the seasons by Louis Félix de La Rue (1731-1765?) executed for the Paris printer Huquier, in whose sale of 1772 the original Boucher drawings were included.[11] In the print the winged cupid, naked, in clouds, is holding a wreath of flowers in his left hand and a flower (?) in his right.

The painter of the flowers on no. 66, Denis Levé, marked only the saucer with one of his two marks (he sometimes used a script L). Born in Saint-Germain-en-Laye in 1730, he worked as a clerk and studied design in order to enter the Manufacture de Vincennes in August 1754. He, too, began working at a salary of 30 livres a month but received raises of only 3 or 6 livres at intervals, earning approximately 66 livres at the time he painted this cup and saucer. He was receiving 90 francs a month when he was pensioned in 1800 with an annual pension of 500 francs until his death on November 7, 1816.[12] A more ornamental treatment of flowers can be seen in the garlands with which he decorated a pair of vases of 1755 in the Frick Collection.[13]

The incised workman's marks on the Markus cup, oo, may be seen also on the cup in the 1763 tea service at Waddesdon Manor and on a 1765 trembleuse cup and saucer in the same collection.[14] The 6 or 9 on the saucer appears on two pieces in the 1977 Paris exhibition and also on a jardinière of 1755 in the Frick Collection.[15] Although it is unlikely that it will ever be possible to associate the incised numerals and other symbols with an individual workman listed in the factory records, the accumulated information about them

may have value in cataloguing pieces without date marks.

<div align="right">V.S.H.</div>

NOTES

1. Svend Eriksen, *The James A. de Rothschild Collection at Waddesdon Manor: Sèvres Porcelain* (Fribourg, 1968), p. 38.

2. Grand Palais, Paris, *Porcelaines de Vincennes: Les Origines de Sèvres,* catalogue by Antoinette Faÿ Hallé and Tamara Préaud (1977), p. 122 (hereafter cited as *Vincennes* [1977]).

3. Eriksen, *Rothschild Collection: Sèvres,* no. 25.

4. I wish to thank Rosalind Savill, Wallace Collection, London, for calling these pieces to my attention and Linda Horvitz, assistant curator of European art, Wadsworth Atheneum, Hartford, Connecticut, for examining them for me.

5. William King, *Catalogue of the Jones Collection,* pt. 2: *Ceramics...* (London: Victoria and Albert Museum, 1924), no. 120, pl. 4; Reginald Haggar, *The Concise Encyclopedia of Continental Pottery and Porcelain* (New York, 1960), pl. 131.

6. Rosalind Savill, "François Boucher and the Porcelains of Vincennes and Sèvres," *Apollo* 115 (March 1982), 162-170, fig. 3.

7. Inv. no. 1968.280/1-2; Sotheby & Co., London, sale catalogue, May 23, 1967, lot. 81, illus.

8. Anne-Marie Belfort, "L'Oeuvre de Vielliard d'après Boucher," *Cahiers de la céramique, du verre et des arts du feu* 58 (1976), 6-35.

9. Eriksen, *Rothschild Collection: Sèvres,* p. 338.

10. Marcelle Brunet, "French Pottery and Porcelains," in *The Frick Collection: An Illustrated Catalogue,* vol. 7: *Porcelains, Oriental and French* (New York, 1974), p. 336 (hereafter cited as Brunet, *Frick*).

11. Pierrette Jean-Richard, *L'Oeuvre gravé de François Boucher dans la collection Edmond de Rothschild* (Paris: Musée du Louvre, 1978), no. 1267, illus. p. 312.

12. Brunet, *Frick,* pp. 329-330

13. Ibid., pp. 206-208.

14. Eriksen, *Rothschild Collection: Sèvres,* pp. 168, 180, with references to other occurrences in the 1760s and 1770s.

15. *Vincennes* (1977), nos. 195, 202; Brunet, *Frick,* pp. 210-212, with references to other pieces as late as 1771.

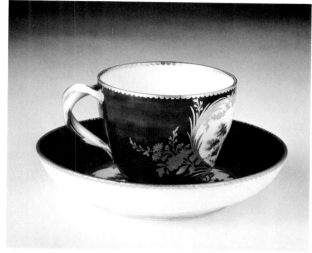

67

67 Cup and saucer

(Gobelet Hébert et soucoupe)

France, Sèvres, 1758

Painted by André-Vincent Vielliard (active 1752-1790)

Soft-paste porcelain *(pâte tendre)* with underglaze-blue ground *(bleu lapis),* decorated in polychrome enamels and gold

Marks:

on base of cup:
(1) in blue enamel: interlaced Ls enclosing date letter F; above, the painter's mark, a label of three points; below, a dot
(2) incised: unidentified mark

on base of saucer:
(3) in blue enamel: interlaced Ls enclosing date letter F; above, painter's mark, a label of three points; below, a dot
(4) incised: 4
(5) inside foot ring of saucer, in underglaze blue: two dots

Cup: h. 5.4 cm. (2⅛ in.), w. 8.5 cm. (3⅜ in.), diam. at rim 6.7 cm. (2⅝ in.); saucer: h. 2.8 cm. (1⅛ in.), diam. 12 cm. (4¾ in.)

1983.643a,b

The cup is pear-shaped with a handle of two twisted or interlacing branches with leaf terminals. The saucer is in the shape of a shallow bowl. The outside of the cup and the inside of the saucer have a deep blue underglaze ground (bleu lapis) on which are reserved a heart-shaped cartouche opposite the handle on the cup and a circular cen-

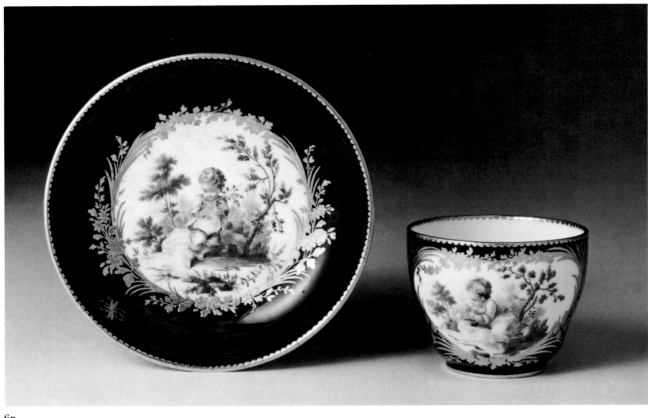

67

67 (1)

67 (2)

67 (3)

67 (4)

67 (5)

tral cartouche on the saucer. Both cartouches are framed symmetrically with chased gold palm leaves and flower sprays, which very consciously take advantage of the white areas left by the painter of the scenes; on the saucer, a gold insect is placed at the lower left (about 7:30), probably to hide a flaw in the glaze. Both pieces have rounded gold dentil rims and plain gold bands at the foot ring. The handle is also partially gilded. Both cartouches are painted in polychrome with children in garden landscapes. On the cup a little girl in profile to the left is kneeling on the rocks on her right knee, her left foot on the ground, and is blowing a soap bubble from a straw; a bowl is on the rock before her. On the saucer, a boy is seated on the rocks in frontal view, looking down slightly to his right; he holds a leafy twig in both hands against his left shoulder; his left knee is slightly bent, with the foot behind the right leg.

The form of this cup, Hébert, is the same as that of no. 66,[1] but this is apparently the smallest size *(3e grandeur)*. It is not unusual to find a completely different shape of saucer. The Markus saucer is clearly identical to that which accompanies the *gobelet Bouillard* in a drawing preserved in the Sèvres Archives inscribed in ink "goblet pour Le

dejeune boilliard fait suivan La Comande du 19 feurÿe 1753."[2] Brunet agrees with Eriksen's assumption that the saucer, too, was designed to hold liquid, although probably not when it was so ornately decorated as this piece.[3] Antoine-Auguste Bouillard was an investor in the Fermes du Roy and partner in the Compagnie Eloy Brichard (see the introduction to this section).

The very deep underglaze-blue ground color of no. 67, which was produced from the earliest days at Vincennes, was referred to as *bleu lapis* in the first sales record preserved at the factory, that of January 1753. The ground color of the Markus cup exemplifies more closely than that of the saucer the cloudy quality of *bleu lapis* when it was first produced. This color was the predecessor of *bleu de Sèvres,* which was introduced in 1763 as *bleu nouveau.*[4]

The painter of the cartouches, André-Vincent Vielliard, is discussed in detail in relation to no. 66. The artistic elements are the same in all three scenes of children: the random rocks and leafy branches in the foreground, the yellowish rocks topped with pale green grass or moss, the flanking trees with their lively branches and leaves and the gray-blue feathery treatment of the trees in the background. Both figures here are also lifted out of prints after Boucher and cleverly dressed and given occupations. On the cup, the girl has exactly the same pose as the right-hand cupid in a group of four in an etching entitled *L'Amour oiseleur,* by Bernard Lépicié (Paris, 1698-1755) after a painting by Boucher, which was first mentioned in the *Mercure de France* in 1734. This and its companion piece, *L'Amour moissonneur,* also served as models for tapestries made at Beauvais.[5]

The boy on the saucer is based on another etching by Louis Félix de La Rue (1731-1765?) and printed by Huquier, *Le Feu,* one of a suite of four pieces depicting the elements. The red chalk drawings for the etchings were in Huquier's sale in 1772. In *Le Feu* three cupids are seated on the ground, the two at the right warming their hands over a fire, which is being rekindled by the third.[6] The central cupid is the model for this boy; since his two hands are in the same position as in the print, he does not really grasp the twig supplied by Vielliard. Belfort shows another use of the same figure, on a *pot à sucre Bouret* of 1758 in the Musée Cognac-Jay, Paris, in which Vielliard has placed a fish in the boy's right hand and a fishing pole in his left.[7]

The incised workman's mark, a numeral 4, on the saucer of no. 67 is the same as on nos. 61, 62, 64, and 65. It is found on nine pieces that were in the 1977 Paris exhibition, two of which are also saucers.[8] Eriksen lists other pieces on which this mark appears between 1753 and 1757.[9] It may also be seen on a jug of 1776 in the Frick Collection.[10] The unidentified incised mark on the Markus cup has not been found on any other pieces.

The two dots in underglaze blue inside the foot ring of the saucer may be the mark of the unidentified workman who pounced on the underglaze-blue color, or they may be the dots referred to by Eriksen as warnings to the workmen firing the kiln so that this piece might be specially placed for firing.[11] The saucer has black specks in the glaze of the bottom, as well as the flaw noted above covered by the gold insect.

V.S.H.

NOTES

1. See discussion at no. 66 for details of the cup's history.

2. See Svend Eriksen, "A propos de six Sèvres du dix-huitième siècle," *Kunstindustrimuseets Virksomhed* (Copenhagen) 4 (1964-1969), fig. 158, p. 146.

3. Marcelle Brunet, "French Pottery and Porcelains," in *The Frick Collection: An Illustrated Catalogue,* vol. 7: *Porcelains, Oriental and French* (New York, 1974), p. 268 (hereafter cited as Brunet, *Frick).*

4. See Svend Eriksen, *The James A. de Rothschild Collection at Waddesdon Manor: Sèvres Porcelain* (Fribourg, 1968), pp. 28, 30, for a detailed discussion of the various names used in France and England in the eighteenth and nineteenth centuries for these and related cobalt blue grounds; see also Brunet, *Frick,* pp. 190-191.

5. Pierrette Jean-Richard, *L'Oeuvre gravé de François Boucher, dans la collection Edmond de Rothschild* (Paris: Musée du Louvre, 1978), no. 1377; this print has a 1742 watermark.

6. Ibid., no. 1278; Anne-Marie Belfort, "L'Oeuvre de Vielliard d'après Boucher," *Cahiers de la céramique, du verre et des arts du feu* 58 (1976), 27, illustrates this subject, fig. 10 bis, as *L'Hiver* in relation to fig. 10, a flower vase of 1757 in the Walters Art Gallery, Baltimore, which uses the two right figures. Fig. 10 *bis* is not the La Rue etching, however, but may be Boucher's original drawing since the subject shown with it, *L'Astronomie,* was also in Huquier's possession and etched by La Rue.

7. Belfort, "L'Oeuvre de Vielliard," fig. 14 (color).

8. Grand Palais, Paris, *Porcelaines de Vincennes: Les Origines de Sèvres,* catalogue by Antoinette Faÿ Hallé and Tamara Préaud (1977), nos. 68, 75, 76, 202, 280, 295, 296, 298, and 369.

9. Eriksen, *Rothschild Collection: Sèvres,* p. 68.

10. Brunet, *Frick,* p. 284.

11. Eriksen, *Rothschild Collection: Sèvres,* p. 46, referring to Comte Xavier de Chavagnac and Marquis G. de Grollier, *Histoire des manufactures françaises de porcelaine* (Paris, 1906), pp. 142-143, quoting a memorandum book by Gravant in the archives of the factory.

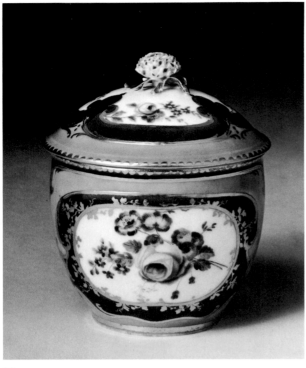

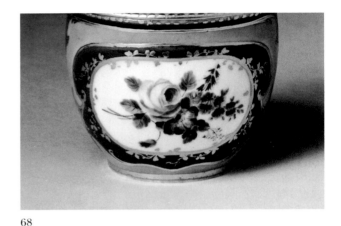

68

68

68 *Sugar bowl and cover*

(*Pot à sucre Bouret*)

France, Sèvres, about 1758-1759

Soft-paste porcelain (*pâte tendre*) with pink and green ground (*fond rose et vert*), decorated in polychrome enamels and gold

Mark:
(1) on base of bowl, incised: T (?)

H. 9.5 cm. (3¾ in.), diam. at rim 7.6 cm. (3 in.)

1983.644a,b

Published: Comte X. de Chavagnac, *Catalogue des porcelaines françaises de M. J. Pierpont Morgan* (1910), p. 88, no. 106; Parke-Bernet, New York, sale catalogue, March 25, 1944, lot 623, illus.; Christie's, London, sale catalogue, Nov. 29, 1973, lot 39, illus.

Provenance: Colls. J. Pierpont Morgan (sale, Parke-Bernet, New York, March 25, 1944, lot 623); Sydney J. Lamon (sale, Christie's, London, November 29, 1973)

The bowl has a slightly convex profile, curving gently in to the foot ring and to the slightly everted lip. The cover is slightly domed, with a turned molding at the rim and a knob in the form of a flower (carnation?) with scrolling leaves. The trefoil reserve on the cover and the two oval reserves on the bowl are framed with deep bluish green on a pink ground. On the cover the green takes the form of C scrolls joined by fleur-de-lis, banded in slightly foliate burnished gold with dots. On the bowl the green forms a narrow band at the rim, dropping into modified trefoils at the sides between the reserves; it also frames the oval reserves with commode-shaped panels and joins the two sides with rococo-shaped areas, all gold-bordered in foliate scrolls of S, C, and wavy shapes; the oval reserves are framed by a plain gold band entwined with delicate gold vines, which have been preserved less well against the white than against the green.[1] There are rounded gold dentil borders at the rims of both the bowl and cover, and a plain band at the foot ring. The flower knob is colored pale yellow with touches of red, and the leaves are gold. The reserve on the cover has sprays of polychrome flowers with leaves, curving from left to right in each lobe to give the effect of a wreath. The panels of the bowl have one spray with stems to the right, the other to the left, and each features a large pink rose with a variety of smaller flowers, buds, and leaves. There is a hole drilled into the inner flange of the cover.

In form this piece is very close to the turquoise sugar bowl dated 1755 in the Rothschild Collection.[2] Eriksen found a drawing of a somewhat larger sugar bowl of this form in the Sèvres Archives; it is inscribed "boete a Sucre Bouret no 1 fait Suivan L'ordre de La Comande du 19 feurÿe 1753." Bouret d'Erigny was *écuyer* and *fermier-général* in the service of the king and was one of the sixteen shareholders in the Compagnie Eloy Brichard.[3]

There were a number of pieces with a pink and green ground in the J. Pierpont Morgan Collection, including a cup and saucer by Méreaud *l'aîné*, with the date letter F for 1758, and a pair of cups and saucers dated 1759, painted by Vielliard.[4] This combination of colors is not referred to in the factory sales records until December 1760.[5]

A 1759 covered *écuelle* with stand in the Louvre[6] has a similar pink and green combination, and both the bowl and stand have the same incised mark as on no. 68, which is very like the mark on a 1763 sugar bowl in the Rothschild Collection illustrated by Eriksen[7]. This is interpreted by him as a T, which he suggests may possibly be the mark of the *tourneur* Pierre-Aymond Tristant, known as Tristant *l'aîné*, who worked as a *tourneur* (thrower) from 1758 to 1788.[8]

The Markus bowl and cover have collection marks in red: P.M. 1612A,B. They were included in the loan exhibition of the J. Pierpont Morgan Collection at the Metropolitan Museum of Art, New York, 1914-1915.

V.S.H.

NOTES

1. This is in contrast to the English Worcester porcelain practice (see no. 83), wherein gold would not adhere to the green and was always applied only to the white adjacent surface.

2. Svend Eriksen, *The James A. de Rothschild Collection at Waddesdon Manor: Sèvres Porcelain* (Fribourg, 1968), p. 62, no. 14.

3. Marcelle Brunet, "French Pottery and Porcelains," in *The Frick Collection: An Illustrated Catalogue*, vol. 7: *Porcelains, Oriental and French* (New York, 1974), p. 270, n. 8.

4. Comte Xavier de Chavagnac, *Catalogue des porcelaines françaises...J. Pierpont Morgan* (Paris, 1910), nos. 95 and 105, lots 624 and 622, respectively, in the Parke-Bernet sale catalogue, March 25, 1944, illus.

5. Eriksen, *Rothschild Collection: Sèvres*, p. 118.

6. Inv. no. OA 6249.

7. Eriksen, *Rothschild Collection: Sèvres*, p. 168.

8. Ibid., p. 284, where the author lists various pieces so marked, which are all thrown in molds, and p. 337, which gives more biographical notes.

69 Tea or breakfast service

(*Déjeuner Duvaux*)

The service consists of (a) a tray (*plateau Duvaux*), (b) a teapot (*théière Verdun* or *Calabre*), (c) a sugar bowl (*pot à sucre Hébert*), (d) a milk jug (*pot à lait tripode*), and (e, g) two cups and (f, h) saucers (*gobelets Hébert et soucoupes*)

Plate XVII

France, Sèvres, 1761

Soft-paste porcelain (*pâte tendre*) with pink ground (*fond rose*), decorated in polychrome enamels and gold

Marks:

(1) 69a, on base, in blue enamel: interlaced Ls enclosing date letter i

(2) 69a, on base, incised: FR

(3) 69a, on base, incised: BP

(4) 69b, on base of teapot, in blue enamel: interlaced Ls enclosing date letter i

(5) 69b, on base of teapot, incised: script E

(6) 69c, on base of sugar bowl, in blue enamel: interlaced Ls enclosing date letter i(?)

(7) 69c, on base of sugar bowl, incised: T (?); on inside of cover, incised: X (not illustrated)

(8) 69d, on base of one foot, in blue enamel: interlaced Ls enclosing date letter i

(9) 69e, on base, in blue enamel: interlaced Ls enclosing date letter i; incised: FR

(10) 69f, on base, in blue enamel: interlaced Ls enclosing date letter i

(11) 69f, on base, incised: 3

(12) 69g, on base, in blue enamel: interlaced Ls enclosing date letter i

(13) 69g, on base, incised: LF

(14) 69g, on base, incised: oo

(15) 69h, on base, in blue enamel: interlaced Ls enclosing date letter i

(16) 69h, on base, incised: script E

69a: h. 4.1 cm. (1⅝ in.), w. 30.1 cm. (12¼ in.), d. 22.8 cm. (9 in.); 69b: h. 10.4 cm. (4⅛ in.), w. 14 cm. (5½ in.), diam at base 4.6 cm. (1¹³⁄₁₆ in.); 69c: h. 9 cm. (3⁹⁄₁₆ in.), diam. at rim 6.7 cm. (2⅝ in.); 69d: h. 8.2 cm. (3¼ in.), w. 8.5 cm. (3⅜ in.), diam. at rim 4.7 cm. (1⅞ in.); 69e: h. 5.5 cm. (2¹³⁄₁₆ in.), w. 8.6 cm. (3⅜ in.), diam. at rim 6.8 cm. (2¹¹⁄₁₆ in.); 69f: h. 2.7 cm. (1¹⁄₁₆ in.), diam. at rim 11.8 cm. (4⅝ in.); 69g: h. 5.4 cm. (2¼ in.), w. 8.6 cm. (3⅜ in.), diam. at rim 6.7 cm. (2⅝ in.);

69h: h. 2.8 cm. (1⅛ in.), diam. at rim 11.9 cm. (4¹¹⁄₁₆ in.)

1983.211-218

Provenance: Colls. Gilbert Lévy, Paris; Alfred Wenz, Paris; purchased, New York, 1983

The tray, which gives its name to the service, is molded in a form sometimes described as "cartouche-shaped,"[1] with two symmetrically placed, applied twisted foliate handles. The teapot has an ovoid body with an applied ear-shaped handle, a slightly curved spout (repaired at the lip), and a low-domed cover with a flower finial. The sugar bowl is pear-shaped with a low-domed cover and a flower finial (cf. no. 61). The three-legged milk jug has a pear-shaped body flaring slightly at the rim, which is scalloped and notched and rises upward and outward at the front to form a spout; a rustic handle, at the rear, rises from the rim, loops back, and joins the body at its fullest bulge. Flowers and foliage applied in relief grow upward from each of the three short, rustic feet and from the attachments of the handle. The cups are pear-shaped, with interlacing branch handles (cf. nos. 66 and 67), and the saucers are bowl-shaped (cf. no. 67).

All the pieces in this service are decorated with one or more rural landscapes in reserved panels, which are shaped generally to conform with the shapes of the pieces. Each panel is framed with a gold band with a chased pattern of triangles, within a narrower dark puce band, and is set against a pink ground (fond rose) ornamented with a trellis pattern in blue, dark puce, and gold. The trellis consists of scrolling, blue, feathered leaves rising upward to right and left from puce bosses; on the tray the bosses have a central gold dot and an outer circle of gold dots and on the smaller pieces only a central dot; there is a gold dotted line marking the center of each leaf. In the diamond-shaped interstices are square rosettes with blue centers and puce petals touched with gold. On the tray the diamonds are consistent in size and larger than on the other pieces; on the teapot and jug the diamonds are larger at the bulging part. The gold dots were applied with the rest of the gilding, as the last stage of decorating, and it is probably not unusual to find some missing (on the cover of the sugar bowl they are lacking from two leaves; on the teapot, one boss lacks its central gold dot; and on the tray, one leaf is without dots, and one boss lacks the outer circle).

A variety of landscapes, painted in natural colors by an unidentified artist, completely fill the reserved panels. On the tray, on the banks of a river a shepherd wearing a red coat with a blue sash and holding a staff is looking back to a group of three sheep; a group of buildings with an obelisk, a grove of fruit trees, and a circular building with a dovecote and a bird weathervane (?), are at his right; in the left foreground, on a grassy knole, there is a tree stump with one sturdy branch bearing green and brown leaves reaching upward into the central arch of the panel; a stone footbridge with two arches, overgrown with ivy, is at the right foreground; the background, painted in pastel tones, includes a round tower at the left and a village among hills in the center; there are many birds in the sky, which, as on all the pieces, is uncolored and without clouds.

The teapot has two circular panels indented at the top. The scene on the obverse is of a large group of farm buildings on the shore of a lake or river; a man in blue, wearing a hat, with a sack on his back and a staff in his right hand, walks in from the left; in the foreground is a rocky, grassy knole with a tree and a stump, the brown leaves filling the center of the sky area; smoke is rising from the nearest of the three chimneys of the largest building; in the distance is a large church with two towers and a domed crossing. On the reverse, two trees intersect in the foreground, one with yellow-green leaves, the other brownish; a farm building at the right has a smoking chimney; in the center, the river is spanned by a triple-arched stone bridge over which two figures are crossing; there are green trees at the left of the bridge and birds in the sky above; in the background are pastel hills and buildings.

The sugar bowl and cover each have two panels; on the obverse of the bowl, a man wearing a blue coat, red trousers, and a hat is fishing in the left foreground; beside him a tree with green and brown leaves, on a grassy knole, curves to the right over a building with an arched entry (a chapel?), to the right of which is a buttressed round tower on which a red banner is flying; in the left background are a small church and hills and birds in the sky above them. On the obverse of the cover is a small farm building with a large square door, a chimney at the right, and a fence; there is a grove of trees at the left and, at the right, a single tree arching to the right, with hills in the distance. The scene on the reverse of the bowl differs from the others in that the central element is a monument: an obelisk overgrown with ivy, with an orb at the peak; there are four statues on pedestals around it; on the grassy mound in the foreground a man wearing a red coat, holding a staff, is reclining; a V-shaped tree with yellow-brown and green leaves is at the left, and, at the right, there is a small

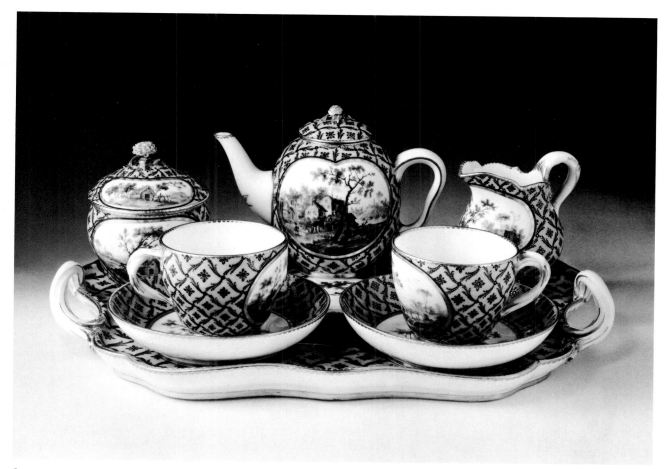

69

group of buildings among trees and shrubs; there
are birds in the sky and very distant, low hills. On
the reverse of the cover, a tree at the left of center
arches to the center, which is open to the distant
hills; a simple building with a smoking chimney is
at the right.

The panel on the milk jug is centered under
the spout and between two of the three feet. At the
left is the end of a castle wall with turreted corners
and buttresses; there is a river in the center with
two trees, one with gray-green and the other with
brown leaves, forming a V on its left bank; a fence
is in the foreground; a pavillion with a straw roof is
at the right; in front of this is a kneeling figure
wearing a white cap, a blue blouse, and a pink
skirt, washing clothes; a pink mountain and pastel
trees are in the background.

The oval panels on the cups are opposite
the handles. On one, e, a tree with yellow-brown
leaves grows from a brown mound in the center
foreground, bisecting the panel; to the left are
smaller trees and a mound of pinkish rock with wa-
terfalls emptying into a pool; at the right, on a yel-
low meadow, a fisherman walks toward the center:

he is wearing a hat, a yellow jacket, pink breeches,
and gray stockings and has his rod over his shoul-
der; there is a ruined church façade in the distance
behind him and hills beyond. On the other cup, g,
on the river bank in the foreground a fisherman in
a brown hat, red jacket, and blue trousers stands
facing left toward the center, his line in the water;
at the left a tree with brownish green leaves leans
over the center; at the left, behind the tree, is the
ruin of a church or wall, with a large arched entry,
and in front of it a small house; on a grassy mound
at the right is a fence, and in the distance behind it
are pink hills, a tower, and a house; there are birds
in the sky.

Both saucers have circular panels with river
or lake scenes. On one saucer, f, crossing trees with
gray-green, brown, and yellow-green leaves, and
smaller bluish green trees and grasses grow on the
bank in the foreground to the left of center; a
clump of broad leaves is at the base of the trees,
dwarfing the fisherman wearing a black hat and
red jacket who is seated on the bank just behind to
the right, his line in the lilac-colored water; across
the water is the remnant of a stone bridge, one

arch remaining, with a towered house on it; there are pink and lavender rocky hills in the distance. On the other saucer, h, there are two trees on a grassy bank in the foreground to the right of center, one with a gray trunk and brownish green leaves growing vertically, the other, with a brown trunk and brownish green leaves, arching to the right and back to center; at the left is a thatched cottage with a central chimney and a few smaller trees growing next to it; a fisherman wearing a black hat and red jacket is seated on the bank to the right of the cottage; a building on a mound at the left in the middle distance has an arched door and a round tower, and some pastel buildings are at the right on a bank; in the far distance at the center can be seen the spire and tall façade of a church; there are birds in the sky.

The gilding of the trellis decoration and around the panels has already been noted. In addition, each piece is edged with a string of rounded gold dentils, and each foot ring has a plain gold

band. On the milk jug the pink ground continues on the underside, but this is an undecorated area encircled by a gold band outlined on both sides in dark puce. The handles of the tray, the teapot, and the cups are white, accented in gold, as are the handle and feet of the milk jug. The relief flowers of the jug are also gilded, and there are two sprays of gold flowers and leaves painted on the outside walls of the tray, just below the handles, one masking a fire crack, the other for symmetry. The flower finial of the teapot is touched with gold, the flower on the sugar bowl is yellow, and the leaves of both finials are green. A flying bird is painted in polychrome on the lower curve of the spout of the teapot; it has a white head, a blue neck, puce wings edged at the top with orange, a yellow breast, black feet, and a short, orange tail. It may have been added to distract the eye from a slight glaze discoloration at the base of the spout.

An eighteenth-century drawing of this form of tray is preserved at the Sèvres factory. It is without either inscription or date, but Svend Eriksen, studying the references to the "plateau Duvaux" in relation to other named trays, concluded by deduction that the Duvaux tray, which was mentioned for the first time in the sales record of 1758, is of the same form as shown in the drawing.[2] Brunet and Préaud confirmed Eriksen's deductions, adding that the "plateau Duvaux" is included in an inventory of the stock of undecorated porcelain, dated October 1, 1759, among about fifteen other trays, some named for other members of the company or other merchants, some merely described as triangular or lozenge-shaped, with plain or pierced borders.[3] Lazare Duvaux (about 1703-1758) was the famous dealer (marchand-mercier) who, until 1754, was the factory's sole distributor, thereafter retaining the right of first choice of all

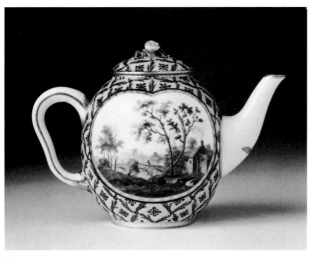

69

69

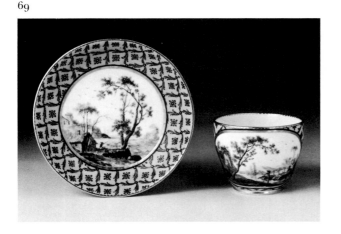

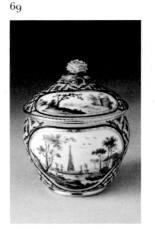

69

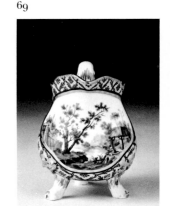

69

69 (1)

69 (2)

69 (3)

69 (4)

69 (5)

69 (6)

69 (7)

69 (8)

69 (9)

69 (10)

69 (11)

69 (12)

69 (13)

69 (14)

69 (15)

69 (16)

the factory's production, much of which he supplied to the court.[4] His *Livre-Journal* for the years 1748-1758, which was published in 1873, has been a primary resource for students of the social history of France in the mid-eighteenth century. It is uncertain whether this *plateau* was named in his honor at the time of his death, November 23, 1758, or whether, as Brunet suggests, this "rather infrequently encountered" form was created for him.[5] In addition to the examples already referred to here (in notes 1-3), there is one of 1760 in the Jones Collection;[6] another, 1761, with pink ground, was painted by Aloncle and given by Marie Antoinette to her daughter, the Duchesse d'Angoulême; a *déjeuner Duvaux* of 1763, formerly in the Paul Auge collection, comprising the same pieces as the Markus service, with pink grounds, similar blue and gold trellis pattern, and reserves with painted landscapes of the same type, was sold in London in 1980.[7] The *plateau Duvaux* is also found in a service of 1768 in the Morgan Collection at the Wadsworth Atheneum, Hartford.[8] An even later example, a *déjeuner Duvaux* of 1769 in the Museum of Decorative Arts, Copenhagen, resembles no. 69 not only in size and number and form of pieces but also in the type of landscapes painted in the reserves; only the turquoise *oeil-de-perdrix* ground is different.[9]

The teapot (*théière Verdun*), of the same form as that in the Waddesdon *déjeuner*,[10] was designed as early as February 19, 1753, the date on the original drawing at Sèvres. It was named for the *fermier-général* Jean-François Verdun de Monchiroux, one of the main shareholders in the factory. Eriksen[11] has attributed the design of the *théière Verdun* to Jean-Claude Ciambellano, called Duplessis, the king's goldsmith, who was responsible at the Vincennes-Sèvres factory for the general artistic development of both decorative and useful pieces from about 1745 or 1747 until his death in 1774.[12] An alternate name for this teapot is *Calabre* (see no. 65), which, according to Tamara Préaud, is found on a model preserved at the factory and which appears in documents as early as December 1752. Mme Préaud suggests that the distinction may be related to differences in size or, possibly, that one name took the place of the other; both were used in the kiln records.[13] Brunet noted a second, smaller, drawing dated 1760, which bears the name "bouret" for Bouret d'Erigny, another shareholder.[14] Judging from published examples, there seem to be at least three sizes for this teapot, of which no. 69b is the smallest.

The sugar bowl (*pot à sucre Hébert*) is a smaller version of no. 61 (the history of the form and its name is given in that entry), and the cups and saucers in this service are of the same form (also *Hébert*) as nos. 66 and 67. The cups of no. 69 are the same size (the smallest) as the cup of no. 67, which has a saucer of the same size and shape.

This type of three-legged milk (or cream) jug was first recorded in an inventory of October 8, 1752, as "1 petit pot à lait à trois pieds."[15] It was made in three sizes as early as November 15, 1752, according to a list of biscuit taken from the kiln.[16] Numerous examples of this type of milk jug have survived, in both soft- and hard-paste porcelain, but they are rarely marked and, when not a part of a marked service, must usually be given only an approximate date.

The incised marks on the tray are probably those of both the workman who molded the piece and the one who applied the handles. The script BP is also found on the tray of the same form at Waddesdon Manor and on other pieces dating from 1757 to 1766.[17] The FR is incised on one of the teacups in this service, 69e, as well as on the tray, and it is also on the cup (*gobelet Calabre*), no. 65 (in the entry for which references are cited for its attribution to the *répareur* Dufresne). The other cup, 69g, has the incised initials LF, which, often in a simpler form, are to be found on a number of pieces dating from 1758 to 1770.[18] This cup also has the oo mark found on no. 66 (see entry for other instances of the mark). The sugar bowl has the same mark as that found on another sugar bowl in the collection, no. 68 (in the entry for which its attribution to the *tourneur* Tristant is discussed). The incised script letter E is found on two pieces in this service, the teapot and one of the saucers, 69h. There are very few published examples of this mark,[19] but in some publications it may have been confused with the very similar numeral 3. The latter, which appears on one of the saucers in this service, 69f, may have been incised by the same workman who marked the bowl of no. 63. (See the entry at no. 63 for a discussion of the frequency of the use of the mark 3 both in the Vincennes and later period).

"Déjeuner" was the term used in the records of the factory in the eighteenth century for small services, the size of which ranged from only one cup, or cup and saucer, on a small porcelain tray, to that of the Markus example and others even more complete, including a tea caddy and a jam pot, for example. Today the term more frequently used is "cabaret," which originally referred to a tea table or tray for serving tea. Lazare Duvaux used both terms in his *Livre-Journal*, but a "cabaret" was always distinguished as Chinese or lacquer and sometimes was a part of a "déjeuner".[20]

V.S.H.

NOTES

1. Yvonne Hackenbroch, *Meissen and Other Continental Porcelain, Faience and Enamel in the Irwin Untermyer Collection* (Cambridge, Mass., 1956), p. 234, a similar tray, Sèvres, 1767; Parke Bernet, New York, sale catalogue, Jan. 6-8, 1944, estate of the late J.P. Morgan, lot 480, Sèvres, 1761, where the two handles are described as "endive-scrolled."

2. Svend Eriksen, *The James A. de Rothschild Collection at Waddesdon Manor: Sèvres Porcelain* (Fribourg, 1968), p. 166, no. 58, Sèvres, 1763.

3. Marcelle Brunet and Tamara Préaud, *Sèvres des origines à nos jours* (Fribourg, 1978), p. 78, pl. XXXI, tray in the Rothschild Collection, Waddesdon Manor, cat. no. 58.

4. Eriksen, *Rothschild Collection: Sèvres*, p. 17.

5. Marcelle Brunet, "French Pottery and Porcelains," in *The Frick Collection: An Illustrated Catalogue*, vol. 7: *Porcelain, Oriental and French* (New York, 1974), p. 270, n. 9 (hereafter cited as Brunet, *Frick*).

6. William King, *Catalogue of the Jones Collection*, pt. 2: *Ceramics…* (London: Victoria and Albert Museum, 1924), pp. 9-10, no. 119, and pl. 9.

7. *Connoisseur* 166 (Sept. 1967), 49, fig. 7 (Palais Galliéra, Paris); Christie's, London, sale catalogue, Oct. 6, 1980, lot 26, illus. (color).

8. Comte Xavier de Chavagnac, *Catalogue des porcelaines françaises de M. J. Pierpont Morgan* (Paris, 1910), no. 132; noted by Brunet, *Frick*, p. 270, n. 9.

9. Gift of the George and Emmi Joreck Foundation, 1983, from the Edmond de Rothschild Collection, according to information given by Dr. Jacobsen of the Museum of Decorative Arts, Copenhagen; see Christie's, London, sale catalogue, March 28, 1977, lot 141, illus.

10. Eriksen, *Rothschild Collection: Sèvres*, p. 166.

11. Svend Eriksen, *Davids Samling Fransk Porcelaen* (Copenhagen, 1980), p. 65.

12. Brunet, *Frick*, p. 193.

13. Grand Palais, Paris, *Porcelaines de Vincennes: Les Origines de Sèvres*, catalogue by Antoinette Faÿ Hallé and Tamara Préaud (1977), p. 133 (hereafter cited as *Vincennes* [1977]).

14. Brunet, *Frick*, p. 262.

15. Brunet and Préaud, *Sèvres*, p. 174, no. 150.

16. Brunet, *Frick*, p. 266.

17. Eriksen, *Rothschild Collection: Sèvres*, p. 166.

18. Ibid., pp. 206-207; King, *Jones Collection*, pt. 2, p. 9, no. 118, 1760 cup.

19. *Vincennes* (1977), nos. 9 and 63, 1757 and 1753 respectively; Geoffrey de Bellaigue, *Sèvres Porcelain from the Royal Collection* (London, 1979), p. 56, 1756 teapot.

20. Lazare Duvaux, *Livre-Journal de Lazare Duvaux, marchand-bijoutier ordinaire du Roy 1748-1758*, ed. Louis Courajod, 2 vols. (Paris, 1873), see index at end of vol. 1 for references to "cabarets" and "déjeuners de porcelaine" as well as "déjeuners de diverses matières."

VIII Chelsea and Derby Porcelain

The four English factories represented in the Markus Collection were all established before the move of the Vincennes factory to Sèvres. However, our knowledge of their early years is less complete.

Like the French, the first English porcelains were soft-paste or artificial bodies, achieving whiteness and translucency by the addition of plastic clay to a glassy frit (see the introduction to section VI). Although no documentation has been found, it has been surmised that French arcanists from Saint-Cloud, Chantilly, or Mennecy may have been involved in the early English attempts at manufacturing porcelain. Soon, as a result of local experimentation and the addition of native materials, three basic types of soft-paste porcelain evolved in England; frit porcelain was made at Chelsea, Derby, and Longton Hall; phosphatic porcelain, using bone ash, was made at Bow; and steatitic porcelain, using soapstone, was made at Bristol and Worcester.

The Chelsea factory was not only the most fashionable but was also the first to successfully produce dated wares. The pieces dated 1745 are quite sophisticated and are neither trial works nor early experiments. They owe their form to contemporary silver, undoubtedly because the earliest known manager of the factory, Nicholas Sprimont (1716-1771), was a silversmith from Liége who worked in London from 1742 to 1747. In an undated manuscript preserved at the British Museum, "The Case of the Undertaker of the Chelsea Manufacture of Porcelain Ware," Sprimont, writing between 1752 and 1757, indicated that he started the venture, inspired by a "chymist." Charles Gouyn, a jeweler, seems to have had a financial interest in the factory in the years before 1750; Sir Everard Fawkener, secretary to the Duke of Cumberland, may have backed the factory subsequently. Some Staffordshire workmen were also involved and may have contributed in their knowledge of the slip-casting technique.

Not only the precise date of establishment but also the exact location of the factory in the Chelsea district of London remain uncertain. Although there are advertisements for Chelsea wares as early as February 1749 and a number of references to the factory in letters, the categorization of the products according to period has been based

both on changes in style and paste and upon the four major marks found on the wares. These periods are: triangle period, about 1745-1749 (during which time an underglaze-blue crown-and-trident mark was also used); raised anchor period, 1749-1752; red anchor period, 1752-1758; and gold anchor period, 1758-1769. The wares were marketed first at the warehouse on the factory premises, then at a warehouse in Pall Mall, and from 1754 to 1763, with interruptions, by annual auction sales lasting up to sixteen days. Sprimont's health began to decline as early as 1757, and he advertised the sale of the business early in 1764. In 1769 the sale of the stock and equipment to a jeweler, James Cox, was concluded, and the remaining finished goods were sold in a four-day sale in February 1770. In the same month the factory was resold to William Duesbury of the Derby porcelain factory. The Chelsea and Derby works were operated together until 1784.

The beginning of the manufacture of porcelain in Derby, as in Chelsea, is wrapped in mystery. A French refugee, André (or Andrew) Planché, who probably finished his London apprenticeship to a goldsmith in 1747 and was living in Derby by 1751, may have been responsible for the earliest identifiable Derby porcelain, a group of small jugs incised 1750 and D or Derby. William Duesbury, then a London enameler of porcelain, mentioned "Darby figars" in his account book. This was in 1752. A report in the *Derby Mercury* of January 26, 1753, mentioned the site of "the China Works near Mary Bridge," and an advertisement in the same paper of July 30, 1756, gave the name of the porcelain manufactory, "Mr. Heath and Company."

John Heath, "Gentleman," Andrew Planché, "China Maker," and William Duesbury, "Enamellor," established a partnership on January 1, 1756, to make, buy, and sell "China Wares" in Derby. Under Duesbury's leadership the factory prospered and gained international recognition and fame. When he died in 1786, the factory was conveyed to his son William Duesbury II. After Duesbury's death in 1797, Michael Kean, who had become a partner in 1795, married the widow. The firm of Duesbury and Kean continued until 1811, when the factory was leased to Robert Bloor, who had been a clerk to the partnership.

No factory mark was used at Derby before the Chelsea-Derby period, 1770-1784; figures and some useful wares from about 1755 on can be identified as Derby by the presence of dark unglazed patch marks under the bases. These were caused by three or more clay blobs or pads used to support the piece during the glaze firing. In the first few years of his management, William Duesbury advertised Derby as "the second Dresden," and many models can be traced to Meissen. About 1760 Derby copied Chelsea in both subjects and styles, even, on occasion, using the gold anchor mark. Some leading painters came into Duesbury's employ from Chelsea, but it was after the business had passed to his son William Duesbury II that the Derby factory became preeminent in England. The fine phosphatic body developed about 1770 by Duesbury senior was an ideal vehicle for the skill of the painters and gilders assembled by his son.[1]

V.S.H.

NOTE

1. In addition to the works cited in nos. 70-76, see John Twitchett, *Derby Porcelain* (London, 1980).

70 *"Goat and Bee" jug*

England, Chelsea, about 1745-1749

Soft-paste porcelain decorated in polychrome enamels

Mark:
(1) on unglazed base, incised: a triangle

H. 10.7 cm. (4¼ in.), w. 8.2 cm. (3¼ in.), d. 5 cm. (2 in.)

1983.645

Provenance: Purchased, New York, December 1956

The small pear-shaped jug is slip-cast; it has slight fluting to the right of each side of its lower section, the lower left side being defined by scrolls. The base of the jug is formed by two recumbent goats, the scrolls following the lines from their heads to their rumps. Both goats are seen facing to the left, that on the obverse with its head toward the spout, while that on the reverse faces the handle. The goats are reclining on an irregular, flat, grassy mound, which is part of the mold, as is the relief spray of a tea plant that curves up under the spout from between the goats to below the lip. The lip has been pulled out to form a spout and has been turned up and cupped in for the upper attachment of the handle. Shaped as an oak branch, the handle loops out, then is joined to the bulbous part of the jug and follows it down to the base, between the goats. The oak leaves, the goats' tails, their long

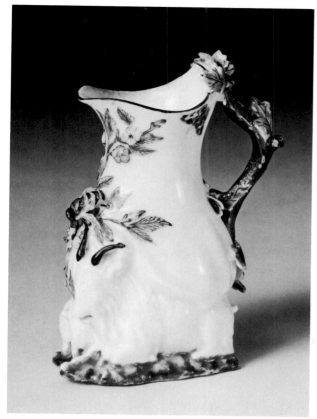

70

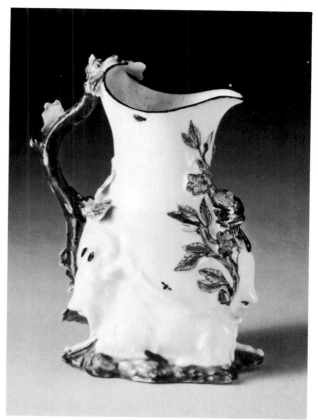

70

horns on the obverse, the bee, here descending, *and some of the flowers have been applied by the repairer.*

The enamel coloring, though brilliant and consistent with other early painting at Chelsea, is limited. The flowering branch has blossoms and buds in yellow, orange, blue, and puce, and the leaves are shaded with yellow and two tones of green, with delicate black outlining and veining; the stem is light brown. The bee has black legs (one missing) and a black, brown, and yellow body with gray wings. The handle is brown with highlights in yellow and texturing in black; the oak leaves, some with yellow edges, are turquoise green and olive green, with black veining. The grassy mound is also a yellowish olive green, with brown at the lower edge. A small multicolored butterfly is painted just below the rim on the obverse, and a ladybug and another very small insect are on the reverse. The rim is outlined in brown. The goats' horns, which are short on the reverse, and long on the obverse, are black, and a thin red line marks their mouths; otherwise, the goats are uncolored.

Although the earliest authors attributed this well-known form, along with all pieces marked with an incised triangle, to Bow, the discovery of several examples incised with the name "Chelsea" and some with the date "1745" together with a triangle led to this reattribution.[1] But there are still many questions about these pieces, which have come to be almost a symbol of the Chelsea factory and certainly have found a place, sometimes in quantity, in all major public and private collections of English porcelain. One author has indicated that there appear to be two or three hundred genuine early examples of the "goat and bee" jug still in existence,[2] but another, using a different criterion, would discount as genuine all examples with long-horned goats, such as the Markus jug.[3]

Through the examination of seven porcelain jugs of this form in the Museum of Fine Arts, Boston, it has been possible to determine two distinct models, which can certainly be considered early. There is also one jug in the group that is clearly a reproduction, possibly by Coalport.[4] The early jugs are all thin and glass-like; most of them have no crazing and have characteristic pinhole translucency. No. 70 seems to have reacted differently to the firing: its pinholes are black rather than white, and there is a gray area around the inside of the rim.[5]

The first of the two models corresponds to the surviving dated jugs and may be distinguished

by both goats having short horns and, more important, by both having full manes.[6] In the second model, of which the Markus jug is an example, the goat on the obverse has long horns applied so that they are in full relief and a full mane, which is less well defined than on the first model. On the reverse, the goat has the short horns of the first model, but the mane has been completely removed.[7] The scroll above this goat is feathered, a feature lacking on the reverse of the first model.[8] One jug in the Katz Collection combines the obverse of model one with the reverse of model two.[9] It is clear that several block molds were used, but whether concurrently in one factory, or in different factories, or at different times cannot be determined. If the original block mold was of plaster-of-Paris, as the working molds surely must have been, it may have required reworking many times in the period of perhaps four or five years during which these jugs were produced, and there may be even more variants than noted here.

Wallace Elliot discussed three models of "our old friends the 'Goat and Bee' jugs."[10] On the basis of his examination of at least twenty examples, both genuine and spurious, Elliot felt that those in his group one (which coincides with my first group) were genuine.[11] His group two was represented by a Coalport reproduction,[12] and he placed in group three (my second group) pieces of the same model as the Markus jug. He illustrated an uncolored example[13] like one in the Katz Collection,[14] stating that the group puzzled him and that he was inclined to include it among the reproductions. Frank Tilley published a colored example of this second group, in the Rous Lench Collection, Worcester (England), describing it as "of superb workmanship" and the same fluorescence as an uncolored example marked Chelsea 1745 in the same collection.[15]

The question of where and by whom these earliest English porcelain specimens were produced is further complicated by the mystery that surrounds the silver design source. Three (or four) silver examples have been mentioned in publications dating from 1897 through 1977; the authors sometimes questioned their authenticity and sometimes carefully avoided the issue; few had ever examined the pieces. In only one instance did the authors, without noting specific examples, suggest that all pieces in silver were nineteenth-century forgeries made to fill a need for a missing rococo prototype.[16] Although the earliest example, first noted in 1912 as "silver-gilt," having London hallmarks for 1724,[17] was never illustrated, it was cited at least four times.[18] A silver jug said to be by Edward Wood, London, 1737, was lent by Dr. H. Bel-lamy Gardner to the Chelsea exhibition in 1924[19] and was published by him several times.[20] This may be the piece noted in 1897 as formerly in the Willett Collection but of generally discredited authenticity.[21] It is possible that the jug formerly owned by Bellamy Gardner is the one now in the Huntington Library, San Marino, California, which is catalogued by Robert Wark as "London, ?1737, ? by Edward Wood"; Wark comments that "it appears probable that jugs in this form are of relatively modern manufacture, utilizing molds from porcelain and transposed or forged marks."[22] A fifth silver example, which has not been published, is in the study collection of the Museum of Fine Arts, Boston (523.1973). It has pseudo-marks for London, 1772-1773, and a maker's mark similar to that of the Huntington piece.[23]

John Austin has suggested a relationship between the goats at the base of the milk jug and those supporting a basket in a large silver centerpiece of 1747-1748 in the Victoria and Albert Museum, one of the last pieces made by Nicholas Sprimont.[24] Sprimont's friend and neighbor, Paul Crespin, also worked in a similar style, incorporating naturalistically modeled animals, as did Charles Kandler (active London, 1727).[25] A leading French exponent of this style was Thomas Germain (Paris, b. 1673, master 1720, d. 1748), although only major works of his seem to have survived.[26] Until an authentic silver prototype is found, we must surmise that the silver model of this early Chelsea form, which is too fine to be called experimental, could have been made either in England or in France.

V.S.H.

70 (1)

NOTES

1. Augustus Wollaston Franks, "Notes on the Manufacture of Porcelain at Chelsea," *Archaeological Journal* 19 (1862), 340. Dated examples are now in the British Museum, London (1905/2-18/6), gift of Charles Borradaile; in the collection of Lord and Lady Fisher, Fitzwilliam Museum, Cambridge; at Rous Lench, Worcester (ex coll. F. Severne Mackenna, no. 21); and at Luton Hoo, Bedfordshire (ex coll. Lady Ludlow). Another example was in the MacHarg collection; another, suggested to read "1743" was in the F. Severne Mackenna collection (no. 20), sold

in 1957, and is now in the Beaverbrook Art Gallery, Fredericton, Canada, according to J.V.G. Mallet in R.J. Charleston, ed., *English Porcelain 1745-1850* (London, 1965), p. 29, n. 2.

2. Frank Hurlbutt, *Chelsea China* (London, 1937), p. 86. From publications I have been able to locate at least thirty.

3. Wallace Elliot, "Reproductions and Fakes of English Eighteenth-Century Ceramics," *English Ceramic Circle Transactions* 2, no. 7 (1939), 71.

4. MFA 522.1973 (study piece); see also Elliot, "Reproductions," p. 70 (illustrations of a spurious Coalport piece and a genuine Chelsea example were reversed in pl. XXII).

5. An undecorated chocolate pot in the Museum of Fine Arts (295.1973a,b) shows the same gray area inside; this is not an indication of later firing, therefore, but is one of the problems of the early productions.

6. Exemplified by MFA 267.1973 (C3), 269. 1973 (C213), 271.1973 (C273).

7. See MFA 1930.355 (ex coll. Alfred E. Hutton), 268.1973 (C187), 270.1973 (C262).

8. F. Severne Mackenna, *Chelsea Porcelain: The Triangle and Raised Anchor Wares* (Leigh-on-Sea, Eng., 1948), p. 23, suggests that the feathered scroll appears only on painted examples.

9. MFA 272.1973 (C276).

10. Elliot, "Reproductions," p. 70.

11. The piece from Elliot's own collection that he showed as genuine is now in the collection of Colonial Williamsburg; see John C. Austin, *Chelsea Porcelain at Williamsburg* (Williamsburg, Va., 1977), no. 6, illus. (color), who points out, p. 24, that the illustration of this jug was inadvertently interchanged with that of the Coalport reproduction in Elliot, "Reproductions," pl. XXII (see note 4, above).

12. See note 4.

13. Elliot, "Reproductions," pl. XXIIc.

14. MFA 268.1973 (C187).

15. Frank Tilley, *Teapots and Tea* (Newport, Eng., 1957), pl. LV, no. 165, and pp. 97-98.

16. George Savage and Harold Newman, *An Illustrated Dictionary of Ceramics* (New York, 1974), p. 137.

17. William Chaffers, *Marks and Monograms on European and Oriental Pottery and Porcelain,* 13th ed., rev., by Frederick Litchfield (London, 1912), p. 947.

18. William King, *Chelsea Porcelain* (London, 1922), p. 20; William Bowyer Honey, *Old English Porcelain* (London, 1931), p. 17; Warren E. Cox, *The Book of Pottery and Porcelain* (New York, 1944), p. 742; Yvonne Hackenbroch, *Chelsea and Other English Porcelain, Pottery, and Enamel in the Irwin Untermyer Collection* (Cambridge, Mass., 1957), pp. 7-8.

19. Reginald Blunt, ed., *The Cheyne Book of Chelsea China and Pottery* (Boston and New York, 1925), no. 14, pl. 4.

20. Bellamy Gardner, "Chelsea Porcelain: The First Period, 1745-1750," *Connoisseur* 76 (Dec. 1926), 232, fig. 1; idem, " 'Silvershape' in Chelsea Porcelain: Nicholas Sprimont and His Work as a Silversmith," *Antique Collector*, Aug. 1937, p. 213, fig. 12.

21. Chaffers, *Marks and Monograms*, 8th ed. (1897), p. 907, quoted by King, *Chelsea Porcelain*, p. 20.

22. Robert Wark, *British Silver in the Huntington Collection* (San Marino, Calif., 1978), no. 128, illus.; the author cites a related "cast" with a date letter for 1777 and Nicholas Sprimont's mark, published by Sir Charles James Jackson, *An Illustrated*

History of English Plate (London, 1911), vol. 2, p. 988, fig. 1351, which had also been noted by Austin, *Chelsea Porcelain*, p. 24, no. 5, n. 1.

23. Both the Huntington and Boston jugs were examined by a former colleague, Leslie Campbell Hatfield, who found them to be of similar character.

24. Austin, *Chelsea Porcelain*, p. 24; for the Sprimont centerpiece, see Carl Hernmarck, *The Art of the European Silversmith 1430-1830* (London and New York, 1977), pl. 406.

25. For an example of Crespin's work, see Arthur Grimwade, *Rococo Silver 1727-1765* (London, 1974), pl. 25, a soup tureen supported by recumbent goats, London, 1740; for Kändler's work see Hernmarck, *European Silversmith,* pl. 284.

26. Hernmarck, *European Silversmith,* pl. 404.

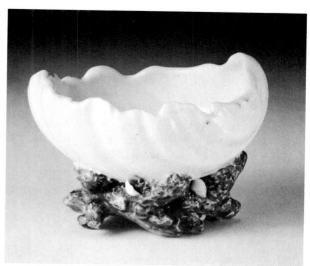

71

71 Saltcellar

England, Chelsea, 1745-1749

Soft-paste porcelain decorated in polychrome enamels

Unmarked

H. 5.7 cm. (2¼ in.), w. 8 cm. (3⅛ in.), d. 7.3 cm. (2⅞ in.)

1983.646

Published: *Antique Collector* 27 (Feb. 1956), xv (two views).

Provenance: Purchased, New York, December 1956

The shell-shaped dish was press-molded and then hand-finished at the upper edge so that each piece made from the mold shows a slightly different scalloping of the rim. The base, a wreath of coral

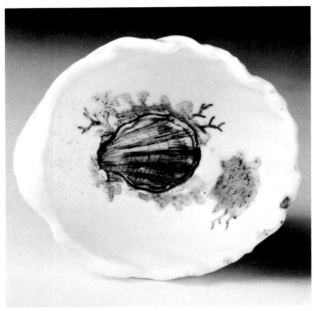

71. *Detail of interior*

branches, was also pressed into a mold, then encrusted with moss-like seaweeds and tiny shells by the repairer. Inside the dish a scallop shell is quite heavily painted in yellow, brown, and touches of gray enamels against a bed of green seaweed flecked with black, from which extend three branches of red coral. To the side of this, away from the cupped valve of the shell, is another green over brown patch, thick and opaque, with two red coral branches. The outside of the dish is undecorated. The coral-shaped foot is colored with red and green enamels, the green denoting the seaweed flecked with black, as inside. The small shells are uncolored. A chip on the rim has discolored to a dark brown, and a few other brown spots indicate less visible flaws in the glaze. There are also many black flecks in the glaze both inside and out. On the coral base, three of the ends have been broken off, and there is a long glaze chip underneath; also, several of the small shells have breaks, all resulting from the everyday use for which such pieces were designed.

Frank Tilley has noted of a saltcellar in the Rous Lench Collection, Worcester (England), that the "imaginative decorator" painted the shell inside "to complete the thematic association between salt and the sea" already set up in the shell form and shell-encrusted coral base.[1] The shell painted inside the Rous Lench piece is very similar to that in no. 71. A pair of salts in the Katz Collection in the Museum of Fine Arts, Boston, shows the same basic form before detailing as no. 71 but has a different shell painted inside, in more delicate colors.[2] Another

pair of enamel-decorated shell salts is at Colonial Williamsburg,[3] and the salt from the Wallace Elliot Collection is at the British Museum.[4] In a description of the salt in the Robert Gelston Collection, it is mentioned that some of the painting recalls the mossy patches attributed to William Duesbury.[5]

Although John Austin maintains that enamel-decorated shell salts are more unusual than those without color decoration, a survey of the selected publications cited here has revealed twelve in color, whereas only four or five have been recorded in white. One of the white pieces, in the collection of Dr. H. Bellamy Gardner as early as 1926, has been so widely published and exhibited that uncolored versions seem more numerous.[6] In his 1926 article Dr. Gardner mentioned that this form of saltcellar is known to exist in silver.

The shell form itself has been variously identified as a "nautilus"[7] and a "deep scallop"[8] but more often simply as a shell or fluted shell. It occurs also—for use, possibly, as a sweetmeat dish—in pieces composed of three of these same shells joined together by seaweed, coral, and small shells.[9]

Although no early documentary reference has been found for the shell salts and the contemporary crayfish salts, they may have been included in the "several other Things as well for Use as Ornament" offered for sale by Nicholas Sprimont at the manufactory at Chelsea on Tuesday, February 28, 1749, according to the announcement in the *Daily Advertiser,* Tuesday, February 21, and Friday, February 24, 1749.[10]

V.S.H.

NOTES
1. Frank Tilley, *Teapots and Tea* (Newport, Eng., 1957), caption to pl. LV, no. 164. I wish to thank Tom Burn for permitting me to examine this piece.

2. 276, 277.1973; see George Savage, *18th-Century English Porcelain* (London, 1952), pl. 6a.

3. John C. Austin, *Chelsea Porcelain at Williamsburg* (Williamsburg, Va., 1977), no. 10, illus. (color).

4. 1938/3.14/97, mentioned in reference to a pair sold at Sotheby Parke Bernet, London, Jan. 23, 1968, lot 316, which, like the pair at Williamsburg and another pair sold at Christie's, London, June 5, 1978, lot 90, have painted decoration on the outside of the shells as well.

5. O. Glendenning and Mrs. Donald MacAlister, "Chelsea, The Triangle Period," *English Ceramic Circle Transactions,* no. 3 (1935), p. 31 and pl. XIIIc. The cataloguer of lot 316 in Sotheby Parke Bernet, sale catalogue, Jan. 23, 1968 (see note 4 above), was more definite, stating the salts were "decorated by William Duesbury," as did Frank Tilley when advertising the Markus salt in the *Antique Collector* 27 (Feb. 1956), xv. See *William Duesbury's London Account Book, 1751-3,* English Porcelain Circle Monograph, ed. Mrs. Donald MacAlister (London, 1931), p. xv.

6. Dr. Bellamy Gardner, "Chelsea Porcelain: The First Period, 1745-1750," *Connoisseur* 76 (Dec. 1926), no. VII; sold at Sotheby & Co., London, June 12, 1941, lot 3; subsequently in the F. Severne Mackenna collection, sold at Sotheby & Co., London, March 12, 1957, lot 148; and in the Selwyn Parkinson collection, sold at Sotheby Parke Bernet, London, June 21, 1966, lot 112. The salt had been exhibited at the Park Lane Exhibition, 1934, and the Cheltenham Art Gallery, April 1947, and was illustrated in *Apollo* 34 (Sept. 1941), 61; F. Severne Mackenna, *Chelsea Porcelain: The Triangle and Raised Anchor Wares* (Leigh-on-Sea, Eng., 1948), fig. 10; *Apollo Annual*, 1949, p. 31, fig. V, no. 9; F. Severne Mackenna, *The F.S. Mackenna Collection of English Porcelain*, pt. 1: *Chelsea 1743-1758* (Leigh-on-Sea, Eng., 1972), no. 37.

7. Glendenning and MacAlister, "Chelsea," p. 31; Sotheby & Co., London, sale catalogue, June 30, 1953, lot 90; *Antique Collector* 27 (Feb. 1956), xv.

8. Sotheby Parke Bernet, London, sale catalogue, Jan. 23, 1968, lot 316 (see note 4, above).

9. Glendenning and MacAlister, "*Chelsea,*" pl. XIIIa; Savage, *18th-Century English Porcelain*, pl. 6b; Austin, *Chelsea Porcelain*, no. 9.

10. *English Porcelain Circle Transactions*, no. 1 (1928), p. 17.

72 Dish (or stand)

Plate XVII

England, Chelsea, 1750-1752

Soft-paste porcelain decorated in polychrome enamels

Mark:

(1) on underside: "flown" raised anchor

H. 3.6 cm. (1⁷⁄₁₆ in.), w. 24 cm. (9⁷⁄₁₆ in.), d. 18.7 cm. (7³⁄₈ in.)

1983.647

Provenance: Purchased, New York, November 1955

The lozenge-shaped dish was pressed over a mold, producing shells in relief at each end, from which shell-form flutes fan in either direction. The scalloped rim was finished by hand. The presence of tin oxide in the glaze has softened the detail of the relief but has also given a smooth, viscous ground for the enamel decoration. This takes the form of a botanical still-life painting filling the cavetto of the dish. Three fruits and a butterfly are clearly taken directly from a print (or prints) and, with their cast shadows, appear to have been placed on the dish. In this trompe l'oeil painting the three-dimensional form of the fruits and leaves is achieved by a combination of the building up of the enamel colors, the white highlights effected by removing flecks of the color, and the fine hatching in black, as in a print. The scattered flowers, florets, and an insect seem to be by another painter; these appear to be randomly placed but in fact are masking flaws in the glaze.

On the underside a small oval area toward one end is free of glaze, marking the place where the medallion with the raised anchor had been attached. It apparently was lost (fled) during the glaze firing or even during the enamel firing. Examined by transmitted light, the paste, typically, has many "moons" of various sizes. There are traces of two (or perhaps three) patch marks on the unglazed base, indicating that the piece was supported by pads of clay rather than stilts during the glaze firing.

The shape of the dish is based upon a silver sauce-boat stand made by Nicholas Sprimont. Four of these stands, bearing London hallmarks for 1746/47, are in the Museum of Fine Arts, Boston, gift of Jessie and Sigmund Katz.[1] They have matching sauceboats and ladles and were on the London market in 1948.[2] The silver stands have chased panels of seaweed and shell encrustation reminiscent of the foot of the shell saltcellar, no. 71; these do not appear on the porcelain dish, reflecting perhaps, at this later period, a change in taste. The difference in size between the silver and porcelain is compatible with the shrinkage that would have occurred, first, in the firing of a clay block mold taken either from the silver or more likely from the wooden model for the silver, and then in the firing of the porcelain dish itself.

The raised anchor sauceboats that are sometimes found with stands of this form are modeled after an oriental prototype (perhaps via Meissen or Chantilly or both). Known examples have Kakiemon-style decoration.[3] The frequent listing of "sauceboats and plates, silver shaped" and often "enamell'd with flowers" in the 1755 sale catalogue[4] is an indication that the form remained in fashion, and gold anchor period (1758-1769) dishes of this shape are known. Many more dishes than sauceboats have survived. Only one lot in the sixteen-day sale of 1755 might refer to such dishes without sauceboats: "Two oval dishes, and 4 less ditto, fine silver shaped enamelled with flowers."[5]

This Markus dish is considerably earlier than the pieces in the 1755 sale, which, according to the title page, were "the last Year's large and valuable Production." The decoration of no. 72 might be considered a forerunner of the botanical designs of the 1754-1758 period. It relates to a style of decoration introduced at Meissen less than ten years earlier, known as "shaded (or shadowed) German flowers."[6] A similar dish with a raised anchor mark and sprays of fruit and leaves casting

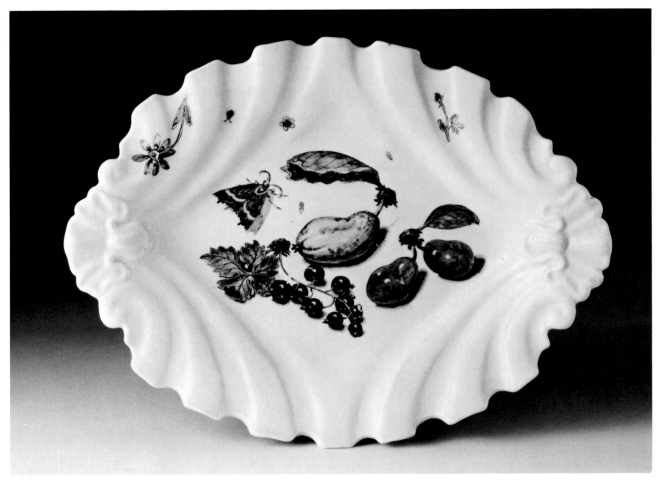

72

shadows is in the collection at Colonial Williamsburg.[7] On that piece, however, the entire decoration is placed in apparently random fashion, probably masking flaws.

The arranged group of fruits on no. 72 is very similar in style to that in two hand-colored prints by Jacob Hoefnagel (1575-1630) in the Museum of Fine Arts, Boston (62.214,215). In about 1592 Hoefnagel engraved a set of about fifty plates from designs by his father, Joris. These consisted of groups of fruits, flowers, and insects and were probably used by the Meissen factory as models. The unidentified Chelsea painter may also have worked from such prints.[8]

V.S.H.

NOTES

1. 69.1358, 71.640, 71.642, 71.644; 69.1358 exhibited, University Art Museum, University of Texas, Austin, *One Hundred Years of English Silver* (1969), no. 83b, illus.; see also Arthur Grimwade, *Rococo Silver 1727-1765* (London, 1974), pl. 32B.

2. George Savage, *18th-Century English Porcelain* (London, 1952), p. 21; the porcelain sauceboat illustrated as similar to the silver ones is in the Katz Collection at the Museum of Fine Arts, Boston, and is catalogued now as "dry-edge" Derby.

3. Museum of Fine Arts, Boston, Katz Collection (61.1261a,b); Colonial Williamsburg (1962.38, 54): John C. Austin, *Chelsea Porcelain at Colonial Williamsburg* (Williamsburg, Va., 1977), nos. 40, 41, illus. (color) p. 61.

4. Austin, *Chelsea Porcelain*, Appendix: reproduction of the 1755 auction catalogue in the collection of Colonial Williamsburg.

5. Ibid., second day's sale, Tuesday, March 11, lot 8.

6. Otto Walcha, *Meissen Porcelain* (New York, 1981), p. 121; William Bowyer Honey, *Dresden China* (Troy, N.Y., 1946), p. 90.

7. Austin, *Chelsea Porcelain*, no. 67, illus. (color) p. 81.

8. I am grateful to T.H. Clarke, formerly of Sotheby's, for calling my attention to Hoefnagel's work.

72 (1)

73 Fluted dish

England, Chelsea, about 1752-1754

Soft-paste porcelain decorated in polychrome enamels

Unmarked

H. 4.4 cm. (1¾ in.), diam. 17.4 cm. (6⅞ in.)

1983.648

Published: Ruth Berges, *Collector's Choice of Porcelain and Faïence* (South Brunswick, N.J., and New York, 1967), fig. 164.

Provenance: Purchased, New York, November 1955

The deep saucer-shaped dish was formed over a mold that had thirty-two flutes at the edge. The rim was finished by hand, some of the scallops being more rounded than others. The foot ring is circular, of a V-section, and has been ground level after the glaze firing; it has discolored to a dirty, yellowish tone, but more recent small chips on the rim show the paste to be white. There are three stilt marks underneath, 4 x 4 x 3.7 cm. (1⁹⁄₁₆ x 1 ⁹⁄₁₆ x 1⁷⁄₁₆ in.) apart.[1] Many black flecks are in the glaze on both the front and the back, and there is some gray clouding at the rim on the back. Examination by transmitted light shows the paste to be off-white with some small moons, typical of the raised anchor but also of the early red anchor period.

73

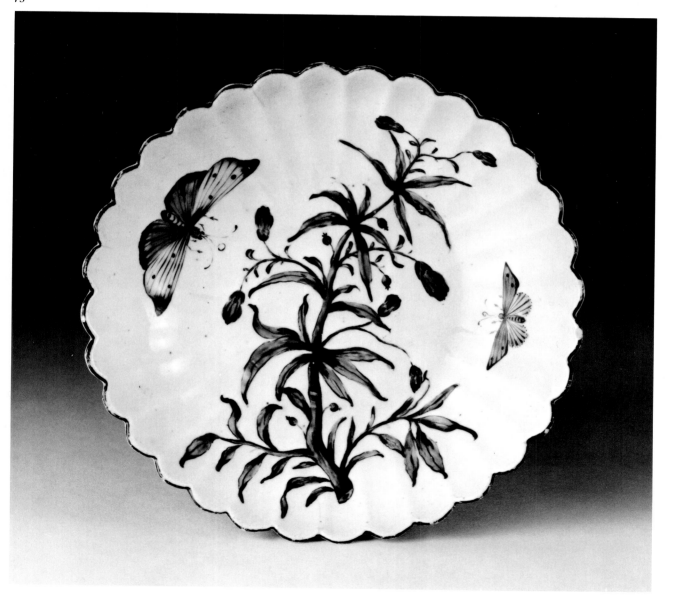

Part of a botanical service, the dish is deco-
rated on the inside with a cut plant with orange
berries growing from the stem and blossoms with
orange calyxes and puce petals. The stem and
leaves are green, more yellowish toward the center,
and are shaded and outlined with brown. There
are two butterflies: the larger, at the left, has yel-
low, orange, and puce wings; the smaller, at the
right, has wings in two shades of puce. The entire
design was first sketched on by the artist in thin
puce lines. The rim is chocolate brown.

This type of realistic botanical painting, inaccur-
ately termed "Hans Sloane" in modern times, was
chiefly based on paintings (or engravings of paint-
ings) by Georg Dionysius Ehret (1708-1770).[2] In
the Chelsea sales catalogues of 1755 and 1756, this
type of painting was called "India plants."[3] On the
first day of sale, Monday, March 10, 1755, lot 7 was
"One dish second size, 4 ditto third size, scollopt
and finely enammell'd with *India plants*," and on
the third day, Wednesday, March 12, lot 23 was
"One round dish third size, 2 ditto fourth size, and
2 ditto fifth size, scollopt and enamelled with *India
plants*."[4] From these catalogue listings one can as-
sume that dishes of this "scollopt," or fluted, form
were made in five sizes, and, from published sur-
viving examples, it would seem that the Markus
piece might be the fifth, or smallest, size.[5] The
fourth size might be represented by a pair of
dishes measuring 21.6 cm. (8½ in.), also with bo-
tanical decoration, formerly in the collections of
Mrs. Humphrey Cook and Mrs. Marjorie Wiggin
Prescott.[6] The largest size known from publica-
tions is 28.6 cm. (11¼ in.).[7]

The wear marks on this dish suggest that it
may have been rubbed when stacked with others of
the same form. The original purpose of a dish of
this size is unclear. On the third day of the 1755
sale, March 12, lot 48 was "Twelve beautiful scol-
lopt desart plates, India plants, all different," and
lot 51, "Nine scollopt soup plates with *India
plants*."[8] On March 25, the fourteenth day of the
sale, lots 32 and 33 were "Four scollopt table dishes
of two sizes, *with India plants*" and "Twelve fine de-
sart plates *same pattern*."[9] The Markus dish may
have been a soup plate, a dessert plate for pudding
or fruit, or a serving, or table, dish. Or it could
have been a stand for a fluted cup-shaped bowl
such as the one at Colonial Williamsburg[10] or an-
other in the Victoria and Albert Museum
(C.198.1940). In the 1755 Chelsea sale, there were
many lots of "scollopt" water cups and saucers, al-
though none were listed as decorated with "India
plants"; some were listed as decorated with "flow-

ers" (bouquets in the Vincennes style) or with no
pattern indicated.[11]

It has been suggested that the plant repre-
sented is a fuchsia, a genus named in honor of the
sixteenth-century German physician and botanist
Leonard Fuchs (1501-1566). This plant does not
appear in any of Ehret's works to which other
Chelsea examples have been traced. As noted by
Synge-Hutchinson, however, Ehret may have had
personal contacts with the Chelsea factory, and his
drawings and paintings could easily have been ac-
cessible to the factory from various sources.[12] Since
more than three thousand of his drawings are still
extant,[13] it may be possible one day to trace the
source of this design.

A Japanese Arita porcelain dish of the same
form, but slightly larger and with Kakiemon deco-
ration, was in the collection of the late A.J. Kiddell
and has the engraved mark indicating that it was
formerly in the Dresden Collection.[14] Chelsea may
have modeled its pieces after either Japanese or
Meissen examples. The former are known to have
reached Europe from the late seventeenth into the
early eighteenth century.

V.S.H.

NOTES

1. These glaze defects, resulting from the piece having been
supported on cone-shaped stilts during the glaze firing, are in-
dicative of a Chelsea origin from 1750 onwards.

2. Patrick Synge-Hutchinson, "G.D. Ehret's Botanical Designs
on Chelsea Porcelain," in The Connoisseur, *The Concise Ency-
clopedia of Antiques*, ed. L.G.G. Ramsey (New York, 1959), vol.
4, pp. 73-77, a continuation of the author's earlier research, "Sir
Hans Sloane's Plants and Other Botanical Subjects on Chelsea
Porcelain," *The Connoisseur Year Book*, 1958, pp. 18-25.

3. John C. Austin, *Chelsea Porcelain at Colonial Williamsburg*
(Williamsburg, Va., 1977), p. 6; John V.G. Mallet, "A Chelsea
Talk," *English Ceramic Circle Transactions* 6, pt. 1 (1965), 20-
22; F. Severne Mackenna, *Chelsea Porcelain: The Red Anchor
Wares* (Leigh-on-Sea, Eng., 1951), p. 22.

4. Austin, *Chelsea Porcelain*, Appendix: reproduction of the
1755 catalogue in the collection of Colonial Williamsburg.
These lots recurred often during the sixteen days of the sale.

5. Two dishes, 17.8 cm. (7 in.), decorated with fables, were pub-
lished in F. Severne Mackenna, *The F. S. Mackenna Collection
of English Porcelain*, pt. 1: *Chelsea 1743-1758* (Leigh-on-Sea,
Eng., 1972), nos. 67, 68.

6. Christie's, London, sale catalogue, Feb. 17, 1969, lot 163,
illus.; Christie's, New York, sale catalogue, March 6, 1981, lot
93, illus.

7. A pair, formerly in the R. Alistair McAlpine collection, was
sold at Christie's, London, March 11, 1974, lot 85, and again,
Christie's, London, June 20, 1977, lot 107. These have Kakie-
mon-style decoration, called "old pattern" in the 1755 auction
catalogue.

8. Austin, *Chelsea Porcelain*, Appendix.

9. Ibid.

10. Austin, *Chelsea Porcelain*, no. 59, decorated with what might be a fable subject; Austin suggests that it may be a "water bowl" (finger bowl).

11. Austin, *Chelsea Porcelain*, Appendix.

12. Synge-Hutchinson, "G.D. Ehret's Botanical Designs," p. 77.

13. Gerta Calmann, *Ehret, Flower Painter Extraordinary* (Boston, 1977), p. 100.

14. Soame Jenyns, *Japanese Porcelain* (London, 1965), pl. 66 A.

The box has a glassy glaze not unlike that of the Saint-Cloud snuffbox (no. 53), and the manner of painting in haphazard brushstrokes resembles that of a bonbon box of similar form at the Museo Duca di Martina, Naples, which is attributed to Saint-Cloud.[1]

"Roses" were included in a list published in June 1756, advertising the first known sale of

74

74. *Base of box*

74 *Covered box in the form of a rose*

England, attributed to Derby, about 1756

Soft-paste porcelain decorated in polychrome enamels

Unmarked

H. 4.9 cm. (1 15/16 in.), diam. at rim 7.6 cm. (3 in.)

1983.649a,b

Published: Ruth Berges, *Collector's Choice of Porcelain and Faïence* (South Brunswick, N.J., and New York, 1967), fig. 165.

Provenance: Purchased, New York, November 1959

Both parts of the box are slip-cast. The lower part has five petals in relief, growing from a calyx with six bulbous sepals, which, with the cut stem, forms the base. A wedge-shaped key, 0.8 cm. (5/16 in.) long, has been attached to the inside of the circular rim, and a notch has been cut in the flange of the cover to fit it. The domed cover also has petals in relief with a depression in the center. The petals are painted in two shades of puce, and the stem and calyx are green shaded with black.

Derby porcelain in the large Assembly Rooms, Richmond Wells, Surrey: "the greatest variety of the Derby Porcelain, in Figures, Jars, Candlesticks; Sauce-Boats, Fruit Baskets, Lettices, Leaves, Roses, and several curious Pieces for Desserts, finely enamelled in Dresden Flowers, reckoned by Judges who have been Purchasers to excel, if not exceed, anything of the Kind in England."[2]

A Derby rose finished somewhat differently from no. 74 was exhibited in London in 1973.[3] Its form, with more petals on the lower part and a twig and bud handle, is closer to that of Meissen examples.[4] The Meissen archives record that Johann Gottlieb Ehder (1717-1750) modeled "1 Tabatiere, welche eine Rose vorstellet" in October 1740.[5] However, it is more likely that Derby was emulating Chelsea at this time. There are numerous references to "roses and leaves for a desart" in both the 1755 and 1756 Chelsea sales, usually in sets of four and sometimes distinguished as either large or small. Illustrated examples, like the Meissen, have twig handles.[6] The red anchor period Chelsea roses "for desart" could have been intended as ornaments, as were the figures listed for dessert, or they could have held sweetmeats or sauces. In later publications roses have been identified as toilet boxes, and they would certainly be

handsome decoration for a dressing table. The French examples mentioned in note 1 were mounted so that their lids were hinged, and a similar treatment might have been intended for the Meissen "tabatiere," although the examples cited in note 4 are unmounted.

<div align="right">V.S.H.</div>

NOTES

1. Maria L. Casanova, *Le Porcellane francesi nei musei di Napoli* (Naples, 1974), pl. 19, mounted in silver. A plain white Mennecy box, apparently from a similar mold, the mounts bearing the Paris discharge mark for 1738-1744, was sold at Sotheby Parke Bernet, New York, Dec. 5-7, 1974 (from the collection of Mrs. Alan L. Corey), lot 92.

2. Edward Hyam, *The Early Period of Derby Porcelain* (London, 1926), quoted by J. Brayshaw Gilhespy, *Derby Porcelain* (London, 1961), p. 26; Franklin A. Barrett and Arthur L. Thorpe, *Derby Porcelain 1750-1848* (London, 1971), p. 20.

3. Winifred Williams, *Exhibition of Early Derby Porcelain 1750-1770* (London, 1973), no. 36, color plate.

4. Ruth Berges, "China Fruits and Vegetables," *Antique Dealer & Collectors Guide*, June 1973, p. 93, fig. 1; Sotheby Parke Bernet, New York, sale catalogue (Garbisch Collection), May 17, 1980, lot 140.

5. Rainer Rückert, *Meissener Porzellan 1710-1810*, exhibition catalogue, Bayerisches Nationalmuseum, Munich (Munich, 1966), p. 158.

6. F. Severne Mackenna, *Chelsea Porcelain: The Red Anchor Wares* (Leigh-on-Sea, Eng., 1951), fig. 72 (miscaptioned 71); George Savage, *18th-Century English Porcelain* (London, 1952), pl. 5b; Sotheby Parke Bernet, New York, sale catalogue (Garbisch Collection), May 17, 1980, lot 30 (there was also a Longton Hall rose box in this sale, lot 16); Sotheby Parke Bernet, London, sale catalogue, July 16, 1982, lots 5, 6.

75 Bowl with pierced cover

England, attributed to Derby, about 1760-1765

Soft-paste porcelain, molded and decorated in polychrome enamels

Unmarked

H. 15.5 cm. (6⅛ in.), diam. at rim 13 cm. (5⅛ in.)

1983.650a,b

Published: Ruth Berges, *Collector's Choice of Porcelain and Faïence* (South Brunswick, N.J., and New York, 1967), fig. 169: "Bow, ca. 1760."

Provenance: Purchased, New York, November 1955

The bowl and cover were slip-cast. The circular bowl is molded to represent a basket, its lower section, above the foot ring, defined by a series of eight acanthus leaves in low relief, from each of which grows upwards a stem with leaves and flowers. These are of two forms that alternate: one has four blossoms midway up, in triangular arrangement, with two upright leaves below and four radiating leaves above; the other has four blossoms in a slight arch midway up, with a fifth blossom just under the rim, two upright leaves below and three leave above the middle group. On the cover, of shaped domed form, basket-molded and pierced, the flower sprays continue upwards in a slightly spiral movement. The flower arrangements are as follows: the first has one blossom at the flange, from which radiate four leaves, then three blossoms in a triangle, with three leaves, then five terminal buds; the second has three lower blossoms arching upwards, with two leaves, then two blossoms, one above the other, with one leaf, then three buds. The finial, which is also molded, is in the form of a double-looped belt, cinched with a ribbon to form a trefoil.

The flowers of each spray, extending from the base of the bowl to the top of the cover, are of one color, and there are four colors in all; the colors on the reverse of the bowl repeat those on the obverse. The colors are, from left to right: puce with yellow centers ringed with brown dots, yellow with a brown dot center, orange with yellow centers ringed with brown dots, and blue with yellow centers with one brown dot. The green leaves have brown veins. The acanthus design at the base is outlined with turquoise; there is a turquoise line on the foot ring and outlining the finial, which is bound with a puce ribbon. The upper edge of the bowl has an iron-red line, and the outer rim of the cover a brown line. The glaze has been wiped off the flange of the cover and the inside of the foot. There is a comma-shaped dab of turquoise on this unglazed foot ring. The piece is only slightly translucent, the glaze grayish and very granular on the inside. There are fire cracks under the base, one fire crack on the cover, and some very slight crazing at the flange of the cover. Both the foot and the cover have been ground down, apparently to remove overflowing glaze. The upper loop of the finial is restored.

Basket-molded bowls of this type are well known, both in polychrome and blue and white, occasionally with gold as well. They are known to have been made at Chelsea and at Derby. Those attributed, as no. 75 has been, to Bow[1] and Longton Hall[2] were probably done so in error. From comparison of this piece with similar published examples, it was evident that only four others were from the same

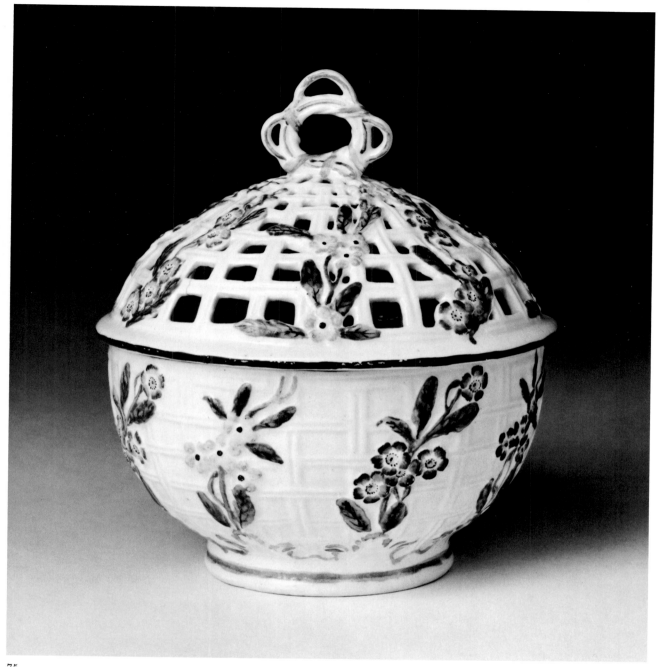

75

mold. One of these is in the Derby Museum and Art Gallery,[3] and the present locations of the other three are unknown.[4]

The other sixteen examples compared have differing arrangements of the flowers and foliage, and the sizes vary from 10.8 cm. (4¼ in.) to 21.6 cm. (8½ in.) in height. Eight of the larger examples, 17.8-21.6 cm. (7-8½ in.), are described as having applied flowers and foliage. Since such descriptions are often quotations rather than based upon examination, I am indebted to John C.

Austin for confirming that the piece at Colonial Williamsburg has applied flowers, leaves, and stems; those on the cover were applied after the basketwork had been pierced.[5] The molded pieces, such as no. 75 and a red anchor marked example, measuring 10.8 cm. (4¼ in.) at the Museum of Fine Arts, Boston,[6] have piercing that follows the outline of the molded leaves or flowers as they cross the open areas.

The Schreiber Collection in the Victoria and Albert Museum has a bowl (with a stand)[7] of

the same form as no. 75. It has the same sprig-molded applied decoration as that on the Williamsburg bowl. A very similar piece in blue and white, with a stand of the same form, is also known.[8] Another type of stand sometimes found with these bowls is circular with a molded trellis border.[9] Neither of the two types of stands seems to have been designed specifically for the basket-molded bowls.

These bowls have been called potpourri bowls, chestnut bowls (or baskets), strawberry bowls, and compotiers. The larger ones with stands might more reasonably be considered serving pieces, but whether for chestnuts (for which they are rather small) or strawberries is difficult to prove. The weekly bills at Chelsea, 1770-1773, refer to "24 Strawberry Compotiers made with Darby clay."[10] The smaller examples seem to relate to potpourri bowls in Meissen porcelain[11] and Dutch silver.[12]

V.S.H.

NOTES

1. Ruth Berges, *Collector's Choice of Porcelain and Faïence* (South Brunswick, N. J., and New York, 1967), fig. 169: "Bow, ca. 1760"; Victoria and Albert Museum, London, *Catalogue of English Porcelain, Earthenware, Enamels, etc. Collected by Charles Schreiber...*, vol. 1: *Porcelain*, by Bernard Rackham (1915), no. 49: "Bow, about 1770"; in the 1928 ed. of the catalogue this piece is no. 288 and attributed to Derby (hereafter cited as Victoria and Albert Museum, London, *Schreiber Porcelain*).

2. William Bemrose, *Longton Hall Porcelain* (London, 1906), pl. 24, and pl. 46, no. 3; the former was sold at Christie's, London, April 5, 1983, lot 214, as "Derby, Wm. Duesbury & Co., 1762-65."

3. Franklin A. Barrett and Arthur L. Thorpe, *Derby Porcelain 1750-1848* (London, 1971), pl. 74; H.G. Bradley, ed., *Ceramics of Derbyshire 1750-1975* (London, 1978), no. 93, illus., described, p. 72, in error, as having applied flowers.

4. Reginald Blunt, ed., *The Cheyne Book of Chelsea China and Pottery* (Boston and New York, 1925), no. 92, pl. 20, a pair from the Talk Collection, lent by Alfred Hutton; Winifred Williams, *Exhibition of Early Derby Porcelain 1750-1770* (London, 1973), no. 47, illus., from the W. M. Moss Collection; Christie's, New York, sale catalogue, Nov. 21, 1980, lot 39, illus., attributed to Chelsea and described as with applied branches, collection of Mr. and Mrs. Walter B. Ford II.

5. Cleo M. Scott and G. Ryland Scott, Jr., *Antique Porcelain Digest* (Newport, Eng., 1961), pl. 166, no. 595.

6. 55.425a,b

7. A.H. Church, *English Porcelain* (London, 1885), fig. 12; Victoria and Albert Museum, London, *Schreiber Porcelain*, rev. ed. (1928), no. 374, pl. 29.

8. Bernard Watney, *English Blue and White Porcelain of the Eighteenth Century* (London, 1963), pl. 64B; Sotheby Parke Bernet, London, sale catalogue, Jan. 25, 1977, lot 58, ex colls. Mrs. F. Smith, His Grace the Duke of Beaufort.

9. See Bemrose, *Longton Hall Porcelain,* pl. 24; Christie's, London, sale catalogue, April 5, 1983, lot 214; Bradley, *Ceramics of Derbyshire,* no. 208, illus.

10. Quoted by Llewellynn Jewitt, *The Ceramic Art of Great Britain* (London, 1878), vol. 2, p. 72.

11. Sotheby Parke Bernet, New York, sale catalogue (Garbisch Collection), May 17, 1980, lot 187 (ex coll. Marryat, 1867, lot 320).

12. M.H. Gans and Th. M. Duyvené de Wit-Klinkhamer, *Dutch Silver,* trans. Oliver van Oss (London, 1961), pl. 85.

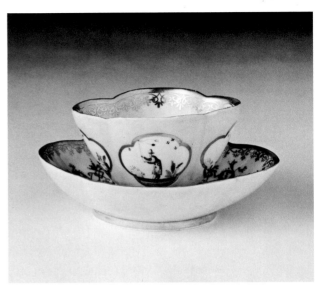

76

76 Quatrefoil teabowl and saucer

England, attributed to Derby, about 1780

Soft-paste porcelain with a turquoise ground, decorated in polychrome enamels and gold

Marks:
(1) on base of teabowl, in pale blue enamel: crossed swords intersected by a V
(2) on base of saucer, in pale blue enamel: crossed swords

Teabowl: h. 4.6 cm. (1 13/16 in.), w. 7.5 cm. (2 15/16 in.), d. 6.3 cm. (2½ in.); saucer: h. 2.9 cm. (1⅛ in.), w. 10.8 cm. (4¼ in.), d. 10 cm. (3 15/16 in.)

1982.782a,b

Provenance: Purchased, New York, December 1956

Both the teabowl (cup) and the saucer are molded in a four-lobed oval form with circular foot rings (see no. 58). The cup has four quadrilobed panels reserved on a bright turquoise enamel ground.[1] Each panel is painted with one or two oriental figures in polychrome enamels and gold, imitating

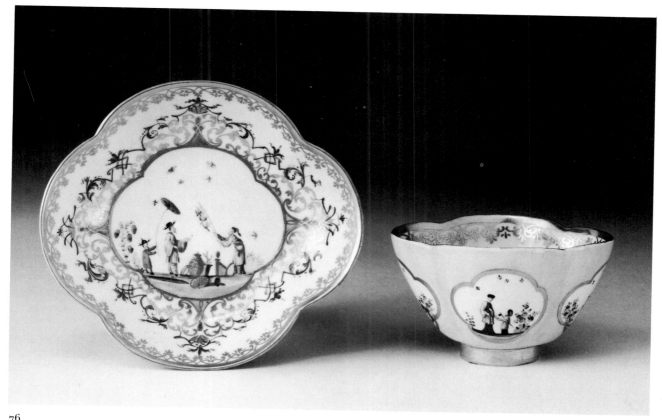

76

the chinoiseries introduced at Meissen by Johann Gregorius Höroldt before 1725 (see nos. 17-20). In each panel the figures are shown at work in a garden, flanked by flowering plants and grasses, the ground brown with yellow-green below; in each there are four stylized insects in the sky. The panels are simply framed with slightly chased gold, and the foot ring is completely covered with a burnished gold band. Inside the bowl, below a gold band is a delicate lace-like border of interlocking scrolls and trefoils in the Meissen style. At the bottom of the bowl, inside, is a group of Kakiemon-style flowers and leaves in purple, red, yellow, blue, and turquoise. The saucer is decorated on the inside with a quadrilobed panel framed in a rich border of gold, puce (simulating Böttger's Perlmutter luster), purple, and red, with scrolls, strapwork, and feathery foliations. There are three oriental figures, also in a garden between flowering plants and grasses, with vases, flowerpots, and an ornamental wall; at the left a child (or dwarf) holds a parasol over the head of a man who is in conversation with a merchant carrying birds that hang from two sticks. The ground is also brown, shaded to tan, over an area of yellow-green; there are six insects in the sky, their wings touched with light

green. The outer border is the same as the inside of the cup. The outside is solid turquoise enamel, with a broad gold band on the foot ring and a slight rim of white at the base. Since the base of the foot ring was wiped clean of glaze before firing, it was not ground down. There are traces of supporting stilts on the foot rings of both the cup and saucer and a small chip on the foot ring of the cup.

No documentation of the production of pieces such as no. 76, which were probably made to replace broken items in a Meissen service, has been located. However, three pieces can be cited from an apparently identical Meissen service. A cup and saucer were in the collection of Dr. Paul von Osterman, Darmstadt-Munich, and another saucer was in an unidentified collection in London.[2] In the black and white reproductions the borders appear the same, but the colors of the Osterman pieces are described as "Gold, Purpur, und Grün" instead of red. The Meissen cup is 0.9 cm. ($5\frac{1}{16}$ in.) higher than the copy, and the second Meissen saucer, the only one for which dimensions are given, is 0.6 cm. ($\frac{1}{4}$ in.) smaller than the copy. For the latter Meissen saucer, the ground is called "seladon" and described as "a solid pale blue."[3]

There is an earlier Chelsea cup (about 1753) in the Schreiber Collection in the Victoria and Albert Museum, with the crossed-swords mark in underglaze blue, probably replacing a Meissen piece;[4] also in the Victoria and Albert Museum are a Derby cup and saucer with a turquoise ground (the cup overfired) marked with crossed swords in blue enamel (C.1068-1924).[5] These have been attributed to the period of 1760-1770 on the basis of the similarity of the turquoise color to that used on the figures produced at Derby at that time. Light blue enameled crossed swords are also found on two octagonal cups and saucers, attributed to Chelsea-Derby, 1770-1784, in the Museum of Fine Arts, Boston,[6] and on another two formerly in the Wallace Elliot collection.[7] The three English cups and saucers from this service that are illustrated are painted with the same scenes, whereas the original Meissen pieces always had different scenes on each. The Chelsea-Derby ground color on these octagonal pieces, which has been variously described as mauve-pink, powdered purple, claret, and maroon,[8] is a close copy of the Meissen "Purpurgrund" (see no. 31).

Although the paste of the Chelsea-Derby examples is much whiter by transmitted light than no. 76, the quality of the gilding is quite similar. The Markus teabowl and saucer, therefore, should perhaps be dated five or ten years later than turquoise-ground pieces of the 1760-1770 period, many of which have only brown or puce line edging. By the 1780s Meissen cups of quadrilobed form with chinoiserie decoration were no longer fashionable but may already have become treasured heirlooms. It is probable, therefore, that the Markus teabowl and saucer were made as replacements rather than in emulation of the Meissen style.

V.S.H.

76 (1) 76 (2)

NOTES

1. The ground color is very close to the "seladon" ground of the Meissen pieces in this collection (nos. 25, 26, 27, 37, 38, 39, 40, 41) but just slightly bluer and brighter.

2. Paul Cassirer, Berlin, *Sammlung Dr. Paul von Osterman, Darmstadt-München: Europäische Porzellane...*, sale catalogue, text by Otto von Falke, Oct. 30-Nov. 2, 1928, lot 212, illus.; Sotheby Parke Bernet, London, sale catalogue, June 17, 1975, lot 159, illus.

3. Sotheby Parke Bernet, London, sale catalogue, June 17, 1975, lot 159; see also lot 160, where it is noted that the identification of this Meissen ground color as "seladon" (rather than the earlier "sea-green") was made in the exhibition catalogue Staatliche Kunstammlungen, Dresden, *Kunstschätze aus Dresden* (Zurich, 1971), pp. 317, 319.

4. Victoria and Albert Museum, London, *Catalogue of English Porcelain, Earthenware, Enamels, etc. Collected by Charles Schreiber...*, vol. 1: *Porcelain*, rev. ed., by Bernard Rackham (1928), no. 195, pl. 27. This has recently been relabeled as "ca. 1753" according to J.V.G. Mallet, keeper, Department of Ceramics, Victoria and Albert Museum.

5. J.V.G. Mallet, "A Chelsea Talk," *English Ceramic Circle Transactions* 6, pt. 1 (1965), pl. 25a (iii); in a recent letter Mr. Mallet has confirmed that this cup and saucer, decorated in polychrome enamels and gold, with gold dentil patterns on the rims, has been attributed to Derby, about 1765.

6. 30.374a,b, 30.375a,b (ex colls. Alfred E. Hutton, no. 201; Richard C. Paine); see Reginald Blunt, ed., *The Cheyne Book of Chelsea China and Pottery* (Boston and New York, 1925), no. 61, pl. 20, together with no. 62, pl. 20, a Meissen cup and saucer from the same service, also now in the Museum of Fine Arts, 30.376a,b (ex colls. Alfred E. Hutton, no. 202; Richard C. Paine). All six pieces have a gilt numeral "29" and the crossed swords, which, on the Meissen, are underglaze blue.

7. Bernard Rackham, "Mr. Wallace Elliot's Collection of English Porcelain (Second Article): Chelsea and the Midlands," *Connoisseur* 79 (Sept. 1927), 10; for one of these see Christie's, London, Dec. 8, 1980, lot 39, illus., with reference to a Meissen cup and saucer sold at Christie's (International), Geneva, Nov. 17, 1980, lot 124. The Christie's reference files indicate that lot 39 had been in the Wallace Elliot sale, Sotheby & Co., London, May 1938, and the Mrs. E. L. Dickson sale, Sotheby & Co., London, June 25, 1957. Also, in the Victoria and Albert Museum are a Meissen saucer with a matching Derby cup (C.76-1932), apparently identical to the Hutton cups, for which J.V.G. Mallet, keeper, Department of Ceramics, suggests a date about 1785.

8. William Bowyer Honey, *Dresden China* (Troy, N.Y., 1946), p. 160.

IX Bow Porcelain

The Bow Porcelain Manufactory, which was named New Canton, was the first factory known to have been built in England specifically for the manufacture of porcelain. The company was founded about 1747 by five partners, the most active of whom were Edward Heylyn, a clothier of Bristol, and Thomas Frye, the well-known Irish portrait artist and mezzotint engraver. John Weatherby and John Crowther, merchants dealing in pottery, porcelain, and glass, were active in the marketing of the porcelain, especially overseas. George Arnold, a wealthy liveryman of the Haberdashers' Company and an alderman of the City of London, who had connections in Virginia and may have been influential in the early use of American clay ("unaker") at Bow, undoubtedly provided financial backing. In 1749 the factory buildings, said to have been designed after those in China, were in operation across the River Lea in Stratford Road in the county of Essex (now east London).

The first patent covering a formula for a porcelain body including "unaker" had been taken out by Heylyn and Frye in 1744. In 1749 a further patent was issued to Frye alone for the first formula to include bone ash (calcined bone) in the paste. By 1753 the factory was sufficiently well established to open a warehouse in the heart of the City, and by 1760 Bow led the commercial production of English ornamental and useful china. Thomas Craft, one of the painters at Bow, testified some thirty years later that the factory had three hundred employees in 1760.

The decline of the Bow manufactory began with the death in April 1761 of Thomas Frye, who had suffered for some years from tuberculosis doubtless brought about by his fifteen years of strenuous work in the factory. John Weatherby died in 1762, and John Crowther continued as sole manager until the spring of 1776, when William Duesbury purchased and moved to Derby the remaining stock and equipment.

From the beginning the Bow manufactory emphasized useful wares to compete with importations from China, but figures were also being produced for two or three years before 1750, the date found on several very competent models. The notice of the auction upon the closing of the second Bow porcelain warehouse in London, 10 April 1758, included "beautiful Groups, and other figures of Birds, Beasts."[1]

V.S.H.

NOTE

1. This brief introduction is based on the fully documented book by Elizabeth Adams and David Redstone, *Bow Porcelain* (London and Boston, 1981). Both authors have contributed much new material, Elizabeth Adams through her research into documents, David Redstone through his part in the excavation of the Bow factory site. They also give full credit and references to those who have contributed earlier research.

77 Pair of ducks

England, attributed to Bow, about 1752

Soft-paste porcelain decorated in polychrome enamels

Marks:
(1) 77a: on base, in red enamel: an anchor within an oval, simulating Chelsea
(2) 77b: on base, in red enamel: an anchor within an oval, simulating Chelsea

77a: h. 8.5 cm. (3⅜ in.), w. 13 cm. (5⅛ in.), d. 7.6 cm. (3 in.); 77b: h. 13 cm. (5⅛ in.), w. 12 cm. (4¾ in.), d. 7.3 cm. (2⅞ in.)

81,82.1980

Published: Christie's, London, *Catalogue of Porcelain and Objects of Art…*, July 23, 1953, lot 36, illus.: "A pair of Bow figures of Geese"; Ruth Berges, *Collector's Choice of Porcelain and Faïence* (South Brunswick, N.J., and New York, 1967), fig. 167: "A pair of figures of ducks…Bow, ca. 1752."

Provenance: Purchased, New York, June 1956

The figures were press-molded and therefore are relatively heavy. Each duck is standing on a pad base with a central pedestal supporting the body. On the front of each pedestal, between the duck's legs, is a rose, with leaves, modeled in high relief; behind the left leg of no. 77a and the right leg of no. 77b are four leaves applied in quatrefoil pattern. No. 77a has its head turned to the left and its bill tucked beneath its wing. The bill and the legs are orange; much of the color on the bill seems to have worn off (?), as has some of that on the legs. The claws are black, and there are black stripes on the legs. The eyes are black, encircled with orange. The body is colored in shades of gray and brown, with black and dark brown used to define the feathers. The rose is yellow, the leaves green with

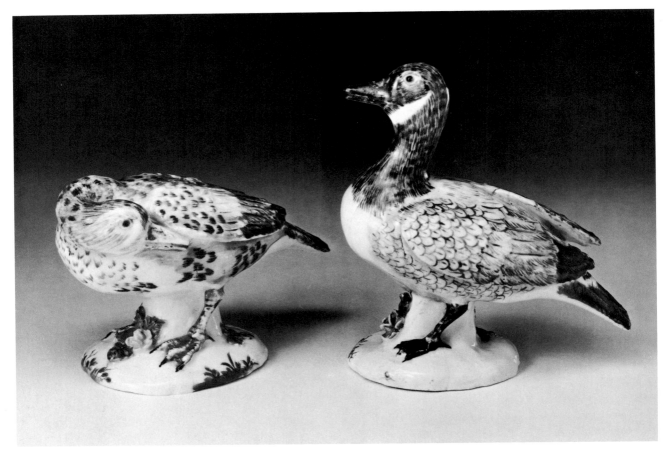

77

77 (1) 77 (2)

black veins, and two leafy patches of green with black outlining are at the edge of the mound. The simulated mark, slightly in relief but smaller than the Chelsea mark, is on the pedestal under the tail.

No. 77b, which has an upright head, is distinguished by a narrow white crescent below the bill. The head and neck have black feathers, as does the tail, while the body and wings are light brown with darker detailing. Both the bill and the legs are black. The eyes have black on yellow pupils and are outlined in orange. The rose between the legs is a salmon color, and the leaves are green with black veining. The mark, which is similar to that on no. 77a, is also under the tail.

Both ducks have suffered considerably from fire cracks, some masked by the enamels and by the crazing of the glassy glaze, which is greenish where it has pooled.

No prototype has been located for no. 77a, either in porcelain or in a print. No. 77b, however, is identical in modeling to the pair of Chelsea raised anchor marked "geese" in the Schreiber Collection at the Victoria and Albert Museum.[1] The Chelsea figures are slip-cast and are much lighter in weight. Both the Chelsea figures and no. 77b are modeled directly after a print of The Dusky and Spotted Duck, signed by George Edwards (1694-1773), dated September 1745, and published in The Natural History of Uncommon Birds, part 2.[2] Neither the Chelsea figures nor no. 77b are painted in keeping with the markings shown in Edwards. In fact, no. 77b, with its white bib, is closer to the print of the Canada Goose in Edwards's work, part 3 (1750), plate 151, which is stated to have been "drawn as it walked in Sir Hans Sloane's yard."

It has been suggested that Chelsea pieces with the raised anchor painted red may have been decorated in William Duesbury's London shop.[3]

This might account for the raised red anchor, simulating the Chelsea mark, on these pieces. The leafy patches at the edge of the base are not as sensitively rendered as those on the Chelsea examples, nor are the feathers, but this might be explained by the varying skill of different painters in the shop.

V.S.H.

NOTES

1. Victoria and Albert Museum, London, *Catalogue of English Porcelain, Earthenware, Enamels, etc., Collected by Charles Schreiber...*, vol. 1: *Porcelain*, rev. ed., by Bernard Rackham (1928), no. 142, pl. 20, (only one illustrated); these are called a pair but are both the same model. The same one is illustrated in F. Severne Mackenna, *Chelsea Porcelain, the Triangle and Raised Anchor Wares* (Leigh-on-Sea, Eng., 1948), fig. 70.

2. George Edwards, *The Natural History of Uncommon Birds*, pt. 2 (London, 1747), pl. 99.

3. Mrs. Donald Macalister, Introduction to *William Duesbury's London Account Book 1751-1753*, English Porcelain Circle Monograph (London, 1931), p. xvi.

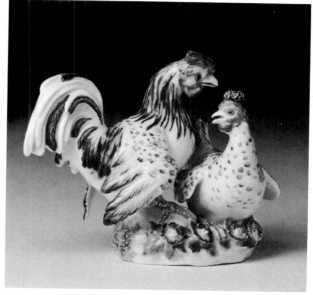

78

78 Group of a cock and a hen

Plate XIX

England, Bow, about 1755-1760

Soft-paste porcelain decorated in polychrome enamels

Unmarked

H. 10.5 cm. (4⅛ in.), w. 13.7 cm. (5⅜ in.), d. 7.3 cm. (2⅞ in.)

1983.651

Published: Sotheby & Co., London, *Catalogue of Fine English Porcelain*, May 12, 1959, lot 37, illus.

Provenance: Coll. Major Adrian E. Hopkins, M.C. (sale, Sotheby & Co., London, May 12, 1959)

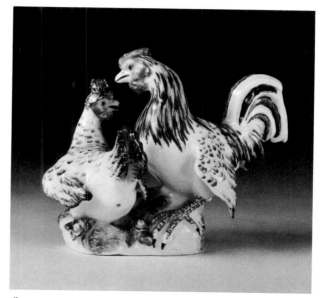

78

The press-molded figures of a strutting cock and a squatting hen have been assembled on a grassy mound base with applied flowers and leaves. The spirited modeling evident in the turning of the heads and the lifting of the wings is accented by the brilliant coloring. Both birds have yellow beaks and iron-red wattles and combs. Their eyes are black beads within a black circle. The cock has iron-red plumage on its neck and at the base of its tail; the tail itself is largely white, with two red tail feathers and a small number in manganese purple. Its back and wings and the hen's breast, back, and wings are dappled in a combination of pale brown and light purple, and the same colors appear on their wing feathers. The tail feathers of the hen are purple, as is the topknot. The claws are striped light brown. The three flowers at the front are colored, left to right, pink, lilac, and blue, and the two smaller ones at the back are lilac and pink; all have six petals and yellow protruding stamens; most are placed against five green leaves. There are three textured patches of green grass. An interesting feature is the technique called sgraffito, used to define the feathers. A heavy coat of enamel is ap-

plied, then scratched away with a fine stylus or pin. The same technique, but using a thicker tool, produces the striping of the claws and the texturing on the heads. The softer feathering on the bodies and wings combines a lighter application of color with the sgraffito. The painter (perhaps in haste?) missed scratching one purple feather on the back of the cock's tail.

The glaze, which is very glassy, is bubbly and slightly crazed where it has pooled on the base. A vent hole has been placed under each of the two tails, and there are two larger holes in the solid, almost flat, base.

This piece and another similar group in the same collection were listed as "rare."[1] However, at least three others can be cited: a group in the Lady Binning Bequest, Royal Scottish Museum, Edinburgh;[2] another, formerly the property of Lady Corah, sold at Sotheby & Co., London, July 20, 1971, lot 10, illus.; and one lent by Mrs. Richard C. Paine to the Museum of Fine Arts, Boston.[3]

The same models of a cock and hen have been produced as separate figures,[4] but Bow also produced another pair, with scroll bases, that is more closely related to Chelsea, Meissen, and even Chinese examples.

It would seem that this group represents one of the few original models of birds produced at Bow, and it justifies Hugh Tait's classification of it as "typical of the homely charm and naïvety of much of Bow's production."[5] It is entirely possible that the group was modeled from one of the popular farmyard prints or even one of the fable prints. The cock is very like that in Francis Barlow's *Aesop's Fables* (1666), p. 3: Cock & Gem.[6]

V.S.H.

NOTES

1. Sotheby & Co., London, sale catalogue, May 12, 1959, lots 37 and 36, illus.; for the latter, see also Elizabeth Adams and David Redstone, *Bow Porcelain and the Bow Factory* (London, 1981), fig. 131 (collection of Albert Amor Ltd.).

2. Hugh Tait, "Bow," in *English Porcelain 1745-1850*, ed. R.J. Charleston (London, 1965), pl. 12A.

3. Loan no. 301.1982 (repaired).

4. Anton Gabszewicz and Geoffrey Freeman, *Bow Porcelain: The Collection Formed by Geoffrey Freeman* (London, 1982), no. 266, pair, ex coll. Lady Ludlow, p. 156, illus., and pl. IX (color); hen alone, Sotheby Parke Bernet, London, sale catalogue, July 20, 1971, lot 9, illus. (ex coll. Lady Corah).

5. Tait, "Bow," p. 50.

6. Reproduced in Edward Hodnett, *Aesop in England: The Transmission of Motifs in Seventeenth-Century Illustrations of Aesop's Fables* (Charlottesville, Va., 1979), pl. 13.

X Worcester Porcelain

The third type of soft-paste porcelain in England contained soapstone (steatised granite) mined in the neighborhood of the Lizard in Cornwall. On March 7, 1748/49, Benjamin Lund, a dealer in copper and brass, was licensed to mine this soapy rock, and by 1750, together with William Miller, a grocer and banker, he had established a small porcelain factory in "Lowd'ns Glass House" in Redcliffe Bank, Bristol. In November of the same year, they were advertising for apprentices.

On June 4, 1751, the twenty-nine "Articles for carrying on the Worcester Tonquin Manufacture" were drawn up. The fifteen investors subscribed sums ranging from £675 to £112.10. The manufacture was to begin July 12, 1751, at Warmstry House in the parish of Saint Alban, Worcester (which had been leased for twenty-one years by one of the subscribers, Richard Holdship, a glover of Worcester), and would employ "the real true and full art mistery [sic] and secret" invented by Dr. John Wall, doctor of physic, and William Davis, apothecary, both of Worcester. The nature of this first secret formula is unknown; the earliest examples recovered on the factory site were steatitic, but it was not possible, because of the water table, to completely excavate the lowest levels.

Documentary evidence shows that Richard Holdship sold steatite to his Worcester partners as early as December 25, 1751, and that, on their behalf, he purchased from Lund and Miller the entire Bristol "stock, utensils and effects and the process of manufacture" on February 21, 1752. The *Bristol Intelligencer* published a note, July 24, 1752, that the china manufactory in that city was "now united with the Worcester Porcelain Company where for the future the whole business will be carried on." The lease of the soapy rock mine was part of this transaction. It was this ingredient, steatite, that ensured the continuing success of Worcester, since porcelain made from it withstood boiling liquid without cracking or crazing and also had a pleasant visual appearance, being a very workable, compact, and crisp clay body.

One of the original partners of the Worcester Porcelain Company was Edward Cave of St. Johns Gate, London, editor of the *Gentleman's Magazine*. The earliest view of the factory ap-

peared in the August 1752 issue of that publication. The engraving showed the layout of the factory, including the location of the "secret room" and noted, "A sale of this manufacture will begin at the *Worcester* music meeting, on *Sept.* 20, with great variety of ware, and, 'tis said, at a moderate price." Cave died in 1754, and nine additional shareholders were brought in.

In 1755 the first of several sales was held in London; three hundred lots were sold in three days at the Royal Exchange Coffee House. In 1756 the proprietors opened a warehouse at London House, Aldergate Street, London. As the twenty-one year lease of Warmstry House was about to expire early in 1772, the *Worcester Journal* of December 5, 1771, announced the sale by auction of the Worcester Porcelain Company on January 2, 1772, with a separate sale of the goods at the London warehouse, then in Gough Square, Fleet Street. The company was purchased by one of the partners, the Reverend Thomas Vernon, and a new company was formed on March 3, 1772, the six shareholders again including Dr. Wall and William Davis.

The Worcester porcelain produced in what has been called the early period, 1751-1783, has long been termed "Dr. Wall porcelain" or "Dr. Wall period." John Wall (1708-1776) took his degree of Bachelor of Medicine at Oxford in 1736 and practiced medicine very successfully in Worcester from 1740 to 1774, when he retired to Bath. He was also well known for his scientific investigations, one of which, dealing with lead poisoning, has been suggested as the source of his experiments to find a fine porcelain. He was also an accomplished amateur artist and may have painted some of the early porcelains. Although he probably had less to do with the daily operations of the factory than his coinventor, William Davis, it is evident from the changes that took place after his retirement (shown by the excavations) that he had a positive effect on the artistic quality of the productions.

On the basis of the excavations at the factory site, Henry Sandon has suggested that the Dr. Wall, or first, period should terminate about 1776, the year of Wall's death, and that a middle period, 1776-1793, which he has termed the "Davis/Flight" period, should be considered, encompassing the production of simpler, cheaper, more competitive wares. Thomas Flight, who had previously been the company's London agent, purchased the entire factory in 1783 and later added a shop on High Street, Worcester, as a showroom. In 1788 he moved the showroom to a larger High Street shop, which was honored by a visit in August of that year from King George III and his family. It was follow-

ing this visit that the king granted a patent allowing the company to call itself "Royal."

The third period, 1793-1840, which Sandon calls "Flight & Barr," is beyond the scope of this catalogue, as is the rival factory begun by Robert Chamberlain in the late 1780s in Diglis (the site of the present factory). In 1840 the Chamberlain and Flight factories were amalgamated, and most of the operations moved to Diglis.[1]

V.S.H.

NOTES

1. These brief historical notes are based on Henry Sandon, *The Illustrated Guide to Worcester Porcelain 1751-1793* (London, 1969). This book, by the curator of the Dyson Perrins Museum at the Royal Worcester Works, presents much new information based on the author's excavations of the original factory site. It also refers to earlier, in some cases classic, works that are still pertinent and valuable to the student and collector.

79 Mug

England, Worcester, about 1756-1757

Soft-paste porcelain decorated in polychrome enamels

Unmarked

H. 12.4 cm. (4⅞ in.), w. 14.3 cm. (5⅝ in.), diam. at base 9.6 cm. (3¾ in.)

1983.652

Published: Sotheby & Co., London, sale catalogue, Oct. 16, 1956, lot 70, illus.

Provenance: Coll. Dr. and Mrs. Hugh Statham (sold Sotheby & Co., London, October 16, 1956); purchased, New York, December 1965

The cylindrical mug was thrown on the wheel and turned to achieve this form, which flares slightly at the lip and at the base. The applied strap handle curves away from the body at the lower attachment. The base has been turned to produce a foot ring one centimeter wide, which is free of glaze. The glaze is slightly bluish, which somewhat decreases the translucency; the paste is a celadon green by transmitted light. The rim has warped in the firing, pulling toward the handle.

The painting, in the Japanese Kakiemon style, consists of a phoenix, or ho-ho bird, with a red crest and a long red tail, a puce back, blue wings, and a yellow head and breast, perched on a bright turquoise rock surrounded by scrolling

79

79

branches with red and yellow peonies, green leaves, and two blue quatrefoils. The design is rendered with fine details: the feathered edges of the tail, the shading of the breast, the very individual eye, the red moss growing from the rock, and the subtle black shading of the rock. The wing-like spreading of the base of the rock is very crisp and

fluid. There are two delicate insects at the left of the design, which spreads almost to the handle on both sides. The patches of red and green dots are typical Kakiemon motifs.

This is one of the early prototypes of the pattern named after the president of the Royal Academy of Art, Sir Joshua Reynolds (1723-1792), who possibly owned a service with this design. The design is also found on Chelsea and, of course, on the Japanese Arita porcelain from which it was derived (see no. 30 for a Meissen tankard with a related design). The bird's tail on this early Worcester version is smaller, and its head is bent downward. Other early versions of the design are on a bell-shaped tankard, height 11.4 cm. (4½ in.), exhibited in London in June 1973;[1] on a miniature vase from the Grant Dixon Collection at Ampleforth Abbey;[2] and on two baluster-shaped vases, lobed, with two triangular handles (an oriental form used earlier at Bristol), one published in 1954,[3] the other, formerly in the Glendenning collection, sold in 1976.[4] The decoration of this last seems closest to that of no. 79.

Dr. Hugh Statham was one of the original members of the English Ceramic Circle, and Mrs. Statham was also elected a member at its foundation in 1927. Their collection reflected their interest in the early periods of Chelsea, Bow, and Worcester; parts of it were sold in five Sotheby's auctions between October 1956 and January 1968. Dr. Statham died on October 11, 1968, at the age of ninety-two, and Mrs. Statham on August 9, 1970, at the age of eighty-nine. Many of the finest pieces from this important collection were placed on loan at the Fitzwilliam Museum, Cambridge, which later acquired them. The last pieces from the collection were sold at Sotheby's on February 23, 1971.[5]

V.S.H.

NOTES

1. Albert Amor, London, *Exhibition of First Period Worcester Porcelain 1751-1784*, catalogue by Anne M. George and John G. Perkins (1973), no. 23, illus.

2. Albert Amor, London, *Worcester Porcelain: The First Decade, 1751-1761*, catalogue by Anne M. George (1981), no. 12, illus.

3. H. Rissik Marshall, *Coloured Worcester Porcelain of the First Period (1751-1783)* (Newport, Eng., 1954), pl. 42, no. 883.

4. Sotheby Parke Bernet, London, sale catalogue, March 30, 1976, lot 22, illus.; see also Albert Amor, London, *Dr. John Wall, 1708-1776: A Commemorative Loan Exhibition of Dr. Wall Period Worcester Porcelain*, catalogue by Anne M. George (1976), no. 9, illus.

5. J.V.G. Mallet, ed., *The Cheyne Book of Chelsea China and Pottery* (1924; reprint ed., London, 1973), p. xiv; *English Ceramic Circle Transactions* 7, pt. 2 (1969), 153; 8, pt.1 (1971), 123.

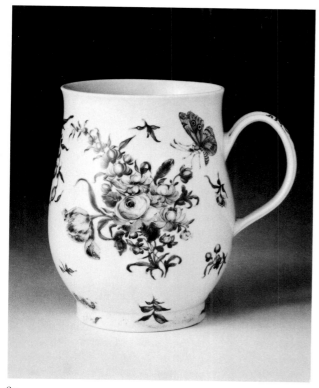

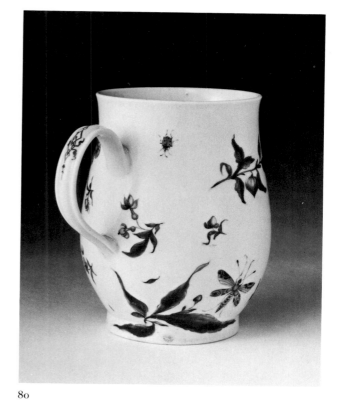

80

80

80 Bell-shaped mug

Plate XX

England, Worcester, about 1760-1762

Soft-paste porcelain decorated in poly-chrome enamels

Unmarked

H. 14.6 cm. (5¾ in.), w. 15.2 cm. (5¹⁵⁄₁₆ in.), diam. at rim 10 cm. (3¹⁵⁄₁₆ in.)

1982.781

Provenance: Purchased, New York, November 1955

The mug was thrown on the wheel then refined on the turner's lathe. The loop handle has a broad central rib. The glaze, which is bluish but paler than that of no. 79, is very fluid. It has pooled in the ridges of the handle and on the foot ring, as well as on the base inside the foot ring. The glaze was wiped from the bottom of the foot ring, but it refilled the margin at the juncture of the base and foot ring, the "pegging" line.[1] The paste is pale celadon green by transmitted light.

The enamel decoration on the obverse consists of a large bouquet of garden flowers centered upon a full-blown pink rose, with a soft yellow tulip to the left. The other flowers are in orange, sepia gray, puce, and soft blue. There are many fine details in both black and self-colors to create the rounded forms of the blossoms and the lively turning of the leaves; the thorny rose stems are clearly indicated. To the upper right of the bouquet is an equally elaborately delineated butterfly, in puce and sepia; its sheer wings have fine detailing, including two circular "eyes" on one wing. A caterpillar at the base to the left of the bouquet is bristling with fine hairs. The bouquet is surrounded with smaller sprigs of yellow and blue flowers to the right, leaves above and below, and, to the upper left, a long spray of puce, bell-shaped flowers. On the reverse a sprig with an orange-red Chinese lantern is near the top, with four other sprigs with blue flowers; the sprig at the bottom left has very large leaves, obviously covering a major glaze flaw. At the upper left is a ladybug, and a puce and sepia butterfly, wings outspread and ornamented in purple and yellow, is at the lower right. On the shoulder of the handle is a Chinese knot motif in iron red, probably inspired by a Meissen model.

The enamel decoration on the Markus mug has been attributed to James Rogers. This can only be a very tentative attribution, since no factory rec-

ords have been preserved for this early period, and several painters can be recognized to have done this kind of floral bouquet and scattered flower sprays in the Meissen style (the so-called *Meissener Blumen*). The mug in the British Museum signed by J. Rogers in 1757 is decorated with birds in a landscape; a number of other polychrome and blue and white pieces have been attributed to him, including at least one with a floral bouquet such as no. 80.[2] The shading on this piece, especially of the tulip, suggests a painter familiar with engraving techniques, and there is evidence that James Rogers was an engraver as well as an enameler.[3]

V.S.H.

NOTES

1. Henry Sandon, *The Illustrated Guide to Worcester Porcelain 1751-1793* (London, 1969), p. 28.

2. Hugh Tait, "James Rogers, a Leading Porcelain Painter at Worcester c. 1755-65," *Connoisseur* 149 (April 1962), 223-233.

3. Ibid., pp. 225, 228.

81 Dish

England, Worcester, about 1760

Soft-paste porcelain decorated in polychrome enamels

Unmarked

H. 2.9 cm. (1⅛ in.), w. 18.2 cm. (7⅛ in.), d. 13.9 cm. (5⁷⁄₁₆ in.)

1983.653

Published: Sotheby & Co., London, sale catalogue (H. Rissik Marshall Collection), Jan. 27, 1953, lot 55, illus.; H. Rissik Marshall, *Coloured Worcester Porcelain of the First Period (1751-1783)* (Newport, Eng., 1954), no. 704, pl. 32; Ruth Berges, *Collector's Choice of Porcelain and Faïence* (South Brunswick, N.J., and New York, 1967), fig. 166.

Provenance: Coll. H. Rissik Marshall (sale, Sotheby & Co., London, January 27, 1953); purchased, New York, November 1955

The dish was formed into a fig-leaf shape by pressing a slab of clay over a mold that included the twig handle and in which the fine veining was incised. The five-sided foot ring of triangular section was probably applied while the piece was still on the mold. The serrated edge was finished by hand.

The glaze is slightly bluish but paler than that of no. 80, and the paste is greenish in the few spots thin enough to be translucent. The dish is decorated in soft enamel colors. A long-billed bird (a bee-eater or a creeper) with yellow breast and pale blue head and wings, shaded with puce, is perched on a leafy branch. There are three large clusters of leaves and one small one, painted in green shaded with blue and outlined and veined with the same reddish brown that is used for the delicate branches. Near the tip of the dish is a ruffled butterfly in profile, painted in puce, green, blue, and orange. The twig-shaped handle is light green touched with yellow and reddish brown.

The mate to this dish is in the Marshall Collection at the Ashmolean Museum, Oxford, and was exhibited in London in 1981. Anne M. George, who prepared the exhibition and catalogue, chose the dish, her "favourite piece of Worcester," for the cover illustration.[1] When Mr. and Mrs. Henry Rissik Marshall offered their collections to the Ashmolean Museum (in memory of their son Lieut. William S. Marshall, who was killed in action during World War II), it was determined that no Worcester duplicates should be included in the gift. No. 81 may have been excluded because of the slight fire crack in the rim. It also differs from its mate in having an edge with a less pronounced sawtooth pattern.

The form of this dish is almost identical to but somewhat smaller than that of Chelsea examples of the red anchor period.[2] These appeared frequently in the auction sales of 1755 and 1756 as part of dessert services. An undated Worcester warehouse price card included "Fig Leaves" with two prices, four shillings and twelve shillings per dozen.[3] This range of prices probably relates to the different types of decoration: underglaze-blue painting[4] and printing, on-glaze printing,[5] and, as here, painting in enamels.[6]

Henry Sandon, former curator of the Dyson Perrins Museum, Worcester, upon seeing the photograph of no. 81, informed me that wasters of this same model have been found on the Warmstry House factory site in Worcester.

V.S.H.

NOTES

1. Albert Amor, London, *Worcester Porcelain: The First Decade 1751-1761*, catalogue by Anne M. George (1981), no. 66, illus. The dish is erroneously stated to have been illustrated in Marshall, *Coloured Worcester Porcelain.*

2. Carl C. Dauterman, *The Wrightsman Collection*, vol. 4: *Porcelain* (New York: Metropolitan Museum of Art, 1970), nos. 148A,B and 149A,B.

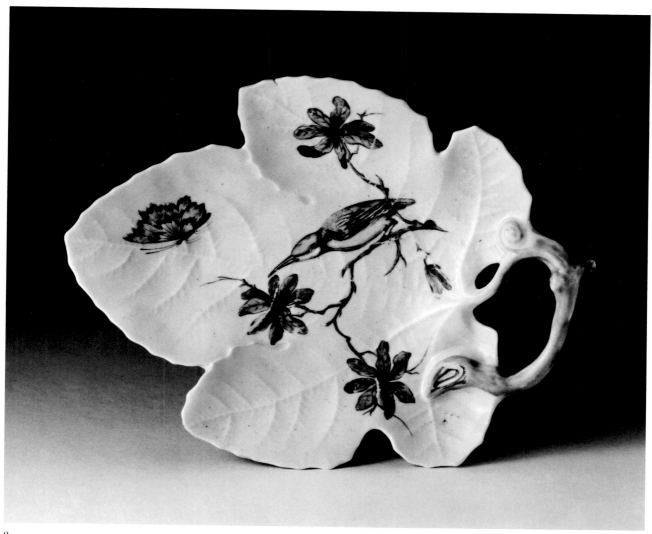

81

3. Henry Sandon, *The Illustrated Guide to Worcester Porcelain 1751-1793* (London, 1969), pp. 8-9.

4. Albert Amor, London, *Blue & White 18th Century English Soft Paste Porcelain,* a loan exhibition…, catalogue by Anne M. George (1979), no. 20, illus.

5. Albert Amor, London, *Dr. John Wall, 1708-1776: A Commemorative Loan Exhibition of Dr. Wall Period Worcester Porcelain,* catalogue by Anne M. George (1976), no. 32, illus.; Sotheby Parke Bernet, London, sale catalogue, Nov. 13, 1973, lot 7, illus.; Oct. 1, 1974, lot 159, illus.; R.J. Charleston, ed., *English Porcelain 1745-1850* (London, 1965), pl. 29B: with matching cauliflower tureen (collection of the late Selwyn Parkinson); the last were also published in Sotheby Parke Bernet, London, sale catalogue, March 29, 1966, lot 37, illus.

6. Sotheby Parke Bernet, London, sale catalogue, June 21, 1966, lot 196, illus.; Nov. 26, 1974, lot 61, illus.

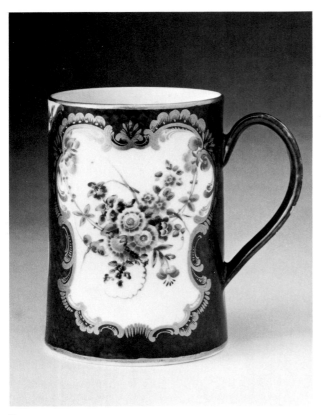

82

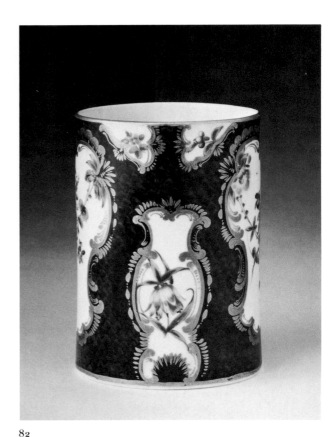

82

82 *Mug*

England, Worcester, about 1770-1775

Soft-paste porcelain with underglaze scale blue ground, decorated in polychrome enamels and gold

Mark:
(1) on base, in underglaze blue: script W

H. 11.4 cm. (4½ in.), w. 11.4 cm. (4½ in.), diam. at base 8 cm. (3⅛ in.)

1983.654

Provenance: Purchased, New York, November 1955

The cylindrical mug was thrown on the wheel, then turned on the lathe for the purpose of finishing the outer surface and cutting back the central part of the base to form a foot ring. The applied, grooved strap handle was attached to form an ear-shaped loop. The scale blue ground and the mark were applied to the biscuit-fired piece and hardened on in the glost kiln before application of the glaze. The two large reserves, sometimes called mirror-shaped, are decorated with finely painted

festoons of European or English (as opposed to oriental) flowers. The flowers are in a palette limited to purple, orange, and pink, some of the last with yellow centers. Shading is done with fine parallel brushstrokes and some stippling. The green leaves are shaded with purple. The painting of the bouquets, with a swirling movement, and the gilded framing of the reserves, with symmetrical scroll, shell, and bead motifs, undoubtedly reflect the influence of French porcelain. The gold shows traces of tooling but is deeper toned than that of Sèvres. The three smaller reserves opposite the handle are similarly framed. The two at the rim seem to continue the floral swag; the reserve below them has one spray with two pink bell-shaped flowers. The reserve on the handle, also framed in gold, has a flower motif in puce monochrome. At the rim and at the foot are simple gold bands.

82 (1)

Henry Sandon, who has had the opportunity to study many sherds and wasters in various stages of manufacture, has described the method of producing the scale pattern: the reserve panels were drawn in outline, and the blue areas washed with the weaker of two strengths of cobalt oxide; when this was dry, the scale pattern was painted over the ground in the heavier strength.[1]

Although scale blue grounds were being done competently by the 1760s, this type of floral decoration was characteristic of the factory work of the last years of Dr. Wall's direction.[2] The paste, which has a creamy translucency, also denotes a later period but still within Dr. Wall's time. As sherds with the script W mark have been found in early levels of the archaeological work at the Warmstry House factory site, Henry Sandon does not agree with the attribution of this mark to the 1780-1785 period suggested by Samuel Clarke.[3]

V.S.H.

NOTES

1. Henry Sandon, *The Illustrated Guide to Worcester Porcelain 1751-1793* (London, 1969), p. 27.

2. Ibid., fig. 81, right; Sotheby Parke Bernet, London, sale catalogue, Oct. 24, 1978, lot 45.

3. Samuel M. Clarke, "Marks on Overglaze-Decorated First Period Worcester Porcelain: A Statistical Study," *American Ceramic Circle Bulletin*, no. 2 (1980), p. 74. (This paper was presented in November 1976.)

83 *Dish*

England, Worcester, about 1775-1780

Soft-paste porcelain with apple-green ground, decorated in polychrome enamels and gold

Unmarked

H. 3.3 cm. (1 5/16 in.), w. 16.9 cm. (6 5/8 in.), d. 11.9 cm. (4 11/16 in.)

104.1980

Provenance: Purchased, New York, December 1956

The oval dish, with a rim of sixteen scallops, was pressed over a mold that was carved in intaglio, producing four branches with rose leaves in very low relief and four rosebuds in higher relief growing from two twig handles, which were molded separately and applied at each end. The oval foot ring, of triangular section, was applied while the piece was still on the mold. The green enamel

ground was painted on so that the scalloped edge was left white, and an irregularly shaped central reserve was also left white; no attention was paid by the decorators to the relief pattern, except for the handle. The green was edged to the outside of the dish, on part of the white rim, with a narrow gold band and to the inside with finely painted shell and scroll ornaments in gold, also on the white.[1] Pendant from this border, again ignoring the relief, are two long, trailing sprays of flowers and foliage and two smaller ones, in natural colors of pink, purple, orange, blue, and green with touches of yellow. The style of painting, with fine brushstrokes, is similar to that of no. 82, but blue has been added to the palette and there is more use of washes of color. Angular, spiky leaves are found on both pieces. The handle is picked out in gold, with a quatrefoil and dots marking the top side. The glaze is thin and slightly bluish at the edges and on the veining of the rose leaves in low relief. On the back the glaze has missed a small spot near one end, and it has been wiped off the inside of the foot ring.

An unglazed waster of identical form, without the handles, was found in pit 2 of the 1969 archaeological excavation of the Warmstry House factory site.[2] Another biscuit waster of the round form of this pattern was found at level 4.[3]

The popular title of the relief pattern, "Blind Earl('s)," refers to the Earl of Coventry, who was stricken with blindness in 1779-1780, and who may have ordered a dessert service of this pattern so that he could feel what he could no longer see. The pattern had long been known to date from almost twenty years before the earl's hunting accident, and evidence from the 1969 excavation confirmed this, but the title will probably never be discarded. So, too, the popular name for this shade of green, "apple green," is clearly not an eighteenth-century term. Of the three greens named in the auction sales of May and December 1769, "Pea Green, French green, Sea green," it seems that this is the first, pea green.[4]

This attractive combination of curving floral sprays and gilt-scroll-bordered green ground is known to have decorated a service belonging to the Marchioness of Huntly (or Huntley), sold in 1882;[5] a plate exhibited in London in 1973 bore a label inscribed "This is No. 233/11 of List No. 1 referred to in INDENTURE OF SALE, etc. between Messrs JAMIESON and THE MARCHIONESS OF HUNTLY. Dated 16th June 1882."[6] It has been pointed out that, although specimens with this type of decoration pass as "from the Marchioness of Huntly's service," they cannot all be from this

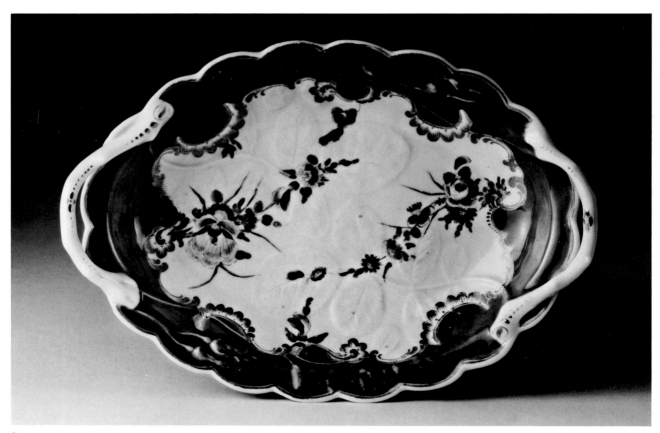

83

service. The authentic Huntly pieces have grass-like vegetation projecting from the floral pendants (as on no. 83), but this is used also on other Worcester pieces.[7]

 Likewise, there is no means of authenticating the original purpose for which dishes of this form were made. Henry Sandon called it an "oval tray," as did Bernard Rackham.[8] The examples in the Marshall Collection are called "sweetmeat dishes."[9] The rare yellow-scale example in the George R. Gardiner Museum of Ceramic Art, Toronto (G83-1-114), formerly in the Parkinson collection, was sold as a "spoon tray,"[10] and a "pair of unusual spoon-trays...decorated in the London atelier of James Giles..." was exhibited in London in 1973.[11] Nancy Valpy illustrated the yellow-scale dish in the second of her two articles on spoon trays but felt that it would have been more appropriately used for sweetmeats than for teaspoons.[12]

<div align="right">V.S.H.</div>

NOTES

1. It has been noted by all the Worcester scholars that this particular green, as also the yellow and pink grounds, did not receive the gilding on top of them.

2. Henry Sandon, *The Illustrated Guide to Worcester Porcelain 1751-1793* (London, 1969), pl. 116.

3. Ibid., pl. 30; the buds are in such high relief that they are clearly hand-modeled and applied, and the same might be true of no. 83; the round dish shown with the waster has been decorated to conform with the relief.

4. Ibid., p. 47.

5. R.L. Hobson, *Worcester Porcelain* (London, 1910), pl. 11, fig. 1.

6. Albert Amor, London, *Exhibition of First Period Worcester Porcelain 1751-1784,* catalogue by Anne M. George and John G. Perkins (1973), no. 80.

7. F. Severne Mackenna, *Worcester Porcelain: The Wall Period and Its Antecedents* (Leigh-on-Sea, Eng., 1950), p. 128, no. 16, and figs. 117, 121.

8. Sandon, *Illustrated Guide,* fig. 116; Victoria and Albert Museum, London, *Catalogue of English Porcelain, Earthenware, Enamels, etc. Collected by Charles Schreiber ...,* vol. 1: *Porcelain,* rev. ed., by Bernard Rackham (1928), no. 568.

9. H. Rissik Marshall, *Coloured Worcester Porcelain of the First Period (1751-1783)* (Newport, Eng., 1954), no. 23, pl. 1, and no. 718, pl. 33.

10. Sotheby Parke Bernet, London, sale catalogue, June 21, 1966, lot 223, illus.; possibly the same piece was sold at Sotheby's, Dec. 7, 1954, lot 160.

11. Albert Amor, London, *First Period Worcester Porcelain,* no. 63.

12. Nancy Valpy, "Some Eighteenth Century Spoon Trays," *Antique Collector* 44, no. 5 (Oct.-Nov. 1973), 268-271, fig. 8.

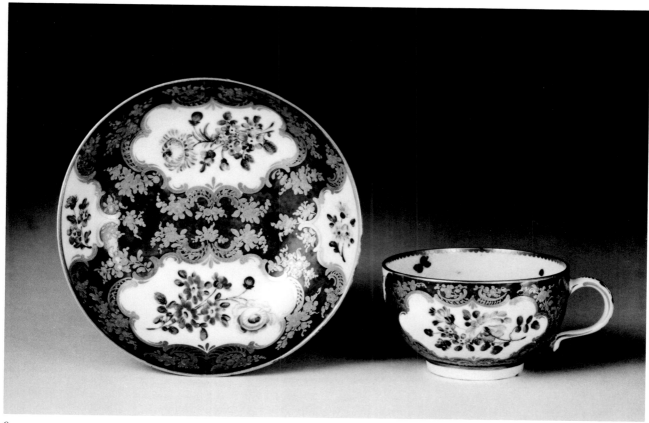

84

84 *Teacup and saucer*

England, Worcester, about 1770-1780

Probably decorated in the London work-shop of James Giles (1718-1780)

Soft-paste porcelain with claret ground, decorated in polychrome enamels and gold

Unmarked

Cup: h. 4.4 cm. (1¾ in.), w. 9.2 cm. (3⅝ in.), diam. at rim 7.5 cm. (2¹⁵⁄₁₆ in.); saucer: h. 2.5 cm. (1 in.), diam. 12.1 cm. (4¾ in.)

88.1980a,b

Provenance: Purchased, New York, December 1956

Both pieces were thrown and turned. The cup has an ear-shaped loop handle. The body is quite thin and by transmitted light shows a greenish cream translucency.

The outside of the cup and the inside of the saucer have been painted in a deep puce, called "claret"; on the cup are reserved three shaped panels, two large and one small, and on the saucer, two large and two small panels. The reserves are painted with sprays of flowers and foliage in natural colors of pink, blue, orange, and yellow. The panels are framed in elaborate rococo scrolls with arched trellises and flowers and foliage in tooled gilding. There is a plain gold band at the rim of the saucer. On the cup a gold dentil band is on the inner rim, a plain gold band marks the juncture of the claret ground and the white foot ring, and the white handle is ornamented with gold lines, dots, and leaf motifs. Inside the cup is a small spray of orange flowers and scattered green leaves masking the largest glaze flaws. Two-thirds of the interior and exterior have black specks in the glaze (minute burst air bubbles.)

These pieces were decorated outside the factory, quite probably in the London workshop of James Giles, who purchased "parcels" of plain white porcelain from the Worcester Porcelain Company. Robert Charleston (see below, note 5), who examined photographs of the Markus cup and saucer, pronounced them definitely the work of Giles. Henry Sandon (see below, note 8), citing the existence of other painting studios, even in Worcester, would assert only that they were decorated outside the factory.

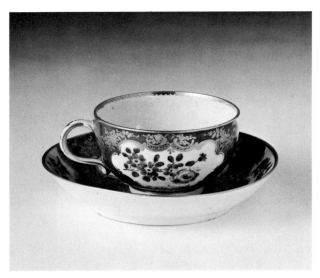

84

A teacup and saucer with very similar decoration were included in the Albert Amor exhibitions of 1977 and 1980.[1] Another teacup and saucer with gilding even closer in style to that of no. 84, and possibly from the same service, were sold at auction in 1965,[2] and a coffee cup and saucer described as having the same decoration were sold in 1974.[3] The last two were not attributed to Giles in the catalogues, but they are clearly of the same workmanship as the teacup and saucer exhibited by Albert Amor as by Giles.

James Giles, who was born in 1718 of Huguenot stock, was apprenticed to a jeweler in 1733, and in 1763 he advertised himself as a "China and Enamel Painter, Berwick Street, Soho."[4] On December 17, 1767, Giles advertised in the *Public Advertiser* as proprietor of the newly opened Worcester Porcelain Warehouse (the name first appearing in this form in an advertisement of January 28, 1768), in Cockspur Street, Haymarket, Charing Cross. He gave up these premises in 1776 but continued to sell and enamel porcelain from a variety of factories, including German and Chinese, in Soho.[5]

Apparently Giles, or whoever did the enameling of the Markus cup and saucer, did the ground as well as the other ornamentation, having purchased the pieces in the white. In a paper devoted especially to the color claret, A.H.S. Bunford suggested that it was created at Chelsea in emulation of the *fond rose* of Sèvres; it was occasionally called "Pompadour" in the 1768-1770 period but was more usually referred to as "crimson."[6] The latter designation was also given in the auction sale at Christie's, March 21-25, 1774, of the stock in trade of James Giles.[7] Possibly this is the color that was called "scarlet" in the 1769 auction sales of Worcester porcelain.[8] The great difficulty involved in firing this color, which is evident in no. 84, was noted by Bunford, who also remarked on the attraction of claret's peculiar warmth for all who appreciate color as a form of decoration.[9]

V.S.H.

NOTES

1. Albert Amor, London, *James Giles, China and Enamel Painter 1718-1780*, catalogue by Anne M. George (1977), no. 68, illus.; idem, *The Golden Age: Masterpieces of 18th Century English Porcelain*, catalogue by Anne M. George (1980), no. 62, illus.

2. Sotheby Parke Bernet, London, sale catalogue, Oct. 12, 1965, lot 146, illus.

3. Sotheby Parke Bernet, London, sale catalogue, Oct. 1, 1974, lot 31, illus.; this was being sold by order of the executors of the estate of the late Mrs. G.C. Stephens, was formerly in the Thomas Berners collection, no. 28, and had been exhibited in the British Antique Dealers' Association, London, *Art Treasures Exhibition* (1932), no. 689.

4. Aubrey J. Toppin, "Contributions to the History of Porcelain-making in London, 2, James Giles, Enameller," *English Ceramic Circle Transactions* 1, no. 1 (1933), 31-38.

5. W.B. Honey, "The Work of James Giles," *English Ceramic Circle Transactions* 1, no. 5 (1937), 7-22. Honey and, later, H.R. Marshall, "James Giles, Enameller," *English Ceramic Circle Transactions* 3, pt. 1 (1951), 1-9, and Robert J. Charleston, "A Decorator of Porcelain and Glass—James Giles in a New Light," *English Ceramic Circle Transactions* 6, pt. 3 (1967), 292-316, have gone well beyond earlier authorities such as R.L. Hobson, Llewellynn Jewitt, and R.W. Binns, in sorting out the types of decoration attributable to the Giles workshop, and all this information has undoubtedly been coordinated in the recent publication by Gerald Coke, *In Search of James Giles, 1718-1780* (Wingham, Eng., 1983), which I have not yet been able to consult.

6. A.H.S. Bunford, "Some Remarks on Claret Colour," *English Ceramic Circle Transactions* 1, no. 5 (1937), 24-29.

7. Charleston, "A Decorator of Porcelain," Appendix, pp. 302-316.

8. Henry Sandon, *The Illustrated Guide to Worcester Porcelain 1751-1793* (London, 1969), pp. 47-48.

9. Bunford, "Claret Colour," p. 29.

XI Tournai Porcelain

Tournai porcelain is perhaps best understood in the context of French ceramics. The city of Tournai, situated in western Belgium, very near the border of France, had been under French domination from 1668 to 1679, although during most of the second half of the eighteenth century it was part of the Austrian Empire. The close connection between the French and Tournai ceramics industries began early in the eighteenth century with the establishment of faience factories in Tournai, one by a Frenchman who also managed the faience factory at Saint-Amand-les-Eaux (in France). The faience made in Tournai was inspired to a great extent by the wares produced at the French faience factories, particularly Rouen. One of these Tournai factories was purchased by François Joseph Peterinck (1719-1799), who also founded the Tournai manufactory in 1750. In December of that year Peterinck hired the brothers Robert (b. 1709) and Gilles (b. 1713) Dubois, French ceramists who had been employed by the Saint-Cloud, Chantilly, and Vincennes porcelain factories in France. Robert, a technician and turner, was probably responsible for selling the porcelain formula to Peterinck. The recipe was for a soft-paste porcelain, which Tournai continued to produce and improve throughout the eighteenth century. Robert directed the factory for several years; Gilles was employed as a painter but appears to have remained at Tournai for only a short time.

Early in 1751 the empress Maria Theresa of Austria (1717-1780) granted Peterinck a thirty-year monopoly for the manufacture of fine porcelain in Tournai and the Netherlands. The factory also received some financial assistance from the municipality. In 1752 Prince Charles of Lorraine (1712-1780), governor of the Netherlands, accorded the factory the title of "Manufacture impériale et royale" and authorized Peterinck to choose an appropriate mark for the porcelain. A tower, from the Tournai coat of arms, painted in black, purple, iron-red, or blue was selected as the first mark. The mark seems to have been used only during the first period of the factory, 1750-1762.

Several other French ceramists, from the Rouen, Sinceny, Mennecy, and Valenciennes factories, were employed at Tournai during this formative period as modelers, sculptors, and painters.

Despite the influx of French artists and an initial reliance on Meissen and Sèvres styles of decoration, the forms and some of the painting of Tournai porcelain during the first period were often original. Among the most distinctive forms developed were plates with spiral reeding or spirally carved ribbing (see no. 85), often with a Meissen *osier* (basketwork) border pattern. For the most part, Tournai forms were quite restrained; more elaborate modeling was reserved for the charming and sensitively executed figural groups made at the factory throughout the century.

Decoration of wares during the first period consisted of light floral bouquets in blue or pale colors as well as some in thicker enamels, although the execution soon became more consistent and reflected the growing influence of the Strasbourg faience factory. Some decoration, again in blue and imitative of Chinese and Japanese porcelain (particularly in the Kakiemon style) was used; it was from this oriental decoration that the most typical Tournai motifs developed: the *décor ronda* and the *décor à la mouche*. These were composed of four floral sprays around the rim of a plate and one in the center and were painted in polychrome and blue, sometimes outlined in gold.

Tournai decoration underwent a marked change with the appointment of Henri-Joseph Duvivier (d. 1771) as chief painter in 1763. Duvivier, who was apparently originally from Tournai, spent his apprenticeship at the Chelsea factory in England. He is best known for his painting of exotic birds and landscapes with figures in manganese purple. Duvivier's directorship of Tournai, a post he held until his death, was significant not only because of his own artistic merit and influence, but also because of the link it established between Tournai and the English porcelain factories. The appearance of fable painting, the use of dark blue grounds, and the style and quality of the gilding on Tournai porcelain of this second period were certainly due to the exchange of artists and workmen between that factory and Chelsea.

The porcelain produced at Tournai during the second period was among the finest ever made by the factory and rivals that made elsewhere in Europe. A great variety of decoration was used, including monochrome scenes in rose, green, or manganese purple against white grounds, pastoral and amorous subjects after Boucher and Watteau, battle scenes, and gilt rococo reserves enclosing fruit, flowers, and birds. Especially noteworthy is the combination of manganese purple landscape scenes within reserves set against dark blue grounds. Tournai painting, in contrast to that found on other European porcelain, was re-

strained and spare. The mark generally associated with the second period is a gold tower in conjunction with blue or gold crossed swords with crosses in the angles. During this period, the factory also made a number of very finely painted boxes.

Joseph Mayer (1754-1825), a long-time employee of the factory, assumed the position of head painter in 1774, and with this began the third period of the factory (1774-1825). Mayer continued for a time to work in the manner of Duvivier but soon introduced the Louis XVI style and neoclassical decoration. The use of the crossed-swords mark was discontinued sometime during the third period. Unmarked and undecorated wares were sold in considerable quantity for decoration elsewhere, particularly in workshops such as that of Anton Lyncker (1718-1781) in the Hague (see no. 86).

Before Peterinck's death in 1799, the management of the Tournai factory had passed to his daughter Amélie and her husband, Jean-Maximilien de Bettignes (d. 1865). The factory remained in their family until 1850, when Boch Frères purchased it, supervising its operation until it closed in 1891.[1]

C.S.C.

NOTE

1. This introduction is based primarily on the catalogue Musées Royaux d'Art et d'Histoire, Brussels, *Le Legs Madame Louis Solvay*, vol. 1: *Porcelaines de Tournai*, 2nd ed., rev., by Anne-Marie Mariën-Dugardin (1980). For the most recent discussion of the relationship of the Tournai factory to the English porcelain factories, see Mireille Jottrand, "Tournai Porcelain and English Ceramics," *English Ceramic Circle Transactions* 10, pt. 2 (1977), 130-135.

85 Plate

Plate XXI

Belgium, Tournai, about 1775

Painting attributed to Georg Christoph Lindemann

Soft-paste porcelain decorated in polychrome enamels and gold

Marks:
(1) on base, in rose enamel: Cross of Lorraine
(2) on base, incised: O

H. 3 cm. (1 3/16 in.), diam. 23.2 cm. (9 1/8 in.)

Published: *Art and Auction*, June 1983, cover illus. (color).

1982.780

The circular plate has a shaped gold edge, the wide rim spirally molded with four groups of three curved panels, which are slightly convex. The panels are painted in puce with a diaper pattern in a darker shade. Each panel is edged by raised green ribbing, which also borders the inside of the rim, there outlined in gold. Four reserves with polychrome floral sprays on a white ground are interspersed between each group of curved panels. On the white ground of the center of the plate is a pale green trellised border edged with small gold flowers. Within this frame is a polychrome estuary scene in a range of subdued hues including brown, lavender, blue-green, pale turquoise, and yellow. To the left, on a promontory extending into the estuary, stand the moss-covered ruins of a castle surrounded by a stone rampart. At the end of the promontory are three figures, and a sail boat is nearby in the water. Two smaller boats are visible as well as a windmill in the distance on the right and a town silhouetted in the left background. Several birds fly overhead. Pilings and large stones with scruffy foliage appear in the foreground.

This spirally molded plate form seems to have originated at the Tournai factory soon after it was was established. It was produced throughout the eighteenth century, decorated with differing styles of floral and landscape motifs, in both polychrome and blue and white. Molding was used on other Tournai tablewares, including oval platters, compotes, and tureens (with stands). The spiral ribbing and another molded border pattern of reeded lines were among the factory's most successful and frequently produced rim designs.

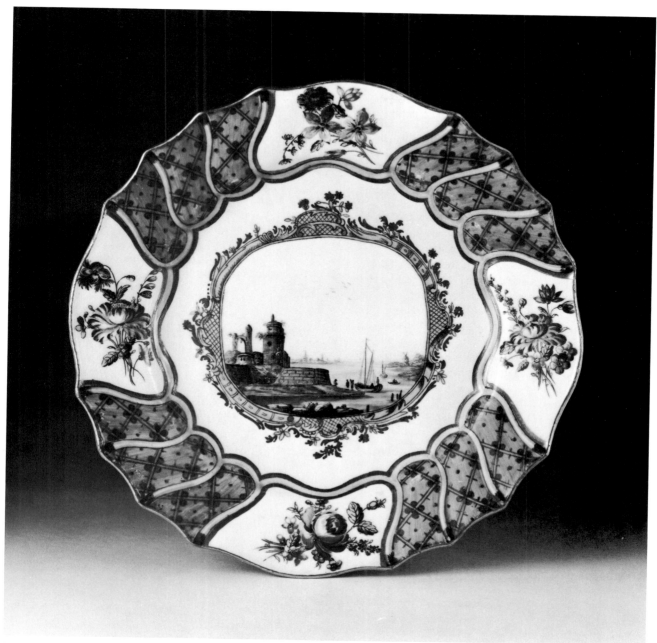

85

85 (1) 85 (2)

Although this plate does not bear a Tournai mark, there can be little doubt about its origin. The early Tournai paste was slightly grayish but was soon improved to a whiter tone and a finer grained texture. The paste of no. 85 compares favorably in color, texture, and translucency with wares of the third quarter of the eighteenth century made and decorated at Tournai as well as with the unpainted wares of the same period that were sold to Anton Lyncker (1718-1781), a Hague porcelain dealer who also owned a workshop that decorated porcelain.

The decoration of the Markus plate cannot be as readily associated with the Tournai factory as can its form and material. The plate is one of a group of tablewares (chiefly plates) whose decoration does not conform stylistically with that generally used on the factory's wares. The other wares in this group include (1) a service of sixty-eight pieces formerly in the possession of the art dealer Wilhelm Heinrich of Frankfurt, from which a plate and an oval platter are now in the Reiss-Museum in Mannheim; (2) another service of the same description that is mentioned by Lucien Delplace; (3) a plate in the Musées Royaux d'Art et d'Histoire in Brussels; (4) a plate sold in London in 1971; (5) a plate sold in Munich in 1983; (6) a plate formerly in the Fernand Michiels collection; (7) a plate in the Hans Syz Collection at the National Museum of American History (Smithsonian Institution) in Washington, D.C.; (8) an oval platter in the Museum für Kunsthandwerk, Frankfurt; (9) two plates in the British Museum.[1]

The pieces listed above are all soft-paste porcelain, and their decoration in palette and subject is similar to that of the Markus plate. All are painted with estuary scenes that include figures and buildings, and all but the Markus plate have at least one tall tree at one side of the central scene. There are slight variations between the pieces in the green and gold trellis border around the central reserve; on the Markus plate it is less elaborate than on most of the others, and the painted and gilded flowers on the edges of the trelliswork are not as numerous and do not extend as far onto the white ground of the center of the plate. The plate in the Musées Royaux in Brussels differs from the others in that the puce diaper-patterned spirals around the central reserve alternate with the gilded white spirals.

The painting on the Markus plate (and related pieces) lacks the delicacy of that on other Tournai wares and differs in style.[2] The flowers in the border reserves are not of the same character as those on the Tournai-decorated plates. The foliage here is larger and more heavily veined. The colors used both in the central estuary scene and in the puce and red border spirals are not generally found, especially in these combinations, on Tournai-decorated pieces. In addition, the shaped green and gold trellis border enclosing the scenes seems to have been used only in combination with these rim motifs and estuary scenes. The painting of the central scene, as well as the scenes on the other plates of this group, is more closely related to German porcelain decoration from the second half of the eighteenth century.[3]

The group of tablewares to which the Markus plate belongs has been attributed to Georg Christoph Lindemann, a painter of landscapes, figures, and flowers on German porcelain. If the attribution is correct, the similarity of the decoration on this group to that on German porcelain can be explained. This attribution is based upon the signature LINDEMANN f. on the reverse of one of the plates.[4] Lindemann was employed from 1758 until 1760 or later at the Nymphenburg porcelain factory,[5] where he worked primarily as a painter of landscapes. After this he apparently worked as a *Hausmaler* and perhaps at the Höchst factory.[6] His signature appears on a Höchst flower pot in the Sèvres Museum,[7] a Tournai coffeepot previously on the London market, and a Meissen plate dated 1767 in the Kunstgewerbe Museum in Hamburg.[8] The name Lindemann is not mentioned in lists of painters, sculptors, and employees of Tournai of 1775, 1777, or 1786;[9] it is included, however, in the accounts of François Joseph Peterinck, the factory's founder, and in his correspondence with a Brussels agent named Antoine Parent. In an entry dated July 4, 1775, a Lindemann is noted as having been paid by Parent on behalf of the Tournai factory. In a letter written in the same year, Peterinck alerts Parent to a small package marked L that has been sent to him and requests that it be delivered to a Mr. Lindemann, "dessinateur de Son Altesse Roiale demeurant à la Cour brûlée."[10] But these documents do not provide conclusive evidence that the Lindemann referred to therein and the painter of the signed plate are the same person.

The reference to the "Altesse Roiale," however, provides a possible clue to the significance of the rose-colored Cross of Lorraine mark that appears on the Markus plate as well as on three of the other plates in this group: the plate sold by Sotheby's in 1971, one of the plates noted by Delplace, and one of the plates in the British Museum, although the last is not gilded. The same mark is also found on the signed plate, in gold.[11] The Cross of Lorraine mark seems to have been used only on pieces decorated in the same manner as the Markus example and then only sporadically. On August 7, 1752, Prince Charles of Lorraine (1712-1780), governor of the Netherlands, bestowed upon the Tournai factory the title of "Manufacture impériale et royale" and authorized F. J. Peterinck to choose a distinctive mark for the factory's products. Two official marks were used: a tower, from the Tournai arms, and crossed swords with crosses in the angles, from the arms of Peterinck.

Since the Cross of Lorraine was not an authorized mark of the Tournai factory, perhaps use

of the mark was restricted to wares decorated at a specific location outside of the factory or to pieces painted by a particular *Hausmaler* or pieces intended for a specific patron. Charles himself does not appear to have been an avid collector; the sale of his personal belongings after his death lists only two pieces of Tournai porcelain.[12] It has been suggested that the mark was used to identify a service ordered by a member of the House of Lorraine; if that had been the case, the mark would have been more likely to appear in a prominent position on the front of the plate as part of the decoration or a coat of arms.[13] The letter from Peterinck to Parent cited above, however, seems to indicate that a Lindemann was at the royal residence, which at that time would have been occupied by Charles de Lorraine. It therefore seems that such a provenance must still be considered for these pieces. The richness of the decoration and the Lorraine mark strongly imply a special order by a patron with royal connections. Perhaps Charles commissioned a service as a gift of state, and other unmarked pieces with the same decoration were sold separately.[14]

Without more definitive proof, the provenance for the pieces in this group must remain conjectural. Attribution of the painting to Georg Christoph Lindemann, though attractive, must also remain tentative. In the absence of further documentation, it would be instructive to compare firsthand the painting on as many pieces as possible from this group with pieces signed by Lindemann.[15]

C.S.C.

NOTES

1. For illustrations of these pieces see the following sources respectively: (1) Hermann Jedding, *Europäisches Porzellan*, vol. 1: *Von den Anfangen bis 1800* (Munich, 1971), fig. 617, p. 212; "Keramische Neuerwerbungen des Reiss-Museums in Mannheim," *Keramos*, no. 57 (July 1972), p. 63; (2) Lucien Delplace, *Considérations sur les porcelaines de Tournai, 1750-1830* (Tournai, 1970), p. 51; (3) Musées Royaux d'Art et d'Histoire, Brussels, *Le Legs Madame Louis Solvay*, vol. 1: *Porcelaines de Tournai*, 2nd ed., rev., by Anne-Marie Mariën-Dugardin (1980), fig. 173, p. 218 (hereafter cited as Musées Royaux, Brussels, *Porcelaines de Tournai*); (4) Sotheby Parke Bernet, London, sale catalogue, March 30, 1971, lot 169, illus. facing p. 66; (5) Neumeister, Munich, sale catalogue, Sept. 14-15, 1983, lot 83, pl. 12; (6) Galerie Moderne, Brussels, sale catalogue, March 13, 1982, lot 242, pl. 5; (7) Hans Syz Collection, no. 1587 (unpublished); (8) Museum für Kunsthandwerk, Frankfurt, *Neuerwerbungen, 1959-1974* (1974), fig. 4, p. 118; (9) the two plates in the British Museum have not been published.

2. Musées Royaux, Brussels, *Porcelaines de Tournai*, p. 217.

3. Mention should also be made here of three plates of the same form as the Markus plate and two rectangular furniture plaques, all of which are painted in the same fashion and palette as the Markus plate, but with two significant differences: the decoration does not include green trelliswork or gilding. The plaques may have been made for the same patron that ordered the service. None of the pieces seem to be marked. For the plates see Eugène J. Soil de Moriamé, *Les Porcelaines de Tournay: Histoire, fabrication, produits* (Tournai, 1910), fig. 226, p. 223; Kitty Rueff, "The Porcelain of Tournai," *Antiques* 64 (Oct. 1953), p. 136, illus.; Sotheby Parke Bernet, London, sale catalogue, Oct. 21, 1980, lot 194, p. 41. For the plaques see Eugène J. Soil de Moriamé and Lucien Delplace de Formanoir, *La Manufacture impériale et royale de porcelaine de Tournay*, 3rd ed. (Tournai, 1937), nos. 439, 440, pls. 54, 55 (color).

4. Delplace, *Porcelaines de Tournai*, fig. 12, p. 52. According to Delplace, Lindemann's signature is under the glaze.

5. According to William Bowyer Honey, *Dresden China: An Introduction to the Study of Meissen Porcelain* (Troy, N.Y., 1947), pp. 159-160, Lindemann was dismissed from Nymphenburg in 1767.

6. Gustav E. Pazaurek, *Deutsche Fayence- und Porzellan-Hausmaler*, vol. 2 (Leipzig, 1925), pp. 380-381.

7. William Bowyer Honey, *European Ceramic Art from the End of the Middle Ages to about 1815: A Dictionary of Factories, Artists, Technical Terms, et cetera* (London, 1952), p. 369.

8. Honey, *Dresden China*, p. 210, n. 364, both the Tournai coffeepot and the Meissen plate.

9. Soil de Moriamé and Delplace de Formanoir, *La Manufacture impériale*, pp. 60-67.

10. Musées Royaux, Brussels, *Porcelaines de Tournai*, p. 10, n. 2.

11. See note 4, above. Other marks are also found on some of the plates in this group. The plate in the Musées Royaux in Brussels is marked with what is probably a spurious Tournai tower mark; see Musées Royaux, Brussels, *Porcelaines de Tournai*, p. 217. A plate from the service formerly in Heinrich's possession in Frankfurt has the crossed-swords mark, also used by the factory; see Jedding, *Europäisches Porzellan*, vol. 1, fig. 617. The remainder have no painted mark, although some have an incised letter or number or both.

12. Anne-Marie Mariën-Dugardin, "Compléments pour servir à l'histoire de la porcelaine de Tournai," *Bulletin des Musées Royaux d'Art et d'Histoire, Brussels* 46-47, no. 6 (1975), 143-144.

13. Delplace, *Porcelaines de Tournai*, pp. 52-53.

14. According to some scholars, the service formerly in the possession of Heinrich in Frankfurt was made for the Prince of Starhemberg; see Anne-Marie Mariën-Dugardin, "A propos de la porcelaine de Tournai: Thèmes traités à Tournai et dans d'autres manufactures européennes," *Bulletin des Musées Royaux d'Art et d'Histoire, Brussels* 36, no. 4 (1964), 60. It seems unlikely that this decoration would have been used on a service for both Charles de Lorraine and the Prince of Starhemberg. None of the Frankfurt pieces have thus far been noted as bearing the Cross of Lorraine mark, but as information about the service is limited, we cannot be sure of this. According to legend, Maria-Theresa (1717-1780), Archduchess of Austria and Queen of Hungary and Bohemia, offered the service to the Prince of Starhemberg, but this is even less certain than the prince's ownership.

15. Madame Mariën-Dugardin, who has made comparisons by examining some pieces as well as photographs, has found considerable similarities in the painting.

The Dutch porcelain industry has an unusual history; the only three factories to produce porcelain succeeded one another, each assuming ownership of its predecessor's wares, molds, and facilities. Each of the three factories, which made only hard-paste porcelain, began production by completing the decoration of wares left unfinished under the previous management. Because there was never more than one factory operating at a time, competition for trained workers and arcanists was not as keen as it was in other European countries, and the decoration of Dutch porcelain reflects this unusual continuity. Many of the modelers, painters, and arcanists who worked for the Dutch factories were from Germany, where they had been employed at one or more of the long-established factories, including Höchst, Frankenthal, and Kiel. Others came from the Tournai factory in Belgium and from some of the French factories.

By the time the first Dutch porcelain became available for sale in about 1762, the market for imported oriental and German porcelains had become firmly established in the Netherlands. The Dutch factories were neither as large nor as labor-intensive as those in Germany and France; nor were they supported by royal patronage as were many factories in those countries. There was some municipal assistance, but funding came primarily from private donation. Although the Netherlands had been the center of the faience industry in the late seventeenth and early eighteenth century, the majority of the pottery factories had ceased production by the third quarter of the eighteenth century because of their inability to compete with imported porcelain (see the introduction to section I). Thus, the Dutch porcelain industry was not able to utilize its native pottery industry and its trained ceramists as was done by many German porcelain factories.

Despite a reliance on German artists and German ceramic forms, the decoration of Dutch porcelain was often original in conception and execution. Although the early Dutch porcelain paste was of uneven quality, it was soon improved and was generally painted with great skill and with sensitivity to the forms and an appreciation for the porcelain body. The painting of all three factories is characterized by a subtle polychrome or often monochrome palette, the latter in shades of sepia, iron-red, puce, or black. Ground colors were used very rarely, and gold was used only sparingly to articulate form rather than as an integral part of the painted decoration. Landscapes and village scenes with one or two figures, bird painting, floral motifs, and some classical subjects were the most popular kinds of decoration.

The earliest recorded attempt to make porcelain in the Netherlands was in 1757 in a factory located in Weesp, a small town near Amsterdam. The factory was founded by Daniel McCarthy, a Scot, who succeeded only in producing a high-grade earthenware or faience. Financial difficulties forced the factory's closure two years later, at which time it was purchased by Count van Gronsveld-Diepenbroick (1715-1772). Production resumed in about 1762 under the direction of Niklaus Paul, an experienced porcelain maker. Paul was succeeded in 1764 by Anton Wilhelm, who had worked previously at the Höchst factory. Other foreign craftsmen included Nicholas François Gauron (b. 1736, active 1753-1788), a modeler with experience at Mennecy and Tournai, who was responsible for the few figures produced at Weesp; Louis Victor Gerverot (1747-1829), a decorator previously employed at Sèvres and five German porcelain factories; and Marchand, a painter from the Tournai factory who specialized in underglaze-blue decoration.

For the most part, German ceramic forms were borrowed and adapted by the Weesp factory, often with the addition of low-relief molding. The paste was of excellent quality and pure white in color. Decoration was most often in polychrome enamels, although monochrome and unpainted wares were also sold. The factory also produced one of the few Dutch services with a patterned ground. By 1771 the cost of operation proved too high, and the factory was closed.

Within the same year, Johannes de Mol (d. 1782), minister of the Protestant Church in the village of Loosdrecht, purchased the Weesp factory's remaining raw materials and wares with the assistance of several Amsterdam businessmen. De Mol's hope was to provide employment and economic stability for the impoverished local residents. He was able to obtain the services of Gerverot and Marchand, the former of whom used the facilities of the Schrezheim factory to experiment with paste, molds, and kilns. Using clay from Passau, Gerverot succeeded in making hard-paste porcelain, which was then produced at the Loosdrecht factory beginning in 1774. Some Weesp molds were used, of which the pair of bottles in the Markus Collection (no. 88) may be an example, but in

general Loosdrecht forms were simpler, and relief decoration was kept to a minimum. Landscapes with views of the local countryside were the most popular subjects for painted decoration. Although the wares were well made and often decorated with considerable skill, the large number of services and individual pieces made at Loosdrecht were not appreciated within Holland. Despite de Mol's attempts to prolong production by procuring loans in 1779 and 1780, the cost of manufacture, lack of clientele, and competition from the Hague workshop of Anton Lyncker, brought about bankruptcy in 1782. For de Mol this was a great personal tragedy; he died only two weeks after his resignation from the factory's board of directors.

The Loosdrecht factory's creditors voted to continue the production of porcelain and retained the services of Friedrich Daeuber, its last director. The factory was moved to Ouder-Amstel, where it resumed operation in 1784. Under Daeuber's capable technical and artistic guidance, the Amstel factory maintained a high standard of excellence, but, once again, sales were unsatisfactory. The factory was sold to the firm of George Dommer and Company in 1800 and was moved to Nieuwer-Amstel in 1809. While the country was under French rule, the factory received some support from Napoleon but had to limit itself to inexpensively produced wares. Neither this support nor the introduction of forms in the fashionable Empire style had any appreciable effect on the poor sales, and the factory was closed soon after the liberation in 1814.

The only domestic competition for the Dutch porcelain factories was the decorating workshop of Anton Lyncker (1718-1781) in the Hague, which began operation in 1777. Lyncker, who was formerly a dealer in German porcelain, used his foreign business connections to import undecorated German and Belgian wares to the Hague, where they were painted, gilded, and marked. Although he asserted that porcelain was made at his factory, contemporary evidence indicates that he imported porcelain but never produced it. By all accounts, the firm seems to have had considerable success. Unlike the other directors of Dutch porcelain factories, Lyncker was a shrewd businessman. A partial explanation for the success of his workshop might be found in the lower cost of decoration as compared with manufacture; if in fact Lyncker did not produce any porcelain, he would not have had to employ mold-makers, turners, or paste and glaze technicians, nor would he have had to maintain and fire high-temperature kilns. He would therefore have been better able to afford to employ the skilled German artists and gilders who produced decoration of superlative quality on finely made porcelain from Tournai, Ansbach, and other German factories. Lyncker's death in 1781 caused a gradual decline in quality and output from his workshop. His widow and son lacked his devotion and business acumen, and the factory closed in 1790. Like the Dutch porcelain factories, the Hague workshop was successful for a short time but was unable to compete with imported porcelain and English stoneware and creamware, which could be produced much less expensively.[1]

C.S.C.

NOTE

1. The information in this introduction is based on M.-A. Heukensfeldt Jansen and A.L. den Blaauwen, "Hollands en Duits porselein in kasteel Sypesteyn te Nieuw-Loosdrecht," *Mededelingenblad vrienden van de Nederlandse ceramiek*, no. 42 (March 1966); Museum Willet Holthuysen, Amsterdam, *Amstelporselein 1784-1814, Mededelingenblad vrienden van de Nederlandse ceramiek*, nos. 86-87 (1977); and W. J. Rust, *Nederlands porselein* (Schiedam, 1978).

86 Covered cup and saucer

Belgium, Tournai, about 1770-1785

Decorated in the Hague, workshop of Anton Lyncker (about 1777-1785)

Soft-paste porcelain, decorated in underglaze blue, polychrome enamels, and gold

Marks:
(1) on base of cup, in blue enamel: a stork; incised: script P
on base of saucer:
(2) in blue enamel: a stork
(3) incised: script g2

Cup: h. 9.8 cm. (3⅞ in.), w. 10.6 cm. (4³⁄₁₆ in.), diam. at rim 7.9 cm. (3⅛ in.); saucer: h. 3 cm. (1³⁄₁₆ in.), diam. 14 cm. (5½ in.)

1983.655a,b

Provenance: Purchased, Amsterdam, 1957

The cup is pear-shaped, with a handle of two twisted, or interlacing, branches with leaf terminals. The cover is gently swelled like the cup and has a rim that protrudes slightly over the upper rim of the cup. A puce rose with green foliage forms the finial. The exterior of the cup and cover and the inside of the saucer have white grounds with shaped, underglaze-blue borders edged and embellished with gold. Opposite the handle on the

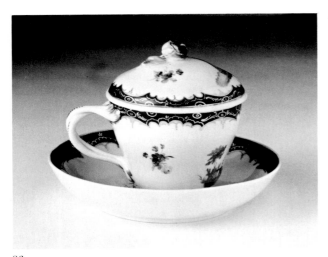

86

cup and in the center of the saucer are large ships flying the Dutch flag. On the cup, to the left of the ship, which is in full sail, is a small wooden dock on which two figures converse. At the end of the dock is a hoist with rungs, and to the left is a tree and some tall grass near the edge of the water. To either side of the sparsely gilded handle are small polychrome floral sprays. The ship on the saucer is at anchor, and its sails are raised and tied. The far edge of the water is bordered by rocks and tall bushes. On the cover just under the front of the rose is a small fishing boat, in full sail. A standing figure is visible near the stern. Polychrome floral sprays are painted on either side of the rose finial.

To supplement the income of the Tournai factory, the owner, François Joseph Peterinck (1719-1799), sold considerable quantities of undecorated porcelain to Anton Lyncker (1718-1781), a well-known porcelain dealer. Lyncker, who was of German origin, established himself in the Hague as a dealer in German porcelain. In 1772 he opened a shop in the Hague for the sale of porcelain[1] and within a few years announced his plans to establish a porcelain factory. In 1776 he became a citizen of the Hague in order to operate such a business legally. An advertisement in the Haagse Courant, January 20, 1777, announced his newly founded porcelain factory,[2] although there is good reason to believe that this "factory" decorated porcelain made elsewhere but manufactured none of its own. Several German porcelain factories supplied Lyncker with undecorated hard-paste porcelain, but the only soft-paste porcelain used by his workshop seems to have been that supplied by the Tournai factory.

Lyncker imported a variety of undecorated and partially decorated wares from Tournai; after the decoration was completed in the Hague, these pieces were sold individually or as entire services. The form of this Markus cup, which may have first been produced at Tournai during the factory's second period (1763-1774),[3] was based on a similar shape that had been used by the Sèvres factory after the late 1750s, known as gobelet Hébert (see nos. 66 and 67). This saucer form had been in production at Tournai since the early years of the factory and was used with other types of cups.[4] Judging by the number of marked examples that are known,[5] this particular model of covered cup seems to have been the one chosen for export to the Hague. By about 1785 this shape would have been out of fashion and may have been replaced by one in the neoclassical style.[6] It seems likely that these cups and saucers were made at least in pairs and probably en suite with other wares depending upon their intended use. The covers suggest that the cups may have been designed for hot chocolate. A cup (missing its cover?) and saucer of the same form as no. 86 are part of a Tournai set that includes a tray, teapot, milk jug, sugar bowl, and another cup of a different form, suggesting that two beverages may have been accommodated by such a service.[7]

As was often the case with the Tournai porcelain sent to the Hague, a shaped underglaze-blue border like that on no. 86 was applied before the pieces were fired at Tournai. The incised marks on the base of the cup and saucer were also added at Tournai. Unfortunately they cannot as yet be associated with any known modelers. The incised P on the cup is found on other Tournai cups of this shape,[8] and the incised 2 can be found on several Tournai saucers of this form. The 2 is often accompanied by a letter, as it is here.[9]

The ships painted on this cup and saucer are somewhat unusual for Hague decoration. Most of the marine and river views by Hague decorators do not feature ships isolated as these are and include more of the coastline or classical ruins and vegetation on the river banks.[10] The ships on no. 86, which prominently display the Dutch flag, may well have been taken from one of the many prints of harbors in such popular eighteenth-century publications as the Navigorum aedificatio, by Sieuwert van der Meulen, or The Great Fishery, of Adolf van der Laan.[11] The influence of Meissen porcelain decoration is also evident in the painting of these ships and in the harbor scenes on other Hague-decorated wares. The small polychrome floral bouquets on the cup and saucer are typical of Hague decoration, as is the pattern of gilding over the underglaze-blue borders.

A stork painted in profile with one leg

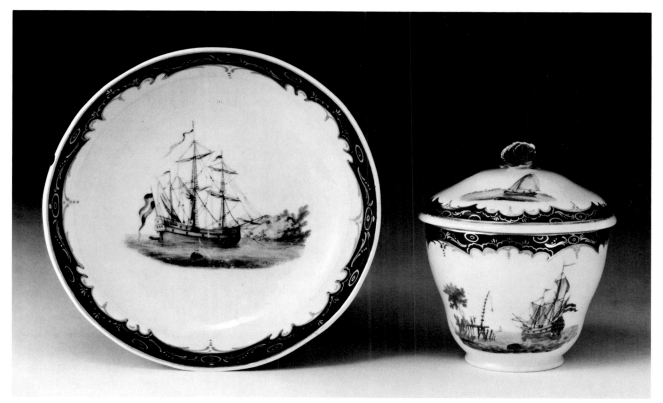

86

86 (1)

86 (2)

86 (3)

raised and an eel in its beak, the emblem of the city of the Hague, was the mark used by Lyncker's decorating establishment; the soft-paste porcelain made at Tournai for export to the Hague was left unmarked at the Tournai factory. Lyncker and Peterinck seem to have chosen certain wares (such as nos. 85 and 86) for decoration in the Hague, although the same forms continued to be decorated at Tournai. Confusion about the origin of the decoration was prevented by the distinctive palettes and styles of painting of each factory and by the absence of Tournai marks on the whiteware sold to the Hague. Both factories seem to have benefited from the arrangement; Tournai received a steady supplemental income, and the Hague workshop obtained a well-made and easily available product.

C.S.C.

NOTES

1. *Ansbacher und Den Haager Porzellan: Beziehungen zwischen zwei Manufakturen des 18. Jahrhunderts*, catalogue by S.M. Voskuil-Groenewegen, A. Lang, and Albrecht Miller (Ansbach, 1980), p. 7.

2. Ibid., p. 8.

3. Musées Royaux d'Art et d'Histoire, Brussels, *Le Legs Madame Louis Solvay*, vol. 1: *Porcelaines de Tournai*, 2nd ed., rev., by Anne-Marie Mariën-Dugardin (1980), pl. B, fig. 13, p. 26 (hereafter cited as Musées Royaux, Brussels, *Porcelaines de Tournai*).

4. Ibid., pl. B, fig. 10, p. 26.

5. This form must have been popular among Lyncker's clientele since it was also imported from German factories for decoration in the Hague; see *Ansbacher und Den Haager Porzellan*, figs. 17, 18, 57, 58, 65.

6. For a Tournai covered cup of neoclassical form, see Musées Royaux, Brussels, *Porcelaines de Tournai*, fig. 128a, p. 186.

7. Eugène J. Soil de Moriamé and Lucien Delplace-de Formanoir, *La Manufacture impériale et royale de porcelaine de Tournay* (Tournai, 1937), pl. 7, fig. 220 (color).

8. Musées Royaux, Brussels, *Porcelaines de Tournai*, fig. 90, p. 152, fig. 107, p. 158.

9. Ibid., and fig. 114, p. 167, fig. 119, p. 175. A similar g is found on a saucer of a different form in the Solvay Collection in the Musées Royaux, Brussels; ibid., fig. 120, p. 176.

10. *Ansbacher und Den Haager Porzellan*, figs. 42, 43, 44, 45, 51.

11. Irene de Groot and Robert Vorstman, eds., *Sailing Ships: Prints by the Dutch Masters from the Sixteenth to the Nineteenth Century* (New York, 1980), p. 8.

87 Milk jug, teacup, and saucer

Plate XXII

Germany, probably Ansbach, about
1770-1775

Decorated in the Hague, workshop of
Anton Lyncker, about 1777-1790

Hard-paste porcelain decorated in poly-
chrome enamels and gold

Marks:
(1) on base of milk jug, in blue enamel: a
stork; incised: L
(2) on base of cup, in blue enamel: a stork
on base of saucer:
(3) in blue enamel: a stork
(4) incised: 3

Milk jug: h. 15.2 cm. (6 in.), w. 13.6 cm. (5⅜
in.), diam. at rim 5.8 cm. (2¼ in.); cup: h.
5.1 cm. (2 in.), w. 10.1 cm. (4 in.), diam at
rim 8 cm. (3⅛ in.); saucer: h. 3.4 cm. (1⁵⁄₁₆
in.), diam. 13.2 cm. (5³⁄₁₆ in.)

1983.656, 657a,b

Published: Ruth Berges, *Collector's Choice
of Ceramics and Faïence* (South Brunswick,
N.J., and New York, 1967), fig. 198.

*The thrown milk jug is pear-shaped with a loop
handle, a large relief-molded spout, and a flat
cover with floral finial. The body of the milk jug is
white. On one side a chestnut-colored stag stands
in profile facing the handle. Behind it is a long,
brown wooden fence, a tall tree with sparse foliage,
several smaller blue trees, some small green bushes
along the fence, and a broad-leafed plant. On the
reverse of the jug a bushy-tailed fox facing the
spout stands with its front legs on a tree stump over-
grown with grass. Behind the fox is a tall green
and blue coniferous tree and, to the left, a smaller
tree with green foliage. Below the trees are some
green bushes. The handle is molded and gilded to
simulate a cut branch. Small blue and yellow flow-
ers with green foliage are applied on either side of
the handle, where it is joined to the jug at the top,
and on the right side at the base of the handle.
The spout is molded in low relief with scales and
branches that are gilded, as is the top rim of the
spout. A gilded pattern of C scrolls and dots deco-
rates the top of the jug and the perimeter of the
cover. The lid is also decorated with three small
puce floral sprays and an applied floral finial,
which is gilded. A single band of gilding decorates
the top of the foot ring. The thrown teacup is
bowl-shaped with a wide loop handle. On the exte-
rior opposite the handle, a large brown hare facing
right crouches on the ground in front of low green
bushes, a tree, and some tall blue grass. The inside
rim of the cup is gilded with the same pattern used
on the top of the milk jug. Inside the bottom of the
teacup is a puce flower spray. The thrown saucer
depicts a reclining brown doe facing left. In the
background is a tree below which are green and
lavender bushes. The inner rim is gilded with the
same pattern as that used on the rest of the set.*

This milk jug, teacup, and saucer are part of a tea
and coffee service decorated in the Hague work-
shop of Anton Lyncker (1718-1781). Several other
pieces are known: a coffeepot and two teacups
with saucers in a private collection in Amsterdam;
a teapot, teacup, and saucer in the Rijksmuseum,
Amsterdam; two saucers in the Hague Gemeente-
museum; and a coffee cup and saucer in the Hans
Syz Collection at the National Museum of Ameri-
can History (Smithsonian Institution), Washing-
ton, D.C.[1] The wares are all painted with animals
in landscape settings, including deer, dogs, otters,
and wild boars, in a palette of brown and green
with occasional use of pale blue and lavender. The
animal subjects are undoubtedly based on German
prints, perhaps engravings by Johann Elias Ridin-
ger (1698-1767). All are gilded with the same scroll
and dot pattern as that used on the Markus set, al-
though the Markus milk jug is the only serving ves-
sel with the pattern on its body as well as its lid.
With the exception of the Markus set and the cup
and saucer in the Syz Collection, which are hard-
paste porcelain, the pieces are soft-paste porcelain
from the Tournai factory,[2] and all are marked in
blue enamel with a stork holding an eel in its beak,
a symbol taken from the Hague coat of arms.

The primary suppliers for the porcelain
decorated in Anton Lyncker's workshop were the
Ansbach factory in southern Germany, which pro-
duced hard-paste porcelain beginning in about
1758, and the Tournai factory in Belgium, which
made soft-paste porcelain only (see nos. 85 and
86). Many of the wares sent to the Hague by the
Ansbach and Tournai factories were very similar
in form, perhaps having been made to Lyncker's
specifications. Thus it was not unusual for one ser-
vice to include both hard- and soft-paste porce-
lain.[3] Some of the pieces sent to the Hague from
Ansbach were marked with the factory's symbol, A
in underglaze blue. Others, however, like the Mar-
kus set, were left unmarked by the factory.[4] The
Markus set has been attributed to Ansbach because
of the similarity of its paste to that of marked ex-
amples. The smooth, creamy paste is highly trans-
lucent, with a gray tonality and only a very few

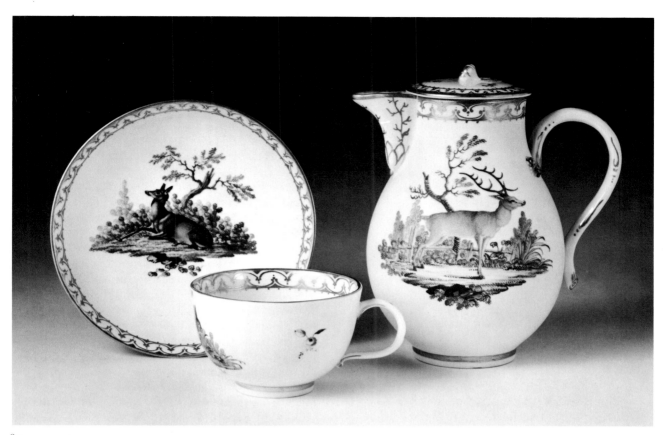

87

87 (1)

87 (3)

87 (2)

87 (4)

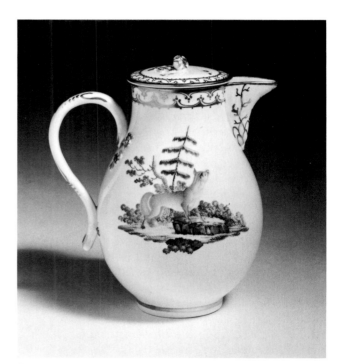

87

minor imperfections. Other German factories supplied Lyncker with undecorated hard-paste wares, including Volkstedt, Höchst, Ludwigsburg, and Meissen.[5]

The marks and paste of wares bearing the Hague stork are particularly important factors to consider when making an attribution because of the uncertainty about the production of porcelain in the Hague workshop and the likelihood that the porcelain was made at another factory.

Before Lyncker opened his shop in the Hague in 1777, he is recorded as having been a dealer in Saxon and Thuringian porcelain; he had begun selling decorated Ansbach porcelain as early as 1769.[6] He often sold these wares at fairs in the Hague, where he probably made the necessary business connections that enabled him to raise sufficient capital to open a store and porcelain "factory" in that city. In an advertisement of 1777, Lyncker claimed to be manufacturing porcelain[7] as well as decorating imported whiteware, but there is good reason to doubt this. His petition to the College of Delegated Councils of States of Holland for a patent to manufacture porcelain in January 1778 was not granted since he had no proof that he had yet made any porcelain.[8] Speaking in his own defense, Lyncker claimed he would be able to make porcelain within a few months and would suspend decoration on imported whiteware shortly thereafter.[9] In a statement before the same organization, Johannes de Mol, proprietor of the Loosdrecht factory, where porcelain had been produced since 1774, reported that he had visited Lyncker's workshop and found no evidence of any porcelain production.[10] De Mol stated that he was shown only imported porcelain from Germany and Tournai. He was also shown an unglazed plate that had purportedly been made on the premises, but that he recognized as soft-paste porcelain from Tournai. De Mol's statements are supported by the fact that no kilns or other evidence of porcelain manufacture have ever been found in the Hague.[11] The system of marking imported Ansbach wares by Lyncker's workshop also raises doubts about the likelihood of porcelain manufacture there. When marked Ansbach wares were received in the Hague, the mark was deliberately, though not always successfully, camouflaged by the Hague stork mark in blue enamel.[12] At least one piece is known on which the Höchst factory mark, a wheel, was disguised in the Hague factory in the same manner.[13]

Another group of wares is marked with the stork in underglaze blue, which is often taken as partial indication that Lyncker eventually produced porcelain, since the mark would then have to be applied before the second firing. It is possible, however, that Lyncker's trade with a factory like Ansbach was sufficient to have the Hague factory mark applied to wares before their second firing in Ansbach. Another possibility is that Lyncker purchased unglazed or biscuit-fired porcelain from Germany, in which case the mark would have been added before the transparent lead glaze was applied in the Hague. A comparison of impressed and incised numerals and letters on pieces with enamel and underglaze Hague marks suggests that all were manufactured outside the Netherlands.[14] The incised 3 on the Markus saucer, for example, is also found on Ansbach-marked saucers of the same form, and the incised L on the milk jug is found on many vessels of German, probably Ansbach, porcelain.

All the pieces in the service to which the Markus set belongs are painted by the same hand, but none is signed or initialed by the artist, who was almost certainly trained in Germany, as were most of the painters employed by Lyncker. Hague factory records list names of painters from Höchst, Frankenthal, Mentz, and Kiel, but identification of their work is difficult since Hague-decorated wares were almost never signed by the artist.[15] The distinctive style of the artist responsible for the Markus service, however, can be associated with several other pieces with animal and landscape painting in a similar palette. These include a ewer and basin painted with birds in the Hague Gemeentemuseum; another ewer and basin in the Rijksmuseum, Amsterdam; a platter and a cup in the Bayerisches Nationalmuseum, Munich; two platters of the same form as the one in Munich, one in a private collection in Zurich and the other in the Württembergisches Landesmuseum, Stuttgart; and a chocolate pot, milk jug, waste bowl, sugar bowl, and two teacups from a service in the Kreis- und Stadtmuseum, Ansbach.[16] On the basis of the similarity between their decoration and that of a signed cup and saucer, several of these pieces, including the Markus milk jug and the coffeepot in Amsterdam from the same service, have been attributed to the Ansbach bird painter, Albrecht Hutter (1754-1804).[17] There is no record of Hutter working in Tournai or the Hague. Although it has been suggested that Lyncker supplied Hague painters with Ansbach porcelain decorated by Hutter as models,[18] the style of the painting supports an attribution to Hutter himself. This must remain tentative, however, until closer examination of all these wares is possible.

C.S.C.

NOTES

1. For the coffeepot, teapot, and three teacups with saucers: Gemeentemuseum, The Hague, *Haags porselein, 1776-1790,* catalogue by Beatrice Jansen (1965), nos. 94, 95, pls. 23, 24, 25, no. 96, p. 37; two saucers: *Ansbacher und Den Haager Porzellan: Beziehungen zwischen zwei Manufakturen des 18. Jahrhunderts,* catalogue by S.M. Voskuil-Groenewegen, A. Lang, and Albrecht Miller (Ansbach, 1980) fig. 33, p. 62; coffee cup and saucer: Hans Syz Collection, no. 254, unpublished.

2. The two saucers in the Gemeentemuseum, The Hague, have been published as both soft- and hard-paste porcelain; see Gemeentemuseum, The Hague, *Haags porselein,* no. 97, p. 37; idem, *Doorniks en Haags porselein: Han onderlinge relatie* (1977), no. 116; *Ansbacher und Den Haager Porzellan,* fig. 33, p. 62.

3. W.J. Rust, *Nederlands porselein* (Schiedam, 1978), p. 117.

4. The A used by the Ansbach factory almost certainly signifies Margrave Karl Alexander, who assumed control of the Ansbach factory in 1757. During the eighteenth century, Ansbach was known as Onolzbach; see Rust, *Nederlands porselein,* p. 118.

5. Ansbach, Höchst, and Meissen are frequently mentioned as suppliers to Lyncker's workshop. For reference to Ludwigsburg as a source of whiteware, see Rainer Rückert, "Porzellan für Wunsiedel," *Pantheon* 33 (April, May, June, 1975), p. 134 and p. 137, n. 25.

6. Adolf Bayer, *Ansbacher Porzellan,* 2nd ed. (Brunswick, 1959), p. 128.

7. M.-A. Heukensfeldt Jansen and A.L. den Blaauwen, "Hollands en Duits porselein in kasteel Sypesteyn te Nieuw-Loosdrecht," *Mededelingenblad vrienden van de Nederlandse ceramiek,* no. 42 (March 1966), p. 15.

8. Gemeentemuseum, The Hague, *Haags porselein,* p. 6.

9. Gemeentemuseum, The Hague, *Catalogus van de verzameling Haagsch porcelein,* catalogue by H.E. van Gelder (1916), p. 107.

10. Gemeentemuseum, The Hague, *Haags porselein,* p. 6.

11. This was confirmed, in conversation, by Dr. A. Westers, keeper of applied arts at The Hague Gemeentemuseum in November 1982.

12. *Ansbacher und Den Haager Porzellan,* figs. 6, 15.

13. William Bowyer Honey, *European Ceramic Art from the End of the Middle Ages to about 1815: A Dictionary of Factories, Artists, Technical Terms, et cetera* (London, 1952), p. 613.

14. D. Arn van Krevelen, "De Haagse porseleinindustrie in het licht van de persoonlijk-heid van Lyncker," *Mededelingenblad vrienden van de Nederlandse ceramiek,* no. 58 (1970-1971), pp. 15-22.

15. Gemeentemuseum, The Hague, *Haags porselein,* p. 8.

16. For the ewer and basin in the Hague: *Ansbacher und Den Haager Porzellan,* fig. 29, p. 59; ewer and basin now in Amsterdam: Elka Shrijver, *Hollands porselein* (Bussum, 1966), pl. D (color), p. 49; three platters and cup: Rückert, "Porzellan für Wunsiedel," figs. 1, 2, 4, 5; chocolate pot, milk jug, bowls, and teacups: *Ansbacher und Den Haager Porzellan,* figs. 89, 90, 91, 93, 94, pp. 108-111. Rückert's attribution to the same artist of a *tête-à-tête* set in The Hague Gemeentemuseum seems less convincing.

17. Rückert, "Porzellan für Wunsiedel," fig. 9, p. 135; the Markus milk jug is mentioned on p. 136, n. 14.

18. Ibid., p. 136.

88 Pair of bottles

The Netherlands, Loosdrecht, about 1775

Hard-paste porcelain decorated in puce enamel and gold

Marks:
(1) 88a, on base, in underglaze blúe: M = O L; incised: L, two vertical strokes, underlined
(2) 88b, on base, in underglaze blue: M: OL; incised: L, two vertical strokes, underlined

88a: h. 18 cm. (7⅛ in.), w. 11.1 cm. (4⅜ in.), d. 7 cm. (2¾ in.); 88b: h. 17.8 cm. (7 in.), w. 11.2 cm. (4⁷⁄₁₆ in.), d. 7 cm. (2¾ in.)

1983.658

Published: Ruth Berges, *Collector's Choice of Porcelain and Faïence* (South Brunswick, N.J., and New York, 1967), fig. 197.

Provenance: Purchased, Amsterdam

The molded bottles have a bulbous lower body, which rises from an ovoid foot ring. The ovoid-shaped necks are flattened and flare gently at the mouth. Painted in puce camaïeu against a white ground, both bottles are similarly decorated with riverside scenes, one with a woman and one with a man. The figures are simply dressed; the woman wears a long dress with rolled sleeves and a hat and carries a basket; the man carries a tall walking stick and wears a long-sleeved shirt with loose-fitting breeches and a tall hat. Both figures stand in clearings bordered by log fences and trees. In the foreground of both are rocks and aerial roots, and some buildings are visible in the distance. On the reverse of both bottles is a small landscape scene with a tree, a log fence, and rocks. The foot ring is decorated with a plain gold band, and gold floral sprays are placed on the sides of the shoulders and on the front and back of the necks. The upper rim has a gilt trefoil border. The interiors of the bottles are partially glazed in white.

The Loosdrecht factory of Reverend Johannes de Mol (d. 1782) produced a greater variety of wares during its eight-year history (1774-1782) than its predecessor, the Weesp factory, or its successor, the Amstel factory. Among the earliest wares bearing the Loosdrecht mark (M.O.L. in block letters or script) were unfinished pieces acquired by Loosdrecht when the factory assumed control of the bankrupt Weesp factory in about 1770. Some of the Weesp molds were also used, but Loosdrecht

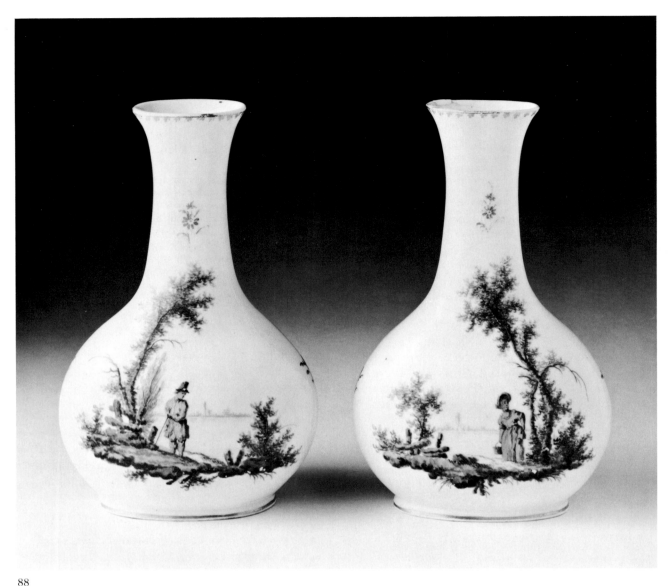

88

88

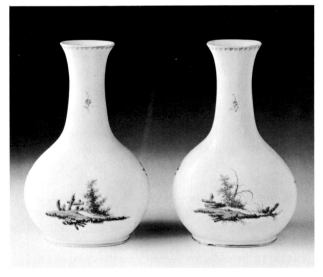

soon began making its own, which were usually characterized by less relief scrollwork than that found on many Weesp wares. Loosdrecht adapted some of the forms from German and French porcelain, but many were original.

A pair of unmarked bottles of the same form and size as the Markus pair has been attributed to Weesp.[1] This would suggest that the mold from which the Markus bottles were made was one of those formerly used at Weesp. The lower bodies of the Weesp bottles are painted in sepia and green with a landscape with cows and a purple and iron-red scale pattern around the upper neck. Another pair of marked Loosdrecht bottles of this form is decorated in a patterned ground surrounding reserves painted with landscape scenes.[2] Some marked Loosdrecht examples, painted with large

polychrome floral bouquets on white grounds, are molded with slight relief decoration on the neck and shoulders, over the central reserve and above the base.[3] The bottles attributed to Weesp do not have any of the relief decoration that appears on these marked Loosdrecht examples. Thus the Markus bottles would seem to have been made at Loosdrecht prior to this adaptation. Another factor in support of an early date for the Markus vases is the thickness and speckling of the paste, features that were corrected by the time the factory closed in 1782.

This vase form is almost certainly an adaptation of a pilgrim bottle, a form used at the Meissen factory beginning in the first decade of the eighteenth century, when it was made there in Böttger stoneware.[4] In turn, the Böttger stoneware form was based on silver or silver-gilt pilgrim bottles that were made in Germany as well as in Holland and England during the late seventeenth century. From the late sixteenth century, the form was also used in Chinese porcelain, some examples of which may have been exported to Europe. This traditional form ultimately derives from dried gourds, which served as water containers and were reportedly carried by pilgrims. Eighteenth-century metal and ceramic pilgrim bottles, which were purely decorative, were almost always made with a cover with an open trefoil finial; from this, chains were suspended on either side, sometimes attached to applied masks or satyr heads on the shoulders.

88 (1)

88 (2)

This form is commonly known as *jachtflesje* in the Netherlands, presumably in reference to an adaptation of the pilgrim bottle that was carried by hunters.

C.S.C.

NOTES

1. W.J. Rust, *Nederlands porselein* (Scheidam, 1978), fig. 13.

2. Museum Willet Holthuysen, Amsterdam, *Het Nederlandse porselein*, catalogue by W.J. Rust (Amsterdam, 1952), no. 203, illus.

3. M.-A. Heukensfeldt Jansen and A. L. den Blaauwen, "Hollands en Duits porselein in kasteel Sypesteyn te Nieuw-Loosdrecht," *Mededelingenblad vrienden van Nederlandse ceramiek*, no. 42 (March 1966), fig. 44, p. 10; Gilda Rosa, *La Porcellana in Europa* (Milan, 1966), pls. 338-339.

4. Willi Goder et al., *Johann Friedrich Böttger: Die Erfindung des europäischen Porzellans* (Stuttgart, 1982), figs. 109-110, p. 176, fig. 137, p. 209 (color).

89 Bell

The Netherlands, Loosdrecht, about 1780

Hard-paste porcelain decorated in puce enamel and gold

Mark:
(1) inside bell, in puce enamel: M: O L

H. 6.7 cm. (2⅝ in.), diam. at rim 9.1 cm. (3⁹⁄₁₆ in.)

1983.660

The bell is of circular section, with a widely flared lip tapering to a domed head under the handle, which is a replacement. The shoulder and sound bow of the bell are molded in relief with single bands of scrolling and beading respectively. Below these bands are solid lines of gold. The flared body is painted in puce camaïeu with a river scene that continues around two-thirds of the bell. In the right foreground a woman wearing a long dress stands facing the river. To her left are some bushes and to her right some wooden pilings and a large basket filled with clothing. On the bank across the river from her is an inscribed pedestal surmounted by a tall urn. On the bank to her right stands another monument, this one with a rectangular base hung with a garland of flowers and a tapered upper section on top of which is a small urn. The river continues into the distance. A tree, a rock,

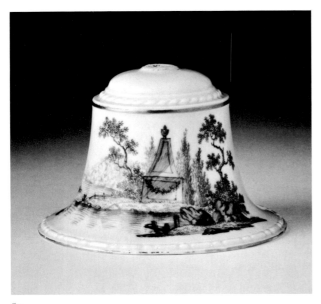

89

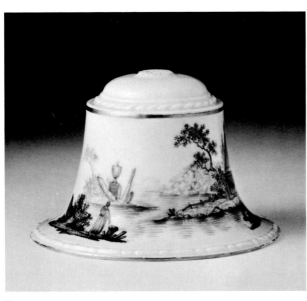

89

89 (1)

and part of a fence are painted on the back of the bell. The interior of the bell is fitted with a porcelain loop, from which a metal chain and clapper are suspended.

Like most eighteenth-century porcelain factories, Loosdrecht produced, in addition to a broad selection of tea and coffee wares and dinner services, a range of more unusual functional and decorative wares and figures. Among these were a variety of baskets, several forms of openwork vases, which were a particular specialty of the factory, and table bells like the Markus example.[1]

Numerous forms of table bells were made at Loosdrecht; often the same shape was used with variations in details of the relief moldings. One form, for example, was identical to that of the Markus bell, with the addition of four portrait medallions molded in relief below the shoulder.[2] Loosdrecht bells do not seem to have been made as part of writing sets as they were at other Continental porcelain factories (see no. 29). Loosdrecht made inkwells, but no pounce pots or the appropriate stands or trays for writing sets are known. Most of the extant bells, like those with relief portrait medallions, do not repeat decorative elements used on any known Loosdrecht services, suggesting that bells were conceived as individual pieces. They were probably intended for use at the dining table but not as part of dinner or breakfast services. The decoration of the Markus bell, with a monochromatic river scene painted against a white ground, is typical of many Loosdrecht bells, although polychrome scenes on white, with patterned grounds on the bell's shoulder are also found.[3] The lines of relief molding were sometimes gilded, whereas they have been left plain on no. 89.

Table bells had been a specialty of craftsmen in the Netherlands since the early seventeenth century, when they were produced by glass blowers in Antwerp.[4] Throughout the eighteenth century bells were made in silver, bronze, and other metals in the Netherlands. Although most silver examples were smaller and had straighter sides and more extensive relief decoration (including raised portrait medallions), they undoubtedly provided the models for porcelain bells.[5] Bells do not seem to have been made at the Weesp or Amstel factories, but German examples, part of writing sets, were decorated in the Hague.[6]

The Loosdrecht mark, M: O L, which represents the factory's legal name, Manufaktur Oude Loosdrecht, and coincidentally the surname of the owner, Johannes de Mol, is not often found in puce enamel as it is on the Markus bell. The three

letters are more commonly applied in underglaze blue and are frequently accompanied by an incised letter and number, probably indicating the workman. Puce enamel marks were not used exclusively with puce painting; they are also found on pieces decorated in other colors. The paste of no. 89 is finer and more translucent than that of the Loosdrecht bottles (no. 88), although its surface, as in the bottles, is speckled.

C.S.C.

NOTES

1. For illustrations of most of the Loosdrecht forms, see M.-A. Heukensfeldt Jansen and A.L. den Blaauwen, "Hollands en Duits porselein in kasteel Sypesteyn te Nieuw-Loosdrecht," *Mededelingenblad vrienden van de Nederlandse ceramiek,* no. 42 (March 1966), pp. 26, 33, 34, 38, 42.

2. Ibid., fig. 63, p. 38. For illustrations of other Loosdrecht bell forms, see D. Kighley Baxandall, "Dutch Porcelain," *Connoisseur* 53 (Jan.-June 1939), fig. 4, p. 259; L. Elsinore Springer, *The Collector's Book of Bells* (New York, 1972), figs. 123a,b, p. 78.

3. Springer, *Collector's Book of Bells*, fig. 123a, p. 78.

4. Ibid., fig. 134, p. 86.

5. For illustrations of eighteenth-century Dutch silver bells, see N.H. Gans and Th. M. Duyvné De Wit-Klinkhamer, *Dutch Silver,* trans. Oliver van Oss (London, 1961), fig. 125; Abraham C. Beeling, Leeuwarden, *Dutch Silver* 1600-1813, sale catalogue, published in conjunction with the exhibition "Fine Arts of the Netherlands," New York, Nov. 20-28, 1982 (Leeuwarden, 1982), p. 25.

6. Museum Willet Holthuysen, Amsterdam, *Het Nederlandse porcelein* (1952), fig. 250, illus.

90 Teabowl

The Netherlands, Loosdrecht, about 1780

Hard-paste porcelain decorated in puce and green enamel and gold

Marks:

(1) on base, in underglaze blue: M.O.L. with * below

(2) on base, incised: L 48 with * below

H. 4.9 cm. (1 15/16 in.), diam. at rim 7 cm. (2¾ in.)

103.1980

Provenance: Purchased, Amsterdam, 1966

The thrown egg-shaped teabowl is painted in puce enamel on a white ground. The central scene depicts two boys in a wooded, rocky landscape with part of a fence to their right. The boys, who appear to be dancing, both wear hats and are dressed

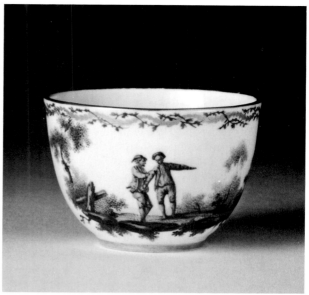

90

in long-sleeved jackets with shirts and knee-breeches. One boy holds the right arm of the other, whose left arm is extended to shoulder height. A tree, a fence, and some rocks are painted on the opposite side of the cup. The upper rim of the cup is gilded, and beneath this, above the painted scene, is a gold garland intertwined with a garland of green enamel. A small spray of similarly painted leaves decorates the bottom of the inside of the cup. The foot rim is decorated with a solid band of gold. The saucer is missing.

The decoration of this finely painted teabowl, like that of nos. 88 and 89, incorporates many of the characteristic features of Loosdrecht porcelain: wooded landscapes, a river view, one or more figures in the foreground, and painting in puce *camaïeu,* iron-red, or sepia against a white ground. Also characteristic of Loosdrecht, particularly of tea and coffee services decorated with monochrome landscapes, are the double garlands along the top of the teabowl.[1] The treatment of the trees on this teabowl, however, differs from that on the Markus bottles and bell. The painter has suggested spatial recession by a lighter tonality of puce in the background and a stippled brush technique. The intertwined garlands along the top edge of the teabowl are skillfully and carefully painted; a light layer of puce has been applied under the pale green enamel to give added richness to the decoration.

Although the production of porcelain began considerably later in the Netherlands than it did elsewhere in Europe, the wares made at Weesp, Loosdrecht, and Amstel show a remarkable

degree of originality. The success of the factories at Meissen and Sèvres provided the impetus for the foundation of many other porcelain factories; painters, modelers, and glaze and paste technicians from these firms frequently helped to establish the new factories in exchange for higher wages. Both the ceramists hired by Reverend de Mol to assist in the production of the first Loosdrecht porcelain had had experience elsewhere. Louis Victor Gerverot had worked as a painter at Sèvres, Ludwigsburg, Ansbach, Kassel, Fürstenberg, and Frankenthal before coming to the Weesp factory about 1768. Marchand had worked at the Tournai factory and, like Gerverot, came to Loosdrecht in 1770 after the close of the Weesp factory, where he had been a painter since 1764.

90 (1)

90 (2)

Despite their previous work, both these painters and the others employed by de Mol were not constrained by their previous training but created new styles of decoration. As at other European porcelain factories, the painted scenes on Loosdrecht porcelain, evident from the pieces in the Markus Collection, were inspired by the surrounding countryside. Although painting in the Chinese and Japanese manner was practiced at Loosdrecht, it was not used as extensively as at many other European factories, nor was it as sensitively interpreted or as skillfully executed as were the genre scenes. By 1774, when production began, painting imitative of oriental porcelain was less popular than it had been earlier in the century. Floral and landscape painting like that on this teabowl and related wares was more marketable. Although Loosdrecht tried to compete with the well-established factories and some of their painters had trained at those factories, their artistic borrowings were minimal. Colored grounds, for example, inspired by those used at the Sèvres factory, were applied to some Loosdrecht services, but the ground colors were much thinner and paler and slightly translucent.[2] Scenes were painted directly

on the ground colors rather than within white reserves with gold or polychrome framing. There was no attempt to incorporate gilding as part of the decorative scheme as was done at Sèvres and elsewhere. Although gilding was very frequently used on Loosdrecht wares, it was only for minor details such as small floral sprays or to accent rims; it was always applied thinly and was never tooled.

The Loosdrecht factory's production consisted primarily of services, both those for everyday use, with underglaze or enamel blue decoration, and more expensive services, to which no. 90 would have belonged, with camaïeu or polychrome enamel painting and gilding. As at Weesp, two different porcelain pastes were used, one with a yellowish tone and one, as in this teabowl, of a clear, bright white. A variety of marks appear on Loosdrecht porcelain. The factory's monogram, M.O.L., used in block letters and script, was applied in underglaze blue, enamel colors, or, rarely, in gold. Incised and painted stars like those on the Markus teabowl are frequently found in conjunction with the monogram, but their significance is unknown. Underglaze stars were sometimes applied singly, but only rarely were incised stars used alone. They do not seem to be indicative of a particular date or painter, nor were they used with any particular kind of decoration or form. It is possible that they were used with a specific paste.[3] The incised letter and numerals designate an unidentified workman; the same numerals appear on many Loosdrecht teabowls, cups, and plates. The fine quality of the paste and the decoration of the Markus teabowl suggest a date of about 1780, by which time the factory had been in operation for ten years and had considerably developed and refined the paste from that used for their earlier wares like nos. 88 and 89.

C.S.C.

NOTES

1. M.-A. Heukensfeldt Jansen and A.L. den Blaauwen, "Hollands en Duits porselein in kasteel Sypesteyn te Nieuw-Loosdrecht," *Mededelingenblad vrienden van de Nederlandse ceramiek,* no. 42 (March 1966), fig. 8, p. 25; Museum Willet Holthuysen, Amsterdam, *Het Nederlandse porselein,* Gemeente Musea Amsterdam, cat. 95 (1952), nos. 188, 193, illus.

2. Heukensfeldt Jansen and den Blaauwen, "Hollands en Duits porselein," fig. 5.

3. It has been suggested that stars were used on the finest pieces; see David Kighley Baxandall, "Dutch Porcelain," *Connoisseur* 103 (May 1939), 261.

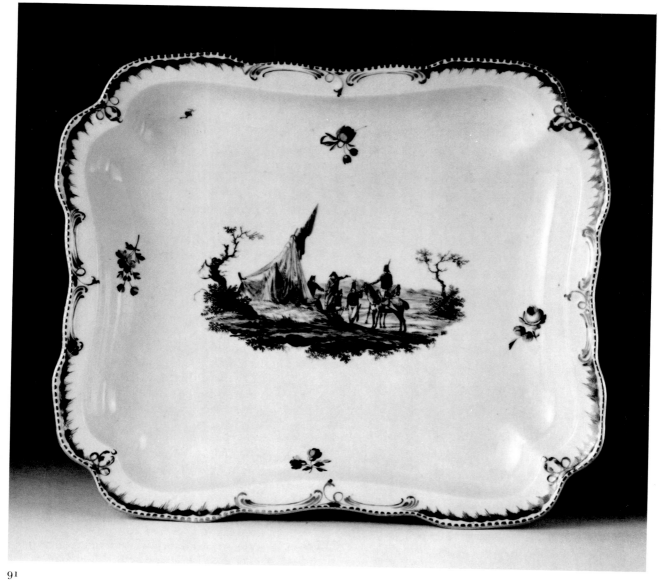

91

91 *Dish*

The Netherlands, Amstel, about 1785-1790

Hard-paste porcelain decorated in poly-
chrome enamels and gold

Marks:
(1) on base, in underglaze blue: Amstel;
 incised: script L 3 *; impressed: two
 vertical strokes
(2) on base, incised: script 4 ' 2

H. 4.4 cm. (1¾ in.), w. 26 cm. (10¼ in.),
d. 23 cm. (9¹/₁₆ in.)

1983.661

Provenance: Purchased, Amsterdam

*The molded, rectangular cushion-shaped dish has
a gently waved upper rim with indented corners
and a canted shoulder. In the center of the dish is a
scene, painted in puce camaïeu on a white ground,
showing five uniformed soldiers in front of a heav-
ily draped tent. The tent is situated on a small rise
overlooking a hilly landscape; at each side is a
scrubby tree. Two of the soldiers stand and gesture
toward the distant hills, and the other three are in
conversation, one sitting on the ground, one stand-
ing, holding a horse's bridle, and one mounted.
The two cavalrymen wear short jackets, white
breeches, and high hats; the other soldiers wear
longer coats and tricorn hats. Four puce flower
sprays are evenly placed around the central scene;
a single flower at the top left of the dish covers an*

imperfection in the glaze. The border, scalloped and scrolled in low relief above the shoulder, is painted in green enamel. The outer rim is decorated with a gilt dentil pattern.

The paste of this Amstel dish is similar to though not as fine as the best paste used by the Loosdrecht factory before it was moved to Ouder-Amstel in 1784; in color and translucency it resembles the Loosdrecht bell (no. 89). The paste of the teabowl, no. 90, by comparison, is bright white with fewer imperfections than this dish, which has a distinct yellow tone and several small, rust-colored imperfections. The change in paste may be attributable to kaolin of a different quality or a change in the porcelain recipe. The palette used for the decoration of the dish is also similar to that found on many Loosdrecht wares; the puce and green enamel colors are the same as those on the teabowl (no. 90), although puce was not applied under the green enamel on the dish as it was on the teabowl. Monochromatic painting does not seem to have been used as frequently at Amstel as it was at Loosdrecht, but since much less Amstel porcelain survives, it is difficult to judge whether the extant pieces are representative of the production. The painting of landscape and figural scenes in a single color probably derives ultimately from the Meissen factory, where it was used from at least 1730.[1]

The majority of Amstel's production consisted of coffee, tea, and chocolate services of varying size for daily use.[2] The Markus dish was originally part of one of the many dinner services made by the factory; it may have been used for vegetables and could well be one of a pair. Military subjects were frequently used as decoration on eighteenth-century porcelain and were usually adapted from seventeenth- or eighteenth-century paintings or prints. The scenes on porcelain seldom represent a particular battle, although the participants are occasionally identifiable by flags or specific uniforms. Ornamental pieces and small services for breakfast, coffee, or tea with generalized military scenes like that on this dish, however, were popular as gifts after a victorious battle (see the introduction to section XIII).

Very few pieces of Amstel with painting similar to that on no. 91 have survived. One notable example is a teapot, with a double scrolled handle, finely painted in polychrome with a scene of cavalry officers on rearing horses.[3] As on the Markus dish, the painting is against a white ground with no enclosing or supporting scrollwork or other borders. This type of porcelain painting was practiced throughout Germany and Holland at the end of the third quarter of the century.[4] The only framing devices used were trees or shrubbery placed on either side of the scenes. This was especially effective on the smooth-sided white porcelain forms made at Amstel since the painting was of a consistently high quality and was thus shown to best advantage. The majority of service pieces were decorated with small, randomly spaced flowers, extensive harbor, river, and village scenes, or birds amidst polychrome foliage. As at Loosdrecht, gilding was used only sparingly.

The form of this Markus dish, based on mid-eighteenth-century Dutch silver salvers,[5] was produced at Amstel with minor variations; some examples have no molded relief decoration around the rim, and others have molded flowers. The same kind of dish was also made with a straighter outer rim and a wider shoulder.[6] This form may have first been produced at Loosdrecht, but no marked examples or others with Loosdrecht-like painting are known. The molded relief pattern used around the top edge of the Markus dish, however, was used on Loosdrecht plates and serving dishes, which suggests the form may have originated at that factory.[7] By the mid-1790s Amstel had begun to produce neoclassical shapes. Although rococo molding like that on this dish was probably not completely abandoned, it is unlikely that this kind of form or decoration would have been popular in light of the more fashionable neoclassical wares being imported into Holland from Germany and France. At about the same time as the new wares began to appear at Amstel, the painting also underwent a change and became drier and less evocative than it had been earlier. The change is probably directly attributable to a change in personnel at this period, when most of the migrant workers, who were from Germany or had been trained there, had been replaced by Dutch workers, who were neither as specialized nor as skilled.[8]

<div align="right">C.S.C.</div>

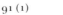

91 (1)

91 (2)

NOTES

1. Rainer Rückert, *Meissener Porzellan 1710-1810*, exhibition catalogue, Bayerisches Nationalmuseum, Munich (Munich, 1966), fig. 114, pl. 36.

2. W. J. Rust, *Nederlands porselein* (Schiedam, 1978), p. 138.

3. Museum Willet-Holthuysen, Amsterdam, *Amstelporselein 1784-1814*, *Mededelingenblad vrienden van de Nederlandse ceramiek*, nos. 86-87 (1977), no. 91, p. 65, illus.

4. Peter Wilhelm Meister and Horst Reber, *European Porcelain of the 18th Century*, trans. Ewald Osers (Ithaca, N.Y., 1983), p. 237.

5. J.W. Frederiks, *Dutch Silver: Wrought Plate of North and South Holland from the Renaissance until the End of the Eighteenth Century* (The Hague, 1958), fig. 412.

6. Museum Willet-Holthuysen, Amsterdam, *Amstelporselein*, no. 24, p. 52, illus.

7. M.-A. Heukensfeldt Jansen and A.L. den Blaauwen, "Hollands en Duits porselein in kasteel Sypesteyn te Nieuw-Loosdrecht," *Mededelingenblad vrienden van de Nederlandse ceramiek*, no. 42 (March 1966), figs. 26, 29, no. 30, illus. (color); H.E. van Gelder, "Een 18e eeuwse regent bestelde een eetservices," *Mededelingenblad vrienden van de Nederlandse ceramiek*, no. 18 (April 1960), fig. 9.

8. Museum Willet-Holthuysen, Amsterdam, *Amstelporselein*, p. 15.

XIII German Enamels

Much of the porcelain, faience, and glass produced in Germany during the eighteenth century is distinguished by the fact that its manufacture and decoration were often independent of one another. Enamel colors, which were painted on a previously fired surface and could be affixed at relatively low temperatures, were frequently applied to these wares by independent decorators known as *Hausmaler*. Although no painted enamels have yet been identified with known *Hausmaler*, the number and variety of eighteenth-century German painted enamels that have survived and that cannot be associated with known workshops strongly suggest the involvement of these independent craftsmen. The *Hausmaler*, who fired their wares in muffle, or low-fire, kilns, used the same sources and designs for the ceramics, enamels, and glass on which they worked and were thus responsible for many of the similarities in the decoration of these materials. The ceramics and painted enamel boxes and plaques decorated by the highly skilled *Hausmaler* were competing for much the same market as the ceramics and enamels decorated by the renowned painters employed by the established German workshops and factories. Painted enamels, however, probably had a slightly broader market since they were less expensive to produce than porcelain, particularly during the first half of the eighteenth century.

Berlin was the most prolific and influential center of enameling in Germany primarily because of the workshop that had been established there by Pierre Fromery (d. 1738) in 1668. The enamels are readily distinguishable, with molded gold or silver reliefwork against a white ground, often embellished with polychrome painting (see no. 92). Dresden, too, produced many enamels, no doubt as a result of the court workshops of artists such as Johann Dinglinger (1664-1731) and the proximity of the Meissen porcelain factory. A few signed and dated examples indicate that the numerous boxes commemorating various battles of the Seven Years' War (1756-1763) were made in Berlin and possibly the Dresden workshops. These boxes, however, are of less interest artistically than historically. Decoration usually consisted of battle plans, maps, or scenes depicting a particular victory for Frederick

the Great (1712-1786), himself an avid collector of enamel snuffboxes. Boxes bearing profile portraits of Frederick, with his monogram and French inscriptions (use of which was due to the king's preference for French), were also common during the mid-eighteenth century. Since these boxes served primarily as objects of propaganda, they were made as quickly as possible, even within a week of the date of a battle. Enamelers were also active during the early eighteenth century in Augsburg, where there had long been a tradition of fine metalwork. The enamels associated with Augsburg are of high quality, with polychrome painting often resembling that of Meissen porcelain.

There are few indications as to the manufacturing locations of most other German enamels. Many painted enamels were mounted for use in toilet services (for example, no. 92) or as tablewares and were unmarked, or their marks are not visible. Except for the politically inspired boxes discussed above, the origin of many of the enamel boxes made in Germany is unknown. Types of box decoration included portraits of well-known personalities against stippled grounds (similar to those found on porcelain boxes), and biblical, pastoral, mythological, and allegorical scenes. Boxes were also painted in imitation of playing cards, sheet music, and newspaper cuttings, or in the form of envelopes, and others bore scenes of *fêtes champêtres* after designs by Daniel Chodowiecki (1726-1801), an engraver and miniaturist who was court painter to Frederick. Many of Chodowiecki's engravings were later adapted for use on Berlin porcelain. The raised scrollwork and diaper patterns employed on many of these enamels were copied by the English enameling factories for their wares.

The production of German painted enamels had dwindled by the 1770s, when porcelain was more widely available and less expensive than it had been earlier in the century. The importation of English enamels to Germany during the second half of the century was also a factor in the decline of the German enamel industry. Transfer printing, which was invented in England and not used in Germany, allowed a more efficient means of production than hand-painting did and thus gave English enamels a commercial advantage over those made on the Continent.[1]

C.S.C.

NOTES

1. For discussions of eighteenth-century German enamels, in addition to the works cited in the notes for no. 92, see Clare Le Corbeiller, *European and American Snuff Boxes, 1730-1830* (London, 1966); Erich Steingräber, "Email," in *Reallexikon zur deutschen Kunstgeschichte,* vol. 5 (Stuttgart, 1967), cols. 49-52. There is still much research to be done, particularly on the work of the less prominent enamelers in Germany and the role of *Hausmaler* in the decoration of painted enamels.

92 *Pair of candlesticks*

Plate XXIII

Germany, Berlin, about 1725-1735

Probably workshop of Pierre Fromery (d. 1738)

Enameled copper with polychrome decoration and gold ; mercury-gilded copper mounts

Unmarked

92a: h. 14.6 cm. (5⁵⁄₁₆ in.), w. 9.9 cm. (3¹³⁄₁₆ in.), l. 12.1 cm. (4¾ in.); 92b: h. 14.5 cm. (5⅞ in.), w. 9.7 cm. (3⅞ in.), l. 12.4 cm. (4⅞ in.)

1982.783,784

The candlesticks are of shaped hexagonal form. Each is constructed of three pieces of copper, which have been enameled in white on the exterior and in blue on the interior and the underside of the base. The sections are joined by two mercury-gilded copper mounts. The deep socket has a slightly extended lip with small sprays of flowers in raised gold and polychrome painting. On each of the flat sides of the socket are raised gold portraits of two men, one bearded, within purple ovals. Beneath the portraits are green branches tied with purple ribbons. At one shaped, curved end is a raised gold depiction of Hercules with a shield and a club, and at the other end, Apollo seated holding a lyre, by a column with the three Muses (or Graces); the figures are on green grounds, flanked by tall flowering branches with raised gold flowers. The stem is of elongated, hexagonal shape with a protruding shoulder and tapered sides. On the sides of the shoulders are brown and yellow buildings on a green ground with trees, among which are raised gold trees and buildings. One end shows a raised gold figure of a winged putto carrying a

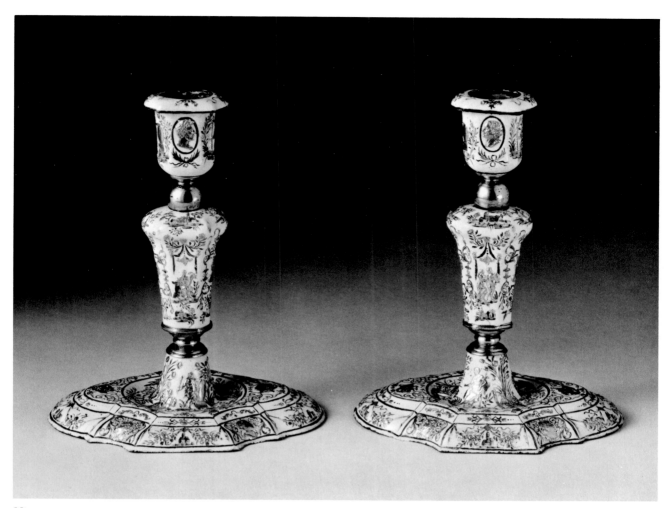

92

watering can and walking toward a small tree in which a bird sits. The other end depicts Leda and the swan, also in raised gold. Both scenes are framed by painted trees and branches on a green ground. One side of the stem has a raised gold figure of Ceres seated on a purple throne beneath a purple swag supported by small gold grotesque and lion masks and a painted branch with gold flowers. Beneath Ceres are a gold tree and a group of gold and painted buildings on a green ground. On the other side stand raised gold figures of Mars and Venus, also framed by motifs similar to those surrounding the figure of Ceres. The ends bear raised gold profile portraits of men in the classical style, one wearing a laurel wreath, the other a decorative helmet. They are framed by elaborate blue, purple, green, and gold baroque strapwork. Beneath the portraits are baskets of flowers in raised gold surrounded by painted flowers. The foot is richly decorated with raised gold figures. Around the base of the stem, clockwise from the front, are

Hercules with a shield and club, Mars and Venus, Perseus with the head of a Gorgon by a flaming altar, Apollo seated with a lyre by a column with the three Muses (or Graces), an enthroned figure of a winged man, possibly Jupiter, and Athena in armor. The figures stand on alternating green and yellow and red grounds. Painted branches bear raised gold tulips and sunflower-like blossoms. Profile portraits of two men in the classical style, one bearded, both facing the stem, are placed to the right and left of the base of the stem. They are surrounded by painted strapwork with gold tulips. Around the outer edge of the foot are alternating, raised gold, profile portraits of a draped goddess and a warrior goddess with a crayfish on the side of her helmet. The portraits are set against painted, diamond-shaped trelliswork in the four indented areas on the outer edge of the foot. The short sides and ends are painted with brown and yellow buildings between which are suspended raised gold and painted floral swags.

This pair of candlesticks was probably part of a woman's toilet service.[1] Its decoration and form are related to those of the Mecklenburg service in Hamburg (Museum für Kunst und Gewerbe), and four other services, in Munich (Schatzkammer, Residenz), Copenhagen (Rosenborg Castle), Warsaw, and Vienna (Museum für Kunst und Industrie).[2] These services vary in size; the Mecklenburg service, for example, contains thirty-one pieces, including a mirror, four pairs of boxes, perfume bottles, hair and clothing brushes, a pin cushion, a covered beaker, a pair of candlesticks, a pair of snuffers with a tray, a table clock, a tall ewer, a water basin and bowls, a covered soup bowl with stand, two small plates, and eating utensils, including egg and marrow spoons — all contained in the original tooled leather and red velvet-lined box with specially fitted compartments for each piece.[3]

Services designed primarily for personal grooming were first made in Italy during the sixteenth century, but it was at the French courts in the seventeenth century that the toilet service was first produced with groups of matching utensils and containers made of precious metals.[4] The earliest German toilet services, which date from about 1680, are almost exclusively the work of Augsburg silversmiths. Whereas early English and other European services were for cosmetic use, the Augsburg services were designed for eating and writing as well and were thus distinguished by a greater number and variety of pieces.[5] In contrast to the silver (or occasionally gold) services made in England and elsewhere in Europe, the Augsburg services were frequently made from a mixture of materials, such as enamel and silver gilt or copper or agate and silver.

The size and variety of objects contained in the Augsburg services were dictated by the customs of the aristocratic clients who commissioned or purchased such luxuries. The vogue, begun in France, for receiving visitors while dressing was manifested in the services by the inclusion of several cups for serving tea, coffee, or chocolate. Since breakfast, on the other hand, was generally eaten alone, services often contained eating utensils and wares for one person such as a soup bowl and an egg spoon. The water pitchers and basins were intended either for washing or for refreshing the hands and face with perfumed water. The numerous covered boxes were designed for both facial and hair powders, cosmetic pastes, hair pieces, and jewelry. Candlesticks such as the Markus pair would have been used to provide light for writing. They were generally accompanied by a pair of snuffers with a tray and a pair of scissors to trim the candles and wicks. A silver-gilt service of

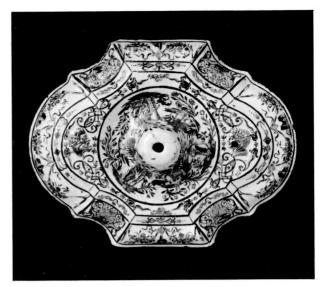

92b. *Detail of base*

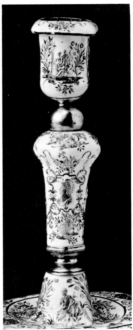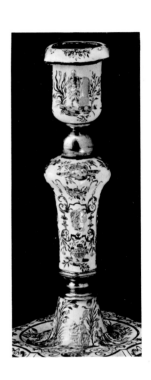

92 a, b. *Details of stems*

slightly later date also contains a third candlestick of different form,[6] known as a chamberstick, which was designed to be carried. Some services also included other writing aids such as inkwells, pounce pots, and quill holders.

Combined services of this type are frequently referred to as "traveling" services. Whether they were in fact transported between an owner's different residences is open to question, particularly in the case of services with decoration as elaborate as that on the Markus candlesticks.

Judging by the pristine condition of these candlesticks and of the Mecklenburg service and the box housing it, for example, it would seem that some services were designed for display, perhaps on festive occasions, rather than for travel.[7] Neither the enamel and gold on these pieces nor the delicate leather tooling on the exterior of the box could have withstood the rigors of travel. It seems that less fragile services would have been intended for travel and daily use.[8]

The services noted above also illustrate the tendency of the Augsburg makers to combine different materials. Enamels were used chiefly as inlays or medallions with silver or gilded copper. The candlesticks from these services are among the few objects made primarily of enamel. The forms used for the pieces to be mounted extensively with enamels, such as candlesticks, brushes, boxes, and beakers, were generally simplified adaptations of contemporary German silver. Some alteration of the rather ornate German baroque forms was made necessary by the nature of the enameling process itself, because decoration with enamel is achieved through painting rather than modeling or cold work such as chasing or engraving.

The concept of enameling with a white ground for a porcelain-like effect actually predates the discovery of porcelain in Europe at the end of the first decade of the eighteenth century.[9] Johann Melchior Dinglinger (1664-1731), court jeweler to Augustus the Strong (1670-1733) in Dresden, used this technique as early as 1697 on a gold coffee set.[10] He is also said to have applied gold over enamel on a centerpiece entitled *Life's Greatest Joys,* completed in 1728.[11] By the early 1720s enamel painting with relief applications was being practiced in Berlin as well as Augsburg.

The style, execution, and quality of the painting and applied gold reliefs of the Markus candlesticks strongly suggest they were made in the Fromery workshop in Berlin. The workshop was established by Pierre Fromery (d. 1738), a Huguenot goldsmith and gunsmith, when he left France and moved to Berlin in 1668. In addition to making enamels, he sold objects of iron, silver, virtu, glass, and porcelain.[12] The attribution of these candlesticks to the Fromery workshop is based on the similarity of the decoration to that of a group of signed enamels[13] and of the services mentioned previously.[14] Because signatures either by a workshop or by an artist are rare, identification of specific enamelers is difficult. Moreover, the Markus candlesticks, like many enameled objects, also lack monograms, crests, and other indications of the original owners.[15] This leads to the supposition that such services and individual pieces were not made exclusively as special commissions but were ordered from silversmiths or jewelers according to the size of the service desired.[16] Considering the labor and materials involved in the manufacture of each piece — requiring designers, mold makers, metalsmiths, enamelers, painters, and gilders — these services and individual pieces must have represented a substantial investment.

Approximate dating of enamel-mounted pieces like the Markus candlesticks is helped by comparison of the forms with marked silver services such as the one in Hamburg and a very similar silver-gilt service in the Schatzkammer of the Munich Residenz.[17] The silver on both of these services has been dated between 1720 and 1725, but it is likely that the kind of enamel decoration on the Markus candlesticks was used for several years.

Many of the gold reliefs on the enamels of pieces such as no. 92 were taken directly from coins and medals by Raymond Faltz (1658-1703) and Jan Boscam (active in Berlin 1703-1706), some of which were made for the Prussian court in Brandenburg at the beginning of the eighteenth century.[18] In addition to their use for toilet services, these medals and coins were the source of relief decoration on many Berlin enamels such as tobacco boxes, writing implements, and various objects of virtu. How the Berlin enamelers and the Fromery workshop in particular came into possession of these coins and medals or the matrices for them is not known. A partial explanation, though, has been found in two issues of the *Berliner Intelligenzblatt* of 1730 and 1731, which advertised for sale "some examples of molds of symbols and breast pieces from noble and other persons... some from the famous medalist Faltz."[19] If the molds were as readily available as this offer suggests, it is not surprising that Fromery and other Berlin workshops had access to them. It has been suggested that Pierre Fromery may have been responsible for cutting the stamps from the wax models of the Faltz medals, but there is no proof of this.[20]

The technique of applying these matrices onto enamel is not known in full detail. It is possible that they were first dusted with powder (to facilitate removal after molding), after which a thin layer of gold leaf was pressed into the mold, followed by a layer of enamel in paste form. When dry, the gold-faced enamel impression was removed from the matrix and applied to the hand-hammered copper object, which had already been coated with enamel and fired once. The polychrome painting seems to have been the final step,

but whether it was affixed in the same firing as the filled gold reliefs is not clear. It seems probable that the figural and floral reliefs were applied and fired after being gilded, since their gilding would have stabilized the detail of the reliefs.[21] It has been suggested that the gold reliefs (also known as paillons) were purchased from "pailloneurs"; a guild of pailloneurs evidently existed in Paris, and there may well have been others in Germany.[22] The same set of figural matrices was used for both of the Markus candlesticks, although the placement differs on the stem. The matrices seem to have been carefully selected, with objects of similar size and shape applied with proportionately sized figures. In contrast to the ancient Greek mythological subjects on the Markus candlesticks are the contemporary provincial motifs of the painting, which include farm buildings, peasants, and swag ornament much like those in the 1696 engravings of Johann Leonhard Eysler (master, 1697-1733).[23]

It is likely that several enamelers were responsible for the Markus candlesticks and the other service pieces discussed above. Of the enamelers who have thus far been definitively associated with the polychrome painting on Berlin enamels, Christian Friedrich Herold (1700-1779) was probably the most influential. Herold was born in Berlin and seems to have worked for the Fromery workshop before moving to Dresden in 1725 to work at the Meissen factory. Although Herold remained at Meissen as a painter until 1777, he continued to work on enamels for Fromery.[24] The style of decoration used on the Markus candlesticks certainly owes much to his influence, but in view of Herold's talents as a painter, it is likely that he would have been involved with only the most ambitious service pieces requiring extensive scenes (such as those on the plaque in the Victoria and Albert Museum, the covered box in Berlin (see note 24), and a covered beaker added slightly later to the Mecklenburg service). A box cover signed "F.G.V. fec.," the location of which is unknown, bears the same type of decoration as that on the Markus candlesticks. Identification of this artist might be of use in the attribution of some Fromery enamels. Although it is not possible to assign the Markus candlesticks to an individual enameler at the Fromery workshop, it is tempting to postulate that they may be from a service such as the one in Vienna, which is also mounted in gilt copper and lacks candlesticks.

C.S.C.

NOTES

1. I am most grateful to Charles H. Truman, assistant keeper, Department of Ceramics, Victoria and Albert Museum, who very generously provided me with an extensive bibliography and information regarding Berlin enamels. I would also like to thank John Herrmann, assistant curator, Department of Classical Art, Museum of Fine Arts, Boston, for identifying the figures on these candlesticks.

2. Walter Holzhausen, "Email mit Goldauflage in Berlin und Meissen nach 1700," *Der Kunstwanderer,* 1930-1931, pp. 4-12 and 78; "Neuerwerbungen des Grünen Gewölbes zu Dresden," *Der Kunstwanderer,* 1925-1926, p. 232; Erich Meyer, "Museum für Kunst und Gewerbe: Neuerwerbungen 1946-49," *Jahrbuch der Hamburger Kunstsammlungen* 2 (1952), 105-113.

3. For complete descriptions and measurements of each object, as well as the names of the silversmiths who worked on the service, see Museum für Kunst und Gewerbe, Hamburg, *Bildführer II: Ausgewählte Werke aus den Erwerbungen während der Jahre 1948-1961: Festgabe für Erich Meyer* (1964), fig. 109.

4. Bernhard Heitmann, "Das Mecklenburgische Toilette-Service," Museum für Kunst und Gewerbe, Hamburg, *Europa,* MKG 3.10 (1980).

5. Ibid.

6. Christie's (International), Geneva, May 12, 1983, lot 137, pp. 64-65.

7. Heitmann, "Das Toilette-Service." The author notes that the only wear on this service occurs where the flame from the candles has worn some of the decoration on the candlesticks and on the undersides of some objects where they would have been placed on a table.

8. Ibid.

9. Holzhausen, "Email mit Goldauflage," p. 4.

10. Joachim Menzhausen, *The Green Vaults,* trans. Marianne Herzfeld (Leipzig, 1970), figs. 96-97.

11. Holzhausen, "Email mit Goldauflage," p. 4. For an illustration of this piece, see Menzhausen, *The Green Vaults,* figs. 102-103.

12. Kunstgewerbemuseum, Berlin, *Europäisches Kunsthandwerk vom Mittelalter bis zur Gegenwart: Neuerwerbungen 1959-1969,* fig. 88.

13. Holzhausen, "Email mit Goldauflage," p. 8.

14. It has been suggested that the enamels on the Mecklenburg service were made in Augsburg, but more evidence is needed to reassign the origin of these enamels; see Augsburg Rathaus und Holbeinhaus, *Augsburger Barock* (1968), p. 315.

15. One exception is a Fromery tobacco box with decoration similar to that of the Markus candlesticks, which is enameled with the initials FWR (Friedrich Wilhelm Rex). See Kunstgewerbemuseum, Berlin, *Europäisches Kunsthandwerk,* fig. 89.

16. Meyer, "Neuerwerbungen 1946-49," p. 105, notes that the five services mentioned all seem to come from noble houses but thinks they may have been sold as finished garnitures. Heitmann, "Das Toilette-Service," on the other hand, states that the Augsburg jewelers planned with the commissioner the design, size, and materials for a service, as well as details of specific ornaments, indicating that services were not ready-made.

17. Museum für Kunst und Gewerbe, Hamburg, *Bildführer II,* fig. 109; Herbert Brunner, *Schatzkammer der Residenz München, Katalog,* 3rd ed. (1970), figs. 815-827, p. 305.

18. Meyer, "Neuerwerbungen 1946-49," p. 106.

19. Ibid.

20. Ibid.

21. I am grateful to Dr. Lambertus van Zelst, director, Research Laboratory, Museum of Fine Arts, Boston, for examining the Markus candlesticks and suggesting the technique outlined here.

22. Charles Truman, assistant keeper, Department of Ceramics, Victoria and Albert Museum, made this suggestion in a letter.

23. Holzhausen, "Email mit Goldauflage," pp. 4-5.

24. Whether Herold worked on these enamels at Meissen or in Berlin during this time is not known, but his continued relationship with the Fromery workshop is proved by the signatures "Alex. Fromery a Berlin" and "Herold fecit" on the reverse of a flat, painted enamel plaque of about 1734 now in the Victoria and Albert Museum. See "Acquisitions in the Department of Ceramics at the Victoria and Albert Museum, 1981-82," *Burlington Magazine* 35 (May 1983), 290. Enamel boxes from the Fromery workshop signed "Herold a Meissen," suggest Herold may have worked on some enamels for Fromery while resident at Meissen. For illustrations of these and discussions of Herold's association with the Meissen factory and the Fromery workshop, see Hugh Tait, "Herold and Hunger," *British Museum Quarterly* 25 (March 1962), 39-41; Otto Seitler, "Email und Porzellanmalereien des Christian Friedrich Herold," *Keramos,* no. 6 (1959), pp. 20-26 (lists enamels signed by Herold); Franz-Adrian Dreier, "Zwei Berliner Emailplatten aus der Zeit Friedrichs des Grossen," *Jahrbuch der Hamburger Kunstsammlungen* 3 (1958), 137-144; Sotheby Parke Bernet, London, sale catalogues, Oct. 16, 1979, lot 4; May 24, 1981, lot 19.

XIV English Enamels

The beginnings of England's painted enamel industry in the mid-1740s correspond to those of its porcelain industry. The manufacture of both enamels and porcelain was begun in response to the success of those industries on the Continent, especially in Germany and France. As in the early porcelain industry, several enameling factories were established within a few years of one another, all as privately funded business ventures. The centers of the English enameling trade were in London (in small workshops and at the York House factory at Battersea), Birmingham, Wednesbury and Bilston (in South Staffordshire), and Liverpool. In both London and Liverpool the decoration of enamels and ceramics was done by some of the same artists. Enamels, however, were far less expensive to produce, and the industry was supported by a growing middle class that was unable to afford porcelain and precious metalwork.

The enameling process allowed the simultaneous production of hundreds of undecorated enamel "blanks," which could be easily stored. Decoration in the most current style along with inscriptions and dates could then be applied to as many pieces as needed. The invention of the transfer print in England during the first quarter of the eighteenth century revolutionized the speed with which enamels could be decorated and was certainly that country's most important contribution to the industry. Snuffboxes constituted a large percentage of English enamel manufacture and were particularly well suited to transfer-printed decoration. Painted German porcelain (see nos. 46-51) and enamel snuffboxes had become necessary accoutrements of fashionable eighteenth-century society, and many were imported into England during the first half of the century. Their decoration often served as inspiration for English boxes (see discussion at no. 98). Unlike their German counterparts, English porcelain factories produced few boxes, which may have contributed to the success of the English enamel box trade.

As the number of factories increased, the range of enamel objects grew to include useful tablewares such as candlesticks, tea caddy sets, sweetmeat dishes, mustard pots, salt cellars, and entire toilet services with boxes of varying sizes, inkstands, scent bottles, and *étuis*. A large number of

small, frivolous enamel trinkets were also made. These came to be known as "toys," a term evidently derived from the word "tye," meaning a small metal box. Many enamel tablewares like the Markus tea caddy (no. 93) were made in the most up-to-date forms inspired by contemporary English silver.

In the manufacture of English porcelain, different paste recipes were used at each factory (see introductions to sections VIII -X), but the basic materials and techniques (other than color recipes) for enamels were more standardized. This uniformity often makes dating and identification of factory and maker difficult. The earliest examples of eighteenth-century painted enamels in England can be found on gold boxes and watch cases into which enameled gold or copper panels were set. From the beginning of the century these were decorated in the workshops of London goldsmiths and jewelers; the painters probably received training from several Parisian and Swiss miniaturists working in London who specialized in this kind of enameling.

There is increasing evidence that the earliest English objects made entirely of enameled copper were produced in Birmingham in the early 1740s. By the mid-eighteenth century Birmingham had become, in the words of Edmund Burke, "the great toyshop of Europe" and was the home of one of the largest and best-known factories of gilt-metal and enamel toys in England, owned by John Taylor (1711-1775). The theory that Birmingham was preeminent in the enamel industry from an early date is strengthened by the discovery that the first patent application for transfer printing on enamels was made from there in 1751. The patent was requested by John Brooks (about 1710-about 1756), an Irish mezzotint engraver who may have been an associate of John Taylor. The early transfer-printed enamels attributed to Birmingham (see no. 96) often have a plain white ground, or one that is sometimes lightly overpainted in translucent enamel pigments. They are also characterized by accomplished flower painting on white grounds and extensive landscapes with classical ruins (like nos. 94 and 95). The variety and, at times, great subtlety of the palette on Birmingham enamels were not equaled elsewhere in England. The city also seems to have been the chief supplier to the English enamel trade of gilt-metal mounts, some of which may have been made by the firm of the famous industrialist Matthew Boulton (1728-1809). By 1759 nearly twenty thousand people were employed by the Birmingham enamel trade. Many of the enamels were specially designed for export to the Continent and to Russia. In Ger-

many, where transfer prints were not used, the importation of these mass-produced wares was partly responsible for the decline of the enamel industry.

The enamels made in Birmingham for export included boxes with printed calendars, portraits of popular personalities, song lyrics, and inscriptions. Subjects inspired by engravings after the works of French and Flemish painters, including Boucher, Watteau, Lancret, and Berchem, were also a mainstay of Birmingham production, and all these wares were equally suitable for both the English and the Continental markets. Many of the transfer prints used at Birmingham were designed by Simon François Ravenet (1706-1774), Robert Hancock (about 1730-1817), James Gwyn (after 1700-1769), and John Brooks. These engravers have traditionally been associated with the York House factory of Battersea in London, but there is now evidence that the first transfer prints made from their engraved copperplates were used on Birmingham enamels. Some of the same transfer prints were used to decorate Bow and Worcester porcelain.

The wares of the York House factory, commonly known as Battersea, which opened in 1753, were limited to decoration with transfer prints. The outstanding quality of the transfers distinguishes them from later Birmingham examples. Battersea transfer prints were at times overpainted in translucent colors to enhance the printed decoration, whereas Birmingham transfers frequently required overpainting in heavier pigments to strengthen the printed image. The superiority of Battersea transfer printing may have been due to the influence of John Brooks, who left Birmingham to become a partner in the Battersea factory. The majority of transfer prints on Battersea enamels were of mythological subjects, usually printed in pale monochrome colors, but two-color printing was also used at this factory. In 1756 the factory was declared bankrupt, and many of its copperplates were purchased and reused by Birmingham factories. Unmounted Battersea-printed lids were also purchased and affixed to painted Birmingham boxes.

Like the Battersea factory, the Liverpool Printed Ware Manufactory limited its decoration of enamels to transfer prints. The firm was owned by John Sadler (1720-1789) and Guy Green (active 1756-1799), who, like John Brooks, claimed credit for the invention of transfer printing and also tried, without success, to obtain a patent. It is probable that the factory purchased its copperplates and equipment from the sale of the Battersea factory in 1756, since only a short time later they began printing enamels and tin-glazed earthen-

ware tiles. The Sadler and Green medallions and plaques, which may have been made elsewhere, were decorated chiefly with portraits printed in brown and black against white grounds.

The London workshops, where some of England's earliest enamels were made, continued to be an important source of painted enamels for many years. Fewer enamels were produced there than in the enamel factories, but the quality of those which survive, like the Markus tea caddy (no. 93) reflects the skill of the painters and the unusual care taken with each object, features that were neither possible nor desirable in a commercial factory. The enamels thus far attributed to the London workshops are, with few exceptions, hand-painted; transfer prints seem to have been used very rarely. The style of some of the flower painting in particular is close to that on Chelsea porcelain and suggests that some painters decorated both enamels and porcelain. Mounts from the London workshops were among the finest used on English enamels and were often double-gilt and elaborately chased.

The South Staffordshire towns of Bilston and Wednesbury were, after Birmingham, the most prolific manufacturers of painted and transfer-printed enamels. The enameling trade in this closely knit industrial region was composed primarily of families whose apprenticeship system was similar to that used in the Birmingham factories. It is possible that each workshop was responsible for a different aspect of manufacture, much like the division of labor practiced at many of the Staffordshire potteries. The South Staffordshire enameling trade, though traditionally associated with French craftsmen, does not seem to have employed foreign specialists, and their enamels often have a rather provincial character. As in Birmingham, enameling in this area began during the 1740s; an extraordinary variety of wares and toys were made there, including small souvenir boxes with short inscriptions and others in the form of animal and human heads inspired by Continental porcelain examples. Raised white diaper and trellis patterns, often gilded, probably originated in Wednesbury and Bilston, and transfer prints heavily overpainted in opaque colors are also associated with these towns.

Many similarities exist between the enamels produced in Birmingham and those of Bilston and Wednesbury, making attribution difficult. No factory or mount marks were used, and artists' signatures are extremely rare. In both centers the transfer print was used as a cost-effective aid to mass production. The inferior quality of transfer-printed enamels from South Staffordshire and later examples from Birmingham, however, allows them to be distinguished from Battersea and early Birmingham wares. Early enamelers like John Brooks were sufficiently proud of their transfer prints to request that they "not be spoil'd, by…the Hands of unskilful Daubers."[1]

By the end of the eighteenth century the market for English enamels had dwindled considerably. Porcelain and other ceramics had become less expensive and more widely available. In addition, the export market on the Continent was closed to English manufacturers owing to the Napoleonic wars. The technology that had allowed the English enamel industry to grow so rapidly eventually led to a dissipation of artistic standards that caused its decline.[2]

C.S.C.

NOTES

1. Eric Benton, "John Brooks in Birmingham," *English Ceramic Circle Transactions* 7, pt. 3 (1970), 162.

2. This introduction is based on the following sources: Bernard Watney and Robert J. Charleston, "Petitions for Patents Concerning Porcelain, Glass, and Enamels with Special Reference to Birmingham, 'The Great Toyshop of Europe'," *English Ceramic Circle Transactions* 6, pt. 2 (1966), 57-123; Eric Benton, "The Bilston Enamellers," *English Ceramic Circle Transactions* 7, pt. 3 (1970), 166-190; Eric Benton, "The London Enamellers," *English Ceramic Circle Transactions* 8, pt. 2 (1972), 137-163. For a discussion of enameling techniques used in England during the eighteenth century, see Susan Benjamin, *English Enamel Boxes from the Eighteenth to the Twentieth Centuries* (London, 1978), pp. 29-37.

93 Tea caddy

Plate XXIV

England, probably London, about 1755-1760

Enameled copper with polychrome decoration; tooled gilt-metal mounts

Unmarked
H. 12.7 cm. (5 in.), diam. at base 6.5 cm. (2⁹/₁₆ in.)

1982.785 a,b

Provenance: Purchased, New York

The baluster-shaped body of the tea caddy is spirally lobed in three sections with a domed circular foot. The circular domed and stepped cover is mounted with a rim of gilt metal, machine engraved with a pattern of wavy lines. The top rim

93

93. *Cover*

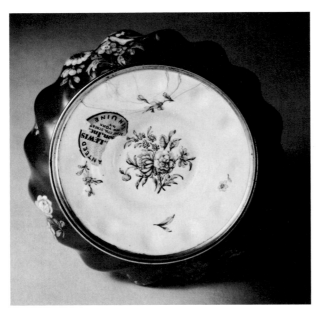

93. *Base of tea caddy*

of the caddy is similarly mounted, and the inside of the rim is faceted and scalloped. The foot is mounted with a thin band of gilt metal with a scalloped edge. The exterior of the tea caddy and cover is decorated with a thick layer of apple-green enamel over white. Two large bouquets of flowers, including roses and tulips, are painted on opposite sides of the caddy in soft shades of pink, yellow, blue, orange, and puce with yellow-green foliage. Smaller bouquets and individual sprays of flowers decorate the rest of the body and the foot. A butterfly and a dragonfly are also included in the painted decoration. Another large bouquet and a ladybug are painted on the cover. The undersides of the foot and the cover are also painted with flowers on a white ground. The interior of the tea caddy is enameled in white.

For much of the eighteenth century, London was a leading center of the English enameling trade. Beginning with the production and decoration of enamel dial plates for watches and clocks in the first years of the century, the London enamel industry soon grew to include all manner of "very proper ornaments for the cabinets of the curious,"[1] including portrait miniatures, plaques, and various objects of virtu. It is evident from several eighteenth-century accounts that snuffboxes and other enamel toys and wares were made in the same workshops as the clock and watch dials.[2] A trade card from the mid-1760s belonging to James Goddard, a London goldsmith, advertised "Watch Cases, Snuff Boxes and Curious work in Gold" and "Dial Plates of all sizes for Clocks and Watches."[3] Enamelers like Goddard probably worked on a variety of objects made throughout the city. Some portrait painters are known to have painted snuffboxes,[4] and others decorated pottery, porcelain, and glass.

 The enamel painters were closely allied with other fine metalworkers and jewelers and numer-

ous specialized artisans working in the city who were renowned for the quality of their work. They had the advantage of a wealthy and sophisticated clientele appreciative of skilled craftsmanship. Familiar with gold boxes and other luxury objects from the Continent available for purchase in London, these patrons and the growing middle class created a market for readily available and less expensive English enamels. A notice in *The London Tradesman,* published in 1747, mentioned that the London enameling trade was "very profitable; a good Workman may have almost any price for his work, and a Journeyman may earn Thirty to Forty shillings a week if he is good for anything."[5]

This tea caddy is related in form, style, and quality to a group of small enamel boxes that are most probably of London manufacture.[6] The sides and covers of most of these boxes are radially lobed or "corrugated" in a manner similar to that of the tea caddy.[7] The exteriors of the boxes are painted with flowers in the same palette and style as the Markus tea caddy on solid grounds of dark blue, yellow, white, or green. The interiors have additional floral sprays, French inscriptions, or mirrors. The gilt-metal mounts of all these pieces are skillfully executed and fitted, some with the "diamond-chain" pattern,[8] and rope-twist handles associated with London manufacture. Most of the mounts are dentated and scalloped like those on the Markus tea caddy and are also "double-gilt,"[9] a process that was used on many London enamel mounts to ensure the longevity of the gilding.

The Markus tea caddy is part of a group of enamels that appear to be painted by the same hand. The group includes a toilet casket in the James A. de Rothschild Collection at Waddesdon Manor, a small, oblong box with a double, centrally hinged lid, and a pair of tea caddies of the same form as the Markus tea caddy and with identical mounts.[10] All are painted with polychrome floral decoration against a solid ground color; the casket and box have the same green ground color as no. 93, and the pair of tea caddies a turquoise ground. The decoration on the casket and Markus caddy includes ladybugs and butterflies, almost certainly the painter's symbols.[11]

Some of the features of the groups of enamels mentioned above are also common to some products of the Chelsea porcelain factory. Shared characteristics include accomplished polychrome flower painting, finely executed mounts, decoration of the undersides and interiors, dark blue and yellow ground colors, and French inscriptions on the interiors.[12] It has been suggested that some Chelsea painters also worked on enamels, or that the enamel lids on some Chelsea boxes were painted in the workshops of London jewelers, who mounted and sold the finished pieces.[13]

The form of the Markus tea caddy is taken from English silver of the 1750s. Samuel Taylor, a London silversmith (mark entered 1744), made numerous tea caddies and sugar bowls of similar baluster shape,[14] which were often sold in groups of three in specially fitted velvet-lined cases, as were many enamel tea caddies. The Markus caddy was almost certainly one of a pair, but it is not known whether it was made *en suite* with another tea caddy or a sugar bowl, as were silver and some enamel caddies.

Enamel tea caddies of comparable but less pronounced baluster shape, but without lobing, were also made.[15] Painted with floral bouquets on a white ground, these are based on the same silver form and are probably of London manufacture as well. Some finely painted and mounted tea caddies with floral decoration have been attributed to Birmingham,[16] but the possibility of London manufacture should not be discounted.

The high quality of the painting, enameling, and mounts on no. 93, the use of a solid ground color, and the similarity to Chelsea porcelain — all suggest that this caddy was manufactured in a London workshop between about 1755 and 1760.

C.S.C.

NOTES

1. Bernard Rackham, "Porcelain as a Sidelight on Battersea Enamels," *English Porcelain Circle Transactions,* no. 4 (1932), p. 48.

2. Eric Benton, "The London Enamellers," *English Ceramic Circle Transactions* 8, pt. 2 (1972), 145.

3. Susan Benjamin, *English Enamel Boxes from the Eighteenth to the Twentieth Centuries* (London, 1978), p. 54.

4. Benton, "London Enamellers," p. 143.

5. R. Campbell, *The London Tradesman, Being a Compendious View of all the Trades…in the Cities of London and Westminster* (London, 1747), p. 187.

6. Benton, "London Enamellers," pls. 95c, 96, 97b, 99a,b; Bernard Watney, "English Enamels in the 18th Century," in *Antiques International: Collector's Guide to Current Trends,* ed. Peter Wilson (New York, 1967), figs. 16, 17; Therle and Bernard Hughes, *English Painted Enamels* (Feltham, Eng., 1967), fig. 50 (right); Mary S. Morris, *A Catalogue of English Painted Enamels, 18th and 19th Century, in the Wolverhampton and Bilston Collections* (Wolverhampton, 1973), no. EM 75; Robert J. Charleston and Donald Towner, *English Ceramics 1580-1830* (London, 1977), fig. 244, color pl. 16; Benjamin, *English Enamel Boxes,* fig. 4, p. 51; Sotheby Parke Bernet, London, sale catalogues, May 24, 1976, lot 99, illus.; April 25, 1977, lot 136, illus.; June 17, 1980, lot 18, illus.; Feb. 2, 1982, lot 54, illus. Eric Benton was the first to publish pieces of this type as London; see *Gilt-Metal and Enamel Work of the 18th Century,* exhibition catalogue (Leamington, Eng., 1967), pp. 18-19, nos. 86-92. Benton discusses these and other pieces at greater length in "London Enamellers," pp. 137-139, 146.

7. Eric Benton has suggested that such corrugations were intended to prevent distortion during the firing, although it seems equally plausible that they were decorative; see "London Enamellers," p. 138.

8. Ibid., pl. 97a.

9. The "double-gilt" process was mentioned in the 1756 sale notice of the Battersea enamel workshop at York House; see Rackham, "Porcelain as a Sidelight on Battersea Enamels," p. 48.

10. For the casket, see Robert J. Charleston, "Painted Enamels Other than Limoges," in *The James A. De Rothschild Collection at Waddesdon Manor: Glass and Stained Glass; Limoges and Other Painted Enamels* (Fribourg, 1977), fig. 53, p. 464, color pl. p. 465; for the oblong box, *Antique Collector* 55, no. 6 (June 1984), p. 51, illus. (color); for the pair of tea caddies, Christie's, London, sale catalogue, Oct. 18, 1983, lot 96, illus. I am grateful to Ellenor M. Alcorn, curatorial assistant, Department of European Decorative Arts and Sculpture, Museum of Fine Arts, Boston, for bringing the box and tea caddies to my attention.

11. The photographs of the oblong box and the pair of tea caddies do not show these symbols, although they might well be included in the decoration of both. For another group of enamels with butterflies and insects as painter's symbols, see Benton, *Gilt-Metal and Enamel Work,* nos. 100-110.

12. Benton, "London Enamellers," pp. 139-140.

13. Herbert Read, "Cross-Currents in English Porcelain, Glass, and Enamels," *English Porcelain Circle Transactions,* no. 4 (1932), p. 9. Although mounts were a specialty of Birmingham, it seems likely that the many skilled and experienced metalsmiths in London could have provided local enamelers with mounts; see Benton, "London Enamellers," p. 150.

14. See Arthur Grimwade, *Rococo Silver, 1727-1765* (London, 1974), pl. 68b.

15. Benton, "London Enamellers," fig. 100a.

16. Howard Ricketts, *Objects of Vertu* (London, 1971), p. 44.

94 *Box*

Plate XXV

England, probably Birmingham, about 1755-1760

Enameled copper with polychrome decoration; metal mounts with traces of gilding

Unmarked

H. 8.3 cm. (3¼ in.), w. 21 cm. (8¼ in.), d. 13.7 cm. (5⅜ in.)

1982.786

Purchased: New York, 1956

The rectangular box has a domed cover decorated with a polychrome pastoral scene. The scene shows several shepherds engaged in various pursuits, framed on the left by trees and on the right by a pedestal supporting a covered urn next to a par- *tially ruined wall. In the foreground, in front of the pedestal and wall, an elegantly dressed couple converse. The man is seated on what may be a fallen pedestal, which supports a large basket and a cloth. To the couple's left are two cows. Behind the cows, in the center of the scene, a woman wearing a full-length dress sits on the ground in front of a boy. In front of them and to their sides are two goats, two cows, and six sheep. In the left foreground a shepherd leans on a cow. In front of him and to his right are four sheep, a goat, and a donkey laden with draped baskets. In the left background a man riding a donkey and another walking behind a donkey move toward a small body of water, accompanied by a dog and a cow. On the far shore is a small tower and beyond it another body of water bordered by jagged cliffs, near which is a sailboat. To the right of the water are numerous trees and bushes, which serve as a backdrop for the central scene. To the right stand the ruins of an overgrown classical portico, and beyond is a building whose walls are surmounted by a balustrade. In the sky are billowing clouds and numerous birds. The back, front, and sides of the box are decorated with asymmetrically arranged floral bouquets on a white ground. The larger bouquets at the center are tied with bowed ribbons. The bottom features small floral sprays around a large purple flower, probably an iris, with three green leaves and a blue bowed ribbon. The interior of the box is enameled in white. The gilt-metal mounts are horizontally ribbed, and the thumbpiece is scalloped and ridged.*

During the eighteenth century, Birmingham, like London, was an important source of finely painted and mounted enamels. Birmingham had long been a manufacturing center of considerable significance, particularly in the field of metalwork, before its enameling industry became well established. Enameling began there perhaps as early as 1741 (thus predating that at York House in Battersea)[1] and grew rapidly enough for Edmund Burke to dub Birmingham "the great toy shop of Europe." The scope of the toy trade is indicated in *Sketchley's Birmingham Directory* of 1767: "These Artists are divided into several Branches as the Gold and Silver Toy Makers, who make Trinkets, Seals, Tweezer and Tooth-Pick cases, Smelling Bottles, Snuff Boxes and Fillegree Work, such as Toilets, Tea Chests, Inkstands &c. &c ... and almost all these are likewise made in various metals."[2] Many of the copper blanks and gilt-metal mounts used for the boxes and other enamel toys decorated elsewhere in England were made in Birmingham. During the second half of the eighteenth century,

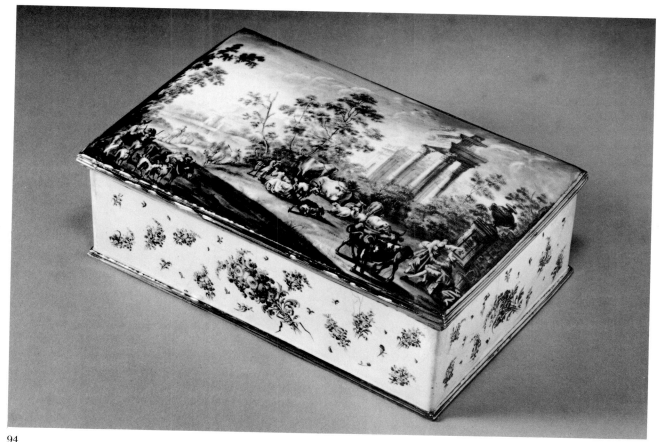

94

at least six firms of enamelers, four individual ena-
melers, and four enamel-button manufacturers
were operative in Birmingham.[3] By 1755 John
Taylor (1711-1775), the leading Birmingham toy
maker, employed five hundred people.[4]

The division of labor at Taylor's factory and
other Birmingham enamel workshops certainly ac-
counted for some of the success of the industry in
that city; such production techniques were no
doubt borrowed from other branches of metal-
work manufacture. Before the use of enamels be-
came widespread, Birmingham had, for many
years, produced small gilt-metal boxes with en-
graved and chased decoration.[5] These boxes often
incorporated mother-of-pearl, tortoise shell, horn,
and gemstones, which required specialized equip-
ment that was later used for enameling. Originally
serving as one of these secondary materials, en-
amel was used for overall decoration by about
1745.

The Markus painted box belongs to one of
several distinct groups of Birmingham enamels
made in the second half of the eighteenth century.
Although its specific use is not known, it was prob-
ably made as part of a toilet service and would have

been accompanied by at least two small boxes, like
no. 95, with similar decoration. A pair of small cir-
cular boxes may also have been part of the service.[6]

A large number of boxes are known with
decoration very similar to that of no. 94 and of
approximately the same size. Their covers are
painted in the same palette as that of the Markus
box, with pastoral landscapes including shepherds,
animals, and, more often than not, classical ruins.[7]
The sides and bases of the boxes are painted with
naturalistic flowers like those on the Markus box,
and the mounts are also comparable.

The decorative scheme of the Markus box
and related pieces is almost certainly derived from
a group of enamel plaques and boxes transfer-
printed with *fêtes champêtres* after Watteau,
Boucher, and Lancret. These pieces include the
well-known boxes and plaques of the *Swan
Group*,[8] distinguished by two swans in the fore-
ground painting, and the *British Fishery* plaque,
made in about 1751.[9] Both the *Swan Group* and
the *British Fishery* plaque are based on engravings
after paintings by Watteau, and both inspired
other Birmingham enamel painters.[10] The boxes
and plaques are painted in the same manner as the

94. *Cover*

94. *Base of box*

Markus box; the sides of the boxes are decorated with similar but more elaborate flowers on a white ground or with additional transfer prints.

The scene on the cover of the Markus box is undoubtedly based on an eighteenth-century print, but the source has not been found for it or for many of the related boxes. These boxes are either painted or transfer-printed, and although the same overall scene does not seem to have been used twice, details are repeated on some painted boxes, indicating a common print source.[11] The group on the left of no. 94 of two shepherds, a cow, and a dog facing a small body of water with buildings on the far shore is repeated with only minor variations on a box in the Bilston collection.[12] Some of the figural subjects may be based on engravings of *Pastorales* after Boucher,[13] but other details such as the animals on this entire group of boxes are more reminiscent of the work of Nicholas Berchem (1620-1683), a Flemish painter whose animals and pastoral landscapes in the Italianate manner were the source of over four hundred engravings by various artists. These prints were well known and widely circulated in England during the eighteenth century and were used by English publishers for model books for craftsmen, such as

Robert Sayer's *The Compleat Drawing Book,* first published in 1758,[14] which were used extensively by enamel painters.[15] (See nos. 96 and 97.)

C.S.C.

NOTES

1. Eric Benton, *Gilt-Metal and Enamel Work of the 18th Century,* exhibition catalogue (Leamington, Eng., 1967), p. 4; Robert J. Charleston, "Battersea, Bilston — or Birmingham?," *Victoria and Albert Museum Bulletin* 3 (Jan. 1967), 7-8.

2. Kenneth Crisp-Jones, ed., *The Silversmiths of Birmingham and Their Marks: 1750-1980* (London, 1981), p. 13.

3. Bernard Watney and Robert J. Charleston, "Petitions for Patents Concerning Porcelain, Glass, and Enamels, with Special Reference to Birmingham, 'The Great Toyshop of Europe,' " *English Ceramic Circle Transactions* 6, pt. 2 (1966), 82.

4. Ibid., p. 64.

5. Eric Benton discusses the relationship between gilt-metal and enamel boxes, with particular reference to those made in Birmingham; see *Gilt-Metal and Enamel Work,* pp. 3-4.

6. See Sotheby Parke Bernet, London, sale catalogue, May 24, 1976, lot 65, p. 29.

7. For comparable boxes see Sotheby Parke Bernet, London, sale catalogues, May 3, 1949, lot. 49, illus.; May 27, 1963, lot 162, illus.; Feb. 1, 1965, lots 342-343, illus.; Oct. 9, 1967, lot 111, illus.; May 18, 1970, lot 50, illus.; Victoria and Albert Museum, London, *Catalogue of English Porcelain, Earthenware, Enamels, and Glass Collected by Charles Schreiber...,* vol. 3: *Enamels and Glass,* by Bernard Rackham (1924), no. 3, pl. 7 (hereafter cited as Victoria and Albert Museum, London, *Schreiber Porcelain);* Egan Mew, *Battersea Enamels* (London, 1926), fig. 66; Bernard Watney, "English Enamels in the 18th Century," in *Antiques International: Collector's Guide to Current Trends,* ed. Peter Wilson (New York, 1967), fig. 12.

8. Watney and Charleston, "Petitions for Patents," frontis., b (color), pls. 88, 89, 90b, and 117a. For a color illustration of the last, see Susan Benjamin, *English Enamel Boxes from the Eighteenth to the Twentieth Centuries* (London, 1978), p. 8.

9. Watney and Charleston, "Petitions for Patents," pl. 71b; Watney discusses the attribution of this plaque to Birmingham on pp. 66-67 and 87, and Charleston on pp. 90-91. See also Charleston, "Battersea, Bilston — or Birmingham?," pp. 3-4.

10. Watney and Charleston, "Petitions for Patents," pls. 73a,d, 76, 77, 91-95; Sotheby Parke Bernet, London, sale catalogue, May 24, 1976, lot 117, p. 44, illus.

11. Benton, *Gilt-Metal and Enamel Work,* no. 18, p. 9. Although scenes do not seem to be repeated in their entirety on this group of enamels, they are repeated on other groups. See Victoria and Albert Museum, London, *Schreiber Porcelain,* vol. 3, no. 8, pl. 16; Sotheby Parke Bernet, London, sale catalogues, Feb. 22, 1977, lot 276; Nov. 22, 1977, lot 165.

12. Mary S. Morris, *A Catalogue of English Painted Enamels, 18th and 19th Century, in the Wolverhampton and Bilston Collections* (Wolverhampton, 1973), no. BI 403, illus.

13. See, for example, Victoria and Albert Museum, London, *Schreiber Porcelain,* vol. 3, no. 3, p. 15.

14. Anthony Ray, "De Animalia von Berchem in de Engelse schouw," *Antiek* 10, no. 8 (March 1976), 804.

15. Berchem's prints also provided the source of decoration for eighteenth-century European ceramics; see Grand Palais, Paris, *Faïences françaises, XVIe-XVIIIe siècles* (1980), fig. 464, p. 296.

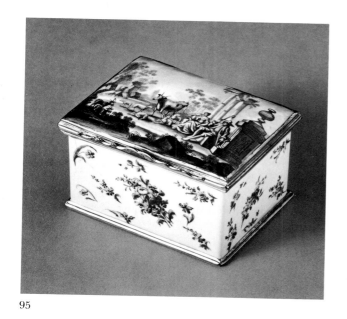

95

95 (1)

water from the animals is a waterfall amid tall rocks. A windowed tower and some trees are visible at the far end of the river. In the foreground, on the opposite bank of the river, are two goats and an outcrop of rocks overgrown with foliage. The interior of the box is enameled in white. The gilt-metal mounts are horizontally ribbed, and the thumbpiece is scalloped.

95 Box

England, probably Birmingham, about 1760

Enameled copper with polychrome decoration; gilt-metal mounts

Mark:
(1) on base, in pink enamel: shell (?)

H. 6.3 cm. (2½ in.), w. 7.3 cm. (2⅞ in.), l. 9.4 cm. (3¹¹⁄₁₆ in.)

1983.663

Published: Sotheby Parke Bernet, New York, sale catalogue, May 16, 1959, lot 208.

Provenance: Coll. Thelma Chrysler Foy; purchased, New York

The rectangular box has a domed cover decorated with a polychrome pastoral scene. The sides are painted with polychrome floral sprays on a white ground. A pink shell is painted at the center of the white base. The scene on the cover shows a shepherd and shepherdess seated on a river bank in front of the ruins of an overgrown classical portico and to the left of a decorated brown pedestal supporting a purple urn. The barefoot shepherd wears a yellow shirt, blue breeches, a red coat, and a brown hat. He holds a long staff in his right hand. The shepherdess, who plays a small clarinet (?), wears a full-length blue dress and a yellow smock. To the couple's right stands a large rust-colored cow, surrounded by five sheep. Across the

This box may well be from the same Birmingham workshop as no. 94. The painting of the lid of no. 95, however, by a less accomplished artist, indicates a date slightly later than that of the previous example. No. 95, too, is undoubtedly from a toilet service and was probably one of a pair.[1] The scene on the cover indicates a print source related to that of no. 94, but the subject here of a shepherd couple, one playing an instrument, is much more common.[2] Although the style of painting on the cover and sides of this box is more abbreviated, the palette, composition, large scale of the figures and animals in the foreground, and absence of a patterned ground all indicate a Birmingham origin. Comparable subjects were used to decorate boxes made in Bilston and Wednesbury, but those boxes are of a decidedly different character.[3]

The predominance on English enamels of scenes based on European prints may be due in part to the number of French artists working in the enameling trade. In a speech before the House of Commons in 1759, John Taylor (1711-1775), the most prominent Birmingham enamel merchant (see no. 94), reported: "there are two or three Drawing Schools established in Birmingham, for the Instruction of youth in the Arts of Designing and Drawing, and thirty or forty Frenchmen are constantly employed in Drawing and Designing."[4] These artists may have been partly responsible for introducing the engravings of shipping, classical ruins, and Italian ports that were frequently used as the sources for enamel panels that are related to the Markus box covers. The panels were set into enamel boxes and japanned toilet

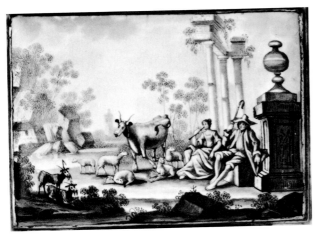

95. *Cover*

boxes.[5] Japanning, a method of varnishing, painting, and gilding iron to look like oriental lacquer, was a speciality of Birmingham.

These panels, which date from the mideighteenth century, are all hand-painted with the same attention to detail and sense of perspective as the Markus boxes, many with tall ruins, urns, and pedestals in the foreground and smaller, faintly painted buildings in the distance. The rushes and other vegetation in the foregrounds of the panels painted with scenes of ruins are quite similar to those on the Markus boxes. When these panels with Italian port scenes were used for the covers of enameled boxes, the side panels were painted, as on the Markus boxes, with floral bouquets against a white ground, but the flowers were more elaborate and botanically accurate, featuring groups of large individual blossoms.[6] Pastoral scenes like those on the Markus boxes do not seem to have been used on any japanned boxes, nor were they used in conjunction with the more elaborate floral decoration. A clear distinction was obviously made in the Birmingham workshops between the more ambitious scenes of Italianate ports and classical ruins and the pastoral scenes. It is possible that boxes like nos. 94 and 95 were intended for the domestic market and the others were exported to the Continent.

An additional reason for attributing to Birmingham the enamel plaques with Italian port and ruin scenes and, by association, the Markus boxes is provided by several small boxes whose enamel lids are painted with similar subjects.[7] The bodies of these boxes are made of gilt metal, shell, mother-of-pearl, and chased silver, which indicate a Birmingham manufacture.[8]

An enamel box in the British Museum (95 5.21, 22) that was obviously made for the domestic market provides some help in dating the Markus box and others with similar decoration. The cover of the British Museum example is painted with a scene quite similar to that on the cover of no. 95. The inscriptions on the sides of the former commemorate the British defeat of the French at four significant battles of 1759, during the Seven Years' War (1756-1763). The inscription on the base reads: "Long live the King." Judging by the inscriptions, the box must have been made between November 1759 and October 25, 1760, when George II died.

The significance of the small pink shell painted on the base of no. 95 is not known. It is rather crudely painted and is unrelated to the painting on the rest of the box; perhaps it is the symbol of the artist responsible for the box. Some other English enamel boxes have painted shells isolated either on the base or inside the box;[9] these were formerly thought to indicate a Battersea origin.[10] The boxes are now attributed to Birmingham, but it is not possible to say whether the shells and scrolls are for identification or decoration.[11]

C.S.C.

NOTES

1. See Sotheby Parke Bernet, London, sale catalogues, Feb. 1, 1965, lot 344, illus.; Nov. 29, 1976, lot 199, illus.

2. See, for example, F.J.B. Watson and Carl C. Dauterman, *The Wrightsman Collection*, vol. 3: *Furniture, Snuffboxes, Silver, Bookbindings* (New York: The Metropolitan Museum of Art, 1970), no. 48, p. 220; Sotheby Parke Bernet, New York, sale catalogue, May 5, 1984, lot 46, illus.

3. Therle and Bernard Hughes, *English Painted Enamels* (Feltham, Eng., 1967), figs. 31, 32; Sotheby Parke Bernet, London, sale catalogue, Feb. 2, 1982, lot 47.

4. Hughes, *English Painted Enamels*, p. 79.

5. Ibid., fig. 71. For a discussion of the Birmingham japanning trade, see Bernard Watney and Robert J. Charleston, "Petitions for Patents Concerning Porcelain, Glass, and Enamels with Special Reference to Birmingham, 'The Great Toyshop of Europe,' " *English Ceramic Circle Transactions* 6, pt. 2 (1966), 110-111. For an illustration of this kind of scene on enamel panels in japanned boxes, see Sotheby Parke Bernet, London, sale catalogue, June 16, 1981, lots 26, 27, illus.

6. Hughes, *English Painted Enamels*, fig. 17; Watney and Charleston, "Petitions for Patents," frontis. (color).

7. Watney and Charleston, "Petitions for Patents," pls. 114, 115.

8. See Eric Benton, *Gilt-Metal and Enamel Work of the 18th Century*, exhibition catalogue (Leamington, Eng., 1967), p. 3.

9. Mary S. Morris, *A Catalogue of English Painted Enamels, 18th and 19th Century, in the Wolverhampton and Bilston Collections* (Wolverhampton, 1973), no. BI 402, text p. 47, illus.

10. Bernard Rackham, "Porcelain as a Sidelight on Battersea Enamels," *English Porcelain Circle Transactions*, no. 4 (1932), p. 55.

11. Single rococo scrolls were sometimes placed on the base of some metal boxes with Birmingham enamel lids, but these seem to serve a purely decorative function; see Watney and Charleston, "Petitions for Patents," pl. 111c.

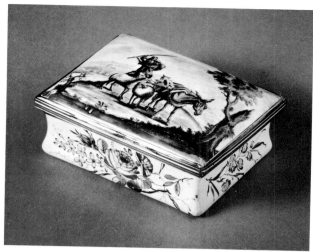

96

96 Snuffbox

England, probably Birmingham, about 1755-1760

Enameled copper, transfer-printed, with polychrome decoration; gilt-metal mounts

Unmarked

H. 4 cm. (1 9/16 in.), w. 6.3 cm. (2 ½ in.), l. 8.3 cm. (3 ¼ in.)

1983.662

Provenance: Purchased, New York, 1955

The rectangular box has a domed cover and waisted sides. The cover and the upper rim of the box are mounted with metal bands that show traces of gilding near the plain thumbpiece affixed to the center of the mount on the cover. The mounts are hinged along the back of the box; those around the cover are impressed with a series of raised lines. The cover of the box is decorated with a transfer print showing a barefoot shepherd with his flock. He is dressed in a blue shirt, red breeches, and a black hat, and carries a red sack on his back. The shepherd raises a long stick over his head to urge along the three sheep and a donkey standing in front of him. On the donkey's back are two panniers that hold several lambs. The group stands on the right bank of a river; in the left foreground is a stump, and on the right stands a brown tree with a broken trunk and a branch with green and brown foliage. The foreground below the tree is brown; that on the rest of the bank is yellow with green and brown overpainting. A man stands on the opposite bank facing the bridge at the far end

of the river. A building with an attached tower is visible beyond the bridge, and a hill rises in the distance. The sky is filled with pale blue and lavender clouds. The front edge of the cover is painted with a dark blue band. The front and back of the box are painted with large flowers in rose-pink, blue, and yellow with red outlining and green foliage edged in red. The sides and base are painted with smaller blue and yellow flowers with similar foliage. The interior of the box is enameled in white.

Hand-painted flowers and pastoral scenes on enamels like nos. 93, 94, and 95, though typically English in style and execution, are closer to German and French enamel and porcelain boxes in conception. More characteristic of English decoration and one of England's most significant contributions to enamel and porcelain decoration, is the use of transfer prints like the one on the cover of this snuffbox. The process involves coating an engraved copperplate with printer's ink that sinks into the engraved lines and is wiped off the smooth surface of the plate. A print of the engraving is made by pressing a piece of paper onto the surface of the plate, thereby transferring the image of the engraved lines to the paper. The paper is then applied to the surface of the object to be decorated and is fired in a muffle, or low-fire, kiln until the image is transferred onto the enamel.

Transfer printing may have been invented by the Irish designer and mezzotint engraver John Brooks (about 1710-about 1756), soon after his arrival in England.[1] Brooks presented three unsuccessful petitions for transfer-printing patents, the earliest of which was made from Birmingham in September 1751.[2] That he was actively engaged in commercial transfer printing in Birmingham the following year is known from an advertisement in the local newspaper offering to print waiters (small salvers) for the trade.[3] Despite several other accounts attesting to the activity of the enameling trade in Birmingham,[4] it is not possible to definitively assign any enameled boxes to that city before 1780.[5] At least one Birmingham factory, that owned by John Taylor (1711-1775), continued to transfer print enamels after John Brooks's departure for London (to manage the York House factory at Battersea in 1753), but no enamels can be attributed to Taylor's factory or to any individual enamelers.

The attribution of the Markus box to Birmingham is made on the basis of its similarity in decoration to other boxes assigned to Birmingham manufacture, one of which is dated 1755,[6] as well as its difference from those associated with London and the other South Staffordshire enameling

centers of Bilston and Wednesbury. The flowers on the base of this box, painted in a naturalistic manner and palette and set against a plain white ground, resemble those on many circular and rectangular snuffboxes associated with Birmingham. The clear rose-pink, blue, and yellow with red outlines are also characteristic of floral painting on Birmingham enamels of this style and period.[7] The transfer print, like many of the others in this group, occupies the entire surface of the lid. The combination of the transfer-printed lid painted in this manner and the type of floral decoration on the base of the box is another feature that relates it to Birmingham. The lack of other ornamentation, such as colored or diapered grounds, scrolling, or raised patterning, is also typical of early wares of this origin.

96. *Cover*

The subject of the transfer print used for this box, *Shepherd Driving the Herd,* is taken from Jan de Visscher's (1636-1692) engraving after Nicholaes Berchem's (1620-1683) *Diversa animalia quadrupedia.*[8] The overpainting has been carefully done, with no attempt to hide the transfer print, as was often the case with later boxes and those made elsewhere in South Staffordshire. Once again, the palette is naturalistic and subdued, and the enamels have a translucency like that found on other boxes thought to have been made in Birmingham in the late 1750s.[9] The subjects of transfer prints used for this group of boxes include other pastoral scenes, as well as harbor scenes and seated lovers amid classical ruins. Although many of the engraved copperplates used at York House, Battersea (where transfer prints were the only form of decoration), were purchased for use on Birmingham enamels after the bankruptcy of the York House factory in 1756, the plate used for no. 96 would not have been one of these. The subjects chosen for the Battersea boxes were more ambitious and were taken from better-known prints. These included mythological, classical, allegorical, and religious themes, royal portraits, and emblems. The translucent pale blue and lavender clouds are also characteristic of this early Birmingham group.

Many of the enamels produced in England were exported to the Continent, Ireland, and Russia, markets of considerable importance to Birmingham enamelers. John Taylor reported to a Select Committee of the Commons in 1759 that he planned to export five hundred thousand pounds' worth of enamel toys that year.[10] Pastoral scenes after Nicholas Berchem like the one on the Markus box were not only well suited to English taste but would also have been popular on the Continent, where Berchem's works were better known.

C.S.C.

NOTES

1. Brooks reportedly left Dublin and settled in London in 1746; see Bernard Rackham, "Porcelain as a Sidelight on Battersea Enamels," *English Porcelain Circle Transactions,* no. 4 (1932), p. 60. Although Brooks is often cited as the inventor of transfer printing, there is as yet no proof of this. There is little doubt, however, that he was one of the first to practice transfer printing on enamels and ceramics. As early as 1786, Brooks's name was associated with the invention; see Bernard Watney and Robert J. Charleston, "Petitions for Patents Concerning Porcelain, Glass, and Enamels with Special Reference to Birmingham, 'The Great Toyshop of Europe,'" *English Ceramic Circle Transactions* 6, pt. 2 (1966), 60-61. William Turner has credited Simon François Ravenet (1706-1774) with the invention of transfer printing; see *Transfer Printing of Enamels, Porcelain and Pottery: Its Origin and Development in the United Kingdom* (London, 1907), p. 49. Reconsideration of Turner's attribution to Ravenet has been suggested by Eric Benton; see "The London Enamellers," *English Ceramic Circle Transactions* 8, pt. 2 (1972), 160. Benton has also suggested that Stephen Theodore Janssen (d. 1777), one of the founders of the York House factory in Battersea, may have invented the process; see "Some Eminent Enamellers and Toy-Makers," *English Ceramic Circle Transactions* 10, pt. 2 (1977), 120.

2. Brooks's other petitions were made in 1754 and 1756. He claimed to be able to transfer print on enamel, glass, earthenware, and porcelain; see Watney and Charleston, "Petitions for Patents," p. 78. The fact that Brooks's petitions were unsuccessful suggests that the transfer-printing process was already known and being practiced elsewhere.

3. Eric Benton, "John Brooks in Birmingham," *English Ceramic Circle Transactions* 7, pt. 3 (1970), 162.

4. Watney and Charleston, "Petitions for Patents," pp. 63-64, 70-71. See also the entry for no. 94 in this catalogue.

5. Benton, "London Enamellers," p. 140.

6. Watney and Charleston, "Petitions for Patents," pls. 77, 116a-c, 120, 122.

7. Ibid., p. 116 and pl. 116a.

8. F. W. Hollstein, *Dutch and Flemish Etchings, Engravings and Woodcuts, ca. 1450-1700,* vol. 1 (Amsterdam, 1949), p. 279, no. 376. I am grateful to David Becker, assistant curator, Department of Prints, Drawings, and Photographs, Museum of Fine Arts, Boston, for identifying this subject.

9. Watney and Charleston, "Petitions for Patents," p. 116.

10. Kenneth Crisp Jones, ed., *The Silversmiths of Birmingham and Their Marks: 1750-1980* (London, 1981), p. 15.

97 Toilet box

England, possibly Birmingham, about 1765

Enameled copper decorated in rose, with stamped gilt-metal mounts

Unmarked

H. 13 cm. (5⅛ in.), w. 15.3 cm. (6 in.), l. 22.5 cm. (8⅞ in.)

1983.666

Provenance: Purchased, New York

The rectangular box with white ground has convex sides and a slightly domed cover. Each of the four sides and the cover are painted with a pastoral scene in rose monochrome within a reserve. The reserves are framed by raised white curvilinear scrolls, and the white ground surrounding the reserves on the sides, cover, and base is decorated with a raised diaper pattern. The panels are joined by stamped gilt-metal mounts, and the cover is hinged along the back edge. The scene on the cover shows a barefoot shepherdess with a spindle in her left hand. She converses with another woman, who is seated on a horse and gestures with her left hand. A donkey and a cow stand before the conversing couple, and another cow stands behind the horse. This central grouping is framed by landscape elements. In the foreground are rocks and bushes; to the left stands a sparsely foliaged tree, and to the right is an outcrop of jagged rock. Behind these rocks is a hillock from which grows a tree, and in the distance are buildings in the neo-classical style. The front panel depicts a shepherdess riding a donkey. To her right, a shepherd guides three sheep over some rocks. Another sheep stands to the right below the donkey's head. In the right foreground is an outcrop of large rocks. In the left foreground is the end of a stone wall, and beyond it are three arches and a building in ruins. In the right background is a cluster of towers. On the rear panel a barefoot shepherdess wearing a long dress and holding a basket tends a flock of goats and sheep. A goat lies in the left fore-ground near some grass and rocks. The ruins of a stone building are in the left background, and to the right a group of buildings can be seen in the distance at the foot of some hills. To the right a river extends into the distance, where a fawn can be seen on the bank. The proper right side of the box shows a barefoot herder seated on the edge of a rocky promontory with one leg tucked under him. He is dressed in a long-sleeved shirt and vest with knee-breeches and a hat. He turns toward a dog seated next to him, presenting his back to the viewer. Behind the dog and to the right of the tree is a long-horned goat. The left background is occupied by some buildings and trees on a rocky hill. On the proper left side of the box a peasant wearing a hat drives a donkey heavily laden with cloth-covered baskets up a hill toward the viewer. The scene is framed by a partially dead tree rising from some rocks. In the distance is a farmhouse.

The concave base is covered by the raised trellis pattern except at the center, which is occupied by an asymmetrical cartouche formed of elements similar to those framing the narrative reserves on the sides and cover. Within this cartouche the same diaper trellis pattern is repeated on a smaller scale. The interior is enameled in white.

This large enamel box offers a good example of the hand-painted enamel decoration that was used before and concurrent with transfer printing. This method must have been more time-consuming and considerably more expensive than transfer printing; thus its use on a large box, where it might be more obvious and appreciated, is understandable. The painting, however, is somewhat deceptive, as it has the appearance of an overpainted transfer print. The short, repeated parallel lines of the brushwork resemble printed graphic illustration. The monochrome rose palette is also reminiscent of graphic illustration as well as English transfer-printed enamels from Battersea and Birmingham and other South Staffordshire workshops. Monochrome transfer printing, which was much more common than monochrome painting, was often used without the relief decoration like that on this box. Such relief is generally thought to indicate a date after the close of the Battersea factory in 1756.[1]

On English enamels puce and rose or brick red were the most frequently used colors for monochrome painting against a white ground; they had long been popular on Continental porcelain and were used on some English porcelain as well. Painting *en camaïeu* was frequently used for boxes, tea-caddy sets, hot-water jugs, and bread

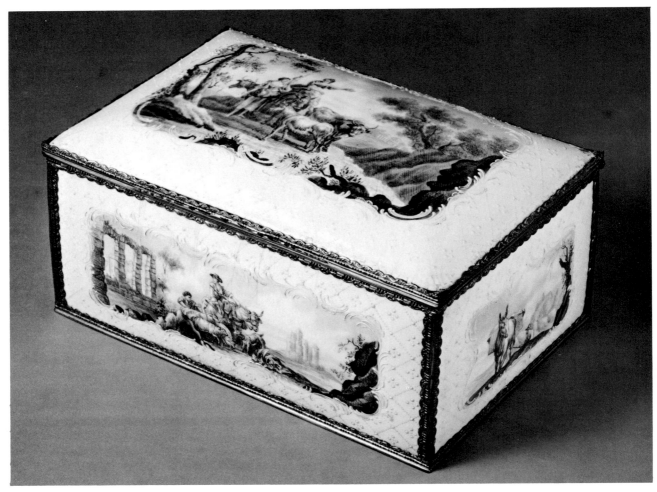

97

baskets. Transfer prints in these colors against white were often enriched by additional hand-painting in a darker shade of the same color, giving greater depth to the design. The combination of these pigments and white, whether used in conjunction with smooth surfaces or scrolled and raised dot patterning, was one of the most effective and appealing decorative schemes on English enamels.

The subject of the painting on the cover of no. 97 is from an engraving after Nicholaes Berchem (1620-1683), a well-known Dutch painter. The image on the back of the box is also taken from an engraving after Berchem.[2] The other scenes are almost certainly after Berchem subjects but have not yet been identified. For a discussion of the use of Berchem subjects on English enamels, see no. 94. The type of pastoral scene used on this Markus box was not as popular on English enamels as were scenes painted in polychrome showing small figures and animals amidst classical ruins, like those on nos. 94 and 95. The scale of the painting on no. 97 is particularly unusual. The figures and animals are less crowded than on most Birmingham or other South Staffordshire painted enamels, and they are much larger in relation to their natural surroundings. The conception of the box as a whole, however, is quite similar to that of a large box attributed to Birmingham, which is transfer-printed in puce from plates used at the York House factory in Battersea between 1753 and 1756. The reserves on the box are surrounded by raised, white enamel decoration very similar to that on the Markus box.[3]

Large boxes like no. 97 were presumably made as toilet boxes and might have been part of a set. Boxes of this size were also sometimes fitted to hold writing implements or as containers for sets of two tea caddies and a sugar canister, which were decorated in the same manner as the boxes themselves. This box was probably made as a part of a toilet service since it lacks handles, locks, and the necessary interior fittings for other containers or implements.

The accomplished painting suggests a relatively early date. The mounts, however, though skillfully made, are not of the same high quality as the painting and, together with the raised enamel decoration, indicate a date in the mid-1760s.

C.S.C.

NOTES

1. Bernard Watney and Robert J. Charleston, "Petitions for Patents Concerning Porcelain, Glass and Enamels with Special Reference to Birmingham, 'The Great Toyshop of Europe,'" *English Ceramic Circle Transactions* 6, pt. 2 (1966), 68.

2. F.W. Hollstein, *Dutch and Flemish Etchings, Engravings and Woodcuts, ca. 1450–1700*, vol. 1 (Amsterdam, 1949), p. 279, no. 378. I am grateful to David Becker, assistant curator, Department of Prints, Drawings, and Photographs, Museum of Fine Arts, Boston, for suggesting Berchem as a source for the decoration on this box.

3. Watney and Charleston, "Petitions for Patents," pl. 6ob.

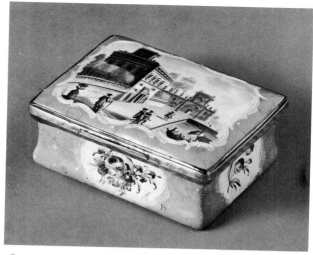

98

97. *Cover*

97. *Side of box*

97. *Back of box*

98 Snuffbox

England, probably Bilston or Wednesbury (South Staffordshire), about 1765

Enameled copper, transfer-printed, with polychrome decoration; engraved metal mounts

Unmarked

H. 4.4 cm. (1 11/16 in.), w. 7 cm. (2¾ in.), l. 9.1 cm. (3⅜ in.)

1983.664

Provenance: Purchased, New York, 1957

The rectangular box has a domed cover and waisted sides. The cover and the upper rim of the box are mounted with metal bands that are hinged along the back of the box. The mounts on the cover are machine-engraved with a pattern of wavy lines; a small metal thumbpiece, also engraved, is affixed at the center of the mount on the front of the box. The box is enameled with a dark pink ground over a layer of white enamel. A pattern of raised, white dotted trelliswork with large dots at the intersection and center of each square is painted over the pink ground. A white reserve bordered with white scrollwork occupies the center of each side and the bottom of the box. The reserves on the front and the back are painted with large bouquets of puce, yellow, blue, and purple flowers with green foliage. The reserves on the sides and bottom of the box are decorated with individual sprays of purple, puce, and yellow flowers with green foliage.

The white reserve on the cover is also bordered with white scrollwork. Within the reserve is

98. *Cover*

a transfer print of an Italianate quay scene. On the left is a brown and puce building flanked by walls, above which appear rows of trees with green, orange, and yellow foliage. Beyond this building to the right stands another building, painted gray-blue; a pale green quay runs in front of both buildings. Several people walk on the quay, some conversing, others carrying baskets and pails. In the water near the quay is a brown gondola carrying several people and bearing a puce flag. The interior of the box is enameled in white.

Snuffboxes decorated in the manner of nos. 98 and 99 have traditionally been associated with the South Staffordshire towns of Bilston and Wednesbury, situated three and a half miles from one another and about ten miles from Birmingham. Like Birmingham, both towns had been active in the metalworking trades for many years before the growth of the enameling industry. The earliest use of enamels seems to have been for the lids of brass or other boxes of base metal, whose mounts were also made in that area. Just as it is not yet possible to attribute any Birmingham enamels to a particular factory, knowledge of the enameling business in these two towns is not sufficient to assign any pieces to specific shops or factories there.

Although it is probable that painted enamels had been produced in Bilston and Wednesbury from the 1740s, the earliest known record of a named enameler in Bilston dates from 1770, when that town's first trade directory was published.[1] It is likely, however, that enamelers were listed as japanners, painters, toy makers, snuffbox painters, or box painters. Enamelers do not seem to have referred to themselves as such until fairly late in the eighteenth century. The Wednesbury Register of Apprentices listed Hyla Holden (1723-1766), a

well-known enameler, as a "box-maker" in 1748, a "box-painter" in 1752, and an "enambler [*sic*]" in 1763.[2] From the end of the third quarter of the century, sources like the Register of Apprentices and parish registers provide the names of enamelers and apprentices and give some indication of the scope of the trade in Bilston and Wednesbury. Unlike the industry in Birmingham, the enameling trade in these communities seems to have been organized around a family network to which nearly all enamelers belonged.[3] It is possible that the small, predominantly family-owned firms in Bilston and Wednesbury may each have specialized in a different aspect of enamel manufacture such as metal mounts, copper lids, and bases.

The enamels produced in this region varied greatly in quality, in contrast to those made in London, which attracted some of the best craftsmen, many of whom were employed by gold- and silversmiths. Both hand-painted and transfer-printed boxes were made in these towns, but the emphasis on mass production favored the use of transfer prints, which were often overpainted, sometimes heavily, in opaque enamels. In general, the enamels associated with this region were less skillfully painted, with a harsher palette and more elaborate raised scroll and diaper patterning, than enamels made in London and Birmingham. Mounts were not as finely chased or gilded and seldom appear to have been double-gilded like those made in London (see no. 93). Emphasis seems to have been on volume and rapid execution.

Italianate harbor scenes based on seventeenth- and eighteenth-century engravings were frequently used as decoration for Bilston, Wednesbury, and Birmingham enamel panels and the lids of enamel and japanned boxes. The transfer print on this Markus box is taken from an engraving by Melchior Küssel (1626-about 1683) after a drawing by Johann Wilhelm Baur (about 1600-after 1641).[4] Baur, a native of Strasbourg who was known primarily for his miniature paintings and watercolors, lived in Italy from 1631 to 1637. After Baur's death, Küssel acquired several hundred of his drawings, from which he made numerous prints that he assembled and published in an album entitled *Iconographia*.[5] The first edition appeared in 1670, and subsequent editions in 1671, 1682, 1686, and 1702.[6] Among the illustrations in the *Iconographia* are Italian coastal views of Naples, Genoa, Venice, Leghorn and Ancona, including the scene on this box.

A closer link between this series of engravings and English enamels may be indicated by the signature "I. de bois" or "Du bois" on a series of English engravings of Neapolitan harbor scenes

copied from a Dutch edition of the *Iconographia*.[7] An Isaac Debois is listed in local Staffordshire records as apprenticed to a clock maker in Darlaston, and an Isaac du Bois is listed as a "chaser" in London in 1741. The scenes on some English painted enamel panels are based on these English engravings; whether the panels are from Bilston, Wednesbury, or Birmingham is not known.[8] Before the widespread use of transfer printing in the early 1750s, scenes from printed sources were copied by hand, thus the same view might be found on both hand-painted and transfer-printed enamels.

The harbor scene on this enamel box seems to have been popular, since it is known on three other English boxes. Two of these are very similar to the Markus box except that they have a yellow ground and raised gilded scrollwork.[9] The scene on the lid of the third box occupies the entire surface of the lid, and the sides are painted with floral sprays on a plain white ground, features that probably account for its Birmingham attribution.[10] Differences in certain details of the transfer prints on the four boxes indicate different copperplates, which suggest different enamel workshops or factories.

Italianate harbor scenes were also depicted on German enamels during the second half of the eighteenth century, inspired by their use on German porcelain, particularly that made at the Meissen factory (see nos. 22, 23, 24), where Baur's *Iconographia* had served painters as a source of decoration.[11] Two enamel panels from the Fromery workshop in Berlin, dated between 1751 and 1756, are decorated with harbor scenes similar to that on the Markus box; these are attributed to Johann Herold (d. 1798), a japanner and box maker.[12] Once again, the scenes on the panels are taken from prints, in this instance based on architectural designs by Giuseppi Gaulli Bibiena (1696-1757). The panels may well have been made as lids for a pair of enamel boxes. Unlike these German and some other English examples, Bilston and Wednesbury boxes such as nos. 98 and 99 do not appear to have been made in pairs or as parts of toilet services.

C.S.C.

NOTES

1. Eric Benton, "The Bilston Enamellers," *English Ceramic Circle Transactions* 7, pt. 3 (1970), 166.

2. Ibid., table 1, p. 167.

3. Ibid., p. 169.

4. Eric Benton's citation of enamel boxes based on Küssel's engravings after Baur's drawings led me to this source; see "Bilston Enamellers," p. 178.

5. Houghton Library, Harvard University, Department of Printing and Graphic Arts, *Drawings for Book Illustration: The Hofer Collection,* catalogue by David P. Becker (Cambridge, Mass., 1980), p. 17.

6. Ibid.

7. Benton, "Bilston Enamellers," p. 178.

8. For a print signed "Dubois" and the related enamel box, see Sotheby Parke Bernet, London, sale catalogue, June 16, 1981, lot 27. Although Eric Benton ("Bilston Enamellers," p. 178) attributed these enamels to Bilston, more recently they have been assigned to Birmingham. See Robert J. Charleston and Donald Towner, *English Ceramics, 1580-1830...*(London, 1977), fig. 242; Bernard Watney and Robert J. Charleston, "Petitions for Patents Concerning Porcelain, Glass, and Enamels with Special Reference to Birmingham, 'The Great Toyshop of Europe,'" *English Ceramics Circle Transactions* 6, pt. 2 (1966), frontis., a (color), pls. 109c, 110a,b.

9. Christie's, London, sale catalogue, Oct. 18, 1983, lot 61; Felice Mehlman, "English Eighteenth Century Enamels," *Antique Collector* 54, no. 2 (Feb. 1983), p. 46, illus.

10. Mary S. Morris, *A Catalogue of English Painted Enamels, 18th and 19th Century, in the Wolverhampton and Bilston Collections* (Wolverhampton, 1973), no. BI 422, p. 49.

11. Siegfried Ducret, *Keramik und Graphik des 18. Jahrhunderts: Vorlagen für Maler und Modelleure* (Brunswick, 1973), figs. 41, 42, p. 72.

12. Franz-Adrian Dreier, "Zwei Berliner Emailplatten aus der Zeit Friedrichs des Grossen," *Jahrbuch der Hamburger Kunstsammlungen* 3 (1958), 143.

99 Snuffbox

England, probably Bilston or Wednesbury (South Staffordshire), about 1770

Enameled copper, transfer-printed, with polychrome decoration; engraved metal mounts

Unmarked

H. 4.4 cm. (1 11/16 in.), w. 7.6 cm. (3 in.), l. 9.7 cm. (3 13/16 in.)

1983.665

Provenance: Purchased, New York, 1957

The rectangular box has a domed cover and waisted sides. The cover and the upper rim of the box are mounted with metal bands that are hinged along the back of the box. The mounts on the cover are machine-engraved with wavy lines; a small metal thumbpiece, also engraved, is affixed at the center of the mount on the front of the box. The box is enameled with a pale turquoise ground over a layer of white enamel. A pattern of raised, white dotted trelliswork, with large dots at the intersections and center of each square, is applied

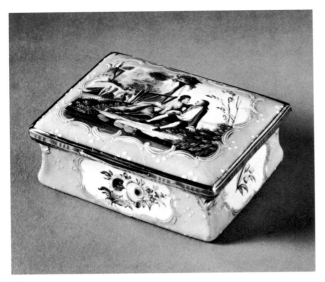

99

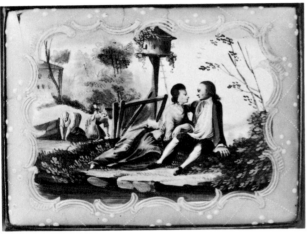

99

over the turquoise ground. A white reserve bordered with gilded yellow scrollwork occupies the center of the front, back, sides, and base of the box. The reserves on the front and back are painted with large bouquets of red, yellow, purple, and blue flowers with green foliage. The reserves on the sides and base of the box are decorated with individual sprays of yellow, puce, and violet flowers with green foliage.

The white reserve on the cover is bordered with gilded white scrollwork. Within the reserve is a transfer print of a man and a woman seated on the grassy bank of a river. The woman wears a full-length dress with a yellow bodice and a purple and red skirt. The man wears a full, white, high-collared shirt, a blue waistcoat, black breeches, white stockings, and black shoes. A tall, brown dovecote overgrown with foliage stands behind the seated

couple. On the far bank two women kneeling on a brown ledge wash clothing in the river. One woman wears a brown and white dress, the other a puce dress. Behind the women is a brown stone building with a water wheel; several tall trees with green and yellow foliage stand to the right of the building. The interior of the box is enameled in white.

The many features common to this box and no. 98 suggest that they are close in date and probably from the same manufacturing center. The style of decoration, the size, and the mounts of the boxes are nearly identical; the scrollwork on this box is only slightly less elaborate than that on no. 98 and was originally gilded. Rectangular, circular, and oval boxes with solid ground colors, raised, white trelliswork, painted or printed lid scenes, and floral bouquets on the sides were the mainstay of the enameling business in Bilston and Wednesbury, especially during the third quarter of the eighteenth century, when thousands of these were made for both the domestic and the export markets.

The English porcelain factories operating during the second half of the century never specialized in boxes as did the Continental porcelain factories, nor was porcelain as generally available in England as it was on the Continent. This led to a larger market for the English enamelers, whose wares could also be produced less expensively than porcelain. In addition, enamels had the advantage of being more suitable for decorations of topical interest and could be adapted to a particular market or occasion. The partially decorated boxes and mounts, whose forms remained nearly the same throughout the period of production, could easily be stored, and a special transfer print or inscription added quickly and inexpensively. Illustrative of this is an advertisement from *Aris's Birmingham Gazette* for March 22, 1756, which announced the sale of "An Assortment of Enamel Goods, with some utensils for the Enamel Business: The Goods chiefly consist of square and round Tops and Bottoms for Boxes of different Sizes, some painted and some plain; there are a few with Mounts."[1]

Despite their differences, eighteenth-century English enamels and porcelain had much in common. The solid ground colors used on enamels were borrowed directly from Chelsea porcelain, and the raised scrolls around the reserves are very like the tooled gilding employed in the same manner on Chelsea and Worcester porcelain. Enamelers and porcelain painters also turned to some of the same sources for their decoration; thus the same scenes inevitably appeared on both types of

wares.[2] The transfer print on the Markus box is copied from an engraving, *Lovers and Dovecote,* by Anthony Walker (1726-1765), an artist who engraved many of his own drawings. The engraving appeared in the third edition of *The Compleat Drawing-Book,* first published in 1755 by Robert Sayer (1725-1794) in London.[3] Such books were collections of works by different artists on various subjects and served as sources for designs on metalwork, furniture, lacquer, and printed fabrics in addition to ceramics and enamels. Some of the other important drawing books, all published in London between about 1760 and 1798, were *The Ladies Amusement or the Whole Art of Japanning made Easy, The Artist's Vade Mecum, The Compleat Drawing Master,* and *The Draughtsman's Assistant.*

Although Robert Hancock (about 1730-1817), an English engraver and mezzotinter whose engravings were used for many enamel and porcelain transfer prints, may have engraved this print for use on Worcester porcelain,[4] Walker's authorship of it is proved by the inscription "A Walker delin et sculp" on the version reproduced in *The Compleat Drawing Book.* Walker's design also appears as a transfer print in black on a porcelain mug from the Worcester factory, in conjunction with a transfer by Hancock of *The Minuet.*[5]

Walker's *Lovers and Dovecote* seems to have been popular for many years. It was included in *The Ladies Amusement and Designer's Assistant,* published in or after 1821.[6] A box with a dark blue ground is decorated with the design in the same manner as the Markus box, and its sides are also painted with floral sprays.[7] A box in the Museum of the City of London, dated between 1756 and 1770, also has this scene on the cover. The sides of the box are decorated with transfer prints, originally used at Battersea, of children representing Arts, Science, and Commerce.[8] A small, circular enamel box that has been variously attributed to Birmingham, Bilston, and Liverpool, and dated between 1750 and 1770 is printed in black with this scene filling its cover.[9] An oval plaque in the Schreiber Collection, attributed to Bilston or Wednesbury, shows the same subject, again printed in black on a white ground with no scrolling.[10] As might be expected, the two examples printed in black show the most fidelity to Walker's composition; neither the Markus box nor the blue-ground box, for example, includes any birds in the scene. Transfers that were not to be painted required greater care in order to be made precise and clear. These qualities are more often found on the transfer prints of the York House factory in Battersea (1753-1756) and on the early examples from Bir-mingham, where the transfer print was exploited more for its artistic than its commercial possibilities.

C.S.C.

NOTES

1. Bernard Watney and Robert J. Charleston, "Petitions for Patents Concerning Porcelain, Glass, and Enamels with Special Reference to Birmingham, 'The Great Toyshop of Europe,' " *English Ceramic Circle Transactions* 6, pt. 2 (1966), 114.

2. For examples of transfer prints common to both enamels and porcelain, see Cyril Cook, *The Life and Work of Robert Hancock* (London, 1948); Herbert Read, "Cross-Currents in English Porcelain, Glass, and Enamels," *English Porcelain Circle Transactions,* no. 4 (1932), pp. 7-14.

3. Robert Sayer, *The Compleat Drawing-Book: Containing Many and Curious Specimens,...* (London, 1755), p. 68.

4. Cook, *Robert Hancock,* fig. 62.

5. Ibid.

6. Ibid., p. 57.

7. Therle and Bernard Hughes, *English Painted Enamels* (Feltham, Eng., 1967), pl. 2 (color).

8. Watney and Charleston, "Petitions for Patents," p. 107, no. 18.

9. Eric Benton, *Gilt-Metal and Enamel Work of the 18th Century,* exhibition catalogue (Leamington, Eng., 1967), no. 110, p. 21. For an illustration of this box, see Sotheby Parke Bernet, London, sale catalogue, Oct. 23, 1979, lot 18.

10. Victoria and Albert Museum, London, *Catalogue of English Porcelain, Earthenware, Enamels, etc. Collected by Charles Schreiber...,* vol. 3: *Enamels and Glass,* by Bernard Rackham (1924), no. 325, pl. 38.

Sale catalogues, which are a valuable source of information and are cited frequently in the catalogue, are omitted from the following list because of limitations of space.

"Acquisitions in the Department of Ceramics at the Victoria and Albert Museum, 1981-82." *Burlington Magazine* 35 (May 1983).

Adams, Elizabeth, and Redstone, David. *Bow Porcelain and the Bow Factory.* London: Faber & Faber, 1981.

Albiker, Carl. *Die Meissner Porzellantiere im 18. Jahrhunderts.* Berlin: Deutscher Verein für Kunstwissenschaft, 1959.

Alfassa, Paul, and Guérin, Jacques. *Porcelaine française du XVIIe au milieu du XIXe siècle.* Paris: A. Levy, n.d.

Amor, Albert, London. *Blue and White 18th Century English Soft Paste Porcelain.* Catalogue by Anne M. George. London, 1979.

_____. *Dr. John Wall, 1708-1776: A Commemorative Loan Exhibition of Dr. Wall Period Worcester Porcelain.* Catalogue by Anne M. George. London, 1976.

_____. *Exhibition of First Period Worcester Porcelain 1751-1784.* Catalogue by Anne M. George and John G. Perkins. London, 1973.

_____. *The Golden Age: Masterpieces of 18th Century English Porcelain.* Catalogue by Anne M. George. London, 1980.

_____. *James Giles, China and Enamel Painter 1718-1780.* Catalogue by Anne M. George. London, 1977.

_____. *Worcester Porcelain: The First Decade, 1751-1761.* Catalogue by Anne M. George. London, 1981.

Ansbacher und Den Haager Porzellan: Beziehungen zwischen zwei Manufakturen des 18. Jahrhunderts. Catalogue by S.M. Voskuil-Groenewegen, A. Lang, and Albrecht Miller. Ansbach, 1980.

Augsburg Rathaus und Holbeinhaus. *Augsburger Barock.* Augsburg: Kunstsammlungen, 1968.

Austin, John C. *Chelsea Porcelain at Williamsburg.* Williamsburg, Va.: Colonial Williamsburg Foundation, 1977.

Avery, C. Louise. *Masterpieces of European Porcelain: A Catalogue of a Special Exhibition.* New York: The Metropolitan Museum of Art, 1949.

Ballu, Nicole. *La Porcelaine française.* Paris: C. Massin, 1958.

Barrett, Franklin A., and Thorpe, Arthur L. *Derby Porcelain 1750-1848.* London: Faber & Faber, 1971.

Bartholomew, Terese Tse. *I-Hsing Ware.* New York: China Institute in America, 1978.

Baxandall, D. Kighley. "Dutch Porcelain." *Connoisseur* 53 (Jan.-June 1939).

Bayer, Adolf. *Die Ansbacher Fayence-Fabriken.* Brunswick: Klinkhardt, 1959.

Beeling, Abraham C. *Nederlands zilver, 1600-1813.* 2 vols. Leeuwarden: C. Beeling & Loon, 1980.

Behrends, Rainer. *Das Meissner Musterbuch für Höroldt-Chinoiserien: Musterblätter aus der Malstube der Meissener Porzellanmanufaktur (Schulz-Codex).* 3 vols. Munich: Idion, 1978.

Belfort, Anne-Marie. "L'Oeuvre de Vielliard d'après Boucher." *Cahiers de la céramique, du verre et des arts du feu (Sèvres),* no. 58 (1976).

Bemrose, William. *Longton Hall Porcelain.* London: Bemrose & Sons, 1906.

Benjamin, Susan. *English Enamel Boxes from the Eighteenth to the Twentieth Centuries.* London: Orbis, 1978.

Benton, Eric. "The Bilston Enamellers." *English Ceramic Circle Transactions* 7, pt. 3 (1970).

_____. *Gilt-Metal and Enamel Work of the 18th Century.* Exhibition catalogue. Leamington, England: The Art Gallery, 1967.

_____. "John Brooks in Birmingham." *English Ceramic Circle Transactions* 7, pt. 3 (1970).

_____. "The London Enamellers." *English Ceramic Circle Transactions* 8, pt. 2 (1972).

_____. "Some Eminent Enamellers and Toy-Makers." *English Ceramic Circle Transactions* 10, pt. 2 (1977).

Berges, Ruth. "China Fruits and Vegetables." *Antique Dealer and Collectors' Guide,* June 1973.

_____. *The Collector's Cabinet.* San Diego: A.S. Barnes; London: Tantivy Press, 1980.

_____. *Collector's Choice of Porcelain and Faience.* South Brunswick, N.J., and New York: A.S. Barnes; London: Thomas Yoseloff, 1967.

_____. *From Gold to Porcelain: The Art of Porcelain and Faience.* New York and London: Thomas Yoseloff, 1963.

Berling, Karl. *Das Meissner Porzellan und seine Geschichte.* Leipzig: F.A. Brockhaus, 1900.

Berling, Karl, ed. *Festive Publication to Commemorate the 200th Jubilee of the Oldest European China Factory, Meissen.* Meissen: Royal Saxon Manufactory, 1910.

_____, ed. *Meissen China: An Illustrated History.* 1910. Reprint [of previous entry]. New York: Dover Publications, 1972.

Beurdeley, Michel. *Chinese Trade Porcelain.* Translated by Diana Imber. Rutland, Vermont: C.E. Tuttle Co., 1962.

Blunt, Reginald, ed. *The Cheyne Book of Chelsea China and Pottery.* 1924. Reprint. Wakefield, England: E.P. Publishing, 1973.

Boger, Louise Ade. *The Dictionary of World Pottery and Porcelain.* New York: Charles Scribner's Sons, 1971.

Boltz, Claus. "Formen des Böttgersteinzeugs im Jahre 1711." *Keramikfreunde der Schweiz Mitteilungsblatt,* no. 96 (March 1982).

Boyazoglu, Jan, and Neuville, Louis de. *Les Faïences de Delft.* Paris: Jacques Grancher, 1980.

Bradley, H.G., ed. *Ceramics of Derbyshire 1750-1975.* London: The Editor, 1978.

Brooks Memorial Art Gallery, Memphis, Tennessee. *Mrs. C.B. Stout Collection of Early Meissen Porcelain ca. 1708-1750.* Memphis, Tenn., 1966.

Brunet, Marcelle. "French Pottery and Porcelains." In *The Frick Collection: An Illustrated Catalogue,* vol. 7: *Porcelains, Oriental and French.* New York: The Frick Collection, 1974.

Brunet, Marcelle, and Préaud, Tamara. *Sèvres des origines à nos jours.* Fribourg: Office du Livre, 1978.

Brüning, Adolf, et al. *Europäisches Porzellan des XVIII. Jahrhunderts.* Exhibition catalogue, Kunstgewerbemuseum, Berlin. Berlin: Reimer, 1904.

Brunner, Herbert. *Schatzkammer der Residenz München, Katalog.* 3rd ed. Munich: Bayerische Verwaltung der Staatliche Schlösser, Gärten und Seen, 1970.

Bunford, A.H.S. "Some Remarks on Claret Colour." *English Ceramic Circle Transactions* 1, no. 5 (1937).

Bursche, Stefan. *Meissen: Steinzeug und Porzellan des 18. Jahrhunderts, Kunstgewerbemuseum, Berlin.* Berlin: Staatliche Museen Preussischer Kulturbesitz, 1980.

Caiger-Smith, Alan. *Tin-Glaze Pottery in Europe and the Islamic World: The Tradition of 1000 Years in Maiolica, Faience, and Delftware.* London: Faber & Faber, 1973.

California Palace of the Legion of Honor, San Francisco. *Cathay Invoked.* Exhibition catalogue. San Francisco, 1966.

Calmann, Gerta. *Ehret, Flower Painter Extraordinary.* Boston: New York Graphic Society, 1977.

Campbell, R. *The London Tradesman, Being a Compendious View of all the Trades…in the Cities of London and Westminster.* London, 1747.

Casanova, Maria L. *Le Porcellane francesi nei musei di Napoli.* Naples: Di Mauro, 1974.

"Catalogue of the Exhibition of Ceramics of France from the Middle Ages to the Revolution." *Cahiers de la céramique, du verre et des arts du feu* (Sèvres), no. 48-49 (1971).

Chaffers, William. *Marks and Monograms on European and Oriental Pottery and Porcelain.* 13th ed., rev., by Frederick Litchfield. London: Reeves, 1912.

Charleston, Robert J. "Battersea, Bilston — or Birmingham?." *Victoria and Albert Museum Bulletin* 3 (Jan. 1967).

—————. "A Decorator of Porcelain and Glass—James Giles in a New Light." *English Ceramic Circle Transactions* 6, pt. 3 (1967).

—————. *The James A. de Rothschild Collection at Waddesdon Manor: Meissen and Other European Porcelain.* Fribourg: Office du Livre, 1971.

—————. "Painted Enamels Other than Limoges." In *The James A. De Rothschild Collection at Waddesdon Manor: Glass and Stained Glass; Limoges and Other Painted Enamels.* Fribourg: Published for the National Trust by Office du Livre, 1977.

Charleston, Robert J., ed. *English Porcelain 1745-1850.* London: Ernest Benn, 1965.

—————, ed. *World Ceramics.* New York: McGraw-Hill Book Co., 1968.

Charleston, Robert J., and Lunsingh Scheurleer, Daniel F. *English and Dutch Ceramics.* Masterpieces of Western and Near Eastern Ceramics, vol. 7. Tokyo: Kodansha, 1979.

Charleston, Robert J., and Towner, Donald. *English Ceramics 1580-1830.* London: Sotheby Parke Bernet, 1977.

Chavagnac, Comte Xavier de. *Catalogue des porcelaines françaises de M.J. Pierpont Morgan.* Paris: Imprimerie Nationale, 1910.

Chavagnac, Comte Xavier de, and Grollier, Marquis G. de. *Histoire des manufactures françaises de porcelaine.* Paris: Alphonse Picard et Fils, 1906.

Chelsea Society, London. *Illustrated Catalogue of the Loan Exhibition of Chelsea China at the Royal Hospital, Chelsea.* London: Claridge, Lewis & Jordan, 1951.

Chompret, J., et al. *Répertoire de la faïence française.* 6 vols. Paris: Lapina, 1933-1935.

Church, A.H. *English Porcelain.* London: Chapman & Hall, 1885.

Clarke, Samuel M. "Marks on Overglaze-Decorated First Period Worcester Porcelain: A Statistical Study." *American Ceramic Circle Bulletin,* no. 2 (1980).

Clarke, T.H. "A Meissen Discovery—Sabina Aufenwerth at Augsburg." *Connoisseur* 181 (Oct. 1972).

—————. "Eine Meissen-Entdeckung—Sabina Aufenwerth in Augsburg." *Keramos,* no. 60 (1973).

Coke, Gerald. *In Search of James Giles, 1718-1780.* Wingham, England: Micawber Publications, 1983.

Cook, Cyril. *The Life and Work of Robert Hancock.* London: Chapman and Hall, 1948.

Cox, Warren E. *The Book of Pottery and Porcelain.* New York: L. Lee & Shepard Co., 1944.

Daendels, H.A. "Catalogus tentoonstelling Japans blauw en wit porselein." *Mededelingenblad Nederlandse vereniging van vrienden van de ceramiek,* no. 101-102 (1981).

Dauterman, Carl C. *Sèvres.* New York: Walker & Co., 1969.

—————. *The Wrightsman Collection.* Vol. 4: *Porcelain.* New York: The Metropolitan Museum of Art, 1970.

de Bellaigue, Geoffrey. *Sèvres Porcelain from the Royal Collection.* London: The Queen's Gallery, 1979.

Delplace, Lucien. *Considérations sur les porcelaines de Tournai, 1750-1830.* Tournai: Casterman, 1970.

den Blaauwen, A.L. "Keramik mit Chinoiserien nach Stichen von Petrus Schenk jun." *Keramos,* no. 31 (Jan. 1966).

Dielmann, Karl. *Historisches Museum Hanau im Schloss Philippsruhe.* Hanau: Historisches Museum, 1967.

Doenges, Willy. *Meissner Porzellan: Seine Geschichte und künstlerische Entwicklung.* Berlin: Marquardt & Co., 1907.

Donnelly, P.J. *Blanc de chine: The Porcelain of Têhua in Fukien.* London: Faber & Faber, 1969.

Dreier, Franz-Adrian. "Zwei Berliner Emailplatten aus der Zeit Friedrichs des Grossen." *Jahrbuch der Hamburger Kunstsammlungen* 3 (1958).

Ducret, Siegfried. "Anna Elisabeth Wald, eine geborene Aufenwerth." *Keramos,* no. 50 (1970).

—————. *Fürstenberger Porzellan.* 3 vols. Brunswick: Klinkhardt & Biermann, 1965.

_____. *German Porcelain and Faience.* Translated by Diana Imber. New York: Universe Books, 1962.

_____. *Keramik und Graphik des 18. Jahrhunderts: Vorlagen für Maler und Modelleure.* Brunswick: Klinkhardt & Biermann, 1965.

_____. *Meissner Porzellan bemalt in Augsburg, 1718 bis um 1750.* 2 vols. Brunswick: Klinkhardt & Biermann, 1971-1972.

_____. "Vorbilder für Porzellanmalereien." *Keramos,* no. 44 (April 1969).

_____. "Die Vorbilder zu einigen Chinoiserien von Peter Schenk." *Keramos,* no. 31 (Jan. 1966).

Du Sartel, O., and Williamson, E. *Exposition rétrospective des porcelaines de Vincennes et de Sèvres.* Exhibition catalogue. Paris: Union Centrale des Arts Décoratifs, 1884.

Duvaux, Lazare. *Livre-Journal de Lazare Duvaux, marchand-bijoutier ordinaire du Roy 1748-1758.* Edited by Louis Courajod. 2 vols. Paris: Société des Bibliophiles Français, 1873.

Elliot, Wallace. "Reproductions and Fakes of English Eighteenth-Century Ceramics." *English Ceramic Circle Transactions* 2, no. 7 (1939).

Eriksen, Svend. "A propos de six Sèvres du dix-huitième siècle." *Danske Kunstindustrimuseum Virksomhed* (Copenhagen) 4 (1964-1969).

_____. *Davids Samling Fransk Porcelaen; The David Collection, French Porcelain.* Copenhagen: David Collection, 1980.

_____. *The James A. de Rothschild Collection at Waddesdon Manor: Sèvres Porcelain.* Fribourg: Office du Livre, 1968.

Falke, Otto von. *Die Kunstsammlung von Pannwitz.* Vol. 2. Munich: F. Bruckmann [1926].

Feulner, Adolf. *Frankfurter Fayencen.* Forschungen zur deutschen Kunstgeschichte, vol. 9. Berlin: Deutscher Verein für Kunstwissenschaft, 1935.

Foote, Helen S. "Early French and German Porcelain Formerly in the J. Pierpont Morgan Collection." *Bulletin of the Cleveland Museum of Art* 31 (Nov. 1944).

_____. "Soft-paste Porcelain in France." *Art Quarterly* 11, no. 4 (1948).

Forbes, H.A. Crosby. *Yang-ts'ai: The Foreign Colors: Rose Porcelains of the Ch'ing Dynasty.* Milton, Mass.: China Trade Museum, 1982.

Fourest, Henry Pierre. *Delftware: Faience Production at Delft.* Translated by Katherine Watson. New York: Rizzoli, 1980

_____ *French Ceramics.* Masterpieces of Western and Near Eastern Ceramics, vol. 6. Tokyo: Kodansha, 1979.

_____. "Sur l'apparition de la polychromie dans la porcelaine française." *Cahiers de la céramique, du verre et des arts du feu (Sèvres),* no. 19 (1960).

Fourest, Henry Pierre, and Giacomotti, Jeanne. *L'Oeuvre des faïenciers français du XVIe à la fin du XVIIIe siècle.* Paris: Hachette, 1966.

Franks, Augustus Wollaston. "Notes on the Manufacture of Porcelain at Chelsea." *Archaeological Journal* 19 (1862).

Frégnac, Claude, ed. *Les Porcelainiers du XVIIIe siècle français.* Paris: Hachette, 1964.

Gabszewicz, Anton, and Freeman, Geoffrey. *Bow Porcelain: The Collection Formed by Geoffrey Freeman.* London: Lund Humphries, 1982.

Gardner, Bellamy. "Chelsea Porcelain: The First Period, 1745-1750." *Connoisseur* 76 (Dec. 1926).

_____. "'Silvershape' in Chelsea Porcelain: Nicholas Sprimont and His Work as a Silversmith." *Antique Collector,* Aug. 1937.

Gemeentemuseum, The Hague. *Catalogus van de verzameling Haagsch porcelein.* Catalogue by H.E. van Gelder. The Hague: Mouton & Co., 1916.

_____. *Doorniks en Haags porselein: Hun onderlinge relatie.* The Hague, 1977.

_____. *Gallipotters Ware and Blue Delft.* The Hague, 1958.

_____. *Gekleurd Delfts aardewerk; Polychrome Delft Ware.* Catalogue by S.M. van Gelder. The Hague, 1969.

_____. *Haags porselein, 1776-1790.* Catalogue by Beatrice Jansen. The Hague, 1965.

Giacomotti, Jeanne. *French Faience.* Translated by Diana Imber. London: Oldbourne Press, 1963.

Gilhespy, J. Brayshaw. *Derby Porcelain.* London: MacGibbon & Kee, 1961.

Glendenning, O., and MacAlister, Mrs. Donald. "Chelsea, The Triangle Period." *English Ceramic Circle Transactions,* no. 3 (1935).

Goder, Willi, et al. *Johann Friedrich Böttger: Die Erfindung des europäischen Porzellans.* Leipzig: Kohlhammer, 1982.

Grand Palais, Paris. *Faïences françaises XVIe-XVIIIe siècles.* Exhibition catalogue by Antoinette Faÿ Hallé et al. Paris: Ministère de la Culture et de la Communication, 1980.

_____. *Porcelaines de Vincennes: Les Origines de Sèvres.* Exhibition catalogue by Antoinette Faÿ Hallé and Tamara Préaud. Paris: Ministère de la Culture et de l'Environment, 1977.

Grégory, Pierre. "Le Service bleu céleste de Louis XV à Versailles: Quelques pièces retrouvées." *Revue du Louvre* 1 (1982).

Guérin, Jacques. *La Chinoiserie en Europe au XVIIIe siècle.* Paris: Librairie centrale des beaux arts, 1911.

Hackenbroch, Yvonne. *Chelsea and Other English Porcelain, Pottery, and Enamel in the Irwin Untermyer Collection.* Cambridge, Mass.: Harvard University Press for The Metropolitan Museum of Art, 1957.

_____. *Meissen and Other Continental Porcelain, Faience and Enamel in the Irwin Untermyer Collection.* Cambridge, Mass.: Harvard University Press for The Metropolitan Museum of Art, 1956.

Hackenbroch, Yvonne, and Parker, James. *The Lesley and Emma Sheafer Collection: A Selective Presentation.* New York: The Metropolitan Museum of Art, 1975.

Haggar, Reginald G. *The Concise Encyclopedia of Continental Pottery and Porcelain.* New York: Hawthorne, 1960.

Handt, Ingelore, and Rakebrand, Hilde. *Meissner Porzellan des achtzehnten Jahrhunderts, 1710-1750.* Dresden: Verlag der Kunst, 1956.

Hayward, John Forrest. *Viennese Porcelain of the Du Paquier Period.* London: Rockliff, 1952.

Hedley, Geoffrey. "Yi-Hsing Ware." *Transactions of the Oriental Ceramic Society* (London) 14 (1937).

Heitmann, Bernhard. "Das Mecklenburgische Toilette-Service." Museum für Kunst und Gewerbe, Hamburg, *Europa,* MKG 3.10. 1980.

Helbig, Jean. *Faïences hollandaises.* Vol. 1: *Pièces marquées.* Brussels: Musées Royaux d'Art et d'Histoire, 1960.

Heukensfeldt, M.-A. Jansen, and den Blaauwen, A.L. "Hollands en Duits porselein in kasteel Sypesteyn te Nieuw-Loosdrecht." *Mededelingenblad vrienden van de Nederlandse ceramiek,* no. 42 (March 1966).

Hobson, R.L. *Worcester Porcelain.* London: Quaritch, 1910.

Hofmann, Friedrich H. "Beiträge zur Geschichte der Fayencefabrik zu Bayreuth." *Münchner Jahrbuch der Bildenden Kunst,* n.s. 1 (1924).

————. *Das Porzellan der europäischen Manufakturen.* Frankfurt am Main: Propyläen Verlag, 1980.

Holzhausen, Walter. "Email mit Goldauflage in Berlin und Meissen nach 1700." *Der Kunstwanderer,* 1930-1931.

Honey, William Bowyer. *Dresden China: An Introduction to the Study of Meissen Porcelain.* Troy, N.Y.: David Rosenfeld, 1946.

————. *European Ceramic Art from the End of the Middle Ages to about 1815: A Dictionary of Factories, Artists, Technical Terms, et cetera.* London: Faber & Faber, 1952.

————. *European Ceramic Art from the End of the Middle Ages to about 1815: Illustrated Historical Survey.* 2nd ed. London: Faber & Faber, 1963.

————. *French Porcelain of the 18th Century.* London: Faber & Faber [1950].

————. "New Light on Battersea Enamels." *Connoisseur* 89 (Jan.-June 1932).

————. *Old English Porcelain: A Handbook for Collectors.* London: G. Bell & Sons, 1931.

————. "The Work of James Giles." *English Ceramic Circle Transactions* 1, no. 5 (1937).

Hong Kong Museum of Art. *Yixing Pottery.* Hong Kong: The Museum, 1981.

Hornig-Sutter, Monika. "Der Stil Christian Friedrich Herolds." *Keramos,* no. 57 (1972).

Howard, David, and Ayers, John. *China for the West: Chinese Porcelain and Other Decorative Arts for Export Illustrated from the Mottaheda Collection.* 2 vols. London and New York: Sotheby Parke Bernet, 1978.

Hudig, Ferrand W. *Delfter Fayence.* Berlin: Richard Carl Schmidt & Co., 1929.

Hughes, Therle and Bernard. *English Painted Enamels.* Feltham, England: Spring Books, 1967.

Hurlbutt, Frank. *Chelsea China.* London: Hodder & Stoughton, 1937.

Hüseler, Konrad. *Deutsche Fayencen.* 3 vols. Stuttgart: Anton Hiersemann, 1956-1958.

Hyam, Edward. *The Early Period of Derby Porcelain (1750-1770).* London: Hyam & Co., 1926.

Impey, Oliver. *Chinoiserie: The Impact of Oriental Styles on Western Art and Decoration.* London: Oxford University Press, 1977.

————. "The Earliest Japanese Porcelains: Styles and Techniques." In *Decorative Techniques and Styles in Asian Ceramics,* edited by Margaret Medley. Colloquies on Art and Archaeology in Asia, 8. London. 1979.

Isaac Delgado Museum of Art, New Orleans. *Fêtes de la palette.* Exhibition catalogue. New Orleans: The Museum, 1962.

Jean-Richard, Pierrette. *L'Oeuvre gravé de François Boucher dans la collection Edmond de Rothschild.* Paris: Musée du Louvre, 1978.

Jedding, Hermann. *Europäisches Porzellan.* Vol. 1: *Von den Anfängen bis 1800.* Munich: Keysersche Verlagsbuchhandlung, 1971.

————. *Meissener Porzellan des 18. Jahrhunderts.* Munich: Keyser, 1979.

————. *Meissener Porzellan des 18. Jahrhunderts in Hamburger Privatbesitz.* Exhibition catalogue. Hamburg: Museum für Kunst und Gewerbe, 1982.

Jenyns, Soame. *Japanese Porcelain.* London: Faber & Faber, 1965.

————. *Later Chinese Porcelain: The Ch'ing Dynasty (1644-1912).* London: Faber & Faber, 1951.

————. *Ming Pottery and Porcelain.* London: Faber & Faber, 1953.

Jewitt, Llewellynn. *The Ceramic Art of Great Britain.* 2 vols. London: Virtue & Co., 1878.

Jonge, Caroline Henriette de. *Delft Ceramics.* Translated by Marie-Christine Hellin. New York: Praeger, 1970.

————. *Oud-Nederlandsche majolica en Delftsch aardewerk.* The Hague: Martinus Nijhoff, 1947.

————. "Een particuliere verzameling Delfts aardewerk." *Mededelingenblad vrienden van de Nederlandse ceramiek,* no. 48 (Sept. 1967).

Jörg, C.J.A. *Porcelain and the Dutch China Trade.* Translated by Patricia Wardle. The Hague: Nijhoff, 1982.

Jottrand, Mireille. "Tournai Porcelain and English Ceramics." *English Ceramic Circle Transactions* 10, pt. 2 (1977).

Justice, Jean. *Dictionary of Marks and Monograms of Delft Pottery.* London: H. Jenkins, 1930.

"Keramische Neuerwerbungen des Reiss-Museums in Mannheim." *Keramos,* no. 57 (July 1972).

King, William. *Chelsea Porcelain.* London: Benn Bros., 1932.

————. "Vincennes Porcelain in the British Museum, I." *Apollo* 12 (Oct. 1930).

Knowles, W. Pitcairn. *Dutch Pottery and Porcelain.* London: B.T. Batsford, 1913.

Koyama, Fujio, and Pope, John A., eds. *Oriental Ceramics: The World's Great Collections.* Vol. 5: *The British Museum.* Tokyo: Kodansha, 1974.

Krevelen, D. Arn van. "De Haagse porselein industrie in het licht van de persoonlijkheid van Lyncker." *Mededelingenblad vrienden van de Nederlandse ceramiek,* no. 58 (1970-1971).

Kunstgewerbemuseum, Berlin. *Europäisches Kunsthandwerk vom Mittelalter bis zur Neuerwerbungen 1959-1969.* Berlin, 1970.

Kunstgewerbemuseum, Cologne. *Europäisches Porzellan und ostasiatisches Exportporzellan: Geschirr und Ziergerät.* Catalogue by Barbara Beaucamp-Markowsky. Cologne, 1980.

————. *Fayence I: Niederlande, Frankreich, England.* Catalogue by Brigitte Tietzel. Cologne, 1980.

Kunstmuseum der Stadt Düsseldorf. *Deutsche Fayencen im Hetjens-Museum.* Catalogue by Adalbert Klein. Düsseldorf, 1962.

Landais, Hubert. *French Porcelain*. New York: Putnam, 1961.

_____. *La Porcelaine française XVIIIe siècle*. Paris: Hachette, 1963.

Lane, Arthur. *French Faience*. New York: D. Van Nostrand Co., 1948.

Lechevallier-Chivignard, Georges. *La Manufacture de porcelaine de Sèvres*. Paris: H. Laurens, 1908.

Le Corbeiller, Clare. *China Trade Porcelain: Patterns of Exchange*. New York: The Metropolitan Museum of Art, 1974.

_____. *European and American Snuff Boxes, 1730-1830*. London: B.T. Batsford, 1966.

Lerner, Martin. *Blue and White: Early Japanese Export Ware*. New York: The Metropolitan Museum of Art, 1978.

Lesur, Adrien. *Les Poteries et les faïences françaises*. 5 vols. Paris: Tardy, 1957-1961.

Lunsingh Scheurleer, Daniel F. *Chinese Export Porcelain: Chine de commande*. New York: Pitman, 1974.

_____. "De Chinese porseleinkast: reizende tentoonstelling van Chinees porselein dat in de 17e en 18e eeuw door Nederland werd geïmporteerd." *Mededelingenblad vrienden van de Nederlandse ceramiek*, no. 52 (Sept. 1968).

_____. "Collectie M.G. van Heel, oud Delfts aardewerk, Rijksmuseum Twenthe, Enschede." *Mededelingenblad vrienden van de Nederlandse ceramiek*, no. 54 (1969).

_____. *Delft: Niederländische Fayence*. Munich: Klinkhardt & Biermann, 1984.

_____. "Enkele zeventiende eeuwse Japanse porseleinen schenkkannetjes naar westerse voorbeelden II. *Antiek* 2 (Oct. 1967).

McClellan, George B. *A Guide to the McClellan Collection of German and Austrian Porcelain*. New York: The Metropolitan Museum of Art, 1946.

Mackenna, F. Severne. *Chelsea Porcelain: The Red Anchor Wares*. Leigh-on-Sea, England: F. Lewis, 1951.

_____. *Chelsea Porcelain: The Triangle and Raised Anchor Wares*. Leigh-on-Sea, England: F. Lewis, 1948.

_____. *The F.S. Mackenna Collection of English Porcelain*. Pt. 1: *Chelsea 1743-1758*. Leigh-on-Sea, England: F. Lewis, 1972.

_____. *Worcester Porcelain: The Wall Period and Its Antecedents*. Leigh-on-Sea, England: F. Lewis, 1950.

Mallet, J.V.G. "Chelsea." In *English Porcelain 1745-1850*, edited by Robert J. Charleston. London: Ernest Benn, 1965.

_____. "A Chelsea Talk." *English Ceramic Circle Transactions* 6, pt. 1 (1965).

Manufacture Nationale de Sèvres. *La Porcelaine de Sèvres*. Paris: Chêne/Hachette, 1982.

Mariën-Dugardin, Anne-Marie. "A propos de la porcelaine de Tournai: Thèmes traités à Tournai et dans d'autres manufactures européennes." *Bulletin des Musées Royaux d'Art et d'Histoire, Brussels* 36, no. 4 (1964).

_____. "Compléments pour servir à l'histoire de la porcelaine de Tournai." *Bulletin des Musées Royaux d'Art et d'Histoire, Brussels* 46-47, no. 6 (1975).

_____. "Plaques de Delft et leurs modèles." *Faenza* 65, no. 6 (1979).

Mariën-Dugardin, Anne-Marie, and Kozyreff, Chantal. *Ceramic Road*. Tokyo: Mainichi Shimbun Sha, 1982

Marshall, H. Rissik. *Coloured Worcester Porcelain of the First Period (1751-1783)*. Newport, England: Ceramic Book Co., 1954.

_____. "James Giles, Enameller." *English Ceramic Circle Transactions* 3, pt. 1 (1951).

Mehlman, Felice. "English Eighteenth Century Enamels." *Antique Collector* 54, no. 2. (Feb. 1983).

Meinz, Manfred, and Strauss, Konrad. *Jagdliche Fayencen deutscher Manufakturen*. Hamburg and Berlin: Parey, 1976.

Meister, Peter Wilhelm. *Porzellan des 18. Jahrhunderts*. (Sammlung Pauls, Riehen, Schweiz.) 2 vols. Frankfurt am Main: Verlag August Osterrieth, 1967.

Meister, Peter Wilhelm, and Reber, Horst. *European Porcelain of the 18th Century*. Translated by Ewald Osers. Ithaca, N.Y.: Cornell University Press, 1983.

Menzhausen, Joachim. *The Green Vaults*. Translated by Marianne Herzfeld. Leipzig: Edition Leipzig, 1970.

Merk, Anton. *Hanauer Fayence 1661-1806*. Exhibition catalogue, Historisches Museum der Stadt Hanau. Hanau: Magistrat der Stadt Hanau, Kulturamt, 1979.

The Metropolitan Museum of Art, New York. *Highlights of the Untermyer Collection of English and Continental Decorative Arts*. New York: The Metropolitan Museum of Art, 1977.

Mew, Egan. *Battersea Enamels*. London: The Medici Society, 1926.

Meyer, Erich. "Museum für Kunst und Gewerbe: Neuerwerbungen 1946-49." *Jahrbuch der Hamburger Kunstsammlungen* 2 (1952).

Meyer, Hellmuth, and Meyer-Küpper, Ursula. "Allegorien der Elemente auf Fliesen." *Mededelingenblad Nederlandse vereniging van vrienden van de ceramiek*, no. 105 (1982).

Morris, Mary S. *A Catalogue of English Painted Enamels, 18th and 19th Century, in the Wolverhampton and Bilston Collections*. Wolverhampton: Art Galleries & Museums, 1973.

Musée National de Céramique, Sèvres. *La Vie française illustrée par la céramique*. Exhibition catalogue. Paris: Edition des Musées Nationaux, 1934.

Musées Royaux d'Art et d'Histoire, Brussels. *Le Legs Madame Louis Solvay*. Vol 1: *Porcelaines de Tournai*. 2nd ed., rev., by Anne-Marie Mariën-Dugardin. Brussels, 1980.

_____. *La Vie au XVIIIe siècle*. Exhibition catalogue. Brussels, 1970.

Museum Boymans en historisch Museum der Stad Rotterdam. *Jaarverslag*, 1941-1943.

Museum für Kunst und Gewerbe, Hamburg. *Bildführer II: Ausgewählte Werke aus den Erwerbungen während der Jahre 1948-1961: Festgabe für Erich Meyer*. Hamburg, 1964.

Museum für Kunsthandwerk, Frankfurt am Main. *Europäische Fayencen*. Catalogue by Margrit Bauer. Frankfurt am Main, 1977.

_____. *Neuerwerbungen, 1959-1974*. Frankfurt am Main, 1974.

Museum Willet Holthuysen, Amsterdam. *Amstelporselein 1784-1814*. *Mededelingenblad vrienden van de Nederlandse ceramiek*, nos. 86-87 (1977).

_____. *Het Nederlandse porcelein*. Catalogue by W.J. Rust. Amsterdam, 1952.

National Gallery, London. *Art in Seventeenth Century Holland*. Exhibition catalogue. London: National Gallery, 1976.

"Neuerwerbungen des Grünen Gewölbes zu Dresden." *Der Kunstwanderer*, 1925-1926.

Neurdenburg, Elizabeth, and Rackham, Bernard. *Old Dutch Pottery and Tiles*. London: Benn Brothers; New York: Himebaugh & Browne, 1923.

Nicolier, Jean. "L'Epoque rose de la porcelaine tendre de Sèvres." *Connaissance des arts* 79 (Sept. 1958).

Pauls-Eissenbeiss, Erika. *German Porcelain of the 18th Century*. 2 vols. London: Barrie & Jenkins, 1972.

Pavillon de Marsan, Paris. *La Faïence française de 1525 à 1820*. Exhibition catalogue. Paris, 1932.

————. *La Porcelaine française de 1673 à 1914: La Porcelaine contemporaine de Limoges*. Exhibition catalogue. Paris, 1929.

Pazaurek, Gustav E. *Deutsche Fayence- und Porzellan-Hausmaler*. 2 vols. Leipzig: K.W. Hiersemann, 1925.

Pfeiffer, Bertold. *Album der Erzeugnisse der ehemaligen Württembergischen Manufaktur Alt-Ludwigsburg*. Stuttgart: Otto Wanner-Brandt, 1906.

Phillips, John Goldsmith. *China-trade Porcelain*. Cambridge, Mass.: Harvard University Press for the Winfield Foundation and The Metropolitan Museum of Art, 1956.

Rackham, Bernard. "Mr. Wallace Elliot's Collection of English Porcelain (Second Article): Chelsea and The Midlands." *Connoisseur* 79 (Sept. 1927).

————. "Porcelain as a Sidelight on Battersea Enamels." *English Ceramic Circle Transactions*, no. 4 (1932).

Rahm, Siv. "Chinese Export Porcelain and Its Influence on Dutch Ceramic Art." *Mededelingenblad vrienden van de Nederlandse ceramiek*, no. 30 (March 1963).

Rakebrand, Hilde. *Meissener Tafelgeschirre des 18. Jahrhunderts*. Darmstadt: Franz Schneekluth, 1958.

Ray, Anthony. "De Animalia van Berchem in de Engelse Schouw." *Antiek* 10, no. 8 (March 1976).

Read, Herbert. "Cross-Currents in English Porcelain, Glass, and Enamels." *English Porcelain Circle Transactions*, no. 4 (1932).

Reichel, Friedrich. *Early Japanese Porcelain, Arita Porcelain, in the Dresden Collection*. Translated by Barbara Beedham. London: Orbis, 1981.

Ricketts, Howard. *Objects of Vertu*. London: Barrie & Jenkins, 1971.

Riesebieter, O. *Die deutschen Fayencen des 17. und 18. Jahrhunderts*. Leipzig: Klinkhardt, 1921.

Rijksmuseum, Amsterdam. *Delfts aardewerk; Dutch Delftware*. Catalogue by M.-A. Henkensfeldt Jansen. Amsterdam, 1967.

————. *Saksisch Porselein 1710-1740; Dresden China*. Text by A.L. den Blaauwen. Amsterdam, 1962.

Rosa, Gilda. *La Porcellana in Europa*. Milan: Bramante, 1966.

Rückert, Rainer. *Meissener Porzellan 1710-1810*. Exhibition catalogue, Bayerisches Nationalmuseum, Munich. Munich: Hirmer, 1966.

————. "Porzellan für Wunsiedel." *Pantheon* 33 (April, May, June 1975).

Rueff, Kitty. "The Porcelain of Tournai." *Antiques* 64 (Oct. 1953).

Rust, W.J. *Nederlands porselein*. 1952. Reprint. Schiedam: Interbook International, 1978.

Sandon, Henry. *Coffee Pots and Teapots for the Collector*. New York: Arco, 1974.

————. *The Illustrated Guide to Worcester Porcelain 1751-1793*. London: Herbert Jenkins, 1969.

Savage, George. *18th-Century English Porcelain*. London: Rockliff, 1952.

————. *18th-Century German Porcelain*. London: Rockliff, 1958.

————. *Porcelain through the Ages*. London: Penguin, 1954.

————. *Seventeenth and Eighteenth Century French Porcelain*. London: Barrie & Rockliff, 1960.

Savage, George, and Newman, Harold. *An Illustrated Dictionary of Ceramics*. New York: Van Nostrand Reinhold Co. [1974].

Savill, Rosalind. "François Boucher and the Porcelains of Vincennes and Sèvres." *Apollo* 115 (March 1982).

Sayer, Robert. *The Compleat Drawing-Book: Containing Many and Curious Specimens,...* London, 1755.

Schnyder von Wartensee, Paul. "Meissner Wappenservice des 18. Jahrhunderts." In *250 Jahre Meissner Porzellan: Die Sammlung Dr. Ernst Schneider im Schloss "Jägerhof," Düsseldorf, Keramikfreunde der Schweiz Mitteilungsblatt*, no. 50 (April 1960).

Schönberger, Arno. *Meissener Porzellan mit Höroldt-Malerei*. Darmstadt: Franz Schneekluth Verlag [1953].

Scott, Cleo M., and Scott, G. Ryland, Jr. *Antique Porcelain Digest*. Newport, England: Ceramic Book Co., 1961.

Seattle Art Museum. *Ceramic Art of Japan: One Hundred Masterpieces from Japanese Collections*. Exhibition catalogue. Seattle, 1972.

Seitler, Otto. "Adam Friedrich von Löwenfinck als Blumenmaler in Meissen." *Keramos*, no. 11 (1961).

————. "Email und Porzellanmalereien des Christian Friedrich Herold." *Keramos*, no. 6 (1959).

Seyffarth, Richard. *Johann Gregorius Höroldt*. Dresden: Verlag der Kunst, 1981.

————. "Marken der 'Königlichen-Porcelain-Manufactur' zu Meissen von 1721-1750." In *250 Jahre Meissner Porzellan: Die Sammlung Dr. Ernst Schneider im Schloss 'Jägerhof,' Düsseldorf, Keramikfreunde der Schweiz Mitteilungsblatt*, no. 50 (April 1960).

Shono, Masako. *Japanisches Aritaporzellan im sogenannten "Kakiemonstil" als Vorbild für die Meissener Porzellanmanufaktur*. Munich: Schneider, 1973.

Schrijver, Elka. *Hollands porselein*. Bussum: C.A.J. van Dishoeck, 1966.

Soil de Moriamé, Eugène J. *Les Porcelaines de Tournay: Histoire, fabrication, produits*. Tournai: Etablissements Casterman, 1910.

Soil de Moriamé, Eugène J., and Delplace de Formanoir, Lucien. *La Manufacture impériale et royale de porcelaine de Tournay*. 3rd ed. Tournai: Casterman, 1937.

Soudée-Lacombe, Chantal. "Grande époque des faïences de Sinceny (1737-1765)." *Cahiers de la céramique, du verre et des arts du feu* (Sèvres), no. 36 (1964).

The Splendor of Dresden: Five Centuries of Art Collecting. Exhibition catalogue. New York: The Metropolitan Museum of Art, 1978.

Staatliche Kunstsammlungen, Dresden. *Böttgersteinzeug, Böttgerporzellan aus der Dresdener Porzellansammlung.* Exhibition catalogue. Dresden, 1969.

_____. *Kunstschätze aus Dresden.* Exhibition catalogue, Kunsthaus, Zurich. Zurich, 1971.

_____. *Meissen: Frühzeit und Gegenwart: Johann Friedrich Böttger zum 300. Geburtstag.* Exhibition catalogue. Dresden, 1982.

_____. *Porzellan Sammlung.* Dresden, 1982.

Steingräber, Erich. "Email." In *Reallexikon zur Deutschen Kunstgeschichte.* Vol. 5. Stüttgart: Alfred Druckenmüller, 1967.

Synge-Hutchinson, Patrick. "G.D. Ehret's Botanical Designs on Chelsea Porcelain." In The Connoisseur, *The Concise Encyclopedia of Antiques.* Vol. 4. Edited by L.G.G. Ramsey. New York: Hawthorn Books, 1959.

_____. "Sir Hans Sloane's Plants and Other Botanical Subjects on Chelsea Porcelain." *The Connoisseur Yearbook, 1958.* London: The Connoisseur, 1958.

Syz, Hans; Miller, J. Jefferson II; and Rückert, Rainer. *Catalogue of the Hans Syz Collection.* Vol. 1: *Meissen Porcelain and Hausmalerei.* Washington, D.C.: The Smithsonian Institution, 1979.

Tait, Hugh. "Bow." In *English Porcelain 1745-1850,* edited by Robert J. Charleston. London: Ernest Benn, 1965.

_____. "Herold and Hunger." *British Museum Quarterly* 25 (March 1962).

_____. "James Rogers, a Leading Porcelain Painter at Worcester c. 1755-1765." *Connoisseur* 149 (April 1962).

Tilley, Frank. *Teapots and Tea.* Newport, England: Ceramic Book Co., 1957.

Tilmans, Emile. *Faïences de France.* Paris: Editions des Deux-Mondes [1954].

Tokyo National Museum. *Ceramics and Metalwork.* Pageant of Japanese Art. Tokyo: Toto Shuppan, 1958.

Toppin, Aubrey J. "Contributions to the History of Porcelain-making in London, 2, James Giles, Enameller." *English Ceramic Circle Transactions* 1, no. 1 (1933).

Turner, William. *Transfer Printing of Enamels, Porcelain and Pottery: Its Origin and Development in the United Kingdom.* London and New York: Chapman and Hall, 1907.

Twitchett, John. *Derby Porcelain.* London: Barrie & Jenkins, 1980.

Valpy, Nancy. "Some Eighteenth Century Spoon Trays." *Antique Collector* 44, no. 5 (Oct.-Nov. 1973).

Van Gelder, H.E. "Een 18e eeuwse regent bestelde een eetservies." *Mededelingenblad vrienden van de Nederlandse ceramiek,* no. 18 (April 1960).

_____. "Delftse Plateelbakkerij 'de Dissel' (Abr. de Cooge, L. Boersse, C. van der Kloot)." *Mededelingenblad vrienden van de Nederlandse ceramiek,* no. 17 (Dec. 1959).

Vecht, A. *Frederik van Frytom 1632-1702: Life and Work of a Delft Pottery-Decorator.* Amsterdam: Scheltema & Holkema, 1968.

Verlet, Pierre. "Sèvres en 1756." *Cahiers de la céramique et des arts du feu* (Sèvres), no. 4 (Sept. 1956).

Verlet, Pierre, and Grandjean, Serge. *Sèvres.* Vol. 1: *Le XVIIIe siècle, les XIXe & XXe siècles.* Paris: G. Le Prat, 1953.

Victoria and Albert Museum, London. *Catalogue of English Porcelain, Earthenware, Enamels, etc., Collected by Charles Schreiber Esq. M.P. and The Lady Charlotte Elizabeth Schreiber and Presented to the Museum in 1884.* 3 vols. London: H.M. Stationery Office, 1915-1930. Vol. 1: *Porcelain,* vol. 3: *Enamels and Glass,* by Bernard Rackham.

_____. *Catalogue of the Jones Collection.* Pt. 2: *Ceramics, Ormolu, Goldsmith's Work, Enamels...* London, 1924.

Virginia Museum of Fine Arts, Richmond. *Eighteenth-Century Meissen Porcelain from the Margaret M. and Arthur J. Mourot Collection in the Virginia Museum.* Catalogue by J. Jefferson Miller II. Richmond, 1983.

Visser, Minke A. de. "Roode Delftsche theepotten van Lambert van Eenhoorn en van de Rotte in het Groninger Museum." *Oud-Holland* 72 (1957).

Volker, T. "The Japanese Porcelain Trade of the Dutch East India Company between 1682 and 1795." *Mededelingenblad vrienden van de Nederlandse ceramiek,* no. 10 (Jan. 1958).

_____. "Porcelain and the Dutch East India Company." *Mededelingen van het Rijksmuseum voor Volkenkunde, Leiden* 11 (1954).

Walcha, Otto. "Böttgersteinzeug in der Sammlung Dr. Schneider...." In *250 Jahre Meissner Porzellan: Die Sammlung Dr. Ernst Schneider im Schloss "Jägerhof," Düsseldorf. Keramikfreunde der Schweiz Mitteilungsblatt,* no. 50 (April 1960).

_____. "Die Formerzeichen der Manufaktur Meissen aus der Zeit von 1730-1740." *Keramikfreunde der Schweiz Mitteilungsblatt,* no. 42 (1958).

_____. "Höroldts erster Lehrjunge, Johann George Heintze." *Keramikfreunde der Schweiz Mitteilungsblatt,* no. 48 (1959).

_____. "Incunabeln aus dem Meissner Werkarchiv." *Keramikfreunde der Schweiz Mitteilungsblatt,* no. 46 (1959).

_____. *Meissen Porcelain.* Translated by Edmund Reibig. New York: Putnam, 1981.

Wark, Ralph H. "Adam Friedrich von Löwenfinck." In *250 Jahre Meissner Porzellan: Die Sammlung Dr. Ernst Schneider im Schloss "Jägerhof," Dusseldorf. Keramikfreunde der Schweiz Mitteilungsblatt,* no. 50 (April 1960).

_____. "Aktuelle Betrachtungen über Adam Friedrich von Löwenfinck." *Keramos,* no. 38 (Oct. 1967).

Watney, Bernard. *English Blue and White Porcelain of the Eighteenth Century.* London: Faber & Faber, 1963.

_____. "English Enamels in the 18th Century." In *Antiques International: Collector's Guide to Current Trends,* edited by Peter Wilson. New York, 1967.

Watney, Bernard, and Charleston, Robert J. "Petitions for Patents Concerning Porcelain, Glass, and Enamels with Special Reference to Birmingham, 'The Great Toyshop of Europe.'" *English Ceramic Circle Transactions* 6, pt. 2 (1966).

Watson, F.J.B., and Dauterman, Carl C. *The Wrightsman Collection.* Vol. 3: *Furniture, Snuffboxes, Silver, Bookbindings.* New York: The Metropolitan Museum of Art, 1970.

William Duesbury's London Account Book, 1751-3. English Porcelain Circle Monograph. Introduction by Mrs. Donald MacAlister. London: H. Jenkins, 1931.

Williams, Winifred. *Exhibition of Early Derby Porcelain 1750-1770.* London: Williams, 1973.

Württembergisches Landesmuseum, Stuttgart. *Ludwigsburger Porzellan.* Stuttgart: W. Kohlhammer Verlag, 1963.

Zimmermann, Ernst. *Meissner Porzellan.* Leipzig: Karl W. Hiersemann, 1926.